THE DANCING LARES AND
THE SERPENT IN THE GARDEN

THE DANCING LARES
AND THE SERPENT
IN THE GARDEN

Religion at the Roman Street Corner

Harriet I. Flower

Princeton University
PRINCETON AND OXFORD

Copyright © 2017 by Princeton University Press

Published by Princeton University Press,
41 William Street, Princeton, New Jersey 08540

In the United Kingdom: Princeton University Press,
6 Oxford Street, Woodstock, Oxfordshire OX20 1TR

press.princeton.edu

Jacket art: *Lares* and *Genius*. Fresco. Imperial Roman, 69–79 CE. From a *lararium* in
Pompeii. In the lower part are two snakes crawling towards a *cista mystica* (sacred chest,
or basket, used to house snakes). Museo Archeologico Nazionale, Naples, Italy. © Vanni
Archive / Art Resource, NY.

All Rights Reserved

Library of Congress Cataloging-in-Publication Data

Names: Flower, Harriet I., author.

Title: The dancing lares and the serpent in the garden : religion at the Roman street
corner / Harriet I. Flower.

Description: Princeton : Princeton University, 2017. | Includes bibliographical refer-
ences and index.

Identifiers: LCCN 2016055317 | ISBN 9780691175003 (hardcopy : alk. paper)

Subjects: LCSH: Lares. | Serpents—Religious aspects. | Cults—Rome. | Rome—Religious
life and customs. | Rome—Religion.

Classification: LCC BL820.L3 F59 2017 | DDC 292.07—dc23 LC record available at
https://lccn.loc.gov/2016055317

British Library Cataloging-in-Publication Data is available

This publication is made possible in part from the Barr Ferree Foundation Fund for
Publications, Department of Art and Archaeology, Princeton University

This book has been composed in Adobe Text Pro

Printed on acid-free paper. ∞

Printed in the United States of America

10 9 8 7 6 5 4 3 2 1

This book is dedicated to the memory of Robert E. A. Palmer

Frontispiece. Robert E. A. Palmer in front of a *compitum* (a small, round structure of uncertain age) at the Piazza di Numa Pompilio, Rome, where the Via Appia and Via Latina meet two vici Sulpicii. Bell tower of San Sisto Vecchio in the background.

CONTENTS

PREFACE

> Each neighborhood had its own shrinelet to the *lares*, the "tute-
> lary deities" we say, of locality. Think of them, as bodyguards,
> or divine soldiers, or perhaps the divine cops on the beat, while
> the famous gods in the big temples were the great warriors and
> commanders.
> —O'DONNELL 2015, 19–20

This book is dedicated to the fond memory of my teacher, mentor, and friend Robert E. A. Palmer (Professor of Roman History at the University of Pennsylvania from 1961 to 1996), who worked consistently and with singular passion on the neighborhoods (*vici*) of ancient Rome, starting in 1959. My research has been inspired both explicitly and implicitly by the rich archive of material he collected and by a series of stimulating conversations that we had. In the end, however, I have not tried to write the book he would have written about the neighborhoods of Rome and local life as viewed from the ground up. As a result of my own thinking, reading, and visits to Rome over the last ten years, my focus and interpretations have diverged from his in many ways. Nevertheless, every page owes something to his erudition and insights, perhaps especially in places where I have struck out in a completely new direction.

Since 1990, much has been written about the development of Rome as a city, including its vici as social neighborhoods, political communities, and administrative units within a great metropolis. By contrast, my discussion takes as its main focus the cult of *lares*. These little local gods, who were often accompanied by a *genius* (protective spirit) and snake(s) on the Bay of Naples, were to be found at crossroads shrines (*compita*) throughout the city and countryside. Local religious life within the neighborhoods (vici) was expressed in its most characteristic forms in the streets and at the street corners, as well as at the hearth in the kitchen or the atrium by the entrance to each house. Romans of all social classes and their slaves maintained an intimate relationship with their various *lares*. The complementary cults practiced at street corners and in domestic contexts were closely connected to but also independent of the grand civic cults in the city—cults overseen by elite priests and magistrates in public temples and other common spaces.

This study seeks to understand religion as integral and omnipresent in ordinary Roman life at its most basic level, especially for the nonelite, the freedman, and the slave, whether male or female. Much of my material comes from republican times or the early years of Augustus—in other words, from a time that was by definition BC—"before Christianity." The Roman world of *lares* is, therefore, also before "Paganism" was thought of or talked about as separate from Christianity or Judaism. Consequently, I try to address the issue of how far we as modern researchers can rediscover and understand traditional Roman religion independent of pervasive comparisons and contrasts with various monotheisms.

I have tried to use as wide an array of ancient sources as possible, while placing each in its own context. Literary and legal texts of many kinds provide information about *lares*, even as archaeology and epigraphy are vital in the study of non-elites. Topography, iconography, and numismatic evidence help to fill gaps in other sources. Analysis of Roman painting is especially important. My discussion includes case studies of three cities: Rome itself across time, Delos in the late second and early first centuries BC, and Pompeii in the mid-first century AD. Much is lost, but what we do have can provide vivid glimpses of shrine and ritual, of everyday relationships between Romans and the gods who protected their homes, neighborhoods, and farms—gods they shared freely with their slaves and dependents, as they formed households and local communities.

It is essential to acknowledge, however, that a simplistic combination of disparate evidence from different times and places has and will not produce a satisfactory reconstruction of *lares* in Rome. As Augusto Fraschetti warned in criticizing earlier research on *lares*:

> . . . questa tendenza "combinatoria" mentre ha cercato di illustrare le articolazioni del tessuto urbano di Roma con materiali di provenienza eterogenea (non solo da Capua, ma soppratutto anche da Minturno e da Delo) immancabilmente ha dato come risultati "combinazioni" tanto più incerte nella misura in cui i materiali, di cui si è servita, sono essi stessi ancora oggetto di discussione, con estrema probabilita, di fatto non immediatamente omologhi.

> . . . this tendency to "combine" has sought to illustrate the articulation of Rome's urban fabric with material from different proveniences (not only from Capua but especially from Minturnae and Delos) and has definitely yielded "combined" results that are all the more uncertain in relation to the degree to which the pieces of evidence that were used are themselves still being debated and are most probably not homologous to each other.
>
> (Fraschetti 2005, 120 [first edition published in 1990])

Rather than searching for a standard "practice" or "system" across time and space, this investigation aims to build with care on a series of individual, detailed studies of extant material. Each example of attested ancient life will be examined in its own context before it can be adduced to inform other examples of (apparently) similar practices. The *lares* flourished in a religious landscape that was rich with variety and dynamic with change, one not defined by orthodoxy in belief or even conformity in practice. Their significance is shown precisely by how their simple cults survived throughout antiquity in an ever-changing world and by how they appealed to many new citizens who had formerly been slaves.

My study is divided into four large "parts," each articulated by smaller "sections." Part I looks at the nature of *lares* as deities. Who were they? What other gods were associated with them and in what ways? Who cultivated them and where? What can their rather standardized iconography and rituals tell us about how Romans lived with them? Part II presents the evidence for cult sites that honored *lares* in Rome, which ranged from civic temples (*aedes*) to a wide variety of smaller, open-air shrines (*sacella*). Some of these little sanctuaries were unique and others were part of a complex and officially recognized network of crossroads chapels (*compita*).

Meanwhile, *lares* were not the only gods worshipped on Roman streets. The streetscape of Pompeii offers the best case study, since it is our only extant example of what street shrines looked like in an urban landscape, although not in a pattern that was typical in Flavian Rome at that time (in the years immediately before the devastating volcanic eruption of AD 79 on the Bay of Naples). Part II also includes a reconsideration of the offerings made to *lares* by a Roman bride on her wedding day (as described by Varro) when she was accompanied in procession to her new home and took on her role as a married woman (*matrona*).

Parts I and II furnish the essential background to part III, which examines how *lares* were celebrated in public, especially at the great midwinter festival of Compitalia, a movable feast that fell in late December or early January on a day announced publicly by the urban praetor. What can this festival tell us about these gods and their worshippers? How did *compita* (crossroads shrines) stand in relation to vici (urban neighborhoods) and their local leaders (*vicomagistri*)? Paintings from Hellenistic Delos, where many Roman and Italian traders had establishments staffed by freedmen and slaves, enhance our understanding of how the republican festival of Compitalia could be advertised and commemorated, over several generations before Mithridates VI of Pontus sacked the island of Delos. Subsequently, evidence from Rome shows how Compitalia became increasingly controversial and its games (*ludi compitalicii*) were even subject to senatorial sanctions in the 60s and 50s BC. The festival developed a popular political overtone and even a reputation for violence, at least in the Rome of Clodius and Milo.

Part IV concludes the study by examining the relationship of Augustus, the first *princeps*, to *lares* cults in Rome. In 7 BC, Augustus completed a great urban reform that created fourteen *regiones* as the administrative units in the city. At the same time, he renamed the *lares compitales* at the crossroads shrines as *lares augusti* (august *lares*), associating his own epithet (the adjective *augustus*) with local cults in the neighborhoods twenty years after he had taken this "holy" name. He added two new festivals for decorating the crossroads shrines with flowers in spring and summer (perhaps on 1st May and 1st August). Augustus' interest in local religion can be read in various ways. On the one hand, it can be seen as a reflection of the earlier history of *lares* cults and the traditional roles of their shrines and festivals. On the other, it is an expression of his own aim to be a new kind of patron who had direct contact with even the humblest inhabitants of the city. The enthusiasm with which freedmen and slaves celebrated these new *lares augusti*, spent their own money to adorn compital shrines, and, on their own initiative, extended the epithet *augustus/a* to other local gods speaks to the success of the princeps' policies and the key role played by *lares* in traditional Roman culture. Meanwhile, a local cult of *lares augusti* at the crossroads shrines seems only to have been found in Rome; it marked the special relationship of Augustus with the capital of the empire. This book concludes with an epilogue that offers a brief reflection of the ban on traditional offerings to *lares* in the fourth century AD as integral to Christian attacks on traditional Roman religion.

* * *

Over the many years since I first started to think about *lares* at the street corners, I have had help from many generous colleagues and friends. I would particularly

like to acknowledge the following: Taylor Anderson, Yelena Baraz, Bettina Bergmann, Seth Bernard, Corey Brennan, Richard Brilliant, Peter Brown, Meghan DiLuzio, Jackie and Bob Dunn, Chris Faraone, Denis Feeney, Stephen Heyworth, Lora Holland, Bob Kaster, Joshua Katz, Michael Maas, John Miller, Josiah Osgood, Dan-el Padilla Peralta, Jason Pedicone, Brian Rose, Jörg Rüpke, Susan Satterfield, Celia Schultz, Jennifer and Arthur Stephens, Nicola Terrenato, Sig. Duccio Valori, Alan Walker, and Nino Zchomelidse. My colleague Michael Koortbojian read the whole manuscript and made many invaluable suggestions. I also gained a range of insights from audiences who reacted to papers I delivered at Bryn Mawr College, Columbia University, the University of Pennsylvania, the University of Sydney, Johns Hopkins University, the University of Erfurt, and the Annual Meeting of the Society for Classical Studies in Chicago (2014). The anonymous readers helped me to improve the manuscript in many ways. Remaining errors and flights of fancy are all my own responsibility.

I owe special thanks to the Classics Department at Princeton University (and its Magie Fund), the staff of Mathey College (Princeton University), where I have had the privilege of serving as Head of College since 2010, and the American Academy in Rome, for a summer stay in 2006. The members of my reading group about republican Rome (known as *SPQR*) provided steady encouragement over the years. The production of this book in its present format was made possible by a generous grant from the Barr Ferree Fund (Department of Art and Archaeology, Princeton University).

Illustrations were drawn by Meg Andrews, Joshua Fincher, and Rosalind Flower. I am especially grateful to the following for assistance in obtaining permissions for illustrations: Alessandro Giammei, Daniel Healey, Nino Luraghi, Pierluigi Serraino, Tesse Stek, Melina Tamiolaki, and Mantha Zarmakoupi. At the Marquand Library of Art and Archaeology (Princeton University), I am indebted to Jessica Hoppe Dagci and John Błażejewski. Crucial editorial help was provided by Nicole Brown, Joshua Fincher, and Isabel Flower. For administrative support at Princeton, I relied on Nancy Blaustein, Susan Lehre, and Tiffany Falter.

The following museums and libraries provided the illustrations for this book, as well as the permissions to publish them: Amsterdam University Press, the Ephor of Antiquities of the Cyclades (Dr. Maria Sigala); Gallerie degli Uffizi (Dr. Eike Schmidt); Mount Holyoke College Art Museum (Taylor Anderson); Nomos AG in Zurich (Dr. Alan Walker); Soprintendanza Speciale per Pompei, Ercolano e Stabia (Dr. Massimo Osanna); W. Bruce and Delaney H. Lundberg; J. Paul Getty Museum; Universitätsbibliothek Heidelberg, Digitalisierungszentrum (Michaela Meiser); Cologne Digital Archaeology Lab in the Archäologisches Institut, Cologne University (Matthias Nieberle); Museo Nazionale Romano (Dr. Rosanna Friggeri and Dr. Carlotta Caruso); Musei Capitolini (Dr. Claudio Parisi Presicce, Angela Carbonaro); Marquand Library of Art and Archaeology at Princeton University (Sandra Ludig Brooke); Istituto Poligrafico e Zecca della Stato (Rafaella Cornacchini); The British Museum (Ian Calderwood); Deutsches Archäologisches Institut, Rom (Daria Lanzuolo); Musei Vaticani (Dr. Antonio Paolucci, Dr. Rosanna Di Pinto); Museo Archeologico Nazionale di Napoli (Dr. Paolo Giulierini, Dr. Alessandra Villone); and the Digital Humanities Center and Photographic Archive at the American Academy in Rome (Maria Sole Fabri). I am very grateful for their generosity.

My editor Rob Tempio again proved great to work with, as did Sara Lerner and Jessica Yao at the Princeton University Press. Jennifer Harris provided superb copyediting.

Michael Flower has been a constant critic and friend over nearly forty years. Without his help and support, this book would never have been written.

<div align="right">

Princeton, NJ
15th August 2016

</div>

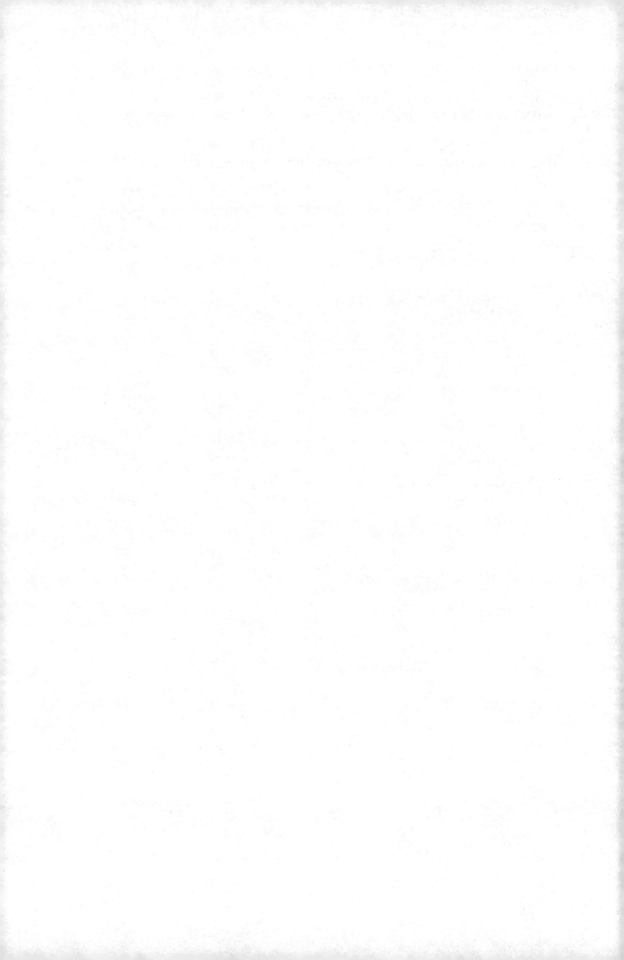

THE DANCING LARES AND
THE SERPENT IN THE GARDEN

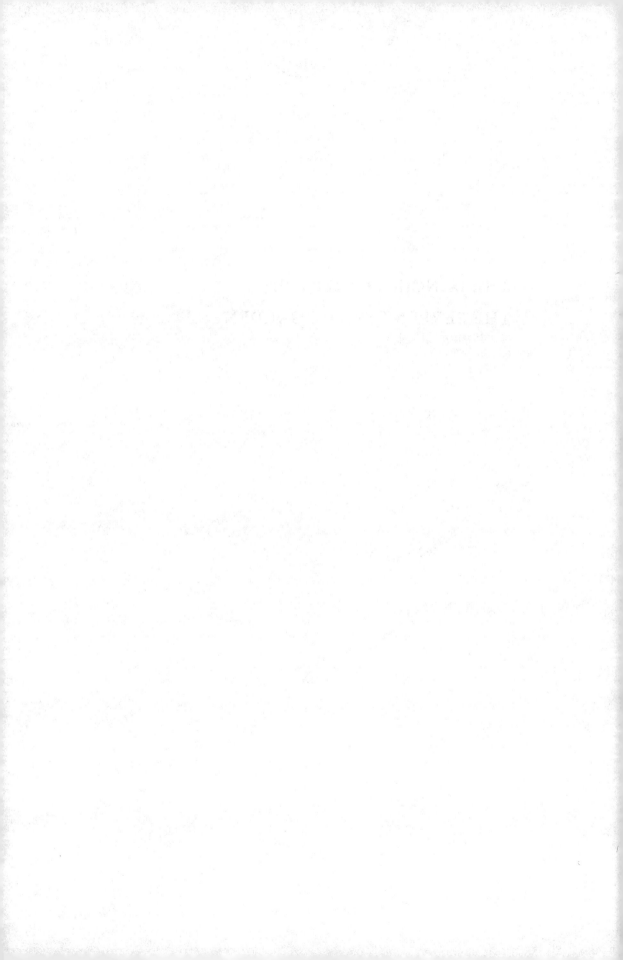

LAR(ES) / GENIUS AND JUNO / SNAKE(S)

vosque lares tectum nostrum qui funditus curant
—ENNIUS *ANNALES* FR. 619

The Romans imagined themselves, whether in town or in the countryside, as living in a world full of gods, which meant a world full of *lares*. From monumental temples to modest altars at street corners, from household shrines to tiny, portable bronze statuettes, inhabitants of Rome (and many other places in Italy and beyond) spent their days under the watchful care of a multitude of different *lares*. As the case of Pompeii, the best-preserved ancient city, reveals, the religious landscape of a Roman(ized) town consisted of a handful of temples in their own dedicated precincts balanced by dozens of street altars and hundreds of domestic shrines inside houses and places of business. The *lares* (and the snakes who so often accompany them on the Bay of Naples) far outnumbered the other, grander gods of civic cult, since they permeated both the various urban networks and individual domestic spaces. In simple visual terms, a person walking around the city streets in the first century AD and entering the houses, shops, or places of production was constantly encountering easily recognizable twin *lares* in similar iconographic patterns, many freshly (re)painted and often accompanied by visible signs of recent offerings. That is to say, the *lares* could be found in both civic and domestic contexts. But what kinds of deities were these *lares*? Why were there so many of them? What can we learn about them from the way they were represented and from the offerings they received?

This first part aims to address these fundamental questions about the nature of the *lares* and of the snakes by using a wide variety of extant ancient evidence that is relevant to these much disputed deities. There can be no doubt that *lares* were thought of as very ancient deities, who were ubiquitous in the home, on the farm, and at the street corner in a town, in a characteristically Roman pattern. In fact, their very names are often used as synonyms for the home in classical Latin. Beyond that, agreement has been hard to reach, since scholarly debates about their identity started in antiquity even in the lifetime of Marcus Terentius Varro (116–27 BC), our most important learned source for Roman religion. But how could educated Romans be in doubt about the character of such familiar gods? And how can we, in turn, negotiate their hesitations and inconsistencies in our own analysis?

The intricate debate about the nature of the *lares* that engaged learned Romans in the first century BC and, consequently, about the meaning of the rituals addressed to them or vice versa, depending on how the argument is framed, was itself a cultural product of the intellectual climate at the time.[1] Amid political strife and religious uncertainty, the years between 60 and 40 BC saw intense debate

1 See Rawson 1985 for an overview, with Fantham 2004 and Stroup 2010.

between Roman intellectuals about origins, meanings, and identity in their culture. Consequently, these men engaged in the avid collection of antiquarian information relevant to their own institutions. The political upheavals that attended the decay of republican government and the emergence of one-man rule, including a series of brutal civil wars, produced a sharp sense of loss and of nostalgia for past practices, especially but not exclusively among the elites. It is essential to keep in mind that republican political habits had been closely associated with traditional Roman religion and its central concept of a state of harmony with the gods that allowed the Roman community to survive, flourish, and take a role of leadership in the Mediterranean. There was much at stake for men like Varro, both personally and collectively.

Subsequently, this ancient discussion about the nature of the *lares* has been the source of modern disagreements over how to understand these deities within the general framework of Roman religious life. In order to come to terms with the debate between ancient writers, we need to understand its parameters and purpose within its original historical and intellectual context. A study of *lares* (together with their frequent companions, a *genius* and a pair of snakes) raises questions that are fundamental to an understanding of Roman religion at the level of its most frequently practiced rituals, those that shaped the everyday religious experience of ordinary Romans and their slaves at home and in the local neighborhood.

Over the last century, two interpretations of the *lares* by modern scholars of Roman religion have presented diametrically opposed readings: either the *lares* were guardian gods identified primarily with places (but, therefore, also with the roads between these different places) *or* they were the (potentially restless) spirits of deceased family members, which would make them underworld spirits.[2] Although the snakes are the most frequently depicted local deities in Pompeii, no extant literary source mentions them. Consequently, they have also been associated either with place, or with the head of the household, or with the dead, according to the view taken of the *lares* or of the *genius* (male protective spirit) who so often appear near them.[3]

But who were the gods who watched over the Roman home and local neighborhood? Were all these spaces really imagined as being inhabited by the spirits of the dead? Did Romans trust and celebrate their *lares* or fear and appease them? In order to find satisfactory answers, we must be logical and careful in our use of a wide range of sometimes completely contradictory ancient sources, which come from different time periods and places. Treating all ancient evidence as equally authoritative has produced a stalemate. In other words, it is not simply a question of theology but of methodology in studying religious practice, from the reading of a

2 For the extensive and heated debate on the nature of the *lares*, the following authors are of particular note. For the *lares* as gods of place: Wissowa 1912; Kunckel 1974; Bömer 1981; Scheid 1990, 587–98; Fröhlich 1991; Foss 1997; Van Andringa 2000; Lott 2004; and Forsythe 2005, 131 and 146. For the *lares* as deified mortals: Samter 1901; Tabeling 1932; Niebling 1956; Cornell 1975 and 1995, 75; Mastrocinque 1988; Carandini 1997; Coarelli 2003; Fraschetti 2005 (first published 1990); Tarpin 2002 and 2008; Scheid 2007; Bodel 2008; Giacobello 2008, 129; and Coarelli 2012, 174–85. Scullard 1981 and Wallace-Hadrill 2008 do not take a position. Robert Phillips in the *OCD*[4] claims it is impossible to choose between the two explanations. It is time to move beyond this dispute about the basic nature of the gods. In what follows, I hope to make a persuasive argument in favor of the *lares* as gods of place.

3 For the (similar) debate about the snakes, see section I.viii later.

text to the analysis of iconography to the understanding of the placement and cultivation of local shrines.

Much innovative and careful work on Roman religion over the last generation has insisted on the primacy of rituals themselves as generators both of experience and of meaning in a religious world that lacked official theological systemization and teaching.[4] A painstaking method of elucidating ritual gesture and action as described in texts can be complemented by the study of religious iconography, especially in cases where visual language is well attested and integrated into cult sites, as is the case for the *lares* and the snakes at Pompeii. Consequently, these approaches avoid the multiple explanations and convoluted combinations produced by syncretism, whether ancient or modern.

In accordance with this methodology, carefully chosen ancient sources must be scrutinized with great care in order to discover what they do and do not tell us about actual religious practices and, consequently, about the logic and significance behind the actions performed. Meanwhile, the debates of ancient authors (mostly antiquarians and learned theorizers) can and must not be confused with the real-life practices of actual participants in the rituals themselves.[5] That is to say, in a culture without an established religion defined by an authoritative book of scripture, theological exegesis was often a private matter and was pursued at will by learned men of leisure, who cultivated debate and dispute for their own intellectual purposes, with a special focus on the arcane and archaic. Their freedom of discussion was based on the fact that their interpretations had no general significance for or application to actual religious life, especially that of ordinary people.

Cicero and his friends were completely at liberty not only to debate the nature of the gods themselves and of man's relationship to them (at their villas in their spare time) but also to circulate the resulting thoughts in writing (often in the form of dialogues) without fear of seeming either ungodly or un-Roman.[6] Cicero's *de Natura Deorum* (45 BC) and *de Divinatione* (44 BC) are key texts that survive from this debate, written in the time of turmoil at the end of Julius Caesar's life and soon after his murder. These same elite Romans were (mostly) quite content to return to Rome from their vacation times and to participate in and even to preside over traditional religious observances in an orthodox manner. They did not worry about or perhaps even perceive a contradiction between their public lives, their official religious functions as magistrates and priests in state cults or as heads of households, and their intellectual debates about the divine and about what religion either had once been or should ideally be. Indeed, many of their learned writings were based either on explaining the venerable origin of various deities or cults or on advocating

4 See Scheid 2001a and 2005a and Prescendi 2007. Their reading of rituals can be complemented by the conceptual approach of Lipka 2009, adapted by O'Donnell 2015, 55–69.

5 Wissowa 1912, 174, already noted the creativity of the Romans in seeking deeper explanations of the *lares*. Almost a century later, Prescendi 2007, 7: "L'exemple des *Lares* et de leur mère montre qu'on ne peut pas entreprendre une recherche sur la pratique et la réalité cultuelle des religions anciennes en partant des réflexions des écrivains de l'Antiquité." [The example of the *lares* and of their mother shows that one cannot investigate the practice and reality of cult in ancient religions taking the reflections of ancient authors as a starting point.]

6 The principal antiquarian authors whose views we have access to are M. Terentius Varro (116–27 BC); Pliny the Elder (AD 23–79); Aulus Gellius (ca. AD 125– after AD 180); S. Pompeius Festus (later second century AD); Maurus Servius Honoratus (late fourth to early fifth century AD); and Macrobius Ambrosius Theodosius (early fifth century AD). See Rawson 1985, 233–49, for an overview of such writing in the first century BC, with Beard, North, and Price 1998, 152–54.

for a completely new approach, albeit usually in a theoretical realm. Their aim was rarely to describe contemporary cult practices in a way that would be most useful for modern scholars.

Whatever the method employed by each writer, the nature of these ancient texts is scholarly, often divorced from actual practices, and essentially personal. Nor did they have a role in civic cult or discourse. These books did not represent the official views of any priestly college or prophetic religious leader, even when written by a Roman who also held a priestly office. We do not have access to a dossier of judgments of priestly colleges in response to individual consultants or to the senate. While the surviving texts obviously have a great deal to tell us about the intellectual climate of republican Rome, especially in the first century BC, they cannot serve either as catechisms or as ethnographic field guides for any Roman cult. Rather, Roman rituals can only really be understood by recovering (as far as possible) their practice, since the thoughts and emotions of the ancient participants are largely lost to us.

Such general considerations are especially applicable in the case of *lares*, since many of their shrines were cultivated primarily by ordinary Romans, and particularly by freedmen and slaves, who were mostly not the writers of academic discussions of religion or antiquarian treatises. By the first century BC, the *lares* cult was organized and overseen by freedmen and slaves or by Roman citizens of a very humble station, especially in its practice at the crossroads shrines (*compita*) in the local neighborhoods (vici).[7] In larger households, such as those of Varro or Cicero, the main focus of the cult was the shrine in or near the kitchen, which was to be found in the domestic realm of the slaves. In other words, Roman authors who were from the educated elite class may not have been as regularly involved in the cult of the *lares* as in many other rituals they chose to write about.

The close association, over time, of traditional Roman *lares* cults with slaves and freedmen can be connected with four interrelated historical factors, each relating to Rome's rapidly expanding empire: the enormous growth of domestic slavery as a result of Rome's victories in war, the Roman habit of freeing slaves (who became new citizens), the practice of absentee farming of estates in Italy (itself funded by the profits of war and based upon the labor of slaves who were prisoners of war), and the development of kitchens as separate rooms, once the houses of the affluent grew larger and more sophisticated in their layout and design. In earlier times, smaller and simpler Roman houses had focused on a central *atrium*, where cooking and eating happened close to a single, main hearth, the focal source of heat and light for everyone. In such a setting, lar(es) had always been present at the center of family life. The moving of food preparation to a designated cooking area, usually in the servants' quarters, resulted in the reconfiguration of the hearth, seat of the lar(es), to a new domestic context. The building of much bigger houses, with rooms for separate functions, was also funded by the increased wealth of the imperial elites and inspired by the Hellenized lifestyles these Roman leaders had encountered abroad.[8] Similarly, these large houses together with their domestic shrines were maintained and staffed by slaves, themselves the spoils of Rome's

7 For the cult of the *lares* as a religion of and for slaves, see esp. Bömer 1981 and Fröhlich 1991.

8 It is not within the scope of this discussion to offer a detailed history of the Roman house. For evidence about cooking and dining from Pompeii, see especially Foss 1994 and Kastenmeier 2007.

imperial wars. Those who gained their freedom remained active participants in the *lares* cult, especially at the compital shrines. Meanwhile, we have little access to the religious practices of the poor, whether freeborn or freed from slavery, many of whom will have lived in one room and perhaps even without a hearth.

* * *

The first part of this book is organized into nine interrelated sections. Since the evidence about the *lares* is so fragmented and disparate, each ancient text or image will be examined in its own right. In order to clear the ground for the discussion that follows, I will first address the debate in the antiquarian sources about the basic nature of *lares*, which may have originated with P. Nigidius Figulus and Varro himself in the first century BC. In this opening section (i), I argue against the interpretation of *lares* as spirits of the deceased and in favor of seeing them as benevolent deities of place and of travel. Moving on from the theoretical classification of these distinctly academic texts, sections ii and iii look at both literary and epigraphic evidence from the archaic Arval hymn onward, with a special focus on republican authors, including Naevius, Ennius, Cassius Hemina, Afranius, Laberius, and notably the well-preserved texts of Plautus and of Cato the Elder. Section iv considers which Latin authors, in both prose and verse, refer to twin *lares* as opposed to a single *lar*, or both configurations of deities.

The idealized description of the cult of the *lar* practiced at the hearth by the *vilica* (female farm manager) given by Cato the Elder in his *de Agricultura* of the mid-second century BC (section v) will then be juxtaposed and compared with the rich evidence provided by the *lares* paintings preserved in and around the kitchens of Pompeii, mostly from the 60s and 70s AD (sections vi and vii). In section viii, the serpents are discussed in their own right, in the characteristic setting of the "gardens" depicted by painters on the Bay of Naples. At the end, section ix draws together the evidence from painted iconography, written text, and ritual custom to suggest an overall interpretation of the *lares* and snakes as "gods of place," who receive gifts and honor from a *genius* (usually the protective spirit of the master of the house, the *paterfamilias*) on the Bay of Naples. The subject of this discussion is the fundamental character of the *lares* as deities (what *kind* of god is a *lar*?), not a search for a single, standard cult for all such deities. Rather many local variants of cultic practice, at different times and in different places, celebrated these cheerful dancing gods as central to the religious world as conceived by the Roman imagination.

I VARRO HESITATES . . .

> For the Romans, the greatest of their antiquarians was the
> first-century Varro . . .
> —BEARD, NORTH, AND PRICE 1998, 8

It is time now to turn with all due caution to the antiquarian texts and to see what
they have to tell us about *lares*. Unfortunately, but hardly surprisingly, their expla-
nations tend to be contradictory, confusing, and sometimes plainly at odds with
older, more direct evidence. For example, Censorinus, writing a book about the
birthday (*de Die Natali*) in the early third century AD, records an opinion of many
earlier authors, including especially the scholar of law and religion Granius Flac-
cus (first century BC) in a work on prayer formulas that he had dedicated to Julius
Caesar:

> Eundem esse genium et larem multi veteres memoriae prodiderunt, in quis
> etiam Granius Flaccus in libro, quem ad Caesarem de indigitamentis scrip-
> tum reliquit.

> Many ancients handed on the tradition that a *genius* and a *lar* are the same,
> among whom (is) also Granius Flaccus in a book dedicated to Julius Caesar,
> which he wrote about the names (and rituals) of the traditional gods (that
> is, those recognized by the *pontifices* in their technical writings).
> (Censorinus *de Die Natali* 3.2)

The notion that the *lar* and the *genius* are the same type of deity is at variance with
nearly all our other evidence. A clear distinction between the two deities is dem-
onstrated beyond any reasonable doubt by the iconography of the many paintings
from Campania that depict them together but as two quite differently rendered di-
vinities, who are honored in different settings and with separate, distinct gifts.

As Censorinus himself goes on to show in detail in his birthday book, the
genius is closely associated with each individual person, appearing at a birth and
leaving the world at death, which is not at all the case with the *lares*.[1] It is highly
suggestive, therefore, that he chooses to cite a commonly held view for which he
even provides a source citation that is so completely at variance with the main ar-
gument of his own book about births and birthdays. Censorinus' strategy as an
author includes such scholarly asides that he thinks his readers will be interested
in. His purpose is variety and learning, not a strictly persuasive and logical argu-
ment for accepted or even acceptable doctrine. Rather he wants the reader to be
aware that he has read widely and is correcting common mistakes. Citing a fa-
mous authority for an opposing view serves, therefore, to enhance Censorinus'
own self-presentation as a scholar and expert.

Meanwhile, much debate, both ancient and modern, has hinged on a famous pas-
sage in Arnobius (ca. 290s AD, writing about 50 years after Censorinus), a learned

1 Censorinus, who was probably a descendant of the republican noble family of the Marcii
Censorini, wrote his birthday book as a present for Q. Caerellius in AD 238. His most important
source seems to have been Varro. The book's popularity is attested by many surviving manu-
scripts. See Sallmann 1983 and 1988, with the new English edition by Parker 2007.

convert to Christianity, whose books of attack on traditional religious practices (*Adversus Gentiles*) were specifically designed to demonstrate his allegiance to his new faith.[2] In this section, he draws on a variety of sources by the authoritative first-century scholars P. Nigidius Figulus and M. Terentius Varro, whose works are now largely lost.[3]

> Possumus, si uidetur, summatim aliquid et de Laribus dicere, quos arbitratur uulgus uicorum atque itinerum deos esse ex eo quod Graecia uicos cognominat λαύρας. In diuersis Nigidius scriptis, modo tectorum domumque custodes, modo Curetas illos, qui occultasse perhibentur Iouis aeribus aliquando uagitum, modo Digitos Samothracos, quos quinque indicant Graeci Idaeos Dactylos nuncupari. Varro, similiter haesitans, nunc esse illos Manes et ideo Maniam matrem esse cognominatam Larum, nunc aerios rursus deos et heroas pronuntiat appellari, nunc antiquorum sententias sequens Laruas esse dicit Lares, quasi quosdam genios, et functorum animas mortuorum.

> If it seems appropriate, we can also say something in brief about *lares*, whom the common people consider the gods of the streets and paths because in Greek the streets are called *lauras*. In various writings Nigidius (Figulus) calls them now the guardians of house and home, then those Curetes who once managed to conceal Jove's wailing with the clashing of their weapons, then the five Digiti from Samothrace, whom the Greeks tell us are named Idaei Dactyli. Varro is similarly hesitant, now saying they should be called *manes* (spirits of the kindly dead), which is why Mania is called mother of *lares*, then again gods of the air and heroes, now declaring the *lares* to be spirits of the restless dead (*larvae*), following the opinion of ancient writers, as if they were sorts of personal protective spirits (*genii*) and the souls of those who have died.
>
> (Arnobius *Adversus Gentiles* 3.41)

Interestingly, Arnobius starts by admitting that he knows perfectly well what the practitioners of the *lares* cult at the neighborhood altars themselves think, which is that the *lares* are gods of the streets or neighborhoods (vici) and roads (*itinera*). Not content with the opinion of the uneducated (*uulgus*), despite its being supported by a fanciful etymology from the Greek, he proceeds to collect a learned list of diverse explanations as to the nature of these gods, making a show of his own erudition and extensive research on this subject. Unfortunately, it is not possible

2 Arnobius the Elder, who died around AD 330, was a Christian rhetorician from Sicca in North Africa, who was writing around the turn of the fourth century AD. We know very little about his life, but see Jerome *Ep.* 70.5 and *vir ill.* 79. His work survives in a single ninth century AD manuscript in Paris. Although the sources he cites are often authoritative, we cannot know how accurately he reproduces what they said. Beard, North, and Price 1998, 8 n. 18, stress the fact that Arnobius and Augustine cite earlier authors for their own purposes and do not, therefore, even try to do justice to their arguments in their original contexts.

3 P. Nigidius Figulus was a naturalist and grammarian, a follower of Pythagoras (Kahn 2001, 91–92), who was praetor in 58 BC. He wrote a nineteen-book work on the gods. He appears as a speaker in Cicero's *Timaeus*. See Liuzzi 1983 (text with Italian translation) with della Casa 1962; Rawson 1985, 309–12; Turfa 2006; Engels 2007, 126–27; and Schmidt in *BNP*. For M. Terentius Varro, see the introduction by Sallmann in *BNP* (for a list of works and bibliography) with Rawson 1985, 312–16; Engels 2007, 165–72; and Wiseman 2009.

for us to judge how far Arnobius may himself be distorting what these earlier writers said.

P. Nigidius Figulus (ca. 98–45 BC), the slightly less eminent of his two chosen authorities, also recorded a version of *lares* as guardians of place, but in other passages seeks to equate the *lares* either with figures of Greek myth who helped Jupiter as an infant on Crete (Curetes) or with the Great Gods of Samothrace (Cabiri).[4] Yet he does not seem to have chosen between these options or put them into a clear relation with each other, at least according to Arnobius. However, ancient authors often cited from memory rather than having an array of texts open in front of them. Arnobius is just providing us with glimpses of what his sources said.

Arnobius then moves on to cite M. Terentius Varro (116–27 BC), the most learned scholar of Roman religion and culture in the mid-first century BC. Here, however, he draws attention to Varro's hesitation, which is not typical of the famous polymath but is described as being shared with Figulus in the case of the *lares*. Varro was well aware of his prominent status as a leading intellectual of his day. He wrote widely and prescriptively on many aspects of Roman history, religion, culture, and custom. In addition, he circulated his criticisms of contemporary politics, fashion, and habits in satirical form in a variety of genres. Varro was a public intellectual who boldly expressed his opinions both on historical matters and on contemporary issues.[5] It was simply not his habit or his intention to express doubt in his writings. Rather, it was part of his scholarly method to demonstrate his virtuosity in collecting the available material to produce an authoritative synthesis, which was usually followed by his own decisive contribution to the debate in question. Varro's hesitation should, therefore, make us realize that the explanations he records were highly debated and debatable even when he was writing. In this case, he was apparently unable to reach a conclusion that he himself found satisfactory, at least according to Arnobius.

Varro offers the following three options for explaining the *lares*: they are *manes* (spirits of the deceased) and that is why their mother is Mania; they are not gods of the underworld at all but of the sky who should be called "heroes" in Greek; their name *lares* should mean ghosts (*laruae*), which makes them souls of the dead (as if some kind of *genius*). Varro's indecision is logically caused by the fact that his three explanations are mutually exclusive, as he himself clearly realized. With very few exceptions, such as Persephone who regularly traveled between the underworld and the world of men, ancient gods belonged to particular spheres. Underworld gods were not and could not be the "same" as the gods of the sky or of the world of men.[6]

4 For the Curetes, young mythological beings who protected the infant Zeus in a cave at Dicte on Crete (or on Mount Ida), see Schwenn *RE* (Kureten); Gordon in *BNP* Curetes; and Burkert 1985 168, 202, 392. For the Great Gods of Samothrace, see Hyginus *Fab.* 139.4. Their sanctuary was well developed by 200 BC and had been recently patronized by Philip V. See Gordon in *BNP* and Cole 1984 and 1989 for an overview. The best recent discussion is Wescoat 2013. Yet each of these examples are collective groups of deities rather than identical twins. The latter explanation may perhaps have some relationship to the early second century BC temple of the *lares permarini* on the Campus Martius in Rome (which is discussed later in section II.xi). This temple has been interpreted by some as an assimilation of the *lares permarini* to the famous gods of Samothrace, although these were more usually identified with the *penates* brought from Troy by Aeneas.

5 Beard, North, and Price 1998, 153: "Varro was himself contributing to the history of religious thought as much as he was commenting on that history."

6 Scullion 1994 usefully clarifies the fundamental distinction between Olympian and Chthonian gods in Greek religion.

Moreover, Arnobius' paraphrase implies that Varro made a deliberate contrast between his first two alternatives, the *manes* and the "heroes." Similarly, although not as explicitly articulated here, *dii manes* (ordinary spirits of the deceased) were classified as being very different from *laruae* (ghosts who were restless and often characterized as malicious). The spirits of the dead (*manes*) were normally associated with their tombs outside the city, where Romans made annual offerings to family members.[7] By contrast, ghosts (*larvae*), described as the spirits of those not properly buried or of individuals who had died violently, wandered around and might even invade and take up residence in a house.[8] Such a house would then be regarded as "haunted," an undesirable condition that needed to be rectified through rituals of exorcism and purification.[9] Under normal circumstances, Roman houses were not imagined as being inhabited by malicious spirits or ghosts. In fact, every head of household took annual precautions, through a series of ceremonies and prayers on the festival of the Lemuria in May, to expel and repel any ghosts or evil spirits from his house.[10]

To sum up briefly: Arnobius cites two learned Romans of Cicero's day, Varro and Figulus, each of whom mentioned three separate but mutually exclusive explanations for the character and name of the *lares*, giving the reader a total of six distinct options. At the same time, Arnobius indicates that Nigidius Figulus and Varro did not themselves engage in another of their typical scholarly habits, that of equating different cult titles or attributes of a deity to produce a kaleidoscopic but syncretistic and unified picture. Rather, each author expressed equivalent reservations (*similiter haesitans*) precisely because the explanations were, in fact, completely at variance with each other within the logic of Roman religious thought.[11]

Varro knew that in the Roman concept of the cosmos a god could not belong both to the world above and to the underworld, just as most deities were not thought of as being both malicious and protective at the same time. Possibly for this very reason, Nigidius completely avoided mentioning associations of *lares* with the world of the dead (although he surely knew of these common ideas) in favor of a different contrast between either Greek myth or Roman local traditions. None of these three authors (Nigidius, Varro, or Arnobius himself) preferred the explanation of the *lares* as gods of place, despite the fact that this was the version associated with the cult practiced at the neighborhood shrines (*compita*) throughout Rome or with the *lar familiaris* at the hearth. The subsequent discussion about *lares* as spirits of the deceased seems to go back to Varro's treatment, as so much else does. The

7 See Cicero *de Leg.* 2.9.22. Prescendi in *BNP* gives a basic introduction to *manes*. Ducos 1995, 137, establishes that *di manes* are not the spirits of the unburied, the *insepulti*. For the cult at the tombs and the festival of Parentalia, see Cumont 1949; Toynbee 1971, 37–39; Lavagne 1987; and especially Scheid 1993.

8 For *larvae* and *lemures*, see Plautus *Capt.* 598 and *Aul.* 642 (spirits that cause madness), with Apuleius *de deo Socr.* 152–153 (*larvae* are dangerous, *lares* are peaceful) and Festus 25L, 77L, 114L. For discussion, see Wissowa 1912, 235–36; Toynbee 1971, 33–39; and Prescendi in *BNP*.

9 Pliny *Ep.* 7.27 is the classic source.

10 The Lemuria fell on 9, 11, and 13 May (Ovid *Fast.* 5. 431–44); Prescendi 2007, 199–200, and *ThesCRA* 2004, 280–81 and 290–91. See Wissowa 1912, 235–36; Toynbee 1971, 64; Scullard 1981, 74–76; and Wiseman 1995a, 71 and 174 n. 82. The offering of beans by the paterfamilias to the *lemures* suggests an offering of food, but one that was designed to include as little contact with the recipients as possible.

11 Rawson 1985, 316: "Nigidius' amalgam was no doubt largely his own. So, certainly, was Varro's combination of Greek philosophy and Roman antiquarianism."

very inability or unwillingness of Nigidius and Varro to define the *lares* precisely should make us wary of how we make use of these and other learned and antiquarian explanations. Rather, they demonstrate that *lares* were not easy to integrate into the world of myth or into a systematic picture of Hellenized religion.

I will now go on to present arguments against identifying *lares* with the dead or the underworld. In order to clear the ground, my discussion will deal with the main examples and arguments used to paint a picture of spooky *lares*. Our basic context for understanding *lares* must come from their ubiquitous presence in temple, local shrine, and domestic cult. *Lares* received simple offerings of ordinary food and flowers from humble people on an almost daily basis. Their iconography showed them as young, merry, dancing figures, in informal dress and without individuality, but regularly associated with the wine they pour in the paintings from Campania. Their annual midwinter festival of Compitalia (see section III.xvii) was a popular occasion of merrymaking, drinking, and the performance of comedies and other entertainments, all of which culminated in a banquet of roast pork supplied from the pigs sacrificed to them. Their iconography or ritual does not, therefore, evoke the underworld or the appeasement of dangerous spirits. Far from being ritually banished from the home along with the spirits of the restless dead, *lares* were the Roman house's most familiar and characteristic deities. Unlike underworld deities, whose offerings were burned as holocausts, *lares* shared the sacrificed pig in a common meal with everyone in the neighborhood.[12] Without antiquarian glosses and scholarly disputes based on dubious etymologies, no modern scholar of Roman religion would have connected *lares* with the dead or with the underworld based on the rituals or sites or occasions of their cult or on the iconography of the many paintings and statuettes that depict them.

Yet many discussions have adduced the words of Varro and Nigidius, in combination with antiquarian notices in Festus (drawing on the encyclopedist Verrius Flaccus), Macrobius, and Servius, as well as philosophical passages in Apuleius, to argue that *lares* were indeed worshipped as deified ancestors, both in the home and at the crossroads.[13] This interpretation is, however, methodologically completely at variance with the significant advances in approach made in the study of Roman religion over the last generation. At the same time, it leads to a curious picture of *lares* shrines throughout the Roman city as if these were all set up either to commemorate or to appease the dead on every street corner and even more implausibly in every kitchen.

In addition to sharing their sacrificial pig with the whole neighborhood at the Compitalia, lar(es) also had a part to play at the regular evening meal of Romans. Lar(es) received a libation between the two courses that were usual at an evening meal.[14] This practice, which is well attested in the first centuries BC and AD, also

12 For the question of whether or not the Romans thought of themselves as sharing a meal with the gods, see the debate between Scheid 2005 and Rüpke 2005.

13 See, for example, Tabeling 1932, 14–16, and Radke 1972, and the authors listed in note 2 at the beginning of part I. Macrobius *Sat.* 1.7.27–35 (early fifth century AD). See the new *OCT* text by Kaster (2011), as well as his 2011 Loeb edition, with an introduction (xi–lxii) and bibliography (lxiii–lxxiii). Festus 108L, 114L, 115L, 238L, 273L, with Glinister et al. 2007. It is notable that Festus gives two other interpretations of *manes* in other passages: 132L, 133L, 146L, 147L, 273L. Servius' commentary on *Aen.* 3.302 and 6.152. Apuleius *de Plat.* 1.12 and *de deo Socr.* 15.

14 A libation for the *lares* between courses at the evening meal is attested by Horace *Sat.* 2.6.66, Ovid *Fast.* 2.631, Petronius *Sat.* 60, and Servius on *Aen.* 1.730. For discussion, see Scheid 1990, 634–35, 639–40; *ThesCRA* 2 (2004) 273–74; and Rüpke 2005.

indicates that *lares* were household gods of the living family, who were associated with food preparation and consumption in a domestic setting. Underworld deities and ghosts were not invited to share a banquet with the living, let alone the family's supper every evening in the home.

We have good evidence for how elite Romans commemorated their deceased relatives who had held high office. These men were represented by wax masks (*imagines*) kept in cupboards in the atrium and labeled with inscriptions (*tituli*) that recorded their names and the highlights of their careers.[15] Unlike the *lares*, who did not have personal names and individual identities, these distinguished "ancestors" were remembered specifically as named individuals, whose deeds were rehearsed with care and elaboration in eulogies at family funerals and in inscriptions at their tombs. Also in contrast to the *lares*, no cult is attested for them within the home (or indeed at the street corner). Streets and neighborhoods in Rome were not named for individuals, living or deceased. Rather families honored their dead, whether famous or obscure, annually with the adornment of their tombs outside the city where offerings were made.[16]

The iconography of *lares*, with their long hair and short tunics, as they danced and poured wine for a feast, suggests nothing of the military and civic achievements associated with the famous Romans celebrated and recalled by the leading political families (*nobiles*) of republican Rome.[17] No *lar* is ever depicted in a toga or in military dress with weapons. In other words, *lares* do not look or behave like Roman "ancestors." Nor is it either attested or credible that wealthy Romans, whether of the political class or not, entrusted the cultivation of their own ancestors to slaves in the kitchen or freedmen at the crossroads. Rome was a society that set great store by traditional gentilicial cults being maintained by blood relatives in each successive generation.[18] Meanwhile, *lares* played no role of substance at a Roman funeral. Rather they were honored precisely at the Caristia, the February festival that celebrated the community of living family members after the completion of their annual visits to the graves to honor the dead. *Lares* are, therefore, specifically designated as members and protectors of the living household.[19]

It has been claimed by some (both ancient and modern writers) that the crossroads themselves were by nature spooky places and that the rituals of the annual winter festival of *lares* called Compitalia, which included the hanging of woolen dolls (*effigies*) and balls (*pilae*) at these compital shrines, suggest an appeasement of threatening spirits.[20] Again, we need to ask ourselves whether every street corner,

15 See Flower 1996, 185–222, esp. 206–10.

16 For annual visits to tombs, see Toynbee 1971, 61–64, and Graf 1997, 29.

17 See already a brief version of this argument in Flower, 1996, 210–11.

18 For gentilicial cults and blood relatives, see Plautus *Merc.* 834, Dionysius of Halicarnassus 1.67.3, and Servius *Aen.* 2.514, with Linderski in *BNP*. For a detailed treatment of *penates*, see Dubourdieu 1989.

19 *Lares* at the Caristia (22nd February): Ovid *Fast.* 2.617–38. For discussion, see Baudy in *BNP* (Parentalia); Giacobello 2008, 44–45; and Robinson 2011 ad loc. Ovid stresses the character of the festival day as turning from the dead honored during the Parentalia immediately before to the living family and community. This explains both the libation to the *lares* and the prayers for the good health of the living emperor. For more discussion, see section IV.xxiv later. The next day celebrates Terminalia, in honor of boundaries and their god Terminus, another theme related to *lares*, who also protected boundaries of properties and of transitions in the life cycle.

20 Smith 1991 sees the *lares* as affected by the spooky nature of crossroads. But see Johnston 1991, who explains the nature of crossroads in town and outside. For dolls in Roman culture, see

or at least the major ones, could really be sinister for a Roman (let alone every house-hold shrine in or near a kitchen!). This festival will be discussed in more detail later (part III).

The spooky crossroads, associated with witches and magic, certainly existed within the Roman thought world, but these places were to be found outside the city gates. It was not the neighborhood shrine, where busy streets intersected near the local water fountain, that was a place for dark spells and curses. Rather Hecate and her followers were sought out in remote places, far from civilized life and outside the civic world of Greek and Roman cities. It was at such a wild and ill-omened crossing of paths that Oedipus had famously met and killed the man he came later to recognize as his own father, Laius.[21] But such bad luck and the fear of unspeakable transgression did not characterize the bustling intersections of Roman cities.

Similarly, the woolen dolls and balls of the Compitalia cannot have represented a substitute for a putative human sacrifice, as some claimed, precisely because one was hung to represent each person in the neighborhood.[22] Figurines were certainly used in some magical spells and for curses, but that does not make every doll of any kind a sinister sign of dark rites. What deities would demand that all their wor-shippers be killed to satisfy them (let alone on an annual basis)? On the contrary, the representation of each living person invites and symbolizes divine protection on the part of benevolent deities for the coming year rather than signifying expia-tion or appeasement through the blood of a scapegoat. These dolls were hung up the night before the festival, when people were free from their daily work, so that they would be ready for the following day of celebration, not in some nighttime ritual for an underworld deity. Beyond its religious function, the assembly of woolen im-ages can be clearly interpreted as a traditional means of counting the population on a local level (see section III.xix and xx later).

Nevertheless, as already mentioned, there were some Romans who tried to understand *lares* as ghosts or spirits of the dead. Why would they do so? The rep-resentation of *lares* as ghosts or underworld forces suggests a reaction to their apparently archaic nature, unusual impersonal names, and special rituals (such as the dolls). Their very lack of individual identity and explanatory narratives al-lowed ample space for speculation, especially at a time when Roman intellectuals were seeking to rationalize and systematize their rituals.

Similarly, debate tends to circle around how to render "*lares*" in Greek. As Ar-nobius shows, Varro himself adduced the translation *hero* to suggest that the *lares* were not underworld deities: some modern scholars have argued the exact oppo-site based on this same Greek word. Varro appears the more reliable authority in this case. Meanwhile, Cicero tentatively suggests the translation *daimon*, but also

Fittà 1998 and D'Ambra 2014, who discusses the well-preserved, jointed doll found in the tomb of Crepereia Tryphaena in Rome.

21 Sophocles *OT* 800–813.

22 See Varro *Men.* fr. 463; Festus 108L, 228L, and 273L, with Macrobius *Sat.* 1.7.27–35 (the only source to name Mania as mother of the *lares*). Ramos Crespo 1988 interprets the dolls as apo-tropaic. Prescendi 2007, 23, sees no evidence for the Roman gods ever eating human flesh, let alone in the shared banquet setting that was usual for animal sacrifice. See also Prescendi 2007, 199–202, on substitutions for human sacrifice, and 178–88, where she traces the whole notion of such substitutions to the antiquarian writings of L. Manilius in the 90s BC.

expresses his own doubts.[23] On Delos, the *lares* seem simply to have been desig-
nated as *theoi* (gods) in Greek in the inscriptions put up by those in charge of the
compital cults (who called themselves *kompetaliastai*) on the island, who were
mostly slaves with Greek names.[24] In our extant evidence, this more neutral but
also more honorific name, therefore, predates the rendering as either *hero* or *daimon.*
Roman *lares* did not have an obvious Greek equivalent.

The simple nature of their cult could indeed be hard to understand and to ex-
plain, especially for newcomers and for those who had grown up in other cultures
such as the many slaves in republican Rome. Meanwhile, ancient explanations
tended to fasten onto a single, anomalous aspect such as their name or the woolen
dolls at the compital shrines, rather than attempting a more holistic interpretation
of their role in Roman religious culture and in everyday life.[25] False etymologies for
names and misreadings of rituals flourished in an age of antiquarian speculation
and theological questioning of traditional practices. The fact that antiquarian writ-
ers were not themselves the main practitioners of the cult, especially in its form at
the local crossroads, will not have helped to make them more informed interpret-
ers. Subsequently, modern scholars have added their own speculative misinterpre-
tations of ancient evidence, based upon a search for deified ancestors or restless
ghosts.

A good example of a problematic misreading applies to a much-cited notice in
Pliny the Elder about Roman attitudes toward food that has been inadvertently
dropped on the floor.[26] What should happen to such a piece of food, which has fallen
during a meal? According to Pliny (writing in the 70s AD):

> Cibus etiam e manu prolapsus reddebatur utique per mensas, vetabantque
> munditiarum causa deflare, et sunt condita auguria, quid loquenti cogitan-
> tive id acciderit, inter execratissima, si pontifici accidat dicis causa epulanti.
> In mensa utique id reponi adolerique ad larem piatio est.

> Also any food that fell from the hand used to be put back at least during
> courses, and it was forbidden to blow off (any dirt) for cleanliness sake; au-
> guries have been recorded from the words or thoughts of the person who did
> so, a very dreadful omen being if a *pontifex* (priest) should do so at a formal
> dinner. In any case putting it back on the table and burning it for (or before)
> the *lar* counts as an expiation (of the omen).

> (Pliny *Nat.* 28.27)

23 Cicero *Tim.* 11 (45–43 BC): *Reliquorum autem, quos Graeci δαίμονας appellant, nostri,
opinor, Lares, si modo hoc recte conversum videri potest, et nosse et enuntiare ortum eorum maius
est, quam ut profiteri nos scribere audeamus* (As regards the remaining [deities], whom the Greeks
call *daimones*, but we [call] *lares*, I think, if this seems to be the right translation, to know and nar-
rate their origin is a greater task than I would dare to undertake).

24 *Theoi* on Delos: *ID* 1745 (fig. III.4 later) with erased relief of dancing *lares* with Mavrojannis
1995, 119, and Hasenohr 2003, 169. Cf. *ID* 1761, 1762, 1769 for inscriptions of those calling them-
selves *kompetaliastai* (celebrators of Compitalia). For Delos, see section III.xviii later.

25 The issue of how to read the antiquarian sources for Roman religion is concisely discussed
by Wardle 2006, 17–18, who quotes Gradel (2002, 3) at v: "Only with extreme caution should phil-
osophical treatises such as Cicero's *de Natura Deorum* or *de Divinatione* be employed in the study
of Roman religion, and as far as its interpretation, they are best left out of account altogether."

26 Pliny *Nat.* 28.27.

It is, therefore, unlucky to drop a piece of food, at least directly from the hand, onto the floor; alternatively, Pliny may actually be saying that blowing on the food was the dire gesture. However that may be, a standard remedy is to burn the food as an offering of expiation to the *lar* (of the household) on the table. Pliny does not, however, make clear how common the ritual of burning such a piece of food off the floor really was. Since he makes no mention of ghosts here, there is really no reason to introduce them. Indeed, the very idea that ghosts were imagined as regular inhabitants of Roman dining areas, waiting like household pets or scavengers around the couches or under the tables for scraps of food to fall, is evidently implausible. Furthermore, it would go against usual Roman practice to share food, especially a piece of food that has been touched and is now on the table, with an underworld deity. Rather, because the *lar* acts as a natural protector of the household and its inhabitants from evil omens and potential prodigies of any kind, he is the recipient of the unlucky piece of food in his role as the general guarantor of good luck.

Another practice suggests that food scraps were regularly offered up as a sacrifice at the end of a formal meal rather than being saved for another occasion or donated. Macrobius refers to this tradition in a section on jokes:

> Flavianus subiecit: "sacrificium apud veteres fuit quod vocabatur 'propter viam.' in eo mos erat ut si quid ex epulis superfuisset, igne consumeretur."

> Flavianus added: "There was an offering that the ancients called 'for the road.' According to this custom, anything left over from a banquet was burned (as an offering)."

> (Macrobius *Saturnalia* 2.2.4)

This habit is also referred to in passing by Plautus, Laberius, and Festus.[27] While the recipients of the food are not specified and could perhaps be chosen according to the occasion, the lar(es) are also obvious candidates, especially for a sacrifice made "for the road"—in other words, for security and prosperity on the way home from the banquet or on behalf of a longer journey that lies ahead.

In addition, a single republican inscription has been used to support the view that a *lar* could be positively identified as a deceased ancestor. The inscription is on a small perperino stone *cippus*, set up as a modest altar, which was discovered at Tor Tignosa (northeast of Lavinium) in 1958.[28] (See figure I.1.) It was found in the same area as the slightly earlier discovery of three larger *cippi* in a similar style dedicated to individual Fates, as well as some pottery, votives, and architectural fragments.[29] The whole assemblage indicates a religious site with material from the late fourth century BC onward.

27 Plautus *Rud.* 148–50; Laberius 87–88; Festus 254.12–14L.

28 The famous Tor Tignosa inscription: *MNR* inv. 135847 = *CIL* 1² 2843 = *ILLRP* 1271 = *AE* 1960, 138 = EDCS 26200348. Degrassi *Imagines* A3 reproduces a classic black-and-white photograph. The stone was found at Tor Tignosa, about 8 km northeast of Lavinium. It measures 33×19–25×17–19 cm with letters 2 cm tall. See Guarducci 1956–58; Schilling 1984; Hartmann 2005, 411–15; and now La Regina 2014 for earlier discussions.

29 For the three dedications to the Fates, see *CIL* 1² 2844–46 = EDCS-15000118, EDCS-15000136, EDCS-15000135 with Nonnis in Friggeri, Granino Cecere, and Gregori 2012, 163–65.

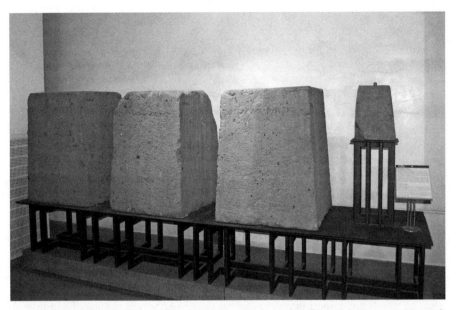

I.1. Inscribed *cippi* from Tor Tignosa, as displayed in the Museo Nazionale Romano, Terme di Diocleziano, inv. 135847. The small, tapered *cippus* on the right bears an inscribed dedication to a *lar*, next to the larger dedications to three Fates. Peperino stone, late third to early second century BC?, 33×19–25×17–19 cm.

The inscription is very hard to read, both because the surface of the stone is uneven and the letters are very worn. It was originally rendered as *LARE AENIA d(onom)* ("a gift for Aeneas the *lar*"). This much discussed reading is reproduced in the 2001 and 2012 catalogues for the epigraphic collection of the Museo Nazionale Romano at the Baths of Diocletian in Rome, where the *cippus* is now on display next to the three larger ones.[30] However, several experts on archaic Latin have rejected this reading on the grounds that it is linguistically impossible.[31] Other readings have also been put forward over the years.[32] I myself was able to read only the first word as *LAR* . . . but very little else.[33] Recently, an argument has been made for the following revised version:[34]

They measure about 90×60–70×59–66 cm, with letters about 3 cm high. In other words, they are about three times the size of the dedication to the *lares*.

30 See Friggeri 2001, 36 (with a color photo), and Nonnis in Friggeri, Granino Cecere, and Gregori 2012, 162–63, for this altar (*MNR* inv. 135847) in its new installation in the epigraphic collection of the Museo Nazionale delle Terme at the Baths of Diocletian. It is notable that these catalogues do not discuss the variant readings. This reading is also cited as the only possible one by Coarelli 2012, 177.

31 Wachter 1987, 373–75, argues that the inscription is illegible and that Guarducci's reading does not make sense. Vine 1993, 88–89, dates the inscription to the late fourth or early third century BC. This is the wrong period for the AE diphthong that has been proposed. He reads the first letter of the second word as an inverted V.

32 Hartmann 2005, 411–15, gives an overview and a diagram of the suggested variants up to 2005.

33 Most recently, I also found the text on the stone to be illegible in May 2015.

34 La Regina 2014 is detailed and very persuasive, basing his reading on a thorough reexamination of the stone.

Lare(bus) A. Venia Q(uinti) f(ilia)

A(ula) Venia, daughter of Quintus, (dedicated this) to the *lares*

(*CIL* 1² 2843)

This new reading, based on a careful reexamination of the stone, would make the inscription the earliest surviving dedication to twin *lares* (or alternatively perhaps a single *lar*?), in this case in the context of a venerable, local sanctuary where they had also been welcomed as guests. Further interest is obviously added by the dedicant herself, who is a freeborn Roman woman, possibly with an unusual personal name (the *praenomen* Aula) or perhaps called Avenia.[35] The dating of the *cippus* has been much discussed and ranges from late fourth to the early second century BC, with a lower date now finding renewed support. A date in the late third to early second century BC would make this inscription contemporary with the evidence from Cato and Plautus discussed later.

This little altar with its shallow inscription on friable stone, which is of strikingly modest dimensions in comparison with the three impressive and clearly labeled *cippi* for the Fates, cannot, therefore, be used as evidence for a cult of a *lar* as equivalent to a specific deified hero of a previous age (Aeneas is the usual candidate). Rather, *lares* were consistently deities without personal names or individual identities or life stories, even when worshipped in the singular, such as a *lar familiaris* in Plautus. Their epithets nearly all referred to a place—for example, *viales, semitales, compitales, curiales, vicinales, permarini, familiares, domestici* (road, path, crossroads, meeting house or district, neighborhood, throughout the seas, household, domestic). This naming pattern is another obvious indicator that they were indeed gods who protected places, and the boundaries of those places. These little *lares* lived in and protected (the boundary of?) a local sanctuary in Latium, where their profile was low, and where they probably received regular offerings on a small scale.

To sum up the argument of this section: the mistaken view that *lares* were (sometimes malevolent) spirits of the dead has been supported by modern scholars on the basis of five distinct types of arguments: antiquarian exegesis (largely invented etymologies and fictitious etiologies), translation into Greek (specifically a particular translation of *hero*), misinterpretation of rituals (dolls at the crossroads and scraps of food on the dining room floor), the topographical character of the crossroads themselves (which are wrongly connected with the underworld), and a single inscription with a mostly illegible text (restored to name Aeneas as a *lar*). In the course of this elaborate debate, antiquarian glosses provided by scholars such as Macrobius or Servius have been amplified by modern researchers playing similar games of reinterpretation as their ancient predecessors. Their arguments tend to be speculative and simplified. Meanwhile, the assertion that *lares* can be simultaneously deceased spirits and guardian gods of place as a result of some late republican syncretism is refuted by Varro himself (even in a paraphrase) and is in any case fundamentally untenable in Roman thought.[36]

35 For female *praenomina*, see Kajava 1994 for a full discussion.

36 Smith 2009 gives a reading based on the highly problematic premise that all ancient texts provide equally valid information and interpretation.

Ultimately, an ancient worshipper needed to know how, when, and where to perform rituals to the deities he or she was addressing. Underworld deities were addressed differently, often at night, and received separate offerings, usually in the form of holocausts (offerings that were completely burned). The cult of the *lares* at the hearth and the street corner, as well as their highly stereotyped depiction in art, indicates their character as protective gods of place, integral to the world of mortals and to its everyday activities of cooking, eating, drinking wine, and traveling. Varro himself seems to have posed this same complete dichotomy between the diametrically opposed interpretations of *lares* he found in his sources. By contrast, Nigidius avoided mention of ghosts or the underworld. Unlike either of these ancient authors, we can be more confident about using detailed analysis of cult practice and iconography, combined with a commonsense approach, to describe the basic character and function of *lares* in a Roman context.

II ORIGINS AND EARLY EVIDENCE

> All the surviving sources suggest that the Romans believed the
> *Lares* to be connected with the dead in some way.
> —ROBINSON 2011, 389

If we knew the origins of *lares*, we would be able to understand these gods. This basic notion has been the subtext of much ancient and modern disputation about the "true nature" of these gods. It has also occasioned the various, evolving myths about their birth. In fact, the few "stories" told about *lares* all revolve in some way around birth and, therefore, focus on issues of parentage in one context or another. Where did the *lares* come from? Who were their mother or their father? Does any *lar* have a child of his own? Those asking such questions were looking for a familial context for their *lares*, which would provide a way to relate them to other deities in their pantheon and to the world of myth they inhabited.

It is evident from the start that lar(es) are thoroughly Roman deities who were never easily integrated into the world of Greek myth that became ever more naturalized throughout the Italian landscape, partly under Roman influence. Nor did their main annual festival of Compitalia apparently have a myth associated with its observance, either to mark its date (which in any case was movable) or to explain how and why it was celebrated. The attributes and dress of various lar(es) are not associated with a narrative or etiology. Nor is the dancing so typical of *lares* explained by a story.

A mother of plural (unspecified) *lares* appears to have a traditional cult that may well have been part of Roman civic religion from an early time. She received offerings from the Arval brothers, whose ancient hymn to these *lares*, protectors of Rome's boundaries and her community, is discussed later.[1] Yet, for whatever reason, she is actually never called upon by name in any ritual context; simply being "mother of *lares*" was apparently enough for her. No visual representation of her has been identified. No statue or painting of *lares* that uses their customary iconography (of which we have many) depicts them with a female figure who could conceivably be identified as their mother. She is not associated with the hearth or the crossroads (or any of the other places) where lar(es) were customarily found.

Not surprisingly, later antiquarian sources give her a wide variety of names, each with a different guise and identity. It was natural for learned men to try to fill the obvious gap in information about her. She could have been a Muse called Tacita, who was associated with Numa, Rome's second king.[2] Alternatively, her name was Mania and she was an underworld goddess by nature.[3] Or perhaps she is Lara, who was better known as Larunda (an ancient Sabine goddess connected with King Titus Tatius) or Muta.[4] Some modern scholars have identified her with Acca

1 Scheid 1990, 578–98, interprets the mother of the *lares* as a goddess of the earth.

2 Numa and the Muse Tacita: Plutarch *Num.* 8.6. Robinson 2011, 369, 374–75, gives an excellent overview, stressing the variety of traditions Ovid had to choose from and the very deliberate nature of his unusual choices.

3 Mania: Varro *LL* 9.61; Festus 114L and 273L; Macrobius *Sat.* 1.7.35; Arnobius 3.41.

4 Larunda: Varro *LL* 5.74–75; Ausonius *Techn.* 8.9; Lactantius *Div. Inst.* 1.20.35. See Lavagne and Gschaid 1996 for an early third-century inscription that names Larunda with Mars in a context that suggests she is a protective goddess. Tacitus *Ann.* 12.24 mentions a possible *sacellum* of Larunda in the Roman forum.

Larentia.[5] In a highly embellished narrative full of unexpected twists and turns, Ovid names the nymph Lara (renamed Tacita, a sister of Juturna), who is raped by a Hellenized version of Mercury after being punished by Jupiter, as mother of the *lares compitales* (the gods worshipped at the crossroads).[6]

Ovid is the only ancient source to give a mythological narrative associated with the birth of any *lares*. His version, however, is full of (self-)parody, humorous juxtapositions of Greek myth with Roman elements, and elaborate variations on the story of the nymph Juturna as retold in the final book of Vergil's *Aeneid*.[7] The birth of twin *lares* at the end of this section is introduced as a complete surprise: Ovid produces them like rabbits out of a magician's hat. They may be intended more as a joke in this context, regardless of whether Ovid is riffing off some genuinely archaic material. The fact that they were not worshipped on the day in question (21st February) provides further possible evidence for Ovid's own authorial interventions. It is very hard to take the information in Ovid simply at face value as the retelling of a traditional myth. In fact, part of the point here may be that *lares* are simply not gods we expect to find in a mythical context.

Unlike the usual genealogies of gods, spirits, or heroes, with *lares* there is consistently much more focus, therefore, on who their mother was than on who their father might have been. As a result, the mother of the *lares* (*mater larum*) remains an elusive figure, hard to dismiss but apparently without a firm identity of her own, either to characterize her or to pass on to her sons. Meanwhile, the Romans were familiar with very many different *lares* in their homes, streets, and fields, but no source puts these gods into an established, familial relationship with each other (for example, all brothers, or some brothers and others cousins, and so on). In other words, it is completely unclear whether "(the) mother of (the) *lares*" is imagined as having been mother to some particular lar(es) (such as the archaic *praestites* or the *compitales* mentioned by Ovid), or to "all" of these gods. Latin's lack of a definite article does nothing to clarify this matter.

Unconnected to these myths about a single mother of unidentified but plural *lares*, the singular *lar familiaris* is represented by some sources as the father of the slave boy Servius Tullius, future king of Rome. Servius' mother Ocrisia had been captured as a prisoner of war from Corniculum and became a slave in the royal household of King Tarquin and his wife Tanaquil.[8] Some traditions about Servius Tullius seem to be old and the name of his mother is firmly established in this

5 For Acca Larentia (and her festival of the Larentalia on 23rd December), see Graf in *BNP*, who does not mention a connection with the *lares*, which is essential to the whole argument of Bodel 2008.

6 Ovid *Fast.* 2.583–616 has Lara (renamed as Dea Tacita) as mother of the *lares* (21st February). Wissowa 1912, 174, already ascribed this story to Ovid himself. Contra Wiseman 1995a, 65–71 and 138–39, who argues that this is an old myth that pertains to the *lares praestites*. Wiseman also connects this story, which he interprets as a traditional myth, with a famous bronze mirror of the fourth century BC from Praeneste, which shows a wolf nursing twins in a complex scene that includes many other figures.

7 Robinson 2011 is very useful. For more discussion of Ovid, see esp. Feeney 1992, 27, and Newlands 1995, 161, who attribute this version to Ovid himself.

8 See Dionysius of Halicarnassus 4.2; Ovid *Fast.* 6.627–36; Plutarch *Fort. Rom.* 10; Pliny *Nat.* 36.204. For discussion, see Thomsen 1980, 57–114; Cornell 1995, 130–41; Smith 1996, 151; and Forsythe 2005, 101–6.

tradition; the identity of his father, however, is much disputed.[9] The variants follow a predictable pattern found in early Roman legends in that they explore all the possible alternatives for a human father—namely, Ocrisia's husband (killed in the war with Rome), a new husband assigned to her by her captors (a client of the royal household), or perhaps even Tarquin himself (since she is now his slave and he is so fond of her son).[10] Livy prefers the first option, which has the advantage of being the most suited to the overall logic of narrative.[11] His Servius, therefore, is the son of two noble parents whom only the fortunes of war have reduced to slavery. In this version, Servius' rise to a position of leadership fits in with the original status of his birth parents.

There are, however, other versions of this story that suggest a divine father for Servius, who is associated with two miraculous stories that involve fire. In one, he is born from the fire on the hearth (that manifests a deity in a vision of male genitalia, either Vulcan or the *lar familiaris*).[12] In the other, a miraculous fire plays around his head as he is sleeping, even while he is still a slave boy, thus marking him out for a royal destiny.[13] Livy is content to describe the halo of fire worn by the favorite slave but does not mention a divine birth.[14] Many other authors also preferred a human father; even Plutarch and Dionysius of Halicarnassus are not impressed with the narrative of a possible divine parent.[15] Meanwhile, some other kings in Latium, including Caeculus the founder of Praeneste, were said to be sons of the fire god. In other words, it is unsurprising for Servius to be assimilated to these other traditions that linked Vulcan at the royal hearth to the birth of future kings.[16]

All these narratives leave the option of the *lar familiaris* as a (not particularly popular or mainstream) variant of a set of elaborate traditions designed to explain Servius Tullius' legendary rise from slavery to kingship. The story perhaps grew logically from the picture of the slave woman Ocrisia tending the hearth as part of her duties in the royal household, not unlike the role of the *vilica* on Cato's farm (see section I.v later). Who was the god at the hearth who could be the father of

9 For the antiquity of some of these stories, see esp. Ogilvie 1965, 158. Servius was a traditional *praenomen* used (only) by two ancient, patrician families, the Sulpicii and the Cornelii, both originally from the area of northeast Latium, where Corniculum had been located (Pliny *Nat.* 3.68).

10 Cicero *Rep.* 2.37 is highly rationalistic.

11 Livy 1.39. Ogilvie 1965 ad loc. discusses the alternative of Vulcan as the father but does not bother to mention the *lar*.

12 The father in the hearth: Dionysius of Halicarnassus 4.2.1–3; Ovid, *Fast.* 6.627–36; Pliny *Nat.* 36.204; Plutarch *Fort Rom.* 10; Arnobius 5.18. Grandazzi 1997, 45, suggests that Servius himself spread a story about a miraculous birth.

13 The miraculous halo of flame is very well attested and was evidently much discussed: Ennius *Ann.* 145; Cicero *de Div.* 1.121; Livy 1.39.1–2; Dionysius of Halicarnassus 4.2.4; Ovid *Fast.* 6.635–36; Valerius Maximus 1.6.1; Pliny *Nat.* 2.241, 36.204; Florus 1.1; Zonaras 7.9.2; Servius on *Aen.* 2.683, *vir ill.* 7.1; Lyd. 5.

14 Livy 1.39: *Ser. Tulli qui princeps in illa urbe fuerat gravidam viro occiso uxorem* (the pregnant wife of Servius Tullius, who had been the leading man in that town, after her husband had been killed).

15 See Plutarch *Fort. Rom.* 10, who notes that Valerius Antias and his circle (*hoi de peri Antian*) rejected a divine birth and suggested that the miracle of the fire halo took place when Servius was already an adult. See *FRHist* 25 F 20 (John Rich) for commentary. Dionysius of Halicarnassus 4.2.1 may contain a reference to the *Annales Maximi* (see *FRHist Ann. Max.* F 8, with commentary by John Rich) and claims that he has consulted a range of older sources.

16 Plutarch *Rom.* 2 (citing Promathion) about Romulus and Remus; Festus 38 L; and Vergil *Aen.* 7.678–81, with Servius, Solinus 2.9, Cato *Origines* 2.29 about Caeculus. For Mutinus Tutinus, founder of Cures, see Dionysius of Halicarnassus 2.48. Cornell 1995, 132–33, is essential reading.

her child? Was it the fire god in the flame or the *lar* who lived in the hearth? Yet there is no evidence that ordinary Romans recalled this narrative in any way at their own hearths. The *lar familiaris* is not recorded as having any other children and does not display the amorous nature of so many other ancient gods. It is also suggestive that in his *Fasti* Ovid picks Vulcan as the father of Servius Tullius, despite his evident interest in *lares* of various kinds.[17] By contrast, Pliny the Elder (writing in the 70s AD) gives us a compressed version of the myths that connect Servius with *lares* in a passage that concludes book 36 of his *Natural History*.

> Non praeteribo et unum foci exemplum Romanis litteris clarum: Tarquinio Prisco regnante tradunt repente in foco eius comparuisse genitale e cinere masculi sexus eamque, quae insederat ibi, Tanaquilis reginae ancillam Ocresiam captivam consurrexisse gravidam. Ita Servium Tullium natum, qui regno successit. Inde et in regia cubanti ei puero caput arsisse, creditumque Laris familiaris filium. Ob id Compitalia ludos Laribus primum instituisse.

> And I will not pass over one famous example of a hearth in Roman literature. They say that during the reign of Tarquin the Elder a penis suddenly appeared from the ashes in his hearth and that Ocresia, a maid of queen Tanaquil who was a captive (that is, prisoner of war), became pregnant after she had sat there. In this way Servius Tullius was born, who succeeded to the kingdom. Afterward, when he was a boy and was sleeping in the palace his head appeared to be on fire. He was believed to be the son of the household *lar*. For this reason he first instituted the games at Compitalia in honor of the *lares*.
>
> (Pliny *Nat.* 36.204)

After this same Servius became king of Rome, it is said that he spread the cult of the gods to the crossroads shrines in the neighborhoods. In other words, the originator of compital cult was described, in at least one tradition, as himself the son of a domestic *lar* who lived in a hearth. According to this legend, the Romans imagined a cult of a single *lar*, in a royal hearth, as predating and somehow generating the cults of the twin *lares* at the crossroads shrines throughout the city.[18] Yet the very way in which Pliny compresses all these different strands, including both fire miracles for good measure, as well as the founding of the games at the Compitalia, also suggests how the role of the *lar familiaris* has been created from other aspects of Servius' (much elaborated) achievements. In the end, this story tells us more about the figure of Servius Tullius than about the nature or the cult of the *lar familiaris* at the hearth.

What is perhaps most notable of all, however, is that even after several possible parents and one potential child have been identified, the lar(es) were ultimately left without any real stories of their own. The divine parent of Servius Tullius is imagined as nothing more than a disembodied phallus. In other words, learned men may have argued about the name of (the) mother of (the) *lares* and the identity of their father, but they apparently had no narrative to tell in which *lares* themselves performed any actions or spoke any words. *Lares* were not gods of myth but gods of place; they were by nature Roman gods rather than more recent Hellenized or

17 Ovid *Fast.* 6.625–28.

18 Tarpin 2014 provides a useful overview of the association of Servius Tullius with the establishment of the city of the four regiones.

originally Greek gods. In light of these considerations, it is highly significant that they kept their simple names and functions even in an increasingly complex religious world, full of ever more intricate tales and convoluted divine genealogies.

The actual origins of the cults of *lares* in Rome must remain a matter for more or less creative speculation. It is possible to imagine that they were related to the world of Etruscan spirits, although the Etruscan divinities known as *lasa* have nothing in common with the *lares*.[19] However that may be, Etruscan religion has been characterized as a worldview tied to a strong sense of sacralized space and a well-defined spiritual geography.[20] The Etruscan gods had clearly separate spheres of influence. The maintenance of properly defined sacred boundaries was integral to the Etruscan view both of the human community and of how the wider cosmos operated. Whether ultimately of Etruscan origin or not, *lares* as gods of place certainly could fit in with an Etruscan sacred geography that had come to include Rome and its surroundings in Latium at an early period.[21]

Beyond a Narrative of Birth

Unlike in the legend of King Servius Tullius' birth, the earliest surviving evidence that we have about *lares* portrays them as guardians of Roman territory and the Roman community as a whole, rather than as domestic deities in a single (royal) household. The "oldest" evidence we can glimpse may be the famous, ancient Arval hymn, although its words are quoted much later, in an inscription of Arval practices from the early third century AD that appears to contain a variety of inaccuracies in its language.[22] The Arval hymn was sung by the Arval brothers, an elite group of a dozen priests who worshipped the ancient agricultural goddess Dea Dia at her temple in a sacred grove outside Rome. Although the foundation of this priestly college is attributed to Romulus, its actual age is unattested in our surviving evidence, which comes from the imperial period.

> Aedes clusa est; omnes foras exierunt. Ibi sacerdotes clusi succincti libellis acceptis, carmen descindentes tripodauerunt in uerba haec:

> enos Lases iuuate, enos Lases iuuate, enos Lases iuuate!
> neue lue rue Marmar sins incurrere in pleores, neue lue rue Marmar sins
> incurrere in pleores, neue lue rue Marmar sins incurrere in pleores!

19 For the Etruscan female spirits called Lasa, attendants of Turcan (Aphrodite), see *LIMC* 6.217–25 (Lambrechts), with Bonfante and Bonfante 2001, 200, and Simon 2006, 58.

20 See Edlund-Berry 2006 for discussion and bibliography.

21 The brontoscopic calendar compiled by Nigidius Figulus provides an interesting example of an Etruscan divinatory text that was said to be designed specifically for those living in Latium. Turfa 2012 provides an excellent, modern edition.

22 *CIL* 6.2104 = 32388 = *ILS* 5039 = *ILLRP* 4 = EDCS-19000364 (entry for 29th May at line 32 ff.), AD 218 (Elagabalus), was discovered in 1778. For text with commentary, see Scheid 1998, no. 100. For further discussion, see Scheid 1990, 644–46, and Katz 1998. For Mars as a boundary god, see Scheid 1990, 621 n. 106. For dance in Roman religion, see Giannotta in *ThesCRA* 2.337–42. She describes the *tripudium* (three-step dance) as a stately dance with apotropaic functions. The repetition in threes would presumably accompany the three steps of the dance. Consequently, the shout of triumph in the last line should have been repeated six times, not five, to yield twice three steps.

satur fu, fere Mars, limen sali, sta berber, satur fu, fere Mars, limen sali, sta
 berber, satur fu, fere Mars, limen sali, sta berber!
Semunis alternei aduocapit conctos, semunis alternei aduocapit conctos,
 semunis alternei aduocapit conctos!
enos Marmor iuuato, enos Marmor iuuato, enos Marmor iuuato!
Triumpe, triumpe, triumpe, triumpe, triumpe!

Post tripodationem deinde signo dato publici introierunt et libellos
receperunt.

The temple is closed; everyone leaves. There the priests shut inside (the tem-
ple), with their robes tucked up and the books in their hands, chant a hymn
as they danced in a three-step pattern with these words:

Oh! Help us, you *Lares*! Oh! Help us, you *Lares*! Oh! Help us, you *Lares*!
And let not bane and destruction, O Mars, assail our people! And let not bane
 and destruction, O Mars, assail our people! And let not bane and destruc-
 tion, O Mars, assail our people!
Be fully satisfied, fierce Mars. Leap the threshold! Take up your position! Be
 fully satisfied, fierce Mars. Leap the threshold! Take up your position!
 Be fully satisfied, fierce Mars. Leap the threshold! Take up your position!
By turns address the Gods of Sowing, all together! By turns address the Gods
 of Sowing, all together! By turns address the Gods of Sowing, all together!
Oh! Help us, Mars! Oh! Help us, Mars! Oh! Help us, Mars!
Triumph, triumph, triumph, triumph, triumph, (triumph?)

After the three-step dance, at a given signal, public slaves came in and
took away the books.

<div align="right">(CIL 6.2104 = 32388, lines 31–38)</div>

This rare archaic Latin text, which seems to be a quotation or paraphrase of an old
hymn, has naturally been the subject of lively discussion from a variety of perspec-
tives. It must be kept in mind, however, that the inscription is very hard to read
and the text of the hymn itself is impossible to date securely on textual or linguis-
tic grounds.[23] For present purposes, its most salient features are that it shows
lares to be gods called upon, together with Mars and the Semones (archaic deities
of the seeds), in a traditional ritual apparently designed to protect the boundar-
ies of Rome's territory in a general way, but with an emphasis on military victory
and triumph. Indeed here *lares* are called on first and receive priority in this
context.[24]

Moreover, the hymn has a repetition of each invocation in a pattern of three that
apparently corresponds to a three-step dance (*tripudium*) performed by the priests
as they sing, in an enclosed setting inside the temple of Dea Dia in their solemn
festal garb. It is fascinating to see that dancing, albeit probably of a solemn kind,

23 See Gordon 1983, no. 75, who calls this one of the worst written and least legible Latin
inscriptions.
24 See Coarelli 2003 for an interesting and imaginative discussion of the *lares* and their pos-
sibly archaic associations with the sanctuary of Dea Dia.

was associated with an invocation of *lares* from very ancient times. Later, *lares* are often represented as themselves dancing, while Mars is not. The implication of the Arval hymn, as performed within the context of the elaborate rituals of the Arval brothers at their sacred grove, was that *lares* definitely belonged within a pantheon of traditional gods of the Roman state associated with protecting territory. They were invited to share festivities that were ultimately connected to preserving the land, crops, and well-being of the Roman people as a whole. In this context, *lares* received a sacrifice of two wethers (castrated male sheep) and their (unnamed) mother an offering of two sheep. Unfortunately, it is not possible to estimate the age of this ritual or to know whether other priests also performed it on different civic occasions, perhaps sometimes in front of an audience rather than behind closed doors. No other *lares* we know of receive sheep rather than the customary pig.

Another piece of at least potentially "early" evidence comes from a prayer quoted by Livy in his description of the *devotio* of the consul P. Decius Mus in 340 BC during the battle at Veseris near Mount Vesuvius.[25] On this occasion, a consul is represented as deliberately sacrificing his own life in exchange for a Roman victory, a ritual only attested for the family of the Decii Mures.

> pontifex eum togam praetextam sumere iussit et uelato capite, manu subter togam ad mentum exserta, super telum subiectum pedibus stantem sic dicere

> "Iane, Iuppiter, Mars pater, Quirine, Bellona, Lares, Diui Nouensiles, Di Indigetes, Diui, quorum est potestas nostrorum hostiumque, Dique Manes, uos precor ueneror, ueniam peto feroque, uti populo Romano Quiritium uim uictoriam prosperetis hostesque populi Romani Quiritium terrore formidine morteque adficiatis. sicut uerbis nuncupaui, ita pro re publica <populi Romani> Quiritium, exercitu, legionibus, auxiliis populi Romani Quiritium, legiones auxiliaque hostium mecum Deis Manibus Tellurique deuoueo."

> The *pontifex* ordered him to put on his toga with the purple border (that is, civilian dress), and with his head covered (with part of the toga) and a hand stuck out from under the toga to touch his chin, standing with his feet on a spear that had been put on the ground to speak these words:

> "Janus, Jupiter, Father Mars, Quirinus, Bellona, *Lares*, divine Novensiles, gods who are the Indigetes, deified mortals, in whose power are both we ourselves and our enemies, and you, divine spirits of the dead, I pray to and worship you, I beseech and seek (this) request, that you prosper the might and the victory of the Roman People of the Quirites, and impose on the enemies of the Roman People of the Quirites fear, terror, and death. As I have pronounced the words, even so for the benefit of the commonwealth of the Roman People of the Quirites, and of the army, the legions, the auxiliaries of the Roman People of the Quirites, I devote the legions and auxiliaries of the

25 Livy 8.9.6. Livy 10.28 describes the *devotio* of this man's son at the battle of Sentinum in 295 BC. For commentary, see Oakley 1998, 477–86, and 2005, 276–81, 290–91, who characterizes the prayer as an antiquarian reconstruction (1998, 484–86), which might or might not reflect some elements of archaic practice. At 1998, 490, he raises the possibility that these *lares* were the *praestites,* as already suggested by Georg Wissowa (discussed later at section II.xii).

enemy, together with myself, to the divine spirits of the dead and to (the goddess) Earth."

(Livy 8.9.6–8)

While it is far from certain that this episode is historical, the prayer (even if invented or embellished) represents how later Romans imagined such a ritualized curse. A Roman commander was described as "devoting" himself and the enemy army to the gods of the underworld. According to Livy (and his sources), the *pontifex maximus* led the prayer pronounced by the commander who was about to ride into the midst of the enemy line in order to bring down a fatal curse on their whole army by his voluntary death at their hands.[26] Here also, a set of *lares* without epithets, perhaps thought of as the same as those invoked by the Arvals, are called upon by the chief *pontifex* in the midst of other gods of the state who protect the Romans in a situation of war.

The *lares* are not named as the gods who receive the actual *devotio*, who are the earth goddess Tellus and the *di manes* (the spirits of the deceased, imagined and addressed as a group). The difference between *lares* and *di manes* is especially clearly demonstrated by this prayer (whether actually traditional or only made to look so). *Lares* are mentioned within the list of state gods, immediately after Bellona. The fact that this general's son at Sentinum in 295 BC and grandson at Asculum in 279 BC are also represented as having (perhaps) sacrificed their lives for Rome in this same way does not help us to date this particular prayer language or the appearance of *lares* in what seems to be a particular setting, closely associated with a single family.[27] The *devotio* prayer is quoted by Livy specifically in the context of the earliest Decius Mus, the occasion when he introduced this custom to his readers.

Meanwhile, actual republican evidence for the cult of various different *lares* comes from the fragments of Ennius' epic poem *Annales* (early second century BC), a fragment of Cassius Hemina's historical work (mid-second century BC), and of three comedians of the third to first centuries BC, Cn. Naevius, L. Afranius, and D. Laberius, whose plays also survive only in quotations and paraphrases. Important information from extant literary works can be found in the comedies of Plautus (late third to early second century BC) and in Cato's *de Agricultura*, the earliest surviving prose work in Latin (ca. 160 BC). Consequently, we do have some information about *lares* and their cult that predates both the birth of antiquarian writing in Latin (mid-second century BC) and the subsequent religious upheavals and debates of the first century BC.[28] Moreover, the variety of genres represented by these authors (epic, historiography, comic drama, and what purports to be a manual of practical advice for a "gentleman" farmer) adds valuable texture and depth to our picture of these deities within Roman republican culture.

26 Macrobius *Sat.* 3.9.9–13 speaks of the *devotio* of cities with Wissowa 1912, 384–85, Versnel 1980 (and in *BNP*), and Leigh 1993.

27 For the son, also P. Decius Mus, see Livy 10.28, with Oakley 2005 ad loc., but also the subject of a historical play by Accius (*Decius vel Aeneadae*); for the grandson, another P. Decius Mus, at Asculum (much more dubious), see Cicero *Fin.* 2.61 and *Tusc.* 1.89. The issue of the historicity of any or all of these episodes can be treated as essentially a separate question from what prayer language may have been available for this ritual.

28 Sehlmeyer 2003 explains the origins of antiquarian writing in Latin in the second century BC.

The earliest of these authors, Cn. Naevius (ca. 270–201 BC) was a popular writer of dramas (comedies, tragedies, and historical plays), as well as the first to write an epic poem in Latin.[29] A precious fragment from his comedy *Tunicularia* (literally "wearing a little tunic," which could refer to the play itself or to its main character) reveals a painter with a Greek name (Theodotus) painting *lares* at a (series of?) compital altar(s) in immediate preparation for the annual winter festival of the Compitalia (a movable feast that fell in late December or early January discussed in part III later):

> Théodotum
> cum Apella comparas qui Compitálibus
> sedéns in cella círcumtectus tégetibus
> Larés ludentis péni pinxit búbulo.

> Do you compare Theodotus with Apelles—Theodotus who, sitting in a shrine, and screened all round with mats, on the day of the Compitalia painted the *lares* at play with an ox-tail (as his brush)?
>
> (Naevius *Tunicularia* 97–100)

In a single sentence, Naevius evokes for us much of the familiar world of compital cult as we glimpse it in the paintings and inscriptions on Delos in the later second century BC and in Campania in the time of the Flavians. Unfortunately, the text in the second line is not secure, so we cannot be sure of the reference to Apelles of Kos, a renowned painter of the fourth century BC. Already at the time of the Hannibalic war, however, *lares* are described as *ludentes* ("at play" or perhaps "celebrating the festival"). These words suggest the familiar iconography of *lares* pouring their wine and dancing, a type of image that may have been influenced by Bacchic iconography in the Greek communities of Southern Italy.[30] If earlier *lares* originally had a different cult image in the home or at the crossroads, we do not know what it looked like. It seems that the *lares* could be worshipped without a cult image, in the fire of the hearth where the food was cooked and sacrifice was offered to them. An aniconic cult would also have suggested the ubiquity of *lares* in the atrium house or at the crossroads of a much smaller, older Rome.[31] But by the third century BC, Naevius suggests that the *lares* at the *compita* were already a version of the merry, dancing gods so familiar in Roman art.

Unsurprisingly, Naevius' painter of *lares* is a Greek with a single name, a character in a play in Greek dress who also recalls slaves who were commonly artists in Rome. What he paints is not high art but popular devotional images, renewed on a regular basis in connection with the annual festival, as was the case on Delos about a hundred years later. The mats he uses protect his paintings in an open-air context. His images can be found on more than one altar. Naevius describes a very Roman scene, celebrating a typical festival for Roman gods, but one animated by the Greek painter of humble status. The connection of compital *lares* and their annual holiday with Rome's slave population is already familiar to this theater

29 For Naevius, see now Manuwald 2011, 194–204, esp. 198. He was most famous in antiquity for his comedies. For the text quoted here, see Warmington 1935.

30 Bacchic iconography of the *lares*: Orr 1978, 1568–69 argues for influence from Southern Italy.

31 Tibullus' old wooden *lares* receive grapes, corn, honeycomb, and cakes (1.10.15–25, with Papakosta 2012). Aniconic *lares* are assumed from the description of the cult at the hearth.

audience in the third century BC before Rome's dramatic expansion in the Mediterranean greatly increased the number of slaves in the city.

In fact, Naevius' play may have been performed at the festival of the Compitalia. We know of two other plays that were simply titled *Compitalia*, one by L. Afranius (early first century BC) and the other by D. Laberius (ca. 105–43 BC), although we do not know what their plots entailed.[32] Naevius' tunics may also recall slave characters, who wore short tunics like those of *lares*. By comparison, Suetonius attests to the theatrical performances staged by Augustus in the local neighborhoods, plays that were described as being performed in "all the languages" in the late first century BC.[33] The evidence for earlier compital plays suggests that Augustus was drawing on a long tradition of Latin dramas in a comic vein. The appearance of lar(es) in the plays of Plautus, many of which were performed for the grander public holidays in Rome such as the *ludi Megalenses*, confirms their presence within the world of humor and light-hearted parody of life in the Roman household and community.[34] If these plays told myths of *lares*, we do not know what they were.

By contrast, Ennius (239–169 BC) mentions *lares* in a much more solemn context in his eighteen-book epic poem about Roman history titled *Annales*, the first hexameter epic poem written in Latin.[35] Only a single fragment (without any context, as it is quoted for purely grammatical interest) of this important Latin poem, so familiar and often cited by Roman authors of Cicero's day, preserves a mention of *lares* in an address to them.

Vosque lares tectum nostrum qui funditus curant

And you *lares*, who take care of our dwelling from its foundation
(Ennius *Annales* F619)

In this case also, a single line actually tells us a surprising amount of information. As in Naevius, *lares* appears in the plural. They are addressed as protective deities connected with the home and its very survival in language that may come from a prayer. The home is evoked both in terms of the roof and the foundations. The *lares*, therefore, completely take care of (*curare*) the home, with which they already appear synonymous. It is striking to see domestic *lares* in the plural in such an early text. However, the actual context of the original may have referred this line to *lares* as protectors of the state collectively by analogy with the home rather than to plural *lares* in a domestic setting. Nevertheless, if these are civic *lares* called upon by priests and generals, they are described in an image that evokes a home, its boundaries, and its roof.[36]

32 L. Afranius was the most important writer of *togata* comedies, which are comic plays performed in Roman dress. See Suerbaum 2002, 263–64, and Manuwald 2011, 263–66. For D. Laberius, an *eques* who wrote literary mimes, see Manuwald 2011, 273–76, and Panayotakis 2005 and 2010.

33 Suetonius *DA* 43.1: *fecitque nonnumquam etiam vicatim ac pluribus scaenis per omnium linguarum histriones* . . . (and he often put on plays even in the local neighborhoods and on many stages in all the languages).

34 Goldberg 1998.

35 Among the many discussions of Ennius, one may particularly note Skutsch 1985 (text with commentary); Gruen 1990, 106–22; Conte 1994, 75–84; Goldberg 1995; Suerbaum 2002, 119–42, and 2003; Gildenhard 2003; Manuwald 2011, 204–9; and now Elliott 2013; Goldschmidt 2013; and esp. Fisher 2014.

36 See Skutsch 1985 ad loc., with Wissowa 1912, 149.

By contrast, the Latin historian C. Cassius Hemina, who wrote in the mid-second century BC close to the time of Ennius and Cato, relates the foundation of the cult of *lares grundiles*, which he attributes jointly to Romulus and Remus before the founding of the city.[37] Hemina's *lares* are also gods of a whole community with a single shared sanctuary. This story should be associated with the shrine to these deities in Rome (which will be discussed in section II.xii later). Separate cults of named *lares*, such as the *grundiles* or *praestites*, were also thought of as ancient and could be found at designated shrines in Rome.

At around the same time as Ennius was composing the *Annales*, his friend and sometime patron M. Porcius Cato (234–149 BC) was writing his book about farming and household management, titled *de Agricultura*.[38] This work is the earliest surviving prose text in Latin (ca. 160 BC, but probably compiled from notes made over many years). Cato represents the cult of a household *lar*, in the singular and closely associated with the hearth (*focus*) and plural *lares* at the *compita* on the edges of his property, as being essential to the existence of his ideal farm. This cult is so important that it must be maintained consistently throughout the year. Although the primary responsibility for its maintenance belonged to the owner of the farm, he must delegate his functions and perhaps also those of his wife both in the house and at the compital shrine where his fields meet those owned by others, to his (male and female) farm managers (the *vilicus* and *vilica*). They were often freed people, if not sometimes still enslaved. The details of his ritual advice will be discussed in detail in section I.v later.

Any interpretation of Cato's injunctions should ideally be based on the economic and social context in which he was writing, as far as we can understand it, as well as on his literary self-presentation.[39] While his religious advice is surely orthodox in its ritual form and content, the "model farm" he envisages is not the traditional plot of land worked by a resident owner. In other words, it is not the kind of farm Cato himself had grown up on in Tusculum. Rather, his book is probably designed for newly affluent Romans (himself included) who could afford to buy several farms, preferably placed in different regions to spread their risks and to allow for a variety of crops or herds.[40] His recommendations are consistently clothed in an aura of tradition and conservatism, an essential aspect of his personal and political persona.

These new farms were designed to make money, not to provide subsistence for a single household. The crops were carefully chosen for profitability: their sale might also be timed according to market fluctuations. The farms, often purchased by new wealth acquired from Rome's expanding empire, were worked by slaves (themselves frequently prisoners of war). Only the overseer(s) might be a freedman. Consequently, the owner would have his main residence elsewhere. In this context, detailed advice was especially needed because the landowner would often be at one

37 Cassius Hemina *FRH* 6 F11 (Peter) = F 14 (Beck and Walter), cf. Chassignet 100–101, with Schilling 1976, 958–59, and Wiseman 1995a, 5–6, and now *FRHist* 6 F 14 with commentary by John Briscoe. This fragment is from book 2. Most of Hemina's work seems to have been written before the middle of the second century BC.

38 Cato's *de Agric.*: For recent editions, see Schönberger 2000, Goujard 2002, and Flach 2005. Dalby 1998 gives an English translation. The fundamental introduction is still Astin 1978, 189–203, and 240–66.

39 Reay 2005 provides an insightful introduction to Cato as a writer about agriculture.

40 Roselaar 2010, 154–200, esp. 157–63, discusses farming for profit with an assessment of Cato, archaeological evidence, and full bibliography.

of his other estates or in town or even abroad and not in a position to visit the farm regularly. Cato's account is, however, far from being a complete or logical survey of farm management. It is not really what we would call a "handbook" at all. There are many omissions or directions that are no more than outlines or reminders, rather than proper explanations for the uninitiated. Cato never mentions the amphora, for example. Furthermore, some descriptions of practical matters are hard to accept at face value; they seem incorrect in light of our present archaeological picture.[41]

My concern here will be with Cato's religious notices, especially those about the cult of *lares* on the farm. It does not seem likely that Cato has invented anything here; his religious advice appears thoroughly conventional, if also incomplete and shaped by his own preferences.[42] For example, he never mentions *lares* in the plural, although his farm is clearly equipped with *compita* (*lares* shrines at its corners) and celebrates the festival of Compitalia at these shrines. Nevertheless, Cato's brief outline of the *lares* cult fits in with other literary and archaeological evidence we have. He represents lar(es) as essential to life on the farm.

As one of his very first acts when he returns (once again) to his farm, Cato's non-resident master is instructed to greet the household *lar.*

Paterfamilias, ubi ad uillam uenit, ubi larem familiarem salutauit, fundum eo die, si potest, circumeat. si non eodem die, at postridie.

When the father of the family comes to the villa, he should make a tour of the property that same day, if he can, once he has greeted the *lar* of the household. If not on that same day, then (he should inspect the farm) on the day after.

(Cato *de Agricultura* 2)

For Cato, this is a piece of very practical advice, as much as a theological description of the religious hierarchy on a Roman country estate. Greeting the *lar* is like inspecting the farm, something vital that needs to be done as soon as possible. This simple sentence is compressed. Cato may be implying that the master first greets the *lar familiaris* at the hearth and then makes the tour of the compital shrines at the boundaries, as he goes around (*circumeat*) the farm. He might, therefore, be greeting all the *lares* on the farm as an integral part of his tour of inspection, a procedure that may appear so normal to Cato that he does not describe it in detail.

The domestic *lar* protected the house and the household members. The master must, therefore, cultivate him assiduously and promptly. The cult activity at the hearth, which needed to be tidied and swept clean daily, was fundamental and took place on the named dates in each month, the *kalends, nones,* and *ides,* as well as on festival days. Other *lares* to be found at the compital altars that marked the boundaries of the property were under the care of the *vilicus.* The *vilicus* presided at the crossroads, the *vilica* at the household hearth, which is presumably where the master greets the *lar* upon his arrival.

41 Terrenato 2012 offers an incisive critique of Cato, both for what he says and for what he does not say in the *de Agric.*, in relation to the current archaeological picture of the Italian countryside.

42 Scheid 2001a and 2005a and Prescendi 2007 have argued persuasively and in detail for the value of Cato's descriptions of religious rituals.

Cato's system of careful delegation was designed to allow the most essential religious rituals of the farm to be performed correctly and at the right time without the presence of the master or his family. This concept of delegation was, in many ways, a religious revolution but one carefully dressed up in a concern for traditional ritual and correct observance. Cato's description is valuable for us in so many ways, not least in its enumeration of (at least some) religious rituals that were the most essential and had, therefore, to be performed by another when the master was away.[43] Cato asserts that the *lar* was central to life on the farm and that those who presided over the cult needed to be the most responsible and accountable individuals available. Most other rituals he describes in the fields could evidently be delegated to anyone, even to a slave, and did not have fixed days or times, but were performed according to convenience, local conditions, or even individual preference.

Meanwhile, Cato makes clear that delegation did not remove the master's ultimate authority over and responsibility for religious observances on his land. Like a Roman magistrate, the master was still the one under whose "auspices" business was performed.[44] Like so many high-ranking Roman officials of his day, he was finding his affairs ever more complex as his domain became more widespread and scattered. He relied on thoughtful delegation and especially on watchful, reliable *lares* to keep his farms safe and productive, one at the hearth and a pair at each "corner," even and especially in his absence.

In conclusion, a variety of quite disparate and sometimes fragmentary testimony provided by citations from authors of the third and second centuries BC indicates that cults of lar(es) in the home and at the crossroads were consistently portrayed as ancient, familiar, and typically Roman—in other words, not in need of explanation to a Roman audience. The traditional Arval hymn for *lares* was performed as part of a public cult administered by elite priests and closely connected to the well-being of the Roman state, which was the central concern of civic ritual. Our earliest physical and epigraphical evidence comes from a small altar apparently dedicated by a Roman woman to plural *lares* at a sanctuary near Lavinium. Fragments of drama and the titles of lost plays suggest a regular celebration of the midwinter festival of Compitalia. Meanwhile, a version of compital cult attested by popular paintings was brought by Romans and Italian traders to the island of Delos in the second half of the second century BC, where it flourished amid the large population of freedmen and slaves (discussed in detail in section III.xviii later). Cato and the evidence from Delos consistently illustrate the delegation of the cult to slaves and freedmen throughout the second century, in both urban and rural settings where masters were often away. There is every reason, therefore, whatever their precise origins, to see *lares* cults as fully integrated into Roman life once our surviving evidence brings them into focus (around the later third century BC).

43 Cato's religious rituals: *de Agric.* 50 (planting), 83 (prayer for the oxen), 132 (banquet for Jupiter), 134 (pig for the harvest), 139 (thinning a grove), 141 (*lustratio* of fields), and 149 (digging). For full discussion, see Scheid 2005a and Prescendi 2007.

44 Lintott 1999a, 114–15, discusses how the Romans used *legati* (deputies).

III A *LAR* INTRODUCES HIMSELF

ego sum lar familiaris ex hac familia
—PLAUTUS *AUL.* 2

T. Maccius Plautus (ca. 254–184 BC) is the earliest Latin author whose works survive, which makes it all the more striking that we have some twenty-one comedies by (or attributed to) him, as well as quotations from and titles of many other plays that circulated under his name.[1] The rich evidence provided by these texts makes Plautus an invaluable source for the lives and entertainments of Romans in a formative period of Roman culture from about 215 to 185 BC. Yet we know hardly anything about his background or his life; his name seems a riff on the typical Roman naming pattern with three names (*praenomen, nomen, cognomen*). Presumably, he was not originally from Rome and probably came from a humble background. His comedies are complex and nuanced, setting a range of satirical observations about Roman life in fictional Greek contexts in plays that adapted Greek originals for the Roman stage.[2] Inevitably, many of the subtler jokes are lost to us. As a result, Plautus is useful but also maddeningly hard to read.

Lar(es) are mentioned as familiar figures in many of Plautus' plays. At the beginning of *Aulularia* ("Little Pot of Gold," first performed around the year 195 BC), a single household *lar* steps alone onto the stage to introduce both himself and the action of the play that is about to unfold.[3] His words and general demeanor reveal who he is and how he lives inside the house. Unfortunately, his dress and overall appearance are not described in his speech. He says that he feels the need to introduce himself in case the audience is in any doubt about who he is. This might suggest that he is not immediately recognizable by any characteristic dress or attributes: perhaps he looks more like a slave than the usual gods on stage.[4] On the other hand, he could also be making a joke, if he was, in fact, immediately recognizable. One wonders what mask the actor portraying him was wearing, if masks were indeed in use in Plautus' day, as seems to have been the case.

The *lar familiaris* is one of the main characters in the play and the source of the action, for he guards the pot of gold that will eventually allow the daughter of the house (Phaedria), notwithstanding the self-centered folly of her miserly father (Euclio), to marry her sweetheart Lyconides, who is the father of the child she is expecting, with a handsome dowry provided by the inherited gold. Consequently, the play describes how the *lar* ensures that an inheritance is passed intact from great-grandfather to great-granddaughter, and by implication to her child in the next generation. In this case, the passing on of wealth is not represented as strictly in the male line nor in terms of preserving a single *gens*. In fact, inheritance by

1 For T. Maccius Plautus, see Slater 1985/2000; Gruen 1990, 124–57; Conte 1994, 49–64; Blänsdorf in Suerbaum 2002, 183–228; and Manuwald 2011, 225–34 (with full bibliography). Christenson 2000, 1–4, provides a useful overall introduction.

2 Wissowa 1912, 169 n. 5, comments on a combination of Greek and Roman themes in Plautus' portrayal of the *lar* in *Aulularia*.

3 For texts of *Aulularia*, see Lefèvre 2001 and Questa 2004.

4 See Pollini 2008 for the dress of the *lares* making them look like slaves, perhaps to suggest the gods' closeness to the humble.

women, especially of significant sums of money, became a subject of discussion and eventually of restrictive legislation during the earlier second century BC.[5]

PROLOGVS

LAR FAMILIARIS

<div style="margin-left:2em">

 1 Ne quis miretur qui sim, paucis eloquar.
 ego Lar sum familiaris ex hac familia
 unde exeuntem me aspexistis. hanc domum
 iam multos annos est cum possideo et colo
 5 patri avoque iam huius qui nunc hic habet.
 sed mí avos huius obsecrans concredidit
 thensaurum aúri clam omnis: in medio foco
 defodit, venerans mé ut id servarem sibi.
 is quoniam moritur (ita avido ingenio fuit),
10 numquam indicare id filio voluit suo,
 inopemque optavit potius eum relinquere,
 quam eum thensaurum commonstraret filio;
 agri reliquit ei non magnum modum,
 quo cum labore magno et misere viveret.
15 ubi is óbiit mortem qui mihi id aurum credidit,
 coepi observare, ecqui maiorem filius
 mihi honorem haberet quam eius habuisset pater.
 atque ille vero minus minusque impendio
 curare mínusque me impertire honoribus.
20 item a me contra factum est, nam item obiit diem.
 is ex se húnc reliquit qui hic nunc habitat filium
 pariter moratum ut pater avosque huius fuit.
 huic filia una est. ea mihi cottidie
 aut ture aut vino aut aliqui semper supplicat,
25 dat mihi coronas. eius honoris gratia
 feci, thesaurum ut hic reperiret Euclio,
 quo illam facilius nuptum, si vellet, daret.
 nam eam compressit de summo adulescens loco.
 is scit adulescens quae sit quam compresserit,
30 illa illum nescit, neque compressam autem pater.
 eam ego hódie faciam ut hic senex de proxumo
 sibi uxórem poscat. id ea faciam gratia,
 quo ille eam facilius ducat qui compresserat.
 et hic qui poscet eam sibi uxorem senex,
35 is adulescentis illius est avonculus,
 qui illam stupravit noctu, Cereris vigiliis.
 sed hic senex iam clamat intus ut solet.
 anum foras extrudit, ne sit conscia.
 credo aurum inspicere volt, ne subreptum siet.

</div>

5 Lex Voconia of 169 BC: Paulus *Sent.* 4.8.20; Gaius *Inst.* 2.226; Gellius *NA* 17.6, with Watson 1971, 29–33, 35–37, 167–70.

In case anyone wonders who I am, I will tell you briefly. I am the *lar* of this household that you saw me coming out from. For many years already I have both been occupying this house and protecting it for the father and grandfather of the man who lives here now. Now this man's grandfather entrusted me with a treasure of gold, with fervent prayers, hidden from everyone. He buried it in the middle of the hearth, begging me to guard it for him. When he died, he did not even want to tell his own son—he was so greedy. He wanted to leave him poor rather than show this treasure to his son. He did leave him a piece of land, not a big one, though, so that he could live on it with great toil and miserably. When the man who had entrusted the gold to me died, I began to observe whether his son would in any way hold me in greater honor than his father had. He took less and less trouble over me and gave me fewer honors. I did the same in return: he also died poor. He left a son behind, the one who lives here now, a man of the same character as his father and grandfather. He has one daughter. She worships me every single day with incense or wine or something else and gives me garlands. It is in order to honor her that I let this man here, Euclio, find the treasure, so that he might give her more easily in marriage should he wish to do so: a young man of very high rank has raped her. This young man knows who the girl he raped is, but she doesn't know him, and her father does not even know that she has been raped. I will make this old man from next door ask for her in marriage today. My reason for doing this is so that the man who has raped her may marry her all the more easily. And this old man who is going to ask for her as his wife, he is the uncle of that young man who violated her chastity by night during the rituals held in honor of Ceres.

But now this old man is shouting inside as usual. He is throwing out the old woman so that she cannot learn his secret. I think he wants to look at his gold, in case it has been stolen.

(Plautus *Aulularia* 1–39)

The *lar* is characterized as the guardian spirit of the household, and his name is *lar familiaris*. In fact, he refers to the house he has just come out of as *familia* ("household," that is, the people) rather than *domus* ("house," that is, the building). He lives at and in the hearth (*focus*), which is where he receives daily offerings from the daughter of the house and guards the hidden pot of gold, buried there by her great-grandfather who has entrusted all his savings to his domestic *lar*. It is unclear whether we are supposed to imagine that a picture of the *lar* is painted beside the hearth or whether he is worshipped aniconically in the hearth's fire itself. Nor is the location of this hearth within the house ever revealed. It could be imagined either in an atrium or in a room set aside for cooking.

This *lar* takes his job as guardian of the family fortune very seriously. However, he has been displeased by the miserly Euclio's father, who did not fulfill his duty in performing the rituals owed to the *lar familiaris* by the head of the household. Miserliness is associated with lack of care for the *lar*, over several generations. Instead, Euclio's daughter Phaedria (who never appears on stage in the surviving sections of the play) has taken over as the faithful one who makes offerings to the *lar* on a daily basis. Consequently, he is so pleased with her that he now chooses to reveal the hidden gold to her greedy father, so that she will be able to have a dowry and not need to marry the rich but elderly man next door (Megadorus), whom her

father has chosen for her. In a plot twist typical of comedy, Megadorus is the uncle (*avunculus* = mother's brother, the more kindly uncle) of the father of her child, Lyconides, who is himself, therefore, not a penniless lover but heir to a considerable fortune.

The daily offerings to the *lar* are described as incense (*tus*), wine (*vinum*), or a little something (*aliqui*). On special days, Phaedria gives the *lar* the traditional garlands of flowers (*coronae*) that appear to be his favorite things. In other words, the *lar* likes the offerings of standard ritual, especially flowers, but will settle for other items, big or small: he appreciates her daily attention. He reproaches her male ancestors for their neglect of household cult, but is in no way offended that a woman has taken over this function. He has been waiting patiently for someone in the home to notice him. Phaedria is richly rewarded for her simple piety. In fact, the *lar* goes beyond answering her prayers to taking action independently on her behalf. The words used for the cult at the hearth are the typical language of Roman ritual. *Venerare, curare, supplicare*, and *obsecrare* describe the actions (to venerate, to cultivate, to beseech, and to beg), while the offerings themselves are *honores* (honors), but also simply gifts (from the verb to give: *dare*). It is for the sake of this honor (*honoris gratia*) that the *lar* now intervenes on behalf of the daughter of the house.

Plautus' play makes quite clear that the *lar* is not a spirit of a deceased ancestor. Rather he is the god of the hearth to whom an ancestor (her great-grandfather who is now long gone) has entrusted (*concredidit*) the gold. He is a god of the living whose concern is the wellbeing, prosperity, and continuity of the family into the future. In the context of Plautus' play, the *lar* is not described as simply a god relegated to a kitchen area and cultivated by slaves. Rather he is central to the family and his cult is primarily the responsibility of the master of the house. He is very well intentioned toward the family and is not an impatient or vengeful deity. He takes simple pleasure in an ongoing relationship of mutual trust and respect with Phaedria. Meanwhile, he sees and knows everything that has been happening in the family. His explanation of the actions that precede the beginning of the play confirms his role as a watchful household god. Other Plautine plays with gods who introduce the action in their prologues include *Amphitryon*, which features Mercury appearing dressed as the slave Sosia, and *Trinummus*, which opens with a debate between *Luxuria* (Abundance) and *Inopia* (Need), reflecting the Roman love of abstract divine qualities, as well as contemporary debates over wealth and its display.[6]

Later in the play, when Euclio is planning his daughter's wedding, despite insisting that he wants to spend as little as possible on the ceremonies, he does go to buy incense and garlands for the *lar* at the hearth in order to ask for a happy marriage for Phaedria.[7] Again, therefore, the importance of the *lar* to family life is stressed. This gesture balances the bronze coins that Phaedria, as the Roman bride, will give to the *lar* of her new home and to the *lares* at their crossroads on her wedding day, according to Varro.[8] References to *lares* in other plays by Plautus confirm the general picture in *Aulularia*. A domestic *lar* receives a garland in the

6 For discussion, see especially Slater 1985/2000, 123–26.

7 *Aul.* 385–87: *nunc tusculum emi hoc et coronas floreas: | haec imponentur in foco nostro lari, | ut fortunatas faciat gnatae nuptias.* (now I have bought this incense and garlands of flowers. Let them be put on our hearth for the *lar* so that he will bless my daughter's marriage). See Hersch 2010 for the *lares* as gods of the wedding ceremony, discussed in section II.x later.

8 Varro *Vit. PR* 1.2 = Nonius 33L, discussed in section II.x.

Trinummus and a salutation from a master in *Miles Gloriosus.*[9] In *Mercator,* the main character wants to move elsewhere, which will mean finding another *lar* in the context of a new home but meanwhile entrusts his father to the family *lar.*[10] Before setting out on his voyage, he calls on the protection of the *lares viales* (lares of the road), traditional gods of the journey.[11]

Despite the fictional Greek settings of his comedies, Athens in the case of *Aulularia*, Plautus uses various *lares* to create a rich picture of conventional Roman domestic religion. Plautus' *lar familiaris*, therefore, receives cult at the hearth in a similar way to the *lar* on Cato's farm, although Plautus' settings are clearly in town. Cato's concern for regular cult at the hearth, entrusted to the *vilica*, mirrors the situation of the daughter of the house envisaged in *Aulularia*. Similarly, Cato confirms the sentiments of the *lar* in *Aulularia* by saying that the master must take responsibility for all household religion, as well as religion on his farm. Cato stresses the basic necessity of cultivating the *lar familiaris*, a god who is all the more vital to a master who is not always there but who hopes his farm will be productive and well run in his absence, so that his heirs will eventually be able to inherit a solid investment.

Nevertheless, there is apparently a basic contradiction between *Aulularia* and *de Agricultura.* One cannot help noticing that in Plautus' play, Euclio and his father are specifically blamed for not cultivating the household *lar* themselves. In contrast, Cato recommends delegating the cultivation of this same *lar* to the *vilica*, who is either a slave or a freedwoman, not a family member. Presumably it is the master's absence from the farm that justifies this arrangement. If Plautus' *lar* is also blaming Euclio for not officially delegating his religious duties, that idea is never explicitly expressed. Nevertheless, at least a generation separates these two texts, which are obviously also in very different genres and styles. The contrast, however, continues to be thought provoking, especially since we have so little extant evidence from second-century BC texts, let alone ones that have survived in more than fragments.

Plautus offers a unique glimpse into the cult at the hearth by allowing the *lar* himself to speak and, therefore, to represent a perspective all his own. He is our only speaking *lar.* It is obviously a pity that *Aulularia* does not survive complete so that we could be sure of everything the *lar* says and does in the drama. The many overlaps with other evidence about the *lar* in the household, from the closely contemporary writings of Cato to the kitchen paintings in Pompeii that were made some 250 years later, serve to confirm the value of Plautus' early evidence. Yet caution is still wise since the context is comedy: we will never really know exactly what was meant as a joke when these plays were first performed. Meanwhile, the variety of *lares* who appear in Plautus complement *lares* introduced by Roman authors into other types of texts based on Greek models, notably tragedies (discussed in the next section).

9 *Trinum.* 39: *Larem corona nostrum decorari volo.* (I want our *lar* to be decorated with a wreath). *Miles Gloriosus* 1339: *Etiam nunc saluto te, <lar> familiaris, prius quam eo.* (Even now I greet you, household *lar*, before I go).

10 *Merc.* 834–37: *di penates meum parentum, familiai lar pater, | vobis mando, meum parentum rem bene ut tutemini. | ego mihi alios deos penateis prosequor, alium larem, | aliam urbem, aliam civitatem: . . .* (I entrust my parents' affairs to you *penates* of my parents and to you father *lar*, so that you may guard them. I am going in search of other *penates* for myself, another *lar*, another town, another state . . .).

11 *Merc.* 864–65: *. . . invoco | vos, lares viales, ut me bene tutetis* (I call on you, *lares* of the roads, asking you to guard me closely).

IV SINGLE *LAR*, TWIN *LARES*

> . . . the household cults lay at the core of Roman religion.
> —SMALL 2007, 201

The prevalence of a single *lar* in Plautus and Cato has been interpreted as evidence for a standard domestic cult of one *lar* at the hearth in the first half of the second century BC and earlier. However, even Plautus himself, in *Rudens*, a play that was first performed in 211 BC (well before the date of around 195 BC usually assigned to *Aulularia*) provides a reference to *lares familiares* in the plural, in the context of domestic cult in a household.[1] A father prepares to sacrifice to the *lares* in thanksgiving for finding his daughter, who has been rescued from slavery.

> 1205 Aliquando osculando meliust, uxor, pausam fieri;
> atque adorna, ut rem divinam faciam, cum intro advenero,
> laribus familiaribus, cum auxerunt nostram familiam.
> sunt domi agni et porci sacres.

It is better to stop kissing at some point, my wife. And make the preparations, so that I can sacrifice to the *lares* of the household when I come in and approach them, because they have magnified our household. We have at home the unblemished lambs and pigs ready (for sacrifice).

(Plautus *Rudens* 1205–7)

It is hard to explain this expression away as a reference to the collective of household deities, also an unparalleled usage. This third-century BC evidence for twin *lares* in the household raises complex questions about what traditional domestic cult looked like and how it evolved. A simple, linear development from a single *lar* at the hearth in the early second century BC (Plautus and Cato) to the twin *lares* depicted in the religious paintings in the houses of Campania by the mid-to-late first century AD is apparently an oversimplification.[2] A century after Plautus, L. Pomponius wrote a play titled *lar familiaris* (household *lar*), which is evidence for a single household *lar* in the early first century BC. Unfortunately, no ancient source comments on the history of lar(es) in the home or makes any explicit reference to a specific moment of change from a single household god to twin, identical deities or, alternatively, to the rationale behind a hypothetical choice between these two options.

Numerous Latin authors, in both prose and poetry, mention domestic lar(es) in a variety of contexts involving the household. These gods are so closely related to the very concept of "home" that they are often evoked either to conjure up a sense of security and belonging or to describe its opposite, notably loss of the home or

1 For commentary on the *Rudens,* see Marx 1928, who notes the rare early reference to plural *lares.* Prescendi 2007, 96, comments on the fact that he has both lambs and pigs ready and set aside for sacrifice. Christenson 2000 dates the first performance to around 190 BC. Regardless of the (much disputed) relative chronology of these plays, the plural is striking in Plautus' lifetime.

2 Wissowa 1912, 173; Fröhlich 1991, 128; and Giacobello 2008, 52–54, argue for a straightforward development from one *lar* to twin *lares* in the home. Tybout 1996 dates the emergence of the twin *lares* paintings (as a type) in Pompeii around 50 BC.

exile from one's native place. The authors that show most interest in these deities generally use a singular *lar* or plural *lares*, to refer to domestic cult as if there were no real difference in practice or meaning. Nevertheless, it seems that the *lares* of the crossroads and those mentioned in state cult (such as the Arval hymn or the names of temples in Rome) are always in the plural with no exceptions.

Prose authors who mention *both* singular *and* plural *lares* in domestic cult include Cicero, Valerius Maximus, Pliny the Elder, Quintilian, Seneca the Younger, Apuleius, Festus, Servius, and Porphyrio.[3] In verse, both numbers of gods appear in the works of Plautus, Varro, Vergil, Horace, Tibullus, Propertius, Ovid, Persius, Juvenal, Seneca, Statius, Martial, and Silius Italicus.[4] In other words, domestic *lares* are very familiar in many kinds of writing in Latin.

A single *lar* is only ever found inside the house. The following authors mention *only* a single household *lar*: Cato, Columella, Curtius Rufus, Granius Flaccus, Livy, Sallust, Catullus, Calpurnius Siculus, Germanicus Caesar, Iunius Silanus, Remmius Palaemon, and Symmachus.[5] By contrast, plural *lares* are mentioned as the *only* option in Petronius, Lucan, Valerius Flaccus, Fronto, Suetonius, Florus, Hyginus, Q. Terentius Scaurus, the anonymous author of the *SHA* biography of Pertinax and the *Digest* (Ulpian).[6] In other words, despite the ubiquity of twin *lares* in domestic settings from Campania, only a minority of Latin authors (none before the middle of the first century AD) attest a comparable cult dominated by a consistent pattern of twin gods in the home. Such a discrepancy between different types of evidence is not untypical.

Moreover, some authors who tell us a great deal about life in their households do not mention a domestic cult of lar(es) at all, perhaps most strikingly the younger Pliny in his letters (early second century AD) that describe many aspects of his domestic routines in detail, both in Rome and at his several, large country villas. No Roman writer refers to the kind of *lares* painting that was so common in and around the kitchens on the Bay of Naples.[7]

The adjectives that describe *lares* in the household are many, but all are consistent with gods of place who protect the home. They evoke belonging (possessive adjectives such as *meus*, *tuus*, and so on [my, your], and related descriptors including *proprius* [own], *adsuetus* [accustomed], or *nullius* [belonging to no one]); landscape (*rusticus* [rustic], *urbanus* [urban]); relationships (*familiaris* [household], *fraternus* [brotherly], *paternus* [paternal], *patrius* [ancestral], *communis* [shared], *socius* [allied], *vicinus* [neighborhood], *hospitalis* [hospitable]); venerable age (*antiquus* [ancient], *avitus* [grandfatherly]); security (*certus* [sure], *securus* [secure], *fidus* [faithful], *perpetuus* [perpetual]) or insecurity (*desertus* [deserted], *incertus* [unsettled]); privacy (*privatus* [private], *secretus* [secret], *clausus* [enclosed] or *apertus* [open]); wealth (*maximus* [greatest], *regius* [royal], *argenteus* [silver], *exornatus* [adorned], *festus* [festive]); but more often poverty or thrift (*angustus* [narrow], *paulus* [small], *parvus* [little], *parvulus* [very small], *pauper* [poor], *exiguus* [modest], *humilis* [humble], *gracilis* [graceful], *modicus* [moderate], *tenuis* [slender]),

3 Both a singular and plural lar(es) in prose: see appendix 1.
4 Both a singular and plural lar(es) in verse: see appendix 1.
5 Only one *lar*: see appendix 1.
6 Only plural *lares*: see appendix 1.
7 Giacobello 2008, 55.

dress or appearance (*incinctus* [belted], *subcinctus* [belted], *bullatus* [wearing a *bulla*], *nitidus* [shining], *renidens* [shiny]), and emotions that reveal empathy with the members of their household when they are in trouble (*trepidus* [fearful], *victus* [defeated], *miserus* [miserable], *raptus* [snatched], *motus* [moved], *fugans* [in flight]). Several other adjectives reflect rarer qualities (*hesternus* [yesterday], *iussus* [ordered], *salutatus* [greeted], *deceptus* [deceived], *innocuus* [harmless], *maculatus* [stained]). The most commonly chosen modifiers express belonging and, to a lesser extent, simplicity.[8] No adjectives attribute negative, malicious, or frightening qualities or intentions to these ubiquitous protective gods, who never express anger.

Some Latin poets, including Vergil, Ovid, Tibullus, and especially Statius, had the habit of inventing epithets based on the names of leading characters or place names taken from foreign cultures to describe *lares* whom they inserted into poems and plays dealing with Greek, Trojan, or other non-Roman themes. Examples of such adjectives are *Assaracus, Ausonius, Albanus, Parrhasius, Cadmeus, Teucrius, Iliacius, Aetolus, Herculeus, Tyrius, Sidonius, Argolicus, Pergameus.*[9] The ubiquity and emotive quality of *lares* in the Roman imagination evidently made them very tempting to deploy even when the imagined or imaginary setting of a given story did not obviously call for these most Roman of gods to play any part. In these contexts, *lares* seem to function as metaphors or analogies since the audience is surely aware that the characters and contexts in question preclude this Roman cult. These Latin renderings of plays on traditional mythological subjects do not use Greek settings to comment on Roman life in the thinly veiled manner of Plautus. This habit of introducing *lares* into foreign *milieux* and inventing what are blatantly "artificial" epithets is especially striking in the case of stories adapted from famous Greek originals, such as the tragedies of Seneca. Meanwhile, one may be equally surprised to come across a singular *lar* in Germanicus' translation of Aratus' *Phaenomena* (a Hellenistic Greek didactic poem about constellations and weather) or Iunius Silanus' translation of Mago (an agricultural manual originally in Punic).[10]

Lares, it seems, were simply useful to have around the house or farm, and they looked even more attractive with descriptive modifiers that placed them in a familiar environment. Their association with domesticity, a feeling of safety and belonging, and a more general sense of being "at home" in a particular place gave them their own, distinctive emotional quality. Yet no surviving author wrote their story in Latin and no one explained their number or nature. Only Plautus allows a *lar* of any kind to speak. The relationship between *lares* at the crossroads and in the

8 The most common adjectives applied to *lares* are *familiaris* and *patrius. Lares* are very often designated by a possessive adjective.

9 Non-Roman place names as adjectives for *lares* (in poetry): *Aetolus* (Stat. *Theb.* 8.737); *Albanus* (Lucan 7.394); *Argolicus* (Stat. *Theb.* 9.515), cf. *Ausonius* (Stat. *Silv.* 5.3.168); *Assaracus* (Verg. *Aen.* 9.259, Sil Ital. *Pun.* 3.566); *Cadmeus* (Stat. *Theb.* 4.57 and 10.585); *Herculeus* (Juv. 8.14, Sen. *Herc. O.* 245); *Iliacus* (Val. Flacc. *Arg.* 2.246); *Laurentis* (Sil. Ital. *Pun.* 1.659); *Parrhasius* (Ovid *Fast.* 1.478); *Pergameus* (Verg. *Aen.* 5.744); *Sidonius* (Stat. *Theb.* 7.600); *Teucris* (Stat. *Silv.* 4.5.2, *Ach.* 1.933); *Tyrius* (Stat. *Theb.* 4.374).

10 For Germanicus' Latin version of Aratus' *Phaenomena* (725 hexameter verses), see Fantuzzi in *BNP* (Aratus). For Mago (whose work was in 28 books), see Ameling 1993, 259–60, and Greene and Kehoe 1995. For D. Iunius Silanus' translation of five agricultural authors from Punic into Latin officially commissioned by the senate after the destruction of Carthage in 146 BC, see Cicero *de Orat.* 1.249, Varro *RR* 1.1.10, Pliny *Nat.* 18.22, and Columella *RR* 1.1.13 and 12.4.2.

home is never elucidated for us. So we are left to make the most, to the best of our ability, of the very ordinary quality of *lares* in Latin texts, unremarkable and, therefore, not remarked upon. Their value was closely related to their essentially Roman identities, as well as to their accessibility to everyone. Even settings where they were not usually to be found apparently invited them to be inserted.

V MONTHLY RITUALS AT THE HEARTH

> at mihi contingat patrios celebrare penates
> reddereque antiquo menstrua tura lari
> —TIBULLUS 1.3.33–34

As already noted, Cato provides some of our earliest and most explicit information about Roman religious ritual in general and about the cult of a domestic *lar* at the hearth on a second-century BC farm in particular. His *de Agricultura* purports to give specific and practical directions for a variety of rituals on an ideal farm. It is the *vilica* who is in charge of cult at the hearth; this is her only mandated religious function.[1] She was often one of the few, or even the only, woman mentioned on a medium sized estate as described by Cato. Literary and epigraphical evidence shows that the term *vilica* is probably a job title, meaning "female farm manager," rather than denoting simply "wife of a *vilicus*."[2] As Cato himself notes, she might be married to the *vilicus* on the farm, but might also be the wife of another man or an unmarried woman. He devotes a detailed chapter to her many duties, just as he does for the *vilicus*; he describes what she should and should not be doing. In this description, he addresses the *vilicus*, who is in charge of the whole farm and those who live there, and by implication to the master, rather than to the woman herself. The *vilica* is not, therefore, explicitly imagined as a reader of Cato's book. While Cato's text is primarily prescriptive rather than descriptive, its advice arises from his experiences on various farms in different capacities throughout his long life.

> Vilicae quae sunt officia, curato faciat. si eam tibi dederit dominus uxorem, ea esto contentus. ea te metuat facito. ne nimium luxuriosa siet. uicinas aliasque mulieres quam minimum utatur neue domum neue ad sese recipiat: ad coenam ne quo eat neue ambulatrix siet. rem diuinam ni faciat neue mandet, qui pro ea faciat, iniussu domini aut dominae: scito dominum pro tota familia rem diuinam facere. munda siet: uillam conuersam mundeque habeat; focum purum circumuersum cotidie, prius quam cubitum eat, habeat. Kal., Idibus, Nonis, festus dies cum erit, coronam in focum indat, per eosdemque dies lari familiari pro copia supplicet. cibum tibi et familiae curet uti coctum habeat. gallinas multas et oua uti habeat. pira arida, sorua, ficos, uuas passas, sorua in sapa et piras et uuas in doliis et mala struthea, uuas in uinaciis et in urceis in terra obrutas et nuces pr<a>enestinas recentes in urceo in terra obrutas habeat; mala scanti[ni]ana in doliis et alia quae condi solent et siluatica, haec omnia quotannis diligenter uti condita habeat. farinam bonam et far suptile sciat facere.

> Make sure that the housekeeper performs all her duties. If the master has given her to you as your wife, be content with only her. Make her respect you. Let her not be too extravagant. She must visit the neighboring and other women as little as possible, and not have them either in the house or in her

1 For commentaries, see Schönberger 2000 and Goujard 2002.

2 Roth 2004 presents a compelling case for the *vilica* as a professional farm administrator. She does not discuss the evidence for the *vilica's* religious duties, which further supports her general argument. For a longer description of a *vilica's* tasks, see Columella *RR* 12 (first century AD).

own part of it. She must not go out to meals, or be (seen) out on regular walks. She must not engage in religious worship herself or tell others to engage in it for her without the orders of the master or the mistress; she should be aware that the master attends to religious rituals for the whole household. She must be neat herself, and keep the farmstead neat and clean. She must clean and tidy the hearth (or make ritually pure and swept) every night before she goes to bed. On the *kalends*, the *ides*, the *nones* (of each month), and when there is a religious holiday, she should hang a garland on the hearth and should make requests to the household *lar* on those days, (accompanied by offerings) according to her means. She must keep a supply of cooked food on hand for you and the servants. She must keep many hens and have plenty of eggs. She must have a large store of dried pears, sorb apples, figs, raisins, sorbs in wine, preserved pears and grapes and quinces. She must also keep preserved grapes in grape-pulp and in pots buried in the ground, as well as fresh Praenestine nuts kept in the same way, and Scantian quinces in jars, and other fruits that are usually preserved, as well as woodland fruits. All these she must store away diligently every year. She must also know how to make good flour and to grind spelt (dinkel wheat) into fine flour.

(Cato *de Agricultura* 143)

A variety of specific household and cooking skills are listed, along with organizational competency with regard to ensuring a sufficient and varied food supply, stored in the most practical ways over the winter. Not surprisingly, Cato's ideal *vilica* is envisaged as being clean, tidy, thrifty, loyal, and self-motivated with regard to managing the household. She should limit her socializing, especially with women who do not live on the farm. Cato's text purports not only to describe "best practices," such as with regard to food preparation and storage, but also to alert his male readers to potential pitfalls in the supervision of a woman employed on a farm.

Cato addresses the marital status of the *vilica* at the beginning of the chapter. If she is legally married (*uxor*), then she must be a freedwoman, since slaves could not be married. If she is not, then she could presumably still be a slave, who might or might not be a concubine. If she is his wife, then Cato orders the *vilicus* to be faithful to her, without any similar advice explicitly addressed to her in return, although this is surely implied. Beyond questions of competence with regard to household tasks, Cato warns against too much opulence (*nimium luxuriosa*), the cultivation of female friends, especially off the farm, going to dinner parties and on walks around the neighborhood, and any kind of personal religious initiative. Any of these activities might perhaps go unnoticed or be considered harmless by some masters. There is obviously a tension here between the desire to encourage thoughtful managing of vital resources and taking responsibility for maintaining high standards, as opposed to limiting the inherent tendency toward initiative of an energetic and locally well-regarded woman, who would naturally build up a robust network of contacts in the area. Meanwhile, the *vilica*'s isolation apparently made it natural for her to seek female friends elsewhere. In this discussion, Cato shows his customary shrewdness and conservatism, as well as attention to detail. His advice may have a moral overtone, but it is also based on an ideal, since the master himself is not there to see what she is doing.

In general, the *vilica* should follow her master's and mistress's religious instructions and preferences, which Cato does not feel the need to elaborate on in further

detail. The cult of the *lar* at the hearth, however, is not optional and must be per-
formed in an orthodox manner on the appointed days on every farm. This cult is
described immediately after the instruction to clean and tidy the hearth every eve-
ning before going to bed, rather than in the earlier directive about religious prac-
tice in general. In Cato's text, the cult of the *lar* operates, therefore, at the basic level
of keeping the household functioning. In other words, the daily sweeping of the
hearth is a question both of tidiness and of respect for the *lar*. Cato's adjective for
clean (*purus*) might also have a religious connotation of ritual purity. In this con-
text, it seems that cleanliness really was next to godliness.

Cato does not, however, advocate daily offerings to the *lar* like the ones that the
daughter performs in Plautus' *Aulularia*. In keeping with the terse style of his in-
structions, we may imagine that his description, therefore, speaks to the essentials
of the cult, the basic gifts that are owed to the *lar*, rather than to the practices of
the especially pious. Needless to say, Cato is not concerned with the spiritual life
of the *vilica* herself. No others in the house seem to honor the *lar* except the master
when he returns and the *vilicus* at the corner of the estate. Nor is there any men-
tion of a cult of the master's *genius* by the members of his household. Despite there
being a variety of religious rituals required for work in the fields, such as before
plowing or before the harvest, none of the *vilica's* many other tasks apparently re-
quires a prayer or ritual that Cato feels the need to specify.

The essential instruction for the monthly cult of the *lar* is as follows:

> kalendis, idibus, nonis, festus dies cum erit, coronam in focum indat, per eo-
> sdemque dies lari familiari pro copia supplicet.

> On the *kalends*, the *ides*, the *nones* (of each month), and when there is a reli-
> gious holiday, she should hang a garland on the hearth and should make
> requests to the household *lar* on those days, (accompanied by offerings) ac-
> cording to her means.

> (Cato *de Agricultura* 143)

Like the *lar* in Plautus and other texts, Cato's *lar* prefers garlands of flowers above
all but seems willing to have, in addition, any other types of offerings that might
be to hand. Unlike many other cults in Cato's manual, this one does not include
the precise prayer language to be used.[3] The *vilica* can say her prayers, presumably
on behalf of the whole household, according to her best judgment. She should also
decide what to give the *lar* according to the resources available on any given day.
The implication is that the god should receive a fair share, especially when things
are going well. Conversely, he will understand and not be offended when less is
available, according to the season or in a lean year. Other than the injunction to
give the traditional garlands of flowers most suited to this particular god, the only
other specific instruction is to honor him on the named days of the Roman month
and on any other feast day that is being observed on the farm.

The *lar familiaris*, therefore, shares in any holiday or festival that takes place in
the house. He is the deity closest to the home and to the *familia* living in it: he is
naturally included as a member of the household. Cato does not provide a sample

3 Most of Cato's major rituals include precisely quoted language for prayers. The prayers are
the most detailed feature of his instructions. See *de Agric.* 132, 134, 139, 141, 149.

calendar to allow us insight into how many festival days were observed on the farm or how long these holidays lasted. One may imagine that things were rather traditional and that agricultural work could not easily accommodate the increasing number of festival days observed in the city.[4] In addition, there might also be holidays or anniversaries of family significance, especially when the master was in residence. Many old, public holidays fell in the second part of the month, after the *ides*.[5] Ultimately, there was no universal calendar that a Roman could refer to for guidance.

The instructions for the *vilicus* are similar to those for the *vilica* and are also part of a separate chapter dedicated to his duties.

Rem divinam nisi Compitalibus in compito aut in foco ne faciat.

[The *vilicus*] should not perform religious ritual except on [the festival of] Compitalia at the cross-roads shrine or at the hearth.

(Cato *de Agricultura* 5.3)

The word order in the Latin seems to suggest that it is only on the day of the annual midwinter festival of Compitalia (discussed in detail in section III.xvii later) that the *vilicus* should be presiding over formal rituals addressed to the gods, understood here as the lar(es) who were honored in each location. This is not, therefore, a rule about the private beliefs or prayers of the overseer as an individual, but about which religious rituals were to be performed on behalf of the household under his supervision, as the representative of the master himself. It was on this day that he also gave the slaves a holiday and a generous ration of wine.[6] It goes without saying that the compital shrines at the corners of the property also needed to be maintained on a regular basis.

By contrast, it is revealing that the named days of the month each belonged in a special way to the household *lar*.[7] If the festal calendar on the farm was indeed simple, then these three named days will have outnumbered the formal "holidays." Each month had three named days for a total of thirty-six flower wreaths and supplications for the *lar* each year. Some years in the pre-Julian calendar would have featured an additional, intercalary month that also had the three named days, at least in the city, which would have yielded three additional garlands for the *lar*. Cato does not provide details about the composition of these wreaths.[8] They will have

4 Graf 1997, 21, argues that the Romans experienced festivals differently according to their social status and place of residence. Feeney 2010 posits an original calendar that included only the named days and a few festivals.

5 Laurence and Smith 1995–96, esp. 137, is the essential discussion. Graf 1997, 19, contrasts Roman festivals (mostly after the *ides*) with Greek ones that usually fell before the full moon.

6 Cato *de Agric.* 57.

7 For offerings on the named days of the Roman month, see also Varro *LL* 6.27–28, Festus 176.20L, and Macrobius *Sat.* 1.15. According to Macrobius *Sat.* 1.15.12, the *nones* was the day on which country dwellers traditionally went to Rome to ask the *rex sacrorum* which festivals to observe between that day and the next *nones*.

8 For wreaths, see Pliny *Nat.* 21 (in general) and Guillaume-Coirier 1999 (a few additional thoughts in Guillaume-Coirier 2002), with *ThesCRA* 2.451–52 (Blanc). Most of our surviving information is about expensive garlands and wreaths; there is not much detailed discussion of "le travail ordinaire exécuté à la maison" (Guillaume-Coirier 1999, 370: the ordinary work done at home).

varied significantly with the seasons and according to the resources of the estate and the skill of the *vilica* or of the slave who made them for her to offer.

In order to carry out her instructions correctly, the *vilica* obviously had to know what day it was every day. Did she have her own calendar? Was she, in fact, in charge of a calendar for the farm? Or did she rely on the *vilicus* for this information? Presumably there must have been practical reasons why the monthly calendar was seen as useful on the farm. Knowing the market days would have been important locally or for going into the city. By contrast, other rituals, especially those in the fields, do not have specific dates. They are simply performed when the next agricultural task presents itself, according to the weather and other local factors. Cato's other religious instructions do not feature close attention to a precise day in the Roman calendar but are geared to the season and the timing of the crops according to local weather conditions. In other passages about religious rituals, he focuses more on "how" to do something, with more detailed instructions for sacrifice and prayer language, rather than on "when."

The named days of each month (*kalends, nones, ides*) were among the oldest features in the Roman construction of time, season, and year.[9] In this sense, time itself, at least in the home, appeared to belong to the *lar* at the hearth. While public priests marked the named days with special rituals, these were not open to the public and would probably have had little impact on most Romans, who may not even have been aware of them.[10] By contrast, the cult of the *lar* both helped and required ordinary Romans, perhaps especially women like the *vilica*, to observe the named days that marked Roman time, thereby giving a religious character to the rhythm of their months. These days are thought originally to have coincided with the phases of the moon in the older lunar calendar, with the *ides* being the full moon, the *kalends* the new moon, and the *nones* the stage between the two.[11]

By Cato's day, these named days had long been fixed on specific dates of each month in a calendar that had both lunar and solar aspects: the *kalends* was always on the first of the month, the *nones* on the 5th (or the 7th in March, May, July, and October), and the *ides* fell on the 13th (the 15th in March, May, July, and October).[12] Interestingly, Cato mentions them in the order *kalends, ides, nones*—in other words, out of their chronological sequence. Does this present the *nones* as a more recent addition to the other two days? The beginning of the month became a more important day and the *kalends* seems indeed to have held special meaning for *lares* of various kinds.[13] If most other festivals were after the *ides*, then the whole first half

9 Cato names the days out of chronological order. Flach 2005, 170, suggests that he is using an alphabetical order, but that would seem to be an anachronistic concept at the time when he was writing. Rather, Cato may mention the named days in order of importance, at least from his point of view. For these named days, see Varro *LL* 6.27–28 and Macrobius *Sat.* 1.15.9–13, with Michels 1967, 19–21 ("dividing days"). For the structure of the Roman month, see Rüpke 2011, 24–32.

10 For rituals performed by state priests on the named days, see Scullard 1981 and Graf 1997, 16. On the *kalends*, the *regina sacrorum* sacrificed a pig or lamb for Juno in the *Regia*. On the *nones*, the *rex sacrorum* announced the feast days on the Palatine by the hut of Romulus. On the *ides*, the *flamen Dialis* sacrificed a sheep (*ovis idulis*) for Jupiter Optimus Maximus on the Capitol. Graf 1997, 17–18, notes that the domestic sacrifices to the lar(es) treated all the days in the same way.

11 For the originally lunar old Roman calendar, see Michels 1967, 21; Graf 1997, 16–17; and Feeney 2010. Rüpke 2011 identifies a lunar calendar with the Etruscans.

12 See Degrassi 1963 for the epigraphic evidence and Rüpke 2011 for general discussion.

13 The *kalends* became the first day of each month (Meslin 1970, 46, sees every *kalends* as sacred to the *lares*).

of each month mainly belonged to the *lar*. Yet he also participated, as an invited guest, in every festival day. In this way, the *lar* marked time, even as he watched over the home, the field, the neighborhood, and the journey in between each place.

To sum up: the *vilicus* presided over the ritual of the Compitalia at the shrines that marked the corners of the property, while the *vilica* (his co-manager, who might be his wife) worshipped at the hearth on the named days of the month and on all festivals.[14] The importance of the cult is reflected in the fact that it is entrusted to the two supervisors who are in charge of the farm. Other rituals are often delegated by Cato to whoever is present and could be performed by any slave working in a field or wooded area. This habit of free delegation saved time and reduced the number of supervisors needed. It is worth noting that the cult of the *lar* receives more careful and consistent attention from the *vilica* than any individual seasonal ritual in the fields.

Unfortunately, Cato does not give any detailed description of the compital rituals at the *lares* shrines at the corners of the estate, beyond instructions to give everyone time off work and a generous portion of additional wine for the slaves.[15] The general impression is that there are, therefore, perhaps more rituals at the hearth than at the *compita*. However that may be, Cato is invaluable in defining what was most essential about the cult of the *lar* in the house. It is this *lar*, rather than any other gods, whom the master greets shortly after he arrives at the farm for each visit. Cato's instructions and emphasis compare and contrast with what we learn from Plautus and other early literary sources and from the paintings of Compitalia on Delos later in the second century. Augustus' new flower festivals at the compital shrines in Rome, probably introduced in 7 BC, also followed on from the customary honoring of *lares* with garlands of flowers (*coronae*) and perhaps fell on the *kalends* of two months of the Spring and Summer (1st May and 1st August are obvious candidates).[16]

14 The *vilicus'* duties are described by Cato at *de Agric.* 5 (long version) and 142 (short version). See Scullard 1981, 40.

15 Compitalia in *de Agric.* 5.3 (the job of the *vilicus*) and 57.1 (distributions of wine to the household on various occasions throughout the year). This festival is discussed in detail in section III.xvii later.

16 Suetonius *DA* 31.4 (for Augustus and the *lares*, see part IV later).

VI KITCHEN GODS

> ... la presenza quasi costante dei larari nella *culina* li rende tra
> gli elementi principali e caratterizzanti della cucina pompeiana,
> tanto da rafforzare l'ipotesi che tutte le cucine fossero munite di
> un lorario ...
> —GIACOBELLO 2008, 111

Because of its special state of preservation after being buried by the eruption of Vesuvius on 24th August AD 79, Pompeii and the surrounding communities provide us with a unique insight into a Roman(ized) town and its suburban setting. The evidence for individual houses and streets in Pompeii is far more complete than in any other Roman community. Consequently, Campania is also the source of most Roman paintings, including those of *lares* and other gods, that survive for us to study. Since the rediscovery of the site in the eighteenth century, Roman life on the Bay of Naples has appeared vivid, absorbing, and fascinating. The attendant risk is that we are tempted to see every detail of life in Pompeii on that fateful day in late August in the reign of the emperor Titus as typical of Rome itself or of any other town in Italy on any other day in antiquity. Pompeii's unique status, therefore, makes it both especially valuable but also uniquely problematic. With these reservations in mind, the paintings of *lares* from Pompeii provide vital information about these deities, both in the home and at the crossroads in Flavian Italy.

Roman influence in Pompeii had been consistently strong even before the town was reorganized as a Roman colony by Sulla in 80 BC (under the new name of *Colonia Cornelia Veneria Pompeianorum*).[1] Sulla's veterans settled here and reshaped local life, as they assumed positions of civic leadership. It has seemed likely, therefore, that the cult of *lares*, especially as attested by the dense network of street shrines that has been discovered, was first established at this time (that is, the 70s BC).[2] These shrines are discussed later in section II.xv. Despite the first princeps' patronage of the town, there is no evidence of a subsequent Augustan reform of these compital cults: no *lares augusti* are to be found at the street corners.[3] As a result, it is indeed tempting to imagine that the street shrines of Pompeii, which are much better preserved than those in Herculaneum or Ostia or anywhere else, can afford an insight into the traditional compital cults of republican Rome, before Augustus' decisive intervention in the urban fabric in 7 BC (discussed in detail in part IV later).[4] By analogy, the hundreds of *lares* paintings in private houses reveal the vital importance of these gods within the Roman domestic sphere.

The impact of Sulla's veterans was decisive in introducing a range of Roman customs, not least the widespread use of the Latin language in place of Oscan.

1 For the history of Pompeii, see Dobbins and Foss 2007 and Laurence 2007. For Herculaneum, see Wallace-Hadrill 2011. For fine reproductions of wall paintings (but excluding those for the cult of the *lares*), see Pappalardo 2009.

2 Fröhlich 1991, 127, has compital *lares* clearly attested before the time of Augustus. Van Andringa 2000, 73, accepts Sullan era *compita*, but as a "hypothesis."

3 Kunckel 1974, 29, and Van Andringa 2000, 77 and 79, argue strongly against *lares augusti* or a *genius Augusti* in Pompeii. Fröhlich 1991, 27, is unsure but tends to think that Pompeii must be like Rome. Tybout 1996 goes so far as to imagine a *genius Augusti* even in domestic cult. Cf. Hänlein-Schäfer 1993 for a similar approach.

4 Van Andringa 2000, 79–80. For street shrines in Pompeii, see section II.xv.

However, some borrowing had occurred before on an entirely local and voluntary basis.[5] Meanwhile, the population of Pompeii was continuously changing, probably more so than in many towns in Italy. With the emergence of the Bay of Naples as the main port area in central Italy, before the emperor Claudius developed the harbor at Ostia in the mid-first century AD, there was a constant influx of people arriving in Italy, merchants of all kinds and slaves. These new arrivals might simply pass through or might stay in the area. Many grand houses came to be owned by wealthy Romans who visited seasonally, especially in the mid- to late first century BC. Consequently, much of the population worked on behalf of elites who lived elsewhere; many of these year-round inhabitants were slaves or had come up from slavery recently. The Bay of Naples was a place of evolving enterprises, whether in business, in wine production and other agricultural ventures, in pottery manufacturing, and in the extensive service and luxury industries that catered to seasonal visitors. The nearby Roman fleet stationed at Misenum also brought sailors, soldiers, and their Roman commanders to the area.[6]

At the time of its destruction, the region was still recovering from the after-effects of a major earthquake in AD 62 (some seventeen years earlier): a significant number of elites had moved or simply stayed away after the quake and left the painstaking rebuilding to their dependents or to others. In fact, some restoration was still in progress or hardly begun in AD 79. This situation had created new kinds of opportunities for the upwardly mobile, ranging from freedmen of Oscan families local to the area to former members of the imperial household. With all these factors in mind, it is not surprising to see that the religious life of the town was rich and diverse, whether on the civic or the household and individual levels.[7] With the ever-changing population came a flood of new ideas that interacted with local and traditional practices. Unlike the situation on Cato's farm, therefore, *lares* were prominent in Pompeii within a complex and diverse pantheon of various gods, many traditional but others more recent arrivals.

Pompeii had a dense network of street altars, especially but not exclusively on the principal streets and at their main cross roads, as well as domestic shrines inside most houses.[8] Unfortunately, early excavators were not interested in local religion in its own right and often failed even to mention, let alone to describe in detail, the many street shrines that were found in situ, some even with the ashes of the last

5 Anniboletti 2007 presents archaeological evidence for six examples of shrines that predate Sulla's conquest of Pompeii. Nearly all were out of use by the early first century BC. These pre-Roman street shrines date to the middle of the second century BC and include altars, niches, money boxes, and some votive deposits. Van Andringa 2000 expresses doubts about this material. So far, there is no explicit evidence for which deities were honored at these early street shrines.

6 For the Roman fleet at Misenum, see the convenient overview by Saddington 2007, 201–17.

7 For the rich religious life at Pompeii, see D'Alessio 2009, Laforge 2009 and 2011, and esp. Van Andringa 2009.

8 A public temple for *lares* was identified by Mau at VII.9.3 on the east side of the Forum at Pompeii. This attribution, now out of fashion, is not accepted by Fröhlich 1991, 36. Van Andringa 2009, 59–74, esp. 68, argues that this precinct honored the *domus divina*. Van Andringa 2000 catalogued thirty-eight street shrines, but Gesemann 1996 has sixty-one. The largest number is recorded and illustrated by Bob and Jackie Dunn on their excellent (and continuously updated) website *Pompeii in Pictures* (http://pompeiiinpictures.com). The household cult of the *lares* is best described by Giacobello 2008 and Van Andringa 2009 (in the context of religious life in general).

sacrifices on their altars.[9] Today also, the paintings on the outside of the houses are much less well protected and preserved than those inside. Not every street shrine honored twin *lares*, but very many surely did.

Recent, careful analysis of religious arrangements inside the houses in Pompeii and the surrounding area has demonstrated that the shrines dedicated to the *lares* cult were most often to be found in or very near the kitchen.[10] In other words, this cult was consistently associated with the household hearth and, therefore, with the food prepared there. Offerings to the *lares* were often made directly on the hearth itself. As already noted, in earlier times or simpler houses, the hearth was to be found in the atrium and cooking took place in the very center of family life.[11] However, by the time when Sulla's colony was established most larger houses in Pompeii already had separate kitchens, where the *lares* took up residence. Their association with the hearth, from the legendary birth of Servius Tullius onward, kept these gods close both to the women who managed the household and to the slaves who prepared the food.

By contrast, the grander shrines in the public rooms of the house (especially but not exclusively the atrium) only very rarely featured paintings of the *lares, genius,* or snakes so typical of kitchen cults. Instead, these shrines contained small statues of the gods (either of bronze or rendered in a variety of other materials) cultivated by the family, deities known collectively as the *penates*, which is to say gods worshipped by a kin group.[12] These deities included an eclectic mixture of the gods of local public cults (such as Venus the patron deity of Pompeii or Mercury the god of trade) with others of personal or gentilicial significance to the family.[13] While small statues of *lares* could frequently be found here, their religious function was different than their role in the kitchen. In other words, the main focus of the shrines in the atrium was not on *lares*, although these familiar gods were usually invited to every religious occasion in the house. The term *lararium*, often used to describe these shrines for *lares* by modern scholars, is not found in Latin until much later.[14] Conversely, the *penates* never seem to have been represented in painted shrines in the kitchens.

When first studied, these various shrines were analyzed based on who worshipped at each. This approach yielded two sets of *lares* shrines, one in the public area for the family, the other in the kitchen for the slaves. In other words, this analysis focused on social status as its decisive criterion of classification. Subsequently,

9 Inventories of street shrines before Boyce 1937 were made by Fiorelli, Helbig, and Mau, but not before the late nineteenth century. Van Andringa 2000, 48, makes clear the vital importance of the images published by Mazois in 1824.

10 Fröhlich 1991 already saw some of the importance of the kitchen as a cult site. Giacobello's 2008 arguments are cogent and forceful. For kitchens in Roman houses, see Kastenmeier 2007. Contra Tybout 1996, 370, who tries to claim that the kitchen cults simply imitated what was found in the atrium. For a particularly interesting discussion of sightlines and domestic shrines, see Rasmus Brandt 2010 (Pompeii and Ostia).

11 Giacobello 2008, 65, records the very few extant hearths in atria at Pompeii.

12 Servius on *Aen.* 2.514: *penates sunt omnes dii qui domi coluntur* (*penates* are all the gods who are worshipped in the house). See Dubourdieu 1989 and Rescigno 2000.

13 Huet and Wyler 2015 offer an insightful survey.

14 See *SHA Aur.* 3.5 and *SHA Sev. Alex.* 29.2–3, 31.4.5, and *CIL* 9.2125 = EDCS-12401636 for the earliest references, with Giacobello in *ThesCRA* (4, 2005, 262–64). Bassani 2008, 23–46, offers a typology of space. In 49–63, she analyzes the Latin terms that were used. Bassani 2008, 61–62, is very clear on this issue.

the vital recognition that we are actually dealing with two different cults, *lares* at the hearth but *penates* in the atrium, has brought us closer to the religious world of ancient practitioners. When a hearth was moved from the atrium to its own space, the lar(es) naturally and inevitably moved with it. *Lares* could be invited to any feast or celebration, as we see in the cult of Dea Dia practiced by the Arvals or on Cato's farm. But their home was the hearth in the house or the crossroads shrine outside the home. Similarly, their worshippers were those who tended the hearth, regardless of their identity, ethnicity, gender, and status over time. Because the *lares* kept their "place" at the hearth, their worshippers changed as the group enlarged. By contrast, the *penates* were by definition gods of those related by blood whose shrines were much less standardized in format or position within the domestic space used by the family. Nevertheless, the family did not lose their traditional connection to *lares* by sharing them with their slaves.

Numerous bronze statuettes of *lares* have been found, both in Italy and in the provinces. They come in two basic styles, the dancing and the standing. The dancing *lares* are much more common and are attested with a wider variety of attributes. Even the standing ones, who look more like a *genius*, often have a distinct sense of motion suggested by movement in their clothing, which can appear as if windswept.[15] Most of these small-scale figures have been found without a context; their standardized iconography and uniform workmanship makes them hard to date with any precision. The standing type is not attested in wall paintings so far but can be seen in the reliefs on some Augustan altars. Here just one example of each is given, simply for the sake of illustration. (See plates 2 and 3.)

The standing *lar* in the Mount Holyoke College Art Museum is a particularly fine example of its type, probably from the early imperial period.[16] He holds a brimming *cornucopia* and a *patera* for pouring a libation, the attributes most common for a *genius* in Campanian painting. His short, wavy hair is crowned by a wreath of rich foliage. He wears a finely pleated short tunic and has a narrow wrap or scarf draped over his left shoulder and tucked into his narrow belt. Its folds hang down in a zigzag pattern characteristic of such bronze standing *lares*. He wears the high boots favored by *lares*. His posture and attributes suggest calm and prosperity.

By contrast, the dancing *lar* in the J. Paul Getty Museum is very much in motion and twice the size of his quieter cousin.[17] He wears a similar but even shorter tunic decorated with rows of triangles, which appears to be hitched up by his folded cloth belt. His wrap is draped over his arms. He is pouring wine from an elaborate *rhyton* adorned with a goat's head and forelegs into a *patera* in the gesture so familiar from the painted *lares*. His hair is longer and very curly. He dances on tiptoes with an advancing step in high, open-toed boots that curl over at the top and are lined with animal skin. Stylistically, he also looks like a *lar* from the early

15 Kaufmann-Heinimann 1998 (with updates in 2007) is the standard treatment of the bronze statuettes. The *lares* are less well represented in finds outside Italy. For an overview of the iconography with a catalogue, see Tam Tinh in *LIMC* 6.1 (1992), 205–12. He sees no iconographical distinction between the domestic and compital *lares*. By contrast, Trimalchio is said to have had *lares* of silver (Petronius *Sat.* 29.8).

16 Mount Holyoke College Art Museum: inv. MH 2013.31 (10.8 cm). A similar *lar* is in the Albertinum in Dresden (H4 044/012), for which see also Tam Tinh *LIMC* 6.1 (1992) no. 8, who calls the mantel a *palla*.

17 J. Paul Getty Museum: JPGM 96.AB.200 (30.8 cm overall with the statuette being 23 cm): see True and Hamma 1994, 316–18 no. 164; Mattusch 2015, 49–51; and Sofroniew 2015, 37–38.

imperial period, but the bronze base on which he stands, to which he has been reattached with a modern bolt, bears a Greek inscription with a name typical of the later third century AD. It reads:

Γενίῳ Αὐρ[...] | Φαλέρου στρα|τιώτης πραι|τωριανός

To the *genius* of Aur[elius] Valerius, praetorian soldier

Very few *lares* statues have their original bases. In addition, we have very few Greek inscriptions that mention praetorian guardsmen, the special soldiers who protected the Roman emperor. The rather haphazard lettering and line division contrast with the fine workmanship of the base itself. Presumably, this inscription labels the statue of the *lar* as itself a dedication to the *genius* (protective spirit) of Aurelius Valerius. By comparison, at Ostia ten silver *lares* on a silver base were given to Jupiter Optimus Maximus by a local official who had seen the god in a dream.[18] If the base does indeed belong to this *lar*, it provides evidence for the very traditional style of iconography that was reproduced over centuries during the imperial period, within the context of domestic cult. On the other hand, it is also possible that the text was added to a piece that had been made earlier.

These small images resemble those of the many other deities cultivated in a personal way by Romans. The relatively few groups of bronze statuettes of deities (including *lares*) found in situ in Pompeii and Herculaneum provide precious glimpses of the personal choices of individuals and families as they set up their household shrines in honor of their *penates*, the gods cultivated by that particular family in the public area of their homes.[19] In the early photographs taken at the time of excavation, *lares* can also be found positioned as framing figures around the group of eclectically chosen deities, a pattern that echoes their typical representation in the much more common paintings from the Bay of Naples. These photographs were, of course, most probably staged by the excavators but they provide rare evidence for these statue groups in their original contexts. Most have been found in atria, but some also in bedrooms, where gods were worshipped in a less public setting. Particularly fine groups of bronze statuettes found in situ in household shrines in Pompeii include those in the House of the Amorini Dorati, the House of the Parieti Rosse and the (much simpler) House of the *lararium* of Sarno.[20] (See figure I.2 and plate 4.)

For our purposes, the *aedicula* in the atrium of the House of the Parieti Rosse is of particular interest, because it includes a modest painting on its back wall with fine bronze figures of deities in front.[21] The juxtaposition is unique and brings out the differences between the two types of ensembles. The painting on the back wall

18 *CIL* 14.4293 = *AE* 1928, 129 = EDCS-11900015.

19 For an excellent discussion of small Roman bronzes in domestic contexts and in hoards, see esp. Cadaro 2015, 55–56.

20 The classic discussion remains Adamo-Muscettola 1984, who describes nine groups of finds. Amorini Dorati (VI.16.7): six gods (Van Andringa 2009, fig. 196); Parieti Rosse (VIII.5.37): the *lares* with Hercules, Asclepius, Apollo, and Mercury (Van Andringa 2009, 258–59, with fig. 197); Sarno (1.14.7): a modest group (Van Andringa 2009, fig. 201).

21 VIII.5.37: Boyce 1937, 77 no. 371; Adamo-Muscettola 1984, 15–20, with detailed photographs; Fröhlich 1991, 291–92 L96; Kaufmann-Heinimann 1998, 222, and 2007b, 199–200. See now Huet and Wyler 2015.

I.2. House of the Red Walls, Pompeii (VIII.5.37), atrium shrine containing bronze statuettes of deities.

of the *aedicula* shows a *genius* dressed in a white toga and holding a *cornucopia* as he pours a libation on an altar between two moderately larger *lares,* all depicted on a bright yellow background. On the front of the *aedicula,* a round altar and two snakes are shown. The style is simple and the execution is basic. In front of the painting, six figures of gods in bronze in very different styles and varying sizes were found. Twin dancing *lares,* each with *rhyton* and *patera,* accompanied a tiny Hercules holding a club, a much larger Mercury (with distinctly Augustan features) apparently repurposed as Asclepius, another Mercury (Hermes) in a much more Hellenized style, and a standing nude Apollo. Each statuette is on a base of a different style; the various bases help to confirm the eclecticism of this collection. A bronze lamp was also found here. As is the case elsewhere, no *genius* is represented in bronze.[22] The arrangement in the photograph of the gods between the *lares* and behind the lamp evokes deliberate placement and may or may not offer a glimpse of what an ancient worshipper would have seen. Here, both the painted scene of the libation offered by the *genius* and the separate bronze *penates* are visible in the same place and at the same time.

22 For groups with statuettes of a *genius,* see Kunckel 1974, 85–89 (thirteen groups, but very few found in situ).

The varying sizes, styles, and origins of the bronze statuettes in these assemblages suggest personal choice and availability, as well as collecting or inheriting over time. As gods of place, *lares* are naturally included in the household shrines cultivated by the family. By contrast, the principal cult of the *lares* was consistently centered on the hearth and, consequently, almost always in the kitchen or its immediate vicinity. In many houses, including the grandest, the only figural painting in the service areas and slave living quarters was the representation of the *lares* and *genius*, which were inevitably most visible to and, therefore, cultivated by the slaves in the house.[23]

An introductory essay about Roman domestic religion by a senior scholar who is an expert on *lares* has, once again, stressed the central importance of the *lares* paintings in our understanding of religion in a Roman domestic setting:

> The main obstacle to understanding religion in the domestic realm is probably the prevailing, ubiquitous inconsistency. There is no clear-cut line between sacred and secular objects and decoration. Strictly speaking, only the main figures of the domestic religion—the *Lares* and the *Genius*—in their painted or three-dimensional form can be judged as unmistakably religious objects. All the other media consist of different layers of meaning which often cannot be neatly separated.[24]

This conclusion may seem provocative and open to dispute but it neatly raises the whole question of how to analyze which iconography is, in fact, "religious" inside the Roman house. While this larger issue goes beyond the scope of the present study, her approach has attracted attention precisely to the unambiguously religious messages in *lares* paintings. Their close association with the hearth and with cooking, the representation of the libation poured by a *genius* (with or without a pig waiting to be sacrificed), and their apparent independence from the world of Greek myth depicted in so many paintings from grander and more public contexts on the Bay of Naples give the *lares* and snakes a unique situation in Roman domestic art. Their characteristic position within the house and the consistent style in which they are executed suggests the very particular value they have as direct evidence for the religious world of the Roman household.

23 For the differentiation of the slaves' quarters in houses on the Bay of Naples, see especially Wallace-Hadrill 1994, 38–44.

24 Kaufmann-Heinimann 2007b, 201.

VII A *GENIUS* POURS A LIBATION

> la phiale ou patère aux mains des dieux, devenue purement
> sémiotique, équivant à un adjectif qualificatif ou plutôt à une
> épithète de nature: "sacré," "saint."
> —VEYNE 1990, 27–28

The rich material from the Bay of Naples, both in Pompeii itself and from surround-ing areas, provides an extensive dossier of painted *lares*, most of whom conform to a standard iconography, apparently produced by a limited circle of workshops in the years immediately before the eruption.[1] *Lares* in or near the kitchen or at the crossroads shrines always appear in pairs, regardless of context, and are often ac-companied by a *genius* and one or two snakes, who are to be found in a separate register. Over the last ten years, incisive new studies of *lares* in Pompeii have moved this field of research forward significantly.[2] The iconography of the *lares* paint-ings, mostly in a manner related to the "fourth style" of Pompeian painting and, therefore, nearly all dated to the years between AD 62 and 79, provides a detailed and reliable source for how these gods were imagined by worshippers, at least in this place and at this particular time. The regular renewal of the paintings shows their importance to the inhabitants or at least to the master of the house. The lack of statuettes in situ in so many domestic shrines confirms this impression. For, like Aeneas, the fleeing inhabitants of Pompeii took their little gods with them: any left behind soon became a primary target of looters.[3] We are, therefore, left with the paintings on the walls as our best surviving evidence for the cult of *lares* on the Bay of Naples, as well as for painted *lares* more generally.

Two features appear to set this Campanian material apart from what is described by the surviving literary sources. As already noted, the snake is the most commonly depicted deity in Pompeii, both in the home and on the street, whether near other gods or on their own. However, no literary source makes any mention of these ani-mals or of the deities they represent, with the result that much debate has ensued over their meaning, either individually or in relation to the painted compositions as a whole. Their iconography and function will be discussed separately in section viii later.

Second, Campanian *lares* always appear in pairs, even in the humblest domes-tic settings. As already discussed, many references in Latin authors to a single *lar* in the household make it seem that the traditional domestic *lar* so vividly depicted by Plautus and by Cato remained a familiar figure in Rome and Latium in later periods. Consequently, it seems impossible to say that the cult of the *lares* in

1 For the *lares* paintings of Pompeii and their artists, see Boyce 1937 (not much about place-ment of shrines but includes the lost ones not in any later catalogues); Orr 1978 and 1988; and Fröhlich 1991, esp. 110–128, 186 (reviewed by Tybout 1996). Giacobello 2008 is the most up-to-date catalogue, but her photographs are often hard to read.

2 Van Andringa 2009 puts the *lares* cult into a wider religious context. Giacobello 2008 is the best new discussion. She catalogues 114 *lares* shrines (130–294), all in or near a kitchen. She also notes the many losses.

3 Boyce 1937, 11, records ca. 27 shrines with figures out of a total number of around 500. Fröhlich 1991, 31 with n. 142, has 46 shrines in Pompeii and Herculaneum (catalogue at 356–58). Van Andringa 2009, 218–19, is an excellent account of what happened to the small bronze gods of Pompeii. See also Small 2007, 207 n. 119.

Campania was exactly "the same" as in Rome, at least by the time that the area was devastated almost 160 years after Sulla founded his veterans' colony here. The presence of twin *lares* in every domestic context, the ubiquity of the snake gods, and the absence of *lares augusti* point to a robust local religious culture despite long-standing and close connections between the Bay of Naples and Rome.

For the purposes of the present study, a consideration of how these *lares* are depicted in a few of the best preserved paintings from Pompeii will serve to elucidate how they were understood in a ritual context in Campania. It is convenient to start with one of the most famous examples of this kind of painting, which is in the Museo Nazionale in Naples, although its exact original context is not certain.[4] (See plate 6.) It has also been dated to the period of about twenty years before the eruption (the fourth style). Obviously, we would be in a better position if we had an ancient commentary on this painting: in the absence of a theological exegesis by the commissioner, the artist, or those who worshipped before this image, the iconography itself provides our primary evidence.

The painting is in two registers, with the upper area occupied by twin *lares* and *genius*, while two snakes are in the bottom portion. In this case, the area designated for the *lares* is relatively a little bigger. A thick dark line provides a distinct separation between the two registers. The two scenes are also distinguished from each other by their backgrounds. The *lares* scene is on a simple piece of ground with only a couple of modest bushes immediately behind the round altar, which is painted in a pattern imitating marble. The upper limit of this scene is marked off by three quite substantial garlands tied with ribbons.[5] The action is framed by the *lares* at either side, by the carefully hung garlands at the top, and by the ground the figures are standing on at the bottom.

In complete contrast, the two snakes appear in a very different, naturalistic setting without boundaries. They crawl through dense vegetation that seems wild and that fills most of their area. The focalization has changed, and we see the undergrowth from the point of view of the snakes. The "garden" of the snakes is very clearly set apart and differentiated from the ritual space of the *lares*. Nevertheless, both contiguous scenes show an offering, whether it is the *genius* pouring a libation or the offering of eggs on an altar for the snakes, without a celebrant being represented in the lower register.

As is typical in many such paintings, the twin *lares* are identical but rendered as significantly larger than the other figures. They are dressed in green and white tunics that are visibly above the knee, and that feature a red stripe down the center. They have modest cloaks that look rather like large scarves of thin material, and they wear high, laced boots. Their curly hair is worn distinctly longer than that of the others. Some motion is implied by their way of standing with their weight on one leg as they direct themselves at a gentle angle both toward the viewer and in the direction of the central sacrifice. Their faces are pleasant, with the slight suggestion of a smile. Each of them skillfully and somewhat ostentatiously pours a stream of red wine from a Greek-style drinking horn (*rhyton*) into a small bucket

4 MAN Naples: inv. 8905 (128 cm high by 183 cm wide) apparently from an undecorated room outside a domestic context (VII.2 or 3?), found on 6th June 1761. The painting belongs to the fourth style (AD 55–79). Fröhlich 1991, L98, claims that the findspot is unknown. See Baldassare, Pontradolfo, Rouveret, and Salvadori 2002, 248 and 250, with Bragantini and Sampaolo 2010, 429 no 222.

5 For the use of garlands and vegetal elements in religious rituals, see Guillaume-Coirer 2003.

(*situla*).[6] They look outward and do not appear to engage directly with each other or with the action at the altar. The arc of the wine they pour and the motion of their cloaks creates a characteristic circular pattern that frames each *lar* and the scene as a whole.

The somewhat smaller figure of a *genius* wearing a toga with a purple stripe (*toga praetexta*) stands at a round altar in the middle. Although he also has his weight on one foot, his pose appears more static. The hem of his toga is covering his head in typically Roman fashion as he is engaged in a ritual action. The cornucopia he is holding identifies him as a deity: he cannot be a human. However, his Roman dress identifies him closely with the paterfamilias whom he protects and represents. His gaze is also turned toward the viewer. His central position and formal dress draws the eye to him as the main actor in the scene. The libation he is performing is the opening prayer (*praefatio*) in preparation for animal sacrifice, as is confirmed by the pig who is being led toward the altar from the left.

The *genius*, who is the guardian spirit of the paterfamilias, is assisted by three of the usual kinds of cult attendants in scenes of animal sacrifice, the flute player with his double flute (*tibicen*), the sacrificial assistant who is leading the pig (*victimarius* or *popa*), and the altar boy carrying the tray of offerings and two garlands (*camillus*).[7] These three figures are much smaller than the three deities, as is usually the case in these paintings. The flute player, however, who is also wearing a toga, is significantly larger than the other two and only a bit smaller than the *genius*. The three sacrificial attendants wear wreaths of foliage on their heads, as many such figures do in Roman art. To judge from the significant differences in size, the three are humans, therefore, a freedman musician with two slave attendants. The strikingly small scale of the slaves is accentuated by the diminutive pig, which fits so neatly into their little world. It is possible that the human attendants recall specific individuals in the household.

The ritual action does not portray the everyday cult of the *lares* or the libations of the *vilica* at the hearth mentioned by Cato for the named days in the month. Rather, this is the special sacrifice of a pig, the preferred sacrificial gift for *lares*. It is unclear whether the viewer is supposed to understand a reference to a specific celebration such as the annual Compitalia festival, especially since the celebrant is not a neighborhood official but a god. When the *genius* pours the libation, the ritual has already begun, as is confirmed by the fact that the flute player is already playing. Everything about the scene evokes the time of ritual as each participant plays his appointed role. It is the sacred time of the sacrifice and prayer. Yet each figure also introduces the idea of the different actions that will follow upon the opening libation, from the various offerings being carried toward the altar to the eventual slaughter of the pig (which is never actually shown in the extant paintings). Consequently, despite the fact that all the elements depicted can be combined to suggest a single, familiar ritual involving animal sacrifice, the scene is not a simple "snapshot" of a sacrifice overseen by a divine celebrant. Rather, all the essential ingredients and parts of the ritual are symbolized and represented by the various

6 Ebbinghaus in *ThesCRA* 2005, 201–3, provides the essential background for the *rhyton*. Hölscher in *ThesCRA* 2005, 244–45, discusses the *situla*.

7 For the flute player, see Fröhlich 1991, 115–17; Schraudolph 1993; and Fless 1995, with Siebert 1999b, 104–5 no. 66, for the flute. For the *victimarius/popa*, see Fröhlich 1991, 117–19. For the altar server, see Fröhlich 1991, 114–15, with Fless 1995.

players in an abstract world that is the sacred space and ideal time of cult itself. The iconography is complex and subtle, as it evokes a series of ritual actions performed by both divine and human actors together in a sacred space where men and gods meet.

To whom does the *genius* pour the libation?[8] Many possible answers have been suggested. Is it to himself? If so, what does the participation of a god in his own cult signify? Or does his action simply show "how" to pour a libation without actually addressing this offering to a particular deity?[9] If the *genius* is honoring himself, then what is the function of the *lares* who frame the scene? These have been repeatedly contended questions. A definitive answer is hard to come by, but a reading that pays close attention to the patterns typical in the iconography is certainly possible.

The hierarchy of the figures' scales, their positions relative to each other, and the presence of the pig, all combine to suggest that the *lares* are the natural recipients of the whole ritual introduced by the libation.[10] First, the *genius* of a Roman man did not receive a blood sacrifice, so the pig cannot be for him. Second, the *lares* are significantly larger and they frame the whole scene. This positioning allows the divine *lares* to define the sacred space of the sacrifice within which the *genius* and the human figures move in their carefully choreographed ritual roles. The libation of the *genius* is the central action. By contrast, the snakes are in a parallel but separate world of their own. The *genius* appears as subordinate to the *lares*, in relative terms, both because he is smaller and because he is offering sacrifice to them. He is within the space that they are protecting. He is, because of his dress and individualistic nature, much closer to the human figures; each person was thought to have a *genius* in his own life. The *genius* is a god in his own right but one who represents both the master of the house and, through him, the whole household.[11] Consequently, his libation both partakes of and models human ritual (also represented by the three human participants), at the same time as transcending it by showing its ideal form.

The size differences between the figures are strictly hierarchical and have a logical function that is integral to the interpretation of the painting's meaning. Once the *lares* are recognized as the rightful and only recipients of the *genius*' libation, and also of the implied ritual actions that will follow upon it, the other gifts and animal sacrifice, the presentation of the scene makes sense. This is not the crude work of an unskilled artist who is combining figures from different models without size adjustments to fit the new composition and producing unintended or

8 Fröhlich 1991, 28, has the *genius* and *lares* sacrifice to themselves (together?). Fless 1995 has them receive cult (without any comment on the iconography of the paintings). Tybout 1996, 372, has the *genius* offer a libation to himself.

9 Veyne 1990 argues that libations poured by gods never have a ritual meaning and cannot, therefore, be addressed either to themselves or to other deities. Thus the libation dish is simply an attribute of a god in a painting. See also Scheid 1990, 327.

10 Jordan 1862, 332–35, was the first to suggest that the *lares* receive the libation, on the basis of a group of only ten domestic shrines. Giacobello 2008, 119–20, supports this view. However, she also says elsewhere that the *lares* assist at the sacrifice of the *genius* (35) and that the *lares* and *genius* both receive offerings (99–100).

11 For the *genius*, see Censorinus *DN* 3.1, with Otto in *RE*; Maharam in *BNP*, with Kunckel 1974, esp. 10–13; Schilling *RAC* 10, 52–83; Hänlein-Schäfer 1996; and esp. Ferri 2010, 163–67. For the iconography of the *genius*, see Romeo in *LIMC* 8.1.599–607.

random differences in scale.[12] Rather each figure, in its iconography, relative size, and position within the composition, has a deliberately religious meaning. Only very few *lares* paintings do not feature these kinds of differences in size.[13] Those paintings tend to be much closer in style to other decorations in the house and were, therefore, probably executed by different painters. The frontal positioning of the divine figures does not suggest a lack of interaction between them within the scene itself. Rather this pattern can be read in more positive terms as enabling a greater level of engagement with the viewer or worshipper at this shrine, as for example is the case with icons of saints hung on an east wall in Orthodox homes.

Furthermore, nearly all *lares* paintings had altars or hearths very near them and were directly designed to engage the people who saw them. A person making a gift or libation on an altar immediately in front of this painting would not simply make an offering addressed to a cult image. Rather, this worshipper would be seeing and probably claiming some share in the libation made by a *genius* to the *lares*, within an ideal ritual time and holy space. He or she would also be reminded of the full range of cult actions, including the sacrifice of the pig, an event that might only happen on a few occasions in the year, depending on the resources of the household.

Comparisons with other *lares* paintings can both confirm and extend my interpretation of this well-preserved rendering. A finely preserved ritual scene, complete with an altar and niche (for offerings or statuettes), was found in 1997 in a kitchen at villa 6 at Terzigno.[14] (See plate 7.) This painting is notable for its vivid colors and its relatively early date within our dossier of extant examples. It has been assigned to the "second style" and dated to the first century BC, perhaps as much as a century before the example from the Naples museum. This earlier scene shows many of the same features and includes two laurel bushes on either side of each *lar*. If the artist is making a reference to the laurel trees of Augustus, he has multiplied them beyond the two represented on monuments in Rome itself. The style is less sophisticated but the colors are brighter and the scene is very lively. The *lares* are a bit bigger than the *genius*, who pours a libation on an impressive fire without any help from attendants. In another typical variation, the sacrifice of the pig is not shown but is evoked by a series of popular pork products depicted nearby, combined with an eel on a stick for good measure. The snakes are very large and they are differentiated very clearly as male and female; they receive both eggs and pinecones on their altar. This painting preserves many finer details, such as the shading on the clothing, the laces on the boots worn by the *lares*, and the fine green foliage of the wreaths on their heads.

12 Fröhlich 1991, esp. 29, 189–210, discusses the "problem" of what he terms "Volkstümlichkeit." Fless 1995, esp. 96, sees no unity in the scenes and attributes the differences in size between the figures to the lack of skill of the artists. Tybout 1996, 365–66, recognizes a hierarchy of size, which he associates with paintings aimed at an audience of slaves.

13 Too often the few *lares* paintings without a hierarchy of size are discussed and illustrated as the main examples of religious paintings in general treatments of Roman art. The two best examples are Fröhlich 1991, L70 Taf. 7 (VI.15.1) from the House of the Vettii (Giacobello 2008, no. 64), and Fröhlich 1991, L8 Taf. 2.1 (I.8.8) from a shop on the Via dell'Abbondanza, which was (re)painted shortly before AD 79. These should, however, be appreciated as untypical examples that call for separate consideration.

14 Villa 6 at Terzigno: the shrine in the kitchen (amb. 11, inv. 86755) was found on 6th June 1997. The painting is 210 cm high by 260 cm wide. It has been dated to the first century BC on stylistic grounds. See Cicirelli 2000, 81 with fig. 46, and 2003, 217; and in Stefani 2005, 35 no. 12, and Giacobello 2008, 221–22 no. 4.

At Pompeii, an early *lares* scene from the kitchen of the modest house of Sutoria Primigenia is dated to the Augustan period.[15] (See plates 8, 9, 10.) This unique scene shows the whole family at a sacrifice, framed by *lares* of exceptional stature and special solemnity. These *lares* wear the Phrygian caps of freed slaves, which are relatively rare on *lares*, suggesting their protection of the servile and recently freed population. Garlands again mark off the sacred scene. A series of pack animals on a journey below may also be benefiting from the protection of these *lares*. It should be noted that there is no *genius* here. Rather, the offering is being made at a small round altar decorated with modest garlands by a man in a *toga praetexta* who is presumably the master of the house. He is being assisted by his wife, who has also covered her head for the offering and who stands immediately beside but slightly behind him. His mortal status is indicated by three factors: his lack of a cornucopia or other divine attribute, his relative size in the composition (the same size as the woman who stands to his right, slightly larger than the slaves, but dwarfed by the *lares*), and his close proximity to the household group he is representing and commending to the gods.

The crowd of a dozen slaves, arranged frontally by size, as if for a photograph, all wear very similar, smartly striped short tunics and make the same gesture of prayer and adoration with their right arms. Cato would have approved of this well-organized household. Again, this scene features a flute player in profile next to the altar, who is visibly larger than the group of slaves in the household. The wall to the left has a single snake with an altar in a garden, a niche for offerings, and a range of pork products that recall the sacrifice of the pig. The garland along the top of both adjacent walls lends the whole composition a carefully calculated and deliberate sense of unity across the different scenes.

While most of the usual elements of such paintings (with the exception of the *genius*) are present here, the position of the family is both visually compelling and highly informative in religious terms. Here, we can really see how the *lares* are envisaged as encircling and protecting the whole household, including every member. The household is a unit, as all its inhabitants stand close together and participate in unison, under the leadership of the paterfamilias. Although he is the celebrant, his wife is rendered as being the same size (bigger than the slaves) and as standing at the altar with him. Her position as female head of the household is an integral one: we may imagine that she also venerated the *lares* on regular occasions, perhaps with the rituals assigned to the *vilica* by Cato.

It is possible to interpret this scene as the main festival of the *lares* at which the pig(s) would be sacrificed and the pork products produced for the season.[16] Yet a sacrificial pig is not actually present in this panel and the action can also be seen as a more general representation of the *lares* cult as a whole, at various moments throughout the year. The presence of this painting in the kitchen next to the hearth may indicate that the paterfamilias entered the kitchen and venerated the *lares* at the hearth in person. This scene, however, looks as if it is taking place out of doors at a typical round altar. This representation of domestic cult would surely have been easily recognizable to Cato, had he visited Pompeii some 150 years after his death.

15 The house at I.13.2 was owned by L. Helvius Severus and his family since the time of Augustus. For the painting in the kitchen (17), see Fröhlich 1991, 261 L29; Giacobello 2008, 100 no. 28; Van Andringa 2009, 225, 228–29, 236, 253–56.

16 Jashemski 1979, 118–19, interprets this as the Caristia, but Tybout 1996, 372, argues for the Compitalia.

Would he have been surprised to see the two *lares* as opposed to the single *lar* he had described at the hearth on his model farm?

By comparison, the intricate and finely executed *lares* painting immediately outside the tiny kitchen in the house of C. Julius Polybius provides further illustration of what might be represented in a special commission by a skilled artist.[17] (See plates 11, 12, 13.) This magnificent painting, probably executed after AD 62, has recently been restored in connection with the opening of Polybius' house as a special destination for guided tours offered to the general public. In keeping with the architectural setting, the format of the painting here is vertical rather than the horizontal composition in the house of Sutoria Primigenia. This painting takes up the whole wall immediately outside a tiny, cramped kitchen, which itself could only have accommodated a much smaller painting beside the hearth. The whole scene is enclosed within a fine red border that lends it a formal air. Keeping the image outside the immediate cooking area both allowed for a much larger format and would also have provided some protection from smoke and grease. The little kitchen was in use at the time of the eruption, although one may wonder how it could have served the number of people who lived in such a big house.[18]

Here we see tall *lares*, wearing distinctive, two-tone tunics and pouring their wine from *rhyton* to *situla*, enclose a scene of a libation with a male and female figure together at a round altar. The hair of the *lares* is so long that it seems to be flowing down their backs. Two tiny slaves, a flute player and an altar boy, attend on either side of the altar. In this case, in contrast with the others already mentioned, the flute player is the smallest figure, barely reaching the knee of the *lar* who towers immediately beside him. The artist exploits and plays both with the shape of the available space and with the conventions of the genre. In a striking variation, a single, huge snake has escaped from his beautifully rendered and carefully separate garden to coil around the altar and share in the main offering to the *lares*. Unusually, he has not been provided with his own altar and gift within his sphere. At the top in the center of the scene is an area delineated for an inscription (*tabula ansata*), but no names of cult leaders or family members are recorded here.

The male and female figures at the altar are the same size and appear to be truly concelebrating, each with head covered for the ritual in the Roman fashion. The male figure, whom some have understood as being bearded, holds the cornucopia, the typical attribute of the *genius*. His female companion, wearing her striking blue tunic covered by a fine red cloak, is not holding anything. Nevertheless, her height and general importance, as well as her close association with the *genius*, show that she must be the *juno*, the guardian spirit of the paterfamilias' wife.[19] Originally,

17 C. Iulius Polybius (IX.13.1–3): Fröhlich 1991, 298 L109; Giacobello 2008, no. 113; and Van Andringa 2009, 249–53 (who calls C. Julius Philippus the last owner of the house). The house was built in the third or second century BC, but this painting (200 cm high by 151 cm wide) was executed after AD 62. See esp. the paired volumes edited by Auricchio 2001 (129: "una dei migliori dipinti di tale genere," "un grando dipinto di gusto popolare"—one of the best paintings of this kind, a big painting in a popular style) and Ciarallo and Carolis 2001. All four painting styles are attested in this house. The wealth of the last inhabitants is shown both by the rich decoration of the house and by analysis of the remains of thirteen people found here. C. Iulius Polybius (*PIR*[2] 3, 62, no. 426, 427) was a freedman of the imperial household or a descendant of one and a candidate in local politics.

18 Auricchio 2001, 222.

19 Giacobello 2008, no. 113, is not certain but tends toward seeing the female figure as a mortal woman. Van Andringa 2009, 252, is sure she is a mortal and sees her as the wife sacrificing with the *genius* of her husband while he is away.

every mortal was imagined as having a *genius*. In time, this pattern apparently evolved to a male *genius* for a man and a female *juno* for a woman.[20] Each guardian spirit looked after the health, well-being, productivity, and life span of its associated mortal. Consequently, the paired *genius* and *juno* represent the husband and wife who live in the house and oversee its cult, as well as giving an ideal picture of their marriage within the religious setting of their household cult. In order for this painting to make sense, both husband and wife need to have been alive when it was being painted. The cult of the *lares* allows for a specifically religious depiction of their marriage, source of the future generations of the family. It is interesting that children in the family are not represented, either here or for the human couple in the House of Sutoria Primigenia. The skeletal remains of what looks like three generations of an extended family found in the House of Julius Polybius suggest that the women who lived here married young and had large families.

This painting is full of carefully conceived individual details that both enhance the overall effect and display the mastery of the painter. The central figures of the *genius* and *juno* appear to be rendered as individual portraits of a couple somewhat advanced in years. Their closeness to each other is emphasized. This juxtaposition is equivalent, at least in some ways, to the much younger man and wife standing together in the kitchen of the house of Sutoria Primigenia. Most paintings only have the master's *genius* as the sole source of prosperity and fertility. At the same time, deep veneration of the *lares* is expressed by the dramatic difference in size between the two kinds of divine figures, an artistic feature that takes full visual advantage of the tall, rectangular space the artist had to work with. Furthermore, the *juno* is actually closer to the altar and could, therefore, conceivably be seen as the main celebrant. Yet the precisely choreographed identical gestures suggest harmony and parity over any sense of precedence between *juno* and *genius*. Meanwhile, the intrusion of the snake, whom the others in the scene do not seem to notice, looks like a humorous touch.

On a wall nearby, an interesting graffito records a prayer to the *lares* for the safe return of a certain C. Julius Philippus, apparently from a military expedition, a request made by a freedman and a slave together.[21] (See figure I.3.)

Pro salute reditum et victoria(m) C. Iuli Philippi votum h(ic) fecit Laribus P. Cornelius Felix et Vitalis Cuspi.

Publius Cornelius Felix and Vitalis, the slave of Cuspius, made this vow to the *lares* for the safety, return, and victory of Gaius Julius Philippus.
 (*AE* 1977.219 = *AE* 1985.285)

It is notable that the freedman and slave dedicators do not share the same master between the two of them, nor are either of them obviously members of a household of the Iulii, whether of Polybius or Philippus. The verb is singular despite

20 For the *juno*, see Pliny *Nat.* 2.16, with Otto in *RE* (*genius*); Fröhlich 1991, 23; and Ferri 2010, 166–67.

21 For the inscription (discovered in 1971), see *AE* 1977.219 = *AE* 1985.285; Giordano 1974, 25–26; Fröhlich 1991, Taf. 14.2; Auricchio 2001, 87, 259; and Van Andringa 2009, fig. 190. There is a painted garland above the area, which gives it a sacral character. Three other inscriptions in smaller letters and written above in different hands include a quotation from an unknown tragedy, and two graffiti apparently relating to visits of Nero and Poppaea to Pompeii. It is less clear how these other texts relate to the *lares* painting.

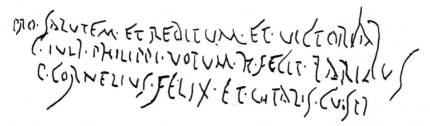

I.3. House of Julius Polybius, Pompeii (IX.13.1–3). Line drawing of an inscription (*AE* 1977.219) on the wall adjacent to the *lares* painting.

there being two men making the vow. A seal found in a large cupboard also attests the presence of Julius Philippus, who may indeed have been the last owner of the house or a relative of Julius Polybius who is also well attested as having lived here close to the time of the eruption. Some reconstructions suggest that they were brothers and that their bodies are those of the two older men who both died in the house in AD 79.[22] Near the dedication the single word *vicimus* ("we won!") does suggest that Philippus returned successfully from his military expedition. The large and well-decorated house of Julius Polybius, therefore, offers an unusual range of information (from archaeology, iconography, and the analysis of human remains) about the cult of *lares* within a particular domestic context and in the years immediately before AD 79.

By contrast, the modest kitchen in the House of the Piglet (*maiale*) provides an example of a series of scenes (also assigned to the fourth style) in closer proximity to a hearth inside a kitchen.[23] (See plates 14 and 15.) The pork products, accompanied by a couple of other items, are immediately next to the fire. Somewhat plumper and squatter *lares* in bold yellow and blue tunics appear alone flanking a round altar with a fire burning on it. Each *lar* has a small laurel tree on either side of him. A little snake is coiled around this altar. Below two snakes are shown either side of their own flaming altar. On the adjacent wall, a small scene with a libating togate figure, also flanked by two laurels, is largely lost. In this vivid series of scenes, the artist has brought the deities to life in their special context of the kitchen. Despite the modest space, he has included many figures and references. The multiplication of laurels reminds us that these were associated with *lares* already on Delos in the second century BC. Alternatively, they could refer to the twin laurels that were planted outside the house of Augustus, whether copied from coins or from reliefs depicting *lares augusti* in Rome or from another source (see part IV). Yet here we have the *lares familiares* at the hearth, not the *compitales* at the crossroads. Similarly, the additional snake around the altar above is superfluous in light of the complete snake scene below the *lares*. It seems, once again, to be an example of pure and playful visual redundancy, as is apparently the case with the laurels. Nevertheless, this ensemble, in its kitchen context, speaks to the everyday experience of those who worked to prepare food for the household in this space.

22 Butterworth and Laurence 2005 offer the hypothesis that Polybius and Philippus were the two men in their seventies whose remains were found in the house.

23 The House of the Piglet: (IX.9.b–c, cucina o): Fröhlich 1991, 297–98 L108; Giacobello 2008, no. 111; Van Andringa 2009, 232–35. This painting is from the same workshop as the one in the House of Popidius Priscus (Giacobello 2008, no. 73).

To sum up: these five different depictions of *lares* illustrate both the development of a standard, popular iconography and, simultaneously, the desire of individual patrons to commission their own versions of such religious paintings for their households to venerate. The world of the household is represented as being enveloped and defined by the protection of the *lares*, whose wine announced the celebration of harmony and good times, especially at their shared winter festival of Compitalia.[24] This world of *lares* in the kitchen did not usually include any deities beyond the snakes and the *genius* or *juno*: it was its own special religious realm within which the family and their household flourished. It was here that the whole household could be represented as coming together to pray, give thanks, sacrifice, and by implication to eat the shared meal of pork. While the leading roles of the master and his wife were affirmed, they were rarely represented in person. The sharing of the slaves in a cult celebrated by a *genius* was evidently integral and essential. The *lares* were, therefore, independent of the grander gods in the atrium or elsewhere, gods venerated by family members and blood relatives. They were both more fundamental and more familiar. The paintings near the hearth did not stress the biological family or children who represented its future. In Pompeii, the houses of the devout had a whole range of shrines to different gods in various rooms, according to individual taste, but everyone needed *lares* in order to have a home and to cook food. These *lares* near the hearth welcomed and protected the slaves, encouraging them to live in harmony with masters who were represented as being pious and benevolent, even as they shared the cult of *lares* with their whole household, through the ideal and efficacious actions of their ever-present guardian spirits.

24 Alföldi 1973, 23, sees the wine of the *lares* as a symbol of the libation for them at every meal. Mastrocinque 1988, 145, associates wine with the heroized dead. For a detailed discussion, see *ThesCRA* 2.444–45, and Prescendi 2007, 87–93 and 109–110.

VIII SERPENT(S) IN A GARDEN

nullus enim locus sine genio, qui per anguem plerumque
ostenditur
—SERVIUS ON *AEN.* 5.85

Each of the paintings of *lares* from Pompeii discussed so far (and many others) in-
cludes either one or two snakes, which are found in or emerge directly from a
garden.[1] Who are these snakes? This question has been answered in a variety of
different ways by scholars, either with reference to Greek art or to local Campan-
ian traditions or a combination of influences. Any viable explanation must make
sense of the very standardized iconography of the snakes in their "garden," in a nat-
ural world parallel to but not identical with that of the *lares*. Clearly, the snakes
are at least as visible as the *lares*, and in fact more numerous in the surviving paint-
ings from the Bay of Naples. Their careful depiction in their own, separate world
of more or less cultivated vegetation strongly suggests that they have a religious role
and sphere in their own right, a context within which they are identified and hon-
ored separately. With only a few exceptions, they do not interact directly with a
genius or the *lares*. They do not make an offering to the *lares* in the way that
the *genius* or the mortal attendants do. Rather they (nearly always) receive their
own distinct offering of either eggs or pinecones on a separate altar within their
garden. The world of the snakes, therefore, appears parallel to but clearly distin-
guished from that framed by the *lares*.

There are, however, a few examples of scenes in which a *genius* pours a libation
directly to one or more snake(s). A nineteenth-century etching by Mazois shows
one example of a painting from Pompeii that depicted a *genius* within a garden
pouring a libation between two snakes.[2] (See figure I.4.) It is, therefore, possible
that the gifts for the snakes are also understood as being left by a *genius*, but with-
out more evidence this must remain a hypothesis. In almost every case, no one is
depicted as making the offering. On rare occasions, the snakes enter the sphere of
the *lares* and try to enjoy some of the gifts on their altar. No one seems to object to
this intrusion. By contrast, no *lar* is ever seen in the garden of the serpents or even
acknowledging their presence in any way.

The snakes are mostly rendered in a similar manner, with variations depending
on the skill, patience, and ambitions of the artist. When there are two snakes in
the same garden, they tend to be clearly differentiated as one male and one female.
The male snake is usually larger, painted in darker colors, and often has a crest on
his head and a wispy beard. The difference between the two snakes is usually easy
to see, as in the case of Villa 6 (see plate 7) and of the painting in the Naples mu-
seum (see plate 6). In many examples, pairs of snakes approach a centrally placed,

1 Boyce 1942 remains the fundamental discussion. See also Fröhlich 1991, 50, with 56–61 and
165–69. He cites 191 examples in his catalogue. Orr 1978, 1572–75, who shows that the Greek *aga-
thos daimon* (benevolent spirit) is a different kind of snake. Further discussion can be found in
Tybout 1996, 361–62; Giacobello 2008, 121–25; and Van Andringa 2009, 232. For snakes as pets,
see Pliny *Nat.* 29.22.72 and Suetonius *Tib.* 72.

2 Mazois vol. 2, 69, plate 24.2. See Kunckel 1974, 29, with Fröhlich 1991, L 113, Taf. 47.2 (=
Boyce 1937, no. 146).

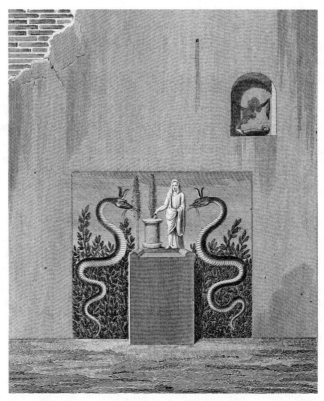

I.4. Nineteenth-century engraving of an altar and wall painting from
Pompeii showing a genius and two snakes.

round altar from different directions. Often two distinguishable offerings are placed
on the altar, clearly suggesting one for each snake.

When only one snake appears, as in the house of Julius Polybius, that animal is
not usually strongly gendered but appears as a generic sort of snake. In other words,
the male snakes do not necessarily outnumber or take precedence over female
snakes. No clear principle emerges for why some scenes have only one snake and
others two within identical iconographic and ritual contexts. Consequently, it is
logical to imagine that the number (or gender) of the snakes is not in itself decisive.

Depicting both kinds of snakes may be related to the notion that a *genius* of place
could be either male or female in Roman thought.[3] There is ample evidence for
this way of thinking. A good early example comes from Cato's *de Agricultura* (139:
si deus si dea es, quoium illud sacrum est [If there is a god or goddess to whom this
is sacred . . .]) in the context of working the land, which is naturally presumed to
be inhabited by gods. Servius mentions a shield dedicated on the Capitol in Rome
and inscribed to the *genius* of the city, whether male or female.[4] Similarly, an altar

3 For a *genius* of place as either male or female, see Kunckel 1974, 10–13, and Ferri 2010, 167,
173-77.

4 Servius *Aen.* 2.351: *in Capitolio fuit clipeus consecratus cui scriptum erat: genio urbis Romae sive
mas sive femina* (on the Capitol there was a consecrated shield on which was written: to the *genius* of
Rome, whether male or female) with *Thes. Lat.* 6. 1828, 33f. Livy 8.26.4 reflects a similar idea.

inscribed to an unnamed deity, either male or female, was found on the Palatine in 1820, seen here in a late nineteenth-century photograph.[5] (See figure I.5.)

sei deo sei deivae sac(rum)
C(aius) Sextius C(ai) f(ilius) Calvinus pr(aetor)
de senati(?) sententia
restituit

Sacred to the (deity of this place), whether god or goddess,
Gaius Sextius Calvinus, son of Gaius, praetor,
restored (the altar) at the request of the senate
(*CIL* 6.110 = 30694 = *ILLRP* 291 = *ILS* 4015 = EDCS 17200112)

This interesting inscription seems to be a late republican reproduction of an earlier text, which preserved at least some features of more archaic language. Its restoration by a magistrate in consultation with the senate confirms official recognition for such unnamed local gods even within the city of Rome. Nevertheless, the representation of both male and female snakes in the same garden in Pompeian painting seems to go beyond a simple expression of doubt about the nature of a singular *genius*; it suggests that a locality could regularly be protected by *both* male and female spirits together.

The snakes, especially when in pairs, offer a visual balance to the twin *lares*. However, they receive different offerings in a distinctly separate setting. Consequently, they cannot be the same as the *lares*, who are in any case always identical to each other and both male. By contrast, paired snakes are not represented as identical. Nor is it at all evident that the snakes should be understood as somehow equivalent to the *genius* and *juno* of the homeowners.[6] Whereas a *juno* is only rarely represented, the snakes are very often in pairs and frequently also depicted on the street in shrines or simply on walls. Moreover, the role of the *genius* is consistently the same: he offers a libation, with or without the *lares* being present. The snakes, like the *lares*, never make an offering of any kind. Rather they are the recipients of offerings or they boldly aim to partake in a gift made by the *genius* to the *lares*. Their role as recipients of gifts placed on altars stresses their status as divine figures in their own right. It should come as no surprise, therefore, that they also have their own separate sphere, which they do not share with any other deity in the iconographic world of the paintings from the Bay of Naples.

Only one inscription provides any other evidence about the painted snakes: literary sources are silent about them. A lost inscription on a wall painting from Herculaneum, which accompanied a snake wrapped around an altar and the young god Harpocrates, labeled this snake as *genius huius loci montis* (the *genius* of this

5 For a good early photograph of the altar as discovered in situ, see Lundberg and Pinto 2007, 48–49. Cf. *CIL* 6.2099 = *ILS* 5047 = EDCS-19000359: *sive deo sive deae in cuius tutela his lucus locusue est* . . . (to the god or goddess who guards this grove or place . . .) (see figure I.5). Courtney 1999, 109, interprets the formula as logically expressing the limits of human knowledge about the divine. Similarly, Macrobius *Sat.* 3.9.7 provides evidence for Roman uncertainty about the gender of the god who protected Carthage.

6 For the snakes as equivalent to the *genius* and *juno*, see Wissowa 1912, 176–77; Otto in *RE*, 1162; and Kunckel 1974, 18. This argument is based on the pairs of snakes mentioned in Pliny *Nat.* 7.122 and Plutarch *TGracch.* 1.4 in relation to the story of the parents of the Gracchi.

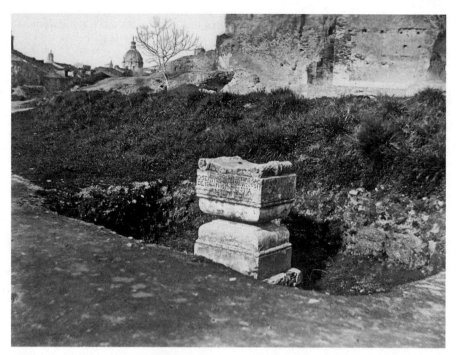

I.5. Altar on the Palatine, dedicated to a local deity, either male or female. Albumen print from glass negative by Gustave Eugène Chauffourier, ca. 1865–70.

place the mountain).[7] (See figure I.6.) The word *loci* appears to have been added later. Although there is a natural environment as the setting, there is not much of a garden by comparison with most of the other paintings. This evidence, scanty though it is, seems to provide a vital key to understanding the snake. Once the snake is recognized as the *genius* of the particular place s/he inhabits, rather than the protective deity of a person, s/he can be used to interpret the combination of different religious scenes that associated a serpent with the *lares* and the *genius* of the householder.

Meanwhile, the "garden" of the serpents emerges as an essential feature of their presentation.[8] They do not naturally live in the more abstract, visually simple space inhabited by the *lares* and the *genius*, a space that has virtually no background in terms of natural features or buildings. Perspective does not seem of much concern to the painter of *lares* scenes. On the other hand, the landscape of the serpents is often wild and thick with vegetation. This "garden" provides the ambitious painter with an opportunity to display his virtuosity in depicting plants and landscape in detail. The lush and realistically rendered world of the snakes is in complete contrast to the scene of the *lares* and *genius*, which is a place that seems to hover in a

7 The painting (inv. MAN 8848) was discovered on 21st December 1748 near or in the Casa del Colonnato Tuscanico (VI.17 or 21?). It is 40 cm high by 50 cm wide and has been dated to ca. AD 45–79. For the inscription, see *CIL* 4.1176 = EDCS-28700265, with *Le pitture antiche di Ercolano* 1757, 207 pl. 38 = Fröhlich 1991, Taf. 13.2, cf. *CIL* 8.14588 = EDCS-25600929. For discussion, see Fröhlich 1991, 54 and 303, L121, and Bragantini and Sampaolo 2010, 430 no. 223. For a togate *genius* with a snake from the theater at Capua, see *CIL* 10.3821 = EDCS-17800434, with Fredericksen 1984, pl. 9.

8 Giacobello 2008, 99, interprets the two registers as the upper and lower world, but this reading seems anachronistic.

type of vacuum bordered by the ritual garlands that announce the religious context in space and time. In practice, this contrast is highlighted by the frequent juxtaposition of the two very different types of scenes. Moreover, the *lares* themselves gain a deeper meaning as "gods of place" in the home when they are combined with quite different "gods of place" who inhabit their own sphere in nature. In other words, each type of divinity plays a distinct role that is complementary to the function of the other gods in the domestic pantheon, even as their spheres of action balance each other in the Roman imagination.

Additional, relevant evidence is provided about snake(s) in a famous passage of Vergil's *Aeneid*, which describes an uninvited snake tasting an offering on an altar.[9] Near the beginning of book 5, Aeneas visits the grave of his father Anchises at Eryx in Sicily. It is, by chance, the anniversary of his father's death and Aeneas plans a sacrifice and games, which will take up much of the rest of this book. As he is about to make an offering at his father's tomb, a snake emerges from below the altar on which Aeneas is sacrificing and comes to taste the gifts placed on that altar, although they have not been specifically designated for him. In other words, the snake behaves in a way that is very similar to what we see in the painting from the House of Julius Polybius (for example).

> dixerat haec, adytis cum lubricus anguis ab imis
> septem ingens gyros, septena uolumina traxit
> amplexus placide tumulum lapsusque per aras,
> caeruleae cui terga notae maculosus et auro
> squamam incendebat fulgor, ceu nubibus arcus
> mille iacit uarios aduerso sole colores.
> obstipuit uisu Aeneas. ille agmine longo
> tandem inter pateras et leuia pocula serpens
> libauitque dapes rursusque innoxius imo
> successit tumulo et depasta altaria liquit.
> hoc magis inceptos genitori instaurat honores,
> incertus geniumne loci famulumne parentis
> esse putet . . .

He had spoken these words, when from the foot of the shrine a huge slippery snake trailed seven coils, in seven folds, peacefully circling the grave mound and gliding among the altars; his back dappled with blue markings, and his scales ablaze with the sheen of gold, as in the clouds the rainbow reveals a thousand shifting colors in the sunlight. Aeneas was shocked at the sight. At last, sliding with his long body between the bowls and polished cups, the serpent tasted the feast, and again, all harmless, crept away beneath the tomb, leaving the altars where he had fed. More eagerly, therefore, he (Aeneas) renews his father's interrupted rites, not knowing whether to think (the snake) was the genius of the place or at the service of his parent.

(Vergil *Aeneid* 5.84–96)

9 Servius on *Aen.* 5.84 explains that no place is without its own *genius*, usually a snake (quoted in the epigraph to this section). See also Persius 1.113: *pinge duos anguis* (paint two snakes) and Servius on *Georg.* 3.417.

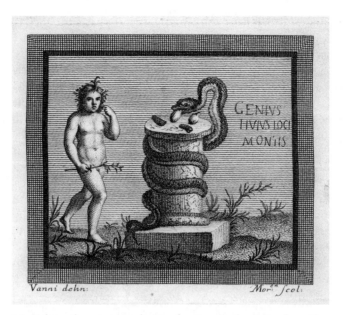

I.6. Eighteenth-century rendering of an inscribed painting from Herculaneum, showing the god Harpocrates with a snake (House of the Tuscan Column, VI. 17?). The inscription (*CIL* 8.14588) is no longer extant. Painting MAN Naples, inv. 8848, 40×50 cm.

For the present purpose, it is interesting to note that Aeneas is not sure of the nature of the snake: two explanations come to his mind.[10] Either the snake is the *genius* of the place or the animal has been sent as a messenger by his father. Aeneas, therefore, does not consider that the snake could actually be (in any real sense) the spirit of his deceased father. Nor, therefore, should we draw such a conclusion. Rather, Aeneas' alternatives indicate that the most obvious explanation for a snake one meets is indeed a *genius* of place.[11]

Vergil's two options present standard Roman thinking about animals in general and snakes in particular. Either the snake is the *genius loci* or his appearance is a prodigy, linked to the fact that Aeneas is present at his father's grave. Many recognized Roman prodigies involved animals of all kinds when seen in unusual places, doing unexpected things, especially at significant moments.[12] In this case, a possible message is imagined as being sent by Anchises to Aeneas. In fact, the two explanations that come to Aeneas' mind are not necessarily mutually exclusive in Roman thought. We might imagine Aeneas' line of thought as: "Is this just the *genius loci* or a special sign from my father?"

Why then does Vergil bother to include the two potential interpretations of the snake? A possible answer should surely be that he uses the encounter with the snake to elucidate Aeneas' own sense of doubt and insecurity: we are invited to see that Aeneas is experiencing his situation as that of a stranger in a strange land. Vergil's

10 For commentary, see Williams 1960 ad loc. Ferri 2010, 176–77, sees polyvalence as a typical aspect of Roman religion.

11 For other snakes in Vergil, see *Georg.* 2.153–54; *Aen.* 2.203–27 and 5.273–79.

12 For Roman prodigies in general, see Engels 2007, who discusses snakes at 454, 515, 544.

readers would themselves have had no doubt that the snake was indeed the *genius loci* and, therefore, a propitious sign of welcome and greeting. Indeed, his harmless nature and benign intention are stressed twice in the passage. For a variety of emotional and cultural reasons, however, Aeneas is so upset and alienated that he is in doubt about the obvious cue of the snake in the landscape, a very southern Italian and Roman scene that will become so familiar to his descendants. This welcoming snake can provide a balance to the destructive snakes Aeneas witnessed immediately before the fall of Troy, which he described to Dido in book 2.[13] He has nearly arrived in his new home in Italy and will soon also have a chance to speak directly with his father Anchises in the underworld, who will explain the future to him clearly.

The best known, historical prodigy that involves a snake at an altar took place almost twenty years before Vergil was born. It was said to have happened in 89 BC during the Social War to the Roman general L. Cornelius Sulla, when he was campaigning near Nola in Campania.[14] The appearance of a snake at the altar where Sulla was sacrificing was greeted by the Etruscan priest (*haruspex*) C. Postumius as a sure sign of imminent victory. This episode is notable because Cicero witnessed it, when he was serving on Sulla's staff (at the age of seventeen) and was evidently present at this sacrifice offered by his commanding officer.[15] In the following description, Cicero's brother Quintus is the speaker recalling the event during a dialogue with his brother.

> ... et ut in Sullae scriptum historia videmus, quod te inspectante factum est ut cum ille in agro Nolano immolaret ante praetorium, ab infima ara subito anguis emergeret, cum quidem C. Postumius haruspex oraret illum ut in expeditionem exercitum educeret. id cum Sulla fecisset, tum ante oppidum Nolam florentissima Samnitum castra cepit.

> As we see written in Sulla's historical account (of his life), an event to which you yourself were a witness, when he (Sulla) was offering sacrifice in front of his headquarters in the territory of Nola, suddenly a snake emerged from the bottom of the altar. Then indeed Gaius Postumius the Etruscan seer (*haruspex*) begged him to lead his army out into battle. When Sulla did so, he captured a very well-equipped Samnite camp within sight of the town of Nola.
> (Cicero *de Div.* 1.72)

Later in this same text, Cicero again confirms, this time in his own voice, that he was himself a witness at what was clearly a well-known event (*de Div.* 2.65). Quintus also mentions that Sulla described the scene in his *Memoirs*, a detailed but unfinished account of his life in twenty-two books, which was published soon after his death in 78 BC.[16] Regardless of how exaggerated and florid Sulla's own description of

13 Vergil *Aen.* 2. 203–27.

14 Engels 2007, 587–89 (RVW 272), collects the evidence for prodigies relating to Sulla in 89 and 88 BC.

15 For commentary and all the references, see esp. Wardle 2006 ad loc. on Cicero's *de Divinatione*.

16 For the dating to 89 BC, see Salmon 1967, 367 n. 1, followed by Engels 2007, 587–88. Contra Christopher Smith in *FRHist* 22 F 17, who puts the episode in 88 BC, around the time of Sulla's (first) march on Rome. Nevertheless, the presence of Cicero as an eyewitness establishes a date in

the snake welcomed by the Etruscan seer may have been, the simple fact of the snake's appearance and its identification as a positive sign at the time is firmly established by Cicero.

For our present purposes, it is striking to see Sulla greeted by a propitious snake precisely in Campania, home of the snakes we meet in the later paintings from the Bay of Naples. Snakes were native to this place and were honored as local gods in paintings, even as they may also have been seen as propitious animals in the Etruscan worldview invoked by Sulla's personal seer Postumius.[17] A snake was apparently disturbed by the preparations for Sulla's sacrifice (perhaps on a temporary altar of earth and stones?). Its appearance was most welcome as a natural sign that Sulla was being acknowledged by a local divinity and that his mission was, therefore, destined to succeed. In fact, Sulla was not completely successful at Nola that year and more campaigning took place when he was consul. Sulla's widely read narrative will probably have interacted with Cicero's own personal memory of the prodigy to create a lasting impression that he recalled when writing the *de Divinatione* (ca. 45–44 BC) some forty-five years after the prodigy in Sulla's camp. Vergil echoed some of Cicero's (and perhaps Sulla's) words in his description of Aeneas being greeted by a snake at an altar in Sicily.

Snakes, then, appear as particularly familiar and protective animals in a south Italian setting. Their role as gods of place on the Bay of Naples is attested by a wealth of paintings from the first century AD. In this context, they provide an important visual and conceptual parallel to the more abstract and symbolic scenes that depict the libation of the *genius* in honor of the *lares*. This parallelism is only enhanced by the paintings in which a snake escapes from a garden to enter the world of the *lares*, an attractively rendered scene marked out by religious reverence. A snake could happily find a share in a meal within the sacred space that was defined by and belonged to the *lares*, gods of mortal households. Unfortunately, we do not know whether snakes were associated with *lares* in similar or other contexts outside Campania. Romans certainly knew of and watched snakes as gods of place and guardians in their own right, but they are not mentioned as part of regular cult in the way that the familiar *lares* were.

89 BC; cf. also Plutarch *Cic.* 3.1; Appian *BC* 1.50; and Livy *Per.* 75. Sulla was a *legatus* at the time, and returned to Rome later in the year to stand for the consulship, which he won for 88 BC. For Sulla's memoirs, see now esp. the very useful commentary of Scholz and Walter 2013, 115–16.

17 Engels 2007, 587 n. 271, argues for a positive reading of a snake as an indication of possible Etruscan and Hellenistic influences. Obsequens 47 records the appearance of a snake to the *decemviri* who were sacrificing at an altar at the Temple of Apollo in Rome in 98 BC (*apud aedem Apollinis decemviris immolantibus caput iocineris non fuit, sacrificantibus anguis ad aram inventus* [The liver had no lobe when the *decemviri* sacrificed at the temple of Apollo; as they were sacrificing a snake was discovered at the altar]). The juxtaposition with the defective liver does not suggest a good omen in this context.

IX A PAINTED LANDSCAPE OF LOCAL GODS

> the goal of divine religious behavior is not so much paradigmatic
> instruction of mortals, or modeling devotional piety for them,
> as it is self-expression that, like a voice seeking an echo in a
> canyon, can only be realized by the mirroring and correspond-
> ing syntax of human ritual.
> —PATTON 2009, 308–9

How, therefore, does the scene with the *lares* (with or without a *genius* pouring a libation to them) relate to the serpent(s) in their garden (who represents the *genius* of the natural environment)? What is the role of the *genius* of the householder in making his sacrifice to the *lares*? What parts do the human attendants play in the ritual performed by the *genius*? How can we make sense of this iconography as a whole, beyond an analysis of its individual constituent elements? These questions arise precisely because these paintings do not depict the world of myth that was so popular in the rooms used by family members. They are the subject of this final section, which draws its inspiration from Campanian painting while keeping the textual evidence in mind. Needless to say, the quality of the surviving paintings varies quite considerably, and some artists do not bring out the full visual impact of the standard elements, while others seem to editorialize or play with conventions. Nevertheless, a holistic reading of the best-preserved iconography suggests that in carefully executed domestic religious paintings a unified vision of a specifically religious worldview was consciously depicted. At the same time, the frequent repainting of these scenes also attests to their religious but also emotional value.

As argued earlier, differences in scale and register are not clumsy or eclectic juxtapositions drawn from unrelated artistic models by unskilled painters. Rather the relationships of scale both to the ritual actions taking place and to the relative positions of all the figures within their respective spheres are vital to the interpretation of each scene. Meanwhile, the frontal or angled orientation of many of the figures, especially the deities, is designed to draw the viewer in to witness and participate in the ritual cycle. The painting addresses itself to worshippers, which is to say any and all who are present. The viewer is, therefore, not detached from the ritual action. In the world of these paintings, the garden of the snakes balances the world of the *lares*: both of these spheres are depicted in relation to the world of men. There is no commemoration of the dead either as a group or individually. Rather the *genius*, by his very nature, performs a libation that must be by and on behalf of the living members of the household, not only blood relatives but also everyone else living under the same roof. Consequently, this libation must also be in a religious version of the present time, since it represents the cultic practices of this particular household, under this individual, living master.

Nevertheless, the sacrifice scene is not simply a representation of a particular, recent event or even a type of event in the household. It is more abstract because nearly all scenes have the sacrifice to the *lares* being performed by the *genius*, not by the paterfamilias himself. Meanwhile, the painting from the House of Sutoria Primigenia shows that mortals could be depicted as celebrants. Most paintings depict a religion practiced and modeled by a god, albeit a deity of a rather particular

Roman kind.[1] The libation sets up a hierarchy of divinities that is consistently mirrored by the respective sizes of the figures. The *genius* (of the master) pays homage to the twin *lares* by means of the libation within a ritual space defined by and for them, in a time that is the continuous present of ritual efficacy. This religious sphere is consistently situated within the specific context of the hearth, where the cooking is done. Through their watching over the fire, the cooking, and the food, the *lares* establish the home and guarantee its sustenance, well-being, and future. This basic idea is reflected by their protection of the *genius*, who calls on their help and honors them with a libation that introduces the sacrifice of a pig.

There is, therefore, a continuous interchange of gift and patronage between the *lares* and the *genius* in an ongoing cycle of honor and favor, protection, and thanksgiving. The sacrifice is always beginning with the libation, as the music of the flute resounds and the fire on the altar is already burning. In visual and symbolic terms, showing twin *lares* enables the framing of the scene and defines the ritual quality of what happens within the space between these identical deities. Meanwhile, the human figures, most of whom are apparently slaves who assist the *genius* in his sacrifice, provide a direct connection with ordinary life in the home and specifically with the people working daily at the hearth under the eyes of the watchful *lares*.[2] The humans are integral to the action within this religious world, in which the *lares* themselves give and acquire meaning in terms of both space and time.

The ritual sphere of the *lares* complements and contrasts with that of the snakes. Each sphere can be depicted separately but they are often juxtaposed, depending on the size of the painting. The lush world of the snakes is not placed underneath because it is the underworld. Rather, their "garden" conjures up the environment of nature that is represented as being separate from the sphere of the *lares*. According to the ancient evidence, the *lares* are associated with the home and, therefore, with the land and house, whether actually owned or simply occupied by the family. That is why they protect the family inside the home, even as they mark the corners of their fields in the countryside or their property bounded by major streets in town. Consequently, the two types of painted scenes complement each other perfectly, as the snakes represent the natural world that is imagined as being inhabited by the *genii loci* (whether male or/and female, singular or plural), even as the *lares* signify the world of men, at the boundaries of their private property and at the hearth of their households. These men do not live simply in the wild as the snakes do but have a home that is defined by *lares*. In the ideal world evoked by these religious paintings, therefore, the realm of nature with its native deities exists in perfect harmony with the ritual sphere of humans, who live in homes made by men but ultimately guarded by *lares*. In other words, here we see a vision of the coexistence of men and gods, in a specifically local and domestic context, even as both mortal and deity perform ritual together.

A pious Roman (guided and protected by his *genius*) would aspire to a good relationship with deities of the natural world, who were imagined as already

1 Patton 2009 is full of interesting ideas about a "religion of the gods," but does not discuss any Roman evidence. In this case, the recipients of the offering (*lares*) are nearly always present in the painted scenes.

2 These small human figures may remind us of the diminutive donors depicted in medieval religious art (known as donor or votive portraits), although those tend to show the elites who could be patrons of the arts.

inhabiting spaces before these were occupied by men, as well as with the gods of his home, his lar(es) and his family gods (*penates*). In other words, these paintings represent a holistic worldview based on a simple but logical "religion of place." Why should I cultivate these *lares*? The straightforward answer is: because I am here in this place that they guard. Whether I am a member of the household (of whatever station) or simply a visitor, this place belongs to and is defined by these particular *lares*. While I am here, I am in their sphere of efficacy and, therefore, dependent on their good will.

Meanwhile, this view of the world and of ritual did not prevent anyone from worshipping other deities in other ways. In fact, the members of the master's family also honored the *penates* and engaged in gentilicial cults within the home, cults reserved for a group related by blood and, therefore, not shared with slaves or guests. But, in Roman terms, the *lares* and snakes defined both what space meant and what ritual was. The spatial nature of the *lares* made it essential but relatively uncomplicated (at least from a theological perspective) to expect and even, therefore, simply to require the slaves to participate in this particular cult. These paintings could also suggest a religious context and value for servile labor in general. Consequently, the *lares* protected the home and property of the paterfamilias, while at the same time creating a religiously sanctioned community within his household. The cult of the *lares* did not depend on distinctions of myth, social status, wealth, ethnicity, initiation, education, expertise, birth, virtue, or family status. It simply required presence, here in this place. The master was so close to the gods of his household that his own *genius* was represented as the main celebrant of their cult, assisted by slaves, whose service is welcomed by the deities.[3] The *lares* also provided a spiritually defined home for these slaves, within the context of the Roman household and its religious world.

<p style="text-align:center">* * *</p>

The variety of ancient evidence discussed in this first part presents a series of intricately interwoven variations on the theme of cultivating the lar(es) in Roman homes over several centuries and in different locations. As argued earlier, the religious paintings from Campania both confirm the ubiquity of these cults inside and outside the home, even as they present us with a well-developed and iconographically distinctive version of the function of *lares* as gods of place on the Bay of Naples. It seems likely that the Pompeian domestic paintings were influenced by the twin *lares* at their numerous street shrines, but ideas may well also have circulated both ways over time.[4] It is not known where the iconography of the individual *lar* as a long-haired, dancing youth dressed in a short tunic ultimately came from.

It is not safe, however, to see every aspect of the Campanian rituals and images as necessarily "standard" Roman practice, even in the first century AD. As noted

3 For *lares* dressed as slaves, see Fröhlich 1991, 31; Foss 1997, 199 (slaves as proxies for *lares*); and Pollini 2008. Giacobello 2008, 95–96, sees the iconography of the *lares* as heroic and Hellenized, in the image of the Dioscuri. At the same time, their iconography (long hair and short tunics) suggests a possible identification with the slaves, who had become their usual daily worshippers in the kitchens of houses great and small.

4 Fröhlich 1991, 33, argues for many mutual influences. Tybout 1996, 359–60 and 373, sees compital influences in domestic paintings.

earlier, literary sources neither reaffirm nor challenge many iconographic and rit-
ual details in the paintings. The snakes may perhaps be local gods of place in
Campania who had learned to live with the newer Roman *lares* in largely separate
but parallel religious worlds or they may have been more widespread but the evi-
dence has not survived. The typical role of the *genius* in making the libation to the
twin *lares* may not, in fact, be a universal feature, as far as we can tell. Plautus and
Cato do not speak of a *genius* in relation to their single domestic *lar*. The paintings
need to be read and appreciated in their own particular artistic, historical, archi-
tectural, social, and geographical contexts. Indeed, many Campanian painters seem
to be well aware of images and trends from Rome, including some associated
with the *lares augusti*, but to have used them for their own purposes, in a local
context, when they chose to refer to them at all.[5]

The Campanian paintings, both in the house and on the street (see section II.xv),
compare and contrast in interesting ways both with the republican "liturgical"
paintings from Delos (roughly 200 years older, some commissioned by households
of traders who had their roots on the Bay of Naples; see section III.xviii), and with
Augustan compital art from Rome (about 100 years earlier, see part IV).[6] Each of
these bodies of evidence will be discussed separately later in its own terms. Care is
needed, however, to avoid simply combining evidence from different times and
places to create an artificial and anachronistic single cult for the *lares* either in the
home or at the crossroads.[7] Different features of ritual were stressed in different
contexts: the libation of the *genius* was crucial at Pompeii, while on Delos painters
represented the games for their annual festival of Compitalia and the prizes to be
won together with the pig sacrificed by humans, who are sometimes named. Mean-
while, the cult at Pompeii may have had a more uniform character because it had
essentially been (re)organized at a single critical moment, with the arrival of Sul-
la's veterans and the founding of the Roman colony in 80 BC. In addition, the paint-
ers active after the earthquake of AD 62 may have created a certain style, but did
so to meet the needs of their patrons. Other towns, including Rome, had different
local experiences and religious histories that shaped both ritual practice and the
representation of the gods.

Nevertheless, continuity and complementarity are also immediately evident.
How we identify and interpret the differences or the similarities between the various
ways of living with *lares* is a complex question of perspective and methodology.
Plautus and Cato, each long-established residents in Rome and writing within
a period of about thirty years of each other, seem to describe a very similar house-
hold cult for a single *lar* at the hearth, whether in town or on a farm in the country.
Plautus, however, paints a vivid picture of much more fervent, even daily cultivation
on the part of family members, both men and women. By contrast, Cato is de-
scribing (prescriptively) duties imposed by the master on a freedwoman or female
slave, who is represented as acting on behalf of the family and as doing what is
strictly necessary rather than expressing her own spirituality. The lively scenes

5 Laurels appear in *lares* paintings on the Bay of Naples: see Fröhlich 1991, 127. These may
have been a regular attribute of *lares*, as we see in the paintings from Delos discussed in section
III.xviii. Van Andringa 2000, 77–80, stresses that there is no evidence of the *lares augusti* at street
shrines in Pompeii.

6 For Delian paintings, see section III.xviii; for Augustan examples, see sections IV.xxv and
xxvi.

7 Note the important warning by Fraschetti 2005, 120, discussed in the preface.

painted at Delos later in the second century BC show that slave and freed could embrace the duties associated with the *lares* with enthusiasm.

Despite their differences, Plautus helps us to understand the vital function of delegation within Cato's system of household management. The *lar* at each respective hearth is not a god primarily of the slaves but of the whole household under the leadership of the paterfamilias. The lar's essential role in making the house a home for everyone means that his regular cult cannot be allowed to be interrupted by the absence of the master and his family. One of the challenges facing the absentee landowner, the intended or imagined reader of Cato's work, is how to maintain ritual correctness and a good relationship with *lares* (and other gods) while he is not there to perform or supervise ritual actions himself. All our different types of evidence suggest that lar(es) are indeed the most important gods of place in the Roman context. That is precisely why they usually appear bigger than other deities on Pompeian paintings and why Cato focuses on them to the exclusion of the other gods of the household or kin group on his ideal farm.

The well-maintained Campanian religious paintings, many of which had recently received offerings in late August of AD 79, suggest an active engagement on the part of a broad section of society on the Bay of Naples. This religious practice would have been familiar to Plautus, who died more than 250 years earlier. The nails found in the walls near many of these paintings seem designed to receive the garlands of flowers referred to as the most popular offering for any *lar.* The paintings bring alive for us one local variation on the cult of *lares*, both in the home and on the street. The cult of the *genius* is less easy to read and appears to be subordinate to that of the *lares* and probably also of the snakes, gods of place associated with the natural environment on the Bay of Naples (and elsewhere?). On the Bay of Naples and in other places, a cult of the master's *genius* is also clearly attested by inscriptions put up by slaves.[8] In the paintings, the *genius* venerates the *lares* on behalf of the household, in an ideal world that portrays harmony between the snakes who protect the place itself and the *lares* who guard the houses and fields established and inhabited by the human population.

8 Many inscriptions attest vows and prayers made by slaves for their masters. For birthday rituals, see Aretsinger 1992.

II

SHRINES FOR *LARES* IN ROME

ipsa dividitur in regiones XIIII, compita Larum CCLXV
—PLINY *NAT.* 3.66

A visitor to ancient Rome would have been greeted by a multitude of *lares* in civic, commercial, and domestic contexts; no place in Rome was without its guardian gods, of which *lares* were the most ubiquitous. The *lares* of Rome had their own public temples; they were, therefore, more integrated into civic life than in any other urban context that we know of from antiquity. In a range of settings, *lares* in Rome also had a more varied iconography than the very standardized imagery found in the paintings on Delos or on the Bay of Naples or in the bronze statuettes from elsewhere in the Roman world. *Lares* of many types, some thought to pre-date the city's foundation, were to be found throughout the urban landscape. Consequently, *lares* were among the most characteristic gods of the Romans and of the sacred landscape in their beloved mother city. Rome's growth to become the dominant metropolis of a world empire would only have served to reinforce the sense of importance attached to its many ways of honoring *lares*; the magnificence of the grandest temples was balanced by a myriad watchful *lares* at the street corners and at particular individual shrines throughout the historical parts of the city.

This second part will move beyond the house into the street to look at the many types of shrines for *lares* in public places in Rome, from the biggest to the smallest. Once again, Varro will help to introduce the whole subject, with his description of a Roman bride making her way from her original home to the house she will live in with her new husband (section II.x). As part of her wedding ceremony, a bride greeted both the domestic *lares* inside her new home and the local *lares*, whom Varro calls *vicinales* (neighborhood), at a crossroads shrine nearby. The *lares* were, therefore, important players in the rituals of arrival and of taking up residence in a home that were the central focus of the Roman wedding ceremony. Sections II.xi, xii, and xiii will go on to examine the various types of cult sites for *lares* attested in the city of Rome, proceeding from biggest to smallest. We will start with two temples (*aedes*) and move on through various local shrines to named *lares* (notably the *praestites* and *grundiles*) and ultimately to the shrines at the crossroads (*compita*). Pliny tells us that the census of Vespasian and Titus officially recorded 265 *compita larum* (crossroads shrines for *lares*) in AD 73–74. These crossroads shrines, which did not have a standard format, will then be considered in relation to other local shrines, particularly open-air ones (*sacella*) that did not have cult buildings (section II.xiv). My examination of the crossroads shrines aims to place them within the larger sacred landscape of the city, from temple to local altar to tiny niche.

Archaeological investigations in Rome have not yet yielded examples of well-preserved compital shrines that have been found in place, let alone providing

information for making anything more than a rough sketch of what the whole network would have looked like at any particular time in the city's history. Consequently, by way of comparison, section II.xv will offer an overview of street shrines in Pompeii. Most of these obviously reflect the situation in and immediately before the eruption of AD 79, when they were very much in use. Nevertheless, the cult of *lares* at street shrines in Pompeii mainly sheds light on the way local shrines there developed after the city became a Roman colony in 80 BC. Although Pompeii had its own particular history and had not originally been built as a Roman city, its streetscapes offer valuable insights into Roman ideas and habits by illustrating the general popularity of shrines and religious paintings outside houses on the Bay of Naples. The Pompeian streetscapes offer a view of religious life that is over 150 years later than the religious paintings from Hellenistic Delos, which will be treated as a separate case study in section III.xviii. As already suggested in section I.i, the standardized iconography of the *lares* preserved in paintings from the Bay of Naples provides a useful contrast with cults in Rome, which seem to have featured traditional shrines to named *lares* with their own specific iconography (for example, the *lares praestites*) alongside the many *lares compitales* or *vicinales*.

In conclusion (section II.xvi), the discussion will return to a broader consideration of the nature of *lares* and of the many places they inhabited and protected. The wide variety of sacred spaces used for *lares* cults confirms the flexible character of these gods, both in space and at various moments in time, as well as the integral roles they played in Roman life at an everyday level.

The focus of part II on iconography, architecture, archaeology, and topography (within the specific urban contexts of Rome and Pompeii), serves as essential background to part III, which will examine the midwinter festival of Compitalia, a celebration with religious and political importance, especially in the local neighborhoods (vici). Each part includes a separate case study by way of comparison with Rome, Pompeii in II and Delos in III. Part III also examines rich epigraphical evidence from republican Capua on the Bay of Naples and Minturnae in southern Latium. In other words, part II explores the physical setting for the rituals and celebrations examined in part III, as well as providing the essential background to the discussion of Augustus' new religious program for Rome's compital shrines in part IV. While much of the evidence analyzed in part II is fragmentary and elusive, it nevertheless provides the basic framework for a study of religious practices within the particular sacred landscape of Rome.

X THE THREE *ASSES* OF THE BRIDE

> While we cannot say that the wedding was celebrated in honor
> of the *Lares*, we must recognize the importance of Nonius' claim
> about the sacrifice of coins the bride made to the *Lares*; it is the
> only explicit evidence we have about what was offered to any
> god at the Roman wedding.
> —HERSCH 2010, 278–79

A famous passage about traditional Roman marriage customs from the first
book of Varro's *De Vita Populi Romani* provides us with an introduction to *lares* in
the Roman life cycle and, therefore also, to the kinds of rituals regularly to be
seen in the city of Rome.[1] In a passage from book one of *De Vita Populi Romani* pre-
served by Nonius, Varro speaks of the three bronze coins (*as*) that a Roman bride
brings with her on her wedding day as she comes to take up residence in her hus-
band's house.

> Nubentes vetere lege Romana asses tres ad maritum venientes solere perve-
> here atque unum, quem in manu tenerent, tamquam emendi causa marito
> dare, alium, quem in pede haberent, in foco Larium familiarum ponere, ter-
> tium, quem in sacciperione condidissent, conpito vicinali solere resenare [?]
> (corrupt text here).

> According to ancient Roman practice, brides coming to their husband's home
> were accustomed to carry 3 *asses* and to give one, which they would hold in
> the hand, to the husband, as if to make a purchase. Another, which they had
> on their foot, they would put on the hearth of the *lares familiares*. The
> third, which would be kept inside a purse, they were accustomed to deposit
> with a ringing sound (?) at the local crossroads shrine.
> (852L, *De Vita Populi Romani* = 1.25 Riposati = 304 p. 63 Salvadore)

The move to the bridegroom's new home seems to have come at the end of the day
and was accompanied by much ceremony.[2] Every part of the proceedings invoked
blessings on the married life of the new couple, while simultaneously averting bad
luck and ill omens in a variety of ways. Special attention was naturally paid to how
the bride arrived at and crossed the threshold of her new home for the first time.
Varro's ritual involving the three coins perhaps came as a climax of this bridal
procession from her family home by torchlight. As he describes it, the bride would
give the first coin to her new husband, the second to the domestic *lares* at his hearth
(named in the plural here by Varro), and the third to the neighborhood *lares* at the
local compital shrine. The date of the wedding may also have created another, more

1 For editions of Varro's fragments, see Riposati 1939, esp. 133–37, and now Salvadore 2004.
The *De Vita Populi Romani* is generally dated to the 40s BC. See also Servius on *Georg.* 1.31: *quod
autem ait "emat" ad antiquum pertinet ritum, quo se maritus et uxor invicem coemebant sicut habe-
mus in iure* (The expression "he buys" refers to the ancient rite by which the husband and wife used
to buy each other in turn, just as we have it in law).

2 For Roman wedding customs, see the detailed treatment of the individual elements by
Hersch 2010, with her full bibliography on each topic. For the costume of the bride, see also La
Follette 1994.

indirect association with *lares*, since the most popular Roman wedding months were December and January (the season of Compitalia) or May (a month ushered in by the ancient *lares praestites*, whose festival fell on its *kalends*).[3]

Varro is our only ancient source for the offering of three *asses*. We do not know when it originated, how common it was, or how exactly it was combined with other rituals that are attested (many just as sparingly) as surrounding the bride's arrival. Varro claims that the custom is "old," but no more details of his explanation survive. Consequently, any general account of the ceremonies at the groom's house is tentative and hypothetical in the present state of our evidence.[4]

The procession of the bride on foot and her arrival at the groom's house marked the marriage, both for the relatives of each family and in the context of the wider community.[5] The willing consent of the two parties made the match binding, a condition that placed much less emphasis on the actual wedding night and the consummation than in many other cultures.[6] Yet because we do not know what came first and what next on the big day, we cannot be sure whether the three coins were usually juxtaposed with other rituals in a typical order. Nor do we know of any traditional words that may have been spoken by the bride to accompany her gifts, either to the husband or to the *lares*. Ultimately, it is quite unclear which of the many rituals carried the most emphasis and emotional value or marked the actual moment when the couple was recognized as "man and wife" by family members and guests.[7] While keeping these challenges in mind, the analysis that follows will, therefore, simply offer a reading of the gift of the three coins in its own terms, as far as possible.

Each coin was carried separately, a custom that helped to articulate and draw attention to the three quite distinct moments of giving, as well as to their established order within the ritual. It seems that the new husband's acceptance of his coin was the moment for the new matrona to take up residence in her official capacity in his (or his family's) home. This is presumably the reason why her first coin is for her new husband and only afterward does she make her gifts to the household and local gods. He takes priority within the logic of this rite of transition. The gift of the coin was a significant gesture for the bride as there was relatively little in the way of formal marriage ceremony between bride and groom, at least for those who were not married by the much more elaborate but relatively rare rite of *confarreatio*.[8] At the same time, the gift of the coin to the husband showed that the bride did not arrive "empty handed," since the coin for him was "in her hand," but was making a (symbolic) gift in return for her place in the home. Her arrival was

3 See Shaw 1987, 70–72, for the seasonal patterns of Roman marriage.

4 This is stressed by Treggiari 1991, 161–70, at the very beginning of her insightful discussion of the wedding ceremony. Hersch 2010, 223, gives a summary overview in her conclusion that is inevitably and rightly couched in very tentative language.

5 Hersch 210, 50–58.

6 Consent in Roman marriage: Treggiari 1991 is the classic treatment of marriage in Roman law. See 166–67 for her excellent discussion of the arrival of the bride with the three coins. Gourevitch and Raepsaet-Charlier 2001, 98–100, offer a somewhat different reconstruction of the order of events at the groom's house.

7 Ovid *Fast.* 4.791–92 has the offering of fire and water to the bride at the entrance as making her a wife. But it is not clear how literally one should read his statement.

8 See Fasce 1984 for a discussion of the legal situation. Her argument that the ritual of the coins is closely associated with the husband's legal powers over the woman in the context of a marriage with *manus* is based on several a priori assumptions and applies only to certain marriages.

apparently signaled in a different way from that of any other person coming to take up residence in the household. Similarly, his acceptance of the coin symbolized his receiving her and presumably acknowledging her status as matrona and *materfamilias* in the home and, by implication, as mother of his future heirs. In fact, according to Roman law and custom, husbands and wives did not regularly exchange gifts as part of their married life together.[9]

It is unclear whether she gives him the coin before or after she crosses the threshold.[10] Her gesture could make sense as the first act after she enters the house. Since she "arrives" with the coin "in her hand," she presumably cannot perform other rituals before handing it over. However that may be, much discussion has focused specifically on the significance of this first gift to the husband, whether symbolic or actual.[11] Varro himself seems not entirely sure of its meaning; his comparison with a purchase is presented as an analogy (*tamquam*). Hence, his gloss is not a formal definition or classification of the gift. Nor is it self-evident that the coin "represents" the dowry. Varro certainly does not make this connection when he mentions the context of a sale. It is not easy to connect this "purchase" made by the bride with the legal conditions of most Roman marriages, which might or might not involve the bride entering into the legal family of the groom (that is, a marriage with or without the legal status of *manus*).[12]

In fact, it may be more useful to examine the gift separately, precisely as a ritual that could be practiced regardless of the legal condition of the particular marriage in each case. Indeed, with the exception of the elaborate but relatively rare *confarreatio*, the wedding rites themselves do not seem to have described or created the various types of legal marriage available to Roman citizens. In this sense, the gift of the coin to the husband, a gesture that mimicked a purchase but did not, therefore, involve the bride "buying" her husband, could have been a way for her to negotiate her arrival in the new space and for him to acknowledge her as a resident with an honorable status through a simple gesture. In any case, this ritual may not have been well understood by those who performed it in Varro's day.

In Varro's order of events, her next gift was to the family *lares* at the hearth, which would be found in the kitchen in most larger houses. A temporary "hearth"

9 No gifts between spouses: Plutarch *QRom.* 7, *Digest* 24; Juvenal 6.200–205, with Hersch 2010, 176.

10 For the (sometimes elaborate) rituals at the threshold, see Pliny *Nat.* 28.135 and 142; Servius *Aen.* 4.458; Plutarch *QRom.* 29 and *Rom.* 15.5; and Lucan 2.359. One is struck by the number of actions the bride needs to do with her hands, while she is said to bring the coins into the house herself. Clearly, attendants were needed to carry and hand over a number of ritual items at appropriate moments. Consequently, we cannot be sure what, if anything, the bride "carried" herself or on her person during the procession. Hersch 2010, 220, points out that the woman is married from the moment she enters the groom's house, not later with the consummation of their union. In fact, as she goes on to argue in 222–26, marriages could legally take place without the groom present at all.

11 Fasce 1984 concentrates almost exclusively on the first coin, rather than giving a more holistic reading of all three in relation to each other. But legal issues cannot necessarily be isolated from religious ritual or from symbolic gestures. For a more religious reading, see Boëls-Janssen 1993, 210–13.

12 Quite a few young grooms would, in any case, not have been *sui iuris* at the time of their first marriage, if their fathers were still alive. Consequently, it is not self-evident that the bride was ever automatically subject to her husband in legal terms. The wedding ceremony did not have much legal force in itself. Moreover, the "ideal" wedding would presumably be constructed (as in most cultures) as a first marriage between young Romans, whereas many would go on to marry again at various different ages.

could, of course, be set up in the atrium to receive her gift on the wedding day.[13] Yet, in religious terms, it would have been more meaningful for her to pay a visit to the actual shrine of the *lares familiares*, in the place where the food for the house- hold was prepared and the regular rituals for these household deities were per- formed. The bride is the only person we know of to offer a coin at the hearth. Was this coin then picked up by the slaves or used for the next purchase of garlands or incense for the *lares*? Other gods of the family (*penates*) do not receive a standard offering from the bride in this context, although we might not be surprised to find a shrine for them in the atrium, the first space that she has just entered.

In other words, this is not an instance of a bride "joining" in the cults set aside for the members of her husband's family or clan whom she has just become part of (if married with *manus*). Macrobius, in fact, suggests that the new wife performed her first religious duties on the day *after* the wedding.[14] Rather, with the gift of the *as,* she greets the gods of place who protect the whole household and everyone who spends time in this home. She also enters into her role as a practitioner in this cult, whereas she might have little or no part to play in the rituals required of her hus- band and his blood relatives.

The coin for the household *lares* is carried "on her foot," presumably in her shoe. She is imagined, therefore, as wearing shoes rather than sandals. The coin in the shoe suggests the connection of the *lares* with the place itself and draws attention to the steps the bride takes as she enters the house for the first time in her new ca- pacity. She might be carried over the actual threshold of the home by her atten- dants but would then take her first steps inside with a coin in her shoe. Again, she does not come without a gift but with a coin specifically designated for the domes- tic *lares* by its position in her shoe. The separate carrying of each coin "reminded" the bride herself of the three distinct offerings she needed to make. Like the coin in the hand, the coin in the shoe would surely be presented soon; its presence in her shoe draws her attention to what she should do next.

Consequently, it seems that the bride would first enter the home, greet her hus- band and the gods of his household, and only *then* leave the house again to pay her respects at the neighborhood shrine at the local crossroads (which might or might not be very near the house).[15] The *as* for the neighborhood *lares* is specifically described by Varro as being the third gift. It is striking to see that the bride arrives in procession at the groom's house and pauses to complete a (sometimes elaborate) series of rituals that allow her to cross the threshold auspiciously, be received by her new husband, and greet the *lares* of his hearth. Yet she must then (apparently quite soon?) leave the house again in order to give her third coin, this one carried in a small purse (*sacciperium*), to the *lares vicinales* at the local compital shrine.

13 A symbolic marriage bed (*lectus genialis*) was apparently set up and decorated (perhaps in the atrium) on the wedding day. See Festus 83L; Arnobius *Adv. Gent.* 2.67; Servius on *Aen.* 6.603, with Hersch 2010, 214–21. Johansson 2010 discusses the *genius* and *lares* at the wedding, with special emphasis on the *lectus genialis*.

14 Macrobius *Sat.* 1.15.22: *postridie autem nuptam in domo viri dominium incipere oportet adipisci et rem facere divinam* (but on the following day the bride must begin to exercise her au- thority in her husband's house and must offer sacrifice) (cf. Festus 187L). The day after the wed- ding featured a dinner party with drinking (*repotia*) hosted by the newly married couple for their friends. See Varro *LL* 6.84; Horace *Sat.* 2.2.59 with Acr.; Gellius *NA* 2.24.14; and Festus 351L, with Treggiari 1991, 169.

15 For a different view, see Palmer 1989/1998, 49–50, who suggests that the third coin could have been offered at the *compitum* when a son came of age.

According to Varro, therefore, rather than greeting the *lares vicinales* at the *compitum* on her way to her new home, she recrosses the threshold, after the rituals of entering and taking up residence in the home have been successfully completed, to greet the *lares* of her new neighborhood with a coin from her purse. Traditional Roman houses (domus) had only a single door (that often led into an atrium) and, therefore, only one threshold. The ritual of the three coins seems to require the bride to enter but then to exit again, before recrossing the threshold of the new home in returning from the *compitum*, all within a short period of time.

The bride, therefore, honors the neighborhood *lares* with her first public appearance as a married woman (matrona).[16] Once again, that gesture is one of giving a gift, this time staged in the familiar action of a woman taking a bronze coin from her purse. This coin is perhaps said to "ring" (the text is not certain), which seems to be a reference to a money box at the *compitum*. The bride might throw the coin into the box in order to produce a typical, bright sound. This would have made her gift more obvious to the neighbors. Just as in the case of the honor paid to the *lares familiares*, the gift to the neighborhood *lares* stresses taking up residence in the context of a religion closely connected to place and to community on a very local scale. Clearly, the bride must either be shown or is perhaps required to demonstrate her own "knowledge" of which compital shrine she is now to worship at locally.[17] Again, no other shrines or temples seem to receive either a prescribed gift or even a courtesy visit on the wedding day, although many houses in Rome would have been near civic cult sites or popular local shrines.

The gift of a coin at the *compitum* may also recall various practices of counting of local residents, whether in this location at the festival of Compitalia or by the offering of a coin (of a specified type) in a shrine to mark an occasion. At the annual midwinter festival of the *lares*, residents hung woolen dolls or balls to represent each person, either free or slave.[18] The *lares* were thus closely associated with the idea of being counted, in the specific context of their festival with its sacrifice of the pig at the *compitum* (these practices are discussed in more detail in section III.xx). Similarly, Dionysius of Halicarnassus records the custom of a young man giving a coin to the goddess Juventas at her shrine when he assumed the toga of the citizen (*toga virilis*) that marked him as an adult.[19] The deposition of a coin, presumably in a money box and usually enacted as a gift to a deity, was an easy way to count individuals in a certain group. The ringing of the coin at the *compitum*, therefore, celebrates the new wife but also recalls other contexts of depositing a coin at a shrine in Rome, on occasions when the donor is recognized and counted as part of a distinct group.

16 Hersch's argument (2010, 176) that the bride offers the coin at the *compitum* of her former home does not make sense of the order of the ritual in Varro. If this was the case, the compital coin should have been the first gift, given on the way to the new home, not the last one.

17 Riposati 1939, 136: "Quest'uso, per quanto oscuro, serve a confermare la stretta relazione che intercedeva fra l'abitazione romana ed i Lari compitali, chiamati così a participare ai solenni e festosi avvenimenti della famiglia" (This custom, although obscure, serves to confirm the close relationship between the Roman house and the *lares compitales*, called on in this way to participate in solemn and festive events in the family).

18 Dolls at Compitalia: see Dionysius of Halicarnassus 4.14 and Macrobius *Sat.* 1.7 with discussion at section III.xvii.

19 Dionysius of Halicarnassus 4.15.5 (cf. Aug. *CD* 4.11).

The public gift of the *as* at the compital shrine mirrors the procession that led the bride to the house of the groom. In an aside, Statius indicates that fires might also be lit at the *compita* to celebrate a wedding, perhaps all along the bridal route, a route that would be illuminated by the torches of the wedding party.[20] It might make sense to suppose that the bride had taken leave of the *lares* at the *compitum* near her home, but only the new *lares* receive a gift on the day of the wedding itself. The stress on various sources of light in many ancient authors who refer to weddings strongly suggests that all of this takes place at dusk or even at night. Meanwhile, only a single *compitum* receives a gift from the bride, who would presumably again need to be lit on her way.

In Plautus' *Aulularia*, even the miserly father gives gifts to his domestic *lar* to secure a good match for his daughter.[21] Similarly, the third-century jurist Ulpian (in book 34 of his edicts) defines a man's legal primary residence as the place where his *lar* "for marriage" was placed.[22] It remains unclear whether this refers to the wedding ceremony itself or more generally to the married life of the couple as husband and wife. Unlike many Roman gods who were thought of as having only very specific spheres of influence and power, *lares* were ubiquitous guardians and were addressed as members of every household and residents of every neighborhood.

Needless to say, this Roman marriage custom is set in the specific context of the Roman home and neighborhood as defined by shrines of *lares* both domestic and those shared with neighbors. It followed upon and completed the earlier gesture of the young woman engaged to be married for the first time, who had dedicated her dolls and other childhood items to the *lares* at her own family shrine before her wedding day.[23] The *lares* were guardians of family life and played special roles in the great transitions from one stage to the next. The dedication of items that marked an earlier stage of life, such as the *bulla* of the Roman boy who has reached manhood or the dolls of the young bride-to-be, speaks both to the successful completion of the stage of adolescence and of a readiness for the adult role that was about to be undertaken.[24] The *lar* protected the Roman citizen family; he was not merely a companion for their slaves.

A fragment of a fine marble altar for *lares* from Rome features two *bullae* suspended by knotted ribbons next to a typical *situla*.[25] (See figures II.1 and II.2.)

20 Statius *Silv.* 1.2.231.

21 Plautus *Aul.* 385–87. For further discussion of this play, see section I.iii.

22 *Dig.* 25.3.1.2: *Domum accipere debemus hospitium, si in civitate maneat: quod si non sit, sed in villa vel in municipio, illic ubi larem matrimonio collocarent* (We must interpret the term "home" to mean where he lives, if he is staying in the city. But if not, if he is in a villa or a provincial town, then that place [is his legal domicile] where they [the husband and wife] set up their *lar* for marriage). This ruling is part of a divorce law and is informing the wife where she must deliver her official notice of divorce. It is quoted in Justinian's *Digest* in the sixth century.

23 For the toys given to the household *lares*, see Nonius 538 = 863L. By contrast, the scholiast on Persius 2.70 says girls might give their dolls to Venus before their weddings.

24 For the dedication of the boy's *bulla* and the girl's dolls, see Horace *Sat.* 1.4.65–66, with scholiast; Propertius 4.1.131–32; Persius *Sat.* 5.30–31, with Porph. and Palmer 1989/98. For a discussion of dolls based on examples found in tombs, notably the jointed ivory doll of Creperia from Rome, see D'Ambra 2014.

25 Palazzo dei Conservatori: Pietrangeli 1942, 128–31; Hermann 1961, 89–90 no. 19; Hano 1986, no. 8 with fig. 21; Lott 2004, no. 56. The inscription is not in *CIL*. Palmer 1989–98, 46–52, talks about lockets for *lares*. The *lares* on the Manlius altar (Vatican 9964) wear *bullae*, as do Trimalchio's *lares* mentioned by Petronius (*Sat.* 60.8). See also *CIL* 6.302 = *ILS* 3447 = EDCS 17700061 for a dedication by an imperial freedman to Herucles bull(atus), the child Hercules.

 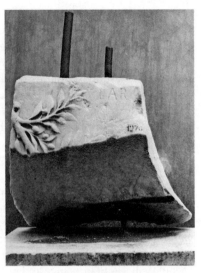

II.1. Fragment of an altar for the *lares*. Front side, showing two *bullae*, an oak wreath, and a *situla*. Augustan. Rome, Musei Capitolini, Centrale Montemartini, inv. 1276.

II.2. Fragment of an altar for the *lares*. Back side. Augustan. Roma, Musei Capitolini, Centrale Montemartini, inv. 1276.

Based on their shape, the *bullae* probably represent ones of metal (bronze or more precious materials); their ribbons would originally have been made of leather. Their detailed rendering is matched by the incised *situla*, a ritual vessel often held by *lares* in paintings and also in reliefs. The two identical *bullae* seem to echo the twin *lares*. These attributes are surrounded by a wreath of laurel with carefully executed leaves and berries. The partially preserved side shows a laurel tree, while the very fragmentary back only has the single word *LAR* written next to another laurel branch. The original size and overall design of the piece cannot be reconstructed but the fine workmanship is evident. The materials, style, and iconography all suggest an Augustan altar from a compital shrine of the late first century BC or early first century AD (see part IV for further discussion). The laurels are typical symbols of the new *lares augusti*, who were to be found at crossroads shrines in Rome after 7 BC.

It should not come as a surprise that the *bulla* is represented at a crossroads shrine, although this amulet seems to have been given to lar(es) in the home.[26] We do not have any marble altars of this kind attested in domestic contexts. As in the case of the bride, ceremonies of transition and coming of age naturally involved different kinds of *lares*, both at home and in the neighborhood. If dedicated by one or more freedmen (as other Augustan compital altars were), this local monument is notable for its celebration of a distinctive mark of free birth, the *bulla* worn by the freeborn citizen boy.[27] Perhaps it commemorated the coming of age ceremony for the son(s) of a freedman or it may represent a more general celebration of their potential to be legally married fathers of citizen children, who were entitled to wear the *bullae* they themselves had not had as boys.

26 Hano 1961, 2342, suggests that the altar could come from a domestic context.

27 For the *bulla* of the freeborn Roman boy (who also wore the purple-bordered *toga praetexta*), see Palmer 1989/98 and Sebesta 1994, 47.

To return to Varro's bride: a number of different items were, therefore, needed in order to carry out her wedding ritual. The entrance to the house, its hearth, and a local *compitum* provide the venues. The bride must wear closed shoes and carry (in another hand or worn on her person) a purse (*sacciperium*), perhaps of a traditional style and color.[28] Most importantly, of course, she needs three bronze *as* coins. Consequently, the ritual, at least as described by Varro, is also linked to the history of these bronze coins. It can be argued, of course, that the practice was older, as Varro intimates, and had evolved from using three other tokens as the gifts. Nevertheless, both the shoes of the bride and her standard purse would not have accommodated large objects; Varro's version of the ritual is surely based on the concept of three small items of recognizable value. *As* coins were specified rather than the bride being able to choose three coins according to her means.

The word *as* originally described pieces of bronze that weighed a Roman pound (ca. 324 grams).[29] The smaller bronze coins were first produced during the Second Punic War. By 211 BC, a new system of 2 ounce *as* coins (44 grams) were valued at 10 to the silver *denarius*. A further devaluation around 141 BC produced a standard of 16 *asses* to the *denarius*. In addition to changing in weight and relative value, the *as* coins were not produced consistently, and none seem to have been struck during some decades of the mid-second century BC, at a time when silver became much more plentiful. There were no new *as* coins for thirty years after Sulla's dictatorship. In other words, at the time when Varro was writing the *De Vita Populi Romani* (in the late 40s BC when he was in his early 70s?), he had himself not seen many new coins produced. Nevertheless, coin hoards show that the bronze *as* was always readily available. Varro's version of the ritual may have originated during the war with Hannibal, whether as an adaptation of an earlier ceremony of gift giving or perhaps more plausibly as a newly invented tradition linked to the very idea of having small bronze coins that were portable. The gift of a modest bronze coin also fits with the simple offerings made to *lares* in many circumstances.

Varro's account of the three *asses* carried by the bride on her wedding day provides important evidence for *lares* as gods of place and community, essential to welcoming the bride into her new home and neighborhood. It was her entrance into the house that made her a matron. This vital time of transition involved many rituals, probably of different ages and origins. The gift of the coins can be linked to the care taken at the threshold, which the bride herself was described as decorating and anointing. The giving of the coins allowed the bride to assume her role both as resident and as matrona and materfamilias. In acting in this new capacity, she gave her gifts to *lares* both in and outside the house, thus confirming a vital ritual link between these two places for *lares* shrines. Her actions certainly make sense in Rome as it had developed as an urban network by the late third century BC. Not unlike the new wife venturing out of the house to her local *compitum*, this discussion will now step out into the street to consider *lares* in their various contexts in the city of Rome.

28 This word is first attested at Plautus *Rud.* 548, a play usually dated around 211 BC, the very time of the coinage reform. We do not know what kind of purse is being described, but Plautus' text implies that it was not small—it could have held a number of coins. For a succinct discussion of Roman purses, see Hurschmann in *BNP*.

29 For the history of Roman bronze coinage, see the classic discussion in Crawford 1974, 35–46 and 595–97. For a succinct overview, see Brennan 2005, 7.

XI TEMPLE: *AEDES*

> eius rei ergo aedem laribus permarinis vovit.
> —LIVY 40.52

Rome had two civic temples (*aedes*) dedicated to specific *lares* who were thought of as being quite distinct from those worshipped either in the home or at the cross-roads. This should not surprise us, since *lares* (and their unnamed mother) are addressed in what appears to be archaic prayer language, in rituals presided over by the highest magistrates and priests of the state religion. As examined in section I.ii earlier, *lares* received prayer and sacrifice performed by the Arval brethren, an order of elite priests who worshipped the agricultural goddess Dea Dia in her sacred grove and temple outside the city. These *lares* seem to have been general protectors of Rome, her fields, armies, and people. It is possible that the *lares* worshipped by the Arvals were indeed those whose temple stood *in summa sacra via*. The other temple, honoring *lares* called *permarini* who were protectors on the seas, was built on the Campus Martius in the early second century BC. These two state temples for *lares* honored very different deities and were probably built at different times and under different circumstances. In this section, they will be discussed separately, before being related to each other in the conclusion.

Lares in Summa Sacra Via

According to the surviving sources, what seems to have been the older temple to *lares* honored gods without an epithet. It is referred to simply as temple of (the) *lares* (*aedes larum*).[1] It is this temple that Augustus described as being *in summa sacra via* in his account of his own building activity (*RGDA* 19.2; see section IV.xxiv).[2] His topographical description, which places the temple "in the highest (part of the) holy road" is an indicator of where their temple stood. Within the same sentence, Augustus mentions several of the other temples he claims to have "built" (*feci*) with the same kind of topographical label (for example, *aedem Magnae Matris in Palatio*: the temple of the Great Mother on the Palatine). In this list, he is simply making explicit, at least to those readers who knew the city, which temples he is referring

1 *Aedes larum*: see Coarelli in *LTUR*, with Haselberger 2002 ad loc. for the Augustan temple. Note that Coarelli classifies this sanctuary as a small shrine: "certamente un sacello di dimensioni molto ridotte (forse del tipo dei *compita*)" (certainly a very small shrine [perhaps of the same type as the *compita*]). His description is not supported by the evidence in the literary texts, which all refer to the structure as a proper temple (*aedes*) and as a well-known local landmark in this part of the "holy road" (Sacra Via).

2 *RGDA* 19.2: *Aedes in Capitolio Iovis Feretri et Iovis Tonantis, aedem Quirini, aedes Minervae et Iunonis Reginae et Iovis Libertatis in Aventino, aedem Larum in summa sacra via, aedem deum Penatium in Velia, aedem Iuventatis, aedem Matris Magnae in Palatio feci.* (I built on the Capitol the temples of Jupiter Feretrius and of Jupiter the Thunderer, the temple of Quirinus, on the Aventine the temple of Minerva and of Queen Juno and of Jupiter the Liberator, the temple of the *lares* at the highest point of the Sacred Way, the temple of the *penates* on the Velia, the temple of Juventas, the temple of the Magna Mater on the Palatine). See commentary in Scheid 2007 (who follows Coarelli for topographical questions) and Cooley 2009 ad loc. Coarelli (*LTUR*) assigns this restoration to 4 BC but without citing any explicit ancient evidence, presumably in reference to Augustus' dedication to *lares publici* at that date. This is no more than a hypothesis.

to. In the case of the *lares*, this specification both suggests the importance of a temple in a prestigious location and distinguishes this building from the other *lares* temple, the (presumably newer) cult of *lares permarini* on the Campus Martius.

Despite the fact that several other buildings are also described by ancient sources as being *in summa sacra via*, including the house (domus) of king Ancus Marcius, the porta Mugonia, a gate that led to the Palatine, an equestrian statue of the early heroine Cloelia, and a shrine of the goddess Orbona (*fanum*), there has been no consensus among scholars as to where this area actually was.[3] Debate on the issue has been long and heated because we do not have reliable evidence about any of these landmarks. Addressing the complex questions surrounding the route of the Sacra Via, which was decisively affected by the great fire of AD 64, is beyond the scope of the present discussion.[4] The simple fact is that we do not know exactly where or how large the location described as *summa sacra via* was. Identifications have ranged from the area near the temple of Vesta in front of the church of Saints Cosmas and Damian ("temple of Romulus"), to that around the Arch of Titus, or even the neighborhood of the Via di San Bonaventura.[5]

The *lares* temple seems to have shared a feast day on 27th June with the ancient Temple of Jupiter Stator, located in the vicinity of the Porta Mugonia but also not yet identified with certainty.[6] This particular Jupiter temple was described as having been vowed by Romulus during his famous battle with the Sabines in the Forum, after the first inhabitants of the new city had seized their neighbors' daughters at a festival. In its first-century BC incarnation, it must have been large, since

3 Landmarks to be found *in summa sacra via*: the house of Ancus Marcius (Solinus 1.23: *in summa sacra via, ubi aedes larum est*, at the highest point of the Sacred Way, where the temple of the *lares* is); porta Mugonia (Varro 852.20L, Coarelli in *LTUR*, and Brocato 2000); statue of Cloelia (Pliny *Nat.* 34.28–29, no entry in *LTUR*); fanum Orbonae (Cicero *ND* 3.63: *ad aedes larum*; Pliny *Nat.* 2.16; Palombi in *LTUR*). Solinus' list distinguishes the location of the *aedes larum* (near the house of Ancus Marcius) clearly and deliberately both from the temple of Vesta and the adjacent *regia* (where Numa lived), as well from the porta Mugonia (where Tarquinius Priscus lived). The statue of Cloelia and the fanum Orbonae are described as being closest to the *lares* temple, while the gate and Jupiter temple are in the more general area.

4 The debate about the Sacra Via: Ziólkowski 2004 summarizes the previous twenty years with very useful maps. The basic disagreement is over whether the road was short or long, and how many different identifiable sections it had. Its course was clearly not stable in antiquity and changed significantly during the first century AD. See also the clear discussion in Coarelli 2012, 29–35, with review by Wiseman 2013.

5 *Summa sacra via*: the location of this "highest (point/section of the) Sacra Via" has been very much disputed, as part of the controversy about the whole road. Coarelli and Carandini both place this area near the Forum and the temple of Vesta, but in different locations. By contrast Ziólkowski 2004 ascribes this name to the sizable section of republican road that once led from the area around the arch of Titus to the Compitum Acilium. In other words, according to this hypothesis, the *aedes larum* would have been somewhere under the big podium built for Hadrian's temple of Venus and Rome.

6 Temple of Jupiter Stator: Coarelli (who identified it with the "temple of Romulus") and Arce in *LTUR*. Ziolkowski 2004 (followed by Zevi 2014) argues in favor of identifying the monument adjacent to the Arch of Titus as the podium of this temple (summarized at 122–23). Coarelli 2012, 30–31, has now apparently abandoned (at least some of) his early arguments, in favor of the traditional position of Ziólkowski and Zevi. Wiseman 2013, 245–46, attributes the historical Jupiter Stator temple to M. Atilius Regulus in 294 BC (Livy 10.36.11 and 10.37.15–16, drawing on Fabius Pictor). Carandini claimed to have found the temple in 2014. Unfortunately, Donati and Stefanetti 2006 do not have a separate entry for 27th June, although they mention this holiday on page 58 under 1st May.

the senate of Cicero's day could meet there.[7] In other words, these two temples (*lares in summa sacra via* and Jupiter Stator) were "near" the Forum, somewhere at the base of the Palatine hill. In the time of Augustus, the temple of Jupiter Stator was described as being on the Palatine.[8] Ovid confirms the connection of *lares* with this feast day (*Fast.* 6. 791) and refers to the flowers sold in this area, perhaps at outdoor stalls rather than in more formal flower shops.[9] The sharing of an annual birthday festival would have allowed for a splendid holiday in the area with both temples open and celebrations that could easily have been designed to complement or to compete with each other. These *lares*, therefore, received a temple that was closely associated with a venerable sanctuary of Jupiter, here also represented specifically as a protector of the Romans and of their city in its earliest years.

Meanwhile, recent archaeological excavations of the area around the temple of Vesta and the adjacent house of the Vestal Virgins have produced a different interpretation, which posits a site for the temple of the *lares in summa sacra via* at a specific point within this complex.[10] (See figure II.3.) It should be stressed from the outset that this hypothesis is not supported by any direct evidence from new iconographic finds or inscriptions. It is based on a particular reading of the literary sources, which are unfortunately not precise as to the exact location of the building. There are two principal reasons why this new idea is not persuasive.

First, the complex in question is composed, over several rebuildings, of two separate cult rooms (*cellae*) of distinctly unequal size. Any cult of *lares* would have the twin gods together in the same shrine, however modest or grand the setting. Two shrines of different sizes with one for each *lar* would obviously be out of the question because it would involve distinguishing the two while giving precedence to one identical twin over the other. This has led the excavators to posit a paired cult that joined these *lares* with their mother, by analogy with the joint cult they received from the Arvals. She, however, is never mentioned in connection with this temple, nor with any other cult site to *lares*. In other words, the new archaeological finds can only be attributed to *lares* by assuming a combined cult site, unattested in the ancient sources about the topography of the city, including Augustus' notice of his rebuilding of this temple.

Second and even more importantly, this cult area (according to the plans provided by the excavators) does not open immediately onto the Sacra Via but seems

7 Senate meeting in 63 BC: Cicero delivered the famous first Catiliarian oration here (Cicero *Cat.* 1.5, 11, 33, 2.12; Plutarch *Cic.* 16.3). See also Livy 27.37.7 for the young girls practicing Livius Andronicus' hymn here in 207 BC.

8 See now Zevi 2014 for evidence from a new fragment of the Augustan *Fasti Privernates*, which lists the festival of Jupiter Stator under 27th June and describes the temple as being *in Palatio*, thus apparently confirming Ziółkowski's argument.

9 Flower sellers in the *summa sacra via*: Ovid *Fast.* 6.791–92 on 27th June: *Lucifero subeunte Lares delubra tulerunt / hic, ubi fit docta multa corona manu / tempus idem Stator aedis habet, quam Romulus olim / ante Palatini condidit ora iugi* (On the following day, *lares* brought a temple here, where many garlands are made by a skilled hand. Jupiter Stator's temple has the same feast, which once Romulus founded at the base of the Palatine). *CIL* 6.9283 = *ILS* 7617 = EDCS-19000732 attests the garland makers/sellers from the Sacred Way (*coronarii de sacra via*). Ziółkowski 2004, 122–23, argues that the stalls used by the flower sellers and makers of garlands would have taken up quite a bit of space. Flowers were presumably especially welcome in the area of a *lares* temple.

10 See Cupitò 2004, Filippi 2010, and Carandini 2011 with drawings of these reconstructions. Cf. Carafa in Carandini and Papi 1995, 265, who identified the *aedes larum* with the *aula absidata* of the republican *atrium Vestae*.

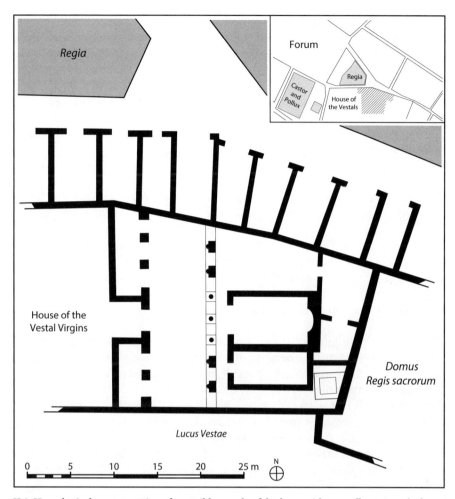

II.3. Hypothetical reconstruction of a possible temple of the *lares*, with two *cellae* next to the house of the Vestals (after Carandini 2011).

to have its main entrance on the other side facing south. It appears as part of the complex belonging to the goddess Vesta, immediately opposite (perhaps originally integrated with) the sacred grove of Vesta (*lucus Vestae*). If this is the *aedes larum*, why does no ancient writer associate it with Vesta's famous temple precinct or grove? Why give smaller and more obscure landmarks to indicate the location of a shrine that was in fact immediately beside or even inside the complex of the Vestals? Moreover, how could such a shrine be accurately described as *aedes larum in summa sacra via*, if its main entrance did not obviously face that road? In our surviving evidence, the *aedes larum* is cited as the only temple and probably the most significant landmark that was located *in summa sacra via*; this situation surely rules out a position next to the *aedes Vestae*, clearly one of the best known and most venerable cult sites in the city. Augustus himself was an important patron of the Vestals and would surely not have hesitated to associate the *lares* temple he restored with them, if it had belonged to their sacred domain.

The formal name of this *lares* temple (*aedes*) indicates that it was a proper temple in its own right, which would mean that it was a separate sanctuary built on

land that was consecrated (*templum*) specifically to the *lares*, and that it most probably had space in front for an altar outside the temple building but within its precinct. We do not have any archaeological evidence to identify its site or physical aspect. The building caught fire in 106 BC and would have been restored after that damage.[11]

in aede larum flamma a fastigio ad summam columen penetravit innoxia.

In the temple of the *lares* a flame pierced through from the pediment to the top of a column without doing any damage.

(Obsequens 41)

The significant fire was recognized as a portent since the damage to the temple was said to have been miraculously slight, despite the fact that the roof was on fire; yet in the following year the Romans suffered a huge defeat at the hands of the Cimbri and Teutoni at the battle of Arausio in southern France. The recording of the portent clearly indicates the importance of this temple within Rome's sacred landscape at the end of the second century BC. The wording only makes sense if it was a proper temple, not a small shrine. It is possible that a portent described by Lucan in connection with the civil war between Pompey and Caesar also took place in this sanctuary.[12]

Subsequently, Augustus claims in his *Res Gestae* to have made a major intervention, which would date to around 16 BC, if his list is arranged in a chronological order.[13] Since Augustus also calls this cult site an *aedes* and includes it with other well-known temples of state cult, there is no reason to think that it was a small shrine. His words rule out a compital context. Indeed, he makes no mention at all of local shrines (*sacella*) or *compita* in his *Res Gestae*, despite his consistently generous patronage of numerous local cults. Needless to say, we do not have any information about the architecture of the temple, but it would perhaps have been in an Italic style in its older phase(s) and might even have been restored in an archaizing style after the fire of 106 BC.

This traditional temple for *lares* has also been associated by some with Augustus' dedication to *lares publici*, paid for by money given to him by the people of Rome to mark the new year in 4 BC (after the introduction of the *lares augusti* at the *compita* in 7 BC, see section IV.xxv with figures IV.1–3).[14] This dedication of

11 Julius Obsequens (writing in the later fourth century AD?) collected the material for his book about prodigies (*liber prodigiorum*) mainly from Livy. His chronological account is designed to argue in favor of the traditional Roman system of prodigy and expiation.

12 Lucan *BC* 1.556–60: *indigetes fleuisse deos, urbisque laborem / testatos sudore Lares, delapsaque templis / dona suis, dirasque diem foedasse uolucres / accipimus, siluisque feras sub nocte relictis / audaces media posuisse cubilia Roma* (we heard it related that the native gods wept and [the] *lares* bore witness to the trials of the city with their sweat, offerings fell down in their temples, dire birds cast a gloom on the day, and wild animals, having left the woods at night, boldly made their nests in the middle of Rome). Cassius Dio 41.14 also mentions this portent without reference to *lares*; presumably the date is 50 or 49 BC. It is also possible that the *lares* at the *compita* throughout the city are meant here.

13 See section IV.xxv later for further discussion of Augustus' interventions.

14 Augustus' dedication to the *lares publici*, paid for with the New Year's money collected in 4 BC: MAN Naples inv. 2606, *CIL* 6.456 = 30770 = *ILS* 99 = *ILMN* 10 = EDCS-17300609 = Lott 2004, no. 16, found near the entrance to the Horti Farnesiani. For general discussion and bibliography, see de Angeli 2001.

an inscribed statue base (now in the Naples museum) was found, apparently in situ, on the slope of the Palatine near the intersection with the road that leads down from the hill, adjacent to the arch of Titus. It was, therefore, at a spot that is indeed a high point in the holy road, in the general area that has been identified as in or near *summa sacra via* (by some scholars).[15] Should the temple of *lares*, therefore, be located beside the find spot of this inscription for *lares publici*? There is no real reason to think so since no archaeological evidence for a temple or identifiable precinct has come to light here. Clusters of different *lares* come as no surprise in Rome (see figure II.12 later). None of Augustus' other dedications made with gifts of money he received from Rome's inhabitants at the New Year are associated with temples in our extant evidence; all are local shrines on a smaller scale that Augustus chose to renew with his special New Year's fund (see section IV.xxiv later). Most are sites we only know about because of the Augustan evidence.

Moreover, why would Augustus refer to the same gods as *lares publici* in an inscription of 4 BC (or soon after), but without this cult title in the *Res Gestae Divi Augusti*, which he finished almost twenty years later (in the last year of his life, AD 13–14)? If the *lares in summa sacra via* had an epithet especially a traditional one in common use, then why did Augustus and others not refer to their temple by using the correct name, which would also have conveniently distinguished it from the other temple to *lares permarini* on the Campus Martius? All *lares* outside the domestic context were part of public cult, but only in this instance were they addressed with the epithet *publici*. To complicate matters the oldest (pre-Julian) calendar (*Fasti Antiates Maiores*) has a feast for *Lares v . . .* (*vicinales? viales?* Of streets or neighborhoods?) on 27th June in republican times.[16] Or were the *lares v . . .* other gods who simply shared a feast day with the temple *in summa sacra via* on 27th June? Many questions are not answerable on the basis of the evidence presently at our disposal. Nevertheless, Augustus' account of his achievements indicates that he completely renewed a traditional temple for *lares* that was *in summa sacra via*, perhaps around 16 BC.

Lares Permarini

The temple of the *lares permarini* on the Campus Martius has a much better attested origin than its cousin *in summa sacra via* but presents another notoriously controversial topographical puzzle.[17] This temple was vowed in 190 BC to new *lares*, described untraditionally as guardians of the seas (*permarini*), by Lucius Aemilius Regillus, the commander of a Roman fleet as *praetor* during the battle

15 See Ziólkowski 2004, 40–42, 50–53, 118–19, 122–23, who argues that the *aedes larum* was most probably destroyed in the fire of AD 64 and not rebuilt. Coarelli 2012 and Wiseman 2013, 248, stress the huge changes to the whole area after the fire of AD 64.

16 27th June: Degrassi in *II* 13.2, 474, with Ovid *Fast.* 6.791–94. The trace of the V is very slight. The *Fasti Polemii Silvii* of AD 449 mark this day as the beginning of summer. We may perhaps see a pattern of *lares* feasts marking the change of seasons, with the announcement of Compitalia at the winter solstice (see section III.xvii for discussion of this festival) and another *lares* festival at the summer solstice. See Palmer 1976 for the *lares vicinales* at the summer solstice and Compitalia for the *lares compitales* announced at the winter solstice.

17 Temple of *lares permarini*: Coarelli in *LTUR* with Kondratieff in Haselberger 2002 and Claridge 2010, 241–46. See Márquez and Gutiérrez Desa 2006, 302–4 for the history of scholarship on the temple in the Via delle Botteghe Oscure since its excavation in the late 1930s.

of Myonnesos against the admirals of Antiochus III "the Great."[18] His was a deci-
sive victory for the Romans and their allies, concerned to limit the naval power of
the Syrian king, who lost half his fleet in this engagement. Regillus celebrated a
splendid naval triumph while *propraetor* in the following year (on 1st February 189
BC).[19] It then took a full decade to complete the building of his temple, which was
dedicated on 22nd December 179 BC by M. Aemilius Lepidus, a prominent relative,
who was censor at the time with M. Fulvius Nobilior.[20] It seems likely, therefore,
that Regillus himself, who never reached the consulship, did not live to see the
temple completed. The temple of the *lares permarini* was an integral part of
the ambitious self presentation of the patrician Aemilii, one of Rome's oldest and
most prestigious families who were enjoying particular prominence in the early
second century BC.

Regillus' temple was dedicated during an extensive building period by two very
active censors. Lepidus went on to inaugurate his own two new temples to Diana
and Juno Regina, both also nearby (*in circo Flaminio*), on the next day (23rd De-
cember) followed by several days of games, both theatrical performances and cir-
cus games, at public expense.[21] The sea battle against Antiochus had taken place in
September and the triumph had been celebrated on the first day of February. Re-
gillus himself might perhaps have preferred the temple to be dedicated on either
of these personal anniversaries. On the other hand, December was often the
month for the movable festival of Compitalia. The dedication day of the *lares per-
marini* obviously fell adjacent to the winter solstice and was immediately preceded
by the great celebration of Saturnalia.[22] On 21st December, *lares* received a tradi-
tional sacrifice at the altar of Consus in the Circus Maximus (see section II.xii later).
The 23rd of December saw the Larentalia in honor of Acca Larentia, who has been
identified by some scholars as the mother of *lares*.[23] The new festival for *lares per-
marini* seems to have been designed to coincide with the time when the urban

18 Regillus' victory: Livy 37.26–32. Brennan 2000, 212, notes that Regillus' inscription claims
that the victory was won fully under his own command (that is, his auspices and *imperium*), which
is confirmed by the fact that he was awarded a triumph. Allegedly, few Roman lives were lost in the
battle (Livy 37.30.7 and Appian *Syr.* 27). For further analysis of the strategy and combat, see Eck-
stein 2008, 330–31.

19 For naval triumphs see, Dart and Vervaet 2011, esp. 273–74 on Regillus' triumph, which is
one of the best attested.

20 Macrobius *Sat.* 1.10.10: *undecimo autem kalendas feriae sunt laribus dedicatae, quibus
aedem bello Antiochi Aemilius Regillus praetor in campo Martio curandam vovit* (On the eleventh
day before the *kalends* is the feast day dedicated to the *lares*, to whom Aemilius Regillus as praetor
during the war with Antiochus vowed a temple to be built on the Campus Martius). See also *II*
13.2.543 and Donati and Stefanetti 2006, 158–59 (*Fasti Ant. Mai.* on 21st Dec., *Fast. Ost.* and *Praen.*
on 22nd Dec.)

21 Temple of Diana (perhaps under the theater of Marcellus): Viscogliosi in *LTUR*. Temple of
Juno Regina (enclosed within the later porticus Metelli): Viscogliosi in *LTUR*. Both of these tem-
ples were vowed by Paullus in 187 BC (Livy 39.2).

22 Livy suggests that Lepidus' primary focus was on dedicating his own temples and on hold-
ing elaborate games associated with these foundations, none of which are recorded as being in
honor of the *lares permarini*. According to this interpretation, Regillus' dedication was simply
taken care of first, for practical reasons, as well as to enable the dedication of three temples by one
Aemilius on consecutive days. Lepidus had not celebrated a triumph, but presided over excep-
tional spectacles as censor. For a somewhat different view, see Zevi 1997, 97–98. I argue that 22nd
December was a special date for *lares*, which suggests that they took priority when the decision
about timing was made.

23 Cicero *ad Brut.* 1.15.8, with Coarelli 2012, 18–19.

praetor would announce the date of Compitalia (the movable festival of the *lares compitales*), giving the traditional eight days' notice before the celebration (see section III.xvii). For these reasons, the dedication of the *lares* temple probably dictated the date, to which the birthdays of Juno Regina and Diana were added, rather than the other way around.

The special attention paid to this temple is attested by the dedication plaque, a copy of which (on bronze?) was posted over the central door of the temple of Jupiter Optimus Maximus, Juno, and Minerva on the Capitol. It is impossible to know whether Regillus was himself the author of this text, or whether it should be credited to the censor M. Aemilius Lepidus or to a poet paid to produce the verses. The contents of this prominent inscription have been partially preserved for us by Livy.[24] The text was probably originally composed in Saturnian verse, although the metrical pattern is not especially helpful in suggesting restorations for the missing parts. We might also expect a separate inscription (in prose) that would have had Regillus' name as well as that of the gods. There may also have been a painting or other dedication(s) on the Capitol.[25]

Supra valvas templi tabula cum titulo hoc fixa est:
 Duello magno dirimendo, regibus subigendis, patrandae paci ad pugnam exeunti L. Aemilio M. Aemilii filio ***
 auspicio imperio felicitate ductuque eius inter Ephesum Samum Chiumque, inspectante eopse Antiocho, cum exercitu omni, equitatu elephantisque, classis regis Antiochi antea inuicta fusa contusa fugataque est, ibique eo die naues longae cum omnibus sociis captae quadraginta duae. ea pugna pugnata rex Antiochus regnumque ***
 eius rei ergo aedem laribus permarinis uouit.
 Eodem exemplo tabula in aede Iovis in Capitolio supra ualuas fixa est.

Above the doors of the temple a tablet was fixed bearing this inscription: "For finishing a great war, for subduing kings, this battle, fought for the purpose of winning peace, (gave victory) to Lucius Aemilius, the son of Marcus Aemilius, as he left the field.
 Under his auspices and command, with his good fortune and generalship, in the area bounded by Ephesus, Samos and Chios, under the eyes of Antiochus himself, of all his army, his cavalry and his elephants, the fleet of King Antiochus, hitherto undefeated, was routed, shattered and put to flight, and there on that day forty-two ships were taken with all their crews. As a result of fighting this battle King Antiochus was defeated and his naval empire (over-thrown).

24 Livy 40.52, with commentary by Gouillart 1986 and Briscoe 2008. Zevi 1997, 87, suggests Ennius, who mentioned Aemilius' triumph in his *Annales*, as the author of the verses (cf. Prop. 3.3.8). The opening words are also quoted by Caesius Bassus (*de Metris* 8), a first century AD grammarian: *apud nostros autem in tabulis antiquis quas triumphaturi duces in Capitolio figebant victoriaeque suae titulum saturniis versibus prosequebantur, talia repperi exempla: ex Regilli tabula* (I found this type of example: "from the plaque of Regillus" in our own records on the ancient plaques that triumphing generals used to set up on the Capitol and record an inscription of their victory in saturnian verses). Regillus' inscription seems, therefore, to have been famous.

25 Itgenshorst 2005, no. 177. Zevi 1997, 84, notes the popularity of adorning the Capitoline temple in this period.

By reason of this victory he vowed a temple to the *lares* throughout the sea."
A tablet with a copy of this text was set up in the temple of Jupiter on the
Capitoline above the doors.

<div align="right">(Livy 40.52)</div>

Despite the gaps in the text, the triumphalist tone is hard to miss. The preserved
part of the inscription avoids indicating the precise office Regillus held, since he
was *propraetor* at the time. The author suggests that the victory over Antiochus III
was due to this one naval success, whereas two famous infantry battles at Thermo-
pylae (191 BC) and Magnesia (190 BC) made significant contributions to the overall
Roman strategy and the commanders were also awarded triumphs.[26] In its com-
plete form, the inscription would have been long by republican standards.

In this text, it is interesting and surprising to see that Regillus' triumph is not
mentioned, which would normally be an essential item in an account of a com-
mander's victory, especially in the context of a temple presumably funded (at
least partly) with booty from this same war.[27] The Aemilii had not celebrated
many triumphs compared to other leading families.[28] Yet every subsequent tri-
umphing general would now pass under Regillus' inscription as he entered the
Capitoline temple. Obviously, there was more to the text than Livy (or his sources)
quotes and the manuscripts have preserved for us. The surviving section of the
inscription focuses on a vignette of King Antiochus the Great watching the de-
feat of his fleet, together with all his army, cavalry, and elephants, in a manner
reminiscent of Xerxes at Salamis in Herodotus' account of the Greek victory over
the Persians in the fifth century BC.[29] It is also notable that this individualistic
text was posted in duplicate elsewhere than on the temple that was vowed by Re-
gillus. It seems likely that this is another instance of the Aemilii competing with
the Cornelii Scipiones, who were famous for cultivating a special relationship
with Jupiter's temple on the Capitol. In any case, permission would have been
needed for an inscription to be posted so prominently over the main door of the
temple, in a collocation that would presumably have mirrored its presentation on
the temple of the *lares permarini* itself. Regillus' posting of the text invited a com-
parison between the two temples.

In looking at the larger context within which Regillus (and his family members)
were building a temple to new kinds of *lares* and inscribing records of their deeds,
the following factors appear significant. The decade before Regillus' vow in 190 BC
saw brisk building activity in Rome, especially with regard to temples vowed on

26 For the Romans' war against Antiochus, see conveniently Gruen 1984, vol. 2, 611–71. An-
tiochus cast himself in the role of a second Alexander; accordingly, his conquerors claimed equiva-
lent kudos for themselves after their victories.

27 Regillus displayed an impressive amount of wealth (a combination of booty and gifts?) in his
triumphal procession: 49 gold crowns, 34,200 Attic tetradrachms, and 132,300 cistophori (Livy
37.58.3–5). While L. Scipio had more booty (not surprisingly), Regillus did very well for a naval
campaign.

28 Previous triumphs recorded for Aemilii were in the years 329 BC, 311 BC, 280 BC, 254 BC,
225 BC, and 219 BC. None of these earlier *triumphatores* appear to be close relatives of Regillus.
For lists and analysis of republican triumphs, see Itgenshorst 2005.

29 Herodotus 8.87–88.

the battlefield.[30] Eight new temples were dedicated in the years 194–191 BC.[31] After the lean years of the long war with Hannibal in Italy, the Romans were busy embellishing and improving their city, even as they were looking East across the Mediterranean in their foreign policy. In addition to temples, the city saw major restorations and other new construction, such as porticoes, markets, and commemorative arches. One may particularly note the porticus Aemilia, a large storage area completed by two Aemillii as *aediles* in 193 BC.[32] The year 191 BC had just seen the dedication of the major new temple to the Magna Mater (Cybele) on the Palatine, which honored the goddess for her help in driving Hannibal and the Carthaginians from Italy.[33]

Consequently, Regillus, finding himself in an environment of competitive and novel building, wanted to make a memorable and noteworthy contribution of his own with whatever funds he already had or could raise.[34] Indeed, the number of other dedications made by the censors of 179 BC indicates how much construction had been completed over the decade during which the new *lares* temple was being designed and built.[35] Other temples, however, were finished in less than the ten years it took the Aemilii to complete their new temple for *lares permarini*. Since the family was so prominent, it seems more likely that the temple was large than that it took them many years to find the funds, but this is obviously also a matter for speculation.

Regillus' victory in 190 BC came exactly seventy years after the first great Roman sea battle, when C. Duilius had beaten the Carthaginians at Mylae off Sicily in the early years of the First Punic War. Duilius had celebrated the first naval triumph, had commemorated his exploits in an inscription on a column decorated with ships' prows (*rostra*) in the forum, and had given a temple to Janus in the Forum Holitorium.[36] Regillus could have presented his accomplishments as being in this proud tradition.

In the war against Antiochus in the East, four victories were recognized and four triumphs were voted for these commanders by the senate. Manius Acilius Glabrio triumphed for his victory at Thermopylae in Greece in 190 BC, Regillus (a naval triumph) and L. Cornelius Scipio Asiagenus (over Asia) both celebrated in 189 BC, and Q. Fabius Labeo triumphed for another naval victory in 188 BC.[37] We

30 Coarelli 1977 gives an overview of buildings in Rome after the Second Punic War. Orlin 1997 focuses on temple building.

31 194 BC: Vediovis, Juno Sospita, Faunus, and Fortuna Primigenia; 193 BC: Victoria Virgo; 192 BC: Vediovis; 191 BC: Magna Mater and Iuventas. See Orlin 1997, 201, for a convenient table and discussion and *LTUR* for further details.

32 Porticus Aemilia: Coarelli in *LTUR* presents the evidence.

33 Temple of Magna Mater on the Palatine: Pensabene in *LTUR*, with D'Alessio 2006 and now esp. Coarelli 2012, 249–82. The cult had been introduced in 205 BC, but the temple took many years to build, even after the victory over Hannibal. The splendid annual games and theatrical performances at the *ludi Megalenses* were held here in honor of the goddess.

34 Orlin 1997, 131, argues that we should not assume this temple was paid for with booty money, since no ancient source indicates that this was the case.

35 Censors of 179 BC: see *MRR* ad loc.

36 Dart and Vervaet 2011 elucidate the history of the eleven naval triumphs recorded in the *Fasti*, with attention to Duilius as the first to be granted this special recognition. The senate, meeting in the temple of Apollo, was also very impressed by Regillus' achievements, according to Livy 37.58.3. For the temple of Janus, see Coarelli in *LTUR*, with Bleckmann 2002, 122–24. For the column, see Chioffi in *LTUR*. Roller 2009 notes that Duilius' monument and image were restored by Augustus after he defeated Sextus Pompey at Naulochos in 36 BC, very near to the site of the great battle of Mylae. For a general discussion, see Kondratieff 2004.

37 Triumphs over Antiochus: 190 BC: M'. Acilius Glabrio (Itgenshorst 2005, no. 176); 189 BC: L. Aimilius Regillus (Itgenshorst 2005, no. 177) and L. Cornelius Scipio Asiagenus (Itgenshorst

do not know the date of Glabrio's triumph, but the other three were all celebrated in February, Regillus on the first and Scipio on the last days of February in 189 BC, which was also the end of the traditional Roman year, according to the calendar in use at the time. Comparison and contrast between an Aemilius and a Cornelius, victors at sea and on land respectively, were very much on show in Rome. Labeo's naval celebration took place on the *nones* of February (5th) the following year.

Only the first two of these four commanders vowed temples, Glabrio to Pietas (a personified divine quality called Dutifulness or Piety) in the Forum Holitorium (dedicated in 181 BC) and Regillus for *lares permarini* (completed two years later, in 179 BC). Unfortunately, any traces of Glabrio's temple have apparently been effaced by the construction of the Augustan Theater of Marcellus and so we have no information about its size or style.[38] Both of these temples were dedicated by relatives. Glabrio's son put up a gilded equestrian statue of his father near the new temple of Pietas, which was said to have been the first of its kind in Rome, and perhaps even in Italy.[39] Glabrio also received an equestrian statue at Delphi, while Regillus and Labeo are both recorded as benefactors to Apollo on Delos in an inscription from 180 BC.[40] Glabrio dedicated some Saturnian verses, perhaps accompanied by a painting, on the Capitol; Scipio Asiagenus was represented by a statue on the Capitol wearing Greek dress and also set up a painting there.[41]

Glabrio's and Regillus' respective triumphs seem to have been voted without controversy, which is perhaps unsurprising given their respective achievements. By contrast, Scipio and Labeo faced heated debate and personal attacks, both over the awarding of their triumphs and also subsequently.[42] Scipio nevertheless celebrated splendid victory games over ten days in 186 BC, but these were financed by funds collected separately.[43] Yet, by the time that Regillus' temple was dedicated, the

2005, no. 178); 188 BC: Q. Fabius Labeo (Itgenshorst 2005, no. 179). Brennan 2000, 361, notes that when two men triumphed closely together, the more senior general usually celebrated first. In February of 189 BC, Regillus appears to have been granted precedence over Lucius Scipio. By contrast, Cicero (*Mur.* 31) only mentions Lucius Scipio as a famous general in the war against Antiochus III. Itgenshorst 2005 provides all the evidence and commentary under each entry in her catalogue. The four triumphs will have fallen within a period of about two years (or perhaps less, depending on the date of Glabrio's celebration).

38 Glabrio's temple of Pietas in the Forum Holitorium (contracted *ex senatus consulto*): Ciancio Rossetto in *LTUR*, with Pliny *Nat.* 7.121 and Orlin 1997, 41–49 and 146–47. This temple may also be under the theater of Marcellus. Glabrio's generosity made him very popular with the people in Rome, but he was soon criticized for helping himself to the booty, including by Cato, who had served under him (Livy 37.57.9–15, with Orlin 1997, 186).

39 Gilded equestrian statue of Glabrio near his temple of Pietas: Livy 40.34.4–6; Valerius Maximus 2.5.1; and Ammianus Marcellinus 14.6.8, with Dondin-Payre 1993, 125, 280–83, and Papi in *LTUR*. The statue may have been destroyed in 44 BC (Dio 43.49.3).

40 Delphi: *Syll.*[3] 607–11. Delos: *ILS* 8765. See Sehlmeyer 1999, 151, for discussion of Glabrio's son's statue at Delphi.

41 Glabrio on the Capitol: Blänsdorf 2011, 74 (painting with Saturnian verses). Scipio on the Capitol: Cic. *Rab. Post.* 27 and Val. Max. 3.6.2, with Sehlmeyer 1999, 148–50, and in *LTUR* (a statue in Greek dress) and a painting of his victory (*tabula victoriae suae*, Pliny *Nat.* 35.22; cf. Livy 37.34 and Val. Max. 3.5.1a).

42 Triumphal debates: Scipio (Livy 37.58.7–8, cf. 38.58–59) and Labeo (Livy 38.47.5). The senate had already awarded two triumphs over Antiochus (one on land, one at sea), which marked victory over the Syrian king. Two more within such a short space of time evidently raised a variety of questions, both about what had actually happened and what the award of a triumph signified. Labeo appears to have achieved much less, according to Dart and Vervaet 2011, 275.

43 Asiagenus' victory games (10 days): Livy 39.22.8–10 (cf. 38.60.9); cf. Pliny *Nat.* 33.138.

Scipios seem to have lost their political influence in Rome, after undergoing questioning about finances and accounts, legal challenges, and even voluntary exile (for Africanus).[44] Indeed very soon after Regillus' victory celebration, Roman commanders faced extensive questioning and intense debates over whether they deserved a triumph or not, particularly in the years 189–186.[45] Consequently, Glabrio and Regillus probably gained more recognition than their colleagues in the war against Antiochus, certainly initially during the awarding of triumphs and the approval for building new temples. Already in 189 BC, however, Glabrio was forced to withdraw his candidacy for the censorship after criticism of his handling of the booty he had won from Antiochus.[46] The silence about Regillus in our sources for the 180s may be due to his death rather than his greater political popularity or success than his fellow-victors.

But who were these new *lares permarini* and where was their temple on the Campus Martius? These gods are not attested elsewhere and there is only one other reference to them, despite the fact that the temple seems to have survived into the imperial period.[47] *Lares* were not gods usually associated with the sea or with naval warfare. Their epithet *permarini* might be a translation of the Greek word *diapontios* ("beyond / across the sea"), but this is not a cult title attested for a Greek god we know of. The Latin adjective seems to mean "throughout the sea," a concept that is untypical for *lares* who were usually identified with a rather particular place and its precise boundary or with travel by road on land again on a specific route. In other words, Regillus was making a novel claim about *lares*, a familiar type of Roman god.

A commonly cited suggestion has been that these are Roman versions of the Great Gods of Samothrace (Cabiri), very influential deities in the Greek East, who protected sailors and travelers on the seas.[48] Their cult was famous for its initiation ceremonies. The names of these gods were not spoken in public and they were often simply called these gods *theoi* in Greek, just as the *lares* would be on Delos later in the second century BC.[49] Unlike *lares*, however, the Cabiri never appeared in the singular, nor are they ever represented or referred to as twins. Some myths associated them with Aeneas and his *penates*, but never explicitly with *lares*. As already argued, in any context *lares* are distinct from *penates*, the gods of the family or clan. In Rome, *penates*, some of whom were also known as *publici*, had their own temple on the Velia.[50] Similarly, we have seen that the evidence from Nigidius

44 For the "trials" of the Scipios, see conveniently now Beck 2005, 362–67.

45 Triumphal debates: Pelikan Pittenger 2008 provides the best overview.

46 Livy 37.57–58.

47 The young Marcus Aurelius wrote to Fronto: *nunc redeo Romam deosque viales et permarinos votis inploro, ut mihi omne iter tua praesentia comitatum sit neque ego tam saepe tam saevo desiderio fatiger* (Now I am returning to Rome and I am beseeching the gods of the roads and the seas with vows, so that you should be my companion on my whole journey and that I should not be worn out by such frequent and fierce longing [for you]). (p. 43, letter 10.2, van den Hout 1988). The manuscript reads *promarinos*, but this should surely be *permarinos*.

48 Great Gods of Samothrace: Cole 1984 is the classic treatment. See also the excellent overview by Graf in *BNP*. Zevi 1997, 92–95 and 101–4, identifies the *lares permarini* with the Great Gods of Samothrace, the Dioscuri, and the *penates* of Rome, all at the same time. The identification of the *lares permarini* with the Cabiri was first suggested by Chapoutier 1935, 315, and most recently reasserted by Pucci 2007 and now by Popkin 2015.

49 For *lares* on Delos, see section III.xviii later.

50 For the temple of the *penates* on the Velia in Rome, see Palombi in *LTUR*. These gods were also associated with the Cabiri, and with the deities Aeneas had brought from Troy, as discussed by Wescoat 2013. It is unclear when a temple was first built for them on the Velia.

Figulus for equating *lares* with Cabiri is much later than Regillus and based on anti-quarian speculations (section I.i); Nigidius cannot be used as secure evidence to associate *lares permarini* with the Great Gods in the early second century BC.

The complex of cult buildings for the Great Gods at Samothrace was mostly in place by the end of the third century. Their sanctuary had enjoyed the patronage of a series of Hellenistic kings, including most recently Rome's opponent Philip V of Macedon. There is evidence of impressive dedications made here by leading Romans in the late third century BC, although few of them would have had a chance to travel to the famous sanctuary during the war with Hannibal.[51] There is no evidence that Regillus visited Samothrace or was initiated into its cult while he was in the East, where he would have been one of the very first Romans to do so.[52]

Overall, therefore, there is very little explicit evidence to link *lares permarini* with the Great Gods. In light of the fact that the temple of the Magna Mater (Great Mother), brought directly from Asia Minor with her exotic priests and foreign rituals, had been dedicated on the Palatine in 191 BC, the year before Regillus' victory, it would seem most logical that Regillus would simply have called his new gods *di magni* (Great Gods), if he had wanted to introduce these deities, who were known to Roman elites, directly from Samothrace. There was certainly no need to disguise foreign gods to make them more acceptable in Rome at the time.[53] Consequently, it seems more likely that he called them *lares* precisely because he thought of them as being these particular kinds of gods. He must have had a specific reason for this unusual choice.

All this brings us to the question of what the temple of the *lares permarini* was like and where it was to be found on the Campus Martius. Can the temple shed any light on the character of these particular new *lares*? Based on archaeological finds in this area in the 1920s and 1930s, two possible candidates have emerged in the remains we know of at present. (See figure II.4.) They are either temple D, the farthest west in the group of four republican temples at the Largo Argentina, or the bigger temple on the Via delle Botteghe Oscure opposite the Crypta Balbi.[54] Neither of these temples is well preserved; each has construction phases that are generally similar and that might conceivably fit with the early second-century BC context

51 Roman dedications to the Cabiri on Samothrace: Marcellus' dedication of booty from Syracuse in the late third century BC is especially telling (Plutarch *Marc.* 30.4–5).

52 The fragmentary inscription *CIL* 1² 3441 cannot refer to Regillus, if only because the letterforms do not seem old enough. See also Wescoat 2013, 73 n. 76. The presence of Romans at Samothrace is mainly documented *after* their victory over Perseus of Macedon at Pydna in 168 BC, a generation later.

53 See Satterfield 2012 for the evidence that the exotic elements of the cult of Magna Mater were very much part of how and why she was received in Rome.

54 For the evidence for each temple (but with different attributions), Temple D in the Largo Argentina: see Coarelli in *LTUR* (*lares permarini*) and Zevi 1995 (Nymphs, built later in the second century and hence not attested in Livy). Temple on the Via delle Botteghe Oscure: Manacorda in *LTUR* (Nymphs) and Zevi 1997 (*lares permarini*). For the Domitianic frieze showing sacrificial implements from this temple, see Siebert 1999b, 284–85 D3, and Márquez and Gutiérrez Desa 2006, 323 no. 16 with bibliography. Unfortunately, the typically Flavian frieze (showing a *gutus, acerra, lituus?*, and *aspergillum*) does not help to identify the recipient(s) of the temple. Rickman 1983 in an incisive overview of the two porticoes argues that the temple on the Via Delle Botteghe Oscure should be for the *lares permarini*. For the porticoes, see also Coarelli in *LTUR* for Porticus Minucia Vetus, built in the late second century by M. Minucius Rufus, cos. 110 BC (cf. Vell. Pat. 2.8.3), and Manacorda in *LTUR* for Porticus Minucia Frumentaria. It is notable that no other temple on the Campus Martius is described by a surviving ancient source as being inside one of these porticoes, both of which were built later to enclose existing sacred buildings.

PORTICUS POMPEIANA

HECATOSTYLUM

PORTICUS MINUCIA (?)

CRYPTA BALBI

Via delle Botteghe Óscure

LARES
PERMARINI (?)

DIRIBITORIUM

II.4. Map showing temples on the Campus Martius, with comparison of temple D and the temple on the Via delle Botteghe Oscure.

of Regillus' temple, although temple D is the less well documented and excavated. More importantly, each also seems to have had a *cella* that featured more than one cult statue, rather than the usual single god for each sanctuary. Both temples were perhaps enclosed within colonnaded porticoes, although these have not been independently dated and securely identified, especially with regard to the Largo

Argentina. Both temples were relatively large: temple D is the biggest of the four republican temples discovered in the Largo Argentina. The temple on the Via delle Botteghe Oscure was even bigger, the largest on the Campus Martius so far and one of the most significant in Rome at the time of its construction.

The discussion has, therefore, been over which temple should be assigned to the Nymphs (whose founder and date of construction is not attested) and which to the *lares permarini* (dedicated in 179 BC). According to Cicero, a fire was set in the temple of the Nymphs by Clodius and his followers in 57 or 56 BC.[55] Neither of these sites, however, shows an obvious destruction layer that could definitely be identified with this historical event, although both were rebuilt in the first century BC. Meanwhile, the whole area was extensively reconstructed under Domitian after the major fire of AD 80, so that earlier republican remains are hard to trace and even more challenging to interpret.[56] If the republican temple on the Via delle Botteghe Oscure had Corinthian columns like those of Domitian's building, it would have been one of the very earliest examples of such a temple known to us.[57]

All that having been said, the argument for the Temple on the Via delle Botteghe Oscure (discovered in 1938) seems to me to be the most attractive in the present state of our knowledge. There are three reasons to assign this imposing temple to *lares permarini*. First, the archaeological date of the podium suggests a first phase in the early second century BC, which is to say in the years covered by Livy's narrative.[58] No mention is made in Livy of a temple of the Nymphs in Rome, which should, therefore, date either before or more likely after 167 BC, when Livy's extant narrative breaks off. The fragments of the early third-century AD Severan marble map of Rome place this temple within a portico labeled Minucia, which fits in with the literary evidence about the temple of the *lares permarini*.[59] No other temples are so described and evidence for another portico in this area is not secure. This identification, therefore, makes the most sense.[60]

It has also been argued that this significant temple corresponds best to the ambitions and self-image of the patrician Aemilii in this period, as well as to the decisive victory over Antiochus the Great being celebrated in the inscription.[61] The temple's position off center within its portico shows that it predates that enclosure. If this (hypothetical) identification is accepted, then we can form at least a basic

55 A deliberately set fire burned the records stored in the temple of the Nymphs: Cic. *Cael.* 78, *Mil.* 73, *har. resp.* 57. We do not know exactly what these records were, or how long they had been kept in this temple. Consequently, this incident does not in itself indicate how large that temple was nor the extent of fire damage to its actual structure.

56 Zevi 1995 gives a list of the temples on the Campus Martius. One may especially note a nearby temple of Vulcan (Manacorda in *LTUR*, which shared a birthday with the Nymphs on 23rd August, the traditional festival of the Volcanalia), but has not so far been identified in the archaeological record. It is also possible that neither is the sanctuary of the *lares permarini* or of the Nymphs.

57 This hypothesis is entertained by Popkin 2015, 350, who argues that Regillus was deliberately imitating the cult and architecture of the sanctuary of the Great Gods at Samothrace. Without more specific evidence, this argument remains highly speculative.

58 Márquez and Gutiérrez Desa 2006 describe and analyze the archaeological remains.

59 For the Severan marble plan, see notes XX [18, p. 230] and XX [62] later.

60 For a thorough evaluation of the evidence and arguments about these porticoes, see Popkin 2015, esp. 347–50.

61 Zevi's 1997 argument is ingenious, wide-ranging, and often highly circumstantial. Nevertheless, his reconstruction does conjure up the splendor of Rome as conceived and built by the Aemilii in the second century BC. It is assumed that Domitian rebuilt on the same footprint according to the usual Roman custom.

idea of the sanctuary, from the evidence provided by the third-century AD Severan marble plan of Rome.[62] (See plate 21.) Even in its original phase of construction, it was a very substantial temple by republican standards (ca. 27×40 m) with columns on all sides.[63] Unusually, eight columns spanned the front and back, while each side had twelve columns. The *cella* also featured an untypical internal colonnade. The deep *pronaos* at the temple's entrance featured a double row of columns on the sides. In other words, no expense was spared in making this temple exceptional both in overall scale and in the details of its design and construction. Again a comparison with the first phase of the closely contemporary Temple of Magna Mater on the Palatine comes to mind.[64]

Aemilius Regillus (and his relatives) appears both thoughtful and ambitious in designing a special booty temple after his important victory at sea over Antiochus' fleet. The temple was built on an exceptionally lavish scale, an elaborate dedicatory plaque was composed or commissioned, a copy of which was placed, by special permission, over the main door of Rome's most important sanctuary, the temple of Jupiter, Juno, and Minerva on the Capitol. This honor indicates the kudos his victory had earned among Regillus' contemporaries. The unusual inscription (whose copy was surely destroyed when the Capitoline temple burned down in 83 BC) was recorded by historians of the second century BC, whose attention was engaged by Regillus' text, later to be incorporated by Livy in his own history. Presumably, Livy might himself also have read the version on the front of the temple inside the porticus Minucia.

Regillus' actions suggest the particular character of *lares*, deities who were especially familiar and completely Roman but flexible enough to express concepts not only of religious traditionalism but also of innovation in a Hellenistic setting. The *lares permarini* were accessible to Romans as protective gods of travel on the seas, even as their Hellenistic temple probably looked completely different from the sanctuary of the (older?) *lares* on the Sacra Via. This contrast was surely pointed and deliberate. At the same time, the whole idea of introducing "new" gods with eastern and marine associations and yet calling them "*lares*" must have been a complete novelty. Everyone in Rome would have known that *lares* were indeed very Roman sorts of gods and that they were associated with particular places on land.

There may well have been something more at stake, however, than merely finding a suitable way of introducing a particular foreign group of gods to Rome, which Regillus could have done more simply and directly, as many other Romans had recently done or would soon do. Claiming that *lares* had helped Regillus and his men to win a victory at sea over Antiochus can, therefore, suggest that the whole Mediterranean, even in the newly accessible Aegean, was somehow a "Roman sea," described as the natural habitat of these particularly Roman gods. *Lares permarini* were indeed quite new but also appealed in a special way to a very Roman sense of a world permeated by protective deities who were associated both with home and

62 See *FUR* frag. 35ee, available online at Stanford's digital Severan marble plan site (http://formaurbis.stanford.edu).

63 Márquez and Gutiérrez Desa 2006, 320, see no archaeological evidence to support Coarelli's hypothesis (1997, 223) that the original temple was much smaller, only the size of the *cella*. The character, size, and height of the podium suggest a large temple.

64 Goldberg 1998 re-creates the original temple on the Palatine and its performance space. D'Alessio 2006 offers a summary of the archaeological evidence. There was extensive rebuilding after the fire of 111 BC, which has obscured the first phase of the original sanctuary.

with journeys. Regillus' imperialistic claim to have been welcomed by Roman style *lares*, ready to help in the seas off Asia Minor and around the Greek islands, was apparently appealing enough to persuade the senators to let his inscription be displayed over the main entrance to the Capitoline temple, a spot uniquely linked to the celebration of each triumphal ceremony and to Rome's sense of imperial destiny. The imperialistic *lares permarini* were themselves suited to a long inscription and a magnificent temple.

A further contrast suggests itself with the temple to the Sea Storms (Tempestates) vowed in 259 BC, seventy years before Regillus' triumph, by another L. Cornelius Scipio after he had been rescued from a storm at sea off Corsica.[65] This temple was in *regio* I, probably near the tomb of the Scipios outside the porta Capena.[66] Interestingly, its birthday is recorded as being on 23rd December, the day after that of Regillus' *lares*, thus creating a striking juxtaposition of feasts for sea *lares* and sea storms.[67] While Romans during the First Punic War had experienced the sea as dangerous and inhabited by fierce storm gods whom they sought to appease, in the early second century BC Regillus claimed a new confidence in traveling and fighting in the eastern Mediterranean with the help of familiar deities. Unfortunately, we have no information about how popular Regillus' *lares permarini* were after their first introduction.

<center>* * *</center>

To sum up: we know of two temples (*aedes*) in honor of very different *lares* in Rome. The older (archaic?) cult was probably that of the temple described as being *in summa sacra via*, whose feast day fell on 27th June, an ancient public holiday that may have honored several kinds of *lares*. One possible context, whether archaizing or really old, is provided by this temple's physical proximity to and neighborly association with a Temple of Jupiter Stator attributed originally to Romulus, with which it shared its birthday. This venerable *lares* temple attracted the attention of Augustus, who reworked it sufficiently to feel entitled to inscribe his own name on his version of the building. These *lares* do not ever seem to have had an epithet but were consistently referred to simply as *lares*, perhaps indicating the (imagined?) priority of their cult over other *lares* in the city. It is not recorded when or by whom their cult was founded. The location of the temple remains heavily disputed, although a spot under the podium of Hadrian's temple of Venus and Rome appears plausible. In any case, there is no evidence that it survived the Julio-Claudian period: it seems to have been destroyed in the great fire of AD 64 or in the subsequent unrest, which culminated in the reconfiguration of so much of the city under the Flavians, starting in AD 70.

By contrast, the other *lares* temple was built in the early second century BC on the Campus Martius, in the area subsequently enclosed within a porticus Minucia, by the patrician Aemilii in honor of *lares permarini*, gods honored for L. Aemilius Regillus' strategic victory at sea over the Seleucid king Antiochus III in 190

65 See *CIL* 6.1287 = 37039c = *ILS* 3 = *ILLRP* 310b = EDCS-17800192 for the record of the temple to the Tempestates in the dedicator's epitaph inside the tomb of the Scipios.

66 See Ziółkowski in *LTUR*.

67 *Fast. Ant. Mai.*, but on 1st June according to Ovid *Fast.* 6.193–94 (Donati and Stefanetti 2006, 161–62).

BC. *Lares permarini* were an unusual interpretation of *lares* as protective deities for Roman sailors and their commander "throughout the seas." In the present state of our evidence, it is likely that this temple was the grand Hellenistic-style structure whose remains have come to light on the Via delle Botteghe Oscure. This temple also had a birthday at a time of *lares* festivals with sacrifices at the altar of Consus in the Circus Maximus on 21st December, the day before the festival for the *lares permarini*, itself closely coinciding with the urban praetor's announcement (at the winter solstice and after Saturnalia) of the date of Compitalia, which would be celebrated in eight days' time. The new cult seems designed to use *lares* as a way of representing and encouraging the expansionist ambitions of Rome in the Eastern Mediterranean in the early second century BC and the role of the resplendent Aemilii in building that overseas empire. The cult of *lares permarini* implied that Romans were at home on the sea, even in the waters off Asia Minor, which were imagined as being protected by such characteristically Roman gods. This temple seems to have survived into late antiquity.

Both temples, therefore, had an association with a cult of Jupiter. The *lares in summa sacra via* was closely paired (in space and time) with the ancient Jupiter Stator, whose precinct and temple commemorated a battle fought by Romulus on the edge of the Forum. On the other hand, the new *lares permarini* had a copy of their dedicatory text fixed over the main doors to the Capitoline temple of Jupiter Optimus Maximus, Juno, and Minerva, Rome's grandest sanctuary. Regillus and his family may, therefore, have been both imitating but also trying to outdo the traditional link of *lares* with Jupiter Stator. Meanwhile, the association of a Jupiter with a *lares* cult evokes a range of ideas about defending Rome, but also about building the empire that was the manifestation of her strength and imperial destiny.

Each of these temples, although seldom referred to in surviving literary evidence, was a prominent landmark in Rome. Unfortunately, we have no detailed information about the religious officials in charge of each sanctuary or about the iconography of their cult statues or their festivals and rituals. The varied character of the different *lares* and of the styles of these two temples would have contrasted both with each other and with the large number of modest *lares* shrines that were to be found throughout the urban landscape of Rome. *Lares in summa sacra via* were a traditional cult, probably associated with protecting Rome's land, whether in war or in peace, as attested by the Arval hymn. *Lares permarini* complemented these *lares* by suggesting that the Romans were protected by friendly and familiar gods wherever they sailed in the waters of the Mediterranean. In this sense, the two *lares* temples balanced each other, as they represented *lares* on land and *lares* on the sea, even as their architectural styles probably created a similarly distinct contrast.

XII SANCTUARY: *ARA* / *FANUM* / *SACELLUM* / *POMERIUM*

praestitibus Maiae laribus videre Kalendae
aram constitui parvaque signa deum
—OVID *FASTI* 5.129–30

In addition to the two temples, we know of three individually named smaller *lares* "shrines" in Rome, as well as an inscription honoring *lares* at an underground altar in the Circus Maximus. The three named *lares* cults were thought of as ancient, being attributed to times well before the institution of a republican form of government in Rome. They are the cult sites in honor of *lares grundiles*, *lares praestites*, and *lares querquetulani*, together with a cult in the Circus Maximus, which featured an inscription honoring Mars and *lares* at an altar dedicated to the traditional Roman god Consus. An association with the founding of the city and the protection of its sacred site and walls is a shared feature of these shrines, with the possible exception of the *querquetulani*. This section will survey these traditional cults and their association with the *pomerium*, the sacred boundary of Rome.

These named *lares* apparently never had temples of their own; their cult sites were modest and are described as "altar" (*ara*) or "open-air shrine" (*sacellum*), or more simply and generically "sanctuary" or "precinct" (*fanum*). They consisted of unroofed shrines on small plots of consecrated (that is to say, carefully delineated) ground, which will have had an altar for ritual, and possibly also simple images of the gods and other natural features associated with the deities. The name of the *lares querquetulani* (*lares* of the oak trees) directly evokes oak trees; they seem to have been housed within a sacred grove (*lucus*), of which there were many of varying sizes in the city before it became a heavily populated metropolis.[1] Very little is known about the age or character of the *lares querquetulani*, whom Varro places on the Esquiline hill.[2] They seem to be local *lares* of some kind, who were to be found in an historical part of the old city, on one of its ancient hill settlements. In other words, what may have been imagined as the oldest cults of *lares* are described as keeping their archaic characteristics, including shrines consisting of an open air altar within a (more or less) rustic, wooded precinct.

Our surviving ancient sources of all types clearly distinguish these *lares* shrines, which were labeled with individual cult titles and were associated with specific places in Rome, both from the two civic temples (*aedes*) and from the many crossroads shrines (*compita*). The logical conclusion is that there was only one cult site for each named pair. By contrast, the hundreds of local shrines at the crossroads (*compita*) throughout the city all honored identical pairs of *lares compitales*, without giving these *lares* names taken from individual neighborhoods or from local topographical features. Neighborhoods could be named after a *compitum* or after a special *lar*.[3] The *lares* (despite being gods so closely identified with places) were

1 For the *sacellum* of the *lares querquetulani*, see Aronon in *LTUR*.

2 Varro *LL* 5.49. Their relationship to the *mons Querquetulanus* (Tac. *Ann.* 4.65, an ancient name for the Caelian), the *virae querquetulanae* (Festus 314L, a type of nymph), and the *porta Querquetulana* (a city gate) is equally unclear.

3 The vicus compiti Acilii is the obvious example of a *compitum* naming a vicus. From the Capitoline base (*CIL* 6.975 = 31218 = *ILS* 6073), we also know of a *vicus larum alitum* (XIII.9) on the Aventine and a *vicus larum +v+++lium (curialium?)* (XIV. 11) in Trastevere. See Lega in *LTUR* for the scant information about these vici.

not named for the *vicus* or for any other geographical district (for example, *regio, mons, pagus*) in Rome.

This naming pattern for identifying *lares* highlights the age and special functions attributed to certain named *lares*, particularly the *grundiles* and *praestites*, about whom a bit more information survives. These named cults raise the interesting but ultimately unanswerable question as to whether *lares* were once thought of as more individualized deities. Yet generalizations are hard to make and the individual names we know of do not form a consistent pattern: the *praestites* (guardian *lares*) seem the most accessible, the *grundiles* (grunting *lares*) are the least easy to understand, the *querquetulani* (oaken *lares*) simply appear rustic.

Lares Grundiles

The *lares grundiles* are represented as among the oldest (insofar as there is any temporal pattern in the timeless world of *lares*) because their story predates the foundation of Rome. Varro's traditional date of 753 BC provides a general frame of reference for the age of the city. The main evidence for the establishment of their cult comes from a precious verbatim quotation from book two of L. Cassius Hemina, an historian writing in the mid-second century BC.[4] He reproduces a tradition about the community of shepherds and how their life was organized before the foundation of the city of Rome.

> Hinc quoque grundiles lares dictos accepimus, quos Romulus constitutisse dicitur in honorem scrofae quae triginta pepererat. Haec ita esse hoc modo adfirmat Cassius Hemina in secundo historiarum:
> pastorum uulgus sine contentione consentiendo praefecerunt aequaliter imperio Remum et Romulum, ita ut de regno pararent inter se. monstrum fit: sus parit porcos triginta, cuius rei fanum fecerunt laribus grundilibus.

> From this term (*grundire* = grunt) we learn that the *lares grundiles* were named, whom Romulus is said to have established in honor of the sow who gave birth to thirty piglets. Cassius Hemina declares that this is the case in book 2 of his *Histories* in the following way:
> "The crowd of shepherds, agreeing without any dissent, put Remus and Romulus in charge with equal formal authority, on condition that they make an agreement between themselves about the royal power. A prodigy occurred: a sow gave birth to thirty piglets; because of this event they made a sanctuary for the *lares grundiles*."
> (Diomedes *GL* 1.384: F 11 Peter = F 14 Beck and
> Walter, Santini, and Chassignet = *FRHist* 6 F14)

This tradition is obviously at variance (and surely in conscious competition) with much that became standard about early Rome by the time that Livy and Vergil were

4 For an introduction to L. Cassus Hemina (number 6 in the new edition of the fragmentary Roman historians), see conveniently Briscoe in *FRHist* vol. 1, 219–23. Forsythe 1990 dates Hemina's work later in the second century. Fornara 1983, 25, calls Hemina the first writer of "annalistic" history in Latin.

writing. Interestingly, this quotation of Hemina does not come from an historio-
graphical source; it has survived by chance as it is cited for a linguistic reason in
reference to the verb *grundire*. The portent of the miraculous sow with her thirty
piglets is dated to the time of Romulus and Remus (with Remus carefully named
first by Hemina), rather than to the arrival of Aeneas in Italy, many generations be-
fore. Fabius Pictor and Cato, both probably writing before Hemina, had already at-
tributed the prodigy of the miraculous sow with her piglets to the time of Aeneas.[5]

Despite the vocabulary of kingship (*regnum*), Hemina's version deliberately
stresses the harmony between the twin brothers and the sharing of leadership be-
tween them on an equal basis. There is no talk (yet?) of founding a new city or of
arguing over who should be its ruler. Perhaps the narrative went on to describe the
foundation of Rome and the subsequent quarrel between the two brothers, after
this idealized period of joint rule.[6] On the other hand, it could have introduced a
completely different story in which Remus did not die and the story of early Rome
was much more harmonious.

It is this egalitarian and peaceful community of rustics that witnesses the prod-
igy of the thirty piglets with its suggestion of exceptional fertility and prosperity and
that founds the cult of the *lares grundiles* to commemorate the occasion. The shep-
herds try to harness the power of the favorable omen by founding a cult for special
lares here. The brief extract from Hemina does not explain who these *lares* are, nor
whether they are twins. Why do they grunt? Are they simply the thirty piglets
themselves, reconceived and hailed as protective spirits?[7] Diomedes thinks the cult
honors the sow herself (*in honorem scrofae*) but does not provide further explana-
tion. However that may be, the animals do not seem to be sacrificed to another
deity, as they are in other versions. Vergil has Aeneas sacrifice mother and babies to
Juno, while Dionysius of Halicarnassus names the ancestral gods (*patrōoi theoi*) as
the recipients, who are usually identified with the *penates*.[8] It is not surprising to see
pigs associated with *lares*, since we know from many sources that pork was the fa-
vorite gift for these deities. It may be that this story justified the customary pig for a
lar. The version in this quotation from Hemina is so compressed that no details are
provided. This same story is also referred to by Nonius Marcellus (164L) using simi-
lar language (probably also drawing on Hemina): *Grundules lares dicuntur Romae
constituti ob honorem porcae quae triginta pepererat* (The *lares grundiles* are said to

5 Fabius Pictor: *FRHist* 1 F3 puts the sow at Alba. Cato (the early books of whose *Origines*
could have been familiar to Hemina) *FRHist* 5 F10 has the prodigy at Lavinium. Lycophron *Alex.*
1254–56 gives a different version that may go back to Timaeus of Tauromenium, suggesting that
the omen of a pig with thirty piglets had a considerable history before Hemina. Varro *RR* 2.4.18
notes that bronze statues of the sow and piglets were to be found in many places and that some
priests still displayed the body of the sow herself. See Dardaney 2012, 72–75, for the artistic evi-
dence. Cf. also Varro *LL* 5.144; Vergil *Aen.* 1.269 and 8.43–50; Servius on *Aen.* 3.390.

6 Most commentators have assumed what we have here must be an early episode in some version
of the traditional story. For the many variations of the foundation legend, see Wiseman 1995a, esp.
5–6. This etiology may, however, be operating independently of the foundation legend. The most
logical reading of Hemina's version is that joint rule was harmonious after the favorable omen. In
other words, it is not impossible that the *lares grundiles* were part of a truly alternative tradition.

7 So Schilling 1976.

8 Vergil *Aen.* 3.389–93 and 8.41–45, 81–83. Dionysius of Halicarnassus 1.56–57. Briquel 1976
sees this story as being about Rome's claim to preeminence in Latium by transferring the famous
prodigy from Lavinium.

have been established at Rome in honor of the sow that gave birth to thirty [piglets]). Both Diomedes and Nonius were writing in the late fourth century AD.

What we can say is that the *lares grundiles* (whether pigs themselves or more likely deities who were their protectors and recipients) were recognized and celebrated as a positive omen for the community as a whole, and apparently specifically for the joint rule of Remus and Romulus in particular. This function puts the sow and her piglets potentially in competition with the more traditional divine sign that announced a single king in Rome, the eagles seen by Romulus (and perhaps also by Remus) in their observance of bird augury in other versions of the foundation story.[9] Unlike the birds, whose flight is anticipated and observed from an inaugurated observation point by an authority figure, the pig presents the birth of her miraculous offspring to the community as a whole at an unanticipated time and in a venue chosen by providence.[10] In Hemina's version, the sow is not hailed as fulfilling a prophecy. Rather, she provides an example of a different and more mundane practice of reading divine signs—namely, the interpretation of unusual events in the life cycle of animals by a group of herders (*vulgus pastorum*). In this setting, no religious experts are called upon: favorable omens are embraced and activated through community recognition. Meanwhile, it remains quite unclear how the promise of the many piglets could have been adapted to accommodate either a quarrel over the kingship or the violent death of Remus.

Hemina is the only source to use the general term *fanum* (sanctuary) to describe a cult site for *lares*.[11] He may have chosen the word because it created an alliteration with the verb *fecerunt* rather than for a specifically descriptive or topographical reason. But who actually founds the cult? In his introductory sentence, Diomedes states that Romulus is the founder, but the quotation from Hemina has a plural verb (*fecerunt*), which suggests either the two brothers are joint founders together or, more logically, the shepherds, who are the subject of the previous sentence, continue to be the main actors. It would obviously be interesting to see the community of shepherds or herders described as the founders of a "popular" cult celebrating *lares* and pigs. Pork was a common staple of the Roman diet.

In either case, Hemina's text invoked deities of fertility and prosperity in the context of shared rule at Rome, which could also be interpreted as an omen foreshadowing the consulship as Rome's political destiny later in her history.[12] The location of the shrine is not specified. It has been suggested that this cult may have been found in the Velabrum, at the place of embarkation from the river, and therefore outside the first city's official limits but at a much frequented site next to the ancient cattle market in the Forum Boarium.[13] This shrine would, therefore, have

9 The augural contest of the brothers competing for supreme power is already attested in Ennius *Ann.* 72–91, esp. 77–78 Skutsch. See Wiseman 1995a, 6–9, 111, 148.

10 See Linderski 1986 for Roman augural law. The traditional, republican system of prodigy and expiation would have been fully functional in Hemina's day. See Engels 2007 for a very thorough treatment and catalogue.

11 Briscoe (*FRHist* vol. 3, 167–68) calls this a "temple," but it is surely much more likely to have been an open-air shrine, especially as imagined in its original, rustic context.

12 Rawson 1991, 254.

13 The corruption in Varro's text at *LL* 5.43 may be emended to include a reference to a pond by the open-air shrine of *lares* (*lacus ad sacellum larum*) as suggested by Robert Palmer. This could also function as the northwest corner of Romulus' *pomerium*, as imagined by Tacitus. See La Regina 2014.

greeted the many visitors to Rome who traveled by boat, even as Aeneas does in *Aeneid* 8.

Lares grundiles are mentioned by Arnobius in his polemic against traditional Roman religion, written in the early fourth century AD.[14] He implies that they are still gods that might be worshipped by some Romans, along with other traditional deities. Consequently, our evidence for *lares grundiles*, slight as it is, stretches over many centuries, from Hemina in the earlier second century BC to Diomedes in the late fourth century AD. Whereas the explanation given by their etiology is very compressed and the iconography associated with their cult is lost, the existence of their shrine in Rome seems directly attested.[15]

Lares Praestites

The *lares praestites* were associated with and apparently guarded Rome's walls.[16] Although the location of their cult site is not known, they are better attested as regards their iconography, festival, and protective function than any of the other named *lares*. Ovid records their feast day on 1st May, which provides evidence for a *kalends* sacred to special, named *lares*.[17]

> Praestitibus Maiae Laribus videre Kalendae
> 	aram constitui parvaque signa deum:
> voverat illa quidem Curius, sed multa vetustas
> 	destruit; et saxo longa senecta nocet.
> causa tamen positi fuerat cognominis illis
> 	quod praestant oculis omnia tuta suis:
> stant quoque pro nobis et praesunt moenibus Urbis,
> 	et sunt praesentes auxiliumque ferunt.
> at canis ante pedes saxo fabricatus eodem
> 	stabat: quae standi cum Lare causa fuit?

14 Arnobius *Adv. Gent.* 1.28: *quid dicitis, o sacri, quid, divini interpretes iuris? Meliorisne sunt causae, qui Grundulios adorant Lares, [Aios Lucutios], Limentinos, quam sumus nos omnes, qui deum colimus rerum patrem atque ab eo deposcimus rebus fessis languentibusque tutamina?* (What do you say, O interpreters of sacred and divine law? Is it for a better reason that people pray to the *lares grundiles*, [Aius Locutius], the Limentini (gods of the threshold), than the rest of us who worship the god who is father of all and beg from him protection from tiresome and tiring things?). Arnobius is deliberately choosing certain types of gods to make fun of in this passage.

15 There is no entry in *LTUR* for these *lares*.

16 *Lares praestites*: for the standard discussion of the shrine, see Coarelli in *LTUR* and 2012, 21 and 183 (shrine next to Vesta's temple that is also a *compitum*). For the festival, see also the entries in two Augustan calendars: *Fasti Venusini* (ca. 16 BC– ca. AD 4) and *Fasti Esquilini* (ca. AD 7) in *II* 13.2.452–53. Schilling 2003, 141–42, suggests that 1st May was once the main holiday for *lares* at Rome. Wiseman's identification (1995a, 70–71) of the twins with a wolf on a famous fourth-century BC mirror from Praeneste as the *lares praestites* is purely hypothetical, particularly given the quite different iconography associated with them in the ancient sources that name them specifically. Coarelli 2012, 165–74, also identifies a painting from the house of M. Fabius Secundus in Pompeii (V.4.13) as depicting the birth of the *lares* as described by Ovid.

17 For Ovid on the *praestites*, see commentary by Bömer 1958 ad loc. Festus (quoted by Paul, 250L): *praestitem in eadem significatione dicebant antiqui qua nunc dicimus antistitem* (the ancients used to say *"praestes"* to mean the same thing as when we now say *"antistes,"* that is, standing in front of). For 1st May, see also Donati and Stefanetti 2006, 57–58, with *Fasti. Ven.* and *Esq.*

servat uterque domum, domino quoque fidus uterque:
 compita grata deo, compita grata cani.
exagitant et Lar et turba Diania fures:
 pervigilantque Lares, pervigilantque canes.
bina gemellorum quaerebam signa deorum
 viribus annosae facta caduca morae:
mille Lares Geniumque ducis, qui tradidit illos,
 Urbs habet, et vici numina terna colunt.

The first of May saw an altar and small images set up in honor of the guardian *lares*. That man from Cures had vowed them, but the passage of time destroyed many things; long old age hurt even stone. The reason for giving them this (nick)name was because they guard everything in safety under their gaze. They also stand before us and they are in charge of the walls of the city, and they are present and bring help. But a dog made of the same stone used to stand before their feet. What was the reason it was standing with the *lar*? Each looks after the home, each is also faithful to the master. Crossroads are dear to the god; crossroads are dear to the dog. Both a *lar* and the hounds of Diana drive away thieves. *Lares* keep watch at night, dogs keep watch at night. I was searching for the two images of the twin gods, fallen to ruin by the force of the years' passing: the city has a thousand *lares* and the guardian spirit (*genius*) of the leader who handed them over, and the streets (*vici*) cultivate the three deities.

(Ovid *Fasti* 5.129–46)

Ovid tells us of their ancient, stone cult images, which showed the twin gods accompanied by a guard dog and equipped with a small altar for offerings. The venerable age and small scale of this shrine are the focus of Ovid's description. His search seems motivated by his knowledge of their feast day on 1st May. The dog that used to stand (*stabat*) before them causes him to explore its meaning in a humorous way. The familiarity and popular nature of these gods leads Ovid to compare them to loyal guard dogs, who look after the home and the walls of the city. This passage contains extensive punning on the epithet *praestites*, which is impossible to convey in translation. The suggestion that dogs like crossroads is particularly tongue-in-cheek. Ovid appears flippant, even by his own standard.

 Yet his final point seems to be that he is still searching (*quaerebam*) for the shrine; its state is so poor that he either sees a dilapidated ruin or perhaps cannot find it at all. In other words, he does not give us the detailed description of an ancient shrine and its lovingly tended traditional cult that we were led to expect at the beginning of the section. At the end, Ovid himself chooses to contrast the old *lares praestites* with the "thousand" new *lares augusti* at the *compita* of Rome. His immediate reason for doing so may have been that one of Augustus' new flower festivals fell on 1st May, which made this old holiday into a festival of the *compita*, apparently at the expense of the *sacellum* that Ovid is having so much trouble finding. Ovid, therefore, explicitly tells his readers that the shrine of the *lares praestites* is *not* compital.[18] He paints a picture of himself seeking throughout the city and being confronted by a crowd of new *lares* at the street corners, whose shrines have superseded older,

18 For confusion of *lares praestites* with *lares compitales*, see for example Coarelli in *LTUR*, who misreads what Ovid is saying in this passage.

more individualized cults. At the same time, his words inevitably suggest that the *praestites* enjoyed an ancient cult that Augustus has not included in his widespread and much heralded restoration of traditional sanctuaries in Rome. Ovid may be evoking the idea of competing *lares*, as traditional cults were superseded or displaced by newer ones. For whatever reason, the festival of *lares praestites* is not included under 1st May in our only surviving republican calendar, the *Fasti Antiates maiores*.

Unfortunately, the text of book 5 of the *Fasti* is corrupt in this section because of the poor state of the manuscripts. It may be that Ovid is saying that this cult was originally native to the Sabine town of Cures.[19] If so, these *lares* are the ones introduced to Rome by Titus Tatius, Romulus' fellow king after the Sabine community had joined with the original population.[20] It is interesting to see that both the twins Remus and Romulus as well as Titus Tatius are associated with the establishment of early *lares* cults at small *sacella* around Rome. Titus Tatius is a figure who appears several times in the *Fasti*.[21] Ovid, however, does not mention the *lares grundiles* celebrated by the herdsmen.

Plutarch, writing in the early second century AD, also discusses the cult of *lares praestites* as a curious feature of Roman religion worthy of comment.[22] He describes them as wearing dog skins and accompanied by a dog. Plutarch's discussion focuses on the dog and its significance, much as Ovid did. Evidently, their cult and its iconography were not lost by the early imperial period, as Ovid obliquely implies. Plutarch is not at all sure of what kinds of gods these *lares* are. He does not tell us where their shrine was.

Their images, however, have been preserved on an unusual silver denarius coin of L. Caesius, struck around 112 BC.[23] (See figure II.5.) The coin features Apollo (?) holding a thunderbolt on the obverse, and twin seated *lares praestites* each holding a staff, with a dog between them, on the reverse. Above is a small bust of Vulcan with his tongs. The identification is confirmed by an abbreviated label giving their names next to their images. It is possible that this coin reproduces the small cult statues that Ovid was looking for. In any case, these *lares* are seated on a rock, are naked to the waist, and wear the little boots common to other *lares*. Their flowing garments do not, however, look as if they are made of dog skins. On their heads they wear soft caps and in their hands they are holding staffs. In a relaxed gesture that sums up the scene, the right hand figure casually strokes the head of the dog, who is standing between them. In this case, we can be sure that the *praestites* had their own specific and recognizable iconography. These young, rustic gods with their guard dog evoke concepts of protection of home and flock, which also extended in a special way to the city of Rome, its walls and community.

According to these origin stories, therefore, the *grundiles* are native gods, while the *praestites* are imported by the Sabines. Each is associated with kingly figures,

19 For the variants in the manuscript traditions, see especially Schilling 2003 ad loc.

20 Titus Tatius as founder of a cult of *lares* (among many other cults): Varro *LL* 5.74. Strabo 5.3.1 names Cures as the hometown of both Titus Tatius and Numa Pompilius. Alternatively, Schilling 2003, 141–42, suggests Manius Curius Dentatus (cos. 290, 275 BC) as the dedicator indicated by the name Curius in Ovid's text.

21 See *Fast.* 2.135, 475–80, 6.93–96.

22 For *RQ* 51, Plutarch's source may be Verrius Flaccus. It is interesting that he uses the transliterated Greek name *hoi larētes* (in the general category of *daimones*) rather than the translation "heroes."

23 *RRC* 298, dated to 112/111 BC by Crawford.

Romulus and Remus or Titus
Tatius respectively and with the
early community of herdsmen.
These "early" *lares* seem to be
associated with the most famil-
iar, domesticated animals, the
pig and the dog. Nevertheless,
the exact location of their shrines
has remained elusive and their
small size has meant that they
have (so far) not been identified
in the archaeological record.

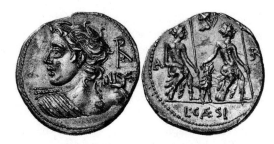

II.5. Silver *denarius* of L. Caesius, with the *lares praestites*
on the reverse. Ca. 112 BC.

The modern view that the cult site of the *lares praestites* can be identified with
the shrine immediately outside the temple of Vesta is entirely hypothetical.[24]
Certainly it would seem odd for both Ovid and Plutarch to have omitted a refer-
ence to *lares praestites* as guardians of Vesta's shrine and house. It must be stressed
that repeated attempts to associate various *lares* with the complex of the Vestals
have not produced any definitive results. (See figures II.3, II.15, and II.16 later.)

Meanwhile, the bust of Vulcan on the coin of Caesius could suggest that the *lares
praestites* were neighbors of a shrine of Vulcan, such as the Volcanal, a very ancient
sacellum in the Forum also attributed to Titus Tatius.[25] (See figure II.17 later.) The
Volcanal itself, although restored by Augustus at the end of the first century BC,
was encroached upon and became reduced in size, although a version of it survived
into late antiquity. Such a pattern of displacement fits in with Ovid's lament for
crumbling shrines from early times. Yet Ovid may also be picking out the *lares
praestites* partly because their shrine had *not* been restored by Augustus when their
neighbor's had been. No definitive explanation has been found so far for the appear-
ance of Vulcan above the *lares* on Caesius' coin.[26]

Pomerium, Sacellum Larum, Ara Consi

Tacitus mentions an open-air shrine of *lares* (*sacellum larum*) as one of the princi-
pal landmarks on the original sacred boundary of the city attributed to Romulus
(*pomerium Romuli*), a boundary that defined the Palatine hill.[27] He does not

24 Pisani Sartorio 1988, VIII 2. See also Coarelli in *LTUR* s.v. Vicus Vestae. Epigraphical evi-
dence has been adduced to argue that this shrine is more likely to have been compital, but there is
no definitive evidence.

25 For the Volcanal, see Dionysius of Halicarnassus 2.50.3 and Varro *LL* 5.74, with Coarelli in
LTUR. The original inaugurated space of this sanctuary was perhaps extensive and covered the
lower slope of the Capitoline where the Temple of Concord was built later. Carandini 2011 in-
cludes the site of the Volcanal in many of his reconstructions of the earliest city.

26 Crawford gives no explanation in *RRC* 298. Pucci's 2007 suggestion that Vulcan is the fa-
ther of the Cabiri has nothing to do with the iconography and cultural context of this coin. Robert
Palmer thought the *lares praestites* were the same as the *lares in summa sacra via* and that the
image of Vulcan referred to the portent of the fire at this temple. On 1st May, Vulcan's *flamen* sacri-
ficed to his consort Maia (Varro *LL* 5.84; *CIL* 6.41294; Gell. *NA* 13.23.2; Macrobius *Sat.* 1.12.18–
20). Are these gods the parents of the *lares praestites* in another myth?

27 For commentary, see Koestermann 1967 ad loc. Coarelli in *LTUR* has emended this shrine
to a *sacellum* for the goddess Larunda (possibly another name for the mother of the *lares*?),

specify which shrine he has in mind, evidently because his marker would have been well known to his readers. As in the cases discussed earlier, this *sacellum* cannot be a compital shrine according to the logic of his wording, since no individual *compitum* would be so easily recognizable without more topographical details or a name (for example, Compitum Acilium). Nor can it be the temple of the *lares in summa sacra via* or Tacitus would not call it an unroofed shrine (*sacellum*). Republican historiography represents Romulus as the founder of sacred spaces that did not yet have temple buildings. It may be that this famous *sacellum* honored the *lares praestites*, but we cannot be sure without more evidence.[28] Tacitus speaks as if he has retraced this archaic *pomerium* himself and invites his readers to do the same: his words go beyond a textual description to bring the route to life. To him, this line is still "visible" in the landscape of Rome in the early second century AD.[29]

> . . . quod pomerium Romulus posuerit, noscere haud absurdum reor. igitur a foro boario, ubi aereum tauri simulacrum aspicimus, quia id genus animalium aratro subditur, sulcus designandi oppidi coeptus ut magnam Herculis aram amplecteretur; inde certis spatiis interiecti lapides per ima montis Palatini ad aram Consi, mox curias veteres, tum sacellum Larum inde forum Romanum; forumque et Capitolium non a Romulo, sed a Tito Tatio additum urbi credidere.

> I think it is not idle to find out about the sacred boundary that Romulus put in place. Consequently, he started his furrow to demark the town at the Forum Boarium, where we see the bronze statue of the bull, since that kind of animal was yoked to the plow. He drew his line to embrace the Great Altar of Hercules; from there stone markers were set up at set intervals along the bottom of the Palatine Hill to the Altar of Consus, next to the Curiae Veteres, then the shrine of the *lares*, from there to the Roman Forum. The Forum and Capitol are not believed to have been added to the city by Romulus, but by Titus Tatius.

> (Tacitus *Ann.* 12.24)

Whether this first ceremonial boundary, imagined as drawn out with a plow by the founder himself, is interpreted as genuinely archaic or as a reconstruction that reflects how Romans viewed the original sacred boundary of the city in Tacitus' own day (a new *pomerium* had been drawn by the learned emperor Claudius when Tacitus was a child), it is vital to note the close association of a *sacellum* dedicated to *lares* with this first boundary. Moreover, another of the four landmarks mentioned by Tacitus, at the altar of Consus in the Circus Maximus, also had an ancient or archaizing cult of *lares* associated with an altar. Tacitus conjures up this "original" boundary line drawn by Romulus, not in a natural landscape in the distant past but

although there is no sign of a problem in the manuscripts here. She is also the recipient of cult from Titus Tatius in the same passage of Varro that mentions Tatius and the *lares*. For her shrine, see also Aronen in *LTUR*. My discussion will follow the more traditional reading of the text here.

28 As argued by Donati and Stefanetti 2006, 58.

29 See Coarelli 2012, 15–29, with map at fig. 6, and Wiseman 2013, 239–40, for detailed discussion of the options, which reveal a variety of different foundation stories. As Coarelli 2012, 185, argues, there was a ring of shrines (several for *lares*) that marked the boundary of the Palatine hill itself.

in the topography of Rome in his own day. It is possible that his sources for this early boundary included the emperor Claudius himself, whether in a speech to the senate or in a written text or inscription.[30] However that may be, *lares* were closely identified in various ways both with the time of its founding and with the delineation and protection of its sacred boundary. A *pomerium*, which defined the sacred space of Rome and also the power of her magistrates, was guarded and marked out by *lares*.

The altar of Consus in the Circus Maximus, also alluded to by Tacitus, is attested by a passage in Tertullian, in the context of a discussion of Consualia, a festival of the agricultural god Consus, which provided the occasion for the rape of the Sabine women according to the traditions about Romulus.[31]

Et nunc ara Consi illi in circo demersa est ad primas metas sub terra cum inscriptione eiusmodi:
CONSUS CONSILIO MARS DUELLO LARES + coillo POTENTES
(corrupt Latin)
Sacrificant apud eam nonis Iuliis sacerdotes publici, XII. Kalend. Septembres flamen Quirinalis et virgines.

Even now the altar of that Consus is sunk underground in the circus (Circus Maximus) at the first turning post with this inscription:
Consus powerful in counsel, Mars powerful in war, lares powerful in [??]
The public priests sacrifice there on the nones of July; the flamen Quirinalis and the Vestal Virgins (sacrifice there) on the twelfth day before the *kalends* of September.

(Tertullian *Spect.* 5.7)

Tertullian depicts for us an ancient cult site that was celebrated with official sacrifices carried out by some of the most important priests of civic religion on fixed festival days. The site is described as being at the first turning post, within the racecourse of the Circus Maximus itself. It honored three different deities, namely Consus (sometimes assimilated to Neptune), Mars, and plural *lares* without an epithet. These gods are called upon as powerful (*potentes*), Consus in giving advice (*consilio*) and Mars in war (*duello*). Unfortunately, the text is corrupt when it comes to the area in which the *lares* exercise their power.[32] Tertullian attests that in his day, in the late second to early third centuries AD, this subterranean altar was still being used on the prescribed days in the traditional religious calendar. The three days of ritual observance were 7th July, 21st August, and 21st December: the subterranean altar was apparently only uncovered on these days.[33]

While the cult is probably ancient, we may imagine that the subterranean altar was restored over time, as the circus itself developed. Since this altar is mentioned by Tacitus as an important point on a *pomerium* attributed to Romulus, it may have been Claudius who (re)built and (re)imagined this site at the time when he was

30 Boatwright 1984–85 discusses the possible sources Tacitus is using and earlier scholarship on this question.

31 For the altar of Consus, see conveniently Ciancio Rossetto in *LTUR*. For the rape of the Sabine women, see Livy 1.9–13 and Plutarch *Rom.* 15 and 19.

32 Robert Palmer had thought of an allusion to garlands here.

33 22nd December is the birthday of the temple of *lares permarini* on the Campus Martius.

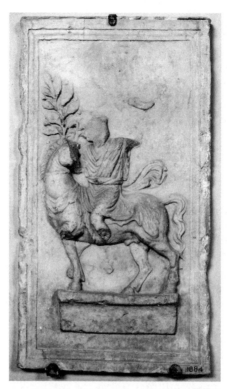

II.6. Carved marble plaque with relief of a *lar* on horseback holding a *rhyton* and laurel branch. 39×70 cm. Musei Vaticani, inv. 1884.

establishing his own new boundary for the city.[34] The association of *lares* with Mars naturally recalls the Arval hymn (discussed in section I.ii). The cult and festival of Consus was imagined as belonging to the earliest time in the city, a legendary time before the first Romans had found their wives.

Let us focus briefly on the image of the earliest city boundary (*pomerium*), the one described as being established with a plow by Romulus himself. Several points on the *pomerium* were associated with cults of *lares*. It is possible that three of these *lares* cults (*grundiles, praestites,* and the cult at the altar of Consus) were situated on or very near "Romulus' *pomerium*" (whether itself archaic or a learned reconstruction), although Tacitus does not mention them by name. These shrines may have had similar forms; we hear of one *fanum* (*lares grundiles*), two *sacella* (*lares querquetulani* and Tacitus' *sacellum larum*), and two altars (*arae* for *lares praestites* and *lares* in the Circus Maximus). Presumably, there should also be a connection between the named *lares* and the old unnamed protectors of Rome, called upon by the Arvals, the general in the *devotio,* and perhaps to be found at the altar to Consus, gods who probably had their main temple *in summa sacra via.*

34 For the complex history of the *pomerium,* see esp. Andreussi in *LTUR.* Carandini 2011, fig. 18, offers a reconstruction of this first ritual boundary marking out the Palatine, based on a *sacellum Larundae* rather than a shrine for *lares.*

In the end, strikingly little information survives about these "older," more individualized *lares* in a world so thoroughly permeated by domestic and compital shrines for local *lares* who had come to conform to a very standardized types. A vicus on the Aventine named for winged *lares* may suggest another variety whose iconography has not survived.[35] Similarly, one may also note a small marble relief panel in the Vatican depicting a unique *lar* on horseback.[36] (See figure II.6.) This may be a rendering of a statue, to judge by the stylized rock base the horse is standing on. Despite some deliberate damage, especially to the heads, we can see that the *lar* was originally holding up a *rhyton* in his left hand. The laurel in his right hand is reminiscent of *lares* on Delos, as well as Augustus' laurel trees. Although he is seated (on a saddle of panther skin), the movement of his clothes recalls the typical dancing type of *lar*. He may also have been a local *lar* in Rome.

In the end, Ovid playfully evokes a lost world of archaic cults for named and individualized *lares* in deliberate contrast to the uniformity of the *lares augusti*, so new in his day. Both types of *lares* cult provided sources for his humor about antiquarian religious lore but also for reflection about the nature of traditional religion and the fragility of its tiny shrines, in the particular context of the new marble city being built by Augustus over several decades of Ovid's lifetime.

35 *Vicus larum alitum* (XIII.9 with Lega in *LTUR*). Attempts to explain away the iconography as a misunderstanding of a different statue beg the whole question.

36 Vatican inv. 1884 (Museo Chiaramonti): *LIMC* no. 90 is 39 cm × 70 cm.

XIII CROSSROADS SHRINE: *COMPITUM*

> septima iam plenae deducitur orbita lunae,
> cum de me et de te compita nulla tacent
> —PROPERTIUS 2.20.21–22

In contrast to temples and smaller cult sites for named *lares*, shrines at the cross-roads (*compita*) were the most numerous and visible outdoor religious sites in Rome. These small shrines all honored the *lares compitales* in their role as patrons and protectors of the local area and its boundaries, whatever its urban character might be (residential, commercial, sacred). Many artisans and traders will in any case have lived above or even in their workshops or stores, a situation that made the distinction between domestic and commercial space ambiguous. At least in simple numerical terms, there will have been more shrines to *lares* inside domestic spaces, as *insulae* (housing many households in multi-storied apartment buildings) multiplied with the growth of the city's population. But most of those would have been accessible to only a few people, either within small apartments or in kitchens that had evolved as separate rooms in the houses of the more affluent. Consequently, it was the *lares* at the crossroads who were most visible and who watched over inhabitants and visitors alike throughout the urban landscape. It was these special neighborhood *lares* shrines, together with those at the hearth, that were at the heart of Roman religion in its most everyday and local setting.

The compital shrine was a place of worship where the largest cross section of Roman society could (at least potentially) perform common ritual actions, regardless of social status, ethnicity, or gender, simply on the basis of living locally. From the most lavishly adorned aristocratic bride on her wedding day to the humblest slave who had just arrived in the city, each greeted and relied upon these *lares* at the crossroads, especially at moments of transition in their personal lives. According to our evidence, the shrines on the streets seem to have been in the care of freedmen, those who had found a path to freedom from slavery and who had, therefore, already been familiar with domestic and local *lares* during their time of servitude.

A *compitum* is defined for us by ancient authors simply as a place where several roads meet.[1] As usual, Varro serves as an important guide.

> Compitalia dies attributus laribus vialibus: ideo ubi viae competunt tum in competis sacrificatur. quotannis is dies concipitur.

> Compitalia is a day dedicated to the *lares* of the roads: for that reason sacrifice is offered at crossroads shrines where the roads meet. This day is observed every year.

> (Varro *LL* 6.25)

This testimony can be supplemented by a later commentary on the satirist Persius.

1 Porph. on Horace *Sat.* 2.3.25: *compita sunt loca in quae multae viae competent* (*compita* are places where many roads come together). For a full list of references, see *TLL compitum* (3.0.2075.53–2077.73).

Compita sunt loca in quadriviis quasi turres, ubi sacrificia finita agricultura
rustici celebrabant; merito pertusa, quia per omnes quattuor partes pateant.

Compita are places like towers where four roads meet, where peasants cele-
brate sacrifices after their agricultural work is finished. For good reason they
are open, since they are accessible from all four directions.

(Schol. Pers. 4.28)

The term *compitum*, from *competo*, meaning to "come together," therefore, refers
both to the crossroads itself as a physical space and by extension to the shrine for
lares set up to mark this spot. These crossroads, as described by most ancient sources
and commentators, are the meeting points of several roads, whether three or four
or more.[2] The shrines are not, therefore, explicitly said to be found on each street
corner. They might also be imagined as being situated in the middle of a crossroads
like modern traffic lights. Moreover, the term *via*, used in the texts cited earlier, usu-
ally describes a major road, originally one that was located outside town. None of
the extant definitions uses the term *vicus* ("street in town") or *clivus* ("street on a hill
in town"). Both descriptions, therefore, are specifically of *compita* outside a town.

By definition, therefore, a *compitum* is a religious location protected by *lares*.
In the countryside, a *compitum* indicated the place where several properties met,
forming a type of "corner" between the fields. Here, altars were set up where the
property owner, his freedmen, and his slaves would honor the *lares* who guarded
the boundaries of the fields and the whole estate. Each owner, therefore, reinforced
his own claim to the land at the same time as duly acknowledging the property
of his neighbors or the public character of common land next to his farm. In town,
a crossroads marked the meeting point between various streets (usually called vici
or *clivi*), rather than a simpler boundary between individual properties. We have
no explicit evidence about whether one type of *compitum* was older. In any case,
the whole question is of little consequence for how life was lived in the historical
period, when both types of *compita* were equally familiar.

Rather, each pattern stresses the vital concept of property ownership (whether
public or private), its recognition, demarcation and protection, regardless of its pre-
cise geographical location. Logically associated with a developed sense of (pri-
vate) property were other cultural practices, such as surveying, placing inscribed
boundary stones, making maps, counting inhabitants by geographical location, and
creating names for local identities, whether on the level of the individual house-
hold, the street, or the larger topographical area. Meanwhile, many individuals who
lived in Rome also spent time in the countryside, whether regularly for seasonal
work or trade or to visit relatives or for leisure and travel.[3]

In both town and country settings, a crossroads might be larger or smaller,
grander or simpler. Compital shrines would, consequently, have taken a wide vari-
ety of forms. As will be discussed later, some had proper little "temples" on podia
with several altars in front, while others consisted of altars open to the sky in tiny
"precincts" (*sacella*); still others consisted of no more than a painting on a wall or
a niche either with a small altar below or served by a shelf or even by a temporary

2 Schol. Pers. 5.35: *ubi multae viae conveniunt in trivium vel quadrivium* (where many roads
come together, either three or four). Cf. Isidore *Orig.* 15.2.15.

3 Purcell 1994 is essential reading. See also Morley 2002.

altar erected only on certain days.[4] The situation of *compita* at intersections also resulted in them often being located near fountains.[5] It was the cult of the *lares compitales* themselves that tied all these different shrines into a recognizable and dynamic network that fostered and reflected local life.

Even as each *compitum* marked out and defined its local "corner," Rome itself was, therefore, imagined as consisting of an officially recognized network of such nodes that had been characteristic of the city from early times. Direct evidence of the official counting of *compita* is provided by Pliny the Elder, in his closely contemporary discussion of the census conducted in AD 73–74 by the emperor Vespasian and his son Titus.[6]

ipsa dividitur in regiones XIIII, compita Larum CCLXV.

[the city] itself was divided into 14 regions, 265 *compita* belonging to *lares*.
(Pliny *Nat.* 3.66)

Although this census obviously came after Rome was reorganized into fourteen regions by Augustus, which is discussed in part IV later, the habit of counting *compita* was probably much older and linked to the office of censor. Vespasian continued and revived many traditional republican practices, including the census carried out with a colleague, in order to bolster his and his son's image and position.[7] The enumeration of *compita* shows that they could indeed be recognized and counted and that this was considered a useful exercise in its own right. The *compita* are mentioned in direct relation to and as subdivisions of the fourteen regiones to which they are juxtaposed in Pliny's list. The urban landscape of the city of Rome is, therefore, described in terms of the fourteen regions *and* the 265 crossroads shrines of *lares*. These *compita* were sites for official public cult. We may imagine that any census count would tend to miss some shrines and is, therefore, more likely to have underrepresented than to have overestimated the actual existing total at any given time. There is also the issue of how reliable the text of Pliny is when it comes to the transmission of the figure 265; ultimately it is impossible to know either whether this was the precise number Pliny originally wrote down or how accurate the official count was.

Nearly all modern scholars have simply equated the *compita* of this census with vici (local neighborhoods defined as "streets"), thus positing a system of one "official" *compitum* per vicus.[8] Yet here we find the number expressed in terms of *compita larum* (without the epithet *augusti*) rather than of vici themselves. Indeed one would think that streets would be easier to count than small shrines at street

4 Marcattili in *ThesCRA* (2005, 222–24) asserts that the small temples are most typical (*naiskos* in Greek), but this is not evident from our ancient sources. He also notes the loss of republican *compita* as a result of so much restructuring under Augustus. Stek 2009, 203–12, gives an excellent overview, especially for the evidence about *compita* outside Rome.

5 Frontinus *Aq.* 2.97 with Pisani Sartorio 1988, 32.

6 For discussion, see Gesemann 1996, 88–89, and Lott 2004, 87–88.

7 Vespasian's traditional census was the last one to be held for a duration of eighteen months, according to the republican pattern. See Levick 1999, 93 and 171 with n. 3. For Claudius' census exactly twenty-five years before, see Levick 1990, 98–101.

8 For those who equate *compita* with vici, see for example, Wallace-Hadrill 2008, 266. Note Tarpin 2014, who stresses how little ancient evidence directly links the vici with the *compita*. This issue is discussed later in section III.xx.

corners. If the aim was to count the vici/streets, then why not simply do so? More-over, the *compita* take on a different topographical and administrative meaning if we recognize them as urban nodes, where several streets met. Their definition in the later authors consistently stresses their character precisely as meeting points where streets diverge but neighbors converge.

Similarly, many discussions have assumed that the number 265 in Pliny can be used for other times in the city's history, for example the age of Augustus.[9] This cannot be the case, especially when we consider the huge changes to the urban landscape in the 60s AD, caused initially by the great fire of AD 64, followed by much clearing, but soon by further destruction during the civil strife that ensued in the struggle for power after the death of Nero. During Vespasian and Titus' cen-sorship in the early 70s much rebuilding and redesigning was still under way. The number of recognizable *compita* may well, therefore, have been lower at this time than either under Augustus or subsequently, in the city of the high empire. Pre-sumably, the point of counting the *compita* was precisely that their number did not stay the same over the years, whereas the fourteen regiones remained in place from 8–7 BC to the end of antiquity. Pliny's formula, therefore, juxtaposes a fixed num-ber of larger administrative units (fourteen regiones) with a number of local shrines that was in flux (265 *compita larum*).

In the present state of our evidence, we are not able to reconstruct a reliable over-view of this network of compital shrines in Rome at any particular historical mo-ment. We cannot measure either the frequency of individual types of shrines or the pattern of their density and overall distribution. As the city grew and developed, *compita* would have been added or removed on a regular basis. Some were in place for centuries, but others may have lasted only a short time or may even have been deliberately installed on a temporary basis. Presumably, major crossroads *should* have had such shrines as a matter of course; in practice modest intersections *could* also be marked in this way. For reasons of space and land use, some shrines for *lares compitales* may also have been constructed near but not actually at an intersection. Even as some houses had many domestic shrines of various sorts, as we see in Pom-peii, so also some neighborhoods will have had numerous street shrines according to the religious tastes and resources of the local inhabitants. The more general topic of local shrines (*sacella*) for a range of deities is discussed in the next section. Mean-while, *compita* do not have an attested relationship with the twenty-seven myste-rious shrines of the Argei (sacra Argeorum), which were arranged in a different but ancient network of local shrines: these had traditional, fixed locations that did not change over time.[10]

The first establishment of *compita* was attributed, at least by the first century BC, to King Servius Tullius, the popular, reforming monarch who was imagined as the author of many basic features of Roman political life in a complex set of

9 Beard, North, and Price 1998, 184: "In 7 BC Augustus divided Rome into fourteen districts and 265 wards." This view is shared by (among many others) von Hesberg 1988, 109; Fröhlich 1991, 27; Scheid 2001b, 102; Lott 2004, 87–88; Fraschetti 2005, 234; Wallace-Hadrill 2008, 275, 290, 295; and Orlin 2010, 212.

10 For the shrines of the Argei, see Coarelli in *LTUR*, with Ziólkowski 1998–89 and Wallace-Hadrill 2008, 260–64. There is not much evidence that Augustus patronized these shrines in any-thing like the systematic way that he approached the *compita*.

multilayered traditions.[11] In this context, it is interesting to note that the named *lares* shrines (*grundiles, praestites,* Tacitus' *sacellum larum*) are associated with the foundation of the city and the guarding of its boundary, much earlier than Tullius' reign (mid-sixth century BC?). In legendary or historical terms, there was, therefore, a distinction in Roman thought between the *sacella* next to the walls or on the *pomerium* and the *compita,* inside the city at the crossroads. Meanwhile, the *compita* are connected, at least loosely, with the establishment of the city of the four regiones, also attributed to Servius Tullius, which existed until the Augustan urban reforms of 8–7 BC. Nevertheless, there is no evidence for a systematic or coherent overall narrative that created a history of *lares* and their shrines in Rome.

Dionysius of Halicarnassus, who lived in Rome for twenty years starting around 30 BC, is our main informant about the king's initiatives in the city. He was writing in the early years of Augustus.[12] He shows no knowledge of the urban reforms that would soon give the imperial city its decisive shape, based on the fourteen larger administrative units (regiones). At the same time, it is interesting that Livy does not choose to include any of the same detail, which must surely have been known to him. Not surprisingly, elite Roman historians writing in Latin do not seem to have been interested in recording the history of local *lares* shrines.

Ὁ δὲ Τύλλιος, ἐπειδὴ τοὺς ἑπτὰ λόφους ἑνὶ τείχει περιέλαβεν, εἰς τέτταρας μοίρας διελὼν τὴν πόλιν καὶ θέμενος ἐπὶ τῶν λόφων ταῖς μοίραις τὰς ἐπικλήσεις, τῇ μὲν Παλατίνην, τῇ δὲ Σουβουράνην, τῇ δὲ τρίτῃ Κολλίνην, τῇ δὲ τετάρτῃ τῶν μοιρῶν Ἰσκυλίνην, τετράφυλον ἐποίησε τὴν πόλιν εἶναι, τρίφυλον οὖσαν τέως· καὶ τοὺς ἀνθρώπους ἔταξε τοὺς ἐν ἑκάστῃ μοίρᾳ τῶν τεττάρων οἰκοῦντας, ὥσπερ κωμήτας, μήτε μεταλαμβάνειν ἑτέραν οἴκησιν μήτ' ἄλλοθί που συντελεῖν, τάς τε καταγραφὰς τῶν στρατιωτῶν καὶ τὰς εἰσπράξεις τῶν χρημάτων τὰς γινομένας εἰς τὰ στρατιωτικὰ καὶ τὰς ἄλλας χρείας, ἃς ἕκαστον ἔδει τῷ κοινῷ παρέχειν, οὐκέτι κατὰ τὰς τρεῖς φυλὰς τὰς γενικὰς ὡς πρότερον, ἀλλὰ κατὰ τὰς τέτταρας τὰς τοπικὰς τὰς ὑφ' ἑαυτοῦ διαταχθείσας ἐποιεῖτο, ἡγεμόνας ἐφ' ἑκάστης ἀποδείξας συμμορίας, ὥσπερ φυλάρχους ἢ κωμάρχας, οἷς προσέταξεν εἰδέναι, ποίαν οἰκίαν ἕκαστος οἰκεῖ. Ἔπειτα κατὰ πάντας ἐκέλευσε τοὺς στενωποὺς [ἱερὰ] ἐγκατασκευασθῆναι καλιάδας ὑπὸ τῶν γειτόνων ἥρωσι προνωπίοις καὶ θυσίας αὐτοῖς ἐνομοθέτησεν ἐπιτελεῖσθαι καθ' ἕκαστον ἐνιαυτὸν πελάνους εἰσφερούσης ἑκάστης οἰκίας· τοῖς δὲ τὰ περὶ τῶν γειτόνων ἱερὰ συντελοῦσιν ἐν τοῖς προνωπίοις οὐ τοὺς ἐλευθέρους, ἀλλὰ τοὺς δούλους ἔταξε παρεῖναί τε καὶ συνιερουργεῖν, ὡς κεχαρισμένης τοῖς ἥρωσι τῆς τῶν θεραπόντων ὑπηρεσίας· ἣν ἔτι καὶ καθ' ἡμᾶς ἑορτὴν ἄγοντες Ῥωμαῖοι διετέλουν ὀλίγαις

11 Servius Tullius: Thomsen 1980; Cornell 1995, 129–42 and 202–3; Poucet 2000, 351–58; Vernole 2002 (with full discussion of earlier bibliography); and Forsythe 2005, 101–8. This king is the subject of widely varying traditions (in Rome and in Etruria) as regards both his birth and his role as a second founder who reformed the army and the city, establishing its four regiones and the sacred *pomerium.*

12 For Dionysius of Halicarnassus (born around 60 BC and, therefore, only slightly younger than Augustus), Gabba 1991 remains the classic treatment. It is interesting to note that Livy describes Servius Tullius much more rationally in his first book, and does not speak about either a divine birth or a role as a religious innovator. Dionysius is our only surviving source to link Servius Tullius with many initiatives on the local level, especially those to do with *pagi* and vici. For his use of sources and the antiquarian character of his writing, see Northwood in *FRHist* vol. 1, 61–64, with Tarpin 2002, 101–6, and Lott 2004, 30–37.

ὕστερον ἡμέραις τῶν Κρονίων, σεμνὴν ἐν τοῖς πάνυ καὶ πολυτελῆ,
Κομπιτάλια προσαγορεύοντες αὐτὴν ἐπὶ τῶν στενωπῶν· κομπίτους γὰρ
τοὺς στενωποὺς καλοῦσι· καὶ φυλάττουσι τὸν ἀρχαῖον ἐθισμὸν ἐπὶ τῶν
ἱερῶν, διὰ τῶν θεραπόντων τοὺς ἥρωας ἱλασκόμενοι καὶ ἅπαν τὸ δοῦλον
ἀφαιροῦντες αὐτῶν ἐν ταῖς ἡμέραις ἐκείναις, ἵνα τῇ φιλανθρωπίᾳ ταύτῃ
τιθασσευόμενοι μέγα τι καὶ σεμνὸν ἐχούσῃ χαριέστεροι γίνωνται περὶ τοὺς
δεσπότας καὶ τὰ λυπηρὰ τῆς τύχης ἧττον βαρύνωνται.

After Tullius had surrounded the seven hills with a single wall, he divided the
city into four regions, which he named after the hills, calling one the Pala-
tine, the next the Subura, the third the Colline, and the fourth of the regions
the Esquiline; and he made Rome a city of four tribes, whereas it previously
had consisted of only three. And he ordered that the inhabitants of each of
the four regions should, like people in villages, neither take up another resi-
dence nor be enrolled elsewhere; and the levies of troops, the collection of
taxes for military purposes, and the other services which every person was
bound to provide to the state, he no longer based upon the three tribes orga-
nized by descent, as before, but upon the four geographical tribes he estab-
lished. And over each region he appointed leaders, like heads of tribes or
villages, whom he ordered to know which house each person lived in. After
this he commanded that there should be set up in every street by the neigh-
bors shrines to the heroes whose images were in front of the houses, and he
made a law that sacrifices should be performed to them every year, with each
family contributing a honey cake. He enjoined also that the persons perform-
ing the sacrifices at these shrines on behalf of the neighborhood should not
be assisted by free men, but by slaves, the service of slaves being considered
pleasing to the heroes. This festival the Romans still continued to celebrate
even in our day in the most solemn and sumptuous manner a few days after
the Saturnalia, calling it the Compitalia, after the streets: for *compiti*, is their
name for streets.[13] And they still observe the ancient custom in connection
with those sacrifices, propitiating the heroes by the ministry of their slaves,
and during these days removing every mark of their servile condition, in order
that the slaves, being softened by this instance of humanity, which has
something great and solemn about it, may make themselves more agreeable
to their masters and be less oppressed by the painful condition of their fate.
(Dionysius of Halicarnassus *Ant. Rom.* 4.14)

This account envisages a single reform that created the urban structure of the city
of Rome a generation before the kings were expelled and a republican from of gov-
ernment emerged. Dionysius, writing as an outside observer with a distinctly
Greek perspective, is clearly attracted to the figure of Servius Tullius as a lawgiver
and founder of military, civic, and urban life. He highlights local life with an em-
phasis on the *compita*, the annual winter festival of Compitalia, and the role of the
slaves in the service of *lares*. Dionysius evokes a vivid sense of the popularity and
impact of the joyful annual festival celebrated throughout the city during the 20s
and teens BC.

13 Poucet 2000, 357 n. 167, has argued that the form *kompitous* in the Greek reflects the ar-
chaic Latin compitus (masculine), rather than *compitum* (neuter) found in classical Latin.

The egalitarian character of this midwinter celebration is especially striking to Dionysius. He remarks on the freedoms and responsibilities allowed to slaves during this time of year, a practice that he feels must have a religious explanation, since it does not make sense to him. He is unaware of the leadership roles and social mobility of the freedmen leaders of the cult (*vicomagistri*), whose festival clothes he has apparently seen. He also does not mention neighbors from different streets meeting at the crossroads, which was the most basic function of the celebration. Since the freedmen presiders were wearing the *toga praetexta*, it is not surprising that he does not notice their unusual status and roles. He evidently takes them to be freeborn and even elites. He is surprised to see slaves assisting these presiders, although slaves had regular roles in many aspects of civic cult attending the highest priests and magistrates.

He has apparently not engaged many local celebrants in conversation to gather more information about what the festival meant to them. His observation of the honey cake is interesting, but he does not mention the many other parts of the customary ritual, whether the *lustratio* procession around the local area, the banquet of meat from the sacrificed pigs, or the hanging of woolen dolls and balls at the *compita* (section III.xvii later). His description of the *lares* as "heroes before the doors" recalls their depiction on the walls of houses in Delos (section III.xviii later), and, therefore, probably also elsewhere in the Greek East, rather than drawing on a specifically Roman source or observing the celebrations in person.[14] He may be suggesting painted images rather than statues.

His stress on the freedom given to slaves is much more reminiscent of the role reversals so typical of Saturnalia, the most important midwinter festival, than of the Compitalia, which he realizes follows soon after, although he has not understood that this second celebration is a movable feast. Consequently, it is quite possible that he has indeed confused elements of the two festivals, which would in practice have been easy to do, since the time between the two celebrations in December was relatively short. Certainly, his narrative does not constitute independent evidence for a reversal of social roles at the Compitalia, a feature not mentioned by other sources. He also does not put either festival into any relationship with the New Year on 1st January. Dionysius' error in calling the roads themselves *compita* reveals both a basic confusion made by a foreigner but also what was probably a practical reality about the relationship between the street and the crossroads shrine, whose cult brought the population together and defined local identity.

Dionysius does not make an explicit connection between Servius Tullius imagined as the son of the household *lar* in the royal hearth, a legend he discussed earlier in this same book, and the *lares* cult at the crossroads that the king is credited with founding.[15] Dionysius, therefore, provides interesting but essentially incomplete information about both the cult's traditions and its annual festival in the first generation after Actium. Consequently, it is also hard to know how reliably his narrative reflects all the details of the origin story about King Servius Tullius, or whether the figure of the founder played any part in the way the festival was celebrated by the late first century BC. In effect, Dionysius simply attests to a showy

14 Anniboletti 2008, 2010, 2011 catalogues the shrines near doors in Pompeii and argues that they are for the *lares viales*, in the manner of the cult on Delos and of the customs described by Dionysius.

15 Dionysius of Halicarnassus 4.2.

celebration of Compitalia attended by slaves in the 20s and teens BC, to the honey cakes, and to its connection with Servius Tullius in some of his antiquarian sources.

Many of the most commonly cited Roman authors, both in prose and verse, refer to *compita*.[16] Virtually all these references do not name a specific *compitum* but refer to them either as a type of shrine in general or individually, but without a distinguishing name or a precise description. Allusions to *compita* range from the emotional and personal to the official, from administrative functions to religious rituals, from private to public in a wide variety of literary contexts and genres. Rural and city *compita* have different characteristics and associations in these ancient texts. Typically, these references are made in passing and do not give more than an overall impression of these familiar shrines as background to Roman life.

Given the modest dimensions of most compital shrines, it has not been easy to identify them in the archaeological remains of Rome, especially in the historical center of the old city where the stratigraphy is so complex and where even significant republican structures were already being destroyed during the first century AD. In addition, it is only relatively recently that archaeologists have become interested in small, local shrines in their own right. As a result, the examples from Rome that follow are few and far between. Every instance has unfortunately relied upon hypothetical arguments and deductions based on a priori positions by the excavators. At the moment, no ancient *compitum* is visible to a modern visitor.[17]

Similar challenges apply to reading our other major source for the city in antiquity, the surviving fragments of the Severan marble plan of Rome (supplemented in some areas by the much smaller pieces of earlier maps of the city).[18] Many details of the city's topography are attested only by the Severan map. One might imagine that an official network of *compita* would have been rendered in some way on maps used by magistrates and emperors. For present purposes, it is significant that quite a bit of the information on the Severan marble plan seems to have been copied (sometimes not carefully) from earlier maps rather than being based on an up-to-date survey of the city compiled in the early third century AD. Only very few examples of small structures at major crossroads have been recorded and might be identified as possible compital shrines.[19] None of these is labeled as a *compitum* on the marble plan itself. Either, therefore, *compita* were not marked on this (type of) map or they were indicated in ways no longer visible to us, perhaps by use of a certain paint color to indicate each shrine or by some other convention. Some important features do seem to have been painted in, such as the Tiber River, which is a blank on the surviving fragments. In other words, the marble plan confirms the theory that most compital shrines were very small. They, therefore, lacked an

16 Examples of *compita* in Latin authors include: Vergil *Georg.* 2.382; Horace *Sat.* 2.3.281, 2.6.50, *Epist.* 1.1.49; Prop. 2.22.3, 4.1.23; Livy 27.23, 34.2, 38.36; Martial 7.97.12, 9.122.

17 See Andrews and Flower 2015 for the argument that the shrine of Mercury on the Esquiline is not a compital shrine.

18 See now the Stanford digital version of this important map: http://formaurbis.stanford.edu, which includes an introduction and full bibliography, as well as a searchable database of the 1,186 surviving fragments. Only about 10–15 percent of this very detailed early third century map survives, so it does not give an overview of the city's neighborhoods. An insightful discussion can be found in Wallace-Hadrill 2008, 301–12. For fragments of earlier maps, see Rodríguez Almeida 2002.

19 Possible *compita* on the Severan marble plan: frags. 1, 11c (identified as the lacus Orphei fountain at a major intersection in the Subura, but possibly [including?] a *compitum*), 18a, 28c, 300ab, 412ab, 554, 661a, and 681.

identifiable "footprint" to be recorded on this kind of incised map, which is drawn to a standard Roman scale of 1:240.[20]

In the present state of our evidence, the list of known compital shrines in Rome is not long. The standard count contains twenty-two possible *compita*.[21] Only five of these have their ancient names attested in our extant sources (Compitum Acilium, Fabricium, Monti Oppii, Aliarium, Pastoris). Two of these names relate their crossroads shrines to families (the Acilii and Fabricii) and one to an unnamed class of individual (a singular herdsman or shepherd, simply called *pastor*). The Mons Oppius indicates a specific location, while the mention of garlic (*alium*) is unexplained.[22] The evidence from ancient authors may, however, also suggest that these individual names were not much used outside specific legal and topographical contexts. Indeed, we may ask whether all or most *compita* necessarily had individual names. Addresses in Rome were usually given by vicus and were, therefore, general rather than specific.[23]

This naming pattern, such as it is, seems to reflect the person or more usually the group of people who have paid to provide the land and to set up the shrine, in the same way that the builders of public buildings would put their names on them (for example, basilica Aemilia).[24] These same families may have continued to maintain shrines over time, even as they were expected to keep up temples and other buildings set up by relatives and ancestors. These shrines, like the larger temples, were considered public and their rituals were recognized as part of the civic religion. Even when they carry a family name, *compita* do not, therefore, tell us about family or gentilicial cult. These names do, however, indicate that this family was or had been prominent in the local neighborhood and probably lived or owned property very near the *compitum*, at least at the time of its construction.

Whether or not we accept Pliny's number of 265 *compita* as a realistic reflection of actual conditions in the 70s AD, it certainly seems plausible that there would have been hundreds of *compita* in a city the size of imperial Rome. By way of comparison, 66 names of vici have survived on the Capitoline Base inscribed in AD 136, of which 32 vici are securely in evidence under Augustus.[25] The *Lexicon Topographicum Urbis Romae* has entries for about 130 named vici on the basis of all types of extant ancient evidence, but only for 5 *compita*, since so few are mentioned by name. In fact, only a single (named) crossroads shrine in Rome, the venerable Compitum Acilium, is both attested in the literary sources and has definitely been identified in the archaeological record. I will now discuss the evidence for the four best-attested possible *compita* that have been excavated in Rome, namely the Compitum Acilium, the *compitum* at the Meta Sudans, the *compitum* at S. Omobono, and the street shrine at the intersection of the Sacra Via and the

20 For this standard scale within the history of Roman mapmaking, see Talbert 2012, 163.

21 Pisani Sartorio 1988 with an approximate map. Her reconstruction is widely accepted.

22 For the Oppius Mons, see *CIL* 1² 1003 = 6.32455 = *ILS* 5428 = *ILLRP* 698 = EDCS-21600036. The mention of garlic may recall the story that heads of garlic were offered to the *lares* instead of human sacrifice, on the initiative of Junius Brutus, the first consul; see Macrobius *Sat.* 1.7.35 with Pisani Sartorio in *LTUR* (s.v. Compitum Aliarium).

23 Roman addresses: Tarpin 2002, 124–26.

24 Van Andringa 2009, 94–99, notes that some compital shrines in Pompeii seem to be associated with large houses.

25 Capitoline base: *CIL* 6.975 = 31218 = *ILS* 6073 = *EDCS* 46000015, with Wallace-Hadrill 2008, 288, and Coarelli 2012, 113–14. For the city under Augustus, see Haselberger 2002, with a convenient map.

Clivus Palatinus. Material from other Augustan *compita*, much of which was found in situ, is treated in sections IV.xxv and xxvi later. The shrine at the entrance to the house of the Vestals appears as the last item in the present section.

Compitum Acilium

The Compitum Acilium was apparently already a well-known landmark in Rome in the third century BC, when the first Greek doctor, Archagathus son of Lysanias from the Peloponnese, was given a space at public expense on land purchased at this local shrine to open a public practice in the city.[26] Pliny tells us that in the year 219 BC, close to the time when Hannibal invaded Italy[27]:

> Cassius Hemina ex antiquissimis auctor est primum a medicis uenisse Romam Peloponneso Archagathum Lysaniae filium, L. Aemilio M. Livio consulibus anno urbis DXXXV, eique ius Quiritium datum et tabernam in compito Acilio emptam ob id publice. vulnerarium eum fuisse credunt, mireque gratum aduentum eius initio, mox a saeuitia secandi urendique transisse nomen in carnificem et in taedium artem omnesque medicos, quod clarissime intellegi potest ex M. Catone....

> Cassius Hemina, one of the oldest authorities, tells us that the first doctor to have come to Rome was Archagathus, son of Lysanias from the Peloponnese, in the consulship of Lucius Aemilius and Marcus Livius in the 535th year of the city [219 BC], and that he was given Roman citizenship and a shop was bought at the Compitum Acilium for this purpose with public money. They thought he was a treater of wounds, and at first his arrival was greatly welcomed. But soon, as a result of his savagery in cutting and burning his name was changed to executioner and people were appalled by his practice and by all doctors, which is most clearly exemplified by [the opinions expressed by] Marcus [Porcius] Cato....
>
> (Pliny *Nat.* 29.12–13, Peter F 26 = Santini F 28 = Chassignet F 29 = *FRHist* 6 F27)

Public money was used to buy the office (*taberna*) used by the doctor, who had been given Roman citizenship. Subsequently, this whole area came to be identified with medical practice of various kinds, despite the mixed reactions to Archagathus' Greek methods of surgery and cauterization.[28]

In the late third century BC, therefore, the land on which the crossroads shrine stood probably still belonged to the prominent, senatorial family of the Acilii Glabriones and space was available for a building to house the doctor next to the shrine, perhaps even on land that had been part of its precinct. The *taberna* in question

26 For the Compitum Acilium, see Dondin-Payre 1987; Pisani Sartorio 1988, IV.2, and in *LTUR*; and von Hesberg 1988, 398–400. For the Augustan material, see also Hano 1986, no. 5; Lott 2004, nos. 12 and 27; and Bergmann 2010, no. 17 (the altar). Lysanias was probably also a doctor to judge from his "healing" name. Palmer 1973 gives an overview of the neighborhood.

27 For commentary on L. Cassius Hemina, see especially Briscoe in *FRHist* 6 F 27.

28 Palombi 1997–98 and 2007 discusses the topography of medical practice throughout antiquity, with very full earlier bibliography.

had perhaps been a preexisting "shop" previously used for a different purpose near the *compitum*. Scholars have posited a suite of purpose-built rooms on the analogy of Hellenistic medical buildings in the East, but without any specific evidence.[29] Meanwhile, Pliny's words show that it is not the family who installs the doctor here; rather the land is purchased with public money to establish what would be a public medical practice. There is no reason to think the doctor himself owned his office. Rather his establishment and services were being provided at public expense. The Compitum Acilium would, therefore, also have been a convenient and easily identifiable address for the doctor's practice, a precise spot rather than the more usual identification of an address only by vicus. The location of the doctor's practice next to the shrine of the *lares* here allows us a glimpse of a *compitum* as a particular node within an individualized local landscape.

Remains of the shrine from the time of Augustus were discovered in 1932 on the modern Clivo di Acilio, at the transition point between the Esquiline and the Palatine. (See figures II.7, II.8, II.9.) The small marble sanctuary, which backed onto a building, consisted of a podium (almost square) with four steps up to a small temple that faced NE toward the Oppian hill and the Carinae district. This late first-century BC temple, decorated on the front with a typically Augustan large oak wreath (*corona civica*), had two columns in front and three along each side. The simple *cella*, much wider than it was deep, was probably completely open so that the cult statues would have been clearly visible from the street. This type of diminutive temple is depicted in a street painting of a shrine for Mercury from Pompeii, reproduced here in the vivid, watercolor rendering of Alberto Sanarica. (See plate 5.) Our lack of other evidence has inevitably made this shrine seem the canonical example of a *compitum*, whereas it would surely have been one of the larger and more lavish ones, certainly judging from the Severan marble plan. In addition to the little temple, there is also evidence of several altars in the immediate area, although their original collocation is not recorded. The *compitum*, which was dismantled after the fire of AD 64, was covered over by the foundations of Nero's golden house and further damaged by medieval construction in the area.

The Compitum Acilium was situated at a point where several roads met in a historical part of Rome, although the ancient street pattern here has not been fully identified nor have all the streets been named, and was presumably already a well-known landmark. The inscriptions from the shrine show that the *compitum* gave its name to a local vicus, whose *vicomagistri* built a little temple in honor of the new *lares augusti* in 6 BC, the year after Augustus' great urban reform.[30] The particular street called vicus Compiti Acilii has not so far been securely identified. The calendar of the Arval brothers describes the *compitum* as being next to the Tigillum Sororium.[31] Traces of a pit for votive offerings confirm the age and importance of the shrine, a venerable history that can be linked with the long influence of the Acilii Glabriones, as well as the general development of this area.

29 So, for example, Palombi 2007, 57 with nn. 9 and 10. For ancient medicine in general, see, Nutton 1986, 1993, and 2004. Evidence from Plautus and Cato attests to hostility to Greek doctors, for which see Gourevitch 1984, 289–321.

30 For the inscriptions, see *AE* 1964, 74a and b (Gregori 2001, no. 503, and = EDCS-12800187 and EDCS-12800188), with Tamassia 1961–62, and Lott 2004, nos. 12 and 27.

31 *CIL* 6.2295 = 32482 = EDCS-45300109 under 1st October fr. 1.3–4, with Dionysius of Halicarnassus 3.22.8. For the Tigillum Sororium, see Cornell 1995, 199–200.

II.7. Compitum Acilium, reconstruction drawing (after Colini 1961–62).

II.8. Compitum Acilium, excavation photograph of remains in situ (1932).

Meta Sudans

The Compitum Acilium was near (originally probably in sight of) the pivotal point where several regions and roads met at the spot later marked by the Meta Sudans, a prominent fountain built by the Flavians, whose remains were demolished in the 1930s to make way for Mussolini's new Via dei Fori Imperiali.[32] The position and

32 See most conveniently Zeggio and Pardini 2007, with colored photographs and full bibliography.

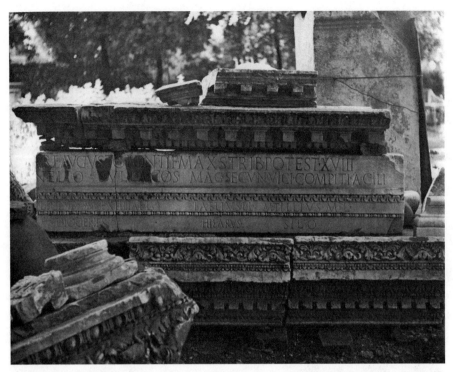

II.9. Compitum Acilium, architrave detail in the garden of the Antiquarium comunale on the Cae-
lian (1960).

aspect of this grand fountain, next to the monumental Flavian amphitheater, was a
popular subject for nineteenth- and early twentieth-century painters and photogra-
phers. (See figure II.10.) Their images, especially those from before the advent of mod-
ern traffic patterns, provide some of the best visual expressions of how important
crossroads were in articulating the urban and religious landscape of ancient Rome.

Recent excavations have shed further light on what the impact of this particular
intersection had been over many centuries. (See figure II.11.) A major shrine discov-
ered on the northeast slope of the Palatine (now identified as the Curiae Veteres)
was an important cult center from archaic times. A series of reconstructions, in-
cluding an extensive project around 80 BC, as well as a number of votive deposits,
show intense activity in the area. The first archaeologically attested fountain at
the Meta Sudans was built by Augustus, who was born nearby in 63 BC.[33] This
monument was restored by Claudius after a fire around AD 54. The area was then
involved in the construction of Nero's Domus Aurea (Golden House), which was
never finished and was demolished to make way for massive Flavian building
projects, including the much-expanded Domitianic fountain, built in the late first
century AD. Subsequently, Constantine was careful to preserve this key point in
the city's topography while he was building his monumental arch nearby.

The Augustan fountain was placed at the meeting point of four or five of the re-
giones in the new scheme of fourteen, presumably soon after the urban reforms of

33 See now King 2010 for a discussion of Augustus' birthplace in relation to his urban reforms.

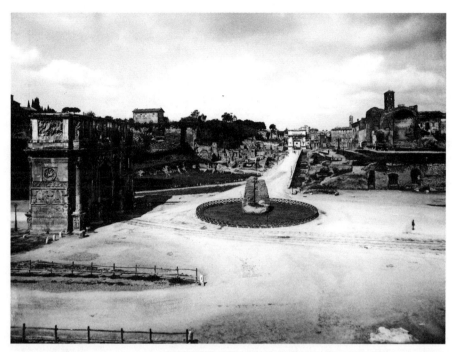

II.10. Nineteenth-century photograph of the Meta Sudans, with the Arch of Constantine on the left and the Arch of Titus straight ahead, straddling the Sacra Via.

7 BC. *Meta* is a word that can mean "turning-post" but also "limit" or "boundary."[34] Recent excavations have identified a small, open-air shrine, which seems to have been a *compitum* associated with the Augustan fountain. The fountain and adjacent shrine for the *lares* appear to form a single sacred complex marking this major crossroad, a meeting of regiones both before and after the Augustan reform of the city, and perhaps a point thought of as being on or very near the original *pomerium* of Romulus. This intersection could mark the spot described by Tacitus as associated with the Curiae Veteres. It is unclear whether a fountain or some other marker existed before the Augustan one; it is certainly plausible to posit a previous crossroads, probably on a smaller scale.

The modest Augustan *compitum* took the form of an open-air shrine (*sacellum*) on a small podium to the east of the fountain. Its footprint is very similar to that of the Compitum Acilium, but it looked completely different; there is no evidence of a building. Unfortunately, very little is left in the way of any more detailed information about this shrine. The excavators posit a simple, unroofed precinct with a single altar adjacent to the fountain. No direct evidence for the nature of the god(s) worshipped here has survived. However, this *sacellum*'s alignment puts it at this major crossroads, which makes a cult of the *lares* seem a highly plausible hypothesis. The excavators have tentatively identified the shrine as the Compitum Fabricium.[35] Varro tells us that the Compitum Fabricium was near the Curiae

34 Coarelli 2012, 88–89, has suggested that this focal point, near Augustus' birthplace, could have been the center of his new system of fourteen regiones.

35 For the Compitum Fabricium, see Pisani Sartorio 1988, I.1, and in *LTUR* with Festus 174L.

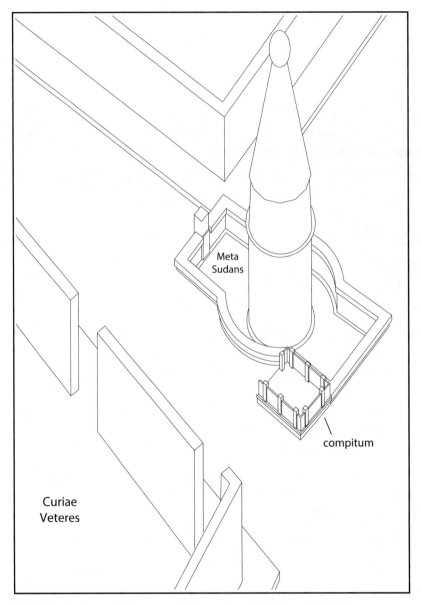

II.11. Meta Sudans *compitum*. General view and detail (after Panella 2006).

Novae, built when the Curiae Veteres of Romulus had become too small for the population.[36] As already noted, the Curiae Veteres have recently been identified at the foot of the Palatine and immediately opposite the Meta Sudans, near the eastern pylon of the Arch of Constantine. The close proximity of the Compitum Acilium to this *sacellum* at the Meta Sudans is also of immediate interest and reveals what would indeed have been a dense network of traditional shrines, at least within the older parts of the city. (See figure II.12.) Yet even at this major

36 Curiae Veteres and Curiae Novae, see Varro *LL* 5.155 and Festus 180L; Torelli on both in *LTUR*, with Cecamore 2002 and Ferrandes in Panella 2013, 118–23.

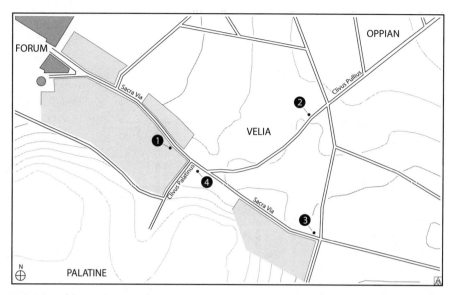

II.12. Map of three *compita* in close proximity: (1) *compitum* at the Clivus Palatinus; (2) Compitum Acilium; (3) *compitum* at the Meta Sudans; and of (4) Augustus' dedication to the *lares publici*.

crossroads, the *compitum* is small and seems not have stayed in place when Domitian built a much bigger fountain in a slightly different spot.

Sant' Omobono

Two other *compita* have been identified based on archaeological evidence but without any surviving literary references or inscriptions. One is beside the paired temples of Fortuna and Mater Matuta on the vicus Iugarius and the other is on the Sacra Via near the Clivus Palatinus. The first of these is immediately adjacent to the shared precinct for Mater Matuta and Fortuna (at Sant' Omobono) and consists of a small *compitum* situated neatly at a crossroads.[37] (See figure II.13.) This shrine, which may have been unroofed, seems to have been entirely composed of travertine blocks salvaged from an earlier monument of the Domitii, which had been erected on the Capitol near the beginning of the first century BC. It is possible that this *compitum* was built at the time of the Augustan reform in 7 BC, but it could also have been constructed earlier. There is no information about when or why the earlier monument of the Domitii was damaged or dismantled. It is also unclear what form a shrine here might have taken before the travertine building materials became available for reuse. Its orientation is strikingly independent of the two temples immediately beside it.

37 Coarelli 1988, 244, and 1991 explains the reused stones. See also Pisani Sartorio 1988, VIII.1, and Mavrojannis 1995, with fig. 8. This *compitum* was discovered in 1937 but has never been fully published in its own right.

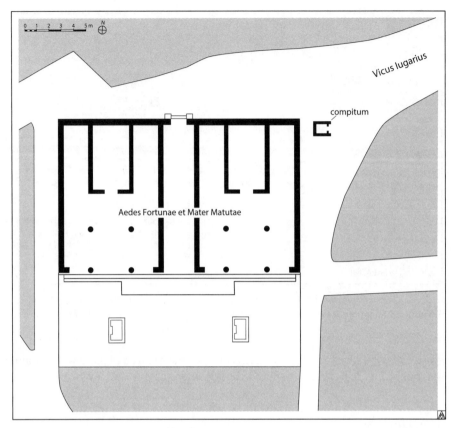

II.13. Sant' Omobono *compitum* (after Coarelli 1988).

Clivus Palatinus

Meanwhile, some traces of the foundation of what could be a *compitum* have recently come to light on the Sacra Via near the Clivus Palatinus, not far from the Arch of Titus.[38] (See figure II.14.) Interestingly, this shrine appears to be associated with a house that has been identified as belonging to Publius Clodius himself, the great cultivator of local politics and restorer of the Compitalia festival. Unfortunately, only the foundations have been found. The excavators posit a small temple like the Compitum Acilium in this space, which seems a plausible hypothesis. In this case, the identification of this small street shrine as a *compitum* for *lares* is not as self-evident from its physical location. It is situated in the middle of the block about equidistant from two cross streets on the Sacra Via. The temptation to identify this as a *compitum* erected by Clodius himself in the 50s BC in relation to his reinstitution of compital celebrations (discussed in section III.xxii) is real for the excavators, but nothing can be sure where there is so little physical evidence. It could also be a shrine to a different local god or a deity cultivated by the patrician Claudii. However that may be, this shrine was not in place for very long.

38 Carandini and Papi 2005, 125–26 with many colored reconstructions. Carandini 1988 had already identified this house as belonging to the famous tribune of 58 BC, P. Clodius.

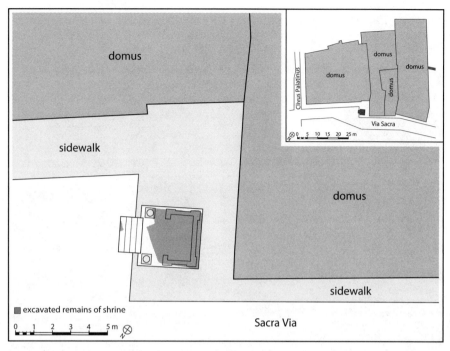

II.14. Clivus Palatinus *compitum* (after Carandini and Papi 2005).

Aedicula at the Atrium Vestae

In addition to the Compitum Acilium and Compitum Fabricium, the most prominent site identified as a *compitum* in Rome is the reconstructed shrine immediately outside the house of the Vestals on the edge of the Forum.[39] (See figure II.15.) The shrine in its present incarnation was restored by the senate and Roman people at public expense in the time of Hadrian.[40] The deity worshipped here, next to the entrance to the house of the Vestals, is not directly attested. It may have held a statue of Vesta herself, who was not represented inside her temple except in the sacred fire itself.[41] The format of the shrine is very similar to the nearby open-air sanctuary for the nymph Juturna at the lacus Juturnae, which is also not a compital shrine.

An inscription (found in 1878 at San Paolo fuori le Mura, obviously not in its original context) records the restoration by a group of *vicomagistri* of an old *aedicula* dedicated to *lares augusti* in regio VIII at the vicus Vestae in AD 223, in the time of the emperor Severus Alexander. The position of the vicus itself has not been securely identified.

39 See Coarelli on Vicus Vestae in *LTUR*, with Pisani Sartorio 1988, VIII.2.

40 *CIL* 6.31578 = EDCS-19500085: *senatus populusque Romanu[s] / pecunia publica faciendum curavit* (The senate and the Roman people saw to its construction at public expense). Compital shrines were not usually paid for with public funds.

41 Scott in *LTUR* (atrium Vestae) considers the identification of the *aedicula* to be very unsure. See Gorski and Packer 2015, 313, for an attractive argument in favor of the small shrine housing a statue of Vesta.

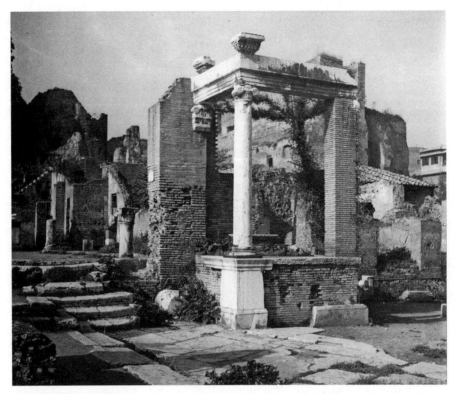

II.15. *Aedicula* at the Atrium Vestae.

Laribus Aug(ustis) et [. . . / permissu Im]p(eratoris) Caes(aris) [[M. Aureli
Alexandri P]] ii Felic[is Aug(usti), pont(ificis) max(imi), trib(unicia)
pot(estate) II, co(n)s(ulis), p(atris) p(atriae)] / aediculam reg(ionis) VIII,
vico Vestae v[etustate conlapsam] / a solo pecunia sua restituer[unt magistri
anni CXXX? . . . /] nius Pius, L. Calpurnius Felix, [. . .] / C. Iulium Paternum
praef(ectum) vigil(um) em(inentissimum) [v(irum), L. Mario Maximo II] /
L. Roscio Ae[liano co(n)sulibus) / curantibus M. Servilio Prisco et M.
Serv[ilio . . .].

For the *lares augusti* and [*gap*] by permission of Imperator Caesar Marcus Au-
relius Alexander Pius (name erased) Felix Augustus, pontifex maximus, in
the second year of his tribunician power, consul, father of the country, the
magistri of year 130? restored the small temple (or large niche) in region 8 at
the vicus Vestae, which had collapsed as a result of age, with their own money
from the ground up . . .
[*gap*]nius Pius, Lucius Calpurnius Felix, [*gap*] Gaius Iulius Paternus, pre-
fect of the *vigiles*, a most eminent man, in the consulship of Lucius Marius
Maximus (for the second time) and Lucius Roscius Aelianus, under the su-
pervision of Marcus Servilius Priscus and Marcus Servilius ? . . .
 (*CIL* 6.30960 = *ILS* 3621 = *AE* 1999.157 = *EDCS* 18600557)[42]

42 The surviving part measures 1 m×0.5 m.

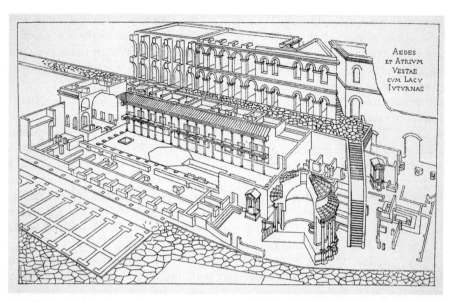

II.16. *Aedicula* at the Atrium Vestae. Reconstruction drawing of the temple of Vesta, the house of the Vestals, and the shrine at the lacus Juturnae.

This text has been used to identify this *aedicula* at the atrium Vestae as a compital shrine. This hypothesis is not supported by any direct evidence. If this inscription does not indicate a restoration of this shrine, it still provides evidence for a *compitum* nearby, which has not been identified yet in the archaeological record.

The small shrine itself, now recomposed of diverse materials, is built against the wall to the right of the door. It is, therefore, much simpler than the Compitum Acilium. It consists of only the two columns in front, which support the roof over the altar. Its position next to the door and against the wall of the Atrium Vestae, where the Vestal Virgins lived, gives it a special character all its own, reminiscent of shrines and religious paintings near doors in Delos and Pompeii, as well as the heroes by the doors mentioned by Dionysius of Halicarnassus. Perhaps most importantly, however, it is not evident that the shrine was ever accessible or visible from the street, a necessary and expected condition for a compital shrine, a shrine designed for use by the whole neighborhood. Rather there seems to have been a wall that enclosed the shrine inside the precinct of the Vestals.[43] There is also no evidence to support an identification of this shrine with the *lares praestites*, as has sometimes been suggested. In the end, therefore, it is not at all clear that this shrine was dedicated to *lares* of any kind. Nevertheless, its situation, especially in the imaginative reconstruction drawn by Hülsen in 1875, shows how such shrines (in this case, the *aedicula* at the atrium Vestae and the similar shrine at the lacus Juturnae) fitted into the urban landscape of the increasingly sophisticated imperial city. (See figure II.16.)

<p style="text-align:center">* * *</p>

43 See also Coarelli 1985, 270, fig. 69.

In summing up, it is important, therefore, to reiterate how very fragmentary our evidence for *compita* in Rome really is.[44] The only ancient town that has *compita* and other street shrines in place in significant numbers, with altars that show signs of recent sacrifice, is Pompeii. However, the Pompeian shrines, which are discussed in section II.xv later, are evidently not exactly the same as those in Rome and were not reorganized as part of the Augustan reform that introduced *lares augusti* in the capital city in 7 BC. Earlier evidence from Delos, which is discussed in more detail in section III.xviii, makes clear that compital cult could and was practiced at shrines adjusted to local conditions in a variety of urban settings and was not, therefore, invariably set up as part of either a network at street corners or as a subdivision of larger *regiones* or other urban administrative units as it was in Rome. Both on Delos and at Pompeii, the number of shrines and the devotion to their *lares* is striking. Nevertheless, it is not possible to compare the number of street shrines between towns or even within a single urban environment over time or in any detail because the evidence is too fragmentary.

Texts and inscriptions, however, show that *compita* were vital, whether in their own local settings or as part of a general network throughout the urban landscape.[45] As we have seen, Rome was conceived of as a network of *compita*, a network that brought people together in and beyond the street and neighborhood (vicus). This web reinforced a shared local culture and identity at the level of the most basic urban units of everyday life. As will be discussed in part III, through the *compita* messages, news, and goods could be distributed from the political center, inhabitants could be counted and accounted for, and religious expiations ordered to be performed by the largest number of people. All this could happen at relatively short notice precisely because the network was in place and operational on a citywide basis. At the same time, local people could use *compita* to exchange their own news and views, political or personal, with their neighbors and to register reactions to events in the city or empire. It is a result of the complex and fragmented archaeological evidence from the center of the city that we have so very little evidence for *compita* in Rome, especially for those before the extensive Augustan reform of 7 BC. The modest dimensions of most *compita* have made them hard to trace on the ground. None of the *compita* we know of in Rome were open in several directions, as the literary sources suggest that rural *compita* often were. Meanwhile, their small scale also meant that they could easily and cheaply be reconfigured as the urban landscape evolved or when a benefactor or a new source of building material became available, in an organic pattern that met local needs while it also connected each neighborhood with the larger urban environment.

44 The situation on the ground at Ostia is even more confusing.

45 *CIL* 5.3257 = *ILS* 3610 = EDCS-04202305 (Verona): walls, a roof, and doors with Boscolo 2013. See also *CIL* 5.844 = *ILS* 5394 = EDCS-01600122 (Aquileia): a *compitum* made of stone; and *CIL* 14.4710 = *ILS* 5395 = EDCS-11900486 (Ostia): walled with columns; as well as *CIL* 3.14120 = *ILS* 4052 = EDCS-29900152: a late *compitum* from Gortyn in Crete.

XIV LOTS OF SMALL SHRINES: *COMPITA* AND *SACELLA*

Nam in libro de religionibus secundo: "sacellum est" inquit,
"locus paruus deo sacratus cum ara."
—AULUS GELLIUS QUOTING C. TREBATIUS TESTA,
A FIRST-CENTURY BC JURIST, *NA* 7.12.5

As we have seen, some compital shrines took the form of *sacella*, (modest) open-air cult sites that included an altar for offerings. Festus (422L) describes this type of shrine in the following way: "unroofed areas consecrated to gods are called *sacella*" (*sacella dicuntur loca dis sacrata sine tecto*). It is vital, however, to note that not *all* such open-air precincts were *compita*, which is to say crossroads shrines dedicated to *lares*.[1] Confusion has arisen because there were indeed *some* unroofed *compita* in Rome, notably the one recently excavated at the Meta Sudans or the shrine Tacitus refers to in his description of the original *pomerium*. Many compital *lares* were, however, worshipped indoors in modest cult buildings or at small roofed altars or in wall niches. According to the first-century BC jurist Trebatius Testa, rural *compita* could be either roofed or unroofed (that is, either *sacella* or not).[2] The topic of *sacella* is large and deserves study in its own right.[3] What follows is a brief overview intended to sketch the relationship between shrines for *lares* and the many other small shrines to be found in Rome.

Small, open-air shrines (in well-defined religious spaces and with altars for cult) honored many different deities in Rome. Some of these shrines were to be found in more public and historic areas of the city, such as the ancient Volcanal, in honor of the fire god Vulcan, near the *comitium* in the Forum.[4] (See figure II.17.) His sanctuary may have started off as a much larger precinct than what is indicated by the archaeological remains. The area consecrated to Vulcan was marked off by *cippi* with iron bars. No building could abut it, and the area was required to be kept clear of all trees and vegetation. It seems to have been paved and to have contained an altar, as well as a column with a statue of the god on top. The regulations for the shrine inscribed on stone were on display here.[5] By contrast, the *sacellum* maintained by the *montani* of Mons Oppius was planted with trees, forming a small grove.[6] *Sacella* were, therefore, arranged in a wide variety of different settings.

Indeed, many of Rome's earliest sanctuaries, such as the Ara Maxima in honor of Hercules or the altars on the Capitol that predated the great temple for Jupiter, Juno, and Minerva, consisted of precincts with altars, not temples. The ancient temple of Vesta is the obvious exception, because the eternal flame that was kept burning on her hearth needed tending indoors. Consequently, since even major

1 Wissowa 1912, 469–70, had argued that all *sacella* were compital. For the meaning and use of these Latin terms, see Fridh 1990.

2 Servius on *Georg.* 2.38.3.

3 See, for example, Palmer 1978 for a survey of twenty-one small shrines for Silvanus in Rome.

4 Menichetti 2005, 314, cites the Volcanal as an archetype of the ancient open-air shrine in Rome. Coarelli 1983, 196–99, argued for Servius Tullius as the original founder of this cult and its precinct. Carandini 2011 sees this as a cult that dates back to the very beginnings of the city.

5 *CIL* 6.30837 = *EDCS* 17300964 reproduces the rules for the shrine, which show that it was roofless and paved.

6 *CIL* 6.32455 gives evidence for this *sacellum*, which was enclosed, leveled, and planted with trees.

II.17. Volcanal, hypothetical reconstruction (after Coarelli 2008).

religious sites took the form of open-air precincts in earlier times, it should come as no surprise that local cults imitated such traditional and venerable formats. The term *sacellum*, however, is usually used to designate a relatively small area of consecrated ground as opposed to the precinct of a temple.

Other *sacella* had the character of local shrines, which might give the name of their deity to the neighboring vicus. *Sacella* could be either publicly or privately owned and are recorded as having a variety of different owners. Several vici bore the names of gods of the state cult (for example, Diana, Vesta, Honos, and Virtus), or local deities who probably had their own *sacella* there (Apollo Sandalarius, Mercurius Sobrius, Iuppiter Tragoedus).[7] The *lares* at each crossroads were all *compitales*; their lack of individuality was integral to their characteristic function in this familiar local context.

It is certainly possible that some *compita* in Rome honored other gods *together with* their *lares compitales*, as is the case at a few street shrines in Pompeii (see section II.xv later), although we have little secure evidence for this practice at the moment. However, neighborhoods clearly also had separate local *sacella* in honor of favorite deities, such as patrons of craft associations in the neighborhood or gods favored by a particular ethnic group who had settled in this part of town. A definitive list is hard to make but examples (in addition to the well-known Volcanal alluded to earlier) include attested *sacella* for Angerona, Concordia, Dis Pater and Proserpina, Hercules Cubans, Carmentis, Diana, Aius Locutius on the Nova Via, Jupiter Conservator on the Capitol, Jupiter Fagutalis, Janus Geminus, Quirinus on the Quirinal, Semo Sancus Dius Fidius, Pudicitia Plebeia, Pudicitia Patricia, Strenia on the Sacra Via, Minerva, Dea Viriplaca on the Palatine, Pax, Volupia, Acca Laurentia, Rumina, Salus, Strenia in her grove, Mutinus Tutinus, and Dea Nenia

7 All the names of known vici are listed in *LTUR* under vicus. For Augustus' restorations of local shrines in Rome, many of them not compital, see section IV.xxiv.

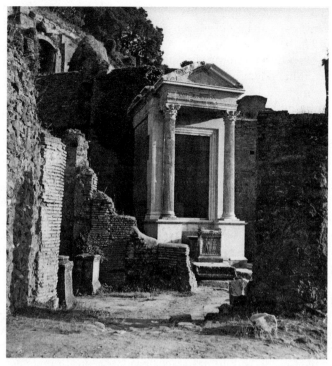

II.18. Shrine at the lacus Juturnae in the Roman forum.

outside the city.[8] The lacus Juturnae in the forum can also be described as a *sacellum*, but one that included a pond (*lacus*) together with a series of altars and a shrine with columns.[9] (See figure II.18.)

It is easier to talk about *sacella* as a general category than to reconstruct a detailed history of any one of these sorts of small sacred spaces. The unroofed area of a *sacellum* was consecrated ground; some way of demarking the sacred space seems essential, whereas the altar could be temporary or portable. As our evidence indicates, such a shrine could be located in an alley, inside a private house, in the living area of a temple guardian (*aedituus*), near a temple to the same deity, or be part of a gentilicial cult.[10] The variety of settings also indicates that some of these must have been very tiny shrines. Two examples can illustrate how the variety of our disparate and patchy evidence has conditioned what we can say: these

8 Twenty-nine shrines are listed as *sacella* in *LTUR*, only one of which is for *lares* (*lares querquetulani*). The Volcanal and the lacus Iuturnae are not included in this list because of the organizational principles used for this lexicon. More prominent landmarks tend to have an entry under their proper name, rather than under a category like *sacellum* or *ara*.

9 For the lacus Juturnae, see Steinby 1989 and in *LTUR*. The shrine is depicted on fragment 18a of the Severan marble plan, but in a phase before the restorations of Domitian and Trajan. This is the location where the Dioscuri, Castor and Pollux, who had their temple nearby, were said to have watered their horses after helping the Romans at the Battle of Lake Regillus. See Dionysius of Halicarnassus 6.13 and *RRC* 335 of 96 BC. M. Barbatius Pollio (aedile under Augustus) made a dedication here (*CIL* 6.36807 = *ILS* 9261 = EDCS-19600477). The *sacellum* included a paved basin, the shrine with its two columns, as well as bases for various statues, of the Dioscuri and probably also other gods.

10 A convenient overview is given by Menichetti 2005 in *ThesCRA*.

are the unnamed shrine visited by two elite Roman women seeking a divine portent for a marriage (perhaps outside the city) and the *sacellum* of Hercules Cubans excavated in Trastevere.

We know of one instance of an aunt and a niece (her sister's daughter), from the politically prominent family of the Caecilii Metelli, seeking divine guidance by spending the night in a small *sacellum*. Cicero tells this story in the voice of his brother Quintus in the first book of *de Divinatione*.[11]

> L. Flaccum, flaminem Martialem, ego audivi, cum diceret Caeciliam Metelli, cum vellet sororis suae filiam in matrimonium conlocare, exisse in quoddam sacellum ominis capiendi causa, quod fieri more veterum solebat. Cum virgo staret et Caecilia in sella sederet neque diu ulla vox exstitisset, puellam defatigatam petisse a matertera, ut sibi concederet, paulisper ut in eius sella requiesceret; illam autem dixisse: 'Vero, mea puella, tibi concedo meas sedes.' Quod omen res consecuta est; ipsa enim brevi mortua est, virgo autem nupsit, cui Caecilia nupta fuerat. Haec posse contemni vel etiam rideri praeclare intellego, sed id ipsum est deos non putare, quae ab iis significantur, contemnere.

> I heard Lucius Flaccus, the *flamen* of Mars, who used to say that Caecilia, the wife of Metellus, when she wanted to make a match for the daughter of her sister, went out to a certain open-air shrine to obtain a sign, which was the custom according to the practice of the ancients. When the girl had remained standing and Caecilia was sitting on a chair and for a long time neither of them said anything, the exhausted girl then asked her aunt to do her a favor and to let her rest on her chair for a while. Then the aunt had said: "Yes, my girl, I give you my seat." Events followed upon this omen. For soon she died, but the virgin married the man to whom Caecilia had been married. I am fully aware that these events can be despised and laughed at, but it is the same to despise the signs sent by the gods as to posit that they do not exist.
>
> (Cicero *de Div.* 1.104)

This vivid story depends on a personal reference by Quintus to an oral source, who is probably Lucius Valerius Flaccus (consul in 100 BC). The identity of the women is not clear, nor the date of the event.[12] The vagueness about "a certain shrine" (*quoddam sacellum*) is telling. It suggests that the location and character of this particular open-air sanctuary is not important, either to Flaccus or to Quintus Cicero, presumably precisely because there were many such places. Yet the two women are said to "go out" (*exisse*) to it, which may indicate that it was outside the city, rather than simply outside their house. The omen is the point of the tale, not its setting, which is commonplace to the audience. For the sake of comparison, a fine painting of a rural shrine from a house in Herculaneum suggests one possible type of venue.[13] (See plate 16.)

11 See Wardle 2006 for a detailed commentary.

12 See Bettini 1991, 90, for a possible reconstruction of the marriage and family patterns implied by the story of the maternal aunt and her sister's daughter. Caecilia seems to be married to a man named Metellus, who is from the same family of the Caecilii Metelli and, therefore, her blood relation. In this case, her sister's daughter would also be marrying a relative. Since all the women in this family were called Caecilia, we do not have any evidence about who she is.

13 MAN Naples inv. 9419.

Valerius Maximus, who tells a very similar version of the same incident, adds the detail that the omen took place while the two women were spending the night at the shrine in a traditional way.[14]

At Caecilia Metelli, dum sororis filiae, adultae aetatis uirgini, more prisco nocte concubia nuptiale petit omen, ipsa fecit: nam cum in sacello quodam eius rei gratia aliquamdiu persedisset nec [aliqua] ulla uox proposito congruens esset audita, fessa longa standi mora puella rogauit materteram ut sibi paulisper locum residendi adcommodaret. cui illa 'ego uero' inquit 'libenter tibi mea sede cedo'. quod dictum ab indulgentia profectum ad certi ominis processit euentum, quoniam Metellus non ita multo post mortua Caecilia uirginem, de qua loquor, in matrimonium duxit.

But Caecilia, wife of Metellus, herself produced an omen when she was seeking one for the marriage of her sister's daughter, a virgin who was now grown up, by spending the night according to an ancient custom. In search of this omen she had been keeping watch for some time in a certain shrine, and had heard no word that seemed relevant to her purpose. The girl was tired after standing for a long time so she asked her aunt if she could give her a place to sit down for a little while. She said to her "Truly, I gladly give my seat to you." Her words that came from her kindness produced a sure omen, since Metellus soon married the girl I mentioned, after Caecilia died.

(Val. Max. 1.5.4)

The shrine must, therefore, have been large enough to make it practical for two people to spend an extended time inside its precinct, although they seem to be staying awake in silence to receive a "sign," rather than seeking guidance in a dream by sleeping in a sacred place. Is the aunt sitting on a chair because she is the one who is "taking the auspices" in the way a magistrate did? This analogy seems less compelling at night, when signs were presumably less visible, unless they were being sought by watching the night sky. Rather the aunt may simply have been given a chair because of her age, which would explain how the niece could ask for a turn without apparently committing a ritual flaw, which would surely have been remarked upon by one of the men who retells the story. The *sacellum* may perhaps have been so small that there was no room for two chairs here. Did they bring the chair with them or was it available as part of the furniture of the *sacellum*? The deity may have had a connection either to the family or to the institution of marriage itself. In this instance, we catch a vivid glimpse of the action inside the small shrine without being told its name, location, or format. Even the most elite Romans therefore naturally turned to tiny *sacella* rather than civic temples and the prestigious priests who served them.

By contrast, we have archaeological and epigraphic evidence for the *sacellum* of Hercules Cubans (Hercules lying down), which was discovered in 1889 near Porta Portese in the Horti Caesaris (but dismantled soon after it was found).[15] (See

14 Cicero is clearly an important source for Valerius.

15 See Nista 1991 and in *LTUR*. The inscriptions are *CIL* 6.30891 = EDCS-18300900 and 30892 = EDCS-18300901. See also 6.332 = *ILS* 1135 = EDCS-17700098, which is a dedication to Hercules Victor by a man of consular rank from around AD 200. This shrine was mentioned in the

II.19. Shrine dedicated to Hercules Cubans by L. Domitius Permissus, from Trastevere. Reconstruction drawing at the time of excavation (1889).

II.20. Tufa statuette of Hercules Cubans. 41×43 cm. Museo Nazionale Romano, Terme di Diocleziano, inv. 54967.

figure II.19.) This small shrine was built into the rock and consisted of a niche with a pediment on top, an offering table in front, and twin altars, one of tufa and one of travertine. It was situated at a place where several roads came together.[16] The whole *sacellum* is labeled as the gift of Lucius Domitius Permessus, by order (*imperium*) of the god. Several images of Hercules were found here, including a reclining Hercules, carved in tufa, for whom the shrine was named. (See figure II.20.) In this case, we can see the format and location of a local shrine, set up by a nonelite individual presumably on private property. However, we do not know who worshipped here or under what circumstances. The shrine seems to have been established in the first century BC and to have been in use for several centuries, thus taking on a life of its own far beyond the original vow and the purpose of the dedicator.

Restoring *sacella* was part of the job of being censor and is attested for the censorships of 184/3 BC and 179/8 BC. Livy has the following information to report about the later of these occasions.

> Complura sacella publicaque loca occupata a privatis, publica sacraque ut essent paterentque populo curarunt.

> They took care that many public open-air shrines, which had been occupied by private persons, were made accessible to the people as public, sacred spaces.
>
> (Livy 40.51)

Needless to say, small *sacella* were especially vulnerable to being absorbed by a variety of building activities, including the encroachment of private structures onto

later regionary catalogue (*Cur. Reg.* XIV). Nearby, seven herms of charioteers were also discovered, although Hercules is not usually associated with chariot racing. Palmer 1981 discusses the whole area and includes a map of the various shrines.

16 Vicus Longus Aquilae, Via Campana, and Via Portuensis.

public land. The senate also concerned itself with these local spaces. In one instance, two *quaestors* oversaw the enclosing of a *sacellum* in accordance with the senate's instructions in an inscription from Hadria.[17]

[?] Sanguri(us) C. f., L. Gargoni(us) L. f., q(uaestores) sacellum d(e) s(enatus) s(ententia) saepiundum couraverunt

? Sangurius, son of Gaius, Lucius Gargonius, son of Lucius, quaestors, saw to the enclosing of the open-air shrine on the basis of instructions from the senate.
(*CIL* 1² 1894 = 9.5019 = *ILS* 5427 = *ILLRP* 304 = EDCS-15400512)

Similarly, an inscribed law from Puteoli gives information about *sacella* in and around a precinct of the temple of Serapis in 105 BC.

eidem sacella aras signaque quae in campo sunt quae demonstrata erunt ea omnia tollito deferto componito statuitoque ubei locus demonstratus erit duumvirum arbitratu . . .

Likewise, the open-air shrines, altars, and statues of deities which are in the field and which will be pointed out, should all be completely dismantled, removed, reassembled, and reestablished in the location indicated at the discretion of the *duumviri* (local magistrates) . . .
(*CIL* 1². 698 = 10.1781 and 1793 = *ILS* 5317 and 5389 = *ILLRP* 518 = EDCS 25900656)

This text records an elaborate contract for building a wall in front of the temple's precinct. In the process, all *sacella* with their altars, shrines, and statues are to be dismantled on the campus and re-erected in the locations designated by the *duumviri* in charge of the contract. This legal text clearly demonstrates the public nature of many small *sacella*, whose maintenance was the concern of the civic authorities in each community. Each consecrated space needed to be moved carefully under the supervision of a senior magistrate. The impression is of a landscape dotted with little shrines that had accumulated over time, many through individual initiatives. By the 40s BC, the maintenance of *sacella* and public paths could be designated as the responsibility of *aediles*.[18]

In general, *sacella* have received even less attention from scholars than *compita*, but they deserve to be considered in their own right together with other traditional sacred spaces, such as holy trees, groves, springs, or ponds (for example, *lucus, lacus*), each of which could also have been included within the consecrated space of a *sacellum*. Many natural settings were labeled as sacred and were maintained or re-created even as the city became more densely populated and open spaces tended to disappear. At the same time, shrines could also be found almost anywhere to honor a very wide variety of deities, from the grandest to the most obscure, simply as expressions of personal or local piety. A thorough investigation of local shrines is beyond the scope of the present study of *compita*. Nevertheless, it is

17 This inscription is written in archaic Latin and very old letter forms.
18 *CIL* 1² 593 = *ILS* 6085 = *EDCS* 20000229.

important to note the basic fact that crossroads shrines for local *lares* would have complemented and supplemented a busy, colorful, unsystematic, and continually evolving landscape of small-scale sacred spaces, each of which would have been sites for their own particular religious rituals and observances. *Compita* would often have been within sight of other shrines that had similar formats. A recognition of the abundance and variety of *sacella* in Rome can help us to appreciate the special characteristics of the shrines for *lares compitales*. *Sacella* often honored a deity in a unique local setting and context: *compita*, by contrast, were part of a network that asserted continuity and commonality over local or individual identity.

XV POMPEII: A CASE STUDY

C(aio) Iulio Caesare dict(atore) iter(um), M. Antonio mag(istro)
eq(uitum) mag(istri) vici et compiti . . .
—INSCRIPTION FROM A CROSSROADS SHRINE
(*CIL* 1² 777 OF 47 BC)

While certainly not identical with that of Rome at any given period, the sacred land-
scape of Pompeii can offer some suggestive points for comparison, as well as hold-
ing its own unique fascination.[1] Pompeii was also full of a myriad small shrines
and sacred images on or near the streets. *Lares* played a large role but many other
deities were to be found, both in civic contexts and as expressions of individual re-
ligious choices, from the grandest villa to the humblest shop or tavern.[2] As a
coastal town that was a Roman colony on the Bay of Naples, Pompeii's streets would
have been crowded with many seasonal visitors, traders, sailors from the imperial
fleet stationed at Misenum, as well as members of the extensive households of those
who owned the luxury villas and town houses in this area. Recent scholarship has
stressed the degree to which their everyday life at Pompeii was permeated by the
gods.[3] This section will offer a succinct overview of *lares* at the street corners in
Pompeii.

It is a simple fact that street shrines were not interesting to the early excavators
of Pompeii: indeed, none were even recorded in the descriptions of their finds be-
fore the later nineteenth century, although typical *lares* shrines can certainly be
seen in engravings published by the French architect François Mazois in the
1820s.[4] Even he complained that they were hard to read in his day. There are many
reasons for this neglect, ranging from a devaluation of the artists to a lack of schol-
arly engagement with traditional religion, especially in its more popular forms. In
every period, these paintings, although often explicitly said to have been in good
condition at the time each one was discovered, were left exposed to the elements.[5]
As a result, there is very little to be seen today in the way of paintings in the streets
and what does survive is barely visible.

Consequently, the paintings outside the houses have not been studied in the
same detail as the domestic shrines, whose more protected environments helped
to keep them in much better condition until scholars became increasingly

1 For a discussion of the *lares* paintings in the kitchens of Pompeii, see sections I.vi–ix.

2 Fröhlich 1991 offers the standard catalogue and classification of paintings in houses and on
façades in Pompeii.

3 See especially D'Alessio 2009 (although she does not include the *lares* cults) and Van And-
ringa 2009 for very rich discussions of the gods at Pompeii, ranging from traditional to exotic.

4 See Van Andringa 2000, 48, who discusses the early inventories by Fiorelli, Helbig, and
Mau. Charles-François Mazois's (1783–1826) engravings were published in several volumes be-
tween 1812 and 1838. They were based on his time in Pompeii, between 1809 and 1811, in the em-
ploy of Napoleon's sister Caroline, Queen of Naples. His drawings are more detailed and realistic
than the idealized scenes of ruins that had been fashionable before.

5 There are very few of the well-preserved paintings in the Naples Archaeological Museum
that were taken from outdoor locations, none obviously from *compita*. See Bragantini and Sam-
paolo 2010 for a recent catalogue organized room by room (lares paintings in room LXXVI, 423–
35; "popular painting" in room LXXVIII = 499–533).

interested in them in the twentieth century.[6] Moreover, catalogues of wall paintings from the Bay of Naples naturally do not include altars and niches that no longer have their outer layers of plaster and paint recorded or preserved.[7] In other words, the extant evidence has fallen into separate categories of research, from art historical to more archaeological to the investigation of ancient religion as a separate field of study in its own right.[8] Further work on street shrines could be very fruitful, since Pompeii obviously offers a unique glimpse of the proliferation of sacred images and cult sites within the urban landscape of a town that was a Roman colony for over 150 years before its sudden destruction. Above all, however, the systematic excavation of a new street would surely provide invaluable information about the whole ensemble of local shrines and their relative spacing, as well as the opportunity for a more scientific investigation of the remains of offerings on their altars.

How many shrines for *lares* are there in the excavated parts of Pompeii? Opinions have varied quite widely, with counts ranging from around 60 to fewer than 40. High counts choose to include some sites of possible earlier street shrines, where there is very little surviving evidence. In addition, six sites of possible street shrines that seem to predate Sulla's imposition of colonial status in 80 BC have recently been identified, although there is no direct evidence for which gods were worshipped here.[9] The physical remains of these small, pre-Roman altars is quite similar to what was in place in the 70s AD, although the earlier shrines had more money boxes for collecting the offerings of the pious. Only one of these older cult sites continued in use into the Roman period when it honored the goddess Salus.[10] It still seems likely, therefore, that the network of *lares* shrines in place at the time of the eruption was established soon after 80 BC by the Roman colonists, many of them veterans of Sulla's army who were rewarded for their loyalty to him with land and a new life on the Bay of Naples. That does not mean, however, that the concept of the street shrine was itself new to Pompeii; there may even have been an earlier network of some kind, whether in imitation of Roman practices or in honor of other deities according to a local pattern.

The standard archaeological catalogue of *compita* from Pompeii was published in 2000 and maps thirty-eight "altars at crossroads" (*autels de carrefour*), based on personal observation, archival research, and what is described as a deliberately inclusive counting method.[11] By contrast, an exhaustive online resource for Pompeii (*Pompeii in Pictures*), also drawing on extensive and very detailed onsite

6 For domestic shrines of *lares*, of which about 500 are attested in the literature, see Boyce 1937, Orr 1978, Fröhlich 1991 (discussed by Tybout 1996), and Giacobello 2008.

7 Fröhlich 1991 is the obvious example. His list of *lares* paintings can be compared with the archaeological lists made by Van Andringa 2000 and *Pompeii in Pictures*. Jackie and Bob Dunn are the creators of this amazing website, which can be found at www.pompeiiinpictures.org/index.htm.

8 Three small buildings have also been identified as possible sites for cult offered to local gods, including *lares*. None of these has a surviving painting or inscription to provide direct evidence. They are at IX.2.1 (= Van Andringa 2000, no. 25, a sort of arcade with multiple entrances), VI.8.14 (= Van Andringa 2000, no. 3, a simpler cult room with small niches), and VIII.4.24 (= Van Andringa 2000, no. 27, with benches and an altar in a niche).

9 Anniboletti 2007 identifies these disused altars at VI.2.16–21, VII.15.8, IX.9, IX.7.20, IX.8.3–7, and IX.8.8. Votive deposits are also a feature of these earlier shrines that was not replicated later. See also Cool and Griffiths 2015 for further evidence of continuity between cult sites, based on pottery finds from pre-Roman times.

10 IX.8.8 = Van Andringa 2000, no. 10 (who is unsure whether this was really a *compitum*). The older altar seems to have been in use no later than the early second century BC, perhaps earlier.

11 Van Andringa 2000, now also supplemented by his more general overview of religion in Pompeii in Van Andringa 2009.

cataloguing, provides evidence for fifty-eight shrines, including many niches, as well as possible sites of former shrines.[12] In practice, both overlapping sources can and should now be combined to yield a much broader and more nuanced picture of Pompeii's streets than ever available before.[13]

There were clearly very many street "shrines" of various kinds, ranging from tiny niches to huge paintings that took up extensive space along the walls. In the better-preserved and documented areas the shrines could be densely spaced; they created a colorful and ubiquitous background to activities in the streets. (See plate 17.) The Roman custom of having few windows on the outside of houses resulted in long stretches of uninterrupted wall space that could be used for ambitious murals. Religious paintings, especially of the huge snakes so popular in Campania, were frequently the genre of choice. The fact that very few statuettes of deities have been found in situ in niches or near shrines has been interpreted to show that both fleeing inhabitants and looters were eager to take these precious objects with them as they escaped the ruin created by the volcano (see section I.vii earlier).[14]

The iconography of the *lares* at the street shrines includes scenes of sacrifice by what seem to be neighborhood officials that have been read as references to the festival of Compitalia and more generally to the way in which cult was organized at these local altars. Otherwise, the depiction of the *lares*, sometimes accompanied by a *genius* pouring a libation, and often paired with scenes of snakes in a garden, is very similar to what has been found in the domestic settings, usually in or near the kitchen (see the detailed discussion in section I.vi–ix earlier). These similarities surely point to the fact that the same artists were painting religious images in each location, as well as to the probability that those who worshipped at the street corners were often the same people who tended the hearths and cooked the food under the eyes of watchful *lares*. Some other gods are also attested in association with the standard scene of the *lares* and in the context of the crossroads shrines. In two large paintings, the twelve gods (*dei consentes*?) are represented in a way that stresses a harmony between the local cult of *lares* and the worship of even the most exalted deities honored in civic cult.[15] These more elaborate shrines give a sweeping and complex picture of polytheism as envisioned on the Bay of Naples.

As far as the configuration of local neighborhoods is concerned, inscriptional evidence attests to four larger geographical units that were important to local identity and political practice. Pompeians were divided into Forenses, Campanienses, Salinienses, and Urbulanenses, according to where they lived.[16] Political patterns do not, therefore, stress the level of the local vicus as a key administrative unit as much as these larger neighborhoods. We do not have independent evidence for

12 The site is continually being updated with more information and photographs, from a variety of sources. Its aim is to map and record detailed information about every structure in Pompeii. It is an essential resource.

13 See also the interesting earlier discussions and maps in Laurence 1994 (second, expanded edition in 2007) and Gesemann 1996 (who identifies sixty-one *compita*).

14 Van Andringa 2009, 218–19. Other little gods made of organic materials would have been swept away by the eruption. On the other hand, not many such statuettes have been found on the bodies of the refugees.

15 VIII.3.11 = Van Andringa 2000, no. 35 = Fröhlich 1991, F60 and IX.11.1 = Van Andringa 2000, no. 14 = Fröhlich 1991, F66.

16 See conveniently Laurence 2007, 39–61, although my interpretation leads to rather different conclusions. Van Andringa 2000, 73–75, sees a city divided by *compita* into units larger than the local vicus.

how many vici Pompeii had or how these might have been described in an official way, although the city we see is the Flavian town that is exactly contemporary with the counting of Rome's regiones and *compita larum* in the census of AD 73–74. If each crossroads shrine for *lares compitales* marked an "official" vicus, then these units were apparently very small, sometimes comprising barely a single block on a street like the Via dell' Abbondanza, our best attested stretch of road. Meanwhile, there is no direct evidence for a cult of *lares augusti* (or of the *genius* of the emperor) at these street shrines.[17] In other words, the network of *lares* shrines in Pompeii is evidently not "exactly like" what was found in Rome, especially after Augustus' urban reform of 8–7 BC. It is, therefore, possible that these *compita* continued to reflect a cult of the *lares* introduced in the 70s BC by the Sullan veterans, while the *compita* in Rome had developed their own history since then. Yet even at the time when the colony was established, the *lares* cult may not have been (intended to be) a faithful copy of what was found in Rome or elsewhere. If Rome had 265 *compita larum* in AD 74, then the number of around 60, which we can see is very incomplete for Pompeii at this same time period, seems high. Even on the very basic level of counting and mapping these street shrines, therefore, Pompeii's religious landscape looks rich, complex, and distinctly regional.

The slow dissolution of the painted plaster on a wall near Pompeii's forum revealed rare inscriptions (now lost) that were written in charcoal. They recorded the organization of a local *lares* cult at the level of the vicus in the years 47 and 46 BC, while Caesar was dictator in Rome.

C(aio) Iulio Caesare dict(atore) iter(um) / M(arco) Antonio mag(istro) eq(uitum) / mag(istri) vici et compiti / M(arcus) Blattius M(arci) f(ilius) / M(arcus) Cerrinius M(arci) f(ilius) / M(arcus) Sepullius [3] / [6] / Q(uintus) Pra[3 letters missing] / C(aius) Corne[lius 3] / [6] / P(ublius) Ro[c]ius [3 letters missing]s / Salvius E[3]ro() M(arci) s(ervus)

// C(aio) Caes]are M(arco) Lepido co(n)s(ulibus) / [3] Blattius M(arci) f(ilius) / C(aius) [H]ermatorius(?) P(ubli) f(ilius) / M(arcus) [3]ius M(arci) f(ilius?) Plutus / M(arcus) Stronnius M(arci) l(ibertus) Nic[3]o / M(arcus) Oppius S(exti) l(ibertus) Aes[chines(?)] C(aius) Cepidius C(ai) [l(ibertus)

When Gaius Julius Caesar was dictator for the second time (and) Marcus Antonius master of the horse, the magistrates of the neighborhood (*vicus*) and of the crossroads shrine (*compitum*) (were): Marcus Blattius, son of Marcus, Marcus Cerrinius, son of Marcus, Marcus Sepullius, (*gap*), Quintus Pra . . . , Gaius Cornelius . . . , Publius Ro(c)ius ?s, Salvius E . . . ro(), slave of Marcus.

In the consulship of Gaius (Julius) Caesar and Marcus Lepidus, ? Blattius, son of Marcus, Gaius Hermatorius (?), son of Publius, Marcus ?ius, son of Marcus Plutus, Marcus Stronnius, freedman of Marcus Nic(?)o, Marcus Oppius, Freedman of Sextus, Aes(chines?), Gaius Cepidius, freedman of Gaius . . .

(*CIL* 4.60–*CIL* 1² 777 = *ILLRP* 763 = *II* 13.1.17 = *ILS* 6375 = *EDCS* 24700038, perhaps associated with street shrine no. 34)[18]

17 Van Andringa 2000, 77. Contra Fröhlich 1991, 33; Hänlein-Schäfer 1996; and Laurence 2007, 41.

18 Van Andringa 2000, 75 and no. 34.

What we have here is two lists of local magistrates carefully dated by the official Roman system. The entry for the first year (47 BC) originally contained nine names, of whom the first two were freeborn citizens and last in the list was a slave. The pattern under the second year is also two free men (the first repeated from the previous year), followed next by at least four freedmen. It is reasonable to think that both lists were similar, which would yield two free followed by a list of freed and enslaved. The title *magistri vici et compiti* (officials of the vicus and of the cross-roads shrine) is not attested elsewhere. It is not made clear whether this means there were two sets of officials, one for the vicus (*magistri vici*) and one for the *compitum* (*magistri compiti*), or just a single office with the combined title (*magistri vici et compiti*). Both scenarios are conceivable.[19] The number nine is also un-usual, since there seem consistently to have been four *vicomagistri* in each vicus in Rome. If one was a slave *minister*, then we might imagine two groups of four offi-cials coming together from two, separate neighborhoods. This hypothesis, how-ever, would surely suggest that each group should have their own slave attendant, which would have produced a list of ten names. A better comparison may be found in the inscriptions from Minturnae, which list by groups of three (see sec-tion III.xix later). Three groups of three officials each would yield nine. An inscrip-tion from Verona dated to 1 BC also gives a list of names in groups of three.[20]

It is worth noting, in addition, that many of the names found inscribed next to *lares* paintings only mention slaves, even as the painted sacrificial groups seem to show the four men ("officials") in charge of the local cult, accompanied by a flute player.[21] The painted scenes are in such poor condition, however, that it is not al-ways clear whether the celebrants are wearing togas or perhaps just tunics. In the Augustan inscriptions from Rome, which mention seventy-five *vicomagistri*, most are freedmen.[22] *Compita* in Pompeii also featured electoral notices in support of local candidates, which must have been addressed primarily to citizens (freed or freeborn) who could vote and not to slaves.[23]

What were the street shrines in Pompeii like? They came in many shapes and sizes, from tiny niches tucked into corners to large altars with extensive religious murals that dominated the whole street. They were clearly part of a network, how-ever we want to interpret the implications of their elaborate and pervasive religious iconography. At the time of the eruption, their paintings were mostly clear and fresh and their altars had recently been used for burnt offerings. Better-attested exam-ples had inscriptions of various kinds, including temporary notices and graffiti writ-ten in charcoal, which also suggests that they were convenient locations to reach an audience.[24] In a town that was still being rebuilt after the earthquake of AD 62,

19 This unique inscription has been much discussed. See Accame 1942, 20; Van Andringa 2000, 75–76; Laurence 2007, 42; Van Andringa 2009, 94–99; Stek 2009, 128; and Cooley and Cooley 2014, E91.

20 See note 45 on page 136 and epigraph on page 226.

21 Inscribed names near *compita*: *CIL* 4.7425. For different sorts of notices, see *CIL* 4.812, 813, 6641.

22 Lott 2004, 92–94 with table 1.

23 Electoral notices near *compita* include especially *CIL* 4.1000 = EDCS-28700837, 7442, 7443, 7856, 8503–16. Cooley and Cooley 2014, 168–77, give a fascinating survey of the 100 + in-scriptions relating to the campaign of Helvius Sabinus for aedile in AD 79, including a map of the findspots.

24 Milnor 2014 gives an up-to-date discussion of Pompeian graffiti, especially from a more literary perspective.

street shrines were generally in good condition in comparison with many houses and other buildings that were under construction or still awaiting long-delayed renovation.

The majority of surviving street shrines feature masonry altars whose facings and associated paintings have been lost, thus reducing them to their cores.[25] Some of these altars have now disappeared completely but are documented in old photographs; there were surely many more that were never recorded in any way.[26] It is common to find these altars at or very near crossroads of various sizes. Nevertheless, our best evidence does not necessarily come from the largest intersections in Pompeii. Much important work has been done recently to map and document these altars, some of which were very modest to start with. The pattern of their distribution is a strong indication of their religious significance. The next largest group of shrines is comprised of niches, which range from tiny to those that contain large altars within them.[27] Some niches are associated with city walls, gates, the inside of small cult buildings, the entrances to the forum and to the macellum. Gods watched over entrances to the city and to its main spaces and buildings. It is difficult to say how many of these niches were part of the *lares* cult. Some certainly featured other deities.[28] The street altars, therefore, appear easier to read and are usually more clearly identified with a cult at a crossroads, where we would expect to find the *lares compitales*.

The largest documented group of paintings shows the characteristic snakes, either on blank backgrounds or in "gardens," but without any other figures.[29] Just as in the houses, these snakes often receive round gifts (eggs, pinecones, and so on) placed on circular altars. Some of the snake paintings are equipped with their own masonry altars, which are usually square. One particularly interesting example (I.8.1), excavated in 1912, featured two huge snakes on a white background and facing each other as they approached a masonry altar that had been placed on top of a ramp.[30] In other words, the whole shrine was both monumental and three-dimensional in its original conception. Celebrants making offerings here climbed the ramp and entered the painted world of the snakes above street level. By contrast, a more recently and not fully published example of a compital shrine in nearby Puteoli is located underground in a small chamber dominated by two huge painted

25 Nineteen cores of street altars can still be seen in situ (with the numbers for Van Andringa's 2000 catalogue in parentheses): I.5.1 (28); I.6.12 (13); I.13.10 (22); I.14.8 (23); I.25 tip; II.2.1 (20); II.8.6; III.10a (12); IV.4g; V.3.1 (9); VII.3.33 (5); VII.9.4; VII.14.14 (34); VIII.2.11 (38); VIII.2.25 (36); VIII.3.17 (37); IX.8.1 (8); IX.8.8 (10); IX.14.1 (11).

26 For example, see especially VI.7.26 at *Pompeii in Pictures*. Others include I.10.1, I.16.4, VI.1.13, and IX.2.19.

27 Niches (thirteen examples cited by *Pompeii in Pictures*) with Van Andringa 2000 numbers in parentheses: I.12.5 (19); I.14.4; II.4.7a (21); VI.8.14 (3); VII.1.42 (32); VII.4.16 (31); VII.8 (30); VII.9.42; VIII.4.24 (27); IX.2.12 (26); IX.4 (7); and two more at the Stabian gate, of which one originally contained a statue of Minerva.

28 Jupiter and Mars are depicted in small niches at the entrance to the forum at VII.4.16 (no. 31 in Van Andringa 2000 = Fröhlich 1991, F48).

29 Nine snakes are attested at street shrines (Van Andringa 2000, with Fröhlich numbers in parentheses): I.1.10; I.3.29; I.8.1 (15 = F4); V.6.19 (24 = F35); VI.4.1 (2); VII.11.13 (33 = F57); IX.2.12 (26 = F61); IX.7.20 (F65); and at the corner of the Via Pomeriale and Via dei Sepulcri outside town.

30 Van Andringa 2000, no. 15 = Fröhlich 1991, F4 had an original width of about 12.5 m. The ramp ascended from left to right.

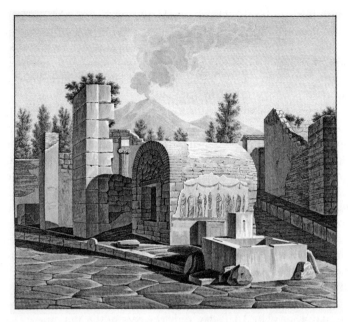

II.21. Nineteenth-century etching of a crossroads in Pompeii (VI.1), with fountain, altar, and a cistern painted with a ritual scene.

snakes with stone heads facing an altar between them.[31] This setting recalls the worship of *lares* underground in the Circus Maximus in Rome. I have argued earlier (section I.viii) that the snakes on the Bay of Naples were worshipped as gods of place, specifically of the natural environment that existed before, beneath, around, and in harmony with the communities built by men.

At the same time, it is important to note that a major fork in a road in Pompeii featured a painting of a religious ritual in honor of a single deity, apparently without reference to *lares* or to snakes (VI.1).[32] (See figure II.21.) At the time when Mazois recorded the painting, it was already very hard to read. The imposing scene was placed on a cistern, above an altar and behind a fountain. The position at a crossroads and adjacent to the fountain is typical for a compital cult. The altar makes the religious context clear. The large painting showed two groups of three individuals approaching a statue of a deity on a base. Shops, a bakery, a tavern, and the grand House of Sallust nearby would have made this a busy place. Were the *lares* or snakes to be seen on another part of the cistern or on any walls nearby? We simply do not know. The main painting seems to have honored the single deity, perhaps the patron god of the local neighborhood or a personal benefactor of the individual who paid for this installation. The six figures cannot be identified on the basis of the evidence we have. The whole scene does not include any of the usual features of a sacrifice, such as a painted altar, a libation being poured, sacrificial attendants, a flute player, or any animals that will be offered to the god. In this case the commissioner(s) and the artist have chosen a unique scene that does

31 De Caro and Gialanella 2002, 30 and 68, and Giacobello 2008, 65 with fig. 1. This is the intersection of the two main streets, Via San Procolo and Via Duomo (Roman *cardo* and *decumanus*).

32 Van Andringa 2000, no. 1 = Fröhlich 1991, F36 (with only a very brief description). Mazois vol. 2, 39 pl. 2.1.

not fit in with the standardized iconography of crossroads cult. This example deserves attention even if only to warn us that identifying every altar at a crossroads as evidence for a cult of *lares* is misleading. Moreover, pottery finds from recent excavation show that cult had taken place here well before the arrival of the Romans.[33] Similarly another small altar at a crossroads (IX.8.8) is labeled with an inscription of dedication to the goddess Salus.[34]

When it comes to explicit evidence for *lares* in the streets of Pompeii, only six paintings survive or are attested in any detail in earlier descriptions, drawings, or photographs.[35] Within this little group, the four clearest examples are within a four-block section of the Via dell' Abbondanza, excavated between 1911 and 1913.[36] It seems evident, therefore, that it is the methods used in excavation that have had a decisive influence on what has survived for us to study. There is no indication of how typical this group of *lares* shrines was; there is no other reason to think that this area had an especially religious tone or function.

It is worth looking first at the other two examples, one found in the eighteenth century and one in the nineteenth, before moving on to our early twentieth-century group. The earliest to be excavated is the shrine near the northwest corner of the forum, at what had been a crossroads before the area was reorganized (VII.7).[37] The painting and altar were recorded by Mazois, although the colors were quite faded in his day. (See plate 1.) Today, only the core of the altar and its top remain in place. Originally, the whole ensemble was covered in stucco. The single scene over the altar was framed by painted columns and topped by a pediment with an eagle inside it, as if inside a tiny temple of its own. This frame led the excavator to identify this as an altar to Jupiter. The main painted scene, however, features four men with a flute player framed by two larger *lares* in flowing tunics pouring wine. Below what I would read as a standard sacrifice to the *lares* two snakes were depicted immediately above the altar. The situation of the shrine against the wall of a house suggests it might have been installed by the owner. There were also benches for sitting nearby. In any case, its iconography and placement confirm a compital cult in the hands of local officials.

The other example is also still in situ and consists of a sizable freestanding masonry altar backed by a flat pillar that had a painting on its front (VI.14).[38] (See figure II.22.) The shrine was built on a generous platform, and its pillar was made of large stones from Sarno. This *compitum* stands at the crossroads of the main road to Stabiae with the important cross street Via della Fortuna (VI.14). In typical fashion, it is situated very near the water fountain at this corner and would have been visible from many angles, surrounded by larger houses and shops. Its paintings, now long gone, were published in an engraving by Breton in 1855 and in descriptions

33 Cool and Griffiths 2015.

34 Van Andringa 2000, no. 10 = Bakker 1994, no. 17. The inscription reads: *Salutis / Salutei sacrum* (belonging to Health / Safety, sacred to Health / Safety; *CIL* 4.3774 = *CIL* 1.1626 = *ILLRP* 253 = *ILS* 3822 = *EDCS* 21800127). This is the shrine that corresponds to one of Anniboletti's earlier altars.

35 They are at IX.11, IX.12, I.11.1, I.11.7, VII.7, and VI. 14.

36 Spinazzola excavated between 1910 and 1923. His findings are published after his death by S. Aurigemma in Spinazzola 1953, esp. 163–85.

37 Van Andringa 2000, no. 29, but not in Fröhlich. See also Helbig 1868, no. 59; Mau 1907, 235; and Pappalardo 2001, 100. The illustration is Mazois vol. 3, plate 7.1.

38 Van Andringa 2000, no. 6, also not in Fröhlich.

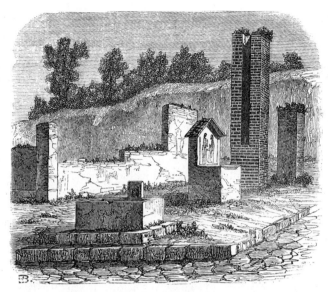

Carrefour de la Fortune.

II.22. Nineteenth-century etching of a *compitum* at the crossroads of the
main road to Stabiae and the Via della Fortuna, Pompeii (VI.14).

by Helbig in 1868 and by Mau in 1902.[39] Here again, the choice was to show four
celebrants in togas, presumably the local *magistri* with their flute player, framed
by the *lares* who protected this spot and received offerings here. In some ways,
therefore, this installation offers a prototype of how we may imagine a *compitum*,
an independent shrine that could be described as a small *sacellum* within a defined
precinct, on which care and resources had been lavished. It celebrated the moment
of the four local men at sacrifice together, the scene that we may perhaps identify
with the annual festival of Compitalia.

These earlier finds are echoed in the shrines excavated with greater attention to
detail along the Via dell' Abbondanza a hundred years ago and reconstructed in
the finely detailed watercolors of Alberto Sanarica. These four have several features
in common, in addition to their shared setting along a busy shopping street, where
some wealthy citizens owned large houses. Each of the well-maintained shrines is
near if not immediately adjacent to a water fountain, is clearly located at a cross-
roads (whether bigger or smaller), and each featured multiple layers of paint show-
ing that it had been restored with similar iconography over many years. Every one
of the altars had recently been in use for a sacrifice, whose charred remains were
found there. The two larger shrines featured four scenes of varying sizes combined
around a small, square masonry altar. By contrast, the smaller installations featured
only the two *lares* over their altars, with the snake(s) below or in the same register.
In other words, these four compital shrines show us a range of what was popular
and available from the artisans who made and painted street shrines. It is interest-
ing to see how very standardized most of the iconography is; the altars are also very
similar (virtually a standard size) regardless of the overall scale and complexity
of the imagery painted on the wall behind. In other words, additional funds and

initiative were spent on paintings, not on larger altars, which would not have been easy to accommodate in a street.

The simplest altar (I.11.1) still has some faded paint preserved to indicate the lively scene of two *lares* pouring wine into buckets on either side of a round altar with a snake wrapped around it.[40] (See plate 18.) Surrounded by garlands and ribbons the *lares* pay no attention to the crested snake, which is boldly poking its snout into the crackling flames on the painted altar. It was on the altar in front of this scene that half a chicken was found charred in the ashes. An inscription, perhaps graffiti in this case, added in red on the plaster to the left of the painting invokes the *lares*: [*per*] *lares sanctos rogo te ut . . .* (by the holy *lares*, I ask you to . . .).[41] One may imagine that this painting and altar represent the kind of basic installation that would have been replicated in many places throughout the town.

Another altar in much poorer condition can be seen on the very next corner of this same block, recessed into an alleyway but on the same side of the main street (I.11.7).[42] The position of this shallow altar raised on a platform suggests that it was reached by standing on the sidewalk of the Via dell' Abbondanza. The painting, which is now completely gone, apparently showed a sacrificing *genius* between two *lares* with a separate depiction of two snakes below. At least five layers of repainting were traceable at the time of excavation. The names of three men were written above inside a *tabula ansata*:

> Primigenius Caeseti(a)e s(ervus), Stalbnus / N(umeri) Marci, Chius C(ai) Viri Primigeni

> Primigenius, slave of Caesetia, Stalbnus, (slave) of Numerius Marcius, Chius, (slave) of Gaius Virius (or Vibius) Primigenius
> (*CIL* 4.7425 = *EDCS* 23800367)

In this case, the three surviving names are of slaves without a cult title to explain their presence. It is not clear, therefore, if they are *magistri* or *ministri* or simply pious locals. Yet the inscribing of the names inside the formal borders of the *tabula* does give them an official air. It also seems as if space was left for adding other names at a later date. The number three is not reflected by the usual number of figures in the sacrifice scenes. With two altars so close to each other, it remains unclear whether only one would have been considered an "official" *compitum*, or whether they both had the same status.

The two larger paintings are the best examples of compital art that we have so far from the streets of Pompeii. They can still be seen in place but are now very hard to decipher. Each contains four scenes of different sizes. The largest shrine is situated immediately behind a water fountain at a crossroads (IX.11).[43] (See plate 19.) Its altar was placed below and to the extreme right, as if to give more space for a

40 Van Andringa 2000, no. 17 = Fröhlich 1991, F7; Spinazzola 1953, 169, fig. 210; Ragghianti 1963, pl. 86.

41 *CIL* 4.8426 = *EDCS* 24600209.

42 Van Andringa 2000, no. 18 = Fröhlich 1991, F8; Spinazzola 1953, 170–75, figs. 213–14; and Della Corte 1965, 343.

43 Van Andringa 2000, no. 16 = Fröhlich 1991, F66; Spinazzola 1953, 175–85, with figs. 215–17, tav. I and XVIII; Della Corte 1965, 306ff. See De Caro and Gialanella 2002, 72–75, for a recently discovered *lares* shrine with twelve gods from Puteoli.

viewer at the fountain to appreciate the scale and richness of the paintings, even when someone was using the altar. Immediately above the altar a snake was making its way in large curls toward a round painted altar with an egg and fruit on it. This simple, classic scene, with the usual garden in the background, was enclosed within a set of garlands tied with ribbons. Above it, the four officiants in the cult, wearing white togas that cover their heads, are seen around a flaming altar on a more opulent scale. Unusually, one of these same men is playing the flute as another pours the libation. They are assisted by an attendant who is rendered as a smaller figure. The much larger *lares* surround the scene and reach almost as far up as the garlands at the top. The *lares* pouring their wine are each flanked by two bay bushes.

In the background, the ghostly figure of a *genius* shines through showing that an earlier version featured a different iconographical scheme, probably without the mortal participants. The complex layers of composition have been further revealed by the partial peeling of paint that now offers glimpses of several different scenes below. The inscribed names in the *tabula ansata* recorded as part of this sacrifice scene read *Sucuusus, Axcliipiadiis, Victor, Cosstas* but seem probably not to refer to the latest version.[44] We see four slaves named, here without any mention of their masters. But were they *magistri* who wore togas in their day? The two versions we can glimpse have been assigned to the late third and fourth styles respectively, with the snake being the most recently painted.

On the left, a larger and apparently much earlier painting is framed by a two-story architectural rendering that looks like a wide shrine, which is completely open at the front. The lower scene shows a *genius* holding a cornucopia, who is offering a libation directly to a snake between two *lares*. The bottom half is lost so that the general setting is not clear. Above the *genius'* libation, a much narrower balcony is filled with a row of twelve gods of the state cult, each with a suitable attribute. The figure of the *genius* and *lares* are much bigger than the gods above. The hierarchy of scale indicates that the main ritual action is the libation made by the *genius* to the twin *lares* and shared in by the snake. The twelve gods are attendants and witnesses, perhaps also understood as participants and invited guests. However, it is not logical to see them as the direct recipients of this single libation poured by the *genius*. This complex scene seems to have been painted in the early Augustan period. It is not clear how it was paired with earlier paintings on the right; at least three layers of the right-hand panel are later. Indeed, by the 70s AD this fine old painting had been covered by whitewash, on which election notices were being written. In this sense, the combination of scenes recorded by the excavators seems not actually to correspond to what anyone saw at any given time at this shrine in antiquity.

Its companion piece is at the end of the next block, at the next cross street but one (IX.12).[45] (See plate 20.) This painted ensemble contains many of the same themes but in a different configuration. Again, the altar is installed all the way to the right of the painted field, which takes up the whole space between the entrance to a shop and the corner of the street. The wall is on the outside of the House of the Chaste Lovers (IX.12.6–8). The altar itself was originally decorated with a variety of pork products, covering very similar designs in earlier versions.

44 *CIL* 4.7885 = *EDCS* 24300358 = Cooley and Cooley 2014, E93.
45 Van Andringa 2000, no. 16 = Fröhlich 1991, F71; Spinazzola 1953, 170ff. with plates 211–14.

Immediately above the masonry altar, a small-scale painting shows four men and a flute player making an offering. This panel was in poor condition at the time of excavation. Above it, a much larger scene features a *genius* in a *toga praetexta* holding a cornucopia and pouring a libation on a bronze tripod between two stately *lares*. In this case, the *genius* is virtually the same size as the *lares*. The *lares* are dressed in green and lean on pillars. A very similar scene, which was drawn on a smaller scale, can be made out in the earlier layer that is barely visible in the background.

To the left of the libation scene, we see two gladiators of different types in the final phase of a single combat. The man on the viewer's left is badly wounded and seems to be facing imminent death. This painting may advertise or commemorate a gladiatorial combat (*munus*) staged for Compitalia through the generosity of a local patron or the enterprise of the *vicomagistri*, reminiscent of the paintings found on Delos (section III.xviii). Next to the altar, there is a large but faded painting of two snakes at a round altar in a garden. Although this shrine is not as well preserved as its grander neighbor, the artist has shown ingenuity in making a type of collage of overlapping scenes of very different sizes divided by carefully drawn red lines. The asymmetry appears pleasing and even sophisticated to the modern viewer. The deities are shown on a much grander scale than the human figures. This whole ensemble seems to have been painted shortly before the eruption.

To sum up: our knowledge of *compita* in Pompeii is vivid but based on evidence that is not easy to interpret. Shared themes are obvious in the surviving iconography; the pattern of street altars is striking if incomplete. The proximity of most of our best examples to water fountains suggests that one could use these installations, which are relatively easy to identify in the excavated areas, as another way to suggest a basic pattern for the most prominent street shrines in the city.[46] A typical map of Pompeii's water supply shows over forty-five fountains in the excavated parts.[47] People who drew water at each source would in any case have formed a natural and organic community of neighbors. Interestingly, the surviving paintings have more in common with the earlier cult on Delos than with Augustan Rome. Meanwhile, neither the snakes nor the *genius* are portrayed in those other places; each was special and essential in Campania. Inside the houses, it is logical to identify the *genius* as the protective spirit of the master of the household. On the street corner, he appears as a more ambiguous figure, probably the *genius* of the colony or perhaps the personal protector of this particular local shrine's or street's patron?[48]

46 Pompeii's water supply: *Pompeii in Pictures* also maps and illustrates forty-six fountains and other installations for supplying fresh water. An overview is provided by Laurence 2007, 45–52.

47 Laurence 2007, map 3.2, as compared to his map 3.1, which shows thirty-seven street shrines.

48 Orr 1978, 1569–75, esp. 1572.

XVI SACRED SPACES AND *LARES* WHO LIVE IN THEM

flore sacella tego, uerbenis compita uelo
 —PROPERTIUS 4.3.57

Dans le polythéisme, les dieux ne sont jamais seuls.
 —VAN ANDRINGA 2009, 3

To pull this disparate material together: this part has considered both the variety of different spaces dedicated to *lares* and the startlingly slim physical evidence that has survived about most of these cult sites, regardless of their age or size, shape or location. *Lares* were indeed ubiquitous gods, at the hearth, on the street corner, in special *sacella* associated with city walls (and other places?), and in grand temples in Rome. In this sense, *lares* could be found in any and every type of shrine or sanctuary (with or without a permanent built structure) and could be treated as household, neighborhood, or civic gods of the whole community. In effect, the worship of *lares* demonstrates how the cult(s) at various sites complemented and overlapped with each other to create a richly layered sacred landscape. In Rome, *lares*, by nature guardians of space and community, received special sacred sites dedicated to them ranging from full-scale temples in Rome to open-air precincts with altars or groves of trees to tiny niches near crossroads.

Each of these cult sites provides its own particular evidence; generalizations remain fragile and speculative. Looking across time periods and between different urban or rural settings ultimately provides us with a series of related but distinct glimpses of everyday life in the company of *lares*. Our literary texts tend not to be descriptive, both because *lares* shrines were so common but also as a result of a lack of elite discourse about popular and local religion. That having been said, we are no better informed about the two temples for *lares* in Rome, the one *in summa sacra via* and the other for the *lares permarini* in the Campus Martius. Although these were significant temples located at strategic sites in the city, one perhaps ancient but the other longer lasting, we have very little detailed evidence about their buildings, festivals, and cult statues and personnel. Nevertheless, the sacred spaces named for and inhabited by *lares* provide the essential settings for the paintings and literary texts investigated in part I and the rituals (both religious and political) that are the subject of part III. In this sense, they deserve our attention here. Any analysis of iconography, ritual, or concepts of the divine benefits from being placed, as far as possible, within its original physical environment.

Lares maintained their characteristic familiarity partly by drawing on their own special places. In the home the *lares* lived near the hearth, which, in larger houses, was usually to be found in a dedicated kitchen. Outside the house, *lares* were most often found at the *compitum*, the crossroads where various streets converged or the edge of the farm, where one property met another at a boundary stone. The hearth and the corner(s) naturally represented the center and periphery of the property and of its domestic world. That is also why the *lares* signified "home," even as they marked space and its limits and defined community in each context. Similarly, the two *lares* temples in Rome balanced each other by being associated with the land (*summa sacra via*) and the sea (*permarini*), described as separate spheres. Each of these areas was defined in terms of home or abroad, setting out or returning to Rome, war and triumph. The triumphal cry of the Arval brothers, who called on

the *lares* in their traditional dance, connected the world of war and victory with the homes and fields that were protected by Rome's soldiers and native gods.

As discussed in this part, Pompeii offers us both individual cult sites as well as an insight into a whole network of urban *compita* where the uniformity of iconography created a landscape visibly permeated by *lares*. By contrast, the archaeology of the city of Rome presents a dense topographical maze without a single fully excavated and documented *compitum* discovered in situ, although there were (at least?) 265 such shrines in the city in the mid-70s AD. *Lares augusti* are well attested in Rome, especially in the late first century BC (as discussed in part IV later). Meanwhile, we have only traces of evidence about unique and apparently archaic cults of named *lares*, such as the *praestites* and *grundiles* or about the different representations of *lares* in Rome, such as the *permarini* or the *lar* on horseback or the winged *lares* on the Aventine. The monuments and urban patterns of republican Rome were soon obscured by the growth of the imperial city. In Rome, *lares* had a more varied iconography and a much wider range of cult sites than in Pompeii, a medium-sized town that had been a Roman colony since 80 BC. Consequently, each "Roman" urban landscape was defined by its own pattern of *lares*.

This study has sought to appreciate meaning and nuance in the variety of these different cult sites. In this sense, it has offered a particular "reading" of sacred space, based on the value of individual shrines, their topography, construction, and adornment. *Lares* could inhabit and define monumental sacred sites (temples), even as they habitually consecrated the most mundane places of everyday life (kitchens or crossroads). My method is, therefore, consciously at variance with the tendency to equate *lares* with each other, a traditional approach that has looked for patterns of syncretism and equivalence in cult titles and functions.[1] For example, I have considered the *praestites* as separate from the *publici* or the *lares in summa sacra via*; others have sought to combine these into a single cult, both in terms of physical space and of ritual practice.[2] Similarly, I have not equated *lares* with other pairs or groups of gods, such as the Dioscuri, or Cabiri, or *penates*. While it is true that some antiquarians, like Nigidius Figulus and Varro, liked to play these scholarly games, such analogies tell us little about how these gods were experienced by their everyday worshippers.[3] A more nuanced approach brings us closer to the religious thought patterns and experiences of ordinary Romans.

All this is to say that the term *lar* designates a "type" or "species" of god, of whom there were very many, perhaps almost an infinite number of pairs, instances, and local variants. Consequently, it is not logical or meaningful to ask whether all the *lares* at the street corners in Rome were "the same" gods. Each was represented as a pair of typical deities, but also the unique inhabitants and protectors of this particular compital shrine and street. In other words, an offering made at another *compitum* on a different street corner was not "transferable" to your local shrine. *Lares* were never described as manifestations of a single deity or divine spirit. Rather both their multiplicity and their similarity was inherent in their ubiquity, as if two

1 An early and influential example of this method is offered by Chapoutier 1935, 313–20.

2 A recent example (following in the footsteps of Chapoutier 1935) is provided by de Sanctis 2007, 509–11, where he equates the *praestites* with the *compitales*. He goes on (520–21) to identify these *compitales* with the *lares* inside the houses. Coarelli 2012 offers a reconstruction based on this approach. Popkin 2015 also relies on Chapoutier's method, without further justification. No ancient evidence supports this approach; it is simply a matter of interpretation.

3 See section I.i for discussion of these Roman antiquarian authors.

sides of the same coin. By contrast, while the majority of street shrines in Rome today honor the Blessed Virgin Mary, worshippers easily understand her as a singular person with a clearly defined life story and identity, despite her many cult titles and varied person. The *lares* who inhabited the street corners before her arrival and who also enjoyed flowers and candles like the ones she continues to receive today, were more individual and local, but equally protective and familiar.

III

CELEBRATING *LARES*

rem divinam nisi Compitalibus in compito aut in foco ne faciat.
—CATO *DE AGRICULTURA* 5.3

[C]arus Petiniae Posilla(e) vilic(us) comp(iti) aram Lari s(uo)
v(otum) l(ibens) s(olvit) l(aetus) m(erito)
—*CIL* 5.7739 = EDCS-05400987 FROM TREBIANO IN LIGURIA

Having examined first the iconography and character of *lares* and then the sites where they were venerated, it is now time to turn to the mid-winter festival of Compitalia, the most important celebration of the *lares compitales* at their crossroads shrines, whether in town or on the farm. The rituals and practices used for their annual festival at the crossroads shrines afford us vivid glimpses of what was a high point in the year for many ordinary people, including especially slaves and freedmen. In a world without a regular day of rest in a weekly or even a monthly cycle, Compitalia was a rare celebration for all the members of the household and neighborhood. Its association with ample rations of wine, merriment, and a "holiday," even for the lowliest agricultural slave and for the oxen he yoked to the plow, made both for eager anticipation and planning, as well as for fond memories afterward. The celebration in its individual components and as an ensemble reflected an ideal of harmony with local gods enacted in a festival shared with neighbors in spaces "next door." Boundaries were recognized, crossed, and reaffirmed in familiar rituals that celebrated a sense of place and of being "at home" and part of a household within a wider community.

Part III has three related themes that will be explored in some detail, before being summed up in a concluding section about local religion and politics at the crossroads (section III.xxiii). The topics under consideration are the annual festival itself, the relationship of the compital shrines to their local administrative structure(s), and the practice of local politics in a compital context in republican Rome. The first two sections will examine the festival of Compitalia. What do we think we know about this annual celebration? A reconstruction of the various rituals attested in our different literary sources (xvii) leads into an examination of the festival as observed on Delos (xviii), which provides our earliest case study for the popularity of this celebration, as organized by the slaves and freedmen of merchants doing business on the island in the later second and early first centuries BC. In this particular context, religious aspects emerge quite separately from the civic framework of a Roman town or country estate, since Delos was a free port administered by Athens (167–69 BC), without Roman magistrates or a Roman municipal setting and consequently without a network of shrines at its crossroads. The paintings and

inscriptions from Hellenistic Delos are earlier than the material evidence we currently have from either Rome or Pompeii.

The second theme (sections xix, xx, xxi) explores the embedded nature of compital cult in local communities, by looking at its celebrants and organizers. Small administrative units in Roman towns and in the countryside (vici and *pagi*), their local leaders (*vicomagistri* and *magistri pagi*), and the types of grassroots organizations that flourished in these neighborhoods (*collegia*) will be examined. Important insights can be gleaned from inscriptions from republican Capua and Minturnae. Local administration has often been discussed quite separately from any detailed analysis of religion; here both aspects will be integrated. In other words, after attending the festival, it is relevant to ask who organized it and how it fitted into local community life beyond the actual day of the annual holiday.

The third topic has been the most frequently treated of the three. In contrast to the rich religious imagery in wall paintings from Delos, which advertised the festival and its ludi throughout the year, Rome provides most insight into the political and social unrest that seems to have centered on the local neighborhoods, their leaders, and the ways in which Compitalia had come to be celebrated by the mid-first century BC. Perhaps not surprisingly, vici and *compita* were integral to political debates and violent confrontations, as republican political culture decayed and one-man rule gradually emerged from its collapse. The importance of Compitalia is made clear by bans and reinstatements of various parts of its observance, notably its popular games (*ludi compitalicii*). The senate and leading politicians tried to enlist local activism for their own purposes while limiting its use by political rivals. Some parts of this (in)famous story have received much more detailed analysis than others. The focus of my study (xxii) will consistently be on the level of the street and on the role of religion, both as a distinct area of human experience and as a key factor shaping identity, aspiration, and the very definition of community and neighborhood. While summing up, a final section (xxiii) also looks at occasions on which priests and magistrates reached out to the network of local shrines, both *compita* and *sacella*, to beseech and appease gods throughout the city on behalf of the whole community.

XVII COMPITALIA: WHO IS MY NEIGHBOR?

dienoni populo Romano Quiritibus Compitalia erunt; quando
concepta fuerint, nefas
—AULUS GELLIUS, *NOCTES ATTICAE* 10.24

The annual midwinter festival of Compitalia was the most important celebration
at the compital shrines in Rome.[1] Each temple in the city had its own special feast
day, but all the *compita* celebrated Compitalia together on a date that was an-
nounced to the public each year by the urban praetor eight days in advance. Be-
cause it was a movable feast, this popular celebration is not recorded on any of the
extant inscribed Roman calendars, nor is it mentioned by Ovid in his calendar poem
Fasti, which covers the first six months of the year in the extant version.[2] In di-
rect contrast with the regular offering of garlands at the hearth of Cato's farm by
the *vilica* on the *kalends*, *nones* and *ides* of each month, the Compitalia was not tied
to a fixed calendar day or even to a specific month. It was, therefore, classed as one
of the movable feasts called *feriae conceptivae*, six of which are attested in the Roman
festival year.[3] The festival of the crossroads, therefore, seems to date back to a time
when information about religious holidays was communicated orally within a tight-
knit community. It is possible that at some earlier times, all festivals had been
announced by a priest or magistrate, before a more fixed calendar was in use.[4]
Compitalia fell soon after the most famous midwinter festival of Saturnalia (17th
December, traditionally named as the fourteenth day before the *kalends* of Janu-
ary) that itself closely preceded the winter solstice.[5]

The public announcement of Compitalia's date by the praetor was designed to
give a traditional eight-day interval for people to prepare for its celebration.[6] As
with other major festivals, the organizers had, however, been preparing all year for
the great day. The difference with Compitalia was that so many more people were
involved at the local level, in contrast to the grand celebrations of civic cult that
were orchestrated and staged by elite priests, but not necessarily observed by

1 There are many discussions of Compitalia, most not very detailed. Particularly notable con-
tributions include Wissowa 1912, 168; Harmon 1978, 1594–95; Bömer 1981, 34; Scullard 1981,
58–60; Mastrocinque 1988, 156; Benoist 1999, 299–315; Tarpin 2002, 106–8; Lott 2004, 35–39;
Marcattili in *ThesCRA* 4 (2005): 223; Fraschetti 2005, 184–90 (originally published in 1990);
Wallace-Hadrill 2008, 266; and Stek 2009, 187–212, 219. See Palmer 1974 for extensive games ap-
parently paid for by *vicomagistri* in the later second century AD.

2 Ovid could have planned to mention the festival in late December, but this part of his poem
does not survive. He does describe the Paganalia in late January in some detail (*Fast.* 1.657–96),
despite the fact that it also was a movable feast. The two similar festivals could have balanced each
other at the end of each month. We do not know if Ovid wrote more of the *Fasti* than we have.

3 For *feriae conceptivae*, see Varro *LL* 6.29–30 and Macrobius *Sat.* 1.16.6, with Michels 1967,
191, and Radke 1990, 29.

4 All festivals announced on the *nones*: see Beard, North, and Price 1998, 56, on the original
functions of the *rex sacrorum*, with Varro *LL* 6.13.28; Macrobius *Sat.* 1.15.12; and Rüpke 2011, 113.

5 For Macrobius' *Saturnalia*, see the new edition by Kaster 2011a and 2011b. For a useful over-
view of the festival, see Dolansky 2011.

6 For the cycle of *nundinae*, the eight-day Roman "week," see Ker 2010, with full bibliography.
There is no specific evidence, however, that the celebration of Compitalia was directly linked to
the nundinal cycle, which would have varied each year even, as our weekdays do not fall on the
same dates each year. Nevertheless, the announcement plays into the concept of the Roman market-
day cycle.

(m)any ordinary people. The three attested dates for Compitalia that we know of from republican Rome fell on 29th December 67 BC, 1st January 58 BC, and 2nd January 50 BC, all celebrations held before Julius Caesar's introduction of the revised calendar of 365 days (45 BC).[7] These holidays, therefore, indicate a date for the announcement of the festival by the praetor on 21st, 22nd, or 23rd December respectively, at a time when this month had only twenty-nine days in the republican calendar. In other words, not only the festival itself but also its announcement came after Saturnalia.[8] Indeed, the two holidays had some features in common, most notably the participation of slaves, who received additional rations of wine on these two occasions.[9] Dionysius of Halicarnassus seems to refer to a season of relatively greater freedom for slaves, probably in the days that included and spanned the interval between Saturnalia and Compitalia.[10] Regardless of its precise date in any given year, Compitalia would, therefore, have been experienced by participants as the culmination of a distinct "holiday season" that extended throughout the second half of December.

Compitalia's announcement came at a time when several other festivals took place in Rome around the winter solstice. On the surviving inscribed calendars (including the *Fasti Antiates Maiores* of about 60 BC, the only extant pre-Julian calendar) and in Macrobius, we find Divalia for the 21st December, an ordinary day for the 22nd December, and Larentalia for 23rd December.[11] Temple birthdays we know of in Rome are the *lares permarini* on 22nd December and Diana, the Sea Storms (*Tempestates*), and Juno Regina on 23rd December.[12] As already noted, 21st December was one of the traditional days when *lares* were honored, together with Mars and Consus, at an underground altar in the Circus Maximus. These holidays would each have been celebrated in their own way, by a specific section of the population. The decision about the date of Compitalia seems, therefore, to have been connected with an official observance of the winter solstice, whether by the praetor himself or by the *pontifices* who were recording the shortest day for a variety of

7 Attested Compitalia dates: 29th December 67 BC (Asconius 65C), 1st January 58 (Cicero *Pis.* 8), 2nd January 50 BC (Cicero *ad Att.* 7.7.3).

8 Macrobius *Sat.* 1.10 offers an extended and somewhat contradictory discussion of the date and length of Saturnalia and of the other festivals in these December days. Saturnalia was originally also a one-day festival, which seems to have lengthened to three days after the introduction of the Julian calendar, partly because of unease about which day was now the appropriate one given that the holiday fell fourteen days before the *kalends* of January. Meanwhile, Macrobius adduces evidence for a more informal seven-day holiday period, beginning on the 17th December. See Pliny *Ep.* 2.17.24 and Seneca *Ep.* 18.1–2, with Scullard 1981, 205–7, and Versnel 1993. Palmer 1997, 62–66, dicusses the reform and extension of the festival in 217 BC, after the great defeat at Lake Trasimene.

9 Additional rations of wine for the slaves: Cato *de Agric.* 57 and 66. See also the scholiast on Persius *Sat.* 4.28.

10 Dionysius of Halicarnassus 4.14.4 uses the phrase "in those days" (*en tais hemerais ekeinais*) in discussing relative freedom given to slaves, especially with regard to dress and leisure time. Yet his own discussion indicates a single day of formal celebration for both Saturnalia and Compitalia in the later first century BC. See note 8 earlier for the length of Saturnalia.

11 Divalia: Pliny *Nat.* 3.65 and Macrobius *Sat.* 1.10.7, with Versnel in *BNP*; Larentalia: Macrobius *Sat.* 1.10, with Graf in *BNP* and Scullard 1981, 210–12 (he considers the identification of Acca Laurentia with the mother of the *lares* as "far from sure"). For an overview of the Roman festival calendar, see Scullard 1981 and now Donati and Stefanetti 2006.

12 *Fast. Ant. Mai.* lists the *lares permarini* on 21st December, but this may be a scribal error. The anniversary is on the 22nd December in Livy 40.52.4 and Macrobius *Sat.* 1.10.10.

other reasons.[13] Meanwhile, the pre-Julian calendar was often out of step with the seasons, especially in the years immediately before Caesar's calendar reform at the time of the attested dates for the holidays in the 60s and 50s BC, a situation that obviously affected the Romans' actual experience of their religious holidays within the seasonal setting appropriate for each celebration.[14]

For the sake of its archaic language, Aulus Gellius (mid-second century AD) has preserved for us the traditional formula spoken by the praetor. His version is confirmed by Macrobius (early fifth century AD), in his great work titled *Saturnalia*.[15]

dienoni populo Romano Quiritibus Compitalia erunt, quando concepta fuerint, nefas.

On the ninth day (counting inclusively from today) it will be (the festival of) Compitalia for the Roman people, the Quirites. Once (the celebrations) have started, (there will be) a religious ban on all business.

(Aulus Gellius *NA* 10.24.3)

The official wording was presumably very similar for every movable feast announced by a Roman official. This formula makes clear that Compitalia was indeed a public festival for the whole Roman population, addressed by their old name of Quirites, on a day when all other business was officially suspended in the city. To be specific, it was not conceived of as a special celebration for the lower classes, or as a purely local or rural festival, or as mainly by or for slaves, who were not citizens. Rather, the celebration of the festival took precedence over the character assigned to any particular day in the Roman calendar. Over time, the participation of an increasing number of slaves and former slaves will have created a marked contrast with the tenor of this announcement, which was addressed specifically to the citizen body. As already discussed (section II.xiii), the festival's founding was attributed (at least by Dionysius of Halicarnassus in the late first century BC) to King Servius Tullius. The king may originally have been the person imagined as announcing the date of the holiday in a prerepublican reconstruction of the early celebration. Regardless of how the origin story is interpreted, the practice of announcing movable feasts according to the cycle of seasons appears traditional in the context of the city.

As the preserved dates from Cicero's day show, the festival might fall in late December or early in January, sometimes even on the first day of the New Year, a day crowded with solemn official business in Rome.[16] It might, therefore, have been possible that a single calendar year saw two Compitalia celebrations, one in January and one in

13 On the key function of the winter solstice in the republican calendar, see Michels 1967, 100–101. She explains exactly how the solstice could have been observed in Rome. It was the noting of the shortest day of the year that seems to have been used by the *pontifices* to decide when to intercalate (that is, to add an additional month after February) in order to keep the civic (lunar) calendar in line with the movements of the earth around the sun. Note in particular the discussion in Rüpke 2011, esp. 71–72. Palmer 1976 reedits and comments on a bilingual epitaph from Latium (*AE* 1928.108) that counts the celebrations of Compitalia as equivalent to the seasons/years, perhaps to commemorate a man who had served as a *vico*.

14 For the frequent misalignment between the republican calendar and the seasons, see Prack 1996, Feeney 2007, and Rüpke 2011.

15 Macrobius *Sat.* 1.4.27.

16 For the first day of January and the New Year in general, see Meslin 1970 and Graf 1998.

December. This flexibility about the day of Compitalia also suggests that it originally predated the time when the first day of January ushered in a New Year, either on the farm or in the political center. The old, political New Year had begun on 1ˢᵗ March (shortly before the start of the fighting season on the *ides* of March), and the consuls were inaugurated in response to the needs of the moment rather than on a fixed day each year.[17] The consuls first took office on 1ˢᵗ January in the year 153 BC.[18]

Interestingly, therefore, it seems (at least originally) to have been of little consequence whether the festival fell in the last days of December or in the first days of January; no big break for a New Year is envisioned here. Regardless of its precise date, Compitalia came too late to be a "formal" celebration of the end of the agricultural year, which had come to a close some weeks earlier. Eventually, in imperial Rome the fixed festival of three days in January (3ʳᵈ to 5ᵗʰ), immediately after the end of the New Year's festivities, gave the *lares* an established spot of their own at the start of the New Year, as well as a celebration over several days, both measures of their significance to the community as a whole.[19] Nevertheless, Macrobius still designates Compitalia a movable feast in the early fifth century AD.[20]

As Cato tells us, the importance of Compitalia can be gauged from the fact that it was the only festival that the *vilicus* could and should supervise independently for everyone on the farm.[21] Far from representing an "inversion" of the role of master and freedman farm manager, however, Cato's instructions about the festival show that it was essential to assign to the *vilicus* the task of celebrating a day that must be observed but which fell at a time of year when the master might not be able or eager to make the trip to his farm(s) in the dead of winter. If he owned more than one property, as an increasing number of wealthy Romans in the second century BC did, he could in any case obviously not supervise the festival in each place on the same day. Consequently, a master must delegate this important role to the most responsible male on his farm, while at the same time carefully limiting that same man's overall religious functions. Cato himself had grown up on a more traditional farm than the ones he is describing in his writings, a farm that was the master's main residence and where his children grew up. He would have participated in Compitalia, both in the country and in Rome, throughout the various stages of his long life.

The prominence of Compitalia on Cato's farm raises the question of who informed the *vilicus* of the appropriate date to hold the celebration each year. Was it the master who needed to send a message from the city after the official announcement had been made? Or was the *vilicus* responsible for gathering this information himself? Other than those for the *lar* at the hearth, religious rituals described by Cato were freely adapted to the agricultural cycle according to the needs and conditions on each farm, on a day that could be chosen locally at will. We do not know whether Compitalia stands out as different, essential, and closely connected to the city of Rome or whether the *vilicus* could pick a day for his celebration, perhaps based on his own observance of the winter solstice.

17 For the old calendar, see Michels 1967 and Rüpke 2011.
18 See Flower 2010, 67–69, for discussion of the realignment of the political year in the middle of the second century BC.
19 See Scullard 1981, 58–60, with *CIL* I² p. 305, for the fixed Compitalia of imperial Rome (3ʳᵈ–5ᵗʰ January).
20 *Sat.* 1.16.6.
21 See the epigraph for part III.

The phases and features of the celebration can be reconstructed, at least in out-
line, from a variety of ancient evidence, although no Roman or foreign visitor gives us
the kind of description that would help us to picture all the details of the festivities on
a single occasion or even during a given time period. Caution is needed since it is al-
ways risky to combine evidence from different sources, places, and times. We know
of the following possible features in the festival (some much more fully attested than
others): a holiday for everyone; the hanging of woolen images (dolls and balls, one
representing each inhabitant) at the *compita*; the placing of yokes at *compita* in the
countryside; the contribution of a ritual honey cake from each household; a generous
ration of wine for slaves; a ritual procession of different animals for sacrifice (*lustra-
tio*) demarcating the local area; the sacrifice of a pig to the *lares*; the sharing of pork
from that sacrifice in a merry banquet; and local games (*ludi compitalicii*) that could
be of varied character according to the available space and resources. Probably be-
cause of its winter season, the festival is not overtly associated in our literary sources
with the garlands or flowers that *lares* were so fond of in the home.

On the farm, the festival was organized by the *vilicus*, often a freedman, but act-
ing in his capacity as representative of the master. In Rome, *vicomagistri*, also freed-
men, seem to have been in charge even from the third century BC (about whom
more later). The *vicomagistri*, chosen annually in the local neighborhoods, presided
while wearing the *toga praetexta* of a magistrate and were accompanied by two lic-
tors.[22] Their special prominence also reflected the inclusiveness of the festival and
the characteristic way in which all inhabitants were involved. The cult of the *lares*
could offer a religious context for a slave to do his job well, become integrated into
the neighborhood community, progress to freedom, and even ultimately to the re-
sponsibility of supervising the organization of Compitalia in a given year. In the
time of Augustus, some *vicomagistri* served more than one term in office.[23]

Let us follow the festival step by step to try to reconstruct what happened as
the day unfolded. As Festus tells us, the night before the festival (or perhaps be-
fore dawn on the day itself?) woolen images were hung at the compital shrines,
whose altars were surely also cleaned and decorated for the occasion.

> Pilae et effigies viriles et muliebres ex lana Conpitalibus suspendebantur
> in conpitis, quod hunc diem festum esse deorum inferorum, quos vocant
> lares, putarent, quibus tot pilae, quot capita servorum; tot effigies, quot
> essent liberi, ponebantur, ut vivis parcerent et essent his pilis et simulacris
> contenti.

> Balls and dolls (male and female) made of wool were hung up at the cross-
> roads shrines at Compitalia, because this day is considered a feast of the gods
> of the underworld, whom they call *lares*. For them are placed as many balls
> as there are slaves, as many dolls as there are free persons, so that they (the
> *lares*) might spare the living and be content with these balls and likenesses.
>
> (Festus 273L)

22 *Vicomagistri*: Calpurnius Siculus *Ecl.* 4.125–26 and Dionysius of Halicarnassus 4.14.2–4.
23 See Lott 2004, 92–94, table 1, for the named *vicomagistri* of the Augustan period; twenty-
eight inscriptions have yielded seventy-five names so far.

Lanae effigies Conpitalibus noctu dabantur in conpita, quod lares, quorum
is erat dies festus, animae putabantur esse hominum redactae in numerum
deorum.

Woolen dolls are given at the crossroads at night on *Compitalia*, because the
lares, whose festival day this was, were thought to be the souls of men added
to the number of the gods (after their deaths).

<div style="text-align: right">(Festus 108L)</div>

Iconographic evidence, both from Delos and from Pompeii, suggests the altars
were decorated with garlands and the surrounding area would probably also have
been prepared for the feast.[24] Each free person was represented by a doll (*effigies*),
each slave by a ball (*pila*), both of which were made of wool.[25] The hanging of the
images prepared the *compita* for the festival itself. It was not until the evening be-
fore that ordinary people would have been free from their daily work and able to
complete the final preparations required to start the celebration on the following
morning. Preparations the night before fit in with a one-day festival in the tradi-
tional republican manner.

A display of yokes was also a custom in the countryside, but this is not repre-
sented in our surviving iconography.[26] If these were no longer in use, they could
fit in with the dedication of other items a person had finished using, such as the toys
of the girl who is about to be married.[27] Such gifts acknowledged the protection
already received from the *lares* and their special help at times of transition to a new
phase in life. Alternatively, a display of yokes that were still in use would symbol-
ize the rare day of rest or the end of the agricultural season, as well as ascribing a
sacred dimension to agricultural labor while seeking a blessing for it for the com-
ing year. Even as each person had a woolen figure at the *compitum*, their yokes
could represent the farm animals that drew the plows and carts. In this way, the
lares were protectors of everyone on the farm.

No source tells us how long the dolls (or yokes and other decorations) stayed in
place nor whether new dolls would usually be made each year. Some have been hy-
pothetically identified in paintings from Pompeii, but none of these is either easy
to see in any detail or specifically labeled.[28] As a result, we do not know how elab-
orate these "dolls" were; they may have been very simple and only designed to last
for the festival day itself. The dolls represented the people as they came together at
the boundaries of their properties and asked for the protection of the *lares* for the

24 For Pompeii, see section I.vi and section II.xv. For Delos, see section III.xviii.

25 See also Varro *Men.* 463 for a further reference to these dolls. For a very different interpre-
tation, see Ramos Crespo 1988, who argues that the dolls bring elements of "magic" to a religious
festival.

26 See the scholiast with Persius *Sat.* 4.28: *quandoque iugum pertusa ad compita figit* (when
he hangs up the yoke at the crossroads shrine that one can pass through). The commentator says:
*in his iuga facta ab agricolis ponuntur uelut emeriti et laborati operis indicium, siue quod omne in-
strumentum existiment sacrum* (at these shrines, the yokes made by the farmers are placed, as if a
testimony to work done and completed, or because they think every tool is sacred). Parker and
Braund 2012, 439–42, discuss the ancient commentaries on Persius.

27 For toys of girls dedicated to *lares*, see Ps. Acr. on Horace *Sat.* 1.5.65–66 and Nonius 538 =
863L

28 Dolls identified in paintings from Pompeii: Fröhlich 1991, 34, with F 29 and F 66 (cf. L 38,
93, 109, 111).

coming year. These figures could also be counted to give a picture of the whole population.

As already discussed (section I.i), there is no need to see nighttime preparations as spooky or connected with the dead. The festival itself clearly took place during the day and included an offering of some of the sacrificial meat from the pig(s) to the *lares*, who were, therefore, not honored with the holocausts that were customary for underworld deities. The antiquarian authors who tell us about the dolls, Festus and Macrobius, both chose this element as the most unusual in the celebration, the ritual that called for an explanation beyond the much more customary procession, animal sacrifice, and feasting with wine.[29] In the antiquarian and scholarly discourse of these learned men, the dolls of Compitalia have become mysterious and frightening substitutes for human sacrifice, rather than representations that register presence and invite protection within a sacred but familiar landscape defined and guarded by local gods.

Macrobius also mentions a cult for Mania, mother of the *lares*, which is not attested by any other evidence from the crossroads shrines.[30] It is possible that she has been introduced into this context from other *lares* cults (such as the ceremonies of the Arvals). She may have seemed a more likely recipient of a symbolic human sacrifice than her merry children. Macrobius does not speak of the origins of the cult or of its festival. He does ascribe a period of actual human sacrifice to Tarquinius Superbus, the notoriously tyrannical last king of Rome. According to his version, put in the mouth of Albinus Caecina in his dialogue, it was Junius Brutus who both ended the monarchy and substituted garlic heads and poppies, to meet the demand for "heads" attributed to an oracle of Apollo. The woolen dolls are described as a subsequent version of this same ritual. No other source mentions Mania in the context of compital cult; it is likely that this is an antiquarian reconstruction rather than actual evidence about how Compitalia was ever celebrated. This elaboration also fits in with the very negative traditions about the last king of Rome and the role of Brutus in ending tyranny. We do not know whether garlic or poppy was offered to *lares* during the historical period, although one *compitum* in Rome was called Compitum Aliarum (garlic crossroads or garlic shrine).

Macrobius also tells us that the dolls were hung at the entrance to the houses (*foribus*), not at the altar to the *lares* of the crossroads.[31] The move from hanging dolls at *compita* to putting them at the doors to each house makes sense in the context of the growth of the city of Rome, since eventually there might simply have been too many woolen figures to accommodate easily at the *compita*, often very compact shrines.[32] In other words, there is no reason to see the dolls at the door as different from those at the compital altar. The moving of the dolls to the entrances of the houses suggests their continuing importance, both in representing each person before the gods and in providing a picture of the city's population in the places where people lived. It is unclear whether visitors were also represented or only individuals considered to be resident in the city (for at least part of the year?). The wedding ceremony may help to suggest a connection between *lares* and the crossing of thresholds (see section II.x).

29 Macrobius *Sat.* 1.7.34.
30 Macrobius *Sat.* 1.7.34 and Varro *LL* 9.61.
31 Kaster 2011a translates "before each household's door."
32 Dumser 2013 gives a recent overview of the growth of Rome.

In this context, the counting of the inhabitants was directly associated with the local area, in other words a count either by household or by *compitum*.[33] The dolls at the *compitum* represented everyone in the area, both male and female (differentiated by each doll), free and slave (clearly separate and probably without gender). Nothing is said specifically about children, who should also have been represented in an accounting of all inhabitants but perhaps depicted only after they were over a certain age. Alternatively, hanging a new doll to signal the arrival of a new baby could have been a special occasion. An easy counting of the local population could, therefore, take place annually and at the same time of year, when the population was more at leisure and perhaps less likely to be traveling than in most other seasons. We cannot be sure who might have counted the inhabitants, but perhaps it was the *vicomagistri*. At the same time, anyone could get an overview of the community and of any sudden fluctuations in population.

A newly freed person would mark his or her transition at the next Compitalia, by hanging up a gendered doll instead of a ball. Unfortunately, no ancient source tells us about what would probably have been a moving and celebratory moment of personal transition for recently freed people, as each publically took on the status of Roman citizen within their local community. It is a feature of this cult that individuals seem to have remained involved after they gained their freedom; worshipping *lares* was apparently not experienced simply as a duty imposed by a master on a slave. The hanging of a doll instead of a ball allowed for public recognition of citizen status beyond the household within the local community of neighbors. In a similar way, the Roman bride deposited a coin at the *compitum* near her new house on her wedding day. As in other contexts, the *lares* appear as guardians of life's major transitions.[34]

Nevertheless, the dolls of the Compitalia clearly also had a primary religious function, which should be considered at least as important if not more fundamental than a practical one of providing an overview of the local population. The hanging of dolls at a *compitum* invoked the protection of the local *lares* that each inhabitant, regardless of status, both sought and acknowledged.[35] The placing of the dolls is in itself a type of ritual, which gave a person a "place" within the city and in relation to the other people living there, while also indicating that everyone was ready to celebrate together the next day. The main qualification was to be present in the area close to that *compitum* at the time of the festival. This ritual, therefore, reinforced the idea that the *lares* were gods of place. We are not told what gestures might accompany the hanging of the dolls or whether individuals were expected to do this for themselves, perhaps with a prayer, or in a more informal way. Alternatively, one designated person may have hung dolls and balls for a whole household, simply as part of the task of decorating the altar.

Each household apparently also offered cakes of a traditional kind, perhaps sweetened with honey, to the *lares compitales*. Dionysius of Halicarnassus (4.14.4) mentions one "cake" (*pelanos*) contributed by each "household" (*oikia*). The exact nature of these cakes remains unclear from Dionysius' term. In connection with a *lustratio* on his farm, Cato mentions two types of Roman cakes, the *strues* and the

33 Census: Lo Cascio 1997 and 2008 provide the essential discussion.
34 The bride and the *lares* are discussed in section II.x.
35 See discussion in section I.i.

fertum.[36] If each household contributed one cake, then this would have yielded a count of the number of individual "households" who were celebrating at each *compitum*. Dionysius' information is closely focused on the slave participants: he may have asked one or more members of his own household to explain the festival to him. Hence he mentions the honey cake, because his household would have contributed one, even as his own slaves also had a day off work to participate. By contrast, he does not describe the woolen dolls or the parade and sacrifice of a pig, which appears as the climax of the religious ritual itself. In other words, Dionysius' information is second hand; he is not a participant in or even a bystander observing the festival's rituals.

The day of Compitalia itself was celebrated by the sacrifice of a fatted pig to the *lares compitales* at the compital shrine and by a banquet of the pork shared with one's neighbors.[37] A solemn procession of purification (*lustratio*) of the area seems also to have been a (possible) part of the ceremony.[38] In other words, the pig(s) for the *lares* (and sometimes other animals) were paraded around the local boundaries before the sacrifice. The parading of a group of different animals (usually three different kinds) was called a *suovetaurilia* and was a standard offering to Mars but could be a gift for any god. This type of ceremony is separately described by Cato as a regular part of life on the farm. In addition it was a practice integral to a number of public festivals, most notably the solemn *lustrum* at the end of the Roman census, according to republican practice.[39]

The central elements of Compitalia, therefore, comprised celebrations typical of civic ritual; the *vilicus* or *vicomagister* supervised the same kinds of actions in cult and at the games that elite priests and magistrates did in the context of the public festivals for the major deities of the city. Meanwhile, literary references in Propertius to a *lustratio*, a pig for the *lares*, and the feasting are allusive.[40] A wealth of iconographic evidence connects the *lares* closely with the sacrifice of a pig at an altar and the display of a range of popular pork products, clearly meant for consumption both on the day and throughout the year.[41] In this sense, *lares* were associated both with a special feast but also with a supply of pork in every season.[42]

Two damaged paintings from Pompeii seem to portray a local *lustratio* procession, but apparently not in the specific context of Compitalia. Unfortunately, the fragmentary state of these two paintings does not allow for a robust analysis either of the exact details of the processions or of the context of their celebrations.[43] Each seems to show a *lustratio* comprising three (four-legged) sacrificial victims, one around the walls of a town (Pompeii?), the other a procession circling a field or

36 Cato *de Agr.* 141, cf. Festus 75L and 408–9L.

37 Pork for the *lares*: Horace *Od.* 3.23.3–4; Tibullus 1.10.28; Propertius 4.1a.23–25.

38 Baudy 1998 remains the classic discussion of *lustratio* within its various Roman contexts.

39 For *suovetaurilia*, see Baudy 1998, 115–21, and Siebert in *BNP*.

40 Propertius 4.1a.23–24 and 2.22a.3, and Asconius 7C.

41 Pigs and pork in paintings are discussed in the examples from Pompeii in sections I.vi–viii and Delos in section III.xviii.

42 See Kajava 1998, Linderski 2000, and Scheid 2005 for the ongoing debate about the source of meat consumed at large public events or distributed at funerals and triumphs. Compitalia raises different issues because it is such a local festival and so many participated. Not all the meat produced by the sacrifices on that day may have been intended for immediate consumption in any case, since pork was also preserved and will have been a welcome dish during the cold winter season that followed.

43 See the detailed description and analysis in Van Andringa 2009, 191–94 and 314–19.

estate supervised by a single officiant, perhaps the property owner.[44] A variety of participants are dressed in different styles and bring offerings (fruit, cakes, garlands) or seem to be engaged in prayer or song. This iconographic evidence, despite its poor state of preservation, confirms the ubiquity and importance of *lustratio* in a variety of settings, whether in town or on a country estate. Such a ritual could be a seasonally repeated occasion, such as the pig paraded and sacrificed for Tellus and Ceres at the Paganalia in late January.[45] Alternatively, the depiction of a festive procession around Pompeii's walls may commemorate a singular reconsecration of the urban space on a particular occasion, for example after the devastating earthquake of AD 62.[46]

Most of the festivities at Compitalia seem to have taken place in the streets and at their crossroads themselves, weather permitting, including the processions, sacrifice, cooking, feasting, and whatever other entertainments were put on. Ludi may be a rather grand term for local competitions or races or plays put on in the streets or nearby open spaces.[47] These ludi could apparently range from theatrical performances to athletic events or boxing matches. The space and resources available in each local area (as well as the density of the population) would have shaped what kinds of entertainments could be staged. At Compitalia, as well as on other exceptional occasions, the streets of Rome were themselves said to celebrate.[48] There was clearly a strong emphasis on the merry eating and drinking, especially for the slaves who were afforded so few real holidays. Although no ancient source talks about dancing at Compitalia, the fact that *lares* are so often portrayed as dancing may indicate that a dance was as characteristic of the celebrations as the wine they pour.[49] The Arval brothers also danced as they invoked *lares* with a traditional hymn in the sacred grove of Dea Dia.[50]

Both in the countryside and in town, the point of the festival was to share a sacrifice and a merry feast with the "neighbors," those on the "other side" of whatever property line or corner was being marked. What made Compitalia special, apart from its mostly familiar religious components, was the fact that everyone in the city (or on the farm) was involved and encouraged to participate together, reaching out beyond their household and street. Each household was not supposed to celebrate separately within its living space or at its own hearth. Rather all came together to celebrate *at the boundaries*, thus observing, crossing, and thereby reinforcing these lines that defined the very shape of the familiar, daily world everyone lived in. Compitalia's format shows that its basic purpose was designed around the goal of bringing neighbors together once a year for the ceremony of a standard animal

44 Sant'Antonio Abate: Stefani 2005, 34; Vos 1982, 331. Muregine: Mastroroberto 2001, 964; Guzzo 2003, 467–68.

45 Paganalia: Stek 2009, 171–86.

46 Van Andringa 2009, 193–94.

47 *Ludi compitalicii:* Cicero *Pis.* 8 with Asconius' commentary; Calpurnius Siculus *Ecl.* 4.125–26; Servius on *Aen.* 8.717; Macrobius *Sat.* 1.7.27–35; and Flambard 1977, 140–44. Suetonius *DA* 31 probably refers to a restoration of these ludi by Augustus, as discussed in section IV.xxiv. Afranius and Laberius both wrote plays titled *Compitalia.*

48 Streets celebrate in a scene on the shield of Aeneas described by Vergil at *Aen.* 8.717: *ludisque viae plausuque fremebant* (the roads ring with applause and games). Servius adds: *hoc est, compitalicii ludi celebrati sunt* (that is to say, the compital games were being celebrated).

49 For dancing in Roman religious practice, see Gianotta in *ThesCRA* 2 (2004): 337–42.

50 For discussion, see section I.ii. Their dance may have had three steps to fit in with the refrain of their hymn.

III.1. Drawing of a Gracchan boundary stone.

sacrifice in the context of recognizing and celebrating proximity. From an early period, therefore, Compitalia ensured and reminded everyone that clearly acknowledged boundaries made for good neighbors. This practice fits in with the traditional Roman respect for boundary stones and markers, which were considered sacred and immovable objects.[51] (See figure III.1.)

In the same way, a *compitum,* a special kind of marker guarded by special boundary gods, was religiously and officially inaugurated and annually celebrated by all the inhabitants in the area. In many instances, the boundaries being observed were markers of private property and of the households that constituted a system of separate domains owned by identifiable individuals or families. Such marking of private property would, however, have been much more evident in the countryside than in Rome. Roman culture consistently put a high value on property ownership, whether by men, by the Roman people (*ager publicus populi Romani*), or by gods. Boundaries with sacred land and temple precincts would also be observed.[52]

Compitalia was, then, a very practical festival that met several fundamental needs of a community. In the first place, it brought everyone together to recognize and to reinforce property lines and household or neighborhood groups every year. The ritual of the *lustratio* and the sacrifice of the pig at the compital altar defined these boundaries. Meanwhile, the whole population was "present" as represented by publicly displayed woolen dolls that could be counted whether officially or more

51 The boundary stones placed by the Gracchan land commission in the years 132–129 BC are among the most interesting examples. Campbell 2000, 452–53, gives a complete list, and Gargola 1995, 25–50, offers a general discussion of space and ritual.

52 The writings of the Roman land surveyors are collected by Campbell 2000.

casually. All sought the protection of *lares*—in this case, those specifically shared with the neighbors—for the coming year. The joint celebration recognized the basic distinctions between free and enslaved, male and female, as shown by the *effigies* and *pilae*. Very few other rituals called for a communal celebration of master and slave, men and women (and children?), to worship the same gods together in a shared ritual. This festival became associated with slaves and freedmen, especially in the city of Rome and also on Delos, but its format speaks to the property rights of the landowner and to the desire of those in authority to count the population and map out their living space, rather than to the lives of their slaves. Nevertheless, it seems that slaves and freedmen regularly found social, spiritual, and emotional outlets in organizing and celebrating this festival.

Cicero does not describe local religious rituals as they were practiced in his own day either at his various properties or in the city of Rome, where he spent so much time. He gives only brief insights into what he himself did on Compitalia. He also observed a day off from public business, but one spent with his family and closest friends, such as his regular correspondent Atticus. He does not mention his role in relation to his own slaves, either in town or in the country. He takes walks with his relatives on the day of Compitalia.[53] It would be fascinating to know whether these midwinter walks ever took the senator and his friends on a tour of the local neighborhoods to see and enjoy the festivities and decorations at various compital shrines, or whether they were private and designed as an escape from the noisy crowds and excessive drinking of the usual celebrants. He specifically mentions having his private baths heated for the assembled visitors the day before the holiday. His compressed wording suggests that visitors needed to arrive on the day before the holiday, presumably because there would be no household staff available on Compitalia itself. On another occasion, he remarks that he will not plan to arrive at Pompey's Alban villa on the day of Compitalia, in order to avoid causing inconvenience for the household staff.[54] His decision probably represents a norm for polite behavior among Roman landowners, who usually took the service of slaves for granted. In the mid-first century BC, therefore, it seems that some property owners like Cicero devised their own leisure activities and left their household staff to venerate the traditional gods and drink their wine among themselves.

To round out this section, it is worth noting that Compitalia, in addition to simply being a movable feast, shared several general features with other such *feriae conceptivae*.[55] Most notably Sementivae in honor of the goddesses Ceres and Tellus in late January coincided with Paganalia, the annual festival of the local *pagi* in the countryside.[56] In other words, a country dweller would have had separate celebrations for *lares* at the boundary of the property (*compitum*) and, a few weeks later, for Ceres

53 Cicero *Ad Att.* 2.3.4: *sed haec ambulationibus Compitaliciis reservemus. tu prid. Compitalia memento. Balineum calefieri iubebo. et Pomponiam Terentia rogat; matrem adiungemus.* (December 60 BC) (But let us reserve these topics for our walks at Compitalia. Remember [to arrive?] the day before Compitalia. I will order the bath to be heated. Terentia [Cicero's wife] also invites Pomponia [Atticus' wife]; we will include [your] mother).

54 Cicero *ad Att.* 7.7.3 (2nd January 50 BC): *ego, quoniam IIII non. Ian. compitalicius dies est, nolo eo die in Albanum venire, ne molestus sim familiae* (Since the fourth day before the *nones* of January is the compital festival, I do not want to arrive at the Alban villa on that day, so that I am not a burden to the household/slaves). He decides to arrive the day before the holiday.

55 For (movable) feasts in general, see bibliography cited in notes 1 and 3 earlier.

56 For Sementivae and Paganalia, see Baudy 1998, 181–96, and Stek 2009, 171–86.

and Tellus in a celebration associated with the local administrative unit, the *pagus*. Fornacalia in mid-February was a festival of ovens, baking, and bread making, celebrating the production of a staple food in the context of the local community.[57] February also saw the celebration of Amburbium, with its procession of purifying the city's boundaries and (re)defining its space.[58] Similar rituals were performed for Ambarvalia in May, another occasion on which a *lustratio* happened, this time around the fields for Ceres.[59] The best attested movable feast, however, was the venerable Feriae Latinae in April, staged on the Alban Mount.[60] This holiday brought Romans and Latins together for a celebration that stressed harmony across boundaries, ethnicities, and geographical identities, while stressing the common language and shared religious ritual of Latium.

Beyond animal sacrifice and meals shared with "neighbors," this group of festivals was characterized by processions of purification (*lustratio*) and (sometimes) the hanging of small images in trees or other spaces decorated for the festival.[61] Some of these items were round clay disks (*oscilla*) that depicted deities; others were models of theatrical masks. While these images were not exactly the same as the *pilae* and *effigies* of the Compitalia, the gesture of hanging up images for a festival was familiar in a number of ritual contexts. In fact, these representations of gods, myths, and the world of the theater, bring out the unique valence of the dolls made of organic material that carefully represented individuals "present" for the festival of the *lares compitales*. Ultimately, Compitalia was both a typical Roman festival of a certain, traditional kind, as well as having its own very special and beloved character, in terms of its broad range of participants, its personalized religion of place, and the drunken merriment and feasting so characteristic of this midwinter celebration.

57 For Fornacalia, see Festus 73 and 82 L; Pliny *Nat.* 18.7; Ovid *Fast.* 2.525–32, with Bömer 1958 ad loc. and Rüpke 2011, 73–74.

58 For Amburbium, see Servius on *Ecl.* 3.77.

59 For Ambarvalia, which was a procession around the fields equivalent to one around a town or village, see Baudy 1998, 127–58, and Graf in *BNP*.

60 For Feriae Latinae, see Cic. *Div.* 1.17–18; Varro *LL* 6.25; Dionysius of Halicarnassus 4.49, 6.95; Plutarch *Cam.* 42; Strabo 5.3.2; Livy 21.63.5–8, 22.1.6, 41.16, 44.19.4; and Dio 46.33.4, with Baudy in *BNP*.

61 For *oscilla*, see Corswandt 1982 and Paillier 1982.

XVIII DELOS: A CASE STUDY

κομπεταλιασταὶ γενόμενοι τὴν Πίστιν θεοῖς ἀνέθηκαν

having held the office of Compitalia-celebrators,
they dedicated this statue of the goddess Good Faith to the gods
(*lares*).
> —JOINT DEDICATION BY NINE SLAVES,
> PROBABLY ORIGINALLY FROM THE AGORA OF
> THE COMPETALIASTAI (*ID* 1761 OF 98/97 BC)

A rich source of independent information about the celebration of Compitalia comes from Hellenistic Delos.[1] Paintings of festivities and gods on the outside of houses and inscriptions set up in public by men who supervised the annual festival (calling themselves *kompetaliastai*, which is to say Compitalia-men) focus on the annual festival in honor of *lares*. These paintings have been dated to between roughly the 120s and 88 BC, when Mithridates VI of Pontus sacked Delos.[2] The evidence for the cult of *lares* on Delos provides exceptional insights, since we do not have equivalent material from republican Rome or elsewhere. There were, however, no shrines at local crossroads on Delos, which did not have a Roman municipal structure; the so-called liturgical paintings and their associated altars were placed near the entrances of houses that belonged to Roman citizens or Italians, many of the latter from the Bay of Naples. In other words, here we see Compitalia without a network of *compita*. In Delos' decidedly cosmopolitan society of traders and merchants from any parts of the Mediterranean, "Italians" (*Italicei / Italikoi*), sometimes also known collectively as "Romans" (*Rhomaioi*), comprised one of the most visible and prosperous ethnic groups.[3] Their celebration of *lares* identified their homes in a striking way; on Delos as in Rome the streets celebrated *lares* but in their own way.[4]

In the aftermath of the Romans' defeat of Perseus, king of Macedon, at the battle of Pydna, the economy of Hellenistic Delos received a decisive boost when the Roman senate declared the island a free port in 167 BC.[5] Subsequently, Delos rapidly grew and flourished under the administration of Athens, which sent colonists to settle the island. The chief magistrate on the island was called *epimeletes* (caretaker/governor), who was chosen annually from the leading families.[6] He oversaw a set of other magistrates and public officials, about whom we are not fully informed. So far, about half of the ancient settlement has been excavated, revealing very rapid development in the second half of the second century BC. The

1 Bruneau and Ducat 2005 provide the definitive archaeological guide to the island of Delos. They speak of *développement puis abandon précipités d'une ville-champignon* (p. 43: "the development and then the rapid abandoning of a town that grew up like a mushroom").

2 Some ensembles could also be later, but probably not after the second sack in 69 BC.

3 For Italians on Delos, see Étienne 2002 and Hasenohr 2007a and 2007b for detailed analysis. Ferrary, Hasenohr, and Le Dinahet 2002 have now compiled a list of attested individuals; 184 Latin gentilicial names have been found, which show a noticable overlap with Capua (Étienne 2002, 13).

4 See note 48 on page 171.

5 See McGing 2003, 83–84, and Bruneau and Ducat 2005, 41–43, for an overview of the historical events. Strabo 10.5.4 also links the rise of Delos to the destruction of Corinth in 146 BC, which had been a significant trade hub and was not refounded for a century.

6 Habicht 1991 discusses the *epimeletes* on Delos.

island's economy depended on trade and commerce, famously including one of the biggest slave markets in the Mediterranean. Other products, such as wine, olive oil, and luxury goods also seem to have provided a livelihood for many traders.[7] Delos was, therefore, a base for a wide variety of businessmen in addition to the Athenian settlers; we know of Greeks, Egyptians, Syrians, Phoenicians, Judeans, Samaritans, and others from Palestine, in addition to the many traders from Italy, who came from Rome, Latium, Campania and Greek cities in South Italy and Sicily.[8]

The island functioned as a vital link between the eastern Mediterranean and other markets, notably in the west, and was known for its banks. The Romans and others from Italy are especially in evidence after 125 BC, presumably as a result of the creation of a new Roman province in Asia Minor. In the first century BC, the island was sacked twice, first in 88 BC by Mithridates of Pontus (the Delians had not joined Athens in siding with the Pontic king against the Romans) and again by pirates in 69 BC. Nevertheless, it was the increasingly direct trade between Italy and the eastern Mediterranean through ports like Puteoli on the Bay of Naples that seems to have brought the end of Delos' commercial success.[9] Although the island was not abandoned, most merchants moved on in search of more lucrative bases elsewhere.

As was the case on Cato's model farm, many masters did not have their principal homes on the island, with the result that their local operations and households were delegated to freedmen entrepreneurs. In a series of inscriptions of a religious character, associations of slaves (joined by a few freedmen) who cultivated *lares*, called themselves *kompetaliastai*.[10] The term *kompetaliastai* is not found elsewhere and seems to mean something like "men who organize (or celebrate) Compitalia." These inscriptions have mostly been found in the so-called Agora of the Competaliastai, a large open area at a key node between the port and the main parts of the city.[11] (See figure III.2.) Three other religious organizations, each named for an individual deity, are attested for Italians on Delos, the Hermaistai (Mercuri), the Apolloniastai (Apolloni), and the Poseidoniastai (Neptuni).[12] These other groups were mainly composed of the freeborn, with only a few freedmen. The Italian community focused its religious and social life around these cult groups honoring its most prominent gods: Apollo, the patron of Delos; Mercury, the protector of trade, commerce, and banking; and Poseidon, the lord of the sea. The three groups

7 Economy of Delos: see Rauh 1993 for an overview of the period from 166 to 87 BC. Vial 1984 and Reger 1994 discuss Delos before 167 BC. More specialized studies can be found in Osborne 1988, Brunet 1999, and Feyel 2006. So far, the archaeological finds have not revealed evidence to verify the much-discussed claim that Delos could process 10,000 slaves each day (Strabo 14.5.2). A recent overview and bibliography can be found in Zarmakoupi 2013.

8 For the inhabitants of Hellenistic Delos, see Hasenohr 2007c. For bilingualism on Delos, see Adams 2003, 642–86.

9 In the second century BC, Lucilius already called Puteoli *Delus minor* (Festus 88.4 = Lucilius 118: little Delos). See also Pausanias 3.23.3–6 and Pliny *Nat.* 34.9.

10 *ID* 1760–66, 1768–71. Exact dates by magistrate are 99/98, 98/97, 94, and 93 BC. In other words, these inscriptions seem to fall roughly within the first decade of the first century BC. We cannot know how long the *kompetaliastai* were active before and after this flurry of epigraphic activity.

11 Agora of the Competaliastai (first excavated in 1894): see Hasenohr 2001, 2002a, and 2004 for convenient overviews and bibliography. Hasenohr 2008 reports on the most recent excavations of this complex site.

12 Other religious groups on Delos: Bruneau 1970, 585–89; Hasenohr 2001, 329–31, and 2002b; and Steinhauer 2014. Trümper 2011 is a very useful discussion of where and how non-Delians met in ethnic groups on the island.

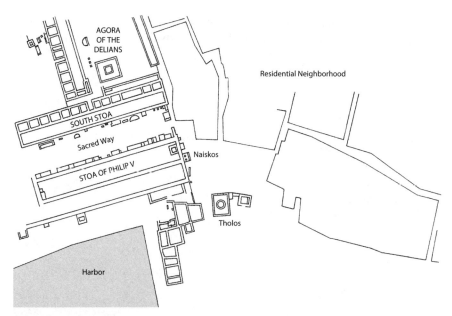

III.2. Map of the Agora of the Competaliastai, Delos.

also cooperated in setting up some inscriptions and votives together in a variety of religious contexts.

By contrast with the associations of wealthy merchants, the *kompetaliastai* were predominantly slaves, drawn from different households, whose inscriptions were in Greek only, not in the bilingual format favored by the three more socially elite organizations.[13] Similarly, and even more interestingly, their association was named for a festival (Compitalia), not a deity. On Delos, the *lares* were simply called *theoi* (gods), which did not yield an obvious name for a religious organization of devotees.[14] Their names were not transliterated (*hoi larētes*), although their festival was. Nevertheless, the choice or creation of the title "Compitalia-celebrators" is a clear indication of the importance attributed to the annual festival itself. Many scenes in the paintings on the houses, which are called "liturgical" by their excavators, illustrate two principal elements of Compitalia—namely, the sacrifice of a pig by men in togas with their heads covered in the Roman style (although some also wear wreaths according to the Greek custom) and various games (ludi) that were held to mark the feast. It would not have been possible, however, for those on Delos to know which day the praetor had announced for the celebration of Compitalia in Rome. The local community must have had their own way of choosing a suitable day each year, presumably also after observing the winter solstice.

An example of a well-preserved inscription is the dedication by a group of nine *kompetaliastai* in 98/97 BC of a statue of the goddess Pistis ("Trust" or "Good

13 Analysis of the *kompetaliastai*: Bruneau 1970 and Hasenohr 2003 provide the fundamental discussions.

14 *ID* 1761, 1762, 1769.

Faith"—that is, reliability, perhaps rendered as Fides in Latin).[15] The text is finely and legibly inscribed on a sizable base of bluish marble, which was found reused in a secondary context. The inscription reads:

Ἀρχέλα[ο]ς Πομπώνιος
 Γαίου καὶ Γ\<ν\>αίου,
Ἡρόδοτος Κλώδιος
 Δέ[κμ]ου,
Σωσιγένης Θεοδώρου
 Νεαπολίτης,
Κλεομένης Ἐγνάτιος
 Ποπλίου Γαίου Γναίου,
Ζεῦξις Αὔδιος Λευκίου,
 Πόπλιος Κορούιος
 Κοίντου Φιλοκλῆς,
Πρόθυμος Γράνιος
 Σπορίου,
Ἀντίοχος Πακώνιος
 Λευκίου,
Ἡρακλέων Τύλλιος
 Κοίντου,
κομπεταλιασταὶ γενόμενοι
τὴν Πίστιν θεοῖς ἀνέθηκαν

ἐπὶ ἐπιμελητοῦ τῆς νήσου
Μηδείου τοῦ Μηδείου Πειραιέως.

Μηνόδωρος Φαινάνδρου Μαλλώτης ἐποίει.

Archelaos Pomponius of Gaius and of G(n)aius,
Herodotos Clodius of Decimus,
Sosigenes of Theodoros from Neapolis,
Kleomenes Egnatius of Publius, of Gaius, and of Gnaius,
Zeuxis Audius of Lucius,
Publius Corvius of Quintus and of Philokles,
Prothymos Granius of Sporius,
Antiochos Pakonius of Lucius,
Hercleon Tullius of Quintus,
having become *kompetaliastai*
dedicated this (statue of) Pistis to the gods (*lares*),
when Medeios, son of Medios, of Piraeus was governor of the island,

Menodorus, son of Phaiandros, of Mallos made (the statue)

(*ID* 1761)

15 *ID* 1761 with a fine color photo at http://philipharland.com/greco-roman-associations /dedication-of-a-statue-of-pistis-faith-by-the-competaliasts-9897-bce/. Hasenohr 2003, 169 and 209–10, notes other statues of deities offered as votives, apparently to *lares*, including Hercules, Zeus Eleutherios (Iovem Leiberum), and Roma by a variety of dedicants.

The men seem all to be slaves, several being owned by more than one family member. Their slave name comes first, then the family name (*nomen*) of their master, followed by his personal name (*praenomen*). Their names may or may not appear in order of rank within their religious or social context. One individual is the property of a Greek from Naples, who is not a Roman citizen. Another, who has a Roman style name, is jointly owned by a Roman and a Greek. As is typical on Delos, this is a strikingly mixed group of individuals from different backgrounds, whose condition may have varied considerably, both in law and in practice. Some were owned in a family, others "belonged" to a business partnership. Nevertheless, they had collected the funds to pay for a significant dedication, made more notable by the signature (in smaller letters across the bottom of the stone) of a prominent freeborn sculptor, a native of Cilicia who was active on Delos at this time.[16]

Their choice was an abstract divine quality, typically fashionable in Rome, in this case "Good Faith," a goddess easily associated with business, trade, and banking. This statue is a gift for the *lares* rather than being given to the faithful goddess herself. *Lares* in Rome and Italy do not usually receive gifts of divine images of other deities. By implication, *lares* are here understood as the ultimate guardians of commerce and trade, of the networks created and protected by "good faith." Similarly, *lares* might enable "good faith" in the relations these slaves have with each other and with their masters. Slaves may have enjoyed a relatively much freer role in business on Delos than those in other cities.

They describe themselves with a customary phrase as "having become *kompetaliastai*" (*kompetaliastai genomenoi*). It is not clear whether this means they made the dedication during their "year in office" or soon after they had fulfilled their functions, as a way of commemorating their term at its end. Most scholars have argued that they had now left office, since other religious groups do not use the same term with their titles.[17] Their duties seem to have centered on organizing the festival of Compitalia. They do not, therefore, immediately appear equivalent to *vicomagistri* in Rome, since they are slaves rather than freedmen and do not have any vici to supervise. As slaves, they would be more likely to be called *ministri* in Rome. But *ministri* without *magistri* were presumably in a more independent situation. It is obviously striking to see the celebration of Compitalia in the hands of the slaves themselves without either vici or *compita* of the Roman kind, or a praetor or other magistrate to announce the day. Consequently, the *kompetaliastai* may or may not be the equivalent of any single cultic group in republican Italy. Scholars have classified their association as a *collegium*, but it remains unclear whether this collective Latin term or any of its implications would have been familiar to these Greek-speakers.[18]

An erased relief showing the dancing *lares* has played a key role in the interpretations of modern scholars who are trying to connect the various types of ancient evidence for *lares* and Compitalia on Delos.[19] (See figure III.3.) This rectangular altar (?) of white marble features a recognizable pair of *lares* facing each other in

16 Menodorus son of Phainandros' name also appears in three other inscriptions on Delos (*ID* 2156, 2157, and 2364). Pliny *Nat.* 34.91 also mentions a Menodorus, who may not be the same artist.

17 See Hasenohr 2003, 211–12.

18 For *collegia* on Delos, see Flambard 1983 and Hasenohr 2007b, esp. 88. Scholars working on Delos have tended to equate a *collegium* with what is called a *koinon* in Greek.

19 *ID* 1745 with Bruneau 1970, 586–89; Mavrojannis 1995, 118–19; and Hasenohr 2001, 340, and 2003, 212.

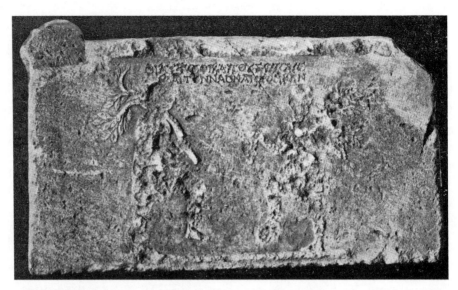

III.3. Erased relief of dancing *lares* dedicated by a group of *kompetaliastai*, from the Agora of the Competaliastai, Delos (*ID* 1745). Marble. 98/97 BC.

profile as they perform a vigorous dance that involves stamping their bare feet. Each holds a laurel branch, a sign of Apollo that was very popular on Delos, whose patron he was. The right-hand *lar* seems to hold a small amphora (perhaps for wine). The Greek inscription is written in rather irregular letters, above and between the two dancing figures. It records the fact that the same donors (*hoi autoi*) gave the images of the gods (on this relief or other statues?) and the temple (*naos*). In other words, this text refers, by implication, to a more detailed votive inscription nearby, probably set up on the temple referred to, which listed the names (of *kompetaliastai*?) and probably gave a date. Unfortunately, the erasure of both the relief and its inscription does not allow us to make a more detailed analysis, especially of the costume and attributes of these *lares*. Nevertheless, this monument provides evidence for a flourishing *lares* cult, with a "temple" in this agora. The deliberate damage done to it may have happened in 88 BC, at the time when Mithridates' troops sacked the island and apparently targeted "the Romans" just as they were doing in Asia Minor.[20] Despite the rather vague nature of the Greek inscription, these "gods" were apparently a familiar target for Mithridates' men, who did not erase (m)any of the bilingual dedications made to the more traditional deities.[21]

Unfortunately, the central sanctuary of the *lares* that is mentioned in this inscription has not been definitively identified among the three small, sacred buildings to be found on this agora, a space very much dominated by the Italian community from about the middle of the second century BC onward. The two main contenders are the ionic style shrine (*naiskos*) built up against the stoa of Philip V, which

20 Flambard 1983, 77: *Mithridate ne s'y trompa point: même en l'absence de conventus, ces trafiquants avaient assez bien réussi pour mériter d'être massacrés.* (Mithridates made no mistake: even in the absence of a conventus [corporation], these merchants had done well enough to deserve being massacred.)

21 For other erasures in inscriptions on Delos, see *IG* 2² 2336 with Tracy 1979, another erasure attributed to Mithridates.

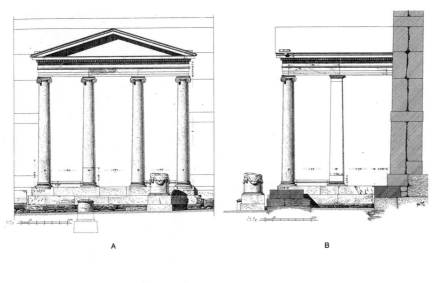

A B

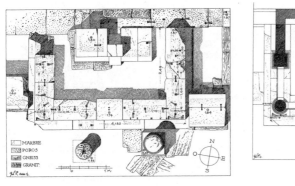

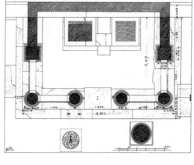

C D

III.4. Drawings of *naiskos*, from the Agora of the Competaliastai, Delos.

contains bases for two cult statues, and a small, round temple (*tholos*) in the middle of the agora.[22] Both structures have been read as possible "compital" shrines, in the sense of being at a major crossroads where four streets converge. The relief of the dancing *lares* was found (apparently) near the *naiskos* in 1894, when the agora was first excavated. On the other hand, the fragmentary dedicatory inscription on the *naiskos* itself was put up by free men.[23] This fact suggests we should identify the *naiskos* as a temple to Hermes (Mercury) and Maia, which is also attested as having stood in this space. The *Hermaistai* (Hermes men) have been posited as the dedicators of this shrine, which features two round altars in front.[24] (See figures III.4 and III.5.)

Many of the dedications made by the *kompetaliastai* were found near the round temple, which has previously been identified as a shrine of Hercules (or Vesta?) by

22 Which is the *naos* of the *lares*? Mavrojannis 1995 argues for the ionic *naiskos*; Hasenohr 2001 puts the case for the round *tholos*.

23 *ID* 1734.

24 See Mavrojannis 1995, 100–105, and Hasenohr 2001, 333–36.

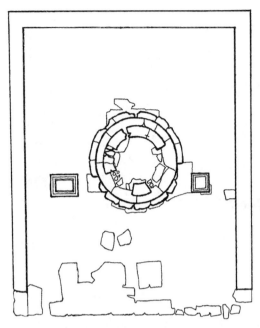

III.5. Drawing of *tholos*, from the Agora of the Competaliastai, Delos.

analogy with round temples attested in Rome. Hercules was popular on Delos and was also cultivated by the *kompitaliastai*. Nevertheless, Delos was far from being a copy of Rome. At least one slave is attested in the very fragmentary dedication text on the round temple, which suggests a possible connection to *lares*.[25] Its shape recalls a hearth, a natural focus for *lares* cult.[26] There is also a round structure that has been identified as a shrine for *lares* at Ostia.[27] However that may be, the presence of a number of very Italian cults gave the agora its own distinctive character. The cult of *lares* allowed slaves to have their own religious organization and to make dedications here in the same way that free Italians did.

The original impact of the agora came from the whole ensemble of its shrines and votive gifts, as well as from the rituals, festivities, and meetings held in this context.

It is not clear, therefore, whether a possible *lares* shrine was thought of as a single, grand *compitum* (something like, for example, the Compitum Acilium), to stand in for what would have been a network of crossroads shrines in a more Roman urban landscape, or as a public temple (*aedes*) for *lares*, such as the one in *summa sacra via* in Rome. The Greek term *naos* can mean either a temple or a shrine, including one inside a larger temple precinct or complex of sacred buildings. This agora could have been a setting for at least some of the festivities at Compitalia (for example the ludi), although the many altars associated with the "liturgical" paintings in local neighborhoods also suggest that cult was performed in the streets. There was, however, no distinctly Italian part of town; the houses with paintings of Compitalia have been found scattered and clustered in a variety of neighborhoods on Delos. Meeting more neighbors and sharing in larger-scale entertainments would have required using a larger, open space in a more central location, such as this agora. Under these circumstances, having the *lares* present and recognized in a special way could have been attractive as a backdrop to the festivities.

25 *ID* 1738 with Hasenohr 2001, 337–47. The last name reads Zenodorus (slave) of Maicius Quintus.

26 Indeed it might also be possible to read the unspecific text of the inscription as referring to the relief of these dancing *lares* as put up near a temple to other, unnamed deities (for example, Hermes and Maia). This interpretation could fit the dedication of these *lares* into the series of gifts of divine images in the shrines of other gods, as was the case with Pistis. See note 15 earlier.

27 For the small round "*compitum*" in the middle of the forum at Ostia, see Bakker 1994, no. 2 with pls. 82 and 83, with critique by Palmer 1996. It is a bit bigger than the *tholos* at Delos, but its central location in the forum may also offer a point of comparison. The extant remains seem to be Trajanic but there may have been an earlier phase.

In this sense, the *naos* of *theoi* (*lares*) on Delos, whatever its architectural form, appears to have been very much a local shrine rather than a building designed specifically as the equivalent of a particular temple or *compitum* in Rome. In practice, the traders on Delos, who came from many areas of Italy, will have brought several local variants of *lares* worship with them. It is unclear how many of these men had ever been to Rome or were familiar with the sacred topography of *lares* to be found there. Their slaves, who organized the rituals and annual festival, had Greek names and had mostly been born in the eastern Mediterranean.

As already noted, in addition to the epigraphical evidence for Compitalia and *lares* in the Agora of the Competaliastai, "liturgical" paintings covered extensive sections of wall near the main door to the house.[28] They were executed while the plaster slip was still wet in a fresco technique. Some fragments suggest that similar paintings could also have been found inside the houses, both on lower and upper floors, but this evidence is sparse.[29] In this traditional genre of fresco painting, the artist was compelled to work fast but confidently before the plaster became too dry to work with. The outdoor situation of these paintings on Delos would have allowed the artist relatively less time, especially on a fine day, under a warm sun and with a fresh sea breeze. The compositions were drawn in broad brushstrokes in a limited palette of standard colors. Black and red were the most used colors, followed by green and brown. Yellow and blue were rarely used.[30] The results could be impressionistic in design and sometimes a bit haphazard in their use of color.[31] The scene from an altar outside a house to the south of the Agora of the Competaliastai (facing the harbor) shows the typical range of colors, as two men in togas with purple borders approach an altar, accompanied by an altar server with a tray of offerings and a pig.[32] (See plate 22.)

The layering of paint shows that the scenes were regularly renewed, every few years. Some walls have as many as twelve layers of paint superimposed, although not every part of an ensemble was necessarily repainted on each occasion.[33] The subjects mostly appear to refer to Compitalia, the *lares* themselves, and a few especially popular gods (Mercury and Hercules), but with a much less standardized iconography than the later paintings from Pompeii. One, rather humorous painting (discussed later) has a note written in Greek to the effect that the painter was unable to fit into the available space the rest of what had been ordered from what

28 The liturgical paintings were first published by Bulard in 1926 (twenty-seven painted ensembles, most of which were already in poor condition at the time he was writing). His interpretation of this material as relating to domestic cult was perceptively challenged by Bruneau 1970. Hasenohr 2003 is now the fundamental treatment. Eight ensembles have been discovered since the 1920s (some can be seen on display in the museum). See Bezerra de Menenses and Sarian 1973, Bruneau 1975, and Siebert 2001 for the publication of more recently excavated paintings.

29 Bulard 1926, 13–14, imagined as many paintings inside as outside. In fact, there does not seem to be enough evidence for a reconstruction.

30 We rely heavily on Bulard 1926 (esp. p. 41) for descriptions and artistic renderings of the colors.

31 See Bulard 1926, 46.

32 No. 10 (north face of the altar, third layer of paint) in Bulard 1926, plates V.1, VII.2, and XIX. See pp. 82–83 for a description of the colors as he observed them in 1921.

33 Bruneau 1970, 619–20, explains the analysis of the layered scenes on Delos. Date ranges have been estimated by counting backward from the year 69 BC. This method yields a hypothetical timeframe of about fifty years for the paintings (that is, 120 BC–69 BC). Hasenohr 2003, 195–96, estimates about five years between each repainting. Needless to say, this calculation is far from being exact. The Delian paintings cannot be dated stylistically in the way that those from Pompeii have been, although most of those are ascribed to the "fourth style."

was clearly a familiar repertoire.[34] In addition to the painted ensembles, an equivalent number of cores of altars have survived, although we cannot tell whether these were all part of the same cult.[35]

The twin *lares* themselves sometimes appear, often holding a *rhyton* or *patera* and a palm branch, and are usually shown in profile but dancing vigorously.[36] (See plate 23.) On Delos, the *lares* carry the palm branch sacred to Apollo, the principal god of the island. These *lares* seem more athletic than their younger cousins on the Bay of Naples. The main subjects of these paintings are the festival itself, rather than representing portraits of the deities in shrines, for the viewer to admire or to worship. They illustrate both main parts of the annual ritual: the sacrifice of a pig by a group of men, usually in togas, and a variety of games (with prizes), which are presumably the ludi associated with the annual celebrations. There are no representations of woolen dolls or honey cakes on Delos or a *lustratio* with its procession of different animals.

The sacrifice scenes are nearly all painted directly on the square masonry altars that are integrated with the painted ensembles.[37] They show the procession of the pig and the pinch of incense or the pouring of a libation from a *patera* onto an altar, which are the gestures that set in motion the sacred ritual. Pork products are in evidence, but the actual sacrifice of the pig is never illustrated.[38] The gods themselves do not appear within the depictions of the sacrifice and there is no hierarchy of size between the actors in the various rituals. The style is more informal than in Pompeii, and various scenes are juxtaposed. Some paintings have the figures labeled; all these men have Greek names (but without a patronymic).[39] This appears as a world peopled by slaves (and some freedmen), from which the traditional master (and his *genius*) is noticeably absent. In this context, the cult of the *lares* flourished, presumably at the behest of the absent property owners, but also to reflect the tastes of the freedmen and slaves of the Roman and Italian merchants.

At the *ludi compitalicii* on Delos, games and entertainments were of predictable kinds.[40] The most popular image is that of a pair of boxers with cloths wrapped around their hands.[41] The three prizes depicted (often on an impressively large scale!) are an amphora (containing wine or olive oil?), a palm branch, and a pork product that looks like a ham. Some frescoes also show crowns, such as those traditionally awarded in Greek athletic contests. A single scene seems to depict a gladiatorial combat.[42] Otherwise, other paintings show a possible horse race and what

34 See note 45 later.

35 Couillond-Le Dinahet 1991, 110–12, describes and analyzes the unpainted altars in the streets on Delos. Delos has yielded a much larger number of altars of various kinds than most Greek sites. See also Hasenohr 2003, 197–98.

36 Hasenohr 2003, 174–76, gives a synthesis of the thirteen representations of *lares*. Many of these figures are incomplete. In six cases, only one *lar* is extant.

37 Hasenohr 2003, 172–76, lists eighteen sacrifice scenes, all of which appear on square masonry altars of a consistent type.

38 Pork products were not typical prizes at Greek athletic competitions, as opposed to amphorae and garlands.

39 Hasenohr 2003, 174, discusses the four examples of name labels.

40 Hasenohr 2003, 176–81, treats the ludi. Thuillier 1985 has shown parallels with games depicted in Etruscan tombs.

41 Suetonius *DA* 45.2 records Augustus' enthusiasm for watching these local boxing matches (with Wardle 2014 ad loc.).

42 Hasenohr 2003, 180 with fig. 2, discusses the gladiators.

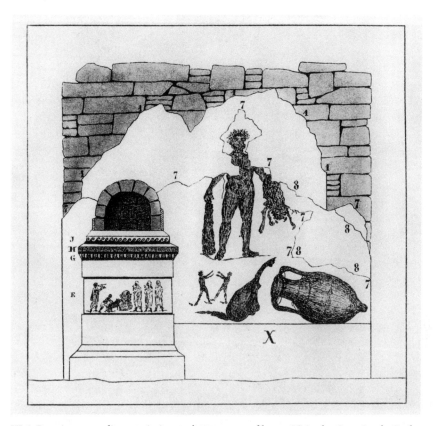

III.6. Drawing, recording a painting at the entrance of house IC in the Quartier du Stade, Delos, seventh layer of paint, west wall with altar. The painting represented a scene of sacrifice to the *lares*: altar with sacrifice of pig presided over by three men in togas; back wall with a variety of scenes including a large Hercules, a pair of boxers, a ham, and an amphora.

seems to be a beast hunt. Some of the paintings may illustrate scenes from plays or mimes performed for the festival, although no one appears to be wearing a mask. The general impression is of the importance of the festival itself and of the self-representation of its organizers, the men in Roman togas and shoes, who presided over the sacrifice for the *lares* of specially fattened and adorned pigs to the music of a double flute. The oversized renderings of hams and amphorae may be advertisements for the prizes available in a given year. There is some evidence of competitors who may have come from abroad to take part in Compitalia on Delos.[43] There seem, therefore, to have been professionals competing or performing, in addition to locals showing off their own prowess.

Two examples can serve to illustrate the ensembles at the entrances to houses. The first (no. 25) comprised a series of paintings, an altar with a niche above it, and a bench to the left of the door of house I C in the Quartier du Stade.[44] (See figures III.6, III.7, III.8.) Originally, the paintings extended on both sides of the

43 Kalamodryas of Cyzikus, a man who was famous for his participation in eating and drinking competitions, seems to have visited Delos. See Hasenohr 2003, 179.

44 Bulard 1926, no. 25.

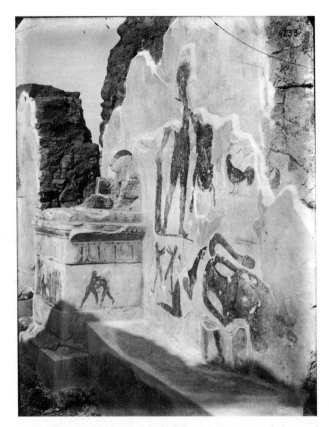

III.7. Photograph of painted altar from Delos, seventh layer of paint on the west face. An overview from the right shows a pair of wrestlers on the side of the altar.

entrance to the house. Eight layers of paint have been identified, featuring a rich variety of different scenes, both on the walls and on the altar itself. This house would, therefore, have been inhabited by "Italians" of means for many years.

As usual the front of the masonry altar featured the sacrifice scene (layer 6), showing three men wearing the *toga praetexta* with their heads covered approaching an elaborate altar. It is possible that there was an attempt at portraiture in the rendering of their faces. A flute player is playing as a servant leads a pig toward the altar. We find ourselves in the familiar world of *lares*. The sides of the altar showed boxers competing in pairs and garlands, which may have been prizes. Later layers seem also to have shown very similar scenes. The niche above the altar was in bad condition at the time of its excavation and may have been unpainted.

The surviving paintings on the walls were mostly from layer 7. To the right, a towering Hercules with his club and lion-skin dominated the ensemble. Below him, two small boxers competed next to two large prizes, a ham and an amphora. The figures were of very different scales and do not seem to have related directly to each other. In other words, the sacrifice scenes were rendered much more realistically and with greater care, while the rest of the wall was covered with a looser, stylized set of images that also seem related to Compitalia. Labels in Greek were in

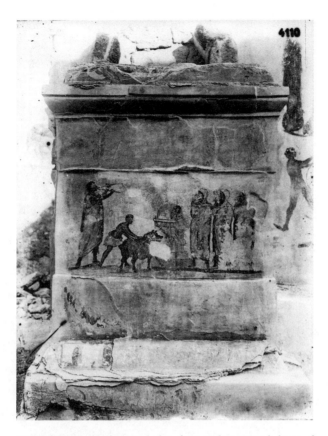

III.8. Photograph of painted altar from Delos, seventh layer of paint on west and north faces of altar. Three men with their heads covered by their togas preside over the sacrifice of a pig that is being led to an altar by a slave. A flute player in a toga provides the traditional accompaniment.

a fragmentary state at the time of excavation. Layer 6, however, featured the famous inscription explaining that the painter had run out of space for the rest of the commission, inscribed in the area just above the amphora.[45] This could also be a joke considering the impressive size of the mural. Other themes in different layers included a radiate head of Sol, a Pegasus, a large star, and a shield. Nearby, a disused entryway to this same house had been marked out by a rendering of the two dancing *lares* with *rhyta*, who were facing each other in the iconography that is typical on Delos.[46] This entryway had only one layer of paint.

A second ensemble (no. 27) was found in the same neighborhood, at I D.[47] (See figures III.9 and III.10.) Three layers of paint stretched out on both sides of the door, including an altar and a niche. The sacrifice scene on layer 2 of the altar is particularly fine. Two named officiants in togas, Crusipus and Heliofo . . . , place pinches of incense from a *patera* on a round altar in parallel gestures. The flute

45 *Eis to loipon topon ouk eichomen* (we did not have room for the rest).
46 Bulard 1926, no. 26.
47 Bulard, 1926, no. 27, with Hasenohr 2003, 205–6.

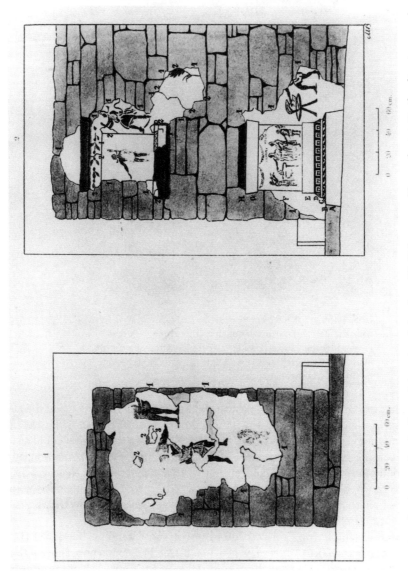

III.9. Drawing juxtaposing the faces of the painted altar from ID, Delos, second layer of paint. On the altar, two men in togas offer incense at an altar, to the music of a flute player. On the back wall, a series of fragmentary scenes include a dancing *lar* in profile and an individual touching a pig's head on a table.

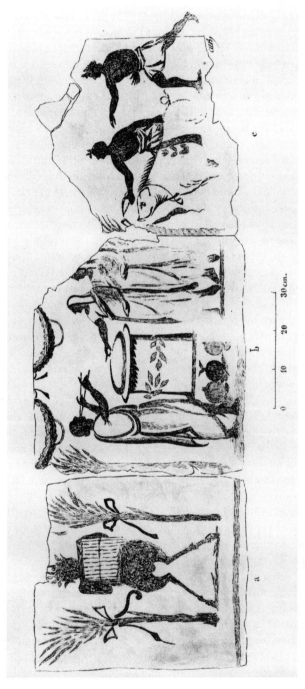

III.10. Drawing, recording the first layer of a painted ensemble with an altar on the exterior south wall of house ID, Quartier du Stade, Delos. The three sides of the altar show Pan playing a pipe; two men in togas offering incense at an altar, to the music of a flute player; and two sacrificial attendants leading a pig to sacrifice.

player is also wearing a toga as he creates the musical accompaniment for the sacri-
fice. Festive garlands hang overhead and large fruits appear in the foreground at
their feet. A magnificently large pig, wearing a little bell around his neck, is being
led to sacrifice by two attendants along the side. The other side of the altar showed
Pan (or Silvanus?) playing his pipe composed of twelve reeds between two palm
fronds tied with festive bows. His ears are pointed and he wears a crown of foliage.

Other themes in various layers on the wall included a man with a pig's head on
a plate, a combat scene, a man in a green tunic, a dancing *lar* with fringed boots, a
cloak, a freedman's cap and a *rhyton*, a man touching a pig's head on a table, and a
large man striking an animal head with a knife. Several figures appeared naked. The
niche also seems to have been painted inside. We can only catch glimpses of the
varied imagery in its three phases included in this complex ensemble.

Although scholars named this genre of painting "liturgical," only some themes
are overtly religious or devotional. Many others seem fanciful, commemorative,
or humorous. Individual elements may only appear once and are not easy to ex-
plain, such as a man climbing a palm tree or a little, naked boy putting a glass bowl
on a table.[48] Since most of the paintings have been lost because they were not con-
served after excavation, the information we have about them is inevitably very in-
complete. New finds, especially of ensembles on the outsides of houses that are
themselves also excavated, could add significantly to our understanding of what is
being represented in these paintings and whether their iconography is also com-
mon elsewhere.

Themes shared with the altars set up by *vicomagistri* in Rome under Augustus
and with Flavian era paintings from the Bay of Naples suggest a common cult for
lares compitales. The merrily dancing gods, the sacrifice of the pig, and the ludi were
perennial elements. At the same time, stylistic differences and varied emphases in
iconography tell a separate story in each place. On Delos, the main focus seems to
have fallen on the annual festival itself, to which various other deities were appar-
ently invited (Hercules, Pan, Mercury, Sol, and so on). Despite their purple-
bordered togas, the celebrants, who may regularly have been named, seem to have
been slaves. Sharing the duty of presiding over the religious rituals among several
men was typical in the cult of *lares*. The games and festivities could be represented
without overt references to a master, property owner, or higher official in the com-
munity of free Romans and Italians. Notable prizes may have attracted voluntary
participants to travel to Delos for the ludi at Compitalia. The Delian paintings were
kept fresh by regular repainting, which involved the updating of some themes and
the reproduction of others.

To sum up: the inscriptions and paintings from Delos provide a vivid glimpse
of the local flourishing of a rather particular form of *lares* cult, even without vici,
vicomagistri, compita at street corners, or the administrative trappings of a Roman
town. There seems to have been little emphasis on boundaries here. Yet it was this
cult that really helped to define the community of "Romans" and "Italians," many
of them actually Greek-speaking slaves or freedmen of Eastern origin. The houses
that featured *lares* paintings for the world to see were not grouped in a definable
"Italian" neighborhood but stood intermingled with houses of others belonging to
various nationalities. As far as we can see, these other houses do not have surviv-
ing religious paintings in other traditions on their outside walls. It is perhaps

48 Palm tree: Hasenohr 2003, 181. Glass bowls: Bruneau 1975, fig. 26.

fitting that the *lares* should seem so at home in the place that operated one of the biggest slave markets in the Mediterranean.

Meanwhile, it is not at all clear exactly what the evidence from Delos tells us about the festival or the cult at Rome or even perhaps elsewhere in Italy. The celebrants are represented as slaves, never the *genius* of a master so common at Pompeii. The sacrifice of the pig is still the central ritual, but the nature of the ludi and prizes may be local. No snakes are found here as at the Bay of Naples, nor do we have any evidence of woolen dolls being hung up or of boundaries being observed. It is also unknown whether the *kompetaliastai* formed a purely local organization or an imitation of a group found somewhere in Italy. Epigraphical evidence from republican Capua and Minturnae (discussed later) compares and contrasts in many ways with the situation on Delos. A simple equation of *kompetaliastai*, most of whom were slaves, with *vicomagistri* in Rome, most of whom were freedmen, and some even freeborn, does not make sense in the context of Hellenistic Delos, an international community administered by Athens.

The masters must have agreed to, and surely encouraged, their households to cultivate the *lares* and their Compitalia on the outside of houses and probably in the public spaces of the town. Interestingly, it was Compitalia rather than any other festival (such as Saturnalia) that marked out the Italian community, both for themselves and for others. This development reflects the large number of slaves and freedmen resident on Delos, who had the means to put on elaborate annual games and to commemorate or advertise their celebrations in specially commissioned paintings and dedications with inscriptions on stone. On Delos, *lares* were essential in creating community and identity in a place where so many had come from elsewhere; they danced even as they protected households and their prosperity.

XIX LOCAL NETWORKS: *VICATIM*

> nuntiata ea clades Romam maiorem quam res erat terrorem
> exciuit; nam ut exercitu deleto ita iustitium indictum, custodiae
> in portis, uigiliae uicatim exactae, arma, tela in muros congesta.
>
> Livy describes emergency measures including a homeguard in
> the local neighborhoods in Rome after news of a defeat by the
> Etruscans in 303 BC.
> —LIVY 10.4.2

The evidence for *lares*, religious associations of slaves and freedmen, and lively street festivals on Hellenistic Delos naturally raises the complex and much-debated relationship of compital shrines to their geographical and administrative settings and hence to the officials in charge of them. The ritual of *lustratio*, in which sacrificial animals were led in procession at Compitalia, indicates that a specific space and its community was being celebrated and (re)defined on an annual basis, under the watchful eyes of *lares*. But which (kind of) space was meant? As we have seen, the answer could vary quite widely. On a farm, the area comprised the property owned by the master, marked out by legally installed boundary stones. In a broader Italian context, however, administrative units that celebrated *lares* at the crossroads were most often called vici. In other words, the *compita* and their festival could be found in many different physical settings, both private and public. While the city needed *lares*, *lares* did not need a city (or even a village) in order to enjoy a merry party with wine and pork at a *compitum*.

The central role of compital altars and festivals on the farm shows that even in Italy *lares* were traditionally to be found on the corners of properties and at the edge of fields, rather than being primarily or necessarily identified with any particular kind of administrative district or municipality in an urban setting. In other words, a household was the smallest unit that could set up a shrine for *lares* at a "crossroads," a meeting point of several geographical entities such as fields or roads. Nevertheless, *compita* also played a traditional role in articulating the larger "urban" landscape, from the smallest group of huts to the sprawling city of Rome. The present discussion is not concerned with reconstructing the administrative patterns of Roman Italy in any detail, a large subject that has been thoroughly investigated in its own right.[1] However, a basic understanding of local administration is essential in situating the cult of the *lares* at the crossroads, especially within the city of Rome itself. This information serves as the essential setting for the dramatic political events discussed in section III.xxii later.

Vicus

Vicus (plural vici) is a Latin word that in typical fashion refers to a variety of small settlements, whether in town or in the countryside, in Rome or in Roman territory or elsewhere. It has been related to the Greek *oikos* (house), but its meaning

1 See Capogrossi Colognesi 2002 for a thorough treatment of various municipal arrangements, with Lo Cascio 2007.

is often closer to *amphodon* (street), *kome* (village), or to the Oscan *amvianud* (neighborhood or city block).[2] Like many Latin words, this seemingly technical term had a variety of overlapping and contrasting uses. Evoking both "house" or "estate" and "street" or "path between the houses," vicus basically refers to a group of residential buildings around a street, which can be termed a "neighborhood" or (more technically) a "ward" or "borough" inside a city.[3] Alternatively, a whole village in the countryside could be described as a vicus. It is characteristically Roman that vicus could mean not only "street inside Rome" but also "village outside Rome" or even "non-Roman native village." The whole concept of a vicus speaks to the pattern of ancient life in narrow streets, where people moved around on foot and met each other face to face in their daily activities or on a journey. Here, the community outside the house was (in) the street.[4] Consequently, any shrine in a street or on a corner was naturally and inevitably part of life in the adjacent vici.

In Rome, vicus was the most commonly used word for "street" or "lane" or "path," the alternative being clivus, which referred specifically to a road on a hill-side ("incline" or "rise"). The label vicus would then be modified by a name in the form of an adjective, for example Vicus Sobrius (Sober street) or Vicus Patricius (Patrician Street) or a noun in the genitive, such as Vicus Honoris et Virtutis (Street of Honor and Courage).[5] There were only two roads called *via* inside the city of Rome: the Sacred and the New (Sacra Via, Nova Via).[6] The "sacred way" apparently came first, and the "new road" was built later to parallel it. Their names suggest that these roads were originally situated outside the city limits at the time when they were laid out, since *via* designated roads outside an urban space, such as those built to radiate out from Rome (for example, the famous Appian Way leading south). These two venerable roads are also the ones that consistently have their adjective first, before the noun *via*. Rome was situated on the very ancient Via Salaria (Salt Highway), the old road used to carry salt from the sea into the interior.[7]

The kinds of names given to vici in Rome are varied, and are commonly taken from a local ethnicity (Vicus Tuscus, "Etruscan Street"), a geographical feature (Vicus Jugarius, "Yoke Street"), a locally practiced trade (Vicus Argentarius, "Banker Street"), or a local deity (Vicus Dianae, "Diana's Street"). A list of each named vicus we know of in Rome comprises about 130 entries, but many amount

2 The study of vici has been decisively shaped by the recent contributions of Tarpin 2002 and 2008 and Lott 2004. Fraschetti 2005 (first edition: 1990) has been very influential, although his contention that vici had no official role in republican Rome has been much debated. Very useful discussions can also be found in Lo Cascio 2000 and 2008 and Wallace-Hadrill 2008. Invaluable earlier treatments are by Accame 1942 and Flambard 1977 and 1981. For vici on the Palatine, see Coarelli 2012, 112–26.

3 See *TLL* for vicus. Tarpin 2002, 87–92, explores some of the ambiguities suggested by the term and concludes that the simple meaning street was relatively late. He concludes (92) that: "Les vici sont donc des ensembles construits disposant d'une voirie." (The vici are, therefore, clusters of buildings around a street). Nevertheless, street names in Rome, both on maps and in literary sources, are nearly all expressed as either vici or clivi. See Palmer 1997, 73, for a useful overview.

4 For a more sociological approach, see Lott 2004, 13–24, and Lo Cascio 2008, 68.

5 See Tarpin 2002, 87–99. He gives a list of inscriptions relating to vici in an appendix (307–26, with eighty-five inscriptions from Rome).

6 Via in Rome: see Santangeli Valenzani in *LTUR* s.v. Nova Via and Coarelli for the Sacra Via. Laurence 1999 gives an introduction to Roman roads in Italy.

7 Via Salaria: Patterson in *LTUR*. See also Stambaugh 1988, 8. This road linked the Sabine country to Rome and from there to the mouth of the Tiber, where salt would be collected for transport inland.

to no more than a name in a single inscription, without indication of location, size, or character.[8] The term vicus can often but need not have an administrative or a judicial meaning, as is explained in a famous definition by Festus, who noted the wide range of competencies enjoyed by different vici, especially outside town.[9] As in so many other situations, a Roman would have taken cues and derived meaning from context.

Despite their fundamental importance and traditional character, we do not have direct information about either the size or the distribution of vici in Rome.[10] Nor do we know whether every part of the republican city was included in a vicus, either in practice or even notionally. We cannot map them in any detail as city "neighborhoods." Indeed, it has been argued that the Romans themselves could not or perhaps did not really "map" their city before Augustus.[11] Needless to say, it seems inevitable that the scale and character of different neighborhoods will have varied widely, both within their purely local context over time and across districts at any one moment in the city's history. A history of Rome written from the perspective of its vici would surely read very differently from the narrative fashioned by senators like Tacitus and intellectuals like Livy or foreigners like Polybius or Dionysius of Halicarnassus.

A famous inscription from AD 136 on a monumental marble base has preserved a dedication for a statue of the emperor Hadrian by some *vicomagistri* of Rome.[12] Discovered on the Capitoline in the fifteenth century, it may have been part of a larger monument or series of dedications. The dedicants describe themselves as *magistri vicorum urbis regionum XIIII* ("the officials of the neighborhoods of the city of 14 regions"). This list is the single most valuable source for names of vici in the city, each listed under a regio with the names of the local officials. Nevertheless, it is incomplete and by now not easily legible. The back of the massive base has been left blank. The surviving entries include 9 vici from regio 1, 6 from regio 10, 17 from regio 13, 12 from regio 12, and 21 from regio 14 (on the other side of the river). Only these 5 of the 14 Roman regiones are represented here, with a total of 65 vici mentioned. Other bases may have been dedicated nearby by *vicomagistri* from different regiones.[13] Meanwhile, no list of individual vici can be shown to be complete for its regio. The rather grand dedication on behalf of "the local *vicomagistri* of Rome" may not have been supported by broad or uniform participation throughout the city.

Regardless, the list of those who did contribute is still impressive.[14] This was obviously an expensive project, and many freedmen were willing to participate.

8 In *LTUR*, 130 vici are included in separate entries, although the format of this lexicon does not allow for a separate discussion of the vicus as a category. The vici we know of are also listed under the entry for the city of the fourteen regiones.

9 Festus 502, 508L, with Letta 2005, Todisco 2006, and Lo Cascio 2008, 69–70.

10 Tarpin 2008 sees the vici of imperial Rome as large units, housing thousands of people each.

11 Wallace-Hadrill 2008 is fundamental; see also Wallace-Hadrill 2003.

12 Known as the Capitoline Base: NCE 2990, *CIL* 6.975 = 31218 = *ILS* 6073 = *EDCS* 46000015 with photograph. See now Gregori and Mattei 1999, 112–15, no. 169. For discussion, see Boatwright 1987, 27; Wallace-Hadrill 2008, 288, who describes it as an altar; and Daguet-Gagey 2015, 350–51. Coarelli 2012, 113–14, posits three statue bases in all, with complete lists of vici.

13 Coarelli 2012, 113–14, posits two other statue bases with complete lists of all the vici in Rome.

14 It is possible that more names were listed on another part of the monument. This hypothesis seems less likely given the scale of the surviving base and the areas left blank.

III.11. Drawing of the epitaph of T. Calidius Primus, a freedman
who lived in the Vicus Tusculus (*CIL* 6.33932).

Hadrian was certainly a special patron of the city, who had become involved with
the local neighborhoods. He himself now chose to oversee the restoration of com-
pital shrines in Rome, with the assistance of the prefect of the *vigiles*.[15] Similarly,
there is evidence that he excused some *vicomagistri* from paying for wild beast
hunts, which suggests the range of duties they were called upon to perform by this
period.[16] The Capitoline base provides striking testimony to the vitality of Augus-
tus' fourteen regiones, as they were embraced by local magistrates in individual
neighborhoods almost 150 years after his reform. While the cooperation of every
vicus in a combined initiative to honor the emperor may have remained an aspira-
tion rather than a reality, the image of a Rome composed of individual vici work-
ing together in harmony across the whole city was obviously meaningful to the
dedicants, and surely also to Hadrian himself.

In this context, it is notable that extant indications of addresses given in ancient
texts and inscriptions nearly all cite only a vicus without a specific block or house
as a way of indicating location.[17] Once you were in the neighborhood, you could
easily ask for the particular house or shop you were seeking. Presumably, there-
fore, these inscriptions also suggest that people would regularly ask: "Which vicus
do you live in?" An example is provided by a somewhat clumsily carved epitaph on
a marble plaque that records a freedman who worked in the well-known garment
district on the vicus Tuscus.[18] (See figure III.11.)

[T(itus) C]alidius T(iti) T(iti) (mulieris)
l(ibertus) Primus uestiarius
tenuiarius de uico
Tusco Calidia T(iti) T(iti) (mulieris) l(iberta)
Hilara Prisco liberto
et sibi et suis

15 Panciera 1970, 138–51, with Boatwright 1987, 26 n. 29.

16 Palmer 1974, 285–88, and 1975, 57–59, links these favors directly to the dedication of the base.

17 For addresses in Rome, see Castrén 2000 and Tarpin 2002, 123–24 and 323–24, R62–76.

18 *CIL* 6.33923 = *ILS* 7575 = *CECapitol* (Panciera 1987) 264 = 321 = EDCS-24100437 = Tarpin
2002, R72, found at the Porta Salaria. See also *CIL* 14.2433 = *ILS* 7597 for his neighbor Lucius
Plutius Eros, an expert in purple dyes.

Titus Calidius Primus, freedman of Titus and Titus and a woman, purveyor
of fine garments from the vicus Tuscus, (and) Calidia Hilara, freedwoman of
Titus and Titus and a woman, for their freedman Priscus and themselves and
their people

(*CIL* 6.33923 = *ILS* 7575)

No tailor in London's Bond Street was prouder of his address. In the context of a
tomb inscription, which is where most of our examples of addresses come from,
the vicus also takes on a more symbolic value, since it is no longer a practical ad-
vertisement for where a person was doing business.

An incident of urban violence in 121 BC illustrates the nature of the vicus as a
geographical area, where a particular address was not readily known to an outsider.
In the chaos after Gaius Gracchus' suicide, his close political associate Marcus Ful-
vius Flaccus (consul 125 BC) took refuge in a local shop. His assassins threatened to
burn down the whole vicus if he was not handed over; inevitably he was betrayed.

Καὶ Γράκχος μὲν διὰ τῆς ξυλίνης γεφύρας ἐς τὸ πέραν τοῦ ποταμοῦ
καταφυγὼν ἐς ἄλσος τι μεθ᾽ ἑνὸς θεράποντος ὑπέσχε τῷ θεράποντι τὴν
σφαγὴν καταλαμβανόμενος· Φλάκκου δ᾽ ἐς ἐργαστήριον ἀνδρὸς γνωρίμου
καταφυγόντος, οἱ μὲν διώκοντες, τὴν οἰκίαν οὐκ εἰδότες, ὅλον ἐμπρήσειν
τὸν στενωπὸν ἠπείλουν, ὁ δ᾽ ὑποδεξάμενος αὐτὸς μὲν ὤκνησε μηνῦσαι τὸν
ἱκέτην, ἑτέρῳ δὲ προσέταξε μηνῦσαι. καὶ συλληφθεὶς ὁ Φλάκκος ἀνῃρέθη.
Γράκχου μὲν δὴ καὶ Φλάκκου τὰς κεφαλὰς ἔφερόν τινες Ὀπιμίῳ, καὶ αὐτοῖς ὁ
Ὀπίμιος ἰσοβαρὲς χρυσίον ἀντέδωκεν· ὁ δὲ δῆμος αὐτῶν τὰς οἰκίας
διήρπαζε . . .

Gracchus fled across the river by the wooden bridge with one slave to a grove,
and there, being on the point of being seized, he presented his throat to the
slave. Flaccus took refuge in the workshop of a man he knew. As his pursuers
did not know which house he was hiding in, they threatened to burn the
whole street/neighborhood. The man who had given shelter to the suppliant
hesitated to point him out, but told another man to do so. Flaccus was seized
and put to death. The heads of Gracchus and Flaccus were carried to (the con-
sul) Opimius, and Opimius gave their weight in gold to those who brought
them, but the ordinary people plundered their houses.

(Appian *BC* 1.26)

The man in the workshop who was a friend of Flaccus could perhaps have been one
of his freedmen or another who owed him a favor; Flaccus may have known many
in this part of town. This individual was torn between his duty to Flaccus, which
may have gone beyond even that of a host to a suppliant, and his natural desire to
save the vicus (including his own place of business) from being burned to the
ground. Consequently, he avoided handing over his patron or friend by finding an-
other man to inform on Flaccus. The way in which the action unfolded suggests
that a *vicomagister* (or other recognized local leader) was present. In practice, he
(perhaps with a group of his colleagues) may have been the person who was respon-
sible for the decision that Flaccus (a popular and respected man of consular rank)
must be handed over to save the neighborhood. However that may have been, the
killers knew how to use local conditions in the city to their own advantage, whether

or not any of them were also from this part of town. Putting pressure on the vicus as a whole produced rapid results without having to resort either to a time consuming house-to-house search or to setting a fire that would inevitably have been hard to control and invidious.

Networking

The existence of the Latin term *vicatim* ("by vicus") provides decisive further confirmation for regular communication from the political center expressed explicitly in terms of a general initiative that reached people where they were living or working in the vici.[19] Livy uses this word in various contexts, notably to describe how Romans were organized to defend the city walls against the Etruscans in 303 BC.[20] Each vicus was responsible for rallying the available forces and for defending an assigned part of the wall. In other words, the home guard that defended the city under attack was organized at the level of the neighborhood. This is essentially the same system that is implied by the Oscan *eituns* inscriptions, which give evidence for how Pompeii was defended against Sulla's siege during the Social War.[21] Inscriptions in red paint were applied directly to stone walls at street corners giving instructions to locals in Pompeii about where the men from that street should gather by the wall and who their local commander will be. An example of this formulaic style of text reads[22] (see figure III.12):

eksuk.amvian<n>ud.eit(uns)	(ex) hoc vico evocat(i)
anter.tiurri.XII.ini	inter turrim XII et
veru.sarinu.puf.	portam Sarinam ubi
faamat.mr.aadiriis.v	(nomina) citat M(a)r(aeus Atrius, V(ibi filius)

Those called up from this block/neighborhood (should go) between tower XII and the Porta Sarina, where Maraeus Atrius, son of Vibius, takes the roll call.

(Vetter no. 24, 91–89 BC)

This inscription is matched by a very similar one nearby so that the inhabitants of the block next door were also summoned to the same gathering place and section of the wall, adjacent to the gate now known as the porta Ercolanese. Their commander may also have been a local. Perhaps he was the equivalent of a *vicomagister*, who was in charge of lists in the neighborhood and could also have had a military role in a crisis.

19 For *vicatim*, see *TLL*. As far as we know, there was no equivalent adverb that meant "by *compitum*."

20 Livy 10.4.2 with Oakley 2005 ad loc., quoted in the epigraph to section III.xix.

21 For the *eituns* inscriptions, see Vetter 1953, 54–57, nos. 23–28, with Latin translations and commentary, and Antonini 2004 and 2007. Remains in situ, as well as locations of lost inscriptions, can be conveniently seen at *Pompei in Pictures*.

22 On the corner of Vico della Fullonica and Vico di Narcisso in region VI between insula 2 and 6 (Vetter 1953 no. 24 found in 1813), with Crawford 2011, vol. 2, 619–20, Pompei no. 3, with full earlier bibliography. See also Varone and Stefani 2009, 317 Taf. 19b, and *Pompeii in Pictures* at VI.6.3 and 4. Unfortunately, a number of *eituns* inscriptions were destroyed as a result of bombing in the early 1940s.

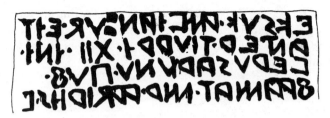

III.12. Drawing of the *eituns* inscription (Oscan, Vetter 1953 no. 24) from Pompeii (VI.3–4).

Livy records two examples of distributions of goods (grain and oil) to people in their local neighborhoods (*vicatim* or the equivalent *in vicos*) in Rome, in 213 and 203 BC.[23]

aedilicia largitio haec fuit, ludi Romani pro temporis illius copiis magnifice facti et diem unum instaurati, et congii olei in uicos singulos dati.

The largess of the aediles was as follows: the *ludi Romani* were celebrated magnificently according to the resources of the times and repeated for a day, and a gallon of oil was distributed to each vicus.

(Livy 25.2.6)

annus insignis incendio ingenti, quo cliuus Publicius ad solum exustus est, et aquarum magnitudine, sed annonae uilitate fuit, praeterquam quod pace omnis Italia erat aperta, etiam quod magnam uim frumenti ex Hispania missam M. Ualerius Falto et M. Fabius Buteo aediles curules quaternis aeris uicatim populo discripserunt.

The year was remarkable for a great fire, in which the Clivus Publicius was burned to the ground, and there was flooding, but grain was cheap. Apart from the fact that all of Italy was open for trade in peacetime, a large amount of grain had been sent from Spain. The curule aediles Marcus Valerius Falto and Marcus Fabius Buteo distributed the grain to the people *vicus* by *vicus* for four *asses* a measure.

(Livy 30.26.5–6)

The earlier episode involves P. Cornelius Scipio, later called Africanus after his defeat of Hannibal. There had been controversy over his election, since he was too young to stand for the office of aedile. After his election, he and his colleague Marcus Cornelius Cethegus aimed to reward the voters and win further popular favor. Interestingly, their distribution of oil was recorded as a single, modest amount (a *congius* is a bit less than a US gallon) to each vicus. The clear implication is that the oil would then need to be subdivided into small portions for further distribution to individuals at the local level. Without *vicomagistri* who had lists in each neighborhood, such an exercise could easily have led to disputes and subsequent recriminations over unfair distributions that would have made the aediles unpopular. A single *congius* each suggests small vici and wartime hardship.

23 For discussion, see Tarpin 2002, 94, and Lott 2004, 40–41.

The later example is a distribution organized by curule aediles, who sold grain at a fixed price locally but to each person or household. Again issues of effective and equitable distribution, this time of surplus grain, required practical solutions. The network of vici was in place and readily to hand for the aediles in each year. It allowed city officials to reach people where they lived, to verify their identity and status as residents, and to avoid the inconvenience and risk associated with crowds collecting at centralized distribution points especially in wartime. For all these reasons, the notices in Livy record these distributions in lists taken from annual accounts of actions taken by magistrates.

These, then, are typical activities that allowed the senate and magistrates to ensure the equitable distribution of a good harvest among the people or to mobilize men of fighting age in time of crisis. Livy could, of course, be accused of anachronism. Yet his reference to *vicomagistri* wearing the toga with the purple border in 195 BC, albeit in a speech, only serves to confirm that he himself definitely thought republican Rome was divided into functioning vici with freedmen organizers (see section III.xx later).[24] This picture would surely have seemed very odd to his readers if many of these features had only very recently been introduced by Augustus. Moreover, these passages may well have been written before Augustus' urban reform of 7 BC. The use of the word *vicatim* by Sisenna, Cicero, and Horace before Livy also suggests that the term could be found in Livy's sources.[25] Subsequently, Pliny the Elder's description of the statues erected to honor Marius Gratidianus in the 80s BC also uses *vicatim*.[26]

The earliest attested instance of the word *vicatim* is in a fragment from book 3 of L. Cornelius Sisenna's histories.[27] The quotation comes from Nonius:

Cum conplures menses barba immissa et intonso capillo, lugubri uestitu, populum uicatim flens una cum liberis circumiret.

When he had let his beard and hair grow unkempt for several months, he went around weeping with his children, going *vicus* by *vicus* to appeal to the people.
(Sisenna F 47 Peter = F 15 Chassignet = *FRHist* 26 F 21)

The identity of the individual is not revealed.[28] The context seems to be the year 90 BC, according to the evidence from the other surviving fragments from book 3. In any case, the scene is basically a familiar one, not tied to a particular time period or to a specific person. A man on trial on a capital charge or in other serious trouble has decided to seek the sympathy of those in the city. We may imagine that he is a senator. Unshaven and with his hair uncombed, wearing dark mourning

24 Livy 30.26.6 and more detailed discussion later.

25 See Cicero *de Dom.* 129, *Sest.* 34, *ad Att.* 4.3.2; Horace *Epod.* 5.97.

26 Pliny *Nat.* 33.132. See also Seneca *Dial.* 5.18.1. These imperial authors may well be drawing on the same earlier source, which used *vicatim* in reference to the statues of Marius Gratidianus.

27 Sisenna F 47 Peter = F 15 Chassignet = *FRHist* 26 F 21, with commentary by John Briscoe. This quotation (and many others of Sisenna) is from Nonius 277L. L. Cornelius Sisenna (praetor 78 BC) was a noted orator and historian with a special interest in rare words.

28 Tarpin's suggestion (2002, 95, with n. 39) of Tiberius Gracchus does not fit with the chronology of book 3, which seems mainly to have dealt with the year 90 BC. As Briscoe explains (*FRHist* ad loc.), the man is probably one of those tried under the *lex Varia*, which targeted Romans who had aided Italians, especially by supplying weapons at the time of the Social War. How much sympathy was there for Italians and their cause in the vici?

clothes, he parades his young children around Rome to appeal directly to the ordinary people where they live and work. In this case, he has even let his beard and hair grow for several months. His way of reaching the population is specifically by vicus (*vicatim*). Presumably, this was a practical method, because he could call on local leaders to help spread his message and to gather a convenient crowd that might include locally influential individuals to hear his appeal and to greet him when he arrived on their street.

Meanwhile, *vicatim* may also be used here to suggest that this man is thorough, trying to reach each part of the city. In visiting the local neighborhoods, he can appeal to the sympathy of those who do not frequent the forum and other gathering places where he would no doubt also put on a show of his misery before walking all around the city. Visiting local vici is an extension of his appeal as he appears in mourning without trappings of wealth or political rank but in the guise of a suppliant. The same type of public performance was, of course, also typical in the setting of a law court. Yet in the vici, his appeal is to people most of whom were not eligible to serve on a jury at the beginning of the first century BC. He was availing himself of a network of local neighborhoods for his own, particular purpose, depending on the context of his distress. Public opinion at the grassroots level mattered to him.

Soon before his death, the popular reformer Gaius Gracchus moved out of his house on the Palatine into a local neighborhood, near or "below" the Forum.[29]

Ἐπανελθὼν δὲ πρῶτον μὲν ἐκ τοῦ Παλατίου μετῴκησεν εἰς τὸν ὑπὸ τὴν ἀγορὰν τόπον ὡς δημοτικώτερον, ὅπου πλείστους τῶν ταπεινῶν καὶ πενήτων συνέβαινεν οἰκεῖν·

The first thing he did when he returned (to Rome from Carthage) was to move from the Palatine to the area near (or "below") the Forum, on the grounds that it was a more democratic neighborhood, where most of the poor and the lower classes happened to live.

(Plutarch *Gaius Gracchus* 12)

There are a number of ways of interpreting this highly unusual move into what was perhaps rental property leased at short notice. Alternatively, Gaius may have been living either in the house of an acquaintance, maybe one of his freedmen, or he may himself have owned rental property in local neighborhoods. Generally the poor did indeed tend to live in the "lower" areas of the city, which were naturally more prone to flooding from the Tiber and consequently to disease.

Events after Gaius' death reveal that the house on the Palatine where he had lived before with his family belonged to his wife Licinia, the daughter of the very wealthy M. Crassus, rather than to him. Thanks to a ruling by her uncle, the famous jurist Publius Mucius Scaevola, Licinia won compensation from public funds for the damage done to her house, which was part of her dowry, after it had been attacked by a mob at the time of her husband's death.[30] Consequently, it seems that Licinia and

29 For Gaius Gracchus' house, see Eck (*LTUR* 1995) and Guilhembet (*LTUR* 1999) for the house on the Palatine. Purcell (*LTUR* 1995, 328) discusses where Gaius may have moved. See also Flower 2010, 76–78. For vici on the Palatine, see Coarelli 2012, 112–26.

30 *Dig.* 24.3.66 with Plutarch *CGracch.* 17.6, Dio 43.50.2 and 47.14. Since there is still talk of Licinia's dowry after Gracchus' death, he cannot have moved out because of a divorce. At this time, the house of M. Fulvius Flaccus was deliberately destroyed (Appian *BC* 1.26, Cic. *Dom.* 102,

the children were still living on the Palatine, after Gaius moved out, in a house that became the target of looters. Gaius may have moved partly to try to protect Licinia's house and possessions, in case violence should ensue. Yet the looters still identified the house on the Palatine with Gaius, regardless of where he was actually living or who the legal owner of this property was.[31]

But there was presumably also a positive choice involved in selecting a particular "working class neighborhood." Gaius' move was a demonstration of solidarity, an appeal for support, and a suggestion that he himself was one of the locals. Similarly, he contrasted his new home with the traditional aristocratic living areas on the Palatine and the Sacra Via. There may be an echo of Valerius Poplicola's legendary move down from his grand house on the Velia, in the early days of republican government.[32] Plutarch's wording implies that he knows of Gaius' professed reason for moving, which was specifically to be closer to ordinary people where they lived. Perhaps, therefore, Plutarch is basing this on a speech by Gaius that was designed to advertise and to explain his new home. Gaius was a famous popular orator, who also circulated written versions of his speeches.[33] Close to the time of his relocation, Gaius made himself notorious by demolishing temporary seating in the forum overnight so that the poor could watch a gladiatorial show without paying for a seat.[34]

It is hard to know exactly where Gaius chose to live, perhaps in the Subura or the Velabrum, both areas near the Forum that housed many ordinary people. The Velabrum is certainly "lower" than the Subura. The two best-known vici leading directly into the Forum were the Vicus Tuscus and the Vicus Jugarius. Plutarch is thinking of a more general area (*topos*) of Rome, rather than a particular vicus. Meanwhile, living near the Forum would also have put Gaius closer to the center of politics, both as an observer and a player, on show for others to see. Presumably he would have held his usual morning reception (*salutatio*) at the new lodging, and would have walked to the Forum from there with his supporters. Shortly before his death, he was seen weeping at the foot of his father's statue in the Forum.[35] Whether Gaius' move was more than symbolic, whether it actually put him in closer touch with networks in local politics, we are not in a position to say. Gaius' political failures do not make his well-publicized relocation less interesting for an examination of the urban landscape of popular politics in Rome in the 120s BC.

Val. Max. 6.3.1c, with Papi in *LTUR*), even as his two sons were killed. It seems that Gaius had not inherited a house on the Palatine that had belonged to his father, Tiberius Sempronius Gracchus (cos. 177 and 163 BC). His speech on the last day of his life (Cicero *de Orat.* 3.214 and Quintilian 11.3.115 = *ORF*[4] no. 48 F 61) may suggest that his mother was still the occupant of his childhood home in Rome.

31 This reaction made sense if Gracchus and Licinia had made their home in this Palatine house for some time.

32 This comparison is explored by Jenkyns 2013, 184–85. For Poplicola, who is also imagined as making a speech of explanation, see Livy 2.7, Dionysius of Halicarnassus 5.19, and Florus 1.9.4.

33 For Gaius as an orator, see Malcovati *ORF*[4] no. 48 (with sixty-nine fragments). Val. Max. 9.5.ext. 4 = Fragment 59 (a speech attacking the consul of 125 BC, M. Plautius Hypsaeus) seems to suggest the importance of the Forum as a place for elites and plebs to meet together.

34 Plutarch *CGracch.* 12. Apparently, even his fellow tribunes of the plebs were planning to profit from the money raised.

35 Plutarch *CGracch.* 14.5. For the statue of Tiberius Gracchus (cos. 175, 163 BC), see Sehlmeyer 1999, 150–51. Münzer (in *RE*) placed the statue near the vicus Tuscus, a possible place where Gaius may have moved.

Counting (in) Vici and (at) *Compita*

A question related to the size and character of the city is how the population of Rome was assessed and counted in antiquity.[36] As discussed earlier, Pliny tells us of the 265 *compita larum* officially counted in Rome in the census of AD 73.[37] *Compita* "counted" as nodes in their own right, points of access to local populations and to their homes in the vici. *Compita* could in turn presumably have yielded counts of individuals (by sex and by legal status) from the dolls hung at Compitalia, and possibly even the number of brides who had offered bronze coins at each crossroads shrine during the previous year, if that information was also recorded locally.[38] As the analysis of Compitalia has shown, being recognized was an integral part of the traditional mid-winter celebration, not only in practical but also in symbolic, personal, social, and religious terms.

Suetonius, however, tells us that a counting of the people (*recensus populi*) could also be carried out at the level of the vicus, but that this method of counting was not traditional. It seems possible, therefore, that counting of and at *compita* was, in fact, an older as well as being a simpler practice. The first official tally of inhabitants in the vici was carried out centrally by Julius Caesar as part of a special census in 46 BC, in his capacity as dictator rather than as a republican magistrate with a colleague.[39]

> Recensum populi nec more nec loco solito, sed uicatim per dominos insularum egit atque ex uiginti trecentisque milibus accipientium frumentum e publico ad centum quinquaginta retraxit; ac ne qui noui coetus recensionis causa moueri quandoque possent, instituit <ut> quotannis in demortuorum locum ex iis, qui recensi non essent, subsortitio a praetore fieret.

> He held a counting of the people, not in the traditional way nor in the usual place, but by *uicus* through the owners of the apartment houses. From 320,000 recipients of the grain dole at public expense, he reduced the number to 150,000. Furthermore, in order to avoid any future proposal for a meeting to draw up a new list, he enjoined that every year the places of those who had died should be filled by the (urban) praetor by lot from those who were not on the list.

> (Suetonius *DJ* 41.3)

Caesar may not have sought or needed the powers of a traditional censor precisely because his new way of collecting evidence for the local populations in each dwelling, street by street, was not what the censors had ever done before. Augustus

36 Hin 2008 offers a new approach to understanding the republican census practices and figures. According to her reading, Augustus was interested in counting the whole population, rather than simply adult males recorded in the republican census figures, which she argues only counted those men who were *sui iuris*. Her case is supported by the evidence for Caesar and Augustus, who took much more care to have official lists of residents in vici available for centralized use.

37 See section II.xiii for a fuller discussion of the census of AD 73.

38 Compitalia: section III.xvii. Brides: section II.x.

39 Caesar's census of 46 BC is discussed in most detail by Lo Cascio 1990, 1997, and 2001. See Lo Cascio 2008 for a convenient summary of the pivotal importance he ascribes to Caesar's census by vicus, which he sees as the foundation of the imperial system of grain doles in Rome. His work builds on that of Nicolet 1987. Tarpin 2001 also provides a cogent argument for lists kept in vici.

imitated Caesar's local counting method, notably around 8 BC when he was reorganizing the city.[40]

> Populi recensum uicatim egit, ac ne plebs frumentationum causa frequentius ab negotiis auocaretur, ter in annum quaternum mensium tesseras dare destinauit; sed desideranti consuetudinem ueterem concessit rursus, ut sui cuiusque mensis acciperet.

> He carried out a counting of the people by *uicus*. And so that the plebs should not be called away from their work too frequently because of the grain dole, he intended to issue tokens three times a year, for a four-month supply. But at their request he agreed to a return to the old habit, according to which each person received a share every month.
>
> (Suetonius *DA* 40.2)

Both Caesar and Augustus, therefore, were concerned to identify those who were, in fact, "residents" of Rome, partly in order to establish and maintain separate lists of who was entitled to the official grain dole.[41] Both leaders aimed to define and also to limit the number of (actual and potential) recipients who were recognized as resident members of the Roman plebs. They wanted to control their annual expenditure on this benefit. Two lists are attested in this procedure: a list of those who received the grain dole (now fixed at 150,000) and a much more complete list of inhabitants who were eligible for the annual lottery to replace deceased recipients of the dole.

Clearly, these efforts provide evidence to suggest that many people came to Rome seasonally and others were eager to get into the city, including probably by misrepresenting their background and legal status. Being entitled to the official grain dole became an elite status in its own right that was eagerly sought after in the imperial city. Meanwhile, the princeps needed to oversee the city as carefully as he did the army, in order to avoid the kind of violence and unrest that had characterized Rome from Saturninus to Caesar. It is easy to underestimate the practical impact of the growth of Rome, not least on the decay of traditional republican political culture.

Nevertheless, lists of inhabitants may have been kept in the vici before Caesar, for a wide variety of reasons. Such lists could ultimately only be maintained by the owners of buildings, who may have passed them on to local magistrates, or more directly to higher officials (aediles? urban praetor?) when requested to do so.[42] The earliest regular grain doles are associated with Gaius Gracchus in the late

40 Augustus' census: Tarpin 2002, 111–27, gives a thoughtful overview of the developments from Caesar's counting in 46 BC to Augustus' census in 8 BC. See now Scheidel 2009b for Livy's reactions to Augustus' census taking.

41 Virlouvet 1995 and 2009 offers the classic treatments of the grain dole in imperial Rome and of the epigraphic evidence provided by the surviving tickets that recipients showed when they received their monthly dole (*tessera frumentaria*). See also Rickman 1980, 158–75, and Lott 2004, 63–65.

42 For the declarations (*professiones*) made by the owners of buildings, see now Dubouloz 2011, esp. 242–43.

120s BC.[43] Other uses of local lists do, however, come to mind. As Livy suggests, the vici were locations for rallying able-bodied men in times of crisis, when the walls needed to be defended. Each vicus would be assigned a section of wall to cover or other tasks to fulfill.[44] At other times, such lists would have been very useful when the senate enjoined the expulsion of various noncitizens from the city. The removal of Italians (and others) from Rome happened on several occasions, although the precise mechanisms for doing so are not documented.[45] The expulsion of individuals who did not have the right to vote implies the existence of a list of voters. It may even have been the case that voters from rural tribes were sometimes identified and canvassed by means of lists in the vici.[46]

It is reasonable to imagine, therefore, that counting and list making were associated both with vici and with *compita* as the city was expanding in various phases of its complex development. Dionysius of Halicarnassus, who does not mention dolls at *compita*, imagines a count house by house being set up by Servius Tullius, at the time when he first established the city's four regiones.[47] The hanging of dolls at doorways rather than at *compita* for the annual festival, as described by Macrobius, may well reflect the desire to identify exactly who was living where by adapting the earlier compital custom to the evolving culture of city government, even as there was little room left at the modest *compita* for the growing number of dolls. But did this "newer" practice devalue the *compita* at the expense of the individual vicus? Did it tend to separate people rather than bringing them together? Did it give *vicomagistri* more power or isolate them from their fellow magistrates in neighboring streets?

* * *

To conclude this brief overview of vici: the relationship of vici to *compita* and to their *lares* is fascinating but not straightforward, either in Rome or elsewhere. Our lack of detailed archaeological evidence for compital shrines in situ is especially challenging. There can be no doubt that both the local neighborhood areas and their crossroads shrines were vital to life in Rome. Their importance is demonstrated by the way both aspects were exported, but not necessarily together, to Roman settlements elsewhere in Italy and abroad. Some features were also imitated and adapted by others with their eyes on Rome. Meanwhile, a simple equation of (a) vicus with (a) *compitum* misses the fundamental purpose of crossroads shrines. It also obscures the nature of the *lares* as protective deities and the character of their most important festival at Compitalia, whose function was to bring people from different places together for a sacrifice and a meal, a celebration designed to

43 Gracchus' grain law (123 BC): Livy *Per.* 60 and Appian *BC* 1.21, with Nicolet 1980, 191–92; Garnsey and Rathbone 1985; Tarpin 2002, 118–19; and Lott 2004, 63. For distributions in general, see Nicolet 1980, 186–205.

44 For discussion of the Oscan *eituns* inscriptions from Pompeii, see note 21 on page 197.

45 Noy 2000, 37–47, notes that several expulsions of Italians seem to have taken place in the 180s and 170s BC, as well as further measures in 126, 122, and even in 65 BC. The 90s BC seem to have seen increasing tensions and profiling of noncitizens or those accused of falsely claiming to be Roman citizens (note the *lex Licinia Mucia* of 95 BC and the ban on teaching Latin rhetoric in 92 BC, sources in Greenidge and Clay 1960). For discussion, see now Kendall 2013, 208–10.

46 Taylor (2013), 66–67 argued that the rural tribesmen in Rome were nearly all from the propertied classes.

47 Dionysius of Halicarnassus 4.14.2.

inaugurate another year of living in harmony within accepted spaces (marked by recognized property lines) and social roles (male or female, slave or free). It is also vital to keep in mind that in commemoration of their year in office many local *magistri* of various kinds chose to represent themselves in religious roles and settings rather than as civic administrators.

XX OFFICERS AND ASSOCIATIONS: *(VICO)MAGISTRI, MINISTRI, COLLEGIA*

Hic Romae infimo generi, magistris uicorum, togae praetextae
habendae ius permittemus.
—LIVY 34.7.2

Dedications of the Augustan period confirm for us what some literary texts also say—namely, that the *vicomagistri* had a decisive role to play in supervising and organizing compital cult for the *lares*, which included especially the annual Compitalia.[1] As already argued, information about the distribution of goods to residents in the vici during the Second Punic War suggests that a local network of neighborhood facilitators was already in place in the later third century BC. The *vicomagistri* appear as the likely candidates to check the lists of inhabitants and to identify who was entitled to a distribution or benefit, or who was required to defend the city in time of need. In addition to Livy's evidence for distributions of goods during the Second Punic War, three further pieces of ancient evidence support the idea that *vicomagistri* were organized and active in the republican city well before Augustus' urban reforms.

Independent insight is offered by the well-known letter of King Philip V of Macedon to the people of Larissa in Thessaly, which was written in Greek in 215 or 214 BC.[2] The letter is embedded in a dossier of other documents within the framework of a commentary in the Thessalian dialect. The king is writing with stern instructions, reiterating his previous injunction that noncitizens be given citizenship (and probably land) in order to increase the population and improve the economy of Larissa. In order to illustrate his point about expanding the citizen body, Philip speaks about the Romans and their habit of manumitting slaves and making them new citizens, holding them up as an example for the Larisaeans to learn from.

ὅτι γὰρ πάντων κάλλιστόν ἐστιν ὡς πλείστων μετεχόντων τοῦ πολιτεύματος | τήν τε πόλιν ἰσχύειν καὶ τὴν χώραν μὴ ὥσπερ νῦν αἰσχρῶς χερσεύεσθαι, νομίζω μὲν οὐδ᾽ ὑμῶν οὐθένα ἂν ἀν- | τειπεῖν, ἔξεστι δὲ καὶ τοὺς λοιποὺς τοὺς ταῖς ὁμοίαις πολιτογραφίαις χρωμένους θεωρεῖν ὧν καὶ οἱ Ῥωμαῖ- | οί εἰσιν, οἳ καὶ τοὺς οἰκέτας ὅταν ἐλευθερώσωσιν, προσδεχόμενοι εἰς τὸ πολίτευμα καὶ τῶν ἀρχαίων με- | [ταδι]δόντες, καὶ διὰ τοῦ τοιούτου τρόπου οὐ μόνον τὴν ἰδίαν πατρίδα ἐπηυξήκασιν, ἀλλὰ καὶ ἀποικίας <σ>χεδὸν | [εἰς ἑβ]δομήκοντα τόπους ἐκπεπόμφασιν.

That it would be best of all if the city (that is, Larissa) were strong, with as many being members of the citizen body as possible, and the land not be as it is now, shamefully left untilled, I think none of you would disagree. It is also possible to observe others employing similar grants of citizenship, among

1 Republican *vicomagistri* are discussed by Tarpin 2002, 96 and 132–34, and Lott 2004, 41–44 and 131.

2 *IG* 9.2.577 with photograph = *SIG*³ 543 lines 26–39 = *ILS* 8763. For discussion, see especially Walbank 1940, 35, 69 n. 6, 296–99; Hannick 1968; Gauthier 1974; Habicht 2006; and Wallace-Hadrill 2008, 446–47.

whom are especially the Romans, who receive into their citizen body even their slaves when they free them, and even give them a share in the public offices, and through this practice they have not only strengthened their own homeland but also sent out colonies to almost seventy places.

(*IG* IX 2.517)

As far as we know, Philip had not himself visited Rome, yet he speaks boldly about Roman policies. There is obvious rhetorical exaggeration, for the Romans had thirty Latin colonies and ten Roman citizen colonies in 214 BC, certainly not the seventy mentioned by the Macedonian king. Needless to say, Philip is using the Romans as an example to support his own argument rather than writing a neutral account of Roman customs at the end of the third century BC. On the other hand, the king's letter provides independent, contemporary evidence from the time of the Second Punic War. The general points that he makes are worth considering.

It is striking that Philip V adduces the Romans as the only example for a local matter in Thessaly. Clearly, they were on the king's mind. One wonders whether the Thessalians appreciated the analogy. Philip is interested in the rise of Rome in Italy, and he seems to have informants in the city who have told him what is going on, at least from the perspective of outside observers. Who were those informants and how often did they report to him? Were they spies in his employ or simply travelers, diplomats, and traders?

The Romans did indeed give citizenship to freed slaves in a much more generous way than other ancient city-states had, just as they also admitted free citizens of other cities as Roman citizens more readily.[3] These new (freed) citizens were one factor in the manpower advantage that the Romans enjoyed over most of their opponents, especially other city-states in Italy. Similarly, Rome sent out many more colonies than most Greek cities, and these expeditions were open to the poor, although not designed specially with freed slaves in mind.[4] The manumission of slaves and the founding of colonies in Italy are certainly two central themes in Roman history of the period: these were two ways in which the Romans set themselves apart, especially when compared with Greek city-states in Italy and Sicily, or in the Hellenistic world of the East more familiar to Philip V.

As to the king's claim that freedmen also held political office, this has most often been seen as an example of a simple error.[5] It was only the sons of freedmen who were eligible for election to the regular magistracies (and to membership in the senate), while former slaves were barred from being candidates for the main political offices in Rome. Nevertheless, better sense can be made of Philip's statement if it is read as a reference to *vicomagistri*, who did hold office locally and who wore the *toga praetexta* for some functions, notably to preside at the Compitalia.[6] In this sense, the king could have a valid point to make (again with some exaggeration):

3 For the Roman citizenship, see Dench 2005, chapter 2 (who mentions Philip's letter on p. 93), and Mouritsen 2011 for freedmen. Gauthier 1974 argued that Philip misunderstood both how citizenship was granted and what it meant in the Roman context.

4 For Roman colonization, see the introduction in Lomas 2014 and now the collaborative archaeological project *Landscapes of Early Roman Colonization* headed by Tesse Stek at the University of Leiden (http://landscapesofearlyromancolonization.com).

5 This has been the opinion of most scholars since Mommsen in 1882.

6 This idea of Robert Palmer is mentioned by Lott 2004, 42–44, who goes on to attribute a different mistake to Philip's informants—namely, that of taking *vicomagistri* for the regular magistrates.

not only did the Romans give their freed slaves citizenship, they also provided a framework of local magistracies that allowed freedmen the trappings of office and some functions similar to those of elite magistrates and priests.

A visitor who was in Rome in late December or early January might easily have been impressed by the spectacle of the *vicomagistri* on the most important day in their year in office, the festival of Compitalia.[7] Similarly, some two hundred years later, Dionysius of Halicarnassus, another foreigner, would be prompted to comment on the magnificence and impact of the compital celebrations. Interestingly, Dionysius noticed only the slave *ministri* and apparently missed the fact that the presiders at Compitalia whom they were assisting were themselves former slaves.[8] Walking around the city would have afforded the opportunity to see many groups of local magistrates celebrating at the various *compita* and performing a *lustratio* around their local areas. The information that all these magistrates, who were dressed just like the senators and higher officials and were accompanied by lictors, were freedmen, would surely have come as a genuine surprise to a visitor from Greece, Asia Minor, or Macedonia. Reliefs on Augustan altars, such as the one from the Vicus Aesculeti, show us the kinds of scenes that made these freedmen look so important (see sections IV.xxvi–xxvii with figure IV.19 later).

It would be quite unsurprising to learn that such an informant had included a description of Compitalia in his report back to Philip V, since this was the occasion on which Roman freedmen were probably at their most visible in the city. There would have been many more *vicomagistri* in togas at Compitalia than the number of regular magistrates in office in any given year, especially at this time.[9] While it is not clear exactly how much Philip knew about local politics in Rome, at least the more visible roles of the *vicomagistri* were characteristic of how the city functioned. Philip's testimony obviously fits in with what Livy has to say about local distributions of goods and news during the war with Hannibal and in the early second century BC.

By comparison, events twenty years later in 195 BC, when there was a heated debate about the repeal of sumptuary legislation, include two separate references to *vicomagistri* and *compita*, in the speeches exchanged by Cato and Valerius on the subject of whether or not the *lex Oppia* should be repealed.[10] Livy reports in detail on this famous debate.

> says Cato arguing against the repeal:
>> Quid enim nunc aliud per uias et compita faciunt quam rogationem tribunorum plebi suadent, quam legem abrogandam censent?
>
>> What else are they doing now other than making their argument for the bill of the tribunes, which is to say for the abolition of the law (*lex Oppia*) on the highways and at the crossroads shrines?
>
> (Livy 34.2.12)

7 Pina Polo 2013 has argued that foreign envoys and diplomats spent extended time in Rome in conversation with the senate and with their influential contacts.

8 See discussion at section III.xvii.

9 The number of regular *magistri* in 215 BC was two consuls, four praetors, four aediles (two plebeian, two curule), eight? quaestors, ten tribunes of the plebs.

10 For the *Lex Oppia* and its repeal, see Briscoe 1981, 39–63; Culham 1982; and Zanda 2011, 114–17.

says Valerius in support of abolishing the law:

hic Romae infimo generi, magistris uicorum, togae praetextae habendae ius permittemus.

Here at Rome we allow the lowest grade, the magistrates of the neighborhoods, the right to wear the toga with the purple border.

(Livy 34.7.2)

Again it seems superficial simply to dismiss these speeches as the composition of Livy himself in a later age.[11] Both these men were famous politicians, engaged in a pivotal debate, and their views and words would have been circulated at the time and passed down by historians.[12] Cato refers directly, in this case in a negative way, to the possibility of canvassing at the compital shrines for a bill proposed by the tribunes of the plebs. He does not choose to mention the vici themselves; interestingly the shrines take precedence in his picture of city politics in the early second century BC. His references are useful precisely because they are simply asides, not a main part of his argument. Similarly, Valerius refers to the *toga praetexta* of the freedmen *vicomagistri* as an accepted symbol of status. Given that such togas are in evidence on the paintings on Delos from later in the second century BC, there is every reason to accept this useful evidence. In other words, Livy's picture of the political debates of 195 BC shows that, at least based on his reading, he believed vici, their *magistri*, and *compita* were all key points in the landscape of Roman political debate in the generation after the Second Punic War.

The third piece of evidence comes from the fraught political situation in Rome in 133 BC (a period for which we no longer have Livy's account available). In that watershed year in Roman political life, Tiberius Gracchus built his political initiative and passed his agrarian reform bill through the support of rural voters, whom he mobilized to come into town to enable the passage of his legislation.[13] These same voters turned out again, a bit later in the year, to vote on his proposal to use the money bequeathed to the Romans in King Attalus III of Pergamon's will to fund his agrarian commission. It is clear that Tiberius was very well connected to rural networks, although the details of how these worked have not been preserved.

However, once the harvest time arrived and Tiberius was seeking election to a second, consecutive year in office as tribune of the plebs, his usual supporters were unable to be present in Rome for the voting. In the last weeks and months of his life, Tiberius seems to have turned to the political networks of the city, probably the *vicomagistri* and other local leaders.[14] There is evidence that he was accompanied by

11 See the useful defense by Lott 2004, 42.

12 M. Porcius Cato (*ORF*⁴ no. 8, with over 250 fragments on seventy-five attested occasions) is by far the best-attested orator in the second century BC. By contrast, no reliable fragments or *testimonia* have been handed down for Valerius. The speeches in Livy are not considered reliable sources of actual quotations from earlier orators. They may, nevertheless, convey something of the tone of a prominent speaker and of the concerns of his day.

13 For Tiberius Sempronius Gracchus in 133 BC, see Badian 1972 and Stockton 1979 for the classic treatments.

14 This argument has been presented at greater length in Flower 2012.

large crowds of enthusiastic supporters in the last weeks of his life.[15] Appian provides
the most explicit account.

ἀσχολουμένων δ' ἐκείνων ὡς ἐν θέρει, συνελαυνόμενος ὑπὸ τῆς προθεσμίας
ὀλίγης ἐς τὴν χειροτονίαν ἔτι οὔσης ἐπὶ τὸν ἐν τῷ ἄστει δῆμον κατέφευγε,
καὶ περιιὼν **κατὰ μέρος** ἑκάστων ἐδεῖτο δήμαρχον αὐτὸν ἐς τὸ μέλλον
ἑλέσθαι, κινδυνεύοντα δι' ἐκείνους.

Since they (his rural supporters) were busy with the harvest, he was com-
pelled to turn in last resort to the people in the city, since there was only a
little time left before the election. He went around each individual part (*vicus*)
asking them to elect him as tribune for the following year, since he was un-
dergoing danger on their behalf.

(Appian *BC* 1.14.3)

Appian asserts that Tiberius turned to the ordinary people (*demos*) in the city and
that he did so by going around to each "part" or "section" (*meros*) to canvas for re-
election to a second tribunate. The most plausible way to understand both Appian's
Greek and the striking fact that Tiberius managed to gain supporters in the city at
short notice, is that he made the rounds of the vici. The danger he described was
probably a reference to prosecution in a court, not to a sense of impending doom.
In order to do so successfully, he would have relied on local connections and on the
vicomagistri. They were the ones who could mobilize a new group of supporters
from the ordinary citizens in Rome, who were vociferous in their support of Ti-
berius around the time of the tribunician elections. As we have seen, the *vicomag-
istri* seem also to have had access to information about how many voters belonging
to rural voting tribes could be found in the city at the time.[16] The spectacle of popu-
lar support for Tiberius, especially in a candidacy that broke the rules of republican
office holding, would have contributed to the fear felt by Tiberius' opponents, a
fear that drove them to murder a sacrosanct tribune by spilling his blood in the sa-
cred space in front of the Capitoline temple during an assembly for voting, itself an
inaugurated event.[17]

There are, therefore, many reasons to accept *vicomagistri* as a regular part of
city administration in republican Rome. At a higher level, meanwhile, it was the
four *aediles* (two curule and two plebeian) who were in charge of the city of Rome,

15 Valuable fragments of Sempronius Asellio (Aulus Gellius *NA* 2.13.1–5 = Peter F6 and 7 =
Chassignet F7 and 8 = Beck and Walter 12 F 7 and 8 = *FRHist* 20 F7 and 8 with commentary by
Mark Pobjoy) describe the large crowds that accompanied Gracchus whenever he appeared in
public at the end of his life and the way in which he entrusted his children to the people. Plutarch
(*TGracch* 14.4) records criticisms by Q. Caecilius Metellus Macedonicus (cos. 143 BC) of the kinds
of men accompanying Gracchus in the city (*ORF*⁴ no. 18 F. 2 and 3). Metellus' speech against Ti-
berius was included with others in the *Annales* of C. Fannius.

16 Taylor 2013, 66–67, argued that the rural tribesmen in Rome were nearly all from the prop-
ertied classes. By contrast, Mouritsen 2001, 82–83, thinks that a solid cross section of rural tribes-
men could be found living in Rome. In 121 BC, the senate ordered all who did not have the vote
expelled from Rome, which suggests that lists of voters could be checked locally (Plutarch
CGracch. 12).

17 The most thought-provoking discussion of Tiberius' death is Linderski 2002.

its roads, temples, market places and certain popular entertainments.[18] They exercised general oversight over public order and safety and were also responsible for distributions of goods in the vici. They had control of how money they collected from fines was spent in the city.

A useful example of aediles working together with *vicomagistri* is provided by an unusual inscription on a slender, tall column, which seems to have served as the base for a (silver?) statue weighing fifty pounds.[19]

Varro Murena,
L(ucius) Trebellius aed(iles) cur(ules)
locum dederunt

L(ucius) Hostilius L(uci) l(ibertus)
Philargurus,
A(ulus) Pomponius
A(uli) l(ibertus) Gentius,
A(ulus) Fabricius
A(uli) l(ibertus) Buccio,
M(arcus) Fuficius
(mulieris) l(ibertus) Aria,
mag(istri) veici
faciund(um) coer(averunt)
ex p(ondo) L (quinquaginta)

Varro Murena (and) Lucius Trebellius, (the) curule aediles, gave the place (for this dedication).

Lucius Hostilius Philargurus, freedman of Lucius, Aulus Pomponius Gentius, freedman of Aulus, Aulus Fabricius Buccio, freedman of Aulus, Marcus Fuficius Aria, freedman of a woman, *magistri* of the vicus, oversaw the installation (of a statue of) fifty pounds in weight.

(*CIL* 6.1324 = 1² 2514 = *ILLRP* 704 = *ILS* 6075)

This text has been dated to around the middle of the first century BC.[20] Its findspot just outside the city may indicate a suburban vicus, but one still within the general

18 For the aediles, see conveniently Palmer 1997, 17–22; Lintott 1999a, 129–33; and especially Daguet-Gagey 2015 for a magisterial treatment of the late republic and imperial periods. Lintott 1999a, 15, notes how little Livy tells us about the job of aedile as supervisor of the city. Their Greek title *agoranomoi* (supervisors of the market place) speaks to their public presence in Rome's commercial and banking spaces. By contrast, their Latin designation suggests a job mainly to do with sacred buildings (*aedes*); for a thorough discussion, see Daguet-Gagey 2015, 35–44. For the aediles in a larger Mediterranean context, see Capdetrey and Hasenohr 2012.

19 *MNR* inv. 275 (222×28×90 cm); *CIL* 6.1324 = 1² 2514 = *ILLRP* 704 = *ILS* 6075 = EDCS-17800478 = Tarpin 2002, R19, discovered in 1865 at around the seventh milestone outside the city of Rome, between the Via Latina and the Via Labicana (Osteria del Curato). See Friggeri, Granino Cecere, and Gregori 2012, 253, for the official catalogue entry. It originally seems to have had a Corinthian capital. The freedmen come from well-known households. For statues of silver, see now the new discoveries of bases from Narona (Croatia) for two statues of women in the guise of Venus from ca. AD 200 (Koortbojian 2013, 89 with 271 n. 35).

20 Degrassi suggested either 67 BC or 44 BC, depending on the identity of this particular Varro Murena. If the earlier date is correct, as the spelling and letter forms seem to confirm, this

purview of the aediles, unless the column has been moved. The curule aediles contributed the setting for the expensive gift of four *vicomagistri,* one of whom had the slave name "fond of silver" or "money-lover" (Philargurus) that he now used as his *cognomen* in his new Roman name. The statue was presumably of a single deity who did not need a label to be readily identified. The context should be a local shrine or *compitum.* This inscription provides striking evidence for the resources and administrative roles of *vicomagistri* in late republican Rome.

It was also the aediles who supervised the so-called minor magistrates in charge of public order, notably the *tresviri capitales* or *nocturni* (board of three men in charge of security or of the night watch) who oversaw local law and order, particularly looking out for petty crime and fires every night.[21] The night watch, which patrolled the city for signs of crime or fires at night, was organized on the level of the vicus. The emergency measures taken by the consuls and senate to counteract the perceived threat posed by a new form of Bacchic initiation cult in 186 BC reveal a rare glimpse of the administrative structures of the republican city. According to Livy, after the senate had issued a ban on the cult, which included the death penalty, and immediately before the consul Aulus Postumius addressed the people in a *contio,* he and his consular colleague instructed each level of city officials to take due precautions according to their respective spheres of operation.

> consules aedilibus curulibus imperarunt, ut sacerdotes eius sacri omnes conquirerent, comprehensosque libero conclaui ad quaestionem seruarent; aediles plebis uiderent, ne qua sacra in operto fierent. triumuiris capitalibus mandatum est, ut uigilias disponerent per urbem seruarentque, ne qui nocturni coetus fierent, utque ab incendiis caueretur; adiutores triumuiris quinqueuiri uls cis Tiberim suae quisque regionis aedificiis praeessent.

> The consuls instructed the curule aediles to search out all the priests in that cult, and to keep them in open custody after their arrest so that they could be brought before the (special) tribunal of investigation (*quaestio*). They ordered the plebeian aediles to take care that no ritual activities take place in secret. The board of three in charge of security (*triumviri capitales*) were given the order to place guards throughout the city, to see that no meetings were held at night, and of making provision against fire. As assistants to the *triumviri,* the five officials for both banks of the Tiber (*quinqueviri uls cis Tiberim*) were to stand guard each over the buildings in his own district (*regio*).
> (Livy 39.14.9–10)

What seems to be going on here is a standard heightening of security awareness in the areas supervised by the minor magistrates, particularly the *tresviri capitales/nocturni* and the very poorly attested *quinqueviri cis uls Tiberim* (five men in charge of both banks of the Tiber). Livy clearly expects his readers to be familiar with these

inscription would be contemporary with some famous events discussed later in section III.xxii. For discussion, see also Daguet-Gagey 2015, 401–2.

21 Lintott 1999a, 137–44, gives a succinct overview of the minor magistrates, focusing on the *tresviri* at 141–42. They also had an important judicial role in punishing local unrest and crime. For public order in general, see Nippel 1995.

humbler magistrates. They were different from the local *vicomagistri*, since they operated at the level of the regio or even of the whole city. The *quinqueviri cis uls Tiberim* are also attested as having a role in basic law and order on both sides of the river, thus indicating that an administrative system existed beyond the four traditional regions attributed to Servius Tullius.[22]

At the level of each street, however, the aediles relied on the support of locally chosen *vicomagistri* and their assistants who knew and were trusted by the people in each neighborhood. Our historical sources naturally focus on exceptional occasions, but local logistics ultimately must have depended on the cooperation of local people. Similarly, it is only because of Frontinus' informative discussion of Rome's water supply, for example, that we hear that two individuals were regularly assigned to be in charge of the water supply in each vicus.[23]

cuius rei causa aediles curules iubebantur per vicos singulos ex iis qui in unoquoque vico habitarent praediave haberent binos praeficere, quorum arbitratu aqua in publico saliret.

For this reason, the curule aediles were instructed to choose two men in each *vicus*, selected from those living or owning property in each *vicus*, under whose charge the public water supply would operate.

(Frontinus *Aq.* 97.8)

Presumably, these were in addition to the *vicomagistri*, who may have been the ones to help coordinate the selection of two reliable, local men to supervise water in each vicus. In any case, they would surely also have worked together with other local magistrates. It is interesting to see that they could be chosen from the wealthier property owners, regardless of whether those individuals were actually resident in the vicus themselves or not.

Interestingly, the religious roles of the *vicomagistri* are consistently more fully documented than the many facets of local administration.[24] Meanwhile, there is no real evidence for anyone other than the *vicomagistri* and local slave *ministri* being "in charge" of the shrines at the crossroads. This situation obviously creates a close connection between the leaders in the vici (and consequently the vici themselves) and the *compita*. Nevertheless, anybody and everybody could make daily offerings to *lares* at a *compitum*, in complete contrast to temples that were usually closed to the public. Strictly speaking, there were no "priests" at the compital shrines. In practice, the tending of local street shrines of all sorts was probably a more informal and communal affair, in contrast to the annual ludi, whose logistics and cost will have required more specific organization.

22 Paillier 1985 sees the existence of the *quinqueviri cis uls Tiberim* as evidence for republican jurisdiction on both sides of the river—in effect, a Rome with five regiones rather than just the four Servian ones. See also Gellius *NA* 12.13.

23 Peachin 2004 gives a detailed discussion of Frontinus' text and the organization of the water supply in Rome.

24 Flambard 1981, 146: "On connait bien leurs cultes, médiocrement leur organisation, très mal leur realité materielle." (We know a great deal about their cults, something about their organization, and very little of their material reality).

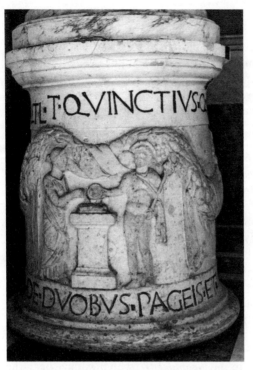

III.13. Altar with carved relief of Mercury and Maia making a sacrifice, dedicated by the *magistri* of two *pagi* and the vicus Sulpicius. Musei Vaticani, inv. 2736.

The flexibility of the situation on the ground is exemplified by a round marble altar in the Vatican Museum, which features both an inscription and relief decoration.[25] This small altar was found outside Rome in 1887, at the eighth milestone beyond the ancient porta Capena. It has been dated to the late republican period on the basis of style and lettering. The scene of sacrifice shows the god Mercury, easily identified by his winged sandals and caduceus, and a female goddess wearing a diadem, probably Maia, on either side of a square altar. These two divinities were closely associated with *lares* on Delos. Mercury is pouring a libation and Maia is joining in the gift with a similar gesture over the altar but from the other side. The two gods, mother and son in some myths, are enveloped in an oversized garland of flowers decorated with ribbons, which is looped over a bull's head on the other side. The inscription in large, clear letters runs boldly along the top and bottom of the altar, either side of the relief. (See figure III.13.)

> T(itus) Quinctius Q(uinti) f(ilius), L(ucius) Tulli[us . . . f(ilius) . . .], Caltili(us)
> Calt(iliae) l(ibertus)
> mag(istri) de duobus pageis et uicei Sulpicei
>
> Titus Quinctius, son of Quintus, Lucius Tullius, son of ?, Caltilus, freedman
> of Caltilia, *magistri* of two *pagi* and of the vicus Sulpicius
> (*CIL* 1² 1002= 6.2221 = 32452 = *ILLRP* 702 = *ILS* 6078)

Three men have set up this gift. The first two are freeborn. They are most probably the *magistri* of the two *pagi*, country districts whose names are not recorded here. Their companion Caltilius, the freedman of a woman, should logically be a *magister* in the vicus Sulpicius.[26] This vicus is later attested in Augustan regio 1 to the south of the site of the Baths of Caracalla. In and around Rome, each *pagus* typically only had a single *magister*, but the vicus would surely have had more, probably four in all. This altar, therefore, exemplifies the coming together of

 25 Vatican inv. 2736: *CIL* 1² 1002 = 6.2221 = 32452 = *ILLRP* 702 = *ILS* 6078 = EDCS-18100934 = Tarpin R 20 = R 104.
 26 See Lega in *LTUR*.

three *magistri* representing distinct entities, two *pagi* and a vicus, all situated in the suburban area outside Rome. It is certainly tempting to suggest that they are meeting at a *compitum*, a crossroads where their three districts met. In which case, we may imagine that the recipients of offerings presented by the two gods were the local *lares*. This altar is a rare attested example of the cooperation between districts and their local officials, who might come into competition with each other but who were supposed to celebrate Compitalia together in a spirit of harmony.

Collegia

Even in the best attested times in the history of Rome, it remains a challenge to discern the aims, methods, and characteristics of the local organizations collectively known in Latin as *collegia*. Nevertheless, the complex world of urban politics appears to be situated in that shadowy but characteristically Roman space between vicus, *compitum*, and *collegia*—the street, the shrine on its corner, and the various organizations to which local, working people living in the vicus chose to belong. This was also, not by coincidence, the same space guarded by *lares* and celebrated at the annual Compitalia.

The Latin term *collegium* indicates "a group governed by rules or a charter," or more generally a "legally sanctioned organization or club." Civic and religious organizations were described as *collegia* ("colleges"), such as the college of *pontifices*, which included these elite priests together with the Vestal Virgins under the leadership of the chief pontiff (*pontifex maximus*).[27] The concept of "collegiality" was also at the very heart of the system of Roman republican magistrates, who were elected and were expected to act in cooperation with others at their same rank. Parallel to this official world of civic and priestly "colleges," a wide variety of private voluntary associations, also known generically as *collegia* ("collectives" or "clubs"), are attested in ancient Rome.[28] These private groups were often convened and organized by leaders of their own called magistrates (*magistri*), who oversaw the collection and spending of funds held in common for mutually agreed-upon purposes. Presumably, the Italian *magistri* in the next section would have called their groups *collegia*; not much explicit evidence has survived. *Collegium* could, therefore, be an official title or term for a group, whether elite or nonelite, that was sanctioned by law and tradition but also a term for a more informal and more suspect club. As will be discussed in more detail later (section III.xxii), in the first century BC, some of these private *collegia* were repeatedly banned, but then soon restored and recreated, according to the changing political mood of the day.

But what local organizations were there in Rome's vici? Cicero, our main informant for this period, is almost uniformly scathing in his references to these local groups, which he characterizes as being made up of the dregs of society, who were

27 For the colleges of priests, see Rüpke's 2008 *fasti* with useful introductions to each group, as well as Rüpke 2002.

28 *TLL* cites a wealth of epigraphical evidence about *collegia*. Diosono 2007, 26–27, gives an overview of the attested artisans and their *collegia* from republican Rome. Royden 1988 surveys the attested magistrates of Roman professional *collegia* in Italy.

incapable of coming together for any good purpose.[29] These very controversies about *collegia* and the right to assemble in Rome encouraged earlier scholars to seek a single type of organization, a "group" worth targeting. Over more than 150 years of scholarly debates their quest has proved elusive.[30] Nevertheless, we can see that in the particular political context of first century BC Rome, many *collegia* came to be seen as unsanctioned, untraditional, and dangerous organizations, the very opposite of what their titles were supposed to imply. Meanwhile, skepticism has grown about the value that should be ascribed to Cicero's pronouncements, especially about those who were followers or dependents of his two political archrivals, Catiline and Clodius.[31]

Indeed, Cicero's political associate T. Annius Milo was collecting popular support and using tactics that drew on very similar networks and political strategies as P. Clodius. Clodius and Milo were both leaders of armed groups, organized on paramilitary lines, which have often been called "gangs" in modern scholarship.[32] It remains unclear whether these armed groups were themselves *collegia* or should more accurately be described as novel (types of) groups that drew their recruits from existing local clubs and self-help organizations. Cicero claims that in January of 58 BC, Clodius was recruiting his thugs in the vici (*vicatim*), although his "levy" took place in the forum.[33] Today, we might call these armed groups "cells," at their worst secret local groups that formed part of a larger, but loosely organized, subversive network with a focus on a charismatic leader; such cells are blamed for destabilizing the existing political status quo, including by accumulating power for individuals outside the formal structures of yearly office holding or senate membership.

The citywide festival of Compitalia, also closely associated with Clodius in the 50s BC, provided one of the most important opportunities for mobilizing the local population. The ways in which the festival was celebrated became a flashpoint for debate and dissension at the highest levels, as Rome's political leaders tried to grapple with grassroots politics and violence in the streets during the first century BC. In 64 BC, certain *collegia*, not individually named in our surviving evidence, and some components of the festival, specifically the games were banned at the same time.[34] In 1843, Mommsen proposed a category of *collegia compitalicia*, which he imagined as those responsible for organizing the festival at the crossroads and

29 For example, Cicero *Flacc.* 18.

30 Perry 2006 gives an overview of the history of scholarship on *collegia*. See also Bendlin 2002 and Liu 2013.

31 Flower 2006, 98–104. For the western empire, see Dondin-Payre and Tran 2012.

32 Lintott 1999b is the classic treatment of violence in republican Rome. See Nippel 1995 for policing the city. Tatum 1999 offers a more balanced picture of Clodius' career and his politics.

33 *Pro Sestio* 34: *isdem consulibus inspectantibus servorum dilectus habebatur pro tribunal Aurelio nomine conlegiorum, cum vicatim homines conscriberentur, decuriarentur, ad vim, ad manus, ad caedem, ad direptionem incitarentur* (As those same consuls were watching, an enlistment of slaves was held in front of the Aurelian tribunal, under the guise of recruiting for a legal club, at which individuals were enlisted according to their vicus, assigned to divisions of ten, and incited to violence, fighting, murder, and plunder). See *Dom.* 5.54, 129; *Pis.* 11, 23, with the commentary of Kaster 2006, 198–200, who notes the military language and the overtones of enlisting an army of slaves as if for a revolt. For Clodius' followers, see Sumi 1997, Papi 2002, and Harrison 2010.

34 Ban on *collegia* in 64 BC: Asconius *Corn.* 75 C and *Pis.* 8 C, with Dio 38.13.2 with Accame 1942; Salerno 1984–85; Flambard 1977; Linderski 1995, 165–203; Lintott 1999a, 77–83; and Tatum 1999, 25–26, 117–19.

its games, in cooperation with the *vicomagistri*, who were more generally in charge of the vicus and *compitum*.[35] He posited that it was these particular groups that were repeatedly banned, but that they may also have continued to operate clandestinely. As has been pointed out, however, there is no explicit ancient evidence for these *collegia*. Mommsen's view has been successfully challenged.[36] Of course, it would be much easier to understand what was happening if there had indeed been uniform *collegia* in each vicus, organizations that we could hold responsible for the celebrations that had become so controversial in their own right.

III.14. Drawing of an inscription from an open-air shrine (*sacellum*) on the Mons Oppius, set up by the local *montani* (*CIL* 1² 1003).

There were undoubtedly many kinds of *collegia* in republican Rome: some were craftsmen's associations (analogous to guilds), others were purely geographic (neighborhood groups), yet others identified primarily with a local shrine or special cult (these look to us like "religious" groups). In other words, we are talking about associations that might combine aspects of a labor union (a local chapter of AFL-CIO) or business organization (Rotary Club) or veterans group (American Legion, Vietnam Veterans) with those of a self-help organization with a religious affiliation (Knights of Columbus) or sometimes, an overtly religious program (Opus Dei, Communion and Liberation, Community of Sant'Egidio).

Two examples can serve to illustrate the kind of inscriptions that were erected by local organizations in republican Rome; they show what our direct evidence for *collegia* looks like. Each provides a vivid glimpse of local life but also reveals how little we really understand about such organizations. On the Oppian hill a neighborhood group called "mountain men" (*montani*) collected funds to improve the open-air shrine (*sacellum*) that was of special significance to their neighborhood.[37] The narrow format of the slab they used accounts for the layout of their words, written in irregular letters. (See figure III.14.)

m[a(gistri)
et flamin(es)
montan(orum) montis
Oppi
de pequnia montan(orum)
montis Oppi
sacellum

35 Mommsen 1843.

36 Nevertheless, *collegia compitalicia* are still mentioned as a matter of course, for example, by Diosono 2007 and Daguet-Gagey 2015.

37 *CIL* 1² 1003 = 6.32455 = *ILLRP* 698 = *ILS* 5428 = EDCS-21600036.

claudend(um)
et coaequand(um)
et arbores
serundas
coeraverunt

The magistrates and priests of the mountain dwellers of the mons Oppius supervised the enclosing and leveling of the open-air shrine and the planting of the trees, (paid for) by the money of the mountain dwellers of the mons Oppius.

(*CIL* 1² 1003 = 6.32455 = *ILLRP* 698 = *ILS* 5428)

The deity honored in the shrine is not named, at least in the surviving part of the text. The local protective god seems to have been Jupiter Fagutalis, Jupiter of the Beech Trees.[38] The shrine (*sacellum*) was composed of a consecrated space that was fenced in and leveled, and of the trees planted within this sacred area. In other words, it was a sacred grove (*lucus*). No altar is mentioned perhaps because one already existed in what may have been a very venerable shrine.

The *montani* have common funds, which were administered by *magistri* with the help of *flamines*, a type of priest who usually served a specific, single deity (for example, *Flamen Dialis*, the priest of Jupiter). Other *flamines* we know of were required to be married, and their wives, known as *flaminicae*, also had religious duties. Here the priests are simply called those "of the *montani* of the mons Oppius" rather than being labeled with the name of a deity in the more usual Roman way. The plural *magistri* and *flamines* may be from several years, rather than representing a single set of annual officials. These *montani* would have joined with others from different hills for the annual festival of Septimontium, the special celebration of the hill dwellers that was the equivalent of Paganalia for those who lived in *pagi*.[39] Meanwhile, the hill would also have been subdivided into vici and clivi, individual streets. The self-identification of the *montani* claimed to predate the creation of a single Rome, even as their grove recalled the days before urbanization. This group, therefore, had a specific identity it asserted, despite the growth of Rome.

My second example is a long stone found in Rome near the porta Praenestina that has two inscriptions, which record both the original building and the later restoration of a communal burial ground for a society of Greek singers.[40] The texts,

38 Jupiter Fagutalis on the Oppian: Varro *LL* 5.152 and Pliny *Nat.* 16.37 (a grove) and *CIL* 6.452 = *ILS* 3620 = EDCS-17300605 with Buzzetti in *LTUR*.

39 Septimontium: Varro *LL* 5.41: *ubi nunc est Roma erat olim Septimontium nominatum ab tot montibus quos postea urbs muris comprehendit* (Where Rome is now there was once a place called Seven Hills for all its hills, which the city later encircled with walls). Varro *LL 6.24: dies Septimontium nominatus ab his septem montibus in quis sita urbs est feriae non populi sed montanorum modo ut Paganalia qui sunt alicuius pagi* (The festival day of Seven Hills was called after these seven hills on which the city was founded. It is a holiday not of the whole people but of the mountain dwellers only, as the *Paganalia* is for those who live in a *pagus*). Cf. Festus 314, 348.

40 *MNR* inv. 124657 (157×56×32 cm, discovered in 1925), *CIL* 1² 2519 = *ILLRP* 771= EDCS-24701277. See Friggeri, Granino Cecere, and Gregori 2012, 231–32 (C. Caruso) for the official catalogue entry. Caruso 2008 collects the information for professional singers in Rome. See now

written in different hands, are clearly separated by a blank line on the stone and are laid out horizontally.

> Societatis cantor(um) Graeco[r]um et quei in
> hac sunhodo sunt de pequnia commune [space for three letters] Maecenas
> D(ecimi) f(ilius) Mae(cia) desi-
> gnator patronus sunhodi probavit M(arcus) Vac[ci]us (?) M(arci) l(ibertus)
> Theophilus
> Q(uintus) Vibius Q(uinti) l(ibertus) Simus magistreis sunhodi d[ec]umiano-
> rum locu[m]
> sepulc{h}ri emendo aedificando cu{u}raverunt

> (Property of) The Society of Greek Singers and those who are in this meet-
> ing/council, (paid for) by common funds,
> ? Maecenas, son of Decimus (of the tribe) Maecia, the assigner of seats
> (in the theater), patron of the meeting / council, acted as approver; Marcus
> Vaccius Theophilus, freedman of Marcus, (and) Quintus Vibius Simus, freed-
> man of Quintus, the magistrates of the meeting of Decumianus' men? (or "of
> those who paid a tenth" or "of the officers"), supervised the buying and con-
> struction of the burial place.

> L(ucius) Aurelius L(uci) l(ibertius) Philo magister septumo synhodi
> societatis cantorum Graecorum quique in hac
> societate sunt de sua pecunia reficiun[d]um
> coeravit

> Lucius Aurelius Philo, freedman of Lucius, magistrate for the seventh time
> of the meeting / council of the Society of Greek Singers and those in this so-
> ciety, supervised the restoration at his own expense.
> (*CIL* 1² 2519 = *ILLRP* 771) (see figure III.15)

The picture is more detailed but not easier to interpret. For our purposes, however, the basic outline is discernable. A professional organization of Greek singers, presumably theatrical performers, acquired and maintained a burial ground, perhaps with a building or an underground tomb on it, for the use of (some of?) those in its association. It could have been a construction with niches to deposit ash urns. For cultural or political reasons, these men are keen to use the Greek term *synhodos* (meeting or council) to describe (an aspect of?) their association, although its official title is in Latin (*societas cantorum Graecorum* = society of Greek singers). The word *synhodos* may refer to the annual nature of the magistracies and, by extension, to yearly meetings of members.[41] Are the Greek singers, in fact, deliberately avoiding the designation *collegium*?

Giovagnoli 2014 for discussion and full bibliography. Differences in spelling within the text confirm the time gap between the two inscriptions, both assigned to the first century BC.

41 Previous editions tend to assume that *synhodos* is no more than a Greek synonym for *societas*, but this reading makes the text very repetitive, to the point of not making much sense.

III.15. Inscribed peperino block used to mark the communal burial ground of a society of Greek singers, 157×56×32 cm. Found in Rome near the Porta Praenestina. Museo Nazionale Romano, Palazzo Massimo alle Terme, inv. 124657.

Their wording seems to suggest that others who are not professional singers, perhaps friends or relatives or benefactors, are also part of the group. They have a freeborn patron (Maecenas!), but he is a Greek who is not evidently a Roman citizen. As assigner of seats in the theater (*disignator*), he is very much part of their world. There are two freedmen magistrates, chosen annually, who oversaw the common fund and its use to buy the land and build the tomb. Burial may or may not have been limited to a subgroup of officers or of subscribers.[42] Subsequently, as the second text shows, a single, affluent magistrate paid for its restoration from his own funds. We may imagine that every aspect of this scenario was shared with other *collegia*, for whom the provision of burial for members was an important and very practical objective, regardless of their occupation. As this inscription suggests, these associations could be large, could include others beyond the core members, could have a variety of officers chosen annually, and might have internal subgroups or committees, sometimes known as *decuriae* (groups of ten).

There is, however, simply not enough surviving evidence to sort out the exact nature of each of these *collegia* and the potential interrelationships between the many different types. A loose legal framework existed to sanction an acceptable *collegium* but there was no formal prototype. Their size, composition, financial resources, and objectives will have varied greatly, both over time and between different parts of the city, as these two examples show. Needless to say, the elite authors of our literary texts were not members of these *collegia* themselves and mostly either ignored or denigrated them. Meanwhile, epigraphic evidence is fragmentary, especially for the republican period, and provides information about those who could afford an inscription carved on stone.

In a city where (work)shops of the same kind tended to cluster together on a single street, such as the well-known jewelers on the Sacra Via or the silk merchants on the Vicus Tuscus, there would often have been no significant difference between a geographic association located in a vicus and a craft *collegium* that looked like a professional guild.[43] Similarly, these groups often had a shared devotion to a

42 Giovagnoli 2014 argues that the burial ground was only for officers of the club, not for ordinary members. For collective identity in the context of tombs, see now Borbonus 2014.

43 Local shops: Flohr 2013 and Wilson and Flohr 2016 with Holleran 2012, who provides an overview of shopping in ancient Rome.

patron deity, whether local or occupational. Many artisans and shopkeepers lived and worked in or above their shops, and would by necessity have kept long hours in order to make ends meet. Meanwhile, ordinary folks would regularly have met at the water fountain, the bakery, or the neighborhood food shop or tavern (*taberna*), since many did not have either running water or a way to cook for themselves in their very modest living quarters. Under these circumstances, *compita* formed a network of pivotal points in the landscape of ordinary people's daily lived experience: the religious needs they met were as basic as the bread and water of subsistence and the vital social connections needed for mutual assistance by working people.

As Rome grew, the number of freedmen or descendants of freedmen increased rapidly during the second and first centuries BC.[44] The very size of the city, unparalleled by the standards of the ancient Mediterranean, with its high mortality rate, would have made traditional support groups such as families or patrons less reliable. Fire, flood, disease, price fluctuations, and petty crime consistently made city life uncertain.[45] In addition, a significant number of people spent only part of the year in Rome and kept their farms in the countryside or bases in other towns.[46] They would come in on business for seasonal work or to sell their goods at certain times of the year. Under such circumstances, real poverty would probably have been a condition that led to rapid homelessness and death.

In the context of ancient Rome, it is logical, even inevitable, that working people sought support and comfort in associations with others in their own situation, both locally and in their particular line of work. Such modest organizations could provide vital opportunities for pooling resources in times of need, as well as a forum for exchanging goods and services or information, whether practical or political. These groups would have grown and adapted organically to meet the needs of a shifting population in each neighborhood. Needless to say, the protection of the gods was both traditional and especially attractive to those who led lives that were unpredictable and precarious. Conversely, the possibility of upward mobility could also suggest divine favor, at least in the lives of some fortunate acquaintances and colleagues. *Collegia* flourished precisely in the neighborhoods, under the protection of local deities, and by meeting practical needs.

It is equally unsurprising that Rome's political leaders (republican or imperial) were consistently suspicious of associations or local groups. Romans never enjoyed freedom of association or of expression, public meetings were in the hands of magistrates in office, and the dissemination of information was carefully guarded, even as rumor and the potential for unrest were perennial features of city life.[47] In other words, although *collegia* were legal clubs, they did not possess any inherent or natural rights to exist. Meeting in a group was always a privileged activity under Roman law, one that could be granted but could also be revoked. Two striking examples from very different periods of Roman history clearly illustrate the suspicion of the republican senate and of an emperor like Trajan toward unauthorized associations of almost any kind and especially the private or secret gatherings they were suspected of taking part in.

44 Bradley 2011, Scheidel 2011, and Hermann-Otto 2013 discuss slaves in Rome.
45 Germs for Rome: Scobie 1986 and Scheidel 2003, 2009a, and 2013.
46 Purcell 1992 is the best treatment. Moatti 2013 gives a useful overview.
47 For rumor, see Laurence 1994, Dubourdieu and Lemirre 1997, and Pina Polo 2010.

The infamous suppression of certain new forms of cult for Bacchus in 186 BC, already alluded to, indicates some of the issues at stake.[48] Widespread measures taken by the consuls and senate against practitioners resulted in many arrests and executions, both in Rome and elsewhere in Italy. Livy's description of the emergency measures taken in the city has already been discussed earlier. In addition, contemporary evidence is provided by a well-preserved inscription on bronze from southern Italy, the so-called *Senatus Consultum de Bacchanalibus*.[49] As part of its injunctions, the central section of this senatorial decree, widely circulated in Italy, outlines the kinds of behaviors imagined as happening in the Bacchic cult cells.

> sacerdos nequis uir eset. magister neque uir neque mulier quisquam eset.
> neve pecuniam quisquam eorum comoine[m h]abuise velet. neve magistra-
> tum, neve pro magistratu[d], neque virum [neque mul]ierem qui[s]quam
> fecise velet.
> neve post hac inter sed conioura[se nev]e comvovise neve conspondise
> neve conpromesise velet, neve quisquam fidem inter sed dedise velet.
> sacra in [o]quoltod ne quisquam fecise velet. neve in poplicod neve in
> preivatod neve exstrad urbem sacra quisquam fecise velet, nisei
> pr(aitorem) urbanum adieset, isque de senatuos sententiad, dum ne minus
> senatoribus C adesent, quom ea res cosoleretur, iousisent. Censuere.

Let no man be a priest, let no man or woman whatsoever be a magistrate, let none of them consent to having money in a common fund, let no one consent to appointing either a man or a woman as a magistrate or an acting magistrate, henceforth let them not be disposed to exchange oaths or pledges or pacts or promises among each other, nor let anyone consent to make a contract among themselves.

 Let no one consent to performing cult rituals in secret. Let no one consent to performing cult rituals either in public or in private or outside the city unless he approaches the urban praetor and the latter gives permission on the basis of the senate's recommendation, as long as no fewer than 100 senators are present when this issue is debated. They declared (their approval).

<div align="center">(CIL 1² 581 = 10.104 = ILS 18 = ILLRP 511)</div>

Regardless of what really was going on in (secret) Bacchic meetings at the time, this text conjures up a specific and detailed list of actions that the senators are worried about and that are imagined as taking place within a recognizable organizational framework.

These include magistrates (both male or female) and priests (only male mentioned here) appointed to direct and guide a group, in the name of a patron deity (in this case Bacchus). Alternatively, there could also be a temporary appointment of someone as an "acting magistrate." These officials would have access to a common fund, presumably composed of donations by the members and gifts of patrons.

48 Bacchanalian conspiracy: Gruen 1996, Flower 2002, and Bispham 2007, 91–95, 116–23.

49 The so-called *Senatus Consultum de Bacchanalibus* was discovered in 1640 at Tiriolo in Bruttium and is in the Kunsthistorisches Museum in Vienna (27×28 cm, *CIL* 1² 581 = 10.104 = *ILS* 18 = *ILLRP* 511= EDCS-15100127).

Fig. I.

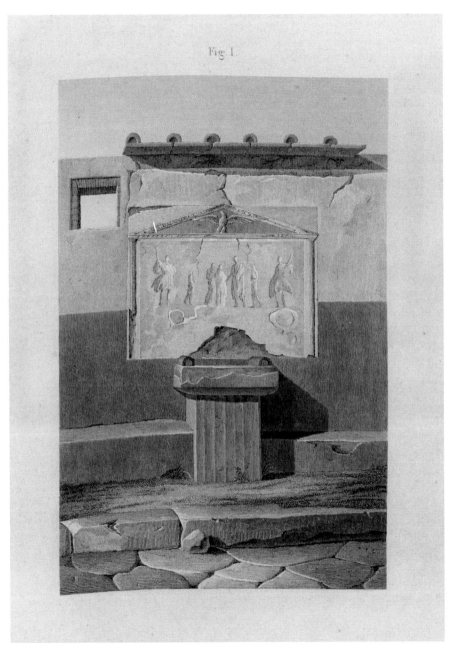

PLATE 1. Nineteenth-century etching of a shrine to the *lares* near the northwest corner of the forum, Pompeii (VII.7).

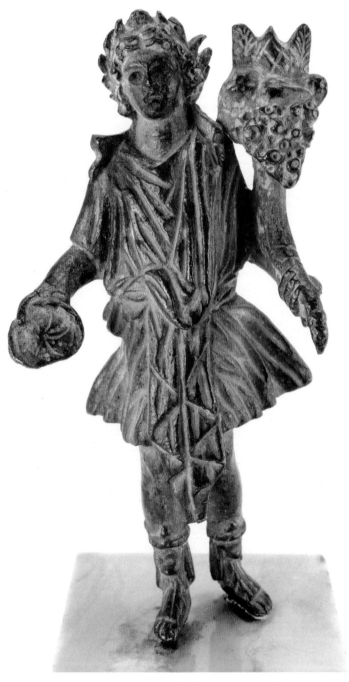

PLATE 2. Statuette of a standing *lar* on a base with a Greek inscription, holding a *patera* and *cornucopia*. Bronze. Roman, first–second centuries AD. 10.8 × 5.6 × 3.2 cm. Mount Holyoke College Art Museum, South Hadley, Massachusetts, 2013.31. Purchased with the Susan and Bernard Schilling (Susan Eisenhart, Class of 1932) Fund.

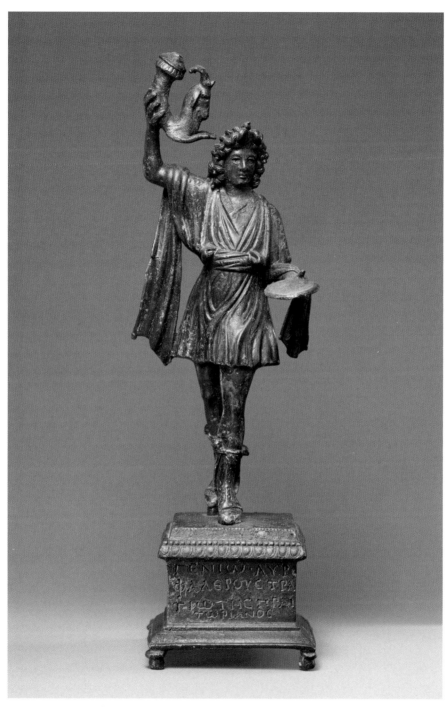

PLATE 3. Statuette of a dancing *lar*, holding *rhyton* and *patera*. Bronze. Roman, third century AD. H overall 30.8 cm; H of figure 23 cm. The J. Paul Getty Museum, Villa Collection, Malibu, California, Gift of Barbara and Lawrence Fleischman, inv. 96.AB.200.

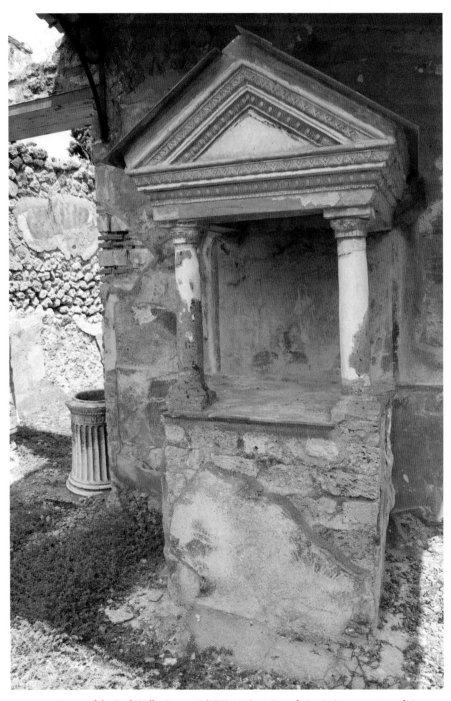

PLATE 4. House of the Red Walls, Pompeii (VIII.5.37), atrium shrine in its present condition.

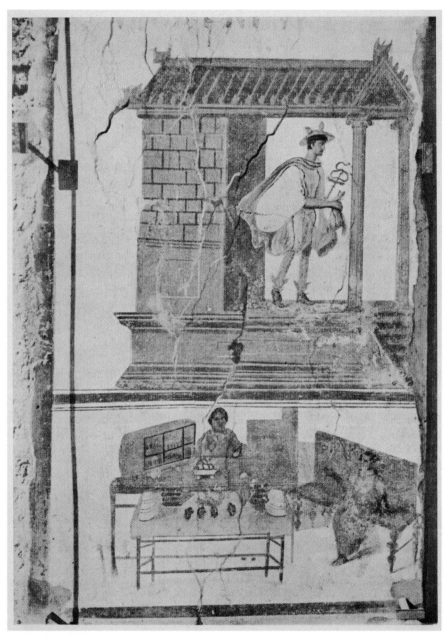

PLATE 5. Painting of a shrine to Mercury from the Via dell' Abbondanza, Pompeii (beside the entrance to the shop of M. Vecilius Verecundus, IX.7.7). Watercolor A. Sanarica.

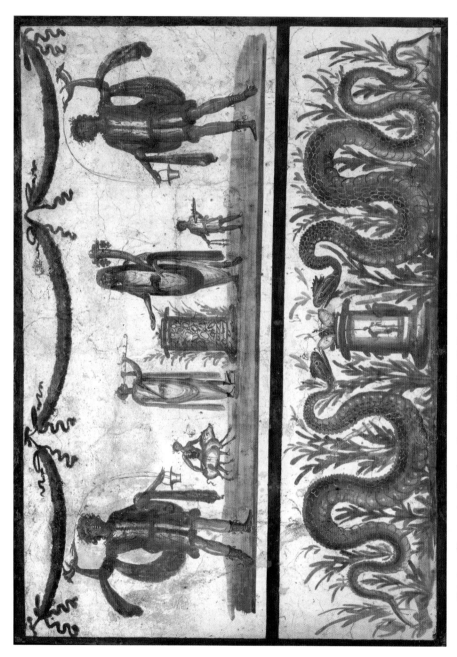

PLATE 6. Painting of *lares* and snakes from Pompeii (VII 2 or 3). Fourth style (ca. AD 55–79). 128 × 183 cm. Museo Archeologico Nazionale di Napoli, inv. 8905.

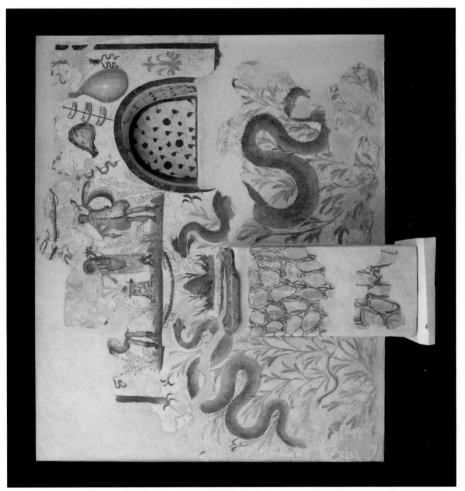

PLATE 7. Painted kitchen shrine, Villa 6 at Terzigno, inv. 86755. First century BC. 210 × 260 cm.

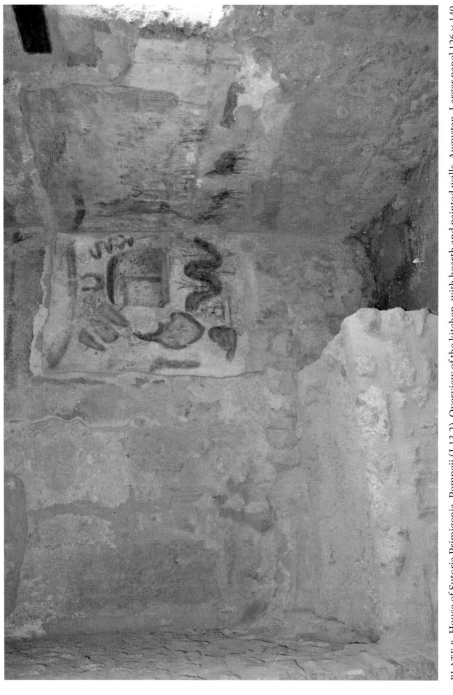

PLATE 8. House of Sutoria Primigenia, Pompeii (I.13.2). Overview of the kitchen, with hearth and painted walls. Augustan. Larger panel 126 × 140 cm; smaller panel 128 × 96 cm.

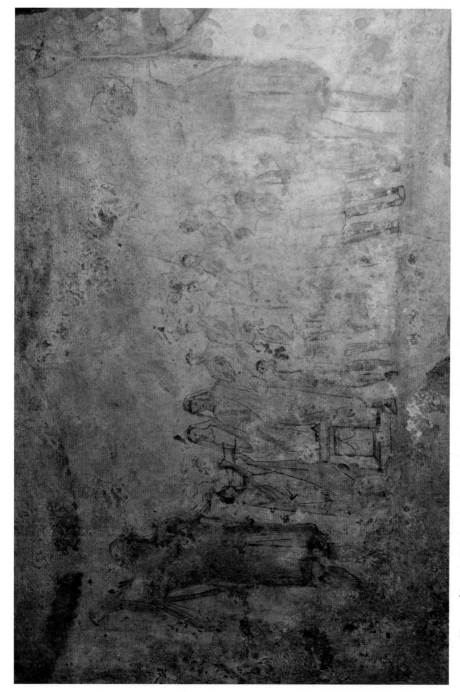

PLATE 9. House of Sutoria Primigenia, Pompeii (I.13.2). Painted scene of a sacrifice to the *lares*.

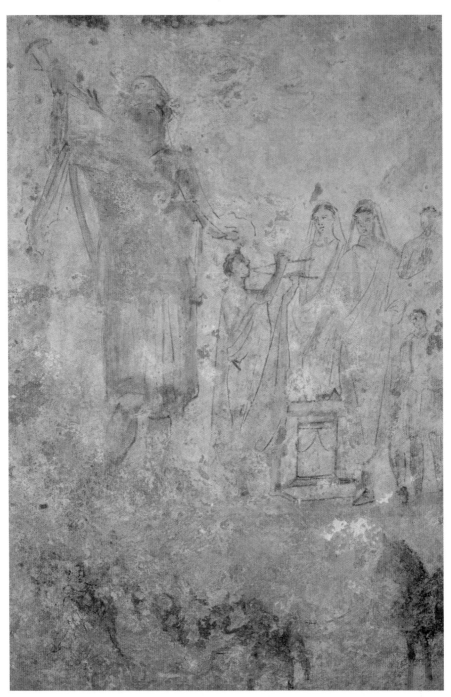

PLATE 10. House of Sutoria Primigenia, Pompeii (I.13.2). Detail of painting, showing the principal celebrants next to a *lar*.

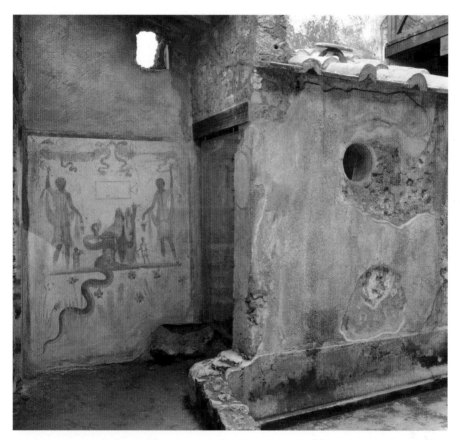

PLATE 11. House of Julius Polybius, Pompeii (IX.13.1–3). View of the painting to the left of the small kitchen. After AD 62.

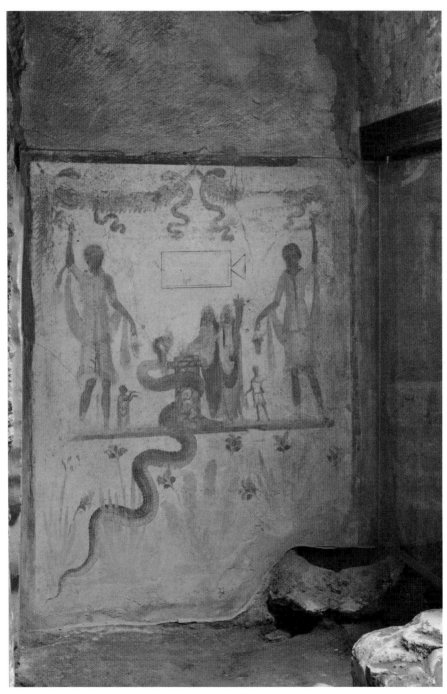

PLATE 12. House of Julius Polybius, Pompeii (IX.13.1–3). Painting outside the kitchen, showing a sacrifice made by a *genius* and *juno* to the *lares*.

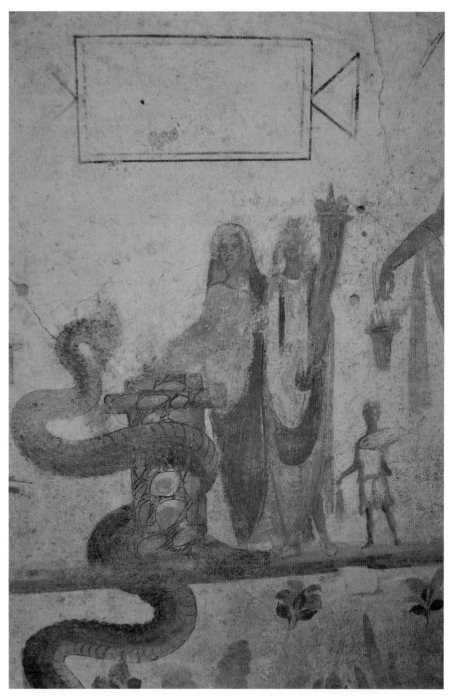

PLATE 13. House of Julius Polybius, Pompeii (IX.13.1–3). Detail of painting outside the kitchen, showing the *genius* and *juno*, with a *camillus* carrying an offering tray and garland with ribbons.

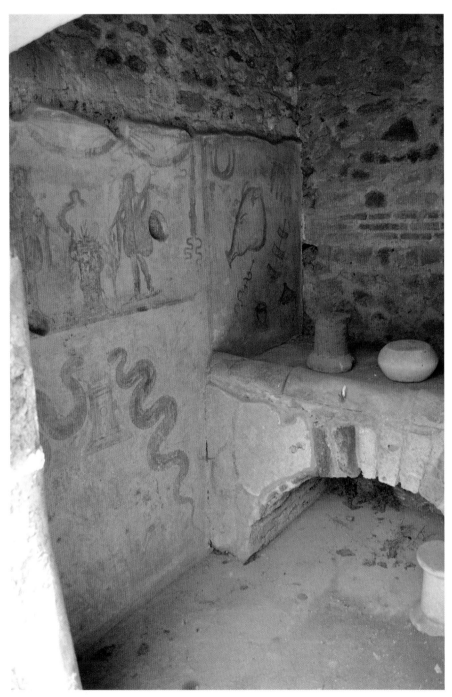

PLATE 14. House of the Piglet, Pompeii (IX.9.b–c). Overview of the small kitchen with its hearth.

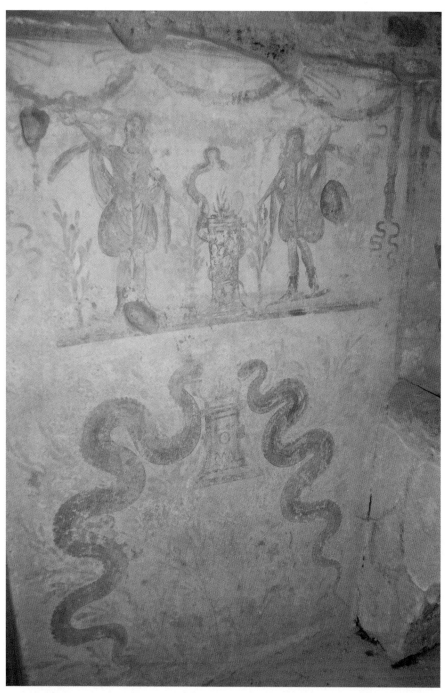

PLATE 15. House of the Piglet, Pompeii (IX.9.b–c). Kitchen painting, showing a scene of *lares* and snakes.

PLATE 16. Painted scene of a rural *sacellum*, from Herculaneum. Ca. AD 54–79. 34 × 61 cm. Museo Archeologico Nazionale di Napoli, inv. 9419.

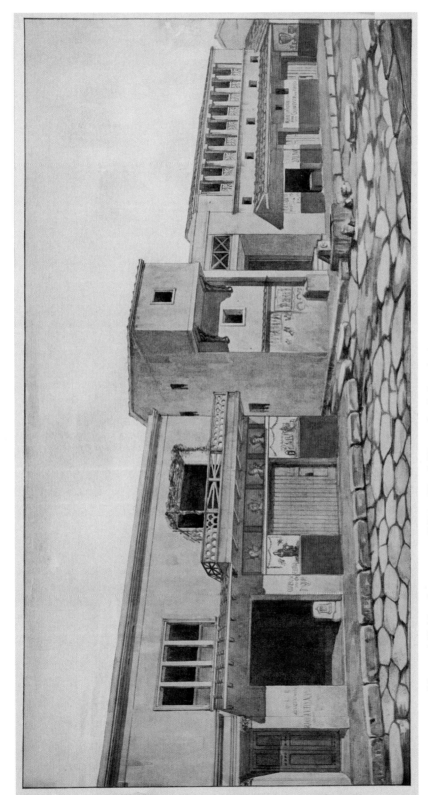

PLATE 17. Overview of the Via dell'Abbondanza, Pompeii (IX.7; IX.11). Watercolor A. Sanarica.

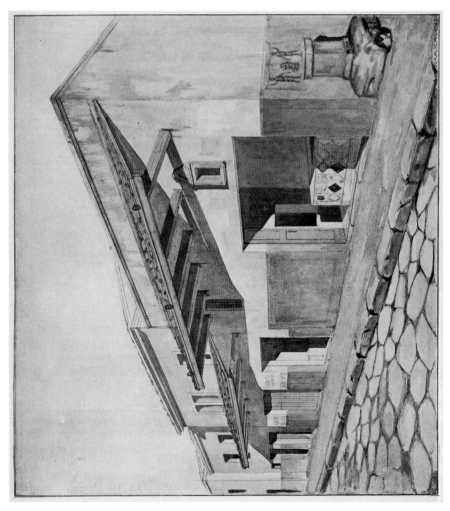

PLATE 18. Via dell'Abbondanza, Pompeii (II.11.1–6). A compital shrine in the alley beside a shop, with elevated masonry altar and a painting of *lares*. Watercolor A. Sanarica.

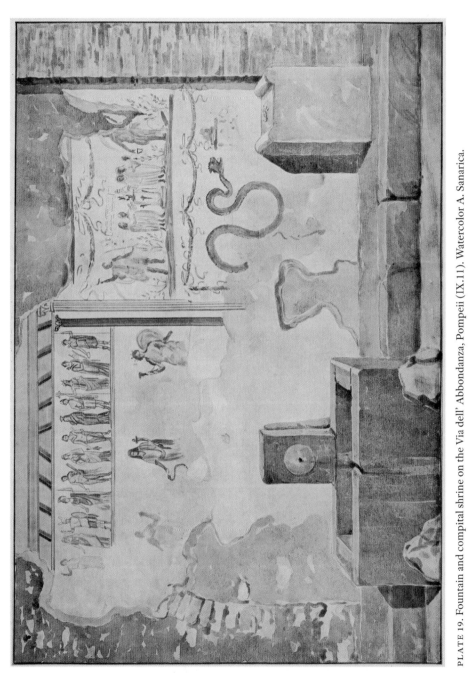

PLATE 19. Fountain and compital shrine on the *Via dell' Abbondanza*, Pompeii (IX.11). Watercolor A. Sanarica.

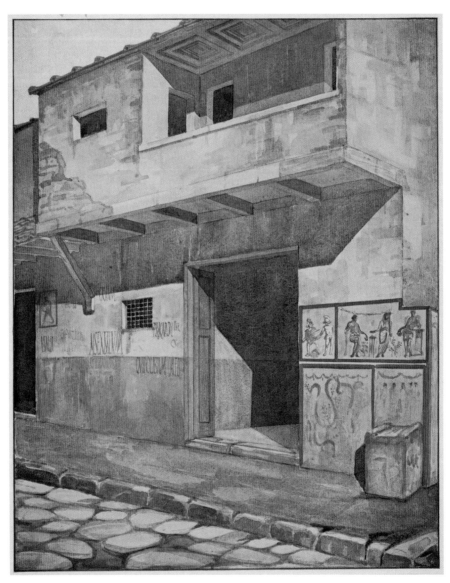

PLATE 20. Exterior of a house on the Via dell' Abbondanza, Pompeii (IX.12.7). Compital shrine comprising masonry altar and an ensemble of paintings. Watercolor A. Sanarica.

PLATE 21. Fragment of the Forma Urbis Romae, showing the temple on the Via delle Botteghe Oscure. FUR fragment 35ee.

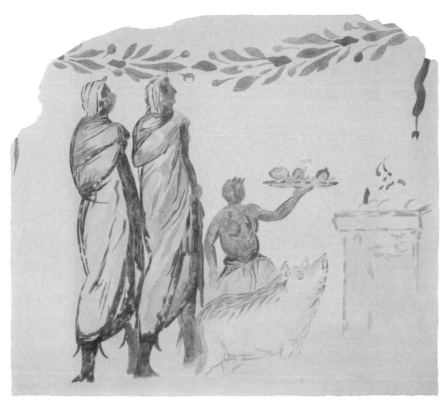

PLATE 22. Watercolor rendering of a painted altar showing two men in togas, a *camillus*, and a pig, from a house on Delos. Condition and colors observed in the early twentieth century.

PLATE 23. Painted twin dancing *lares* framed by garlands of fruit and flowers, a small table with three receptacles at the top left, from the façade of an unexcavated house opposite the Maison de la Colline, wall Δ 4 no. 20, 85 × 50 cm, Delos. Archaeological Museum of Delos.

PLATE 24. *Ara augusta* dedicated by Lucius Lucretius Zethus on the Campus Martius in Rome. AD 1. Museo Nazionale Romano—Palazzo Massimo alle Terme, inv. 72473.

Loyalty to this group, expressed through oaths or promises or contracts, is of particular concern to the senators. The quasi-civic structure of such an organization, which is presented as a potential threat to the republican status quo, is balanced by concern about the religious rituals themselves, some of which were imagined as taking place in secret. Other parts of the decree mention special cult sites and buildings (*Bachanalia*), which are ordered to be destroyed within ten days of receiving this injunction. Groups that were allowed to continue were envisaged as small and as headed by women.

Meanwhile, there is an interesting tension expressed by the conditions for obtaining an exception, based on petitioning the senate through the urban praetor. In other words, some groups might be quite legitimate, but others, with what look like identical structures, could be subversive and dangerous. The senate was always walking a fine line trying to ban religious groups or fraternal organizations that were new and unacceptable, while not abolishing older associations, whose prayers, priesthoods, and good works might be needed by the community. No information survives about exceptions, who obtained one and why. We do not know whether the ban on *collegia* in 64 BC (some 120 years later) used any similar wording or legal concepts to attack those groups designated as contrary to public interest (*adversus rem publicam*). In 186 BC, religious groups were targeted in ways that were no different than if they had been political clubs.

Almost 300 years later, when the younger Pliny, governor of Bithynia and Pontus, wrote to the emperor Trajan in the early second century AD about setting up a local fire brigade in the town of Nicomedia, the emperor refused his request.[50] In a famous response, Trajan asserted that any local association, formed for whatever urgent and practical purpose (such as fighting fires), would inevitably end up as a political club, in other words a possible or even probable locus for subversion of organized government and of Roman authority. Pliny ends his letter of request with the following simple proposal.

> tu, domine, dispice an instituendum putes collegium fabrorum dumtaxat hominum CL. Ego attendam, ne quis nisi faber recipiatur neue iure concesso in aliud utantur; nec erit difficile custodire tam paucos.

> But you, my lord, see whether you think an association of firefighters (engineers) should be established, of around 150 men. I would take care that no one who was not a fireman was enrolled and that the group was not sanctioned for any other activities by law. It would not be difficult to supervise so few (men).
>
> (Pliny *Ep.* 10.33)

Trajan's rather impatient response is worth quoting in full:

> Tibi quidem secundum exempla complurium in mentem uenit posse collegium fabrorum apud Nicomedenses constitui. Sed meminerimus prouinciam istam et praecipue eas ciuitates eius modi factionibus esse uexatas. Quodcumque nomen ex quacumque causa dederimus iis, qui in idem contracti

50 For commentary, see Sherwin-White 1966 ad loc.

fuerint, hetaeriae eaeque breui fient. Satius itaque est comparari ea, quae ad
coercendos ignes auxilio esse possint, admonerique dominos praediorum, ut
et ipsi inhibeant ac, si res poposcerit, adcursu populi ad hoc uti.

Based on examples of many similar organizations, you thought of the possi-
bility of establishing an organization of firemen among the Nicomedians. But
let us call to mind that this very province and especially these municipalities
have had trouble with these kinds of divisive political organizations (in the
past). Whatever we call them and whatever their rationale is, once they have
come together in a group, they will soon form a political faction. Conse-
quently, it will be more convenient to gather all the equipment, which could
be useful for fighting fires, and to instruct the property owners that they take
responsibility for fighting fires and, if need be, to summon volunteers on the
spot for this purpose.

(Pliny *Ep.* 10.34)

Trajan's opinion reflects the long history of Roman elite attitudes toward associa-
tions of ordinary citizens, especially in town. It applied as much to Rome as to
any town or village in the empire. It was so strong that it evidently outweighed
even a pressing need to control fires in a crowded urban environment. Interest-
ingly, however, Trajan apparently admits that many such *collegia* were in exis-
tence in other places, which is what has given Pliny the idea in the first place. Mean-
while, the emperor's alternative model meant calling on each property owner in
Nicomedia to make his own private provisions to fight fires in his home or apart-
ment building and by implication on his willingness to help his neighbors when
they were in trouble.

In other words, suspicion of local, professional, or fraternal associations tended
to place more responsibility on property owners and their households, the basic
units in society, and on natural cooperation between immediate neighbors who
logically had an interest in stopping a fire that might spread to their own property
or lodgings. Breaking things down to the level of individual households was seen
as the most practical and prudent strategy by Roman administrators, who divided
people up in order to be surer of their own control of information, resources, and
networks. Trajan's words remind us that Augustus, after earlier administrative
experiments, had eventually removed fire safety in Rome from the traditional
jurisdiction of local vici, when he established the *vigiles*, professional groups of fire-
fighters composed of publically owned slaves, who lived in barracks strategically
placed throughout the city.[51]

In sum, even as the city of Rome provided a natural environment in which the
kinds of self-help groups known collectively but imprecisely as *collegia* tended to
form and flourish, its republican political culture also supplied a time-honored
framework for monitoring, questioning, and suppressing such private or local
groups however useful and popular. In this regard, things did not change much

51 The *vigiles* were created in 6 BC, in conjunction with the creation of the new city of four-
teen *regiones* (Suet. *DA* 30.1 and Dio 55.8 and 26), divided into seven cohorts (one for every two
districts) under a commander (*praefectus vigilum*) of equestrian rank. Already in 23 BC, Augustus
had enrolled 600 slaves to fight fires under the supervision of the curule aediles (Dio 54.2.4), thus
superseding the republican system. Sablayrolles 1996 gives a thorough treatment and Ramieri
(*LTUR* s.v. *cohortium vigilum stationes*) discusses the archaeological evidence for their barracks.

under the principate. In order to understand what was going on in Rome in the first century BC, it is vital to acknowledge that notorious popular leaders such as Clodius did not invent either a completely new Compitalia festival for local *lares* or the urban landscape of the vici and *collegia* in Rome in the 50s BC. Rather, as will be argued in more detail later, he and others before him drew on a long history of urban (and rural) networks and on their strong sense of local identity that was focused around vici and *compita*, but also articulated by a wide array of groups and organizations, known loosely as *collegia*, which had taken shape over time in each neighborhood to meet the immediate needs of residents, often artisans and shopkeepers. Similarly, in limiting *collegia* and local ludi, the senators of the 60s BC were not innovating or even intending to set precedents, but asserting what they saw as existing legal conditions of private clubs, traditional limits on political expression by ordinary people in the city, and a standard approach to rowdy behavior at popular festivals.

XXI *MAGISTRI* AND *MINISTRI* IN ITALY

Magistri
M(arcus) Licinius M(arci) f(ilius) Pusillio
Sex(tus) Vipsanius M(arci) f(ilius) Clemens
Q(uintus) Cassius C(ai) f(ilius) Niger
ministri
Blandus C(ai) Afini Asclae ser(vus)
Murranus P(ubli) Clodi Turpionis ser(vus)
Auctus M(arci) Fabrici Hilari ser(vus)
compitum refecerunt tectum
parietes allevarunt valvas
limen de sua pecunia Laribus dant
Cosso Cornelio Lentulo L(ucio) Pisone Augure co(n)s(ulibus)
—*CIL* 5.3257 = *ILS* 3610 = EDCS-04202305
FROM VERONA (1 BC)

The study of *vicomagistri* in republican Rome has inevitably been shaped by the fascinating evidence for *magistri* of various kinds in Italian towns, in Roman colonies, and on the special, sacred island of Delos. Local officials in republican Rome are mostly attested by literary sources writing much later, such as Livy. By contrast both vici as administrative units and local *magistri* clearly flourished in a number of other communities, as can be seen from the epigraphic record. In other words, the argument for republican vici as local administrative units with a characteristic religious dimension before the imperial period relies on a combination of information from different places. Although no other community offers an exact copy of Rome, it would have been odd for colonies and municipalities to create vici with Roman names and boards of "*magistri*" in various places if Rome had nothing of the kind at the time.

Republican vici and local *magistri* are attested in Italian towns, notably in colonies founded by Rome.[1] Some vici have names that recall places or landmarks in Rome. Others are named after locally prominent families, in a pattern that is unlike that attested for Rome, for example at Puteoli.[2] A particularly interesting example of local vici is provided by Ariminum, a town on the Adriatic that was founded as a Roman colony in 268 BC. Epigraphic evidence from the imperial period shows that the urban area was divided into seven vici; we know the names of four, as well as part of a fifth.[3] They were called vicus Dianensis, vicus Germali, vicus Aventini, vicus Velabr(i), and vicus For[tunae?]. In other words, these areas, which seem to

1 Attested local groups of "*magistri*" include: Alexandria *CIL* 3.12047; Amiternum *CIL* 1² 1854 = 9.4372; Antium *CIL* 10.6638; Anxanum *CIL* 1² 1762; Aquileia *CIL* 1² 2193 = *ILLRP* 199; Aquinum *CIL* 1² 1549 = *ILLRP* 765; Capua *ILLRP* 705–23b; New Carthage *CIL* 1² 2270 and 2271; Concordia *CIL* 10.6512; Cora *CIL* 10.6512; Cosa *CIL* 1² 1994; Interamna Praetuttiorum *CIL* 1² 765; Lanuvium *CIL* 14.2121; Mantua *CIL* 1² 753; Marruvium *AE* 1974. 301; Minturnae *ILLRP* 724–46; Pescina *CIL* 9.3657; Pompeii *CIL* 1² 777; Praeneste *CIL* 12 1455; Samos *CIL* 1² 2260; Supinum *CIL* 9.3857; Tolosa *CIL* 1² 779. See the convenient collection of inscriptions for republican *collegia* at *ILLRP* 696–779. Fontana 1997, 52–65, discusses the cult of *lares compitales* in Aquileia.

2 See Camodeca 1977 and Frederiksen 1984, 319–58, for Puteoli, and Menella 1983 for Pisaurum.

3 Coarelli 1995 gives a thorough analysis of vici in Ariminum.

date back to the founding of the colony, tend to be named for larger sections of Rome or deities of civic cult, not after individual vici in the mother city. A comparison can be made with Cales, the oldest Latin colony, which had a vicus Palatinus and a vicus Esquilinus recalling famous hills in Rome.[4]

There is also separate evidence for boards of local officials who call themselves *magistri* or *ministri* in various communities in republican Italy, the most frequently cited being Capua and Minturnae.[5] These two towns have produced significant sets of inscriptions that record what seem to be organized groups of individuals who cultivated a variety of gods (including *lares*), under the leadership of locally chosen leaders, who style themselves *magistri*. The inscriptions, all in Latin, are of comparable date to those set up by the cult groups on Delos.

From Capua, we have twenty-eight inscriptions set up by *magistri* between about 112 BC and 71 BC.[6] The texts come from different proveniences. The groups vary in size, with the full complement usually at ten or twelve men in a college. Unfortunately, many of the lists of names are incomplete, so that the size and composition of groups is not fully revealed. Nevertheless, the final lines with the enumeration of gifts are mostly preserved. Their texts commemorate buildings, fortifications (*plutei*), walls, a theater and pavements that they have set up or restored in honor of a variety of gods, including Venus Jovia, Ceres, Jovius Compagus, Jovius Optimus Maximus, Spes, Fortuna, Fides, Castor and Pollux, Mercury Felix, Juno Gaura, Diana Tifatina, and *lares*. In 71 BC, Juno Gaura had a slave bought for her by one of the groups.[7] Most of the associations are composed of free or freedmen. Significant sums of money seem to be involved in these construction projects and their associated games.

Capua's special status as a community whose municipal structure was destroyed by the Romans in 211 BC needs, however, to be kept in mind. In other words, it seems that because there was no regular municipal administration beyond the larger district known as pagus Herculaneus, led by a single *magister pagi*, both elites and freedmen had created their own "colleges" to raise funds and manage municipal construction, as well as to put on ludi.[8] Although the context is represented as religious, many projects are not gifts for gods. These associations also provided social prestige for locals who had no opportunities for ordinary political careers. The formal consular dates give the inscriptions an official air. Subsequently, a Roman colony was founded here in 59 BC, which provided a new framework for public works and social or political advancement.

Of particular interest to us is a dedication to *lares* by a college of *ministri*, the only group of slaves attested in such an inscription, together with a single freedman, fourteen men in all. This text was put up in 98 BC.[9]

4 *CIL* 10.4641 and 1² 416 = *ILLRP* 1217 = *ILS* 8567 = EDCS-19700379 with Coarelli 1995.

5 *ILLRP* 705–23b (Capua) and 724–46 (Minturnae) with commentary by Degrassi.

6 Capuan *magistri*: the inscriptions are published in an improved version with commentary by Frederiksen 1959, 126–30. See also Frederiksen 1984, 264–75 and 308–9, and Bömer 1981, 98–101. Capua's special constitutional position also makes a comparison with Delos interesting.

7 *CIL* 1² 686 = 10.3783 = *ILLRP* 722 = *ILS* 6303 = EDCS-17700042 of 71 BC.

8 Pagus Herculaneus: *CIL* 1² 682 = 10.3772 = *ILLRP* 719 = *ILS* 6302 = EDCS-17800034 of 14th February 94 BC.

9 *CIL* 1² 681 = 10.3789 = *ILLRP* 718 = *ILS* 3609 = EDCS-17700048 = Frederksen 1959, no. 13, now lost. This inscription was copied twice in the sixteenth and seventeenth centuries.

Hisce ministris Laribus faciendum coe[ravere

C. Terenti(us) C. l. Pilomus(us)	Lucrio Teren[ti. s.	Alexan[
Pilemo Helvi A. s.	(Pilotaer(us) Hos[ti s.	Nestor[
Helenus Hosti Q. s.	Pilomusus Sext. Cn. s.	Nae[
Pilotaerus Terenti Q. s.	Pilemo Baloni Balon.	Flac[
	Dipilus Sueti M. s.	Nicepor[

Haec pondera et pavimentum faciendum et[. . .
Q. Caecilio Q. f. Q. n. T. Deidio T. f. co[s

These *ministri* oversaw the setting up (of the dedications) for *lares*:
Gaius Terentius Pilomus(us), freedman of Gaius; Pilemo, slave of Aulus Helvius; Helenus, slave of Quintus Hostius; Pilotaerus, slave of Quintus Terentius; Lucrio, slave of ? Terentius; Pilotaer(us), slave of ? Hostius; Pilomusus, slave of Cnaius Sextius; Pilemo, slave of Balonius and Balonius/a; Dipilus, slave of Marcus Suetius; Alexander (slave of ?); Nestor (slave of ?); Nae(. . .) (slave of ?); Flac(. . .) (slave of ?); Nicepor(. . .) (slave of ?). They oversaw and . . . the setting up of these weights and this pavement, in the consulship of Quintus Caecilius, son of Quintus, grandson of Quintus, and Titus Didius, son of Titus.

(*CIL* 1² 681 = 10.3789 = *ILS* 3609 = *ILLRP* 718)

The gift apparently consisted of a set of weights and a paved area so we may think in terms of a marketplace. The use of demonstratives is notable: *these* men set up *these* items. The missing part in line 7 could be another gift or more probably another verb of overseeing or checking the final installation of the weights and pavement. As so often, those serving and honoring *lares* are slaves, who call themselves *ministri*, but who have their own college of officials that mimics the cult organizations of the *magistri*. The single freedman listed first may have been elected to the group while still a slave or he could be serving as a leader, perhaps someone who had participated before, while in servitude.

There is no archaeological context to suggest a secure connection with a *compitum*, vicus, or *pagus*. Nevertheless, this text shows that groups of *ministri* could collect funds and contribute to the local infrastructure without the supervision of a *magister*. The *ministri* appear as a separate college, with a different social status, not as assistants to higher officials within an organizational hierarchy. The *lares* are their own special gods. This is the only Capuan inscription with the surviving name of a deity in the dative, making explicit the gift *to* the *lares*.[10] We may also imagine that they were also *ministri* of (the) *lares*.

In contrast, Minturnae in southern Latium was (re)founded as a Roman colony in 296 BC, having been a settlement of the Ausones before.[11] Its rich epigraphic record is often compared with the Capuan material, but the two communities had little in common, in more general political, historical, or cultural terms. In the early 1930s, twenty-nine inscriptions from Minturnae set up by local *magistri* were discovered together, reused in the construction of the podium for Temple A, an Augustan sacred

10 Bömer 1981, 99.
11 For Minturnae, see Coarelli 1989 and Uggeri in *BNP*. For the founding of the Roman colony, see Livy 10.21 and Vell. Pat. 1.14.

building.[12] The texts all seem to come from the
first half of the first century BC but only two
have a precise date recorded, one by consuls
(65 BC) and the other by the local *duumviri*,
whose year we do not know.[13] It seems that
dating formulas by local magistrates and/or
Roman consuls were probably to be found on
other parts of each monument. Before being
reused, nearly all of them were damaged in a
major fire.[14] Many were then cut down for in-
stallation in the temple's podium resulting in
the loss of some letters on one side.

This collection comprises a set of very sim-
ilar inscriptions on *stelae*, perhaps originally
part of altars in a standard format, but there is
no need to imagine that they were all put up
together in one original setting. Rather they
represent a type of dedication made by slaves
and/or freedmen in groups of twelve, naming a
range of deities: Ceres, Spes, Mercury Felix,
and possibly Venus. It is not entirely clear
whether the gods also gave their names to
some of the individual groupings or were
mentioned simply as recipients of these dedi-
cations. The texts are formatted as annual lists
of group members. It appears that most stones
were in very good condition at the time of the

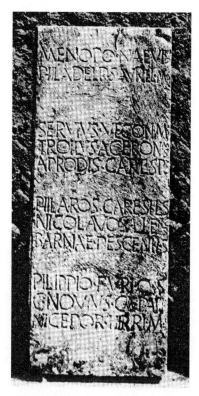

III.16. Inscribed list from a local associ-
ation, Minturnae.

fire, some showing clear traces of red minium in their lettering and of the guidelines
used to lay out the letters.[15]

There is no specific mention of *lares* here, but there are three reasons why
these inscriptions have been connected with *compita* and their gods. First, by
analogy with the colleges of slaves and freedmen that are directly associated with
lares and Compitalia in Rome, Delos, and Capua. Second, one of the Minturnae
texts mentions theatrical performances (*ludi scaenici*) organized by slaves and
freedmen, for which the obvious venue would be at the Compitalia.[16] A slave

12 The inscriptions are published in Johnson 1933, with an excellent commentary and archaeologi-
cal explanation. See Degrassi in *ILLRP* (esp. vol. 2, 1963, pp. 151–53), 724–46, for twenty-three of the
texts, and also Bömer 1981, 101–5, for analysis. Many of them were destroyed during World War II.

13 *CIL* 1² 2683 = *ILLRP* 735 = EDCS-24700176 = Johnson 1933, no. 6, and *CIL* 1² 2702 = *ILLRP*
742 = EDCS-24700191 = Johnson 1933, no. 25 (of unknown date). Dating the remainder by letter-
forms is not straightforward. Degrassi offers a hypothetical arrangement by date in *ILLRP* but
does not include all the texts, while their original publication ordered them simply according to
their archaeological context in the podium of Temple A.

14 The exceptions are Johnson 1933, nos. 15 and 25.

15 The length of the interval between the fire and their reuse for Temple A is not evident. They
may also have been in storage for some time.

16 *CIL* 1² 2687 = *ILLRP* 727 = EDCS-24700180 = Johnson 1933, no. 10: *isdemque lu[dos]
fecer(unt) scaen[icos]* (the same men put on theatrical competitions at the games). See Coarelli
2004 for discussion of theatrical performances at Minturnae.

even describes himself as being in charge of the games (*magister ludi*).[17] Last, sixteen of the Minturnae inscriptions list their members by groups of three individuals, yielding four standard groups with three names in each group. There is a single line left blank between each group, which made this pattern very visible on the stones.

One of best preserved of the inscriptions provides an example of what such a text looked like, with its list of eleven slaves and one freedman, who is the last but one on the list.[18] The names read (see figure III.16):

Menop(h)o(n) Naevi N. s.	Menophon, slave of Numerius Naevius
Philadelp(h)us Aurel(i) M. s.	Philadelphus, slave of Marcus Aurelius
xxxxx	blank space with guidelines visible
Servius Vecon(i) M. s.	Servius, slave of Marcus Veconius
Troilus Aceron(i) M. s.	Troilus, slave of Marcus Aceronius
Ap(h)rodis(ius) Cares(i) P. s.	Aphrodisius, slave of Publius Caresius
Philaros Caresi L. s.	Philaros, slave of Lucius Caresius
Nicolauos Allen(i) C. s.	Nicolauos, slave of Gaius Allenius
Barnae(us) Pesceni L. s.	Barnaeus, slave of Lucius Pescenius
P(h)ilippio(n) Furi Q. s.	Philippion, slave of Quintus Furius
C. Novius C. M'. l. Papia(s)	Gaius Novius Papias, freedman of Gaius and Manius
Nicep(h)or(us) Hirri M. s.	Nicephorus, slave of Marcus Hirrius
	(*CIL* 1² 2692 = *ILLRP* 739)

The stone is not cut and shows no sign of having been burned. The fine guidelines were still visible, even in the third line, where an additional name was never inserted, but was obviously anticipated as part of the first group. This layout may provide evidence that we are dealing with *magistri* from four vici coming together at a single *compitum*. Such an interpretation was already suggested in their initial publication.[19] It is certainly tempting to consider a possible origin in the local vici, although the context is not identical with cults attested elsewhere.

Even more strikingly, however, six inscriptions record all female groups, one freeborn woman (Tertia Domatia S. f.) and the other members all slaves or freedwomen.[20] In all but one of these inscriptions, the women also arranged

17 *CIL* 1² 2705 = *ILLRP* 726 = EDCS-24700194 = Johnson 1933, no. 28: *Chillus Arri C. s., mag(ister) ludi* (Chillus, slave of Gaius Arrius, magistrate in charge of the games). This inscription includes the slave Philemo, who seems to be owned by the Roman general Marius.

18 *CIL* 1² 2692 = *ILLRP* 739 = EDCS-24700184 = Johnson 1933, no. 15.

19 Johnson 1933, 119–23. He did, however express some doubts because the lists cannot be used to reconstruct an outline of property owners by vicus; he saw too much overlap among the big slave-holders. Consequently, he interpreted the groups as belonging to cults that did not have temples.

20 The *magistrae* of Minturnae: Johnson 1933, nos. 3 (*CIL* 1² 2680 = *ILLRP* 724 = EDCS-24700175); 4 (*CIL* 1² 2681, not in *ILLRP* = EDCS-26201049); 8 (*CIL* 1² 2685 = *ILLRP* 737 = EDCS-24700178); 9 (*CIL* 1² 2686 = *ILLRP* 725 = EDCS-24700179); 11 (*CIL* 1² 2688, not in *ILLRP* = EDCS-26201051); 17 (*CIL* 1² 2694, not in *ILLRP* = EDCS-26201053). Cf. Schultz 2006, 69–74, for a broader epigraphic context of *magistrae*, especially in epitaphs.

their names in four clusters of three. The one such inscription with a heading, which is the list without subgroups, calls them *magistrae* (magistrate), rather than *ministrae*. It is under the heading *hasce. mag. v. d. d.*, where V has been proposed as Venus, the presumed recipient of the dedication. However, none of the other texts has such a stark abbreviation in the name of a deity. It is also possible that the word vici or vicorum is intended here. As luck would have it, this was the most heavily damaged of all the inscriptions. Nevertheless, the evidence for women being officially in charge of compital cult elsewhere is virtually nonexistent.[21]

Yet at Minturnae, we clearly have "boards" of women, many of servile status but not from a single household, boldly styling themselves *magistrae*, and putting up dedications in patterns very similar to their male counterparts. Nevertheless, four of the groups of women are split evenly between slave and freedwomen, a fifth is incomplete, and the last one has eleven freedwomen and a single slave. By contrast, the lists of males are dominated by slaves, with four lists entirely composed of slaves. The others most typically contain only one or two freedmen with ten or eleven slaves. Consequently, the male and female groups are parallel but composed differently within the overall framework of twelve participants. It is also notable that in both sets of lists, names are not necessarily listed in order by social rank, as is the common pattern in so many Latin inscriptions.

Most of the inscriptions are simply lists of names, which yield a fascinating inventory of slave-owners and slaves within a specific time period and location. At Minturnae, a small number of wealthy families, some native to the area, owned many slaves, who came from a variety of backgrounds, as far as we can tell from their names.[22] Only a few inscriptions have any explanations of context or intent. There are two dedications to the goddess of Hope (Spes), one to Ceres, one to Mercury Felix, and two mentions of games, one specifically theatrical. These *magistri* seem to be paying for their dedications with their own money. Above all, the inscriptions found at Minturnae give a vivid picture of the possibilities for community beyond the household and for leadership roles open to slave men and women, albeit surely mostly from wealthy households. Their roles as *magistri* (and *magistrae*!) in relation to a range of gods and to annual ludi allowed them roles similar to those of the elites in political settings relating to civic cult. Interestingly, *magistri* never seem to own the slave *ministri* themselves. If these dedications were not at *compita* or related to vici, then they were at least similar and equivalent.

The Italian evidence, therefore, in addition to hinting at commonalities between communities, also reveals that patterns could vary significantly according to each individual setting. Both main examples (Capua and Minturnae) seem closer to the sacred landscape conjured up by the fascinating inscriptions on Delos, which were set up by various groups under the names of their patron gods, than to what we know of

21 Women are attested by a single compital altar in Rome, which is MNR 49481 (Hano 1986, 15bis; Hölscher 1988, no. 221; Galinsky 1996, 308; Lott 2004, no. 66). For discussion, see section IV.xxvi later.

22 The 335 entries yield 191 individuals from 121 *gentes*. For an analysis of the names and families, see Johnson 1933 and Guidobaldi and Pesando 1989. Slaves mostly have Greek or Italian names, but there is also evidence of individuals with origins in Syria, Palestine, Thrace, Africa, and a Celtic region. Minturnae traditionally had a significant slave population. According to Orosius (*Hist.* 5. 9), 450 had been crucified here after the slave revolt in 133 BC.

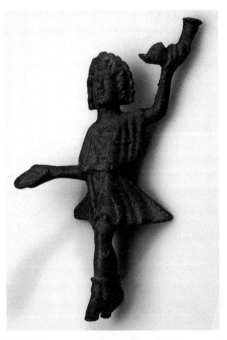

III.17. Statuette of a dancing *lar* with *rhyton* and *patera*, from the sanctuary at Torre di Satriano, Lucania. Bronze. First century AD.

vici and their *magistri* in republican Rome. It is also possible, however, that some of these Italian towns preserved older patterns while local life had evolved in Rome, as the city grew in size and complexity. Nevertheless, it is safe to say that cult groups were obviously very popular ways to get together and to get things done, across a broad social spectrum and in various places. Such groups were consistently identified with a cultural context that was self-consciously Roman, as indicated by the consular dates, Roman naming patterns, the use of Latin, and many familiar deities.

In the countryside, the picture is often not as clear. New readings of rural festivals, including both Paganalia and Compitalia, as spreading outward from Rome and as specific signifiers of Roman customs are persuasive, but it must be stressed that there is little explicit ancient evidence.[23] No rural *compitum* has been securely identified or excavated so far.[24] Small statuettes of *lares* and inscriptions mentioning vici (some with Romanized names) have been found at Italic sanctuaries, but only in modest numbers. An attractive example of a little, dancing *lar*, which has been dated to the first century AD, from the Lucanian sanctuary at Torre di Satriano is an isolated instance.[25] (See figure III.17.) Local conditions had more influence and created much greater diversity than was once imagined by earlier generations of scholars. Ultimately, many rural festivals (and the local organizations they relied upon) were never described or depicted; the intentions and experiences of their celebrants inevitably remain obscure. The evidence from Delos that includes inscriptions and paintings is unique.

All this is to say that many questions still remain open for future research. Did the Romans "require" local people (living in vici or *pagi*) to participate in Compitalia and other aspects of the cult of *lares*, which would, in turn, have created a need for organizers? If so, what was their aim and how did they achieve it? Integration? Courting popularity? Census taking for the purposes of taxation and military service? Fostering and measuring publicly expressed allegiance to Rome? All of these? Or were rural Compitalia celebrations more spontaneous, without such administrative and even imperialistic overtones? How was Compitalia

23 Stek 2009 has argued for this model in detail.

24 For epigraphical evidence attesting *compita*, see for example, *CIL* 1² 3078 (Picenum), 9.1618 = *ILS* 6507 = EDCS-12401124 (Beneventum), 5.844 = *ILS* 5394 = EDCS-01600122 (Aquileia) and 5.3257 (Verona) with Stek 2008.

25 Stek 2009, 211 with fig. 9.8. This *lar* is later but is still used by Stek to support his general argument.

experienced in the countryside or the towns of Italy? Was it a new and strikingly Roman festival or a simple variation on the familiar practices of procession, sacrifice, dancing, and drinking, already widespread in Italy? In the present state of our knowledge, a variety of models can be constructed, but each would be equally hypothetical and would vary in usefulness according to its applicability to each local community.

XXII POLITICS AT COMPITALIA

cum conplures menses barba inmissa et intonso capillo, lugubri uestitu, populum
uicatim flens una cum liberis circumiret.
 —L. CORNELIUS SISENNA (F 47 PETER = F 15
 CHASSIGNET = *FRHIST* 26 F 21)

In Rome, local networks had been operational for centuries, political opinions had
been expressed at street corners and at Compitalia for many generations. Yet as the
city grew in size, reaching people in their neighborhoods only became more not
less important. In addition, fundamental political changes in the second century
BC gave Compitalia new potential, especially within the urban landscape of Rome
itself. It was in the year 153 BC that the two consuls, Rome's chief magistrates,
started to take office on 1st January.[1] One result, probably largely unintended, was a
striking juxtaposition between Compitalia and the political New Year. Previously,
the festival of the *lares* at the street corners had been celebrated long before the
beginning of the old new year on 1st March. Consequently, neighbors and neigh-
borhoods had come together during a relatively quiet season, whether on the farm
or in the city. In the middle of the second century BC, however, that pattern changed
radically, as the people's principal neighborhood festival vied with and provided a
venue to comment on the political spectacle and drama of a new set of magistrates
taking office. Twenty years later, the use of a secret ballot process, phased in dur-
ing the 130s throughout various voting assemblies, made it increasingly important
to court the people's favor and to stage shows of popularity.[2]

No Roman author ever wrote a political history of neighborhood life or of Com-
pitalia in republican Rome. Yet in the 80s BC, the bitter civil strife between Sulla
and the Marians affords several key insights into urban politics, in effect an out-
line of the deeper background to the notorious ban on certain compital practices
enacted by the senate in 64 BC. In the later second century BC, the Gracchi had
already shown the potential for popular support in the local neighborhoods of the
city. Politicians of every background and persuasion learned valuable lessons from
the successes and failures of local initiatives during those years. The senate had also
had the opportunity to try a variety of approaches in reaction to expressions of pop-
ular political will, ranging from new legislation to the deployment of emergency
powers and the use of force. By the year 100 BC, armed "gangs" are visible in our
evidence for Rome, although their origins and evolution are lost to us. As already
discussed, the limitations and expulsions of Italians from the city in the 90s BC sug-
gest local networks that "knew" who was living in Rome and where.

In 85 BC, twenty years before the senate intervened to outlaw subversive *colle-
gia* and their raucous celebrations, at a time when Sulla was in the East and Cinna
controlled Rome, Marius Gratidianus (a nephew of the recently deceased general
Marius), the (urban?) praetor in that year, received statues and offerings of incense,

1 The inauguration of the new political year coincided with the 600th anniversary of Rome,
according to the chronology later advocated by Varro. See Flower 2010, 67–69, with Livy *Per.* 47,
Fasti Praenestini, Cassiodorus *Chronica*, and Michels 1967, 97–100; Richardson 1986, 128–32; and
Brennan 1995, 53–54.

2 The secret ballot was phased in slowly during the 130s BC. See Flower 2010, 72–75, for the
ongoing debate about its rationale and impact.

candles, and wine in the vici.[3] Direct evidence comes from Cicero, a relative both of Marius and of Gratidianus himself.

> Et ea res, si quaeris, ei magno honori fuit; omnibus vicis statuae, ad eas tus, cerei. Quid multa? Nemo umquam multitudini fuit carior.

> And that matter, if you ask, brought him great credit: statues in all the *vici*, offerings of incense and candles before them. What more (can I add)? No one was ever dearer to the masses.

> *(de Off.* 3.80)

Gratidianus had received the credit for a reform of the coinage that addressed economic troubles.[4] As a result, he was hugely popular. The statues in the vici are confirmed by Pliny the Elder, who says that it was the voting tribes who set them up there.

> statuerunt et Romae in omnibus vicis tribus Mario Gratidiano, ut diximus, easdemque subvertere Sullae introitu.

> The voting tribes set up statues of Marius Gratidianus in all the *vici* at Rome, as we mentioned, and these were overthrown when Sulla entered.

> (Pliny *Nat.* 34.27)

Both sources claim that the vici all participated. Regardless of who had suggested this initiative, its implementation within a short time frame is testimony to a high level of coordination between neighborhoods, whose organizational effectiveness had been honed by several emergencies in the preceding decade, including repeated assaults on the city itself by rival Roman armies. The images of Gratidianus may have been placed near the compital shrines, where one statue could be seen by people from several vici. The offerings of libations (wine and incense) and candles recall the cult of the *lares*, including the celebration of Compitalia, and may even have been offered on the same altars. If he was urban praetor, Gratidianus would himself have been involved with announcing and celebrating the festival in either or both of the two years in which he held office.

Tributes to Gratidianus are one of the earliest examples of divine honors accorded to a living man in Rome and are situated within the context of neighborhood cults. Interestingly, the statues are described as having been put up by the voting tribes, which perhaps had connections with local leaders, at least according to Pliny's sources. In other words, a patron of commerce received thanks expressed

3 M. Marius Gratidianus' (*RE* 42) honors: Cicero *Off.* 3.80, Pliny *Nat.* 33.132 and 34.27, and Seneca *de Ira* 3.18.1. For discussion, see Flambard 1981, 162; Sehlmeyer 1999, 199–201, and in *LTUR*; Marco Simon and Pina Polo 2000; Gradel 2002, 51; Lott 2004, 9–50, 59, 171; and Flower 2010, 94–95. By contrast, Weinstock 1971, 295, imagines that Gratidianus was receiving a traditional type of honor, whose previous recipients have simply not been recorded. See Palmer 1978–80 for the continuing habit of putting up the statues of benefactors in the vici after Gratidianus' death—for example, for C. Verres after his praetorship in the late 70s.

4 For the coinage reform of 85 BC, see Crawford 1968, Lo Cascio 1979, and Brennan 2000, vol. 2, 460. The details of the new law are not clear; they seem to involve securing the value of the currency, whether through revaluation and/or eliminating devalued coins or forgeries. In any case, the practical effect on shopkeepers and tradesmen was perceived as significant at the time.

in terms of divine honors near the compital shrines of Rome. These honors were variations on the tributes to Gratidianus' uncle Marius, to whom Romans had spontaneously poured libations at their evening meals after his victory over the Cimbri in 101 BC.[5] Both Marii were being recognized as personal and collective saviors.

A generation before Gratidianus became the darling of the vici, a spontaneous cult to the Gracchi brothers had grown up after Gaius' violent death in 121 BC.[6] Divine honors and first fruits of crops were offered at the places where they had been killed, on the Capitoline in the case of Tiberius and on the Janiculum in the sacred grove of Furina (*lucus Furinae*) for Gaius.[7] But ordinary people also made offerings, some on a daily basis, in their local neighborhoods. This spontaneous, popular cult seems also to have taken place at the *compita*. We do not know whether or in what ways images of the Gracchi had been displayed or even venerated during their lifetimes. A compital cult of recent political martyrs would illustrate a combination of "religion" with "politics" that was characteristic of local networks as places to express opinions held by ordinary people. The impact of the Gracchi can be gauged by the popular outpouring of grief at their deaths and the crafting of commemorative rituals, even in the face of government repression. Some thirty-five years later, the *plebs* hailed Gratidianus as a worthy successor to the Gracchi, and apparently offered him even greater honors. His popular acclaim may be a measure of the relatively sharper insecurity felt by the population of the city by the mid-80s BC.

The exceptional prominence afforded Gratidianus, who held a second praetorship in the late 80s BC, was surely a key factor that contributed to his gruesome (ritual?) murder at the grave of one of his most prominent victims, Q. Lutatius Catulus, after Sulla had recaptured the city.[8] Gratidianus was the most high-ranking political opponent taken alive by Sulla. It seems that the statues of Gratidianus were rapidly removed when Sulla stormed the city, or perhaps even in the days immediately before the final battle. Some, if not all, were replaced by statues of Sulla, as an inscription from a statue base put up by the Vicus Laci Fundani on the Quirinal attests.[9] (See figure III.18.)

L(ucio) Cornelio L(uci) f(ilio)
Sullae Felici
Dictatori
vicus laci Fund(ani)

5 Libations for Marius after Vercellae (30th July 101 BC): Val. Max. 8.15.7 and Plut. *Mar.* 27.9, with Flower 2010, 88–89.

6 Cult for the Gracchi: Plutarch *CGracch.* 18.3, with Alföldi 1971, 134–35, and 1973, 24; and Marco Simon and Pina Polo 2000, 155–56.

7 Tiberius died on the Capitol, as he was running away from the area immediately in front of the Capitoline temple (Plutarch *TGracch.* 19). Gaius was killed by his slave Philocrates (at his own request) in the *lucus Furinae* on the Janiculum near the eighteenth century Ospedale San Gallicano (Plut. *CGracch.* 17.2, *de vir ill.* 65, Calzini Gysene in *LTUR*).

8 Death of Gratidianus: *Comm. Pet.* 3.10, Sallust *Hist.* 1.44M, Livy *Per.* 88, Val. Max. 9.2.1, Seneca *de Ira* 3.18.1–2, Lucan 2.173–92, Flor. 2.9.26, Oros. 5.21.7, Asconius 84C, and Augustine *CD* 28, with Hinard 1984, 303–7.

9 *CIL* 6.1297 = I[2] 721 = *ILS* 872 = *ILLRP* 352 = *ILMN* 32 (MAN Naples inv. 2640) = EDCS-17800202 inscribed on a travertine base and found on the Quirinal in the sixteenth century, but now in the archeological museum in Naples. For the vicus laci Fundani on the Quirinal (now Via XXIV Maggio), see Coarelli in *LTUR*. Ramage 1991, 110, thinks all the vici honored Sulla.

III.18. Base of a statue of Sulla from the Vicus Laci Fundani, found on the Quirinal Hill. Museo Archeologico Nazionale di Napoli, inv. 2640.

To Lucius Cornelius, son of Lucius
Sulla Felix
Dictator (given by the)
Vicus laci Fundani

(*CIL* 6.1297 = 1² 721 = *ILS* 872 = *ILLRP* 352)

It is interesting to see the whole vicus as dedicant, without the name of an official or donor. We may imagine that many if not all vici displayed statues of Sulla or other evidence of their support of his dictatorship, even if only as a gesture of self-defense, whether at their *compita* or in other locally prominent locations. It was precisely this use of images that Augustus would later react against in his careful control of the display of his own statues in the city and his policy of using money donated by ordinary people to renew local shrines with images of the gods, rather than to spread his own portraits in the vici (see section IV.xxiv later). Statues of Sulla are also attested in various cities in Italy and in the East.[10] His name is mentioned several times on Delos, where the *collegium* of Italian traders set up a statue for him even before he returned to Rome to seize power as a dictator.[11]

10 Statues for Sulla outside Rome: Suessa (*CIL* 1² 720 = 10.4751 = *ILS* 870 = *ILLRP* 351 = EDCS-20400540); Clusium (*CIL* 1² 723 = 11.2102 = *ILS* 873 = *ILLRP* 356 = EDCS-22100256); Alba Fucens (*CIL* 1² 724 = 9.3918 = *ILS* 874 = *ILLRP* 355 = EDCS-14804948); Sutrium (*CIL* 1² 2508 = 11. 7547 = *ILLRP* 354 = EDCS-21000521); Larinium (*CIL* 1² 2951b = *AE* 1975, 219 = EDCS-09400182). For further discussion of Sulla's epigraphical impact, see Mayer 2008. For the inscriptions from the East, see conveniently Ramage 1991, 107–11, with examples from Halicarnassus, Athens, Oropus, and Stratonikeia, as well as Santangelo 2007.

11 Sulla on Delos, from early 87 BC: *CIL* 1² 711 = 3.7234 = *ILS* 869 = *ILLRP* 349 = *ID* 1850 = EDCS-24900115 for Sulla as proconsul, and *CIL* 1² 712 = 3.7235 = *ILS* 7271 = *ILLRP* 350 = *ID* 1852 = EDCS-24900116 on a Corinthian capital: *L. Cornelius L. f. Sulla cos. | de pequnia quam conlegia |*

Direct evidence of Sulla's own interest in local life is provided by his settling of more than 10,000 able-bodied freedmen in Rome, each called Lucius Cornelius after him as their patron.[12]

τῷ δὲ δήμῳ τοὺς δούλους τῶν ἀνῃρημένων τοὺς νεωτάτους τε καὶ εὐρώστους, μυρίων πλείους, ἐλευθερώσας ἐγκατέλεξε καὶ πολίτας ἀπέφηνε Ῥωμαίων καὶ Κορνηλίους ἀφ᾿ ἑαυτοῦ προσεῖπεν, ὅπως ἑτοίμοις ἐκ τῶν δημοτῶν πρὸς τὰ παραγγελλόμενα μυρίοις χρῷτο.

He added more than 10,000 slaves of the proscribed to the plebs (*demos*), choosing the youngest and strongest, to whom he gave freedom and Roman citizenship, and he called them Cornelii after himself. In this way he made sure of having 10,000 men among the plebeians always ready to obey his commands.

(Appian *BC* 1.100)

These men were slaves owned by Sulla's political opponents, who had been killed in his proscriptions. Subsequently, they were confiscated together with the rest of their owners' property by the dictator and given a new life in Rome in his name. We may imagine that the 10,000 Cornelii were spread throughout the city's neighborhoods, probably *vicatim*, and formed their own network of young men loyal to Sulla's regime. They would surely have been given housing and a way to start a productive life, so that they could marry and have children who would be more Cornelii. They would have been of much less use if they soon became indigent or were all concentrated in a single part of town. Appian does not specify whether some were also women (all new Corneliae), perhaps assigned as wives to the Cornelii. An interesting inscription seems to be further evidence for their loyalty to Sulla:[13]

L. Cornelio L. f.	To Lucius Cornelius, son of Lucius,
Sullae Feleici	Sulla Felix,
dictatori	dictator
leiberteini	(the) freedmen (gave this statue / base)
	(*CIL* 6.1298 = 10.6007 = 1². 722 = *ILLRP* 353 = *ILS* 871)

The unusual way in which the dedicators describe themselves as simply "(the) freedmen" makes sense in the context of a mass of men all called Lucius Cornelius. Were they unsure or uncomfortable with their new names? Was this inscription put up in a time of uncertainty? Or, conversely, were they simply so well known or

in commune conlatam (Lucius Cornelius Sulla, Son of Lucius, consul; [this statue was paid for] by the common fund collected by the association).

12 Ten thousand Cornelii: Appian *BC* 100 and 104 with Seager 1994, 203; Lintott 1999b, 77–83; Thein 2002, 183; and Christ 2002, 134. For Sulla's settlement of his veterans, see now Thein 2010.

13 *CIL* 1² 722 = 6.1298 = 10.6007 = *ILS* 871 = *ILLRP* 353 = EDCS-17800203, found at Minturnae. It seems probable that the stone was moved from Rome. Alternatively, it may record a local group of freedmen, perhaps formerly the property of Sulla's enemy Marius (so Gabba 1967, 275–76). It is certainly possible that some of the 10,000 Cornelii in Rome were former slaves of Marius.

notorious that they did not need to identify themselves more specifically? Were these freed people all male?

Sulla's actions indicate the importance of local politics in the 80s BC and the desire of the dictator to stay informed at a grassroots level by special informants who were loyal to him and who could potentially be deployed to intervene on his behalf. It would have been more cost effective to sell all of them at public auctions, together with the other property that had belonged to their masters, or to keep them as publicly owned slaves, who could have worked on the many new building projects in Rome.[14] Alternatively, they could have been given or sold cheaply to Sulla's supporters or even to his veterans, who were settling new colonies throughout Italy. Many Sullan veterans could have made good use of affordable and able-bodied help on their new farms. Giving these slaves their freedom, places to live in Rome, and the opportunity to make a new life in the city was surely an expensive and logistically complex project. One wonders how they were welcomed by local inhabitants.

As Appian goes on to note in the following sentence, the way in which the Cornelii were deployed in the city is reminiscent of Sulla's settlement of his veterans in colonies throughout Italy, whom Appian numbers at 120,000 men. The veterans represented groups of loyal followers together in units that could have been called up again at short notice. This comparison may also have worked on the more basic level of how these freedmen (and freedwomen?) were chosen and assigned to different neighborhoods, perhaps organized in units like the *decuriae* of the *collegia* or in the cohorts of an army. They were indeed Sulla's "army" in the vici, where they surely set a precedent for later politicians, notably Clodius. Unfortunately, the details of the later history of these Cornelii are largely lost to us: Sulla's death within less than three years may have caused (at least some of) them to disperse from Rome and even to change their names.

Amid the violent politics of the 80s, the call to defend the walls of Rome must have become a familiar one in the vici, as Rome was repeatedly attacked and captured by rival armies of Roman soldiers.[15] Sulla had first marched on Rome in 88 BC. Following Sulla's departure for the East, Cinna marched on the city in 87 BC. Sulla returned to Italy in 83, and took Rome again by force in late 82 BC. Each side hunted down their leading opponents, as well as created general havoc in the city. The harsh climate of political division and civil war surely brought out the vital importance and potential of the vici in helping people survive, as well as the influence (real or potential) of carefully chosen local leaders. Soon after the very public execution of Gratidianus and of his political allies, Sulla made every effort to win over the people of Rome with the fine shows he put on during his year as dictator in 81 BC. His public rhetoric stressed consent to his establishment of a new type of constitutional government (*res publica*) based in the rule of law, which was symbolized by his new senate house (*curia*) and speaker's platform (*rostra*), set against the backdrop of the monumental complex we now call the "Tabularium."[16] It seems

14 In 56 BC, P. Clodius made an unsuccessful attempt to have all the publicly owned slaves that Cato brought back from Cyprus called Clodii after himself. See Dio 39.22.4–23.2, with Tatum 1999, 221. By contrast, Benner 1987, 64–65, goes rather beyond the ancient evidence in interpreting these as freedmen, which would make Clodius' gesture more parallel to Sulla's with his Cornelii.

15 For an overview of events, see Badian 1962 and 1970, Seager 1994, and Hölkeskamp 2000.

16 For the *curia* and *rostra*, see Coarelli in *LTUR*; for the forum, which was repaved, see Purcell in *LTUR*. Sulla's new senate house was surely called *curia Cornelia*, although there is no such entry in *LTUR*, which only has curia Hostilia and curia Julia.

likely that his program of a return to order and to rebuilding the city will have appealed to ordinary people, many of whom may have felt the effects of local crime in addition to political violence during periods of factionalism.

Above all, Sulla's magnificent games and banquets provided a truly striking contrast with the lean years since the bloody Social War. Especially notable were his triumph over Mithridates of Pontus in January of 81 BC (when he officially adopted the name Felix), his celebration of giving a tithe of his great personal wealth to Hercules (probably in August), a magnificent funeral for his wife Caecilia Metella soon after, and his victory games on 1st November (the first anniversary of his capture of the city).[17] Each of these occasions, as well as others such as the additional triumph(s) celebrated this year (by Licinius Murena and possibly also Valerius Flaccus), will have featured holidays, parades, handouts, and distributions of food in the city.[18] Local leaders will presumably have helped to bring Sulla's message of a new age (apparently starting on 1st June 81 BC) into the streets, where Sulla's images were on display. Like King Servius Tullius, original patron of Rome's neighborhoods, Sulla ceremonially extended the *pomerium*, Rome's ritual boundary.[19] His identification of Rome as the capital of a world empire was designed to appeal broadly and to rebuild morale after an extended period of civil strife.[20]

While Sulla abolished the grain dole, he seems to have implemented other measures to help secure Rome's food supply, including the building of new, large granaries for the city.[21] This was also the time when the popular cult of Stata Mater spread from the forum into the vici, providing further assurance of protection against fire.[22] Sulla had been born in Rome (in 138 BC) and was known for the wide range of friends he cultivated, including many theater people of humble origin: the vici were very much part of his plan for a new republic. His appreciation of their role and potential reflects his own personal experience of them. The widespread mourning that was encouraged after his magnificent funeral at public expense confirmed the ties all Roman citizens were expected to have with him: Roman women wore mourning for a year as if for a father.[23] Immediately after his death, therefore, the memory of Sulla would again have been very visible throughout the city.

To sum up so far: despite the rather sparse evidence available for the generations of the Gracchi and of Marius and Sulla, compared to the time when Cicero was active in politics, it is clear that Roman politicians of various backgrounds turned to the people in their local neighborhoods, on their streets, and at their crossroads shrines. The Gracchi had already made a series of moves calculated to mobilize local support. Sisenna attests to similar tactics used by men on trial who made

17 For Sulla's self-representation, see Ramage 1991, Behr 1993, Mackay 2000, and Thein 2002. For his memory in later time periods, see now Eckert 2016.

18 For triumphs in 81 BC, see Itgenshorst 2005, nos. 243, 244, and 245: Sulla in January, L. Licinius Murena, and perhaps also C. Valerius Flaccus. No triumphs are recorded in the time when Cinna was in control of Rome.

19 For the *pomerium*, see Andreussi in *LTUR* and Baraz in *TLL*.

20 For Sulla's imperialism, see Santangelo 2007 and Thein 2014.

21 Rickman 1980, 165, and Vanderbroeck 1987, 121–23, discuss Sulla and the grain dole.

22 For Stata Mater, see Festus 416L with Lott 2004, 167.

23 Mourning Sulla: Cicero *Leg.* 2.22.57, Livy *Per.* 90, Plutarch *Sulla* 38, Appian *BC* 1.105–6, Licinian. 32F, with Flower 1996, 123–24, and Thein 2002, 313–35.

local appeals at the beginning of the first century BC. In the 80s BC, Marius Gratidianus and Sulla reached deep into the vici to connect with local opinion makers, while building powerful images of themselves as benefactors of the common people. The role of Sulla's freedmen, both those close to him in his immediate entourage like the notorious Chrysognus and the thousands of others whom he chose to settle in Rome, attests to his appreciation for the service and loyalty of the lowly, who owed their positions entirely to his generosity.[24] At the same time, vici, *compita*, and local rituals also provided ways for people to give voice to their own political opinions and to support or to thank their leaders. Such gestures empowered groups who had little say in the elections for senior magistrates or time to listen to speeches in the forum.

<p style="text-align:center">* * *</p>

Within a decade of Sulla's death, the 60s and 50s BC saw grassroots politics become more prominent (at least according to our surviving sources), after Rome's traditional political culture had been swept away by his radical reforms, which had not, however, succeeded in creating an orderly and generally accepted constitutional government.[25] Pompey's restoration of the powers of the tribunes of the plebs in 70 BC opened the door to a new era of popular politics, both in the service of prominent leaders and in its own right. The special commands voted to Pompey in the 60s provided examples of popular acclaim and of the renewed role of these plebeian tribunes, friends of the mighty, who claimed to represent what the people really needed and wanted.[26] It should be kept in mind, however, that this greater visibility, including information about Clodius' associates are concerned, is a side effect of the much richer sources available for these years, especially in the writings of Cicero, who does not, however, speak often about Compitalia in any detail.

The special role of local politics can be seen clearly at the end of 67 BC. A bill proposed by the new tribune C. Manilius to allow freedmen to be distributed among the voting tribes according to the tribal affiliation of their former masters, rather than being limited to the four urban tribes according to existing practice, was introduced at an unorthodox special voting assembly on the day of Compitalia, 29th December.[27] The complex issue of which tribe freedmen should vote in was the subject of a very long-standing debate in republican politics.[28] Placing these new citizens in the tribe of their former master, whose name they now shared, was logical, yet would surely have made it easier for patrons to control the votes of

24 Sulla's powerful freedman L. Cornelius Chrysognus (*RE* 101) is attacked by Cicero in the *Pro Roscio Amerino*.

25 For popular politics in the late republic, see especially Vanderbroeck 1987, Millar 1998, Yakobson 1999, and Mouritsen 2001.

26 For excellent overviews of the 60s BC, including Pompey's commands, see Wiseman 1994 and now Steel 2013, 140–50.

27 C. Manilius' (Crispus? *RE* 10) proposal: Asconius 45, 64, 65 C; Dio 36.42. 1–4, with Gruen 1974, 407–9; Kondratieff 2003, 448; and Steel 2013, 151, with n. 38.

28 Freedman voting tribes: Taylor 2013 (= 1960), 132–49 and 371–74, and especially Treggiari 1969, 39–52. The distribution of freedmen into the voting tribes was already a political issue in the fourth century BC. The tribe assigned to a freedman would then be naturally passed on to his sons, unless a transfer was arranged in a subsequent generation—for example, by acquiring property in a rural district.

their dependents but also for freedmen to have more impact in their own right. Conversely, the traditional allocation of all the freedmen in the four urban tribes automatically limited their political identity and influence. C. Cornelius, an activist tribune in 67 BC, had already raised the voting issue.[29] Manilius himself would go on to propose Pompey's special command against Mithridates, with Cicero's support.[30]

Regardless of the merits of Manilius' particular proposal, his tactics were unconstitutional and disruptive. Despite the fact that his bill was surely welcomed by many slave owners, he tried to force its passage quickly without allowing the standard amount of time for its repeated public reading (the traditional *trinum nundinum*, or twenty-four days). In addition, he illegally introduced public business on the holiday of Compitalia and used violence, as well as occupying the Clivus Capitolinus. What did he think he was doing? Presumably, he had proposed the measure as soon as he became tribune on 10th December and evidently wanted to secure its passage before the new consuls (M.' Aemilius Lepidus and L. Volcatius Tullus) could take office on 1st January. The movable feast of Compitalia fell on the last day of the year, according to the announcement of the urban praetor, and offered a time when freedmen and slaves were easy to mobilize.[31] As the day unfolded, Manilius' use of force was countered by equally unlawful violence on the part of L. Domitius Ahenobarbus, who was about to take office as quaestor the following morning.[32] The events of this memorable Compitalia show some of its political associations and potential at this time; to the extent that freedmen were unhappy with their station and prospects in Roman society, this special day provided them with an opportunity for protest, because it was their day of greatest prominence and a celebration of their roles in the city. Alternatively, it is possible that the urban praetor (whose identity we do not know) could have put Compitalia on this day to try to stop Manilius. We may suspect that this was not the first political Compitalia. It comes as no surprise that the senate quickly annulled Manilius' law on technical grounds.

The venerable festival of Compitalia had, therefore, become rowdy and a focus for radical, sometimes revolutionary politics in an urban setting. This development is all the more striking considering the fact that, as we have seen, the traditional announcement of the praetor reminded participants that the festival day itself was not one for public business or, therefore, for political assemblies to pass new laws. The very notion of proposing a bill or even making a political speech on what had always been a purely local day of real vacation and religious observance shows how much things had changed. Those who tried to conduct political business at and by means of Compitalia were presumably seeking a larger audience, more popular participation by humbler, newer citizens, and a level of local engagement that had not

29 For C. Cornelius (tr. pl. 67 BC, *RE* 18), see conveniently Gruen 1974, 213–15.

30 For Manilius' law, see Cicero *de imp. Cn. Pomp.* with Steel 2001, 114–56, and 2013, 147–48.

31 Unfortunately, we do not know the identity of the urban praetor for 67 BC, who announced the date of the festival. He may have been a political ally of Manilius. Accame 1942, 15, argued that the Compitalia of 67 BC marked the key moment when regular republican government was first threatened.

32 L. Domitius Ahenobarbus, quaestor in 66 BC (pr. 58, cos. 54, *RE* 27): Asconius 45C and Schol. Bob. 119 Stangl.

been usual in traditional republican politics. They were probably also courting a rowdier crowd.

Nevertheless, activist tribunes and their political agendas are not the whole story. Some initiatives may also have come from opinion-makers in the vici. There is no particular reason to imagine that local leaders were all merely the pawns of ambitious magistrates. What we see is inevitably a reflection of Compitalia in elite sources as a locus of disorder and violence, very different from the charming rural festival on the farm or the collegial neighborhood barbeque. This picture may well be a caricature. Nevertheless, the ban enacted by the senate shows that there was a clearly articulated and publicly expressed concern, prompted by several years of incidents, some of them probably lost to us.

In 64 BC, the senate famously banned both the games (*ludi compitalicii*) and certain *collegia* in Rome.[33] The inclusion of the games at Compitalia in this measure (if it was indeed a single *senatus consultum* rather than two separate measures) is especially striking since we know that there had been violence on many other occasions and in different venues during the previous years.[34] Was Compitalia, therefore, especially egregious now? We may imagine that Compitalia celebrations had drawn significant attention in 66 and 65 BC, even as we know they had in 67 BC.[35] Unfortunately, the evidence for this decree, which was never apparently proposed as a bill or voted into a formal law by an assembly, is slight and difficult to interpret. We rely on a passage from Cicero's speech attacking L. Calpurnius Piso Caesoninus (consul 58 BC), and on Asconius' commentary on Cicero's words, written about a century later. The wording of these passages has been much discussed, but with a primary focus on the newly illegal *collegia*, which are presumed to have been the main target and, consequently, to have been involved in organizing the notorious games that were also banned.[36] For our purposes, the senate's censure of the festival itself is of interest in its own right.

33 For discussion, see esp. Gruen 1974, 228–33; Flambard 1977 and 1981; and Fraschetti 2005, 190–203 (although he does not think there were any official vici before Augustus). Kaster 2006, 199–200 shrewdly points out Cicero's ambivalent and changing attitude to "clubs," depending on whether he hoped to enlist some for his own political purposes. Meanwhile, the fundamental law allowing private clubs under certain guidelines, already found in the Twelve Tables (8.27 = Gaius in *Dig.* 47.22.4), was continually in force. Bendlin 2002 argues for the ubiquity of club membership, especially during the imperial period.

34 There had certainly been violence in the courts in 66 and 65 BC, in conjunction with the trials of the tribunes Cornelius and Manilius (Asconius 59C, Schol. Bob 119 Stangl). Accusations apparently also swirled around an alleged plot to murder the new consuls (L. Aurelius Cotta and L. Manlius Torquatus) on 1st January 65 BC, although this so-called First Catilinarian Conspiracy is now thought to be an invention (perhaps by Cicero). See Cicero *Cat.* 1.15, *Sull.* 68, Sallust *Cat.* 18.4–6. Nevertheless, accusations of planned violence also played a role in creating a general sense of instability and fear, with one special focus being the beginning of the political year, the very time of Compitalia (for which see Tarpin 2002, 128). The fear of violence in Rome in late 63 BC at the time of the arrest of those who had conspired with Catiline was also focused on safety and security in the city, including the possibility that the conspirators would be rescued by their supporters in Rome and that a popular uprising would occur, resulting in deliberately set fires in the city (Sallust *Cat.* 50). See also Alföldi 1973, 18–21 for the Compitalia in the decades before Augustus.

35 Accame 1942, 15, provides an imaginative reconstruction.

36 Lott 2004, 51–55, surveys the earlier scholarship and suggests a close connection between the *collegia* and the games. See also Treggiari 1969, 168–77.

Cicero says:

Aude nunc, o furia, de tuo dicere! cuius fuit initium ludi compitalicii tum primum facti post L. Iulium et C. Marcium consules contra auctoritatem huius
ordinis; quos Q. Metellus—facio iniuriam fortissimo viro mortuo, qui illum
cuius paucos paris haec civitas tulit cum hac importuna belua conferam—sed
ille designatus consul, cum quidam tribunus pl. suo auxilio magistros ludos
contra senatus consultum facere iussisset, privatus fieri vetuit atque id quod
nondum potestate poterat obtinuit auctoritate. Tu, cum in Kalendas Ianuarias compitaliorum dies incidisset, Sex. Cloelium, qui numquam antea praetextatus fuisset, ludos facere et praetextatum volitare passus es, hominem
impurum ac non modo facie sed etiam oculo tuo dignissimum.

Dare then, o fury, to tell of your (consulship)! Its beginning was the compital
games, then staged for the first time after the consulship of L. Iulius and
C. Marcius (64 BC), against the specific injunction of this senate. Quintus
Metellus—I do an injury to that most brave man, now deceased, when I
compare him, the like of whom our community has produced few, to this
savage beast. Anyway, as consul-designate Metellus was able while still a private citizen to put a stop to the celebrations, when a certain tribune of the
plebs urged the *magistri* to hold the games in contravention of the senate's
decree promising the protection provided by his veto power. Metellus
achieved what he could not yet do through legal political power by means of
his personal prestige. You (on the other hand), when the day of the compital
feast fell on the first of January, allowed Sextus Cloelius, the kind of man
who had never before worn a toga with a purple border, preside over the
games and flit around in his *toga praetexta*, a vile man, (in fact) quite like
you not only in looks but also in outlook.

(Cicero *In Pis.* 8)

Asconius comments (including an embedded quotation of Cicero):

L. Iulio C. Marcio consulibus quos et ipse Cicero supra memoravit senatus consulto collegia sublata sunt quae adversus rem publicam videbantur esse constitua. Solebant autem *magistri* collegiorum ludos facere, sicut magistri vicorum
faciebant Compitaliciis praetextati, qui ludi sublatis collegiis discussi sunt. Post
vi deinde annos quam sublata erant P. Clodius tr. pl. lege lata restituit collegia.
Invidiam ergo et crimen restitutorum confert in Pisonem, quod, cum consul
esset, passus sit ante quam lex ferretur facere (Kal. Ianuar.) praetextatum
ludos Sex. Clodium. Is fuit familiarissimus Clodii et operarum Clodianarum
dux, quo auctore postea illato ab eis corpore Clodii curia cum eo incensa est.
quos ludos tunc quoque fieri prohibere temptavit L. Ninnius tr. pl. Ante biennium autem quam restitueretur collegia, Q. Metellus Celer consul designatus
magistros vicorum ludos Compitalicios facere prohibuerat, ut Cicero tradit,
quamvis auctore tribuno plebis fierent ludi; cuius tribuni nomen adhuc non
inveni.

In the consulship of Lucius Iulius and Gaius Marcius (64 BC), whom Cicero
himself also mentioned earlier, the private associations (*collegia*) that seemed

to be subversive of the republic were suppressed by a decree of the senate. Moreover, the magistrates of these associations were accustomed to put on games, just as the magistrates of the neighborhoods did wearing the purple striped toga for the compital games. Those games were discontinued when the associations were suppressed. Six years after they were banned, Publius Clodius restored the private associations by passing a new law as tribune of the plebs (58 BC). For this reason, he brings Piso into ill repute and charges him with restoring them, because, when he was consul, he allowed Sextus Cloelius to hold the games (on 1st January) wearing a toga with a purple border. That individual was a very close associate of Clodius and a leader of Clodius' paramilitary organizations. It was at his command that after Clodius' body had been carried into the senate house, the building was burned with him. Lucius Ninnius, a tribune of the plebs, then also tried to stop the games (given by Cloelius). But two years before the associations were restored, Quintus Metellus Celer, as consul-elect, had forbidden the magistrates in the neighborhoods from celebrating the compital games, as Cicero recounts, although the games were protected by the legal power of a tribune of the plebs. I have not yet been able to find the name of this tribune.[37]

(Asconius *In Pis.* 6–7C)

An analysis of this series of events needs to start from Cicero's published version of his attack on Piso, a political rival who had recently returned from serving as governor of Macedonia. The text is based on remarks made in the senate in 55 BC, probably on more than one occasion. Unfortunately, the pamphlet that contained Piso's response has not survived. Cicero's speech against Piso is a famous example of vituperative rhetoric, a tour de force by Rome's leading orator at the height of his persuasive powers. Meanwhile, it has justifiably been described as "a masterpiece of misrepresentation," which contains many evident distortions and even blatant falsehoods.[38] This passage is near the beginning of the "speech," which opens with an elaborate comparison between Cicero's consulship in 63 BC, described in glowing terms, with Piso's five years later, the object of Cicero's scorn. Piso's consulship had coincided with Clodius' tribunate, and his populist reform program, as well as with the exile of Cicero himself, a political disaster from which the speaker never fully recovered.

Interestingly, Cicero starts his criticism of Piso the consul with the scene at the unsanctioned Compitalia on 1st January 58 BC on Piso's first day in office. Apparently, Cicero thinks this will make an impression on his audience. He conjures up a vivid picture of an illegal and shameful celebration, presided over by one of his favorite targets, Sextus Cloelius, a close associate of the wicked Clodius himself.[39] Cicero claims that this was the first time the *ludi compitalicii* were held since the senate's ban, after an earlier attempt at the very end of 61 BC had been thwarted

37 The tribune may be C. Herennius, as argued by Lott 2004, 56 with n. 78.

38 Nisbet 1961, xvi. The introduction to his commentary on the *In Pisonem* is one of the best overviews of politics in the early 50s.

39 For Sextus Cloelius (whose exact name has been a subject for debate), see Flambard 1977, 126–28; Damon 1992; and Linderski 1993, 645–46. Damon explores Cicero's extreme dislike of him. He is the man thought responsible for the destruction of Cicero's house on the Palatine (Cicero *Cael.* 78) in 58 BC. Kelly 2006, 199–200, discusses his long exile as a result of his actions after the murder of Clodius in 52 BC.

by his friend Q. Caecilius Metellus Celer (consul 60 BC).[40] His focus is not, however, on any actual violence or other illegal behavior at these games. Rather, he protests their very performance, including especially the leading role played by the lowly and despicable Cloelius, who he claims was wearing the *toga praetexta* for the first time on this occasion. The fact that the games took place in 58 seems clear; exactly how controversial or scandalous they were at the time is less evident. Further analysis is called for.

There was, as we have seen, no single, principal location or ritual that marked Compitalia, which was a local festival at the many compital shrines throughout the city. Nor, therefore, was there a single celebrant "in charge" of the festival, as there was with the public ludi presided over by a magistrate, such as a consul or an aedile. To the extent that Cicero is suggesting a close comparison with these great games, he is clearly misleading. Cloelius appeared dressed in a *toga praetexta* as a *magister*, but inevitably of a single vicus or perhaps a *collegium*. Cicero here dignifies one person with a great deal of attention, presumably because that individual was an easy target. If Cloelius was the *magister* of a *collegium*, why has Cicero not bothered to hold that same organization up for ridicule? This silence makes it seem more likely that Cloelius was indeed a *vicomagister*, perhaps in one of the more prominent neighborhoods near the political center.[41] To say that this was the first time he wore a toga with a purple stripe is to indicate that he was a freedman, since freeborn boys wore this toga when they were children. But the same was true for every other freedman *vicomagister* in Rome, unless he had held this local office before in a previous year. Cicero's rhetoric consists of a simple (and crude) slur based on Cloelius' social rank and standing. The very fact that he could not come up with a more substantive criticism of something transgressive that actually happened at the games, or even in Cloelius' own vicus under his watch, strongly suggests that nothing illegal or untoward took place.

In other words, Piso indeed permitted the *ludi compitalicii* to be celebrated, for the first time after a hiatus of five years, a popular celebration that also marked his inaugural day as consul, with his colleague A. Gabinius. These may well have been rather splendid games, being celebrated partly at the behest of Clodius, several of whose bills had been proposed on 10th December and would shortly be voted into law on 4th January.[42] The time was right for celebrating in the vici and at the *compita*. Funds had obviously been raised during 59 BC, perhaps with the cooperation of the popular consul Julius Caesar, and the day seems to have gone well. Despite

40 Q. Caecilius Metellus Celer (pr. 63, cos. 60, *RE* 86) was a close friend and ally of Cicero. See *MRR* for his career and consulship. He opposed the transfer of P. Clodius to the plebs, which did not happen until 59 BC in the consulship of Julius Caesar.

41 Lintott 1999b, 81 with n. 3, argues that Cloelius was *magister* of one of the *collegia*, perhaps the *scribae* of which he was a member (Cicero *Dom.* 47–48, 83, and Asconius 33C, T15). See Purcell 1983, Badian 1989, and Damon 1992 for the *scribae* in Rome. Asconius, however, does not seem to have a specific idea in mind here. His wording does not necessarily imply that the *magistri* of the private *collegia* all also wore the same *toga praetexta* as the *vicomagistri*, who were officals of the state in charge of a holiday that was a public festival. On the other hand, it would presumably not be surprising to find a prominent individual holding office both in a *collegium* and in a vicus, perhaps even in the same year, contra Treggiari 1969, 170, who reads Cicero as claiming that Cloelius is not himself a *magister* of any organization, which is why he is being criticized for wearing the *toga praetexta*.

42 Tatum 1999, 114–49, gives a systematic treatment of Clodius' legislation, arranged chronologically. See also Fezzi 1999 and Harrison 2010.

being held in contravention of a senatorial decree of 64 BC, as Cicero is at pains to point out, these games, in fact, seem to have shown that Compitalia could be harmoniously celebrated without violence or other illegal activities. Again, the fact that nothing is specifically said here by Cicero of *collegia*, illegal or otherwise, suggests a traditional celebration of ludi in the vici. Some people may have been shocked at the time, others were probably relieved to see the popular games return without an egregious incident to mar the traditional holiday.

Asconius, in turn, gives us his version of the background to what Cicero has to say about Compitalia.[43] It is Asconius who introduces the topic of *collegia* and the attempts of the senate to control these private clubs, but his narrative is neither logical nor easy to follow. He may well be right that *collegia* had traditionally contributed in various ways to the celebration of Compitalia by the *vicomagistri*. But that does not mean that the *ludi compitalicii* necessarily stopped simply *because* certain *collegia* were dissolved (or went underground?). Cicero himself does not dwell at all on *collegia,* although such organizations were frequent and easy targets, but censures an unsanctioned celebration of *ludi compitalicii*. In doing so, he adds the interesting information that there had been a previous attempt to celebrate such ludi, one allegedly prevented by his political ally the consul-elect Metellus some three years earlier. These popular ludi had become an occasion for political self-expression, as well as for unruly behavior that may not have had a particular ideological or political purpose.

Nevertheless, there is more to be gained by looking at the celebration of Compitalia in its own right, separately from the shadowy history of the notorious *collegia*. In this sense, there were surely two distinct provisions in the senate's recommendations in 64 BC, one about clubs and the other about games. In the case of the *collegia,* only "new" and "unrepublican" ones (*adversus rem publicam*) were banned, as Asconius himself admits.[44] We cannot know either how many or which organizations were affected. In 58 BC, Clodius rapidly restored and expanded the role of *collegia* in Rome, thus evidently putting an end to whatever restrictions the senate had tried to put in place.[45] His legislation does not seem to have been challenged for over a decade until Caesar's law (of 46 BC ?), later extended by Augustus, which put new restrictions on associations.[46] By the

43 Quintus Asconius Pedianus (ca. 9 BC–ca. AD 76) was a learned historian, probably from Padua, who lived in Rome. His commentaries on Cicero, which survive only in fragments, addressed to his sons, were designed to explain the political background to the speeches. See Marshall 1985 and Lewis 2006 for useful commentaries, with Fraschetti 2005, 203–11.

44 For the repeated bans on *collegia,* see Taylor 2013 (originally 1960), 76–77; Linderski 1968; Treggiari 1969, 169–77; Ausbüttel 1982; and Lintott 1999b, 77–83.

45 For the *lex Clodia de collegiis,* see Cicero *Red Sen.* 33, *Dom.* 129, *Sest.* 34, 55, *Pis.* 9, *Att.* 3.15.4; Asconius 7C; Dio 38.12.2, with Tatum 1999, 117–19, who argues that Clodius' new organizations included humbler men who had not had the means to join *collegia* before, because of the need to make a financial contribution to the organization. In other words, Clodius probably went well beyond restoring *collegia* that had been banned in 64 BC. For a detailed chronology, see Kaster 2006, 395. Russell 2016 gives a compelling reading of Clodius' tactics in early 58 BC.

46 Mouritsen 2001, 149–51, argues persuasively, based on his reading of Cicero's *Pro Plancio*, that Crassus' *Lex Licinia de sodalitatibus* of 55 BC was aimed at electoral bribery clubs organized by elites, not at the *collegia* of freedmen and slaves who had no real say in the voting assemblies. According to this reading, Clodius' new *collegia* did not meet an immediate legal challenge. Contra Treggiari 1969, 175–77. Subsequently, private organizations were limited both by Caesar (*lex Iulia,* 46 or 45 BC?, Suetonius *DJ* 42.3) and by Augustus (*lex Iulia,* 21 BC?, Suetonius *DA* 32.1), each using the simple criterion of age as a key factor in determining respectability and legality.

time Caesar intervened, moreover, the political landscape looked very different. After Clodius had been killed by Milo and the senate house had been burned to the ground by an angry mob during Clodius' funeral early in 52 BC, persistent fears of angry crowds and popular violence had been fully realized.[47] In other words, it seems that this particular ban on some *collegia* only lasted about five years, between 64 BC and the beginning of 58 BC.

It is less easy to say whether the same was true for the injunction against ludi at Compitalia. These are mentioned infrequently in our sources in any case. Cicero's words of 55 BC do not specify whether the ludi were *still* banned at the time when he was speaking. To draw attention to Piso tolerating the first recelebration in 58 BC does not in itself actually indicate whether they were either technically illegal and/or a usual part of the festival's current practice. It would certainly have been logical for Clodius, whose political base was very much in the vici, to make them legal again, but perhaps no new formal legislation was actually needed to restart such a traditional custom. If the celebration of 58 had been an isolated incident, why would Cicero not have drawn our attention to that very fact? Why not say that Piso was the *only* consul to tolerate this kind of event? The simplest explanation is that the senate's ban on the games was for a certain number of years (ten or perhaps fewer?), as a warning against further violence and unrest, as well as a penalty for bad behavior.[48] Consequently, the games could have been legal again by the time Cicero was attacking Piso and writing up his speech.

To sum up: no bill was introduced or law passed in 64 BC, probably because the senators were simply making adjustments to what they saw as the status quo in legal terms. Subversive *collegia* were banned, but these had never been legal since the right to associate had always been strictly controlled in Rome. A temporary ban was probably put on *ludi compitalicii* for a fixed number of years, as a warning against violence on the day of Compitalia. The two measures were related, since some members of dubious *collegia* had apparently been blamed for the type of unrest seen at Compitalia, behavior that was in any case illegal in Rome.

The popularity of *ludi compitalicii* is self-evident, from what Cicero and Asconius have to say, and from earlier evidence, such as the paintings and inscriptions from Delos and the records of games celebrated by slaves and freedmen *magistri* in republican Capua. Writing in the 40s BC, Varro speaks in familiar terms of Compitalia; Dionysius of Halicarnassus says the celebrations were very splendid when he was in Rome, in the twenty years immediately after the battle of Actium, but

47 Most immediate information comes from Cicero's *Pro Milone*. In addition, see Livy *Per.* 107, Appian *BC* 2.21, Dio 40.49–50, and Schol. Bob. 116 Stangl, with Tatum 1999, 241–42. For the *curia* building, see Coarelli in *LTUR* under *curia Hostilia*, although this senate house was surely called curia Cornelia after Sulla, who had built it. That is also why his son Faustus was chosen to supervise its rebuilding after the fire of 52 BC, a project he never accomplished. See note 16 earlier.

48 A possible later parallel might be the well-documented ten-year ban on gladiatorial games at Pompeii, enacted by the senate in AD 59 under the emperor Nero. This ban was a penalty imposed after a bloody riot between the Pompeians and their neighbors from Nuceria, who had come to watch the games. See Tacitus *Ann.* 14.17, with Laurence 2007, 173. Cooley and Cooley 2014, 80–85, D 39–46, collect the evidence of how the riot was commemorated, apparently with pride, in wall paintings, inscriptions and graffiti at Pompeii, although the local magistrates (*duoviri*) were probably dismissed over the incident at the time.

without being specific about their content.[49] Suetonius does ascribe a "revival" of the *ludi compitalicii* to Augustus, but this may simply mean he put them on a new footing, for example in the way that they were financed or organized.[50] We have no evidence of an interruption or discontinuation after the notorious celebration of 58 BC, an event that may have been held up by Cicero precisely because it had, in effect, overturned the senate's injunction (early?) and had marked the start of a new series of annual celebrations. In this case, however, it is also relevant to keep in mind that Cicero was surely writing before Clodius' death and the subsequent sharp rupture in Roman politics in 52 BC.

Meanwhile, the traditional, religious aspects of the annual holiday certainly still took place every year, as a matter of course. Each December, the urban praetor announced the day for the festival. The festivities were organized locally by *vicomagistri*. Cicero's letters show that he considered the holiday a normal part of life, especially at a country estate, both before and after the ban of 64 BC.[51] The cult of the *lares compitales* was integral to Roman life and to its civic religion. Local officials were needed to supervise the *compita* (now more than ever!) and for everyday administrative duties connected to the water and food supply, as well as to law and order or responses to fires and other emergencies. There was no way for the senate to dismiss the *vicomagistri* without putting other officials in their place. A power vacuum would have been a disaster in terms of keeping local life relatively orderly and contained. In fact, special ludi at Compitalia would certainly have made good sense during the 50s, in the years when Clodius often played such a leading role in the city and when grassroots politics flourished in the unstable space created by the disintegration of traditional, republican political culture but before the emergence of one-man rule.[52] If Compitalia increased in scale under Clodius' influence, it is not surprising that Cicero does not necessarily mention this fact.

49 See Fraschetti 2005, 224, with Varro *LL* 6.25 and Dionysius of Halicarnassus 4.14.4. There is also the evidence from the anonymous *Comm. Pet.*, which has been dated by some to around 64 BC (for example, Tarpin 2002, 129), but is thought by others to be a later rhetorical exercise.

50 Suetonius *DA* 31.4 with Louis 2010 ad loc. Lott 2004, 11, 62, takes Suetonius at his word, and assumes that the ludi had been interrupted by Caesar in the 40s BC, perhaps as long as 40 years before Augustus put them on a new footing. Nevertheless, in the same list Suetonius mentions the Lupercalia, a festival we know was still very much celebrated under Caesar. Did this festival also fall into disuse after the *ides* of March, 44 BC? Even as Augustus put his name on some restored temples in Rome as if he was their builder (for example, the great Temple of the Magna Mater on the Palatine, originally dedicated in 191 BC), he may well have taken credit for "reviving" games and festivals that were not necessarily (what we would call) defunct.

51 Compitalia is mentioned casually as a day of rest with family and friends in Cicero's letters at *Att.* 2.3.4 (December 60 BC!) and 7.7.3 (2nd January 50 BC).

52 Clodius' time of greatest political influence (from 58 BC until his death on 18th January 52 BC) would have seen six possible occasions for Compitalia celebrations. He had more clout in his years in office.

XXIII RELIGION AND POLITICS AT THE CROSSROADS

> eius pestilentiae causa et supplicatum per compita tota urbe est
> et P. Licinius Varus praetor urbanus legem ferre ad populum
> iussus ut ii ludi in perpetuum in statam diem uouerentur.
> —LIVY 27.23

Part III has focused broadly on the celebration of Compitalia, the great midwinter festival of *lares compitales*, which was also the main festival of the streets and neighborhoods in Rome, under the leadership of their freedmen *vicomagistri* (in their purple-bordered togas and attended by their lictors), but also involving any and every local group (*collegium*) that was willing, often eager, to participate in the planning and partying. The whole city celebrated at the invitation of the urban praetor, who announced the date around the time of the winter solstice. It was this festival more than any other that was associated with ordinary people in Rome and with a (relatively) freer expression of their political views. Partaking in some of the carnival atmosphere of Saturnalia, but also recalling the special season after the end of the agricultural year, Compitalia was a celebration that had its own particular character, customs, and importance in (re)creating community and identity. Behind it lay an organic network of compital shrines and local organizations, coordinated by annually chosen freedmen *vicomagistri*.

Compitalia was, however, not the only occasion on which all the *compita* coordinated for prayer and ritual on a single, shared day. This network of sacred spots could also be called upon in consultation with the senate to counter a prodigy, disease, or other time of crisis. Three such instances survive in our ancient sources, which also suggest that such supplications happened on other occasions. These communal days of prayer and expiation are recorded in the regular lists of prodigies that were handed down for each year in official sources.[1] They appear, therefore, as a natural component of the religious landscape of republican Rome in the late third and second centuries BC.

During the war with Hannibal, Livy records a religious supplication (*supplicatio*) organized at each *compitum* throughout the city in 208 BC in response to a widespread plague. Other religious remedies for this epidemic included most notably making the great games for Apollo, the ludi Apollinares (first celebrated in 212 BC), an annual event through a law introduced by the urban praetor.[2]

> eo anno pestilentia grauis incidit in urbem agrosque, quae tamen magis in
> longos morbos quam in permitiales euasit. eius pestilentiae causa et suppli-
> catum per compita tota urbe est et P. Licinius Uarus praetor urbanus legem
> ferre ad populum iussus ut ii ludi in perpetuum in statam diem uouerentur.
> ipse primus ita uouit, fecitque ante diem tertium nonas Quinctiles. Is dies
> deinde sollemnis seruatus.

1 For the republican system of prodigy and expiation, see MacBain 1982 and now the detailed treatment in Engels 2007.

2 For the Ludi Apollinares, see Palmer 1997, 68–79; Bernstein 1998, 171–86. Engels 2007, 468–70, analyzes the prodigies of the year 208 BC.

In that year, a serious disease broke out in the city and in the countryside, which, however, resulted more in prolonged illness than in death. Because of this epidemic prayers were offered at the *compita* throughout the city and the urban praetor Publius Licinius Varus brought a bill to the people (for approval) to promise the celebration of those games perpetually on a fixed day. He himself first made the vow (to the gods) and celebrated (the games) on the third day before the nones of Quintilis. This day then became the annual observance.

(Livy 27.23)

Even before the epidemic, the year had started badly with many prodigies, which resulted in the consuls having to delay their usual departure from the city to continue the war because they had been unable to deal satisfactorily with all the bad omens. Subsequently, they would both die as a result of an ambush laid by Hannibal, a disaster that was inevitably interpreted as a result of their failure to avert the omens at the beginning of their year in office. The ludi Apollinares were major games in a Greek style that became a locus for the development of theatrical performances in Rome, as well as for Greek religious rituals being celebrated in an official capacity. The promise to hold such games for Apollo each year represented a significant investment of resources on the part of the community and is a measure of the challenge they were facing.

At these moments of crisis, we see the whole population being invited to pray at their own *compita* to gain the favor of their *lares* in averting the disease and perhaps also to make the rounds of other *compita*. We may imagine that the urban praetor was also responsible for this call, an invitation that could have been made in the same way as the official announcement of the date of Compitalia. Particularly significant is the use of *compita* as part of expiatory rituals that were centrally organized to restore the ritual integrity of the state and its good relationship with the gods.

A *supplicatio* was a day of prayer and offerings, either seeking help or giving thanks for favors received, that usually involved all the temples in the city being opened and citizens making the rounds to as many of them as possible.[3] Ceremonies of sacrifice would be presided over by the priests of the civic religion. At the *compita*, we see similar rituals of prayer requests and customary offerings, but multiplied on a local level and scale. Turning to the *compita* suggests both the importance of the protection provided by *lares* and the urgency of seeking as many participants as possible in petitioning the gods. Presumably, fuller participation could be expected and perhaps even enforced at the level of neighborhood shrines. Did people go around to many different *compita* or did they mainly stay in their own "neighborhood," which is to say around the several *compita* at their nearest street corners?

Twenty years later, in 188 BC another ritual was performed at all the *compita*, this time for three days before the new magistrates set out for their provinces.[4] This expiatory ritual was organized by the priests responsible for consulting and

3 For *supplicationes*, see Livy 10.23.1; 22.1.15; 31.9; 35.40.7; 40.37.3; 41.21.11.
4 See Livy 38.36.4, with commentary by Briscoe 2008 and Engels 2007, 502–3, as well as Obsequens 2.

interpreting the Sibylline books (the *decemviri sacris faciundis*) in response to an eclipse of the sun.

> Priusquam in provincias novi magistratus proficiscerentur, supplicatio triduum pro collegio decemvirorum imperata fuit in omnibus compitis, quod luce inter horam tertiam ferme et quartam tenebrae obortae fuerant.

> Before the new magistrates set out for their provinces, a supplication for three days at all the *compita* was ordered by the college of ten men (*decemviri sacris faciundis*), because there had been an eclipse of the sun between the third and fourth hour.

> (Livy 38.36.4)

The eclipse of 188 BC took place on 17th July (according to the Julian calendar), which was equivalent to 13th November according to the prevailing republican calendar.[5] In other words, the magistrates seem to have been very much delayed in taking office this year, which would at this period normally occur on 1st March. A similar ritual, perhaps also over several days and ordered by the Sibylline Books, is mentioned by Julius Obsequens for the year 165 BC in response to famine and a plague.[6]

> Pestilentia fameque ita laboratum ut ex Sibyllinis populus circa compita sacellaque operaturus sederit.

> The city was so burdened by disease and famine that the (whole) population was enjoined by the Sybilline books to sit (in supplication) at the *compita* and the (local) open-air shrines (sacella).

> (Obsequens 13)

Interestingly, the devotions in 165 BC specifically included the other small shrines (*sacella*). In effect, the whole population (*populus*) was being asked to pray at every "shrine," however tiny or local, to every god, perhaps over several days. On this occasion, all resources were being mobilized to gain divine favor in a ritual that truly created a single community throughout the city. *Sacella* are clearly and officially distinguished from *compita* in this official appeal.

It is possible that all three instances involved a similar procedure. The praetor would make the announcement, on the basis of a decision made in consultation with the senate and the priests. This pattern may suggest that the *decemviri* also had a special relationship of some kind with the *compita* and other shrines. Unfortunately, we cannot know whether the prophetic books they were in charge of, which were written in Greek hexameters, actually directly mentioned *compita* or, to put it differently, whether the *decemviri* themselves regularly interpreted a certain formula in the books as such a reference. The books could have recommended prayers to appease local or city gods, the gods of place, or all the gods in

5 Le Boeuffle 1989, 45, presents the scientific evidence for the date of this eclipse.

6 Obsequens is drawing much of his information from Livy, in this case from book 46. See Engels 2007, 221–34 and 528.

the city. The actual words of the prophecies were not allowed to be revealed, only the measures decided upon by the senate in consultation with religious experts.

When the compital network was fully operational it could be deployed at relatively short notice, often early in the political year when prodigies were usually addressed before the new campaigning season. This practice would inevitably have been interrupted by the loss of the Sibylline books in the accidental fire in 83 BC that destroyed the great Capitoline temple, where they were kept.[7] A supplication at the *compita*, therefore, attests the official role of the crossroads shrines in civic cult, their prominence in the religious landscape of the city, and the desire of elite priests and the senate to call on locals to coordinate shared expiations on a given day(s) throughout the city because their prayers and sacrifices were vital to Rome's safety.

* * *

These two parts (II and III) have focused on the many guises of *lares* in the city of Rome, a city of myriad *lares*. *Lares* appeared as the most Roman of gods but also the most accessible and welcoming to the new arrival, the visitor, the stranger, the slave. Their venerable age combined with a simple theology, a lack of native myth, and a joyful tone conspired to make *lares* supremely popular and infinitely adaptable. Unlike so many old Roman cults, their rituals were neither limited nor limiting when it came to participants or offerings. Their role as protectors made them lovable and attractive; they watched over boundaries in space and temporal moments of transition in people's lives. They became associated with the New Year when 1st January was designated as the beginning of the political year. The shrines at the crossroads mirrored lar(es) at each hearth (and vice versa). For those without a hearth of their own, the *compita* would have been all the more important as sites where protective *lares* could be invoked. Roman elites took risks when they distanced themselves from the *lares* at the street corner.

The cult of the *lares* illustrates a religion that was above all practical in everyday life. It was built around a splendid and popular annual festival, well timed at midwinter, whether in the city or in the countryside. The *lares* created community by both setting and celebrating boundaries, even as they invited inhabitants to cross over their usual divisions to sacrifice and feast together with those who lived in other households and separate neighborhoods. Compitalia was, therefore, a festival of the vici together, not of the individual street or household. *Lares* watched over the slaves and afforded them a rare day of vacation, with eating and drinking, processions and games of their own. For as far back as we have evidence, the organizing of Compitalia seems to have been in the hands of freedmen in Rome. Outside Rome, slaves are also attested as those in charge of the festivities. However, these venerable gods belonged to all local residents, a fact that enhanced the status of the freedmen and slaves who supervised their cult. Freedmen were eager to continue the cult in their new life as citizens; they did not experience these rituals as a "religion of slaves."

The *compita* of Rome formed a ready network that Roman leaders could use to gain access to local people for a wide variety of purposes whether official or more

7 For the destruction of the Capitoline temple and the loss of what was apparently the unique copy of the Sibylline books in 83 BC, see Flower 2008.

personal. They allowed magistrates and priests to distribute goods or ask for prayers while avoiding situations where people crowded into a central location, especially in times of fear or famine. Local opinions were formed, reflected, and measured at compital shrines. In this sense, *compita* could serve as points of contact, and as barometers or safety valves as ideas bounced between the political center and the locals. As the Roman calendar evolved, Compitalia became closely associated with the beginning of the civic year for magistrates and citizens; this new juxtaposition furthered the potential for political tendencies during the celebrations.

Compita, often consisting of little more than wall paintings and niches, were set up at or near crossroads, especially where three or more streets came together. Unlike other shrines that could belong to families, *compita* were officially recognized sacred spaces integral to civic cult. We have very limited access either to the contours of this grassroots network as it existed on the ground or to the official picture of it (map? list?) from the perspective of the political center. *Compita* were counted in the imperial census and had probably been for centuries before, when a census happened more regularly at five-year intervals. By definition, therefore, both in their physical placement and through their most important annual festival, most *compita* were not and could not be simply equivalent to a single vicus (or to any other subdivision or geographical area). Rather, *compita* by their very nature marked places where several vici (or other geographic units) met at a recognized crossroads. The identical twin *lares* themselves embodied the crossing point of more than one entity. These dancing *lares* patrolled local neighborhoods, where they also fostered positive interactions with those living immediately beyond each very local space. Similarly, the *compita,* although in the care of the local *vicomagistri,* did not "belong" to a single *collegium* or type of association, or even to a wealthy family that had paid for and named the local shrine, but were sites for shared rituals for inhabitants according to the character of each neighborhood. Moreover, the freedmen *magistri* drawn from different households changed annually, thus avoiding a monopoly of influence around a local shrine.

Republican Rome grew and thrived as a huge city made up of many small "neighborhoods" described as streets (vici), each ideally in an established and cordial relationship with its surrounding neighbors. This system was practical, flexible, and allowed for a larger sense of urban community beyond the water fountain or local shops. The network of *compita* helped to shape the republican city, which did not have many centralized services or a professional police force under the republican administration. The *compita* could, however, also be destabilizing, as they provided the most obvious and accessible venues for local political expression and for the formation and dissemination of independent opinions or rumors, including those in opposition to the actions of the senate or of the magistrates in office. The compital network was a two-edged sword, which many Roman politicians tried to wield, with varying degrees of success. Augustus' interest in these shrines and their magistrates provides a type of commentary on their vital role in republican Rome, especially over the previous generation.

IV

AUGUSTUS AND *LARES AUGUSTI*

Imp(erator) Caesar August[us pontif(ex) maxim(us)] co(n)s(ul) XI
tribun(icia) potes[t(ate) X]VII lares aug(ustos) mag(istris) uici
dedit
—*FASTI OF THE MAGISTRI VICI* FROM THE AVENTINE, 2 BC[1]

Augustus' reimagining of the cult of *lares* at the crossroads throughout Rome is one of the most striking and wide-reaching aspects of the princeps' religious program, one that also had political and social implications. Extant ancient sources that document its effects are rich and diverse and yet simultaneously allusive and incomplete when it comes to describing the implementation of the reform itself. A wealth of inscriptions and iconographic evidence reveals the rapid spread of a new cult of *lares augusti* ("holy" or "august" *lares*) throughout the crossroads shrines (*compita*) of the city of Rome in and soon after 7 BC. This intentionally novel cult was overseen by locally chosen magistrates (*vicomagistri*), mostly freedmen assisted by slave attendants (*vicoministri*). The *vicomagistri* were recruited specifically from the local neighborhoods (*vici*), which were now officially reorganized as small subsections in a city of fourteen large districts (*regiones*), as opposed to the traditional four attributed to King Servius Tullius. The princeps' initiative, therefore, involved a "renaming" of the *lares compitales*, traditional deities worshipped at compital shrines where several roads converged to form a crossroad, with his own personal epithet, so that they now became *lares augusti*.

The enthusiasm of local freedmen and slaves in celebrating their own status as neighborhood officials, and especially their roles as presiders over the cult of these new "august" *lares*, contrasts starkly with the lack of detailed description or commentary in surviving literary sources, all the works of elite authors. In effect, we do not have a narrative account of this highly visible religious innovation (nor indeed of the major, simultaneous administrative redistricting of the city). At least in theory, of course, we always knew that the surviving authors of ancient literary texts do not give us a complete picture of Roman life in its everyday manifestations, but the example of the *lares augusti* is especially well-documented through inscriptions put up by freedmen and slaves. These *lares* provide a vivid instance of an everyday set of images that were of central importance to local neighborhoods but apparently of little concern to Romans of higher social status.

Furthermore and perhaps most strikingly of all, Augustus himself does not refer to any aspect of this cult of *lares augusti* in his own account of his life and career in the *Res Gestae Divi Augusti*, a description of his achievements that he completed during the last year of his life. At the same time, there is (as yet) no evidence of a similar network of *lares augusti* at the crossroads in any other city of the empire.

1 *Fasti of the Magistri Vici*: MNR inv. 121558; *II* 13.1 no. 20 and 13.2 no.12 = Lott 2004, no. 22.

The placing of new *lares* at compital shrines, therefore, reflected the special status of Rome as a capital city and her own very particular relationship with her "leading citizen," the princeps, exactly twenty years after he had taken the new name Augustus.

The nine subsections of this fourth part will explore the nature of Augustus' religious reform, its implementation by the princeps, and its impact in the city.[2] I will use a combination of approaches to elucidate the variety of ancient source material and the intersections between the different pieces of surviving evidence. A consideration of Octavian/Augustus' role and image in the city before 8/7 BC, in section xxiv, will serve to introduce a more detailed analysis of the moment of religious reform itself (section xxv), as far as we can understand it from our slim evidence. Section xxvi looks at *lares augusti* in their own right and in the context of their cult at the crossroads shrines. In section xxvii, I argue that no cult of Augustus' *genius* was to be found at the crossroads in Rome or in the home during his lifetime. Consequently, a new and different explanation needs to be found for the sacrifice of a bull, which is depicted on a few compital altars (section xxviii). For many reasons, this bull was not an appropriate gift for the *genius* of Augustus, to which it has so often been ascribed by modern scholars.

Sections xxix and xxx look at other deities who were characterized as "august" (*augustus/a*) in this same time period, starting first with the famous altar of Pax Augusta, dedicated by the senate in the Campus Martius in 9 BC, immediately before the beginning of the cycle of urban and religious renewal that would introduce *lares augusti* throughout the city. These official initiatives (Pax Augusta and the *lares augusti*) received an immediate response in the rapid spread of the epithet *augustus* to local gods in Rome on the initiative of freedmen *vicomagistri*. In other words, while only a few gods were ever officially called "august" by Augustus himself or by the senate, local people were free to give this name to their favorite god(s) at will, in emulation of and tribute to the princeps. After these clarifications of the cult of the *lares augusti* and other august gods, section xxxi goes on to situate the great reform of 7 BC within the cycle of Augustan time, both in the yearly calendar of festivals in Rome and more especially as part of the pattern of anniversaries commemorated across the years and decades. This section, therefore, explores and contextualizes the whole concept of a "new age" in the local vici of Rome as the background to Augustus' narrative of his times. The final section (xxxii) draws these various themes together in a brief overview.

As I hope to show, an investigation of the *lares augusti* and their cult within the larger context of Augustan religious revivalism and renewal reveals their unique place within the official image of the Augustan new age of prosperity and harmony. At the same time, individual monuments such as the so-called Belvedere altar (see section xxv) and the altar from the Vicus Sandalarius (see section xxvi) provide invaluable evidence for grassroots reactions to Augustus' policies and to the new cult of *lares augusti*, which was closely connected to the commemoration of

2 For general discussion of Augustus and the local neighborhoods, see Accame 1942; Alföldi 1973; von Hesberg 1988; Coarelli 1988 and 2000; Galinsky 1996 and 2005; Tarpin 2002; Lott 2004, esp. 81–127; Fraschetti 2005 (original edition 1990), 228–34; and Wallace-Hadrill 2008. The best overviews of life in the city of Rome are by Purcell 1994 and 1996. The known vici of Rome are listed alphabetically under vicus in *LTUR* and Haselberger 2002 (thirty-two named vici listed as Augustan), both with maps. Erdkamp 2013 gives a useful introduction to the city of Rome. Coarelli 2012, xx, discusses vici on the Palatine.

specific times and achievements connected with the princeps. Consequently, the *lares augusti* emerge as pivotal to Augustus' self-representation within the city, as he aimed to put his stamp both on time and space in a refashioned Rome, conceived as the magnificent capital of a people destined for world empire under the guidance of their charismatic and pious leader, a man directly in touch with local life in the vici.

XXIV AUGUSTUS AND ROME BEFORE 7 BC

> spectavit autem studiosissime pugiles et maxime Latinos, non
> legitimos atque ordinarios modo, quos etiam committere cum
> Graecis solebat, sed et cateruarios oppidanos inter angustias
> vicorum pugnantis temere et sine arte.
> —SUETONIUS *DA* 45.2

The princeps already had a long history of living and building and worshipping in the city before the great urban reform of 7 BC. In fact, Octavian had been born in one of Rome's oldest historic districts at the foot of the Palatine in the consulship of Cicero (63 BC).[1] Although his family originally came from Velitrae in the Alban Hills of Latium and still owned property there, he had regularly experienced everyday life in Rome while he was growing up in the turbulent 50s and early 40s BC. Subsequently, he had been actively involved with the urban population ever since his return to Rome from studying in Greece soon after the murder of Julius Caesar on the *ides* of March 44 BC.[2] The tone for his relationship with ordinary people in the city had been set when he appeared before them, at the age of eighteen, as Caesar's posthumously adopted heir. In that role, it was he who paid out the generous donations left in Caesar's will to the *plebs* of Rome.[3] While his political position depended most directly on Caesar's veterans and on their willingness to recognize him as their (potential) new military leader, his image as a benefactor of the city populace was a decisive factor in his eventual emergence as Rome's leading citizen (princeps). Throughout the 30s BC, it was Octavian (as opposed to the other triumvirs Lepidus and Antony) who was frequently present in Rome while he was intent on building his position as the recognized leader of all Italy.[4]

It is no coincidence that Octavian's closest political ally, the distinguished general and former consul M. Agrippa, held the relatively junior office of *aedile* in 33 BC, just at the time when the special powers of the triumvirs were set to expire.[5] In that capacity, Agrippa laid the groundwork for many of the administrative reforms and for the particular attention to the practicalities of daily life that would characterize the new princeps' approach to the city once he had emerged as its leading benefactor. A very fragmentary inscription on a small-scale travertine slab from that same year suggests that Agrippa and Caesar's heir were already

1 Octavian's place of birth: Suet. *DA* 5: *Palati ad capita bubula* (on the Palatine at the Oxes' Heads; with Louis 2010 ad loc.), and Servius on *Aen.* 8.361 *in curis veteribus* (near the Old Meetinghouse). The house was presumably, therefore, at the base of the Palatine facing the site of the Flavian amphitheater and the Arch of Constantine. Velitrae is about twenty-five miles southeast of Rome in the Alban hills of Latium. King 2010 offers an interesting reading of Suetonius' placement of Augustus' birthplace in terms of a shrine set up to honor a founder.

2 For the political situation after the *ides* of March 44 BC, see esp. Gotter 1996 and Osgood 2006, 31–32.

3 See Osgood 2006, 37–38 and 40–41, with Galinsky 2012, 15. Lott 2004, 61–80, 83, traces the life of the neighborhoods from the dictatorship of Caesar to the reform of 7 BC.

4 For the oath of personal allegiance to Octavian, see *RGDA* 25.2–3, with Osgood 2006, 357–64. For the triumviral period in general, see Pelling 1996 and Welch 2012. Scheid 2005, 180, notes that Octavian controlled the election of priests in Rome from 40 BC onward.

5 For Agrippa as aedile in 33 BC, see Horace *Sat.* 2.3.182–186 and Pliny *Nat.* 36.121 (still a famous aedileship a century later!). For discussion, see Rodaz 1984, 145–57; Coarelli 1988, 77–78; von Hesberg 1988, 100; Favro 1996, 110–20; and Lott 2004, 70–72, 99.

restoring local shrines, including possibly compital ones, in a city neighborhood (Vicus Salutaris?).[6]

M(arcus) Ag[rippa L(uci) f(ilius)]
aed(ilis) [iussu]
Imp(eratoris) Cae[saris Divi filii]
[II]Ivir(i) r(ei) [p(ublicae) c(onstituendae) II aediculam?]
[vi]ci Salu[tis or taris? reficiund(am) cur(avit)?]

Marcus Agrippa, son of Lucius, aedile, by order of Imperator Caesar, son of the deified (Julius Caesar) *one of three men (appointed) to set up constitutional government in his second term, saw to the rebuilding of a shrine? of the Vicus Salutaris or Salutis* (restorations in this text are conjectural)
(*CIL* 6.40319 = 31270 = *ILLRP* 434 = *ILS* 128 = EDCS-00900022)

Although this version of the text is heavily restored, it offers a suggestive glimpse of local patronage during the famous aedileship of Agrippa. It is interesting to see travertine used here, rather than the luna marble that was soon to become the hallmark of Augustan Rome. In other words, local shrines and monuments, in addition to grand ones, were consistently of concern to the future princeps as vital parts of the urban fabric and as opportunities for advertising his piety and involvement at the neighborhood level. He turned his attention to local religious restorations from the beginning, at the same time that he was so active in rebuilding numerous more imposing temples of civic cults. Meanwhile, even in his early years of triumviral power, Octavian does not seem to have erected or accepted the gift of statues of himself at compital shrines in the manner of earlier politicians such as Marius Gratidianus or Sulla (see section III.xxii).[7] Rather, as we see in this case, his name was recorded in inscriptions that accompanied restored or rebuilt shrines and newly donated images of gods, even when other magistrates (in this case Agrippa as aedile) had the primary responsibility for the local intervention. Meanwhile, as already noted, *lares* in the household and at the street corner are mentioned, often in passing but with affection and reverence, by numerous ancient authors in both prose and poetry (including many references from the literature of Augustus' own time).[8] Horace, Vergil, Propertius, and Tibullus, who all died before 7 BC, provide valuable evidence for the familiarity and emotional value of *lares*, including those at the *compita,* in the years before the introduction of the *lares augusti*.[9]

6 *CIL* 6.40319 (with Alföldy's extensive restorations) = 31270 = *ILLRP* 434 = *ILS* 128 = Lott 2004, no. 1 = EDCS-00900022 (Antiquarium comunale del Celio, inv. 4076) from the collis Salutaris near the Porta Salutaris (at the crossroads of present-day Via della Consulta and Via Quirinale). The fragment measures 47×36×10 cm. See also Coarelli in *LTUR* on the temple of Salus. *CIL* 10.4830–1 = *ILS* 80 = EDCS-20400619–20 show that Agrippa and Octavian were honored by a vicus in Campania in 29 BC.

7 For the images of Marius Gratidianus in the vici, see Cicero *Off.* 3.80; Pliny *Nat.* 33.132, 34.27, with Sehlmeyer 1999, 199–201 and in *LTUR*; Marco Simon and Pina Polo 2000; Gradel 2002, 51; Lott 2004, 49–50, 59, 171; and Flower 2006, 94–95, 306 n. 23. For Sulla, see *CIL* 6.1297 = *ILS* 872 = *ILLRP* 352 = EDCS-17800202 from the Vicus Laci Fundani, with commentary by Ramage 1991, 110, quoted and discussed in section III.xxii with figure III.18.

8 For a fuller list of Latin authors, see appendix 1.

9 The following references in Augustan poets are listed in roughly chronological order. From the 20s BC: see Horace *Sat.* 2.3 and 2.6.50; Vergil *Georg.* 2.382; Tibullus 1.1.20; Propertius 2.20.22 and

Octavian's victory over Antony and Cleopatra in the East was celebrated by a splendid triple triumph on 13th, 14th, and 15th August 29 BC.[10] As an integral part of these festivities, Octavian once again turned to the city population as he invited them to celebrate his military successes with him, rivaling the grandest parties put on by earlier generals. His patronage of local festivities and theatrical performances during these August days reached into the neighborhoods of the city and catered to the tastes of plebeians and even the humblest inhabitants. These celebrations are alluded to by Vergil in his description of Actium on the shield of Aeneas in book 8 of the *Aeneid* in a way that suggests his readers remembered them over the following decade.[11]

Octavian had taken part, at the age of sixteen, in Caesar's magnificent triumph in April of 46 BC, when the parade of booty and captives was spread over four whole days. His personal experience of that unique celebration surely informed both what he chose to imitate and what he did not. Some seventeen years later, he kept his own triumph to three days, stressed his victories over foreign enemies rather than over his Roman rivals, and made this both his first and his last triumph. In other words, in his new role as princeps and under his new name of Augustus he never chose to celebrate a traditional triumph himself. Rather, he preserved and enhanced the memory of that very special triple triumph precisely by not repeating a similar ceremony, even after the month of that celebration had itself been renamed from *Sextilis* to *Augustus* in honor of his achievements.

In 28 BC, Octavian again imitated his adopted father (Julius Caesar), this time in conducting a census of the city population based on the lists kept by homeowners and landlords in the vici.[12] Such lists had been useful in helping to organize distributions at the local level, most recently as part of his magnificent triumphal celebrations a few months earlier. Even as he held the traditional office of censor and set out to count all Roman citizens in the city, the methods he used were those of the dictator Caesar, not those of the traditional censors of republican Rome, whose regular role he did not restore. In other words, Octavian was fully engaged both with administration and with spectacle in the city even at the most local level, well before the redefinition of his position in 27 BC or his great urban reform twenty years later.

Consequently, although most fine details have not been preserved, we can see that his administrative initiatives, his attempts to provide entertainment for the local inhabitants, and his communication of political messages specifically aimed at ordinary people were based on a deep appreciation of the value of local knowledge. That knowledge was drawn from the vicus, the fundamental unit of urban and community life. As discussed in part III, each vicus, with its crowd of landlords and shopkeepers, was administered by local *vicomagistri* who communicated

2.22a.3; Horace *Odes* 3.23.4; and Tibullus 2.1.60, 2.4.54. From the mid-to-late teens: see Propertius 4.1a.23, 4.3.54–57; Horace *Odes* 4.5.34. For discussion of *lares* in Tibullus, see also Papakosta 2012.

10 For the triple triumph, see *Tr. Barb.* under 29 BC, *RGDA* 4 (cf. 27.1), Livy *Per.* 133, Suetonius *DA* 12 (with Wardle 2014 ad loc.), and Dio 51.21.5–9. Gurval 1985, 19–36, provides a detailed account (he plays down the celebration of the Actium victory). For an overview of the celebrations and honors of 31–29 BC, see Osgood 2006, 303, 384–85, 390–96, with 298, for the triumph of 36 BC.

11 See Vergil *Aen.* 8.715–27 for a poetic version with Louis 2010, 343.

12 For Julius Caesar's census *vicatim*, see Suetonius *DJ* 41.5 and the *Tabula Heracleensis*, with Nicolet 1985. Lo Cascio 2008 provides the best overview of the evidence and its discussion by scholars. See also Tarpin 2002, 98–99; Virlouvet 1995 and 2009; Lott 2004, 63–65; and Wallace-Hadrill 2008, 290–93. For Augustus' census, see Suetonius *DA* 40.2: *populi recensum vicatim egit* (he carried out a counting of the people by vicus) with Louis 2010 and Wardle 2014 ad loc.

regularly with the city administration, the annually elected magistrates, and now ultimately with the princeps as leader of Rome. Suetonius suggests that Augustus enjoyed attending local entertainments in person and made a point of sharing his enthusiasm for popular spectacles, especially the informal (undoubtedly bloody) boxing matches, with ordinary people in the narrow alleys.[13] In this practice he differed both from Julius Caesar, who had made himself unpopular by doing paperwork even at public festivals, and from his successors, who would concentrate on staging increasingly elaborate mass spectacles in vast new arenas, built in central public locations.[14]

In the only reference to *lares* in his *Res Gestae*, Augustus himself confirms that the temple of *lares in summa sacra via* was one of the temples that he claims to have "built" (*feci*).[15]

Aedes in Capitolio Iovis Feretri et Iovis Tonantis, aedem Quirini, aedes Minervae et Iunonis Reginae et Iovis Libertatis in Aventino, aedem Larum in summa sacra via, aedem deum Penatium in Velia, aedem Iuventatis, aedem Matris Magnae in Palatio feci.

I (re?)built the temples of Jupiter Feretrius and Jupiter the Thunderer on the Capitol, the temple of Quirinus, the temple of Minerva and Juno the Queen and of Jupiter the Liberator on the Aventine, the temple of the *lares* at the highest point of the Sacred Way, the temple of the Ancestral Gods on the Velia, the temple of the God of Youth, the temple of the Great Mother on the Palatine.

(*RGDA* 19.2)

Despite his bold claim, there is every reason to believe that in this case, just as in the other temples in this list, Augustus restored or rebuilt an existing sanctuary rather than founding a new temple in a newly consecrated location. The controversies surrounding the topographical position of this temple are discussed in section II.xi earlier. Since the temple of the *lares* is included in a list of (prominent) temples of the state cult patronized by the princeps, and is described as an *aedes* by Augustus, it is logical to assume that it was indeed a temple and not simply a small shrine. It was definitely not a compital altar at a crossroads, since these were never described as *aedes* and are in any case not mentioned in the *Res Gestae*. This *aedes* would have received a new inscription in the princeps' name presumably with the same verb *feci* that he used in his later account. Its restoration could certainly have fitted in with the program of rebuilding temples that he sponsored in the early years, perhaps around 28 BC. Alternatively, if the list in this sentence of the *Res Gestae* is arranged chronologically, then the restoration would have happened around or shortly before 16 BC, based on the dates of the temples that are mentioned before and after. This later date would put the rebuilding around the

13 Augustus in the vici: Suetonius *DA* 45.2 cited in the epigraph to this section with Mann 2002, 125–30, and commentary by Wardle 2014, 337.

14 For Julius Caesar at the games, see Suetonius *DA* 45.

15 The *lares* temple is mentioned between the temples of Minerva (restored in 16 BC) and of Iuventas (also in 16 BC). Last in the list is the temple of Magna Mater on the Palatine, restored in AD 3. For those who associate this temple directly with the dedication to the *lares publici* of 4 BC, the restoration has traditionally been taken either to predate or to be contemporary with that *stips* inscription. See section II.xi for more discussion of this temple and its location.

time of the new golden age inaugurated by the Secular Games (*ludi saeculares*) in 17 BC, ten years before the compital reform. In either case, the restoration of the temple seems to predate, and to be separate from, the introduction of the *lares augusti* at the *compita* and the dedication to *lares publici* by Augustus from 4 BC (discussed later). *Lares* were honored by Augustus throughout his life in many settings according to Roman tradition.

Similarly, Suetonius mentions ludi associated with the local neighborhood festival of Compitalia in a list of ancient religious festivals that Augustus revived and restored.[16] Just as the temple of the *lares* is listed with other prominent temples of the civic religion, so also the games held at Compitalia occur naturally to Suetonius in the same category as other great priesthoods, traditional rituals, and public festivals of great antiquity. Interestingly, he juxtaposes the annual celebrations for local *lares* with the unique *ludi saeculares* of 17 BC.

> Nonnulla etiam ex antiquis caerimonis paulatim abolita restituit, ut Salutis augurium, Diale flamonium, sacrum Lupercale, ludos Saeculares et Compitalicios.

> He also restored several of the ancient ceremonies that had fallen into disuse over time, such as the Augury of Safety, the priesthood of the flamen Dialis, the sacred Lupercal, the Secular Games and the games at the Compitalia.
> (Suetonius *DA* 31.4)

As discussed in detail earlier in section III.xvii, Compitalia was traditionally a movable feast that fell after the great celebration of Saturnalia in late December or early January. It would eventually be fixed on 3rd to 5th January in the later empire, but was still movable under Augustus.[17]

Suetonius here lists more "revivals," although some of the festivals he mentions in his list were hardly obsolete in the first century BC.[18] The example of the Lupercalia, famously celebrated together by Caesar and Antony a month before the Ides of March in 44 BC, is only the most obvious one.[19] Augustus may well have reformed its celebration. Compitalia as a religious holiday was certainly being celebrated continuously throughout the first century BC; Augustus "restored" its ludi (whether by reintroducing some aspects or by reorganizing them) in the context of the traditional winter festival.

Fortunately, as we have seen, Dionysius of Halicarnassus provides contemporary testimony about this neighborhood festival since, as he himself tells us, he came to Rome immediately after Octavian's victory in the East in 30 BC but wrote before

16 Wallace-Hadrill 2008, 266–69, has Julius Caesar restore full celebration of Compitalia in the 40s BC, whereas Rüpke 1998, 27–44; Scheid 2001b; Fraschetti 2005, 227; and Louis 2010, 271, put the revived ludi in or soon after 12 BC. See also Tarpin 2002, 106–8. For an overview of imperial festivals in Rome, see conveniently Benoist 1999, 299–316. As argued in section III.xxii, the ludi may only have been banned for a few years.

17 See *II* 13.2.390–91, with Meslin 1970, 46–49, 54. Evidence comes from the Calendar for January from AD 354, as well as mosaics in Carthage, Catania, and St. Romain en Gal.

18 Wardle 2014, 255–56, takes Suetonius very much at his word here and proposes that the games had been banned under Julius Caesar's *lex Iulia de collegiis* (Suet. *DJ.* 42.3, with Yavetz 1983, 85–96). This interpretation relies on the traditional equation between *collegia* and ludi.

19 For the Lupercalia festival, see Ulf 1982; Wiseman 1995b; Binder 1997; Fraschetti 2005, 225–26; and Louis 2010, 271.

the urban renewal of 8/7 BC.[20] Dionysius remarks on the visibility and vitality of Compitalia, which he recognizes as the most important annual festival in the vici (as discussed in section III.xvii). He does not mention ludi but this is not surprising since he does not describe the celebrations themselves in any detail.[21] Consequently, Augustus seems to have patronized the festival and fostered a renewed local celebration of civic identity. Compitalia (together with the local census and its associated updating of food distribution lists) attests to the role of *vicomagistri*, who were both administrators and religious celebrants within the context of each neighborhood and at its principal shrine, the *compitum* at the crossroads.[22] In sum, religious and civic activities centered both on the vici and at the *compita*, their cults and local festivals, were integral parts of Augustus' ongoing urban project over the decades before his introduction of *lares augusti* in 7 BC.

In addition to the probably increasingly splendid observance of Compitalia, the beginning of January was a time when local people came to commemorate and to celebrate their relationship with the princeps, as their benefactor. Perhaps even before the two new consuls (who would give their names to that year) started to take office on 1st January, the New Year had been one of the traditional times for exchanging gifts between family members and friends in Roman culture.[23] Augustus played on a variation of this custom when he set up a regular, annual gift exchange between himself and the inhabitants of the city on every 1st January. By no coincidence, this day also marked the occasion for soldiers in Rome's armies to swear their annual oath of allegiance to the princeps in the presence of his image, in their winter camps or wherever else they might be stationed.[24]

Notices both in Suetonius and in Dio, as well as a series of inscriptions from Rome, reveal the custom for ordinary Romans in the city to give the princeps a small monetary gift known as *stips* or *strena* on the first day of each calendar year, a token of their esteem and their good wishes for him in the coming year.[25]

> Omnes ordines in lacum Curti quotannis ex uoto pro salute eius stipem iaciebant, item Kal Ian. strenam in Capitolio etiam absenti, ex qua summa pretiosissima deorum simulacra mercatus uicatim dedicabat, ut Apollinem Sandalarium et Iouem Tragoedum aliaque.

20 Dionysius of Halicarnassus (1.17) says he came to Rome at the end of the civil war, in the middle of the 187th Olympiad (that is, 15th August 32 BC–13th August 29 BC), which should be in 30 BC. He then stayed for twenty-two years, which would bring him to 9 BC counting inclusively. He should, therefore be writing and publishing soon *before* the urban reform of 7 BC. See Lott 2004, 30–37, 99, and Fraschetti 2005, 224–25. Wiater 2014, 1–50, gives an excellent introduction to Dionysius in his Roman milieu.

21 Rüpke 1998 and Louis 2010, 271, both date the new games after Augustus became *pontifex maximus* in 12 BC. Scheid 1999, 18–19, dates the revival to the year 12 BC itself. Suetonius' list may in itself imply a date after 17 BC if it is arranged chronologically. Lott 2004, 35–37, suggests the games were reformed in 7 BC, at the same time as the larger urban reorganization.

22 *Vicomagistri* before 7 BC are stressed by Tarpin 2002, 330, 347–48, and Lott 2004; contra Fraschetti 2005, 113–242. Wallace-Hadrill 2008, 264–69, provides a useful overview of republican vici but ascribes little value to Dionysius' account.

23 Meslin 1970 is still the fundamental discussion, esp. 39–46, with Graf 1998.

24 Dio 51.19.7 and 59.3.4, with Meslin 1970, 28, and Scheid 2001, 99.

25 For discussion, see Meslin 1970, 31–34; Tarpin 2002, 108–9; Lott 2004, 73–80, 115; as well as the commentaries of Louis 2010 and Wardle 2014 for Suetonius *DA* 57.

Every year, all classes (of citizens) tossed an offering (*stips*) into the *lacus Curtius* (in the Roman Forum) to mark a vow for his (Augustus') good health and safety. In the same way, on the 1ˢᵗ January (they donated) a gift (*strena*) on the Capitol, even when he was away. From these collected funds he acquired very valuable statues of the gods and dedicated them in the local neighborhoods, for example Apollo Sandalarius and Jupiter Tragoedus and others.

(Suetonius *DA* 57)

Suetonius mentions two collections, one at the *lacus Curtius* in the forum on an unspecified day and another specifically on the first of January on the Capitol, the latter being observed even when Augustus was away from Rome. Epigraphic evidence confirms what Suetonius says but the inscriptions call this collection *stips* rather than *strena*; the Latin terms were perhaps interchangeable, even as both customs were probably observed for the New Year.[26] Augustus, in turn, used the money he had been given, collected from many small donations and carefully designated by year, to pay for very expensive (*pretiosissima*) new statues of gods that he set up as his own gifts in the local neighborhoods, labeled with his name but also with the year of each *stips*.

Suetonius, who organizes his material thematically, does not indicate how, why, or when this gift exchange started. Dio records the custom under the year 11 BC, which would have been the first year that started with Augustus as *pontifex maximus*, but the vagueness of his language does not make this date seem secure even purely in the context of his own account.[27]

ἐπειδή τε ἀργύριον αὖθις ἐς εἰκόνας αὐτοῦ καὶ ἐκείνη καὶ ὁ δῆμος συνεσήνεγκαν, ἑαυτοῦ μὲν οὐδεμίαν, Ὑγιείας δὲ δημοσίας καὶ προσέτι καὶ Ὁμονοίας Εἰρήνης τε ἔστησεν. ἀεί τε γὰρ ὡς εἰπεῖν καὶ ἐπὶ πάσῃ προφάσει τοῦτ᾽ ἐποίουν, καὶ τέλος καὶ ἐν αὐτῇ τῇ πρώτῃ τοῦ ἔτους ἡμέρᾳ οὐκέτι ἰδίᾳ που κατέβαλλον αὐτό, ἀλλ᾽ αὐτῷ ἐκείνῳ προσιόντες οἱ μὲν πλεῖον οἱ δὲ ἔλαττον ἐδίδοσαν. καὶ ὃς προσθεὶς ἂν ἕτερον τοσοῦτον ἢ καὶ πλέον ἀντεδίδου, οὐχ ὅπως τοῖς βουλευταῖς ἀλλὰ καὶ τοῖς ἄλλοις.

When the senate and the people once more contributed money for statues of Augustus, he would set up no statue of himself, but instead set up statues of Salus Publica, Concordia, and Pax. The citizens, it seems, were nearly always and on every pretext collecting money for this same object, and at last they ceased paying it privately, as one might call it, but would come to him on the very first day of the year and give to him in person, some more, and others less; and he, after adding a matching contribution or even more, would return it, not only to the senators but to all the rest.

(Dio 54.35.2)

26 For *strena*, see also Festus 410L, who defines it as a gift on a holy day that sought good luck for the recipient.

27 Dio 54.35.2, who dated the first gift to the year 11 BC, represents the statues of local deities as substitutions for statues of Augustus himself, which the princeps did not want to put up throughout the city. The earliest *stips* text we have dates to 10 BC. See Palombi in *LTUR* under *Ianus, Concordia, Salus, Pax, sacellum, statuae et ara* for discussion of Augustus' gifts of statues to the vici.

Dio, therefore, connects the origins of the custom with the desire of ordinary people to have statues of Augustus erected throughout the city, an issue that one imagines had surely come up well before 11 BC. The princeps skillfully redirects this impetus to spending the funds on especially opulent images of gods, distributed in local areas, and (according to Dio) adding further contributions at his own expense. If Augustus donated his own funds (as matching grants?), he did not choose to record that fact in any of the surviving inscriptions, which describe the dedications in a straightforward way as made in the name of the princeps but entirely paid for by the *stips* collected on a particular new year's day. In other words, in a continuous and seasonal cycle of gift giving ordinary Romans gave Augustus money as a token of their appreciation at the New Year; he in turn used these funds to give statues to gods in Rome, thus creating new monuments (at existing cult sites) labeled in joint commemoration of his own generosity and of the gifts of the people to him. These special statues recalled Augustus' popularity and piety precisely in the vici, which they enhanced.

There can be no doubt that both Suetonius and Dio are referring to the same custom, although the details they record are a bit different. Meanwhile, it is important to keep in mind that this New Year's ritual was very particular to Augustus himself and that it soon fell from favor under his successors.[28] In other words, Suetonius (in the early second century AD) and Dio (in the early third century AD) were no doubt familiar with some of the statues and inscriptions put up under Augustus, but not with the actual gift exchange itself or with the associated mechanisms for choosing each venue and completing the dedication of its new statue in the princeps' name.

So far, five similarly inscribed statue bases for *stips* dedications have come to light, each from a different year for a different deity in a different part of Rome.[29] (See figure IV.1.) These surviving texts date over a period of twenty years, between 10 BC and AD 10. The inscriptions reveal that a reciprocal relationship between Augustus and the people, based around the setting up of religious statues in neighborhood contexts, was well established and continuous both before and after Augustus donated new statues of *lares augusti* at the *compita* in 7 BC. Indeed, just as it seems very likely that the custom continued to the end of Augustus' life (AD 14), so also we may imagine that this New Year's gift exchange had started earlier than the oldest surviving example we presently know of. It could even have originated in the triumviral period, when Octavian was building the image of societal consensus he relied upon, perhaps in the mid-30s, after the defeat of Sextus Pompeius and the retirement of Lepidus from public life or more plausibly at the time when Agrippa was aedile and the triumviral powers were on the point of expiring. Alternatively, it could have been initiated around the time of the settlement of 27 BC, when the new name of Augustus and other honorific badges were bestowed on Caesar's heir. (See figure IV.2.)

If we combine the information from Suetonius and Dio with the epigraphical evidence, the list of gods honored by the princeps in the city includes Concordia, Salus Publica, Pax, Mercury, Apollo Sandalarius, Vulcan, Jupiter Tragoedus, and the *lares publici* (as well as epigraphical evidence for dedications to two more gods whose names have not been preserved). The list is obviously heterogeneous and also

28 See de Angeli 2001, 207–8.
29 The five extant *stips* texts are discussed together in Panciera 1980, 205–6.

IV.1. Plan of Augustan Rome, showing locations of New Year's dedications (*stips*): (1) Mercury 10 BC; (2) Vulcan 9 BC; (3) unknown deity 8 BC; (4) *lares publici* 4 BC; (5) unknown deity AD 10.

varies according to our source of information. Suetonius displays his interest in local cults by mentioning Apollo Sandalarius, presumably from the well known Vicus Sandalarius, and the otherwise unattested Jupiter Tragoedus.[30] By contrast, Dio is especially focused on cults of more abstract deities (Concordia, Salus Publica, Pax), who were also popular recipients of civic ritual in public contexts. Unlike the *lares* honored by Augustus in 7 BC, none of these deities received the epithet *augustus/a*, not even Pax, who was so designated by the senate in 13 BC. Even if only one new statue was paid for by each annual fund as the inscriptions so far suggest, there would have been many of them throughout the city.[31]

For our present purposes, the dedication to the *lares publici*, which was funded by the *stips* of 4 BC, is obviously of special interest. This dedication is attested by an inscription cut from a marble statue base (presently in Naples), which was discovered in the mid-sixteenth century near the arch of Titus at the foot of the Palatine.[32] The lettering and wording of the dedicatory text are similar to those for the other two inscriptions that survive intact, which are for Mercury on the Esquiline (10 BC) and for Vulcan at the Volcanal (near the arch of Septimius Severus) in the forum (9 BC). This base, however, is slightly smaller than the one for Mercury and much smaller than the monumental dedication for Vulcan.[33] Regardless of

30 For Apollo Sandalarius, see Coarelli in *LTUR*; for Jupiter Tragoedus, see Aronen in *LTUR*.

31 In other words, the time between 11 BC and AD 14 alone would have yielded twenty-five years of *stips* gifts. If the custom started as early as 35 BC, it could have been continuously practiced for almost fifty years.

32 In 4 BC for the *lares publici* (MAN Naples inv. 2606, *CIL* 6.456 = 30770 = *ILS* 99 = *ILMN* 10 = Lott 2004, no. 16= EDCS-17300609). For general discussion and bibliography, see de Angeli 2001.

33 The stone measures 115×89×10 cm, with letters ranging from 3 to 4.5 cm in height.

IV.2. Drawing of three *stips* texts (Mercury 10 BC, Vulcan 9 BC, *lares publici* 4 BC).

the iconography used for these particular *lares*, its width is modest (89 cm) for accommodating the statues of two gods side by side. Despite the use of marble and the fine quality of the letters in their typically Augustan style, the scale of the statue base suggests a local context. Conversely, the small size may also be related to the very expensive material(s) used for the statue, as suggested by Suetonius' description of these as exceptionally costly.[34] Expensive stone would have advertised the princeps' generosity and recalled his use of colored marbles in his major building projects in the city. Meanwhile, the epithet *publicus* recalls Dio's mention of Salus Publica as another recipient of a similar new year's dedication. The very well preserved text reads (see figure IV.3):

Laribus Publicis sacrum,
Imp(erator) Caesar Augustus,
pontifex maximus,
tribunic(ia) potestat(e) XVIIII,
ex stipe quam populus e[i],
contulit K(alendis) Ianuar(iis) apsenti
C(aio) Calvisio Sabino L. Passieno Rufo co(n)s(ulibus)

Sacred to the public *lares*, (given by) Imperator Caesar Augustus, pontifex maximus, holding the tribunician power for the 19th time, (financed) from the donation which the Roman people collected for him, in his absence, on the first of January in the consulship of Calvinius Sabinus and Lucius Passienus Rufus.

(*CIL* 6.456 = 30770 = *ILS* 99)

34 Evidence for silver statues at Narona (Croatia) offer a possible parallel for the use of precious metal; see Marin 1998 and Koortbojian 2013, 89 and 271 n. 35. Nevertheless, these statues were much later (ca. AD 200) and on a larger scale than most dedications we know of in the vici.

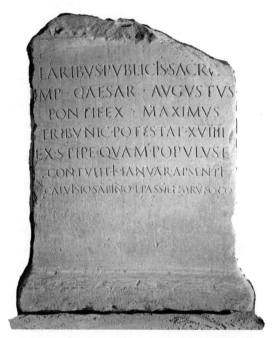

IV.3. Inscription from a marble statue base for Augustus' dedication to the *lares publici*. 4 BC. 115×89×10 cm. Museo Archeologico Nazionale di Napoli, inv. 2606.

As is the case with the other surviving inscriptions, this text is also notable for its clarity and a sparing use of abbreviations. It looks as if it was deliberately designed to be (relatively) easy to read. The formulaic language readily identifies it as part of the well-known New Year's series. Yet in this case the gods are named first in the text (rather than at the end) and their names are not in noticeably larger letters. Augustus' titulature is relatively brief here. This is the only source that indicates he was away from Rome at the beginning of 4 BC. It is possible that some language has simply been copied from another *stips* inscription, although the figure indicated for Augustus' tribunician power (XVIII) fits in with a date in the first half of 4 BC. The epithet "public" (*publici*) may also imply "of the Roman people" (*populi Romani*), although this idea obviously remains unelaborated here.[35]

As I have argued elsewhere with reference to the shrine of Mercury that is still in situ on the Esquiline, there is no reason to assume that all or even any of these New Year's dedications were necessarily at compital shrines.[36] When Suetonius says the statues were put up in the neighborhoods (*vicatim*) that does not necessarily mean specifically at the *compita*. There is certainly no other evidence that would make us identify the ancient Volcanal in the forum, recipient of a large new base and statue in 9 BC, as a *compitum*, whose principal gods were *lares* rather than Vulcan himself.

35 For *publicus* as applied to gods who protect the community, see *TLL* under section C. Examples include Val. Max. 3.2.17 for the *aedes* of Fides Publica and Pliny *Nat.* 21.11 for public and private *lares*, both of which received garlands as offerings.

36 See Andrews and Flower 2015 for full discussion and illustrations.

In the case of the *lares publici*, although the precise details of the archaeological context are lost, the dedication itself evidently honors *lares* who are specifically called *publici*, not *compitales* or *augusti*. In other words, this inscription provides clear evidence that Augustus honored other *lares*, even soon after introducing new *lares augusti* at the *compita*. The princeps' dedication of statues of these *lares publici*, protectors of the city and its people, on the ancient Sacra Via and near the place where he had himself been born almost 60 years before, draws attention to his veneration of these particular "public" *lares*. By contrast, the extant dedications to *lares augusti* were all made by *vicomagistri* or *ministri*, around this very same time. Again, the comparison with his slightly earlier dedications to Vulcan and to Mercury, suggests that Augustus was probably renewing an ancient cult site, now in disrepair or perhaps recently damaged, rather than founding a new one. Newer *lares* coexisted with much older ones, and each kind was venerated by Augustus.

The *lares publici*, therefore, need to be appreciated in their own, very special Roman context: given in celebration of a particular New Year, close to Augustus' sixtieth birthday, and adjacent to his birthplace. Yet, as was so often the case, these new associations with the princeps must have been enhanced by whatever traditions the existing cult already had. In addition, their statues (and open air shrine/ altar?) on the rise of the Sacra Via were situated in close proximity to several of the other *lares* shrines we know of.[37] As discussed in part II, there were notable *compita* at key urban nodes, next to the Meta Sudans (possibly the Compitum Fabricium) within view of these statues and at the Compitum Acilium, only a bit farther away (see figure II.11). These *compita* would presumably have received new statues of *lares augusti* from the princeps as part of the urban reform only three years before. In addition, the foundations of a possible republican *compitum* (which would no longer have been in place under Augustus) have been identified near the intersection of the Clivus Palatinus on the same side of the road as these statues of *lares publici*. The *aedes* of *lares in summa sacra via* was also not far away. Both in space and in time, therefore, these "public" *lares* had a central position in the city as restored and reimagined by Augustus, even as they reiterated his image as a restorer of traditional cults on hallowed ground.

In conclusion, Augustus' urban intervention in 8 and 7 BC needs to be read within the historical and political context of his role and image in the city since the mid-40s BC. Augustus' decision to extend his patronage in a special way to *lares* at the compital shrines of each Roman neighborhood came after decades of interactions with Rome's population, some carefully staged, some more spontaneous and even chaotic. Surely not coincidentally, Augustus' censorial powers of 8 BC marked the 25th anniversary of Agrippa's famous aedileship. The urban reform he put in place at that time was carefully planned and designed to build on what had come before. Meanwhile, initiatives such as the New Year's gifts continued each year, by their very nature independent of the compital reforms. It was on New Year's day that people gave a present to Augustus, not at the Compitalia, although that festival was celebrated in the days immediately around 1st January.

In 12 BC, five years after the new age celebrated by the *ludi saeculares*, Augustus became *pontifex maximus*. Many new initiatives in the religious sphere soon followed, as this priesthood now gave Augustus a distinctive role, one that he had been waiting patiently for over many years. The appointment of a new *flamen*

37 For discussion of *lares* shrines in Rome, see sections II.xi–xiii.

Dialis after a hiatus since the 80s BC would certainly fit well into this time of religious renewal. According to Dio, the first New Year's gift of a *stips* would have marked the first January of Augustus' new high priesthood. Five years later, the new ludi at the reformed Compitalia in honor of the new *lares augusti* also followed naturally, both within a context of religious initiative and of urban reform.

The cult of *lares augusti* must, therefore, especially in its early years, have appeared as a very bold and particular new initiative. As far as we can tell from the surviving evidence, with the obvious exception of his two completely new manubial temples, virtually all of Augustus' previous attention to existing cults, priesthoods, and sanctuaries had been carefully presented in the guise of "restoring" or "upholding" traditional Roman religious practices: Augustus was the self-described savior of Rome and of its traditional values and religious customs. Regardless of the precise accuracy (in each particular case) of such revivalist claims, the official story had been remarkably consistent over the decades. Nevertheless, in 7 BC Augustus departed from his familiar script and deliberately launched a "new era" in the local neighborhoods of the city to coincide with a reformed cult of *lares* at the crossroads shrines, all in his own name and in his special month.

XXV THE REFORM OF 7 BC

> Spatium urbis in regiones uicosque divisit instituitque, ut illas
> annui magistratus sortito tuerentur, hos magistri e plebe
> cuiusque viciniae lecti.
> —SUETONIUS *DA* 30.1

A wealth of epigraphical and artistic evidence attests to the date and widespread effects of Augustus' reforms of city administration and local religion in Rome. The new *lares augusti*, described explicitly by the *vicomagistri* of one neighborhood as a gift of the princeps to them, are directly associated with the start of a new era of office-holding by these same local officials, now counting from 1st August 7 BC.[1] A variety of finds document the enthusiasm with which *vicomagistri* adorned their local cult sites with new altars, small sanctuaries *(aediculae)*, pavements and steps defining their consecrated space, and other accoutrements.[2] A sudden proliferation of dedications to other deities, now also called *augusti* (apparently based on local and individual initiative), may also include material that was dedicated close to or in conjunction with the compital shrines themselves, as well as providing a range of evidence for other possible local shrines in the charge of the *vicomagistri*. These "other" new august gods are discussed separately later in section IV.xxx. Our initial focus, however, must be on *lares augusti* themselves in the context of their traditional *compita*.

Unlike the examples of local statues of gods discussed in the previous section, neither the extant material from the *compita* of the *lares augusti* nor any of the other dedications to august gods was paid for by Augustus. Everything we have so far in honor of the *lares augusti* was commissioned by locals, predominantly by the neighborhood magistrates, the *vicomagistri* (freedmen) or their associates and helpers, the *ministri* (slaves).[3] The main focus of the compital shrines, whose situation at the crossroads continued to have its traditional religious value in the sacred topography of the city, was consistently on *lares*, who are usually the only deities to be depicted on the altars dedicated in their name.[4] No inscription on these dedications to *lares augusti* refers to another god.

1 Galinsky 1996, 308: "Religion was the conduct of social policy by other means." For the reform of 7 BC, see esp. Coarelli 1988 and 2008; Zanker 1988, 129–35; Beard, North, and Price 1999, 184–86; Gradel 2002, 116–28; Tarpin 2002, 137–63; Lott 2004, esp. 84–98 (mechanics), 96–106 (ideology), 118–28 (policy); Fraschetti 2005, 224–28; and Wallace-Hadrill 2008, 275–90, 301.

2 It is important to stress that no *compitum* in Rome has been found intact and in situ so far. Laurence 2007 has argued that only Pompeii has yielded fully extant *compita* in situ. See also Lott 2004, 136–48.

3 For named Augustan *vicomagistri*, see Lott 2004, 92–94 table 1: Twenty-eight inscriptions have yielded seventy-five names so far. No imperial freedmen appear, although no. 8 records slaves of an imperial freedman (Lott 2004, 97). Most gifts are relatively thrifty and suggest that the wealthiest did not participate. Lott 2004, 96–97: "The continuing social restrictiveness of the office of *magister vici* is one of the most significant features of the Augustan neighborhoods." On the basis of an altar that shows two women pouring libations (Museo Nazionale Romano inv. 49481), Galinsky 1996, 308, argues that women could also be in the local associations and take part in cult (contra Lott, 2004, 98). See section III.xxi for female *magistrae* at Minturnae.

4 Coarelli 1988, 79, sees the compital cult of *lares augusti* as an example of radical novelty disguised as tradition. By contrast, Tarpin 2002, 135: "plus un mélange d'archaïsme et de nouveauté que comme une veritable révolution" (more a mix of archaism and novelty than a real revolution). Scheid 2001, 102–4, stresses the religious importance of compital cult. A winged Victory is the

An outline of the actual reform of 7 BC, however, can only be pieced together from scattered and brief references in ancient authors.[5] Three ancient authors allude directly to the moment of reform, but without giving a detailed narrative account of the events as they unfolded. In chronological order they are Ovid (a generation younger than Horace and writing his poem *Fasti* in the early first century AD), Suetonius (active in the early second century AD), and Cassius Dio (in Rome in the early third century AD). All three had lived in the city for years and were familiar with the imperial households of their day, in one capacity or another.

Despite being a contemporary of Augustus and a resident of Rome around 7 BC, Ovid is the least useful of these writers because an account of 1st August in his calendar poem called *Fasti* is either lost or, more probably, was never written at all.[6] Nevertheless, he is clearly interested in *lares* of various kinds and refers specifically but allusively to the new cult of *lares* at the *compita* in his entry for 1st May.[7] He stresses the myriad new *lares* throughout the city but then hurriedly puts off further discussion to the month of August. A more detailed account under the anniversary of the new era of the *vicomagistri* associated with the introduction of the *lares augusti* would undoubtedly have been invaluable.

Without much help from Ovid, we are left with the two later prose accounts of Suetonius and Dio. Dio, who was writing more than 200 years later, records the urban reform under the year 7 BC and highlights the responsibilities entrusted to the *vicomagistri* (whom he calls *stenōparchoi* in Greek, that is, "commanders of the alleyways").[8] However, he focuses purely on their administrative duties, with special attention to their responsibility for fighting fires. He does not discuss the religious aspects of their magistracy. His representation of the urban reform, a program that he only dimly perceives as a systematic reorganization of the whole city, describes it purely as a reaction to one large fire near the forum area, which had supposedly been set by debtors seeking relief from their financial constraints. This is obviously insufficient as an explanation or context for a complete restructuring of city administration. Dio realizes that Augustus instituted reforms that created important aspects of city administration still in operation in his own day. Although he had himself risen to the rank of consul (over 220 years after the reform), he does not know the extent or focus on the details of this Augustan reform, nor does he place it in the context of ongoing urban renewal. Meanwhile, Dio's lack of interest in the compital shrines may stem from simply taking for granted a cult practiced by the humble, whose religious experiences were evidently not on his horizon and certainly not the subject of his book about Roman history. Yet we know from inscriptions that *vicomagistri* in Dio's Rome were still counting their local eras from

only deity other than the *lares* on any of the extant altars; she appears on the Belvedere altar and the altar from the Vicus Sandalarius.

5 See note 1 in section xxv earlier. Tacitus *Ann.* 15.40.4; Dio 55.8.7, with Wallace-Hadrill 2008, 259–312, esp. 275–76. For general treatments of Augustan Rome, see Favro 2005, Haselberger 2007, Erdkamp 2013, and Evans 2013.

6 See Pasco-Pranger 2006, 295–96, for a concise analysis of the question of whether the poem was ever finished or not. For the related question about the date of the version we have, see Robinson 2011, 525–31. Ultimately, we cannot know exactly when any particular passage of the *Fasti* was written or edited.

7 Ovid *Fast.* 5.111–58.

8 Dio 55.8 and 9.1.

7 BC, even as they were restoring and renewing the altars and shrines for *lares augusti* at their own expense.[9]

By contrast, Suetonius, writing under Hadrian, provides a number of useful references to Augustus' urban reforms, albeit in very succinct form and scattered by topic throughout his biography of the first princeps, rather than treated as a chronological moment or a discrete subject in its own right. He records the redistricting of the city (by the larger regio and the smaller vicus) and the appointment of local *vicomagistri*.[10]

spatium urbis in regiones uicosque diuisit instituitque, ut illas annui magistratus sortito tuerentur, hos magistri e plebe cuiusque uiciniae lecti.

He divided the area of the city into *regiones* and *vici*, and established that they should be overseen by magistrates chosen annually by lot, and that these magistrates should be drawn from the *plebs* of each neighborhood.

(Suetonius *DA* 30.1)

It is an indication of his extreme brevity that Suetonius does not explain the striking difference between the four old regiones (traditionally thought to predate republican government) and the fourteen new Augustan ones. Similarly, as discussed earlier, he simply mentions in a list of diverse religious revivals the reintroduction of *ludi compitalicii* without telling us what this entailed or exactly when it happened.[11] He does tell us elsewhere about theatrical productions Augustus sponsored in the vici, apparently on various occasions, plays put on in "all" the languages.[12] Such performances may also have become a regular part of the Compitalia. His description of Augustus sometimes attending local boxing matches also makes sense in this same context; such events are depicted in second century BC wall-paintings from Delos. In effect, Suetonius is in many ways the most informative author when it comes to Augustus' interventions in local life in the city. Nevertheless, the *compita* and vici themselves are not a topic he has chosen to highlight in his biography of Augustus.

It is also to Suetonius that we owe our only information about two new annual flower "festivals" that Augustus instituted at the compital shrines in the spring and summer, presumably also starting in 7 BC.[13]

9 For third-century inscriptions with the Augustan vicus era, see *CIL* 6.30959 = EDCS-18600505, *AE* 1946, 189 = EDCS-15100069, *CIL* 6. 30961 = EDCS-18600506, *CIL* 6.30960 = *ILS* 3621 = EDCS-18600557, and *CIL* 6.453 = *ILS* 3616 = EDCS-17300606 (Lott 2004, nos. 43–47).

10 See Kolb 1995, 400–409; Louis 2010; and Wardle 2014 ad loc., and Fraschetti and Palombi in *LTUR*. Daguet-Gagey 2015, 428–30, gives an excellent overview of Augustus' urban reforms.

11 Suetonius *DA* 31.3.

12 Suetonius *DA* 43.1: *fecitque nonnumquam etiam uicatim ac pluribus scaenis per omnium linguarum histriones*... (he frequently put on theatrical performances in all languages even in the neighborhoods and on many stages). For the text, see Kaster 2016b, 105–7. Louis 2010 ad loc. takes this to mean Latin, Greek, Oscan, and Etruscan, whereas Wardle 2014 ad loc. does not think Etruscan would still have been in use. See also Suetonius *DJ* 39.1 for the celebrations after Julius Caesar's victory at Munda described in a very similar way. See also König 2005, 229–30.

13 See Louis 2010 ad loc. for a traditional interpretation. Wardle 2014, 256, suggests 1st May and 27th June for the new festivals, commenting "Augustus' restoration of the games and cult was not motivated by romantic antiquarianism or idealism but by his desire to channel the dangerous energies of the ward associations (*collegia*) into safer, and more controlled avenues."

compitales lares ornari bis anno instituit uernis floribus et aestiuis.

On his initiative, the *lares* at the crossroads shrines were to be adorned twice
a year with spring and summer flowers.

(Suetonius *DA* 31.4)

Presumably, he means that Augustus arranged for public funds to decorate the city's
compita on two additional days in the year. Yet, even in this specifically compi-
tal context, Suetonius does not mention the *lares augusti* at all! In effect, he still
calls the *lares* at the crossroads *compitales*. His silence is mirrored by the similar
omission of the compital reform in Augustus' own *Res Gestae*.[14] Meanwhile, Au-
gustus' autobiography written in Greek (in thirteen books) did not go beyond
the mid-20s BC, or perhaps even ended with his triple triumph of 29 BC.[15] It was
not an account of the new "Augustan age" in Rome in Augustus' own words.

To sum up the state of our available sources: the contrast between the detailed
contemporary information for the administrative and religious innovations of 7 BC
provided by inscriptions (and their related images) and the cursory and incomplete
references in literary texts is frustrating but not entirely surprising. Educated Ro-
mans (of senatorial or equestrian rank such as Dio and Suetonius) did not express
an interest in the administrative details of Augustus' great redistricting of the city.
By their day, the fourteen regions were simply a matter of course. Similarly, if they
were informed about religious life and traditions at the compital shrines and in the
vici, they did not choose to write about these topics in the context of their literary
works (biography [Suetonius] and general history [Dio], respectively). Perhaps
other authors whose accounts have not survived took a greater interest. Unfortu-
nately, we have nothing for the vici equivalent to Frontinus' account of the aque-
ducts and the organization of the water supply in Rome.[16] Meanwhile, our situation
could be much improved by the careful excavation of even a single intact compital
shrine in situ using the techniques of contemporary, scientific archaeology.[17]

Nevertheless, even without explicit ancient commentary we can see that the re-
form of compital cult was an unprecedented intervention in the Roman religious
landscape in a number of ways. The reform was not equivalent to the construction
of a new temple with booty money (*de manubiis*) by a general in fulfillment of a vow
made on a battlefield, which was the most usual way in which new cults had been
introduced to the city over the last several centuries.[18] Augustus dedicated two
important temples in this customary manner, to Apollo on the Palatine (vowed in
36 BC before Naulochus, dedicated in 28 BC) and to Mars Ultor (vowed in 42 BC
at Philippi, but dedicated only in 2 BC).[19] These magnificent temples served to

14 For the *RGDA*, see now the revised text with commentaries by Scheid 2007 and Cooley
2009. Scheid 2001, 86, notes the absence of the reform of 7 BC, but attributes this (surely correctly)
to the nature of the text, rather than to the (un)importance of the reform.

15 For Augustus' autobiography in Greek, see Smith 2009 for the most recent edition of the frag-
ments and *testimonia* with discussion and bibliography and the essays in Smith and Powell 2009.

16 See Peachin 2004 for a full discussion of Frontinus in context.

17 The recently excavated *compitum* at the Meta Sudans (see section II.xiii) is effectively an
empty space. We do not know anything about its altar(s), paving, trees, or other possible features.

18 For republican temples built with booty money, see Aberson 1994 and Orlin 1997. For
booty in general, see now Coudry and Humm 2009.

19 For Augustus' new temples in general, see Scheid 2001, 91–94. Mars Ultor: vowed at
Philippi (Ovid *Fast.* 5.569–78; Suetonius *DA* 29.2), it was dedicated in 2 BC on 1st May or 1st

commemorate important victories and to portray Augustus as a traditional Roman triumphing general. The grand scale of their precincts, with porticoes and a new forum, shrines, and precious decorations confirmed their significance. Activities traditionally held in other places were deliberately transferred to these venues.[20] They also shaped and monumentalized a narrative of Augustus' success that highlighted the complementary themes of his personal valor and the favor of the gods toward him. Nor had the Sybilline Books apparently been consulted about a prodigy and advised renewed attention to the *compita* as had happened in the past (see section III.xxiii). These books were not much in use under Augustus, although they had been invoked to import many new deities to Rome in earlier times, before the original texts were lost in the great fire that destroyed the Capitoline temple in 83 BC (20 years before Augustus was born).[21]

By contrast with other favorite gods, *lares* were never acknowledged as personal saviors nor as avengers of the princeps. Indeed, at least as far as we know, there was no "narrative" of their relationship with Augustus; no vow or exchange of gifts and favors is recorded anywhere. Their shrines were not equivalent to the very fine temple of Jupiter Tonans that Augustus dedicated on the Capitol in 22 BC in thanksgiving for having been saved from a lightning strike while traveling in Spain.[22] Nor was the new compital cult presented as a revival or restoration of an archaic cult, as had been the case with so many of Augustus' earlier religious projects.[23] Presumably some "reason" for intervening in the compital cult must have been given at the time, but it has left no trace. The stark novelty of the reform in itself invited the celebration of a new beginning, even as Augustus chose to highlight this very aspect by introducing a new era rather than by downplaying his own intervention.

Mention should be made in this context of the famous Belvedere altar in the Vatican, which features a representation of what seems to be the princeps himself in the act of handing over two small statues of *lares* of the typical dancing kind in front of an altar.[24] (See figures IV.4, IV.5, IV.6, IV.7, IV.8.) Unfortunately, this intricately decorated, rectangular altar is very badly damaged, both through weathering and as a result of some deliberate attacks, especially on the heads of the principal figures. The whole top is gone and the upper part of the altar itself is also missing in many places.

August. See Kockel in *LTUR* (Forum Augustum), who thinks construction was not started until about 19 BC, after the standards had been recovered from the Parthians. Apollo on the Palatine: Propertius 3.31.9, *RGDA* 4.1, and Pliny *Nat.* 34.24.32. See Gros in *LTUR* for this magnificent temple with a grand portico and libraries, with Miller 2009.

20 See Scheid 2001 for a succinct and incisive overview of Augustus' religious activities, which stresses the urban impact of his new temples in their grand sanctuaries and of the activities that took place in these venues.

21 Suetonius *DA* 30.1, with Louis 2010 and Wardle 2014 ad loc. and Servius *Aen.* 6.72. For the burning of the temple and the loss of the prophetic books in 83 BC, see Flower 2008.

22 Jupiter Tonans on the Capitol: this magnificent small temple was built fast in the mid-20s and was dedicated on 1st September 22 BC. See Suetonius *DA* 29, *RGDA* 19, and Dio 54.4.2, with Gros in *LTUR*, Louis 2010, and Wardle 2014 ad loc.

23 For religion under Augustus in general, see Gros and Sauron 1988, 59–60; Galinsky 1996, 288–94; Beard, North, and Price 1999, 167–210; and Scheid 2001 and 2005, who stresses innovation before 28 BC. Gradel 2002, 117: "Typical of such Augustan restorations, the new cults from 7 BC onward had, below the formal level, little resemblance to their republican precursors." Similarly, Cooley 2009, 195: "In reality, however, his 'revivals' were often bogus archaisms, innovations to help secure his leadership at Rome."

24 The "Belvedere" altar (long kept in the Belvedere cortile): Vatican (Museo Gregoriano Profano) inv. 1115, measures 67 cm×97 cm and is 95 cm high (including the plinth).

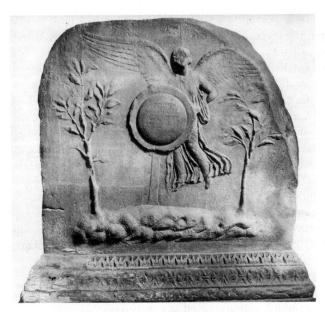

IV.4. Belvedere altar, Victory and shield. 12–2 BC. Musei Vaticani, Museo Gregoriano Profano, inv. 1115.

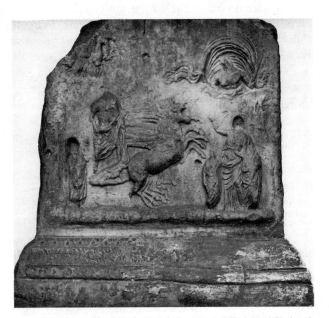

IV.5. Belvedere altar, apotheosis scene. 12–2 BC. Musei Vaticani, Museo Gregoriano Profano, inv. 1115.

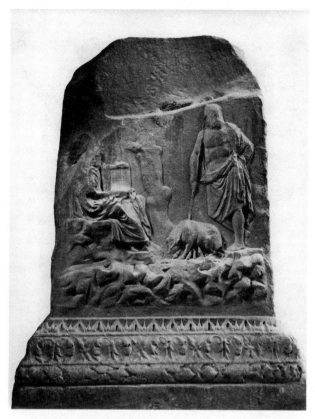

IV.6. Belvedere altar, sow and prophecy. 12–2 BC. Musei Vaticani,
Museo Gregoriano Profano, inv. 1115.

Consequently, there has been much debate and little certainty about how to interpret
its iconography and context.[25] It was apparently found on the Palatine, near the site
of Augustus' house.

The only inscription to survive on it is in small, shallow letters on the round
shield carried by a large winged Victory, who hovers between two laurel trees on
one of the long sides.[26] It records a dedication by the senate and people of Rome to
Augustus, with abbreviated titles that indicate a date between 12 and 2 BC. Although
the Victory goddess appears in an idealized, "Augustan" outdoor setting, flanked
by the twin laurel trees, the shield with its inscription seems to refer to the *clipeus
virtutis* that Augustus received in 27 BC (or in 26 BC) and presumably also, there-
fore, to the statue of Victory that he put up in the senate house.[27] In other words,

25 The bibliography is very extensive. I have especially benefited from Zanker 1969; Alföldi
1973, 30 n. 119; von Hesberg 1978, 914–15; Fraschetti 1980; Hano 1986, no. 10; Hölscher 1988, no.
223; Fless 1995, no. 9; Galinsky 1996, 319–20; Tarpin 2002, 157–62; and Dardenay 2012, 67–69.
See also Spinola in La Rocca 2013, IX.1, and Boldrighini in Paris, Bruni, and Roghi 2014, 96–99.

26 *CIL* 6.876 = *ILS* 83 = *AE* 1980.40 = *EDCS* 17301009 (with a useful photograph of a squeeze
of the inscription on the shield).

27 See Cooley 2009, 266–71, for the issue of when Augustus was awarded the shield inscribed
with the four virtues.

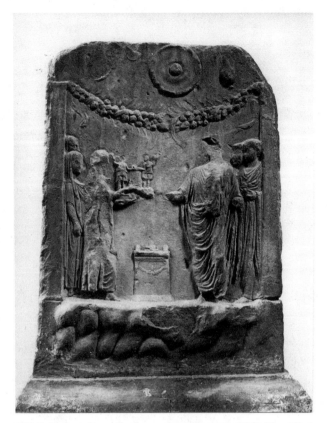

IV.7. Belvedere altar, gift of statuettes of *lares*. 12–2 BC. Musei Vaticani, Museo Gregoriano Profano, inv. 1115.

the inscription is apparently a reference to a specific shield previously given to Augustus, but with an approximation of his contemporary titles rather than his ones at the time of the gift and no details of the four virtues he was praised for. It reads as follows:

> Senatus populusq(ue)
> Romanus
> Imp(eratori) Caesari Divi f(ilio) Augusto
> pontif(ici) max<im>(o) imp(eratori) co(n)s(uli) trib(unicia)
> potestat(e)
>
> The senate and the Roman people (gave this to)
> Imperator Caesar Augustus, son of the Deified, pontifex maximus, imperator,
> consul, holding the tribunician power
> > (*CIL* 6.876 = *ILS* 83 = EDCS-17301009)

The style and presentation of the inscription, with its irregular, lightly incised letters and untypical line breaks, shows that it cannot be an official text, but is a reference to one. The most notable feature in this regard is the absence of numerals in

Augustus' titles, both for the consulships and the tribunician power. Since there is no space for any numerals to be added after the consulship, it cannot simply be unfinished.[28] The inscription was small and was not presented as the text of dedication for the whole altar.

Meanwhile, it is impossible to say whether there would originally have been any other inscription on the altar. The relief scenes are crowded and the relatively large base is also richly decorated; a dedicatory text could perhaps have been put somewhere on the top. As has been suggested before, it is logical to identify this altar as another dedication by a group of *vicomagistri* in a compital context.[29] It certainly has some features in common with the altar from the Vicus Sandalar-

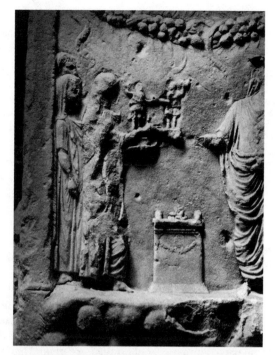

IV.8. Belvedere altar, detail of the three attendants receiving the gift of the *lares* from Augustus. 12–2 BC. Musei Vaticani, Museo Gregoriano Profano, inv. 1115.

ius, which also shows a (similar) Victory goddess with a round shield, which she is hanging on a trophy. The slightly confusing inscription on the shield of the Belvedere altar, which seems to refer to but does not reproduce the *clipeus virtutis* in the senate house, makes best sense in a local context. But it is above all the similarity in size and proportioning of the reliefs that invites a comparison between these two altars, as well as the aim of including so much detail on a single monument of relatively modest scale.[30]

The artist of the Belvedere altar has represented four very different but very Augustan scenes on his altar. He is at pains to make the most of each relief, even within a modest visual field. The Victory goddess with her shield on one long side is balanced by a very damaged scene of an apotheosis on the other, as a male figure ascends to the sky in a chariot, while being watched by several onlookers and greeted by gods above. A somewhat unusual version of Aeneas (?), a seated figure

28 Buxton 2014 has argued that the inscription is simply unfinished and represents an official dedication. This seems highly unlikely on epigraphical grounds. Meanwhile, both the weathering and the deliberate damage make it seem more probable that it was a well-known altar set up in a prominent place in the city.

29 See Zanker 1969 (followed by Hano 1986, 10) and Price in Beard, North, and Price 1998, 186. Lott 2004, no. 65, is doubtful about a compital context. Hölscher 1988, no. 223, thinks the workmanship is too fine and the imagery too complex for a compital altar. Carandini 2008, 73–75 and 194–98 (D. Bruno), argues that the altar comes from the *lararium* in the house of Augustus himself on the Palatine. This argument builds on Cappelli 1984–85.

30 For the Belvedere altar, see notes 24 and 25 earlier. By comparison, the altar from the Vicus Sandalarius is very similar, at 90×60 cm, and is 110 cm high without the top.

reading from a (prophetic?) scroll, and the prodigious sow with piglets is shown on one short side. This prodigy with the pig is balanced by a depiction of Augustus, accompanied by two men in togas, who is himself handing over two typically small statues of dancing *lares* to three veiled figures, who are also very damaged.

We are obviously at a significant disadvantage because it is so hard to see who is being deified.[31] Is it a person who was already officially a god, such as Romulus (Quirinus) or Julius Caesar? Or is it an individual who is close to Augustus, recently deceased but not recognized as a *divus*, such as Agrippa (who died in 12 BC) or Drusus (who died in 9 BC)? Either Agrippa or Drusus, both of whom were celebrated generals, could be recognized by the complementary scene featuring Augustan victory. But would a local altar go so far as to depict the deification of a person who had not officially received this honor? Such a bold move seems unlikely in the context of a vicus. Is the identity of this individual, in fact, the "key" to the whole altar, in the way that the augury scene (*tripudium*) has tended to define our understanding of the altar from the Vicus Sandalarius?

For present purposes, the scene with the *lares* is clearly of most interest. It is the only subject that is definitely contemporary, since we cannot be sure about who is being deified or when. Without a surviving dedicatory inscription or topographical context, it is unclear whether there is a "front" to the altar.[32] The *lares* scene provides a striking visual image of an imposing figure, who must surely be Augustus, handing over diminutive statues of twin dancing *lares*. This gesture is precisely the one commemorated on the *Fasti of the Magistri Vici*, which is our only explicit evidence for Augustus giving *lares augusti* directly to *vicomagistri*.[33] In this scene also, Augustus himself "gives" a pair of *lares*, which have logically been read precisely as *lares augusti*. Moreover, he does so in a carefully defined religious setting and with his head covered, as for sacrifice. There is, however, no little statue of a *genius* included here. Augustus is standing in front of a small square altar that has been decorated with a garland and has several offerings on it. The scene is outside, on rocky ground, and framed by pillars on either side with a large garland suspended between them. The gesture of giving is carefully enclosed within this religious setting in a way reminiscent of later *lares* paintings from the Bay of Naples. An interesting comparison can also be made with a similar scene of a patron who is probably Augustus handing over a single statue of a deity (Minerva). The scene of giving the statue is balanced by the depiction of a sacrifice to Minerva. Here, the context is a small marble votive altar set up by a group of slaves who were woodworkers (*ministri lustri secundi*), found close to San Giorgio in Velabro in Rome, near a *schola fabrum tignariorum*.[34]

In addition, a degree of abstraction is introduced by three large instruments of sacrifice that are depicted in the field above the garland. Here, we see an augural staff (*lituus*), a sacrificial dish (*patera*), and a jug (*urceus*). The representation of

31 Buxton 2014 now adds Drusus to the list of possible candidates, which includes Aeneas, Romulus, Julius Caesar, and Agrippa. Again, the context seems important. If this altar is compital, would it portray the apotheosis of someone not officially a *divus*?

32 At a *compitum*, all four sides might be important. On the other hand, the evidence from Delos, Pompeii, and *compita* in Rome (so far) all suggests there was usually a single, main direction, as was the norm for larger sanctuaries.

33 For the *Fasti of the Vicomagistri*, see note 1 on page 255, note 7 on page 337, and figure IV.28 later.

34 Capitoline Museum inv. no. 1909 = *CIL* 6.30982 with Ryberg 1955, 87, fig. 40; Zanker 1988, 133–34, with fig. 111; Schraudolph 1993, L121; and Ulrich 2007, 338.

these objects also connects this altar to others dedicated by *vicomagistri*, including again the famous altar from the Vicus Sandalarius. The references are a combination of eclectic items, presented in different scales, since the scene below does not actually depict either a libation and sacrifice or a ritual of augury. Nevertheless, these objects were all very much associated with Augustus in a variety of settings. The altar also shows his twin laurels and refers to the shield with his virtues. Only the oak wreath is missing from the typical repertoire of "Augustan" symbols. If the event or year referred to is indeed 7 BC, then it would be exactly twenty years after he received the honorific name and symbols of his special prestige.

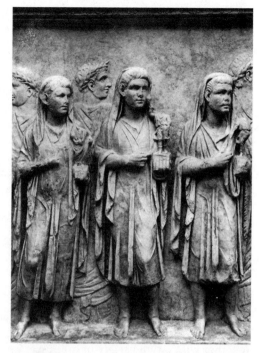

IV.9. *Vicomagistri* relief, detail of three *ministri*. Musei Vaticani, inv. 1156.

Unfortunately, the extensive damage to the relief makes the figures other than the princeps very difficult to identify, with the result that the narrative remains ambiguous for us. Augustus' two male companions (priests? consuls? family members?) do not have their heads covered and seem to watch rather than to participate actively in the solemn event. The three recipients of the *lares* statuettes, who are shorter than the other figures, wear long, loose clothing and have their heads covered and their feet bare.[35] Naturally, they have been identified as *vicomagistri* or *vicoministri*, despite the fact that there are only three rather than four of them. If they are *vicomagistri*, however, they should be wearing togas; their simpler and specifically religious style of dress has, therefore, suggested that they are slave *ministri*. A comparison can be made with the somewhat similar garb of the three men who are carrying small statues (including two *lares*) on the so-called Relief of the *Vicomagistri*, which is usually dated to the middle of the first century AD. (See figure IV.9.) These three much discussed individuals also remain unidentified.

However, closer inspection reveals that the three figures on the Belvedere altar seem to be women, which problematizes the context of Augustus handing over *lares augusti* specifically to be worshipped at a compital shrine.[36] Their height, the way

35 Tarpin 2002, 160–61, identifies these three as definitely women, as does Carandini 2008, 73–76. Contra Zanker 1969; Hölscher 1988, no. 223 (slave *ministri*); and von Hesberg 1978, 914–15 (three young men).

36 For a fragmentary altar with women sacrificing to the *lares* (found near the Victor Emmanuel Monument), see Museo Nazionale Romano (Terme) inv. 49481, with Hölscher 1988, no. 221; Schraudolph 1993, L 104; and Lott 2004, 98 and no. 66, who both think that the setting cannot be compital because women did not hold local office. Contra Galinsky 1996, 308, who uses this altar as evidence that women did have a recognized role in compital cult. Candida 1979, 95–98 no. 39,

they stand, and the length of their clothing all suggest that they are indeed women. As the only official female priests in Rome, the Vestal Virgins have been identified as obvious candidates for this interaction with the princeps, although their relationship to compital cult is not well attested by other ancient evidence. Moreover, the dress and number of these women do not immediately identify them as Vestals on iconographic grounds. If we think that the costume of these three women is like that of servants (*ministrae*) who take part in civic cults, then they may perhaps be the female slave attendants of the Vestals, rather than the high priestesses themselves, who are receiving the two statues of the *lares*.

Ultimately, the scene of handing over the *lares* seems very specific (in time and probably also in this place), while being frustratingly unclear to us in the present state of our knowledge. In this sense, it dramatizes the intimacy and power of this gift, although so simple, given by the princeps himself to specific recipients, during a religious ceremony in front of an altar. The fact is that there were probably many other events, especially but not exclusively in connection with the establishment of the cult of *lares augusti* in 7 BC, that we are not informed about in our written sources. It is essential to keep in mind how sparse our evidence really is. The relief on the Belvedere altar confirms how elaborate and carefully staged a gift of little *lares* could be.

The solemnity and religious overtones of the scene with the presentation of the *lares* (*augusti*) is powerful, regardless of who the recipients are. It is represented together with a rich variety of other scenes, some clearly from early times (the prodigious sow), another perhaps more recent (the apotheosis?), and one more abstract (an "Augustan" Victory with Augustus' laurel trees and special shield). Meanwhile, the pairing of the *lares* with the scene of the prodigious sow on the other short side may recall a range of themes, including the fact that pigs are the favorite sacrifice to *lares* and that the ancient *lares grundiles* were associated with the famous sow, although in a variant of the myth that does not seem to be the one depicted here.[37] If the Belvedere altar was dedicated in a local vicus, then its complex iconography needs to be read within that local context, rather than as if this were a monument of civic art commissioned by Augustus or the senate. The comparison with the altar from the Vicus Sandalarius remains essential; although the two artists certainly have very different styles, their repertoires overlap and their intentions are similarly ambitious, wide-ranging, and closely keyed to current events.

In conclusion, as far as we can see from the surviving evidence, Augustus' introduction of *lares augusti* at the *compita* was celebrated as an historical and religious moment in its own right, rather than as a commemoration of an earlier event or as the fulfillment of a religious vow or as an episode in a narrative of Augustus' personal, spiritual autobiography. Whatever specific explanation may have been given by Augustus for the introduction of the *lares augusti* is lost to us. Meanwhile, the history of compital cults was simply not a subject for a writer like Suetonius, despite his interest in so much other minute and specific information in a biographical context and his access to palace archives, including a wealth of

identifies the two figures as males, as does Hano 1986, no. 15[bis]. The only detailed discussion is Hölscher 1984.

37 For the *lares grundiles* and their shrine in Rome, see section II.xii.

documents relating to Augustus. Similarly, amid a wide array of detailed information, Augustus' *Res Gestae* did not commemorate his extensive, popular initiatives in local religion in Rome, either the *stips* that funded an expensive statue program in the local neighborhoods over at least a generation or the introduction of *lares augusti* in (all) the hundreds of *compita* at one special moment in the city's religious history.

XXVI *LARES AUGUSTI*

> larib(us) aug(ustis) ministri qui k(alendis) Aug(ustis) primi inierunt
> —*CIL* 6.446–47 = *ILS* 3612–12A

Augustus' association with the neighborly *lares*, through the sharing of his name and his function as donor, gave him a completely novel role. In a sprawling city of around a million people, *lares augusti* afforded him greatly enhanced visibility throughout the network of crossroads shrines that articulated communication and communities. They allowed him a type of presence on every street corner. His choice of these traditional crossroads shrines is a decisive indication of their existing function in expressing local identity as part of an urban network, within a well-established religious and cultural framework.[1] At the same time, Augustus was setting out to do something entirely new, as is also indicated by the number of extant dedications to *lares augusti* that date to the years immediately after the reform. The significance of the reform, from our perspective, is inevitably defined by the enthusiasm and energy with which many humble (new) Romans, as well as slaves who were not citizens, responded to his innovation. In this context, it is worth recalling that not all of Augustus' projects had been greeted with cheers and applause by his intended audience(s).[2] In this case, however, an initiative that certainly came from the princeps himself, and must have been centrally organized, was embraced and enhanced locally and at individual expense throughout the city.

An immediate example that is worth citing is the pair of inscriptions, set up soon after the reform, which were found on the Tiber Island in 1676.[3] (See figure IV.10.) There was only one vicus on the island, the Vicus Censori.[4] Two clearly inscribed, large marble panels (cut from their monumental context) named the same four slaves as *ministri* who entered office on 1st August in the first year of the new era, although they do not appear in the same order on both texts.

> Larib(us) Aug(ustis)
> ministri
> qui k(alendis) Aug(ustis) primi inierunt
> Antigonus M. Iuni Erotis (servus)
> Anteros D. Poblici Barnai (servus)
> Eros A. Poblici Damae (servus)
> Iucundus M. Ploti Anterotis (servus)

1 Propertius 2.20.22 (ca. 25 BC): *cum de me et de te compita nulla tacent* (when no crossroads was not talking about you and me—that is, our relationship). See also Vergil *Georg.* 2.382; Tibullus 1.1.20, 2.1.60; and Horace *Sat.* 2.3.281, 2.6.50. Lott 2004, 120, sees the reform as stopping the influence of the local elites in the neighborhoods, which were now tied directly to Augustus. The Compitum Acilium is an obvious example of an important crossroads shrine that had a long history before Augustus.

2 See Dettenhofer 2000 and Flower 2006, 130–32.

3 Museo Nazionale Romano (Palazzo Massimo), inv. 47808 (107 cm high×85 cm wide): *CIL* 6.446–47 = *ILS* 3612a and b = Hano 1986, no. 7 = Lott 2004, no. 8 = *EDCS* 17300599 and 17300600 (with a series of different photographs), and Jovine in Gasparri and Paris 2013, 83, and in Paris, Bruni, and Roghi 2014, 120–21.

4 For religion on the Tiber Island, see esp. Renberg 2006–7 and Degrassi in *LTUR*, with *CIL* 6.451 = 30769 = *ILS* 3619 = EDCS-17300604 and *CIL* 6.821 = EDCS-17300959. The vicus itself was probably centered on the road that connects the two bridges.

IV.10. Inscribed dedication to *lares augusti* by *ministri* of first year, 7–6 BC, from the Tiber island. 107 cm×85 cm. Museo Nazionale Romano, Palazzo Massimo alle Terme, inv. 47808.

For (the) august *lares* (given by)
the first *ministri* who entered office on 1st August:
Antigonus, slave of Marcus Iunius Eros
Anteros, slave of Decimus Poblicus Barna
Eros, slave of Aulus Poblicius Dama (or Damas?)
Iucundus, slave of Marcus Plotius Anteros

(*CIL* 6.446–47 = *ILS* 3612 and 3612a)

The two panels probably belonged to the same monument, which has been identified as either a statue base or more probably an altar.[5] Both panels are decorated with laurels at each side and part of an oak wreath with its ribbons suspended in the middle. The sides are also adorned with laurels. These slaves seem to have freedmen as their masters; Eros and Anteros belong to two men with the same family name. Yet the other two masters were also called Eros and Anteros, presumably as slaves themselves before. The arrangement of the four names on the stone creates two different echo patterns that do not look like a coincidence. It is a powerful testimony to the princeps' local popularity that these slaves (of former slaves) were immediately ready to erect such a monument at their own expense on marble, doubly inscribed, and with appropriate relief decorations in the first year of the new era. The service of these very *lares* (*augusti*) gave them a context for

5 *CIL* 6.446–47 cites testimony for both inscriptions belonging to the same base. Hano 1986, no. 7, considers it to have been an altar, rather than a statue base.

IV.11. Inscribed dedication to *lares augusti* by *ministri* of sixth year, 2–1 BC, Vicus Statae Matris. Front side. Roma, Musei Capitolini, Centrale Montemartini, inv. 2144.

joining together from different households and pooling their resources to enhance their local compital shrine in such a very new style. A local workshop was ready for their order.

By comparison, the slave *ministri* of year VI in the Vicus Statae Matris inscribed their names inside the oak wreath that recalled Augustus' *corona civica* on an altar they dedicated to *lares augusti* (dated precisely to 18th September 2 BC with the names of the consuls).[6] The visual effect is powerful and direct. (See figures IV.11 and IV.12.) As already noted, the *corona civica* was a military award given to a soldier for saving the life of a fellow citizen. Here, we see four men who are definitely not citizens write their names inside such a wreath. They recognize and extend the princeps' protecting and saving functions beyond the citizen body, even as they were surely themselves hoping to attain the coveted status of Roman citizen.

For twenty years before the introduction of *lares augusti* to Rome, the princeps had used the name, or perhaps rather the epithet, of "Augustus" to designate himself.[7] This title was to become the word that would describe imperial power for centuries to come. Yet initially, its meaning was not elucidated nor its significance familiar. *Augustus* was an existing Latin adjective meaning "holy" or "revered," although not apparently a very common one: as far as we know it had not been used as a personal name by an individual before 27 BC.[8] Suetonius and Augustus both call it a *cognomen* (the third name in the standard configuration of three used by Roman men).[9] This third name could be an adjective, but was often a noun.

6 Musei Capitolini inv. 2144: *CIL* 6.36809a–b = *ILS* 9250 = Lott 2004, no. 23 = *EDCS* 19600479, with Hano 1986, no. 6, and Hölscher 1988, no. 220. The similar inscription on the back surrounds a *patera* in a less well conceived design.

7 For the name *augustus* (16th January 27 BC), see *RGDA* 34, Vell. Pat. 2.91.1, Ovid *Fast.* 1.609–616, Suetonius *DA* 7.2, Dio 53.16.7. Dio 53.20 has a tribune of the plebs urge adherence to the new name at a *compitum* in 27 BC. For discussion, see esp. Erkell 1952, 1–39; Fears 1981; Kienast 1982, 79–81; Ramage 1987, 100–107; Fishwick 1987; Lott 1995; Gradel 2002, 113; Lott 2004, 73; and Wardle 2014 ad loc. On divine epithets, see Radke 1979.

8 For examples of the adjective *augustus* from before 27 BC, see esp. Cicero *Ver.* 2.5.186, *ND* 1.119.11, *Brut.* 83.6, 295.8. Clark 2007, 264–65, explains its range of meanings and flexibility.

9 Suetonius *DA* 31.2: *in cuius ordinatione Sextilem mensem e suo cognomine nuncupauit magis quam Septembrem quo erat natus, quod hoc sibi et primus consulatus et insignes uictoriae optigissent* (as part of this calendar reform, he renamed the month Sextilis [sixth month] after his own

Augustus himself, however, did not use *augustus* as a regular part of his family name. When he adopted his two grandsons Gaius and Lucius in 17 BC, he did not give them this name, which was, therefore, reserved exclusively for himself during his lifetime.[10] In this sense, he was not using it as a family *cognomen* like "Caesar." Its origin and inspiration is not explained by the princeps or by anyone close to him, according to our surviving evidence. A religious overtone is the most noticeable initial feature of what would eventually become a political label.

A significant departure from existing practice came when the senate built an altar dedicated to Pax Augusta (august Peace) to celebrate Augustus' return to Rome from military campaigns in Spain

IV.12. Inscribed dedication to *lares augusti* by *ministri* of sixth year, 2–1 BC, Vicus Statae Matris. Back side. Roma, Musei Capitolini, Centrale Montemartini, inv. 2144.

and Gaul.[11] The altar was planned in 13 BC. In this new cult, the same adjective that the princeps had been using for nearly fifteen years was given as an epithet to the goddess Peace. Her elaborately carved monumental altar was dedicated in 9 BC and represented a first official extension of the princeps' personal epithet to a divinity in Rome, in this case one of the abstract divine qualities the Romans were so fond of.[12] The senate's initiative, which was surely welcomed by the princeps, did not, however, lead to a further spread of the cult of Pax Augusta in the city or indeed to any other local reaction we know of.

The only potential evidence that survives for any earlier cult of a deity being called "august" comes from a fragmentary and long-lost text set up by freedmen outside Rome in 59 BC.[13] Unfortunately, this frequently cited inscription is incomplete and has been muddled in its transmission in a manuscript tradition, all of

cognomen rather than September, when he had been born, because this month was when he had held his first consulship and won splendid victories in battle). See Louis 2010 and esp. Wardle 2014 ad loc. Augustus *RGDA* 11: *et diem Augustali]a ex [c]o[gnomine] nos[t]ro appellavit* (And the senate called the day Augustalia from my *cognomen*) The name of the day is better preserved in the Greek version.

10 For the adoption of Gaius and Lucius in 17 BC, see Vell. Pat. 2.96.1, Suetonius *DA* 64.1, and Dio 54.18.1.

11 For the Ara Pacis Augustae, see section IV.xxix later.

12 Clark 2007 gives a full discussion of divine qualities in republican Rome showing what Augustus inherited.

13 *CIL* I[2] 753 = *CIL* 5.4087 = *ILLRP* 200 = EDCS-04203140: the first line is traditionally restored as *[A]ug(ustis) Laribus* (for the august *lares*). The dedication was made by nineteen agricultural slaves in Transpadine Gaul in a rural context in 59 BC. Cf. *CIL* 5.4865 = *II* 10.5.3.1027 =

which obviously makes it unpromising evidence for an otherwise unattested cult of *lares augusti* at a time when Octavian was still a small child. Renewed examination of the context and history of this text suggests that it is much more likely to have been a simple dedication to local *lares* without any epithet.[14] Ultimately, it is impossible to say whether the adjective *augustus* was already associated in the minds of any Romans with *lares* before the princeps was given this name in 27 BC or indeed before the introduction of the new cult of *lares augusti* to the neighborhoods of Rome in 7 BC.[15] There is no extant evidence that predates Augustus' initiatives. Meanwhile, a much more obvious reference for Augustus is cited by Suetonius in a famous line of Ennius in his *Annales* that describes the city of Rome as founded *augusto augurio* (by august augury).[16] The full original impact of the introduction of a cult of *lares augusti* to Rome is no longer accessible to us: in what follows, its novelty will be stressed, since there is no evidence that the cult was present in Rome or nearby before the Augustan reform.

Many questions arise about religious innovation at compital shrines in Rome. What did it mean to call the *lares* at the crossroads shrines *augusti*? Were these *lares* still the *compitales* worshipped at shrines that were still called *compita*? If not, how and why had they been replaced by other *lares* of a different sort? These issues bear on the religious character of the reform and on the way in which the princeps' image was affected by the *lares* that shared his special epithet.

The most useful evidence comes from the inscriptions put up by the *vicomagistri*. All the dedications that spell out the names of these *lares* (rather than abbreviating them) make clear that *augustus* is an adjective describing the *lares*, never a genitive singular form of Augustus' name.[17] Dedications to other august deities in Rome show the same pattern of using the adjectival form.[18] In other words, the *lares* are "august," but never explicitly designated as Augustus' own personal or household *lares* in Rome in his lifetime.[19] Crucially, Suetonius, writing in Rome in the early second century AD, still calls these gods *lares compitales* in his notice

EDCS-05100014 from Brixia. Gradel 2002, 113–14, 127, argues on the basis of this restoration that *augustus* must have been a common epithet.

14 Gregori 2008 provides a complete reexamination of the inscription. He restores the opening line of the inscription as *[Hisc(e) ? m]ag(istreis) Laribus d(onum) d(ant)* (these magistrates? gave this gift to the *lares*). This is an attractive and carefully argued hypothesis, in light of the list of nineteen dedicators, all of whom are slaves.

15 There is only slim evidence to suggest that "holy *lares*" (*lares augusti*) of a pre-Augustan kind may have been venerated in Pompeii in the first century AD according to Van Andringa 2009, 246–47.

16 Suetonius *DA* 7 quoting Ennius: *augusto augurio postquam incluta condita Roma est* (after famous Rome was founded by august augury) (155 Sk). For commentary, see Wardle 2014 ad loc.

17 There are three clearly legible inscriptions that spell out the names of the *lares augusti*: Lott 2004, nos. 7 (Sala delle Muse, Vatican, 7 BC), 20 (Vicus Sandalarius, Uffizi, of 2 BC), and 23 (Vicus Statae Matris, Musei Capitolini, of 2 BC, with an additional letter I for good measure!).

18 See Panciera 2003, 237, with his catalogue of ninety inscriptions from Rome.

19 Pomponius Porphyrio (an early third-century AD commentator on Horace, whose text survives in a fifth-century version) is the source for this equation. On Hor. *Sat.* 2.3.281: *Ab Augusto enim, Lares, id est dii domestici, in compitis positi sunt et libertinis sacerdotes dati, qui Augustales appellati* (The *lares*, which is to say the household gods, were put at the crossroads by Augustus and freedmen were appointed as their priests, who were called Augustales). Zetzel (BMCR 2009.02.06) calls his commentary "the usual amalgam of useful knowledge, idiocy, and misinformation." It does not seem to be sound to prefer this evidence to the direct testimony of contemporary sources, as does (for example) Tarpin 2014, 61.

about the two new flower festivals introduced by Augustus.[20] Suetonius uses the traditional epithet that both described where these deities were worshipped (at the crossroad) and what their function was (to protect the local area associated with that particular crossroad). In other words, he thinks they can still be called by their traditional name, which would indicate that the epithet *augustus* was essentially an addition rather than a substitution for the descriptive epithet of place *compitales.*

Similarly, the shrines at the crossroads are consistently described in a variety of ancient authors as *compita,* and more specifically as *compita Larum*—for example, in Pliny's frequently quoted notice of the official counting of these crossroads shrines during the census taken by Vespasian and Titus in AD 73 (see section II.xiii).[21] The inscription from the Compitum Acilium confirms this pattern for the Augustan period.[22] The Compitum Acilium had a venerable history stretching back to the third century BC. It was reshaped and endowed with a notable series of new gifts (a small temple, an altar, a pavement) in the years following the introduction of *lares augusti* here. The collection of archaeological and inscriptional evidence from this reformed *compitum,* all of which was apparently found virtually in situ, illustrates how the new *lares augusti* were introduced precisely into an existing cult site and how the energy of the *vicomagistri* then transformed and embellished that famous crossroads area in a way that consciously memorialized the reform of 7 BC.

There is no reliable contemporary ancient evidence to indicate that *lares augusti* were ever equated with the familial *lares* that belonged to Augustus' private domestic cult.[23] In fact, it is quite unclear how a Roman could have understood the placing of a domestic *lar* in the setting of a compital shrine. The *lar* (or *lares*) worshipped in the house did not move outside the property and was only displaced when the household itself moved.[24] Such a relocation is often referred to by ancient authors as a distressing and traumatic event for a Roman who is losing his home or going into exile.[25] Having no domestic *lar* was synonymous with being

20 Suetonius *DA* 31.5. Gradel 2002, 136, contradicts this statement by claiming that the *lares augusti* are *not* the *compitales.* Laurence 2007 imagines two competing sets of *lares,* the old *compitales* and the new *augusti,* but without any explicit ancient evidence for this religious conflict.

21 See Lott 2004, 173.

22 The Compitum Acilium is mentioned by Pliny *Nat.* 29.12 as the place of business for the first Greek doctor in Rome, Archagathus, son of Lysanias, who set up his practice in 219 BC. Remains of the *compitum,* which was removed to make way for Nero's golden house, were discovered in 1932. A shrine and several altars were found together (see Lott, 2004, 148–52 with nos. 12 and 27). For further discussion, see Colini 1961–62; Tamassia 1961–62; Hano 1986, 2341 no. 5; Dondin-Payre 1987, 87–109; von Hesberg 1988, 398–400; and Pisani Sartorio in *LTUR* and section II.xiii.

23 Van Andringa 2000, 70, makes clear that no *lar familiaris* can be found outside a domestic setting. Pliny *Nat.* 21.11 speaks of both public and private *lares.* Lily Ross Taylor 1931, 180–91, proposed that Augustus used the office of *pontifex maximus* in 12 BC not only to make part of his house public but also to spread the cult of his private *lares* throughout the city. Fraschetti 2005, 234–39, goes a step further with this line of argument by claiming that these *lares augusti* were identified with the dead of the princeps' own family. A similar argument can be found in Tarpin 2002, 161–62, 241–45. Contra Lott 2004, 86–87 and 106–8. See further discussion in Favro 1996, 135–38, and Gradel 2002, 115–16.

24 Household *lares*: Cicero *Sest.* 30, Catullus 31.7–10, Horace *Sat.* 2.6.66, *Epist.* 2.2.51, Tibullus 1.3.34, Val Max. 2.4.5, 7.7.3.

25 Moving a *lar*: Cicero *Dom.* 108, *De leg.* 2.42, *Ad Fam.* 1.9.20; Horace *Carm Saec.* 39, *Epist.* 1.1.13; Propertius 3.3.11, 4.10.18; Tibullus 2.5.20; Martial *Ep.* 11.82.2; Ovid *Fast.* 4.802, *Trist.* 3.12.52.

homeless.[26] Moreover, how could hundreds of pairs of *lares* all over the city simultaneously be described as being *the lares* of a single household and, therefore, as "belonging" to the individual who was head of that household? Such a conception is highly problematic in Roman religious terms, especially for *lares* who were by their very nature gods of place. The modern hypothesis that posits a simple insertion (by an unparalleled process of reduplication) of Augustus' domestic gods into the compital shrines has for too long obscured an allusive and nuanced religious gesture by making it seem the heavy-handed mandate of a despot who had little feeling for traditional religious sensibilities.

To reiterate: the *lares* at the crossroads were, by definition, *lares compitales* because they were worshipped at the *compita*. In other words, most Roman *lares*, including the ones at the crossroads, had epithets taken from places precisely because they were gods of place. It would make no sense to say that the domestic lar(es) of any individual household had been moved outside to the shrine at the crossroads, the traditional home of another equally well-established pair of such deities. Moreover, the uniform iconography of the *lares* in the house depicts them in an identical way to those at the crossroads shrines. *Lares* were gods of place who were easily recognized by their well-established iconography and categorized by their immediate physical context and setting.

By contrast, throwing one's household *lares* out of the home into the street was a gesture of exceptional despair, for example taken by some Romans in AD 19 in reaction to the news of the death of the beloved Germanicus, heir to the emperor Tiberius.[27]

> lapidata sunt templa, subuersae deum arae, lares a quibusdam familiares in publicum abiecti, partus coniugum expositi.

> The temples were stoned, the altars of the gods overturned, some people threw out their household *lares* into a public space, others exposed the babies of their (legal) wives.

> (Suetonius *Cal.* 5)

Within the logic of Suetonius' list of extreme and essentially impious actions, the casting out of the *lares* comes as the penultimate item, immediately before exposing a legitimate child (by implication one that would otherwise have been raised). The first two items consist of attacks on public sanctuaries; the second two are ways in which life in the home itself is given up for lost, either by discarding one's household protectors or by abandoning one's child, which represented the future of the family. This example again indicates that Augustus had not moved his household *lares* from inside his own home to the street.

Consequently, it is evident that Augustus endowed the existing gods of the crossroads shrines, who could not all have simply been displaced or discarded, especially by someone who presented himself as an upholder of traditional Roman religion, with an additional epithet taken from his own special "name." This fact is

26 No *lar*: Livy 1.29.4 and 26.25.12. See esp. the curse at Ovid *Am.* 1.8.113–14: *di tibi dent nullos lares, inopemque senectam* (may the gods give you no *lares*—that is, make you homeless—and a destitute old age).

27 For discussion, see esp. Versnel 1980, with Gonzalez 1999, 139 and 199, and Fraschetti 2005.

confirmed both by Suetonius, who still calls the *lares* at all the crossroads of Rome *compitales* and does not even bother to mention their new epithet, as well as by the continuing existence (and increased visibility) of the *compita* themselves, whose *lares* were now designated with the adjective *augustus*. This new cult title was an unusual addition to very traditional deities and connected them in a special way with the princeps, without actually spelling out the full impact of the shared qualities and functions that are being implied. Yet a degree of multivalence was not uncommon in traditional Roman religion. Although *lares augusti* were introduced directly and at one time by the princeps, that did not make his sweeping gesture unsubtle. He was not enforcing a new creed or requiring assent to a dogma, but adding a special adjective of his own, which was by now very familiar, to beloved local deities.

In many ways, the finest local monument to survive with the names of the *lares augusti* spelled out in full is the famous altar from the Vicus Sandalarius, a street adjacent to the new Forum of Augustus with its magnificent temple of Mars Ultor.[28] This is the same vicus, home to the sandal makers, that seems at some point to have received a special statue of Apollo Sandalarius donated by Augustus from a New Year's *stips*, according to Suetonius. This altar has recently been restored and reinstalled in a new gallery in the Uffizi Museum in Florence. It was acquired by Fernando de Medici in 1584 and initially kept in his villa in Rome, before being moved to Florence in 1783. Its present condition, therefore, sets it apart from our other compital items, most of which are thoroughly battered. It has attracted the attention of many scholars since the sixteenth century, especially because it features an intact historical scene in relief involving members of the imperial family, which refers to the taking of military auspices by feeding a sacred chicken (*tripudium*).[29] Moreover, its inscription dates it to the first half of 2 BC, very close to the nearby dedication of the new forum with its temple of Mars Ultor (probably on 12th May).[30] It offers an important parallel to the scene of Augustus handing over small *lares* on the Belvedere altar.

In terms both of time and of physical proximity, therefore, the Vicus Sandalarius Altar offers a vivid and immediate local reaction to the Augustan program, at the very moment when the princeps received the title of *pater patriae* five years after the great urban reform. This was the culmination of Augustus' self-definition, and these *vicomagistri* had the resources and the motivation to inscribe themselves into his story even as it was unfolding. It would be fascinating to know how they worked with the artist to come up with the design and the wording of the text, what was their idea and what his suggestion. (See figures IV.13, IV.14, IV.15, IV.16.) The altar has, however, been restored at various times since it came to Florence, with the result that some of its features are perhaps not original and other elements have been lost. My interpretation inevitably relies on what can be seen in photographs and on the actual altar in its present condition.

28 Vicus Sandalarius Altar: Uffizi inv. no. 972, with Mansuelli 1958, no. 205; Hano 1986, no. 2; Rose 1997, no. 33; Bergmann 2010, no. 21; Pollini 2012, 137–45; and Santangelo 2013, 263–66, all with extensive earlier bibliography. A new catalogue is in preparation at the Uffizi.

29 For the ceremony of the *tripudium*, see Cicero *Div.* 1.27; 1.77; 2.71–73 and *CIL* 14.2523 = *ILS* 2662 = EDCS-05800492 on a relief panel that shows the chickens in a cage (in the Palazzo Albani del Drago) with Linderski 1986, 2174, and Koortbojian 2013, 75, with fig III.22. A general discussion can be found in Foti 2011, esp. 104–7.

30 The dedication of the forum of Augustus is dated to 12th May 2 BC by Simpson 1977.

IV.13. Altar from the Vicus Sandalarius, *tripudium* relief. 2 BC. Galleria delle Statue e delle Pitture degli Uffizi, Florence, Inv. Sculture n. 972.

The whole altar is very finely executed, and the artist shows a subtle and humorous appreciation for the subjects made popular in the art of his day. He demonstrates both his skill in creating a completely new set of scenes and his ability to play games with the standard components of Augustan visual culture. In order to get an overview, all four sides need to be read together, in the context of the inscriptions on the monument. The rectangular altar is made of marble and seems to have been designed as a freestanding monument, presumably at a crossroads. The two inscriptions and the historical nature of the auspices scene make this long side appear to be the "front," but every side is important for the overall message. In fact, the *lares augusti* are depicted and receive their dedication in the dative on one of the short sides. Since they appear to be the deities honored with the dedication of the whole altar (and its associated rituals), one can make a case for their side being the one that most clearly defines the function of the whole installation. This is evidently a compital altar. The two longer sides show the *auspices* balanced by a (somewhat) abstract combination of Augustan motifs (the two laurel trees, the *corona civica*, a jug, and a libation dish). The *lares augusti* are balanced on the other short side by a winged victory goddess with a large shield, adorning a trophy composed of foreign armor. In this sense also, the altar is unusual in

IV.14. Altar from the Vicus Sandalarius, Augustan symbols. 2 BC. Galleria delle Statue e delle Pitture degli Uffizi, Florence, Inv. Sculture n. 972.

including a deity other than the *lares*, but she does not receive a dedicatory inscription or other label. The top and base are also very finely decorated.

The scene of feeding the chicken has been much debated, yet its overall reference seems a clearly and closely contemporary one, as is also suggested both by the consular date inscribed into the background of the relief itself and by the very Augustan iconography of the other long side that complements this relief.[31] Here, we see Augustus as *augur*, with his head covered for a ritual, next to a chicken used during the *tripudium*, a process of consulting the gods through the feeding of such sacred birds. We see the chicken pecking, which is surely meant to imply that the omens are favorable. Augustus is flanked on his right by a young man who is depicted with the features of a family member; this should be Gaius Caesar, Augustus' eldest grandson, adopted as his son, who was about to leave for military service in the East in 2 BC. The basic message is unambiguous; Augustus plays the role of a priest and receives favorable auspices for his heir in the next generation. The *vicomagistri* celebrate and share in this dynastic moment.

31 See especially Rose 1997 and 2005 for the interpretation of the participants and Koortbojian 2013, 73–76, for the eclectic character of the scene.

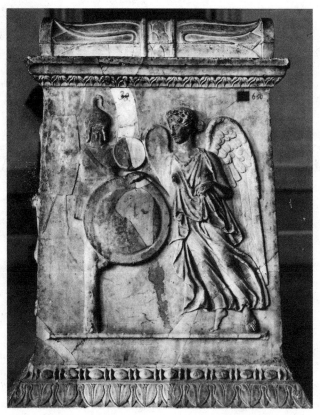

IV.15. Altar from the Vicus Sandalarius, Victory with trophy. 2 BC. Galleria delle Statue e delle Pitture degli Uffizi, Florence, Inv. Sculture n. 972.

The woman wearing a diadem and torque, who stands on the other side of Augustus, has been interpreted as another priestly figure, perhaps the most senior priestess in the cult of the goddess Cybele, the Magna Mater. She holds a *patera* and makes a gesture as if to pour a libation, although no altar is present. Alternatively, she has been identified as another family member, perhaps Livilla, whom the young Gaius married before he set out on campaign.[32] According to this reading, the two figures on either side of Augustus represent the newly married couple, with the auspices perhaps referring also to their recent marriage rituals and the happy life they will have together. This iconography would, therefore, also mirror Augustus' policies that encouraged marriage and traditional family life, although this woman is not evidently dressed as a bride. Ultimately, it is interesting that the

32 The woman does not look like Livia (Augustus' wife) and cannot be Julia (his daughter, the mother of Gaius), who was disgraced and banished at that time. See Marcattili 2015 for the suggestion of Livilla as Gaius' wife here. Unfortunately, we know so little about the costume of the Roman bride that it is hard to say whether the iconography of this female figure confirms or refutes the identification as Livilla (Claudia Livia Julia, daughter of Drusus and Antonia; *PIR*[2] L 303). She was only twelve years old in 2 BC (Dio 55.18), but this portrait could be an idealization, since the iconography has a focus on future roles and achievements. For her eventual disgrace and the extensive memory sanctions imposed on her in AD 32, see Flower 2006, 169–82.

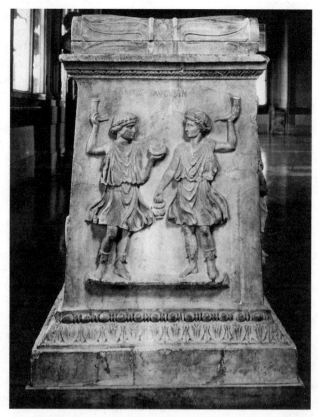

IV.16. Altar from the Vicus Sandalarius, *lares augusti*. 2 BC. Galleria delle Statue e delle Pitture degli Uffizi, Florence, Inv. Sculture n. 972.

woman (a mortal, not a goddess) has been so much harder to identify than the two male figures.

Consequently, the scene seems to be alluding to different rituals or perhaps to various distinct moments in a sequence of ritual actions on a given day or over several days. Consulting the chickens is separate from pouring a libation, which may, in turn, be the first gesture in an animal sacrifice that is only hinted at here. The variety of references in this scene is matched by the range of objects combined in the abstract scene on the other long side. No location is specified in the background, but related ceremonies may have played out in the new Forum Augustum nearby, after its inauguration in May. Alternatively, the *tripudium* could have been held in conjunction with the beginning of the military campaign season, on the traditional date of the *ides* of March. This is the only compital altar to feature an augural ritual along with a libation. Needless to say, none of these rituals seems to be addressed specifically to *lares augusti*. Rather the altar serves to celebrate and commemorate a civic ritual(s) in the context of a dedication to *lares augusti*.

The artist displays consummate skill in evoking the language of state art in a small space, while making the figures seem quite natural in their own framework. His rendering of Augustus and Gaius is true to imperial portrait types; the same may also have been the case for the woman who is not known to us. It seems

probable that this relief is an original composition (or combination of motifs) by this artist rather than an exact copy of another monument, whether public or private. The choice to place the dedicatory text with the names of the *vicomagistri* immediately below this contemporary scene creates a special connection between these particular named freedmen, in their function as *vicomagistri* of the Vicus Sandalarius, and religious, military, and dynastic celebration(s), presided over by Augustus himself. His closeness to them is inscribed through both his name (in the context of his consulship of 2 BC) and his portrait in this relief. Presumably, the Victory adorning the trophy expresses the pious hope of these freedmen that the young Gaius will return home covered with glory, even as his adoptive father has before. In the event, he died at the age of twenty-four in the East, barely six years after the dedication of this altar.[33] In this particular sense also, the altar provides us with insight into a very particular moment in the life of Augustus and his family, one that is shared and celebrated by this local vicus adjacent to his new forum.

The more time one spends looking at its composition, the more features seem intentionally designed to make the most of the iconography and format. As noted, the *tripudium* scene is logically associated with victory on the short side to its right, while the *lares augusti* are easily juxtaposed with other symbols that each recognizably signify *augustus* to their left. Another ingenious feature of this altar is this very way in which it can be read either by pairing a long side with a short side, or by juxtaposing the visual message in each side of the same length. The short sides are occupied by the deities, *lares augusti* and a victory goddess, each closely associated with Augustus and his family; the long sides are focused specifically on the princeps himself, first in person but next in his well-known symbolic attributes that spell Augustus.

The other long side features an array of Augustan symbols, but this time the artist has played with our expectations by rendering the objects in wildly different sizes. The other three sides all use a logical scale that looks naturalistic within each visual frame, even without much in the background. But on the "back," a huge oak wreath takes up the center of the composition, while being framed by twin laurel trees. The edges of the field are filled by imposing sacrificial instruments; the jug for pouring the wine to the gods is half the size of the laurel tree next to it, which itself pokes its upper branches over the massive oak *corona civica* adorned with an exceptionally opulent, floating ribbon. On the other side, a big *patera* seems to make the neighboring laurel bend to accommodate it. This difference in size appears abstract and symbolic to a modern viewer. The front centers on Augustus in a priestly role, while the back articulates a similar idea with the laurels and oak to say "Augustus" and the jug and *patera* to evoke "ritual" and "sacrifice." Meanwhile, the differences in scale deliberately play both with the deployment of these symbols, so common in Augustan art, and with the aesthetic of more vernacular reliefs that did not display the same concern for proportional scale and perspective found in civic art. On the front, a complex scene evoking civic cult is easily shrunk to look natural in the available space, so much so that it can be surprising to see the small size of the altar if one is only familiar with it from photographs. On the back, much "smaller" objects become huge and draw our attention

33 Gaius Caesar died of an illness on 21st February AD 4 at Limyra in Lycia, where he received a cenotaph (for which see Ganzert 1984).

to the limited field that they seem ready to burst out of. This artist shows he can innovate across these fields and can keep surprising us, as we walk around and around the little altar.

No less sophisticated is his brilliant rendering of the *lares augusti* themselves, the actual recipients of the altar with all its fine decoration. This is the only pair we know of in Augustan art that are *not* depicted as identical twins, in mirror image of each other (unless this effect is the result of later restoration?). They each hold up a *rhyton*, but one has a *patera* and one a *situla*. Even more provocative is the fact that the wreaths they wear on their heads are not quite identical. Their gestures toward each other as they suddenly seem to find themselves face to face and unusually close to each other stress these surprising differences. Similarly, their feet show that they are both standing quite still, but their tunics are visibly in motion in the way typical for those *lares* that are depicted dancing. Are they twins or not? Are they dancing or not?

Meanwhile, it is highly unusual for any *lares* to interact with each other; rather they are usually oriented outward toward the viewer. Here, they themselves seem to be caught in a sudden moment saying: "Oh, it's you? What a surprise!" Yet by now, a pair of *lares augusti* were not surprising at a *compitum* in Rome. The artist plays multiple variations on their usual iconography, both to show his own skill but also to engage his viewers, who keep looking to see what is usual and what less so. The whole scene can, of course, also be appreciated as humorous. Yet it expresses profound affection for these *lares*, who are both familiar and yet still quite new.

In conclusion, something needs to be said about the inscriptions, which are unfortunately incomplete.[34] Here, the dedication to *lares augusti* is both spelled out in full and put right above their images, highlighting the interplay of word and image. Were you really wondering who these *lares* were? Now you know. Similarly, the decision to put the consular date prominently in the immediate background of the *tripudium* relief, and separated from the dedicants below, gives additional weight to this very year, and juxtaposes Augustus' name with his portrait.[35] Most consular dates on inscriptions are not foregrounded in this way; many appear at the end of the text in smaller letters, as is the case in Augustus' own closely contemporary dedication to *lares publici* on the Sacra Via. The dedication by the *vicomagistri* runs along the bottom of the front, between the *tripudium* relief and the base, and is inscribed in a special tablet of its own (in the form of an elongated *tabula ansata*). The self-styled *magistri* of the Vicus Sandalarius are listed in the nominative, which indicates that they are the donors of the altar, although no verb of giving or paying is expressed. They are giving the altar to the *lares* in the dative (*laribus augustis*), although these gods are named only on the short side. In most cases, the whole text of a dedication is in one place so that it can be read at one time, since the dedicants want you to know to whom they are making their gift as you are reading their names. Just as is the case with the iconography, the way the text is written also assumes the viewer is familiar with the genre and context of what is being presented.

34 *CIL* 6.448 = *ILS* 3614 = Tarpin 2002, R 32 = Lott 2004, no. 20 = EDCS-17300601.

35 [*Imp(eratore) Caesare*] *Augusto XIII M(arco) Plautio Silvan(o) co(n)s(ulibus)* (in the consulship of Imperator Caesar Augustus for the thirteenth time and Marcus Plautius Silvanus).

D. Oppi]us (mulieris) l. Iaso, D. Lucilius D. l. Salvius, L. Brinnius (mulieris)
l. Princeps, L. Furius L. l. Salvius,
Mag(istri) Vici Sandalarii

Decimus Oppius (?) Iaso, freedman of a woman, Decimus Lucilius Salvius,
freedman of Decimus, Lucius Brinnius Princeps, freedman of a woman, Lu-
cius Furius Salvius, freedman of Lucius, the magistrates of the Vicus
Sandalarius

(*CIL* 6.448 = *ILS* 3614)

Three names of freedmen *magistri* are clearly visible: Decimus Lucilius Salvius
(freedman of a Decimus Lucilius); Lucius Brinnius, who was suggestively called
Princeps (presumably by his former owner who was a woman); and Lucius Furius,
also called Salvius (freedman of a Lucius Furius). A fourth was apparently D. Op-
pius Iaso (freedman of a woman), but the beginning of his name was lost, appar-
ently during the early sixteenth century. The first few letters of the text have been
restored in such a way that his female owner has now disappeared. As is typical of
other such lists, each man was freed by a different master or mistress and a differ-
ent family.[36] Their positions as *magistri* of the Vicus Sandalarius certainly make us
expect the names of four freedmen in the nominative. Meanwhile, it is notable
that the *vicomagistri* do not specify the year of their office in the usual way, which
may well mean that the numeral V has been lost from the inscription.[37] No other
dedications made by any of these men have survived.

This altar provides exceptional testimony to the charisma of *lares augusti* in a
compital context. They are depicted as integral to Rome's civic cult and military
aspirations, as well as having a protective function in a dynastic setting. Most dis-
cussions of this altar do not take the full context and range of its iconography into
account. In other words, everything we see on the altar needs to be understood in
the context of a dedication specifically to *lares augusti* set up by these freedman
magistri in the Vicus Sandalarius. No better illustration could be found of the way
in which this cult helped former slaves to take an official role in local life, but also
to identify themselves directly with Augustus and specifically with his role as a
priest in Rome. The *magistri* chose to list their own names juxtaposed with a relief
of the princeps and his presumptive heir in a religious role closely linked to Rome's
imperial and military aspirations, not with a depiction of themselves and their own
functions in the service of the *lares augusti* at this compital shrine.

36 I was able to see the altar in the new gallery at the Uffizi on 29th October 2013. Dessau (*ILS*
3614) has *D. Oppius) l. Iaso*. Rose (1997, no. 33) has *[D. Oppius] l. Iaso*. Tarpin (2002, R32) has
D(ecimus) Oppius (mulieris) l(ibertus) Iaso. Lott (2004, no. 20) has *D. Oppius C. l(ibertus) Iaso*.

37 Nearly all *vicomagistri* indicated their year of office by a number in their text (for example,
primi, secundi, and so on, or by numbering the year itself), which is why Lott 2004 can arrange his
useful catalogue of these inscriptions by these years of office.

XXVII *GENIUS AUGUSTI?*

Hic forsitan quis quaerat, quid causae sit, ut merum fundendum genio, non hostia faciendum putaverit. Quod scilicet, ut Varro testatur in eo libro, cui titulus est Atticus id est de muneribus, id moris institutique maiores nostri tenuerunt, ut, cum die natali munus annale genio solverent, manum a caede ac sanguine abstinerent, ne die, qua ipsi lucem accepissent, alii demerent.

— CENSORINUS *DE DIE NATALI* 2

The equation, which is in fact a confusion in modern scholarship, of the domestic cult of Augustus' *lares* (which certainly existed within his own household) with the cult of *lares augusti* at the compital shrines has primarily been caused by the belief in a widespread cult of Augustus' *genius* in Rome during his lifetime. Despite their ubiquity in the ancient sources, *lares augusti* have been overshadowed and defined by an essentially unattested *genius Augusti*. Although the received interpretation of the *genius Augusti* at the compital shrines relies almost entirely on a speculative hypothesis put forward by Lily Ross Taylor in 1931, only recently have serious doubts about this *genius* cult started to be expressed.[1] As a result, it has proved virtually impossible to understand *lares augusti*, who remained *lares* at traditional crossroads shrines, in their own right. Indeed, the existence (or not) of a cult of the *genius Augusti* in close association with the *lares augusti* at the same compital shrines has raised a series of much debated questions, which remain vital to the interpretation of Augustus' public image and his whole religious program in Rome.

Did Augustus encourage or even require a cult of his *genius* by Romans in Rome and Italy, perhaps immediately after his victory in the civil war that resulted in his emergence as Rome's single leader? Did a mandatory libation to his *genius* put all Romans, including the great and the good, into a directly subservient position that obliged them to make a religious gesture toward the princeps' *genius* equivalent to that usual for slaves, who regularly cultivated the *genius* of their master within the household? Did Augustus then innovate in a different way, over twenty years later, by putting a cult of his own *genius* (together with his household *lares*) in the compital shrines throughout the city of Rome? In other words, did Augustus displace the existing *lares compitales* and replace them, in a single religious reform, with duplicates of his personal household gods, imagined as looking like a *genius* and two *lares* in the configuration familiar from the paintings in Pompeii? Would such a gesture then have made the whole city part of the princeps' household? Would the cult of the *genius Augusti,* therefore, have put the *vicomagistri* in each vicus into the position of behaving as if they were freedmen of the imperial family rather than of the masters who had legally freed them?

To put it plainly and despite modern claims to the contrary, the answer to all of the preceding questions is a resounding "no." The extant ancient evidence does not support the existence of any officially sanctioned cult of Augustus' *genius* in Rome

1 A cult of Augustus' *genius* is posited by Taylor 1931, 184–94; von Premerstein 1937, 128–31; and Alföldi 1973, 25. See more recently Galinsky 1996, 301; Tarpin 2002, 137–64; Letta 2002 and 2003; Fraschetti 2005, 323; and Rosso 2015. Gradel 2002, 115–30, 162–97, rejects a libation to Augustus' *genius* at the evening meal but accepts a *genius* cult at the *compita* in Rome. Lott 2004, 110, takes the reverse position, accepting the libation but rejecting the compital cult. Mouritsen 2011, 249, hesitates about the *genius* at the *compita*. Wiseman and Wiseman 2011 also express caution at p. 140: "Some, at least, of these altars were shared with the cult of Augustus' *genius*."

during his lifetime. Once it is acknowledged that the paintings from the street shrines of Pompeii do not reflect what was usual in Rome and do not include any explicit references to *lares augusti* (or to the *genius Augusti*), there remains no visual or material evidence for a cult of the *genius Augusti* in Rome.[2] Moreover, of the ninety Latin inscriptions from Rome that attest a cult to a deity with the epithet *augustus/a* from antiquity, none mentions a *genius Augusti*, or even any other deity or divine quality labeled with a genitive singular of Augustus' name.[3] The scattered literary texts used to support this hypothesis do not, in fact, do so; these passages will be discussed later.

Two settings for a *genius* cult have been accepted by many scholars—namely, a libation to Augustus' *genius* at banquets (whether public or private) by all Romans, and a cult of the *genius Augusti* at all compital shrines in Rome, which is imagined as including animal sacrifice. Neither is supported by reliable ancient evidence for Rome during Augustus' lifetime.[4] These two hypothetical rituals need to be considered separately.

Dio is the only source explicitly to mention a senatorial decree enjoining a libation to Octavian at all evening meals, an honor apparently awarded in 30 BC immediately after his victory in Egypt and most probably voted before his return to Rome.[5] Dio does not, however, speak of a libation to Octavian's *genius* but simply of a libation to *him*—in other words, a divine honor bestowed directly and deliberately on a mortal. Scheid interprets the practice of taking an oath by Julius Caesar's "Fortune" (*tyche*) introduced by the senate in 44 BC as a precedent for the cultivation of Octavian's *genius* after Actium.[6] But there is no evidence that *tyche* should be understood as *genius* as opposed to Fortuna (for example) in this context: the argument is inevitably circular. Moreover, Octavian was careful to avoid following the example set by Caesar, especially in the last months of his life. If indeed we should imagine an oath by Caesar's *genius*, as part of the extravagant honors the senate was heaping on him, then it would serve as a further argument against inserting an unattested *genius* of Octavian in 30 BC.

2 Lott 2004, 174, and Van Andringa 2000, esp. 78–80, show that there is no evidence of a cult of the *genius Augusti* at Pompeii. Yet Wallace-Hadrill 2008, 278–79, 293, still assumes that the cult of the *lares* and *genius* were to be found at every *compitum*, and Charles-Laforge 2011 builds an elaborate argument for a cult of Augustus' *genius* in Pompeii despite the lack of any specific evidence. Lott 2004, 112, documents dedications to the imperial *genius* outside Rome in other contexts. Rosso 2015 tries to address the missing iconography of the *genius* by positing that a single man sacrificing should be read as the *genius Augusti* in the reliefs from the vici.

3 See Panciera 2003 for the inscriptions mentioning the august gods in Rome, although he also still assumes that there was such a cult both in the home and on the street, despite all the evidence he has so carefully collected and so thoroughly analyzed.

4 A particularly interesting discussion can be found in Scheid 2001b, 98: "Dans le culte public de l'État romain, seuls des rapprochements étaient possibles." (In the public cult of the Roman state, only approaches [to deification] were possible); and 100: "Aucun temple, aucun autel officiels ne furent dédiés à Auguste, ou meme à son Génie, sur le territoire de la ville de Rome." (No temple or altar was ever dedicated to Augustus, or even to his *genius*, within the territory of the city of Rome). Nevertheless, Scheid accepts the cult of Augustus' *genius*, both at meals in the home and at the crossroads. He calls the compital cult the first public cult of the emperor's *genius* in Rome (102).

5 Dio 51.19.7 (30 BC). Accepted by Galinsky 1996, 301; Scheid 2001b, 100–101; Tarpin 2002, 153; and Lott 2004, 111. Rejected by Gradel 2002, 207–12, who presents many convincing arguments against this practice for Augustus and even beyond.

6 Dio 44.6.1, with Scheid 2001b.

Moreover, there was a clear precedent for this kind of a libation directly to a mortal at the evening meal in the spontaneous libations to the great general Marius poured by many Romans at dinner after his victory over the Cimbri in Northern Italy in 101 BC, although only a few elderly Romans could have remembered participating in this acclamation some seventy years earlier.[7] Such a libation recognized the individual as the savior of each Roman who participated and, by extension, of the community in general. Whether the unofficial libations for Marius were practiced over a longer period of time remains unclear and will have depended on the inclinations of individuals. In the earlier case also, there is no evidence for a libation to Marius' *genius*. Rather Marius was given divine honors (in the form of a libation) in his lifetime by his fellow Romans. This famous example was surely at least part of the reason why senators did indeed suggest such an exceptional honor for Octavian.

It was both possible and apparently not unusual for ordinary Romans to accord their own form of spontaneous divine honors (including a libation) to an individual whom they recognized as a personal benefactor of special merit.[8] An obvious example would be someone who had saved that person's life. This practice is attested in Roman sources, although mainly for ordinary citizens rather than for the elites. Such a habit did not make much sense as part of the competition between the political office-holders (*nobiles*) who were the leaders of republican Rome. The gesture of reverence toward a personal savior generally remained just that: it had no larger implications for religious practice or for the formal status of any given individual within the Roman community as a whole.

In a military context, the saving of a citizen's life was recognized by the official award of the oak wreath (*corona civica*), while the saving of a whole legion or army earned a grass crown (*corona graminea*).[9] The latter was a simple grass wreath presented by soldiers to their general on very special occasions. Octavian had indeed also been awarded a grass crown, but by the senate on 13th September 30 BC, in close proximity to the distinction of the libation at banquets (together with a number of other signal honors).[10]

There is no reason, therefore, to doubt that the senate chose to honor Octavian with a libation in a gesture that recalled the more spontaneous hailing of his distant relative Marius as the savior of Rome. At the same time, the libation could be construed as a way to present his victories, both at Actium and Alexandria, as having been won over a foreign enemy who posed an immediate and essential threat to Rome, as the Cimbri had done in the time of Octavian's grandfather. Nevertheless, there is no reason to believe either that Octavian continued to receive divine honors at every Roman supper or feast thereafter, nor is there any evidence

7 Val. Max. 8.15.7 and Plut. *Mar.* 27.9, with Classen 1963, 327–29; Marco Simon and Pina Polo 2000; Gradel 2002, 51; and Flower 2006, 88–89.

8 See, for example, Horace *Odes* 4.5.34 and Ovid *Ex Pont.* 2.8 and 4.9. In these cases, there is no mention of a *genius* but of a *numen*. For discussion, see Tarpin 2002, 153; Gradel 2002, 44–49; and Koortbojian 2013, 158–70.

9 Maxfield 1981 discusses military decorations in general. For the *corona civica*, see Gellius *NA* 5.6.11–14, with Bergmann 2010, 135–83. For the *corona graminea* (*obsidionalis*), see Pliny *Nat.* 22.6 (including a citation of Sulla's memoirs), with Scholz and Walter 2013, F10, and *FRHist* 22 F 16 (Christopher Smith, who dates to 89 BC), with Bergmann 2010, 112–34.

10 For Octavian's grass crown (13th September 30 BC), see Pliny *Nat.* 22.6.13, with Cooley 2009, 265, and Bergmann 2010, 189–91 and 185–205.

that a libation was ever poured specifically to his *genius* in this or any other context outside his own household.[11]

After he returned to Rome from Egypt, Octavian clearly responded to the senate's honors by accepting some but declining many others, even as Rome's elite were themselves struggling to negotiate their own status in relation to his new position of unique prominence.[12] As we know from hindsight, the process of shaping and portraying his political powers and general position within Roman society was only in its very early stages in 29 BC and would not be finally defined (at least in his opinion) until he was named *pater patriae* in 2 BC. Despite the fact that the grass crown was such a signal honor shared with only a few outstanding leaders in the history of Rome's wars, Octavian did not make much of this award. Perhaps the grass crown was still too closely associated with Sulla, who had commissioned a painting of himself wearing this decoration for his villa.[13] It is also possible that Caesar had made much of his award, although in other ways he tended to avoid any association with Sulla.[14] Instead, by January 27 BC, Octavian had selected the much more commonly awarded oak wreath as one of his three distinctive attributes, a military decoration that suggested the idea of saving the individual citizen while, at the same time, stressing the newly named Augustus as himself one of that same crowd of citizens, a *civilis princeps*.[15]

Similarly, there is no explicit evidence for a libation to Octavian at the evening meal after those early days and once he became known as Augustus. Indeed, it is quite evident that Octavian was at pains *not* to accept the kind of blatant and unambiguous divine honors that had been so characteristic of the last months of Julius Caesar's life.[16] Augustus' decision to live simply in an ordinary house, to wear plain (often homemade) clothes, to be protected in the city by bodyguards in civilian dress with concealed weapons, and to stress both his personal standing (*auctoritas*) and the fact that he had no more formal powers (*potestas*) than his colleagues in each political office, would all have appeared as utter nonsense if he had simultaneously received officially mandated divine honors in every Roman household on a daily basis and openly at every public banquet presided over by the priests and magistrates.[17] Octavian was no fool when it came to crafting an image that

11 Hänlein-Schäfer 1985 shows that temples were built to Augustus, not to his *genius*.

12 Dio 51.19–20 records these honors.

13 For Sulla's grass crown in a painting on the wall of a villa later owned by Cicero, see Pliny *Nat.* 22.12: *scripsit et Sulla dictator ab exercitu se quoque donatum apud Nolam legatum bello Marsico, idque etiam in villa sua Tusculana, quae fuit postea Ciceronis, pinxit* (Sulla the dictator recorded [in his memoirs?] that he had been given [a grass crown] by his army at Nola when he was a legate during the Social War, and this occasion was depicted in a painting at his villa in Tusculum, which later belonged to Cicero). Apparently, therefore, this fresco was not painted over by subsequent owners after Sulla's death in 78 BC. Cicero died thirty-five years after Sulla.

14 Bergmann 2010 has argued that Caesar is portrayed on many of his coins wearing the grass crown, thus making it his special attribute of choice. In that case, Augustus' *corona civica* would be a pointed contrast.

15 For the *corona civica* of the emperor, see Bergmann 2010, 185–205.

16 See Gradel 2002, 54–72, for a convenient summary.

17 Rowe 2013 has put the discussion of Augustus' *auctoritas* on a new footing. He has suggested that *auctoritas* (as described by Augustus at *RGDA* 34.3 *auctoritate omnibus praestiti*, I excelled all in personal standing) refers specifically to Augustus' position as leading man in the senate (*princeps senatus*), rather than his personal prestige in general. His argument has been refuted by Galinsky 2015. Either way, my point here is the same; Augustus claims to be acting within a constitutional framework and in harmony with traditional norms. It is obviously

would set him apart from the singular honors that had ultimately cost his adoptive father Julius Caesar his life.

The hypothetical libation for the princeps' *genius* was posited by modern scholars, first to try to explain the initial divine honors voted by the senate and second to try to find what seemed to them a possible context for a continuing ritual, one that did not actually make sense in Rome, especially after January 27 BC. Once the idea of the libation to the *genius Augusti* is disposed of, an equally hypothetical cult of Augustus' protective spirit at the *compita* can be considered in a more realistic and historically accurate setting. Again, the same questions arise, but in a possibly even more pointed form.

Why would Augustus, twenty years after accepting his new name and after so many careful moves to define his status as princeps, introduce an unprecedented religious cult, which implied that everyone in Rome was his social subordinate and that he was not, after all, *primus inter pares*? Would he want to appear as the new "master" of Rome's freedmen, in place of the men who had legally freed them and given them the citizenship in accordance with tradition and with Augustus' own legislation about manumission? In this context, it is especially notable that none of the *vicomagistri* whose names we know were former members of the imperial household.[18] The *vicomagistri* were locally chosen from the inhabitants of each vicus, not imposed from outside or drawn from a group of handpicked men loyal to Augustus. Moreover, very few in a given year were drawn from the same household. In other words, Augustus did not imitate Sulla, who had freed 10,000 young male slaves, all of whom took his name (Lucius Cornelius), and then settled them in Rome.[19] There is, therefore, no attested special connection between the *compita* and the *familia Caesaris* (slave or freed).

What, then, is the ancient evidence for a cult of the *genius Augusti* at the *compita*? The answer is extremely little, and what exists has been adduced in a series of increasingly circular arguments backed by an appeal to the imagined libation at the evening meal. It is almost universally claimed that the bulls led to sacrifice on some compital altars commissioned by *vicomagistri* are victims intended for the *genius Augusti*. Yet this deity is not depicted or alluded to on any of these altars.[20] There is ample evidence, moreover, that the *genius* of an individual Roman did not normally receive animal sacrifice of any kind.[21] A living man's *genius* was primarily honored on his birthday, since this deity corresponded to his personal guardian and

interesting that Augustus chose *auctoritas* rather than *dignitas* (personal standing), the term preferred by Julius Caesar.

18 Lott 2004, no. 8, is a dedication by slaves of an imperial freedman.

19 For the ten thousand Cornelii, many of whose descendants were presumably to be found throughout the vici over seventy years after they were granted their freedom; see *ILLRP* 353 = *ILS* 871, with Appian *BC* 1.100 and 104, and Flower 2006, 92–93. These Cornelii might, in fact, have cultivated Sulla's *genius*, at least in the short time left before his death in 78 BC. For Sulla and the vici, see section III.xxii.

20 Ryberg, 1955, 54: "With very little violence to old accepted observances, with all the appearance of restoration of the old cult of the vici which had fallen into neglect, the *Lares* were set up at the *compita*, accompanied by the *Genius Augusti* whom people were accustomed to include in the worship of their own *Lares*." Rosso 2015 has interpreted single togate figures on these altars as the *genius* of the emperor, even without any divine attributes, such as a cornucopia.

21 Censorinus *DN* 2.2 (drawing on Varro).

life force.[22] The usual gifts for the *genius* were flowers, cakes, incense, and wine.[23] In fact, Censorinus, in his famous discussion of birthday celebrations, stresses the bloodless nature of the cult of a man's *genius*. Since every Roman, together with his friends and household, would have been expected to acknowledge his *genius* on his birthday, this cult was very well known. While animal sacrifice certainly became a regular feature of the new cult of the *divi* (members of the imperial family deified after death), there is simply no reason to think that an animal was ever sacrificed to a living man's *genius* under Augustus.[24] The explanation for bulls being led to sacrifice on the reliefs of compital altars must be sought elsewhere, as is discussed later. Moreover, there is no evidence for a cult of Augustus' *genius* on his birthday (23rd September), either at the compital shrines or in any other public religious context in Rome. If a cult of his *genius* had existed, then Augustus' birthday would inevitably have been expected to serve as its main feast day according to Roman custom.

Nevertheless, a *genius* has been imagined on a badly damaged compital altar from the first year of the newly reformed era.[25] (See figures IV.17 and IV.18.) This famous altar, long housed in the Vatican, features the *lares augusti* with two spindly laurel trees between them on its front and two *vicomagistri* with a flute player pouring libations on each side. As is typical, each man presides even as they all concelebrate together. On the back there is a *corona civica*. The front of the altar also depicts a single togate figure pouring a libation next to but facing away from the twin figures of the *lares*, who are oriented inward toward each other. This togate figure has been described as a *genius*, despite the fact that he holds no divine attribute, such as a cornucopia, and that he is not positioned between the *lares* in the configuration that is so common in the later paintings from Pompeii.

Unfortunately, the inscription that runs along the top is very badly damaged. The phrase *genius Caesarum* (*genius* of the Caesars; *not genius Augusti*) has been suggested to complete the inscription's first line. The text appears as follows:

laribus augustis C[xxx
Q. Rubrius Sp. f. L. Aufidius Cn iciniu[s]
Col. Pollio Felix P . . . [P]hileros
[m]agistri qui k(alendis) Augustis primi mag[isterium ini]erunt

For the august *lares* . . . C/G xxx
Quintus Rubrius Pollio, son of Spurius, of the tribe Collatina
Lucius Aufidius Felix
Cn. ? P. ?

22 Censorinus *DN* 2.3 is the key text. For the Roman birthday, see Marquardt 1964, 250–51, with Aretsinger 1992. Birthday poems: Tibullus 2.2 and 4.5; Ovid *Trist.* 5.5.

23 For the *genius* and his gifts (flowers, consecrated cakes, wine, and incense), see Pliny *Nat.* 18.84 and Censorinus *DN* with Maharam in *BNP*, Schmidt and Otto in *RE*, Kunckel 1974, and Romeo in *LIMC* 8.1.599–607. Generally, living and eating well was said to please a person's *genius*.

24 Gradel 2002, 110, argues that no living emperor was regarded as a state god after Julius Caesar but that Caesar was termed *divus* in the last months of his life. See esp. the discussion of Koortbojian 2013.

25 Vatican inv. no. 311 of 7 BC (Salla delle Muse, *CIL* 6.445 = *ILS* 3613 = Lott 2004, no. 7 = EDCS-17300598) For discussion, see Alföldi 1973, 31; Hano 1986, 2338 no. 1; Fless 1995, no. 10; and Galinsky 1996, 304.

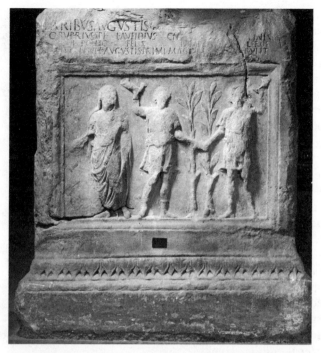

IV.17. Compital altar, front, *lares augusti* and laurel trees, togate figure pouring a libation. 7 BC. Musei Vaticani, Museo Pio Clementino, Sala delle Muse, Inv. 311.

. . . icinus Phileros
the first magistrates who entered office on the *kalends* of August
(*CIL* 6.445 = *ILS* 3613)

Even from the beginning, the restoration of the first line was far from sure, particularly since it is based on comparanda that are much later.[26] The overall wear on the altar suggests that it was outside and in use for a long time, as is the case for most other compital altars. The first line is essentially gone after the dedication to the *lares*, whose names are spelled out in full in large letters. Doubt has long been expressed about the presence of a legible *m* at the end of the line, the only letter that possibly survives from the word *sacrum*. What we are left with now is the trace of a C or G after the *lares*, followed by a long empty space. Unfortunately, the chipping of the top edge of the stone also makes it impossible to estimate accurately how many letters are missing but there would have been quite a bit of room here for more words.

It is important to note that the surviving C/G is much smaller than the *LARES AUGUSTI* next to it, in lettering the same size as that used for the names of the four freedmen *vicomagistri* listed below. This shift of letter size despite ample space on

26 *CIL* 6.445 has the text as restored by Henzen but on the basis of parallels that are all after the Julio-Claudian period and not from Rome. As noted, there is very little to go on, as the text is very badly damaged. Dessau (*ILS* 3613) already warned *supplementum non certum, cum etiam littera m non omnino certa videatur* (the supplement is not certain, since even the letter M does not seem at all secure).

the stone in itself speaks against the idea that Augustus' *genius* was listed here. If a cult to his *genius* had been paired, as it were on an equal footing, with the new *lares*, then the letters of the top line should all have been the same size in honor of these deities. Putting the emperor's *genius* in much smaller letters simply does not make sense. This inscription from the first year of the new era is hard to reconstruct because it is not formulaic and spells out its wording at full length, as the last line attests even in its fragmentary state. Reconstructions of the top line must remain hypothetical. A consular date is listed in some of these texts, but the first consul's name for 7 BC should start with T (Tiberius Claudius Nero) not C. His colleague, who should strictly always have been listed second in the order in which they had been elected,

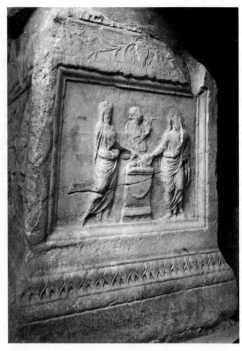

IV.18. Compital altar, right side, two *vicomagistri* and flute player at an altar. 7 BC. Musei Vaticani, Museo Pio Clementino, Sala delle Muse, Inv. 311.

was, however, the notorious Cn. Calpurnius Piso, whose name does start with a C. Piso was disgraced after his treason trial in AD 20 following his role in events surrounding the death of Germanicus in Syria: some inscriptions in Rome show erasures of his name, but it is impossible to tell whether there was ever a deliberate erasure here before the top of the stone was lost.[27]

Alternatively, since all four *vicomagistri* are listed below in the inscription and represented in pairs on either side of the altar, perhaps another official was mentioned here, who may be represented by the togate figure pouring the libation on the front of the altar. If this figure is not a *genius*, he must be a man. His importance is suggested by his position on the front next to the *lares* themselves, although he does not obviously face or interact with them, whoever he may be. Some inscriptions do list the name of a praetor or tribune of the plebs before the list of *vicomagistri*, but the surviving examples are all rather later.[28] Most of these texts refer to the restoration or moving of a *compitum* by permission of either a praetor or a tribune of the plebs. Perhaps Augustus himself was represented here. However that may have been, this battered altar cannot be used to "prove" the existence of a cult of Augustus' *genius* at a compital shrine in 7 BC.

27 For erasures in Piso's inscriptions, see Flower 2006, 135–36 and 318 n. 72 with earlier bibliography.

28 Perhaps the most interesting comparison is *CIL* 6.453 = *ILS* 3616 = EDCS 17300606, but see also *ILS* 3617–20, which are all later restorations of *compita*. These inscriptions, however, introduce the name of the additional magistrate with either *iussu* (by order of) or *permissu* (by permission of) rather than with the first initial of the person named.

Similarly, a variety of references to homage and divine honors for Augustus in various poems of the period do not actually mention his *genius*.[29] The term that is the most commonly used is *numen*, a word that refers to the divine nature of a god and not to the spirit of a man.[30] A *genius* cannot be the same as a *numen* because such an equation would nullify the distinction between man and god. Every individual has a *genius* but only immortal gods by their very nature possess *numina*. The whole point of attributing a *numen* to Augustus, therefore, involves his elevation well beyond the ordinary sphere of mortals. Moreover, these poems all refer to situations in which individuals offer their own personal homage to Augustus and salute his *numen* in a private context. As argued earlier, such personally attributed divine honors had their traditional place in Roman culture and could be invoked without implying a general theological position that had been officially adopted by the community as a whole.[31] In fact, it was precisely the individual context described by the personal voice of a flattering poet that made statements so at variance with Augustus' carefully crafted public image possible and even unproblematic. There could be little doubt that the man who called himself *divi filius* was himself aiming precisely for divine status but as a *divus* after death, not before.

According to a restoration in an Augustan calendar, Tiberius dedicated an altar to the Numen Augusti in Rome on 17th January, perhaps on the Palatine and possibly in AD 6. This day was Augustus and Livia's 45th wedding anniversary.[32] Such an altar would have been a significant step in civic cult, which directly recognized Augustus' godlike essence, close to his seventieth birthday.[33] Recognizing his *numen* would have gone beyond lending his epithet to Pax or Providentia, but without actually deifying him; it clearly further anticipated that he (*divi filius*) would be recognized as a *divus* in the (near) future. If such a cult had indeed existed, it would surely in itself have made a widespread cultivation of the *genius Augusti* at the same time problematic. Yet, we cannot be sure of the existence of this altar or of a civic cult like this in Rome in Augustus' lifetime.

In a typically elusive and barbed sentence, albeit expressed here in the voice of the critics of the princeps at the time of his death in AD 14, Tacitus claims that Augustus enjoyed every divine honor.

nihil deorum honoribus relictum cum se templis et effigie numinum per flamines et sacerdotes coli vellet.

29 Poems for or about Augustus do *not* mention his *genius*. See Horace *Odes* 4.5.29 ff. (14/13 BC), Ovid *Fast.* 2.633ff. for the Caristia, and Petronius *Sat.* 60 for a toast to the emperor's health at dinner. The last two examples clearly show a pious wish or prayer *on behalf of* the emperor (*feliciter*, good luck) rather than *to* him as a deity.

30 For the *numen* of the emperor, see Pötscher 1978, 380–92; Fishwick 1991, 375–87; and esp. Gradel 2002, 7, 234–50. Papi 1994 presents much interesting material from Italy, but again the *genius* is restored in the inscriptions; the largely circular argument is based on the idea of a well-attested *genius* cult in Rome.

31 See Koortbojian 2013, 158–70.

32 *Fasti Praenestini* 17th January: *II* 13.2, p. 115 (as restored by Mommsen), with Palombi in *LTUR*. Torelli 1992, 66, and Scheid 2001b, 98, accept this altar. Alföldi 1973, 42–44, ascribed the Grimani relief in the Louvre to it. This altar is not listed by Haselberger 2002 in his inventory of Augustan Rome.

33 Prescendi sums up the essential idea in *BNP*: "Neither his person nor his *genius* was meant, but the divine power inherent in the emperor, and the force of the gods that manifested itself in and through the emperor."

(They were saying that) no honors were left for the gods, since he wished himself to be worshipped with precincts and images of the divine by priests of various kinds (*flamines* and *sacerdotes*).

(Tacitus *Ann.* 1.10)

The overall claim is exaggerated, generalizing, and focused specifically on civic cult, because within a polytheistic worldview, honors paid to one god did not necessarily deprive another. The Roman religious pantheon had always been open to new deities of many kinds. Nevertheless, the wording is suggestive, especially in its use of the term *numen*. If a cult of a *genius* was common, and not only for freedmen, then why is it not mentioned in this litany of complaints about the princeps being willing to accept or even demand honors beyond what was usual for his fellow citizens?

The only exception to this consistent and logical pattern in the surviving Latin authors and inscriptions would appear to be Ovid's entry for 1ˢᵗ May in his *Fasti*, a complex poem that comments on the Roman calendar day by day. In a much-quoted passage, the poet says

mille lares geniumque ducis qui tradidit illos
urbs habet, et vici numina trina colunt.

The city holds a thousand *lares* and the *genius* (protective spirit) of the leader who handed them over, and the neighborhoods/streets worship three gods.

(Ovid *Fasti* 5.145–46)

It is obviously puzzling and problematic that this allusive reference should be our only direct evidence for a cult of Augustus' *genius* at every compital shrine in Rome. Can we really build a whole cult on this one couplet? Moreover, the text of book 5 of the *Fasti* is not nearly as secure as that of the earlier books; not all of the more authoritative manuscripts contain the word *geniumque* and most of the lesser ones do not.[34] Meanwhile, the mention of three *numina* again apparently equates Augustus directly with immortal gods, even in this same context, whereas the *genius* was not usually thought of in this way, as already noted.[35] So even if we accept the wording of the text as it stands, the reference to the princeps' *genius* (a type of protective deity he shared with every other Roman) is immediately complicated by his being designated as possessing a *numen*, the essence of a deity that no other mortal in Rome laid claim to.

A comparison helps to suggest something of Ovid's narrative technique. A passage in book 2 of the *Fasti* (2.545) describes Aeneas making a sacrifice at the tomb of his father Anchises, as if this also was an offering to his deceased parent's *genius*

34 Modern critical editions with *apparatus criticus* are Bömer 1957, Schilling 2003, and Alton, Wormell, and Courtney 2005. Variant readings in *Fasti* 5, 145: some manuscripts have *geminumque ducem* or *geminique* (only M) or *duces* (G). *Geniumque* is in U (an eleventh-century MS in the Vatican) and G (an eleventh-century MS in Belgium). The best manuscript of the *Fasti* (A, which is a tenth-century MS in the Vatican) stops at line 24 of book 5.

35 For the *genius* leaving the world when a man dies, see Censorinus *DN* 3. Horace *Epist.* 2.2.183 says that a *genius* belongs to a living person, while the dead are associated with the *di manes*. Cf. Varro at Augustine *CD* 7.13. Similarly, in Greek a man's *genius* is often rendered *tyche* (fortune) rather than *psyche* (soul).

(see section I.viii).[36] This is a highly unusual use of *genius* (always singular) instead of *di manes* (always plural), which was the most usual way to describe the dead. In addition, Ovid's version is self-consciously situated in dialogue with the famous scene early in *Aeneid* 5 when Vergil portrays Aeneas at an altar puzzled by the appearance of a snake at Anchises' tomb in Sicily. Aeneas wonders whether the snake is the *genius loci* or a messenger from his father. Ovid's riff humorously rejects both alternatives in portraying Aeneas' sacrifice as addressed directly to the *genius* of Anchises. When read as a literary conceit, this scene has much less of a theological implication than has often been assumed. Consequently, we can see that Ovid plays games, including ones with different *lares*, as well as with the concept of what a *genius* could be in Roman religious thought.

The introduction of the *lares* at the crossroads here is also surprising as it comes at the end of the description of a feast day that is celebrated for the *lares praestites*, whose iconography and function are very different from the *compitales*.[37] Ovid underlines this surprise with an intervention in his own voice in the next line (*Quo feror?*). Why am I mentioning these *lares*, who belong in the month of August? The elements of parody are further brought out, for example, by the reference to dogs liking the crossroads just as *lares* do (5.140). The *lares* at the crossroads were never portrayed with dogs; this is a deliberate muddling of categories that also conjures up an image of stray dogs urinating at corners. In this sense also, we need to ask ourselves how "literally" we want to read what seems to be deliberately presented both as a quite surprising analogy and as something of a scholarly and literary joke? How surprised would Ovid be to see his couplet used as basic, factual evidence for a compital cult of Augustus' *genius* coupled with the *lares augusti*? Rather, Ovid himself may be playfully suggesting that the cult of *lares* throughout the city, to whom he pointedly does not give their new epithet as *augusti*, imply a *genius* as well, "as if" in a household cult belonging to the emperor. Meanwhile, he deliberately undercuts and problematizes his point by referring to three gods called *numina* in the next line.

But, it may be asked, is Ovid providing evidence that a cult of Augustus' *genius* was added later, sometime after the initial introduction of the *lares augusti* at the compital shrines in 7 BC? This hypothesis is disproved both by the lack of evidence for a *genius* in the restorations of compital altars in Rome over the following centuries (either in the inscriptions or in the imagery) and by explicit statements in ancient authors. We may especially note the public rejection of the cult of the emperor's *genius* in the younger Pliny's *Panegyricus*, a laudatory speech addressed to the emperor Trajan in AD 100 and published soon after.

> Simili reuerentia, Caesar, non apud genium tuum bonitati tuae gratias agi, sed apud numen Iouis optimi maximi pateris: illi debere nos quidquid tibi debeamus, illius quod bene facias muneris esse qui te dedit.

With similar humility, Caesar, you do not allow us to give thanks for your goodness by addressing your *genius* but rather the divine being of Jupiter Best

36 See Robinson 2011 ad loc.

37 Bömer 1958, 300, already took note of the muddling of very different *lares*, but interpreted this in terms of Ovid not having enough information for 1st May. For discussion of the *lares praestites*, see section II.xii earlier.

and Greatest: it is to him that we owe what we owe you, your good deeds are
the gift of him who gave you.

(Pliny *Pan.* 52.6)

How could Pliny reject the cult of the living emperor's *genius* if Augustus had made
it a norm a century earlier? Furthermore, Dio suggests that Gaius was the innova-
tor in this field, a development that may come as no surprise in light of his grandi-
ose behavior. The elite Arvals did not honor the *genius* of the ruling emperor in the
early imperial period.[38]

In the end, the cult of Augustus' *genius*, fully equipped with daily libations in
the home and regular animal sacrifice at the street corner, needs to be recognized
as a phantom of early twentieth-century classical scholarship.[39] There is no reliable
ancient evidence for such a cult, nor can it easily fit in with what we do know both
about religion in Rome in the time of Augustus and about his meticulously cu-
rated self-representation. In other words, since there is no trace of the *genius* of
Augustus having any role beyond the expected and traditional one within the em-
peror's own private household, there is no need to invent such a cult. Furthermore,
in the absence of an interloping and self-important *genius*, the *lares augusti* can
once more be appreciated as the principal gods of the crossroads and by far the most
ubiquitous deities to share the *princeps'* sacred epithet in Rome, in his own special
month.

38 Dio 54.4.4, with Scheid 2001b, 90, who notes that public sacrifices for the emperor's *genius*
and temples seem indeed to have started with Gaius.

39 Gradel 2002, 126: "In fact, were it not for the literary evidence, we would have no way of
knowing that the *Genius Augusti* was always included in the cult together with the *Lares.*" This ap-
proach begs the whole question of how we use the ancient evidence and how hypotheses easily
become established orthodoxies without a revisiting of the ancient sources. Other recent discus-
sions that take the *genius* very much for granted, and even describe him as if he was attested in this
context, include Eder 2005, Pasco-Pranger 2006, and Rosso 2015.

XXVIII WHO GETS THE BULL?

> Agrum lustrare sic oportet: impera suouitaurilia circumagi:
> "cum diuis uolentibus quodque bene eueniat, mando tibi, Mani,
> uti illace suouitaurilia fundum agrum terramque meam, quota
> ex parte siue circumagi siue circumferenda censeas, uti cures
> lustrare."
> —CATO *DE AGRICULTURA* 141

Once a cult of Augustus' *genius* has been eliminated from the compital shrines, the question remains as to why a bull is occasionally depicted in the sacrifice scenes to be found on altars dedicated by *vicomagistri*. In the past, this bull has almost universally been interpreted as the sacrifice to the *genius* of the living emperor and, in turn therefore, as secure evidence for a cult of that *genius* in this particular context. This reading obviously loses most of its persuasive value in the absence of other indications of a cult of Augustus' *genius* during his lifetime. There is plenty of evidence from many different sources that *lares* at the *compita* and elsewhere had traditionally received a pig as an offering.[1] Although the Arval records mention a wether (a castrated goat or ram) in the context of an old-fashioned (or archaizing) sacrifice to *lares* at the sacred grove of Dea Dia outside Rome, other sources (ranging from Delian wall paintings of the second century BC to references by Augustan poets to frescos from Pompeii painted in the 70s AD) indicate a pig as the preferred victim for *lares*.[2] Interestingly, the altar from the Vicus Aesculeti does show a pig, but together with a bull, at a single ceremony. (See figures IV.19 and IV.20.)

Five examples of sacrifice scenes with bulls from possible Augustan contexts are extant.[3] They are: the altar from the Vicus Aesculeti; a very fragmentary altar of Augustan date that was reused as part of a fountain; a damaged altar in the Vatican; the Soriano altar; and the Manlius altar from the theater at Caere. The last two examples are from outside Rome and may not, therefore, belong to or illustrate the compital cult of the city. The Soriano altar is made of Greek marble, whereas the other items of compital provenience are all of the Italian luna marble that Augustus favored. The Manlius altar shows a bull being struck by a *popa*, and it has a *lar* flanked by laurels on each side. In this case, the inscription may be a secondary text that rededicates the altar outside Rome: it was found in the theater at Caere. However, these two altars, which are better preserved than many from Rome, do illustrate

1 See Horace *Odes* 3.23.4 and *Sat.* 2.3.165. The liturgical paintings from Delos show pigs offered to the *lares*, presumably at Compitalia. More modest offerings include the *crista galli* (cock's combs; Juvenal 13.233).

2 In a separate ritual, which seems archaic, the Arvals sacrificed two castrated sheep (wethers) to the *lares* and two rams to the mother of the *lares*. See Scheid 1990, 587–98, 619–23. Cicero *Leg.* 2.55 speaks of one wether for a single *lar*.

3 Vicus Aesculeti altar: Mus. Cap. inv. 855, *CIL* 6.30957 = *ILS* 3615 = EDCS-18600503, with Hano 1986, 3; Panciera 1987, 68–70; Hölscher 1988, 217; Lott 2004, 26, 142–44; Bergmann 2010, no. 30; La Rocca 2013, V.6. Fragmentary altar reused in a fountain: Pal. Cons. inv. 1276 with Hölscher 1988, 219, and Bergmann 2010, no. 35. Fragmentary altar in the Vatican: Vatican inv. 958 (Belvedere cortile) = Siebert 1999b, I 13, with Panciera 1987, 73. Soriano altar: Pal. Cons. inv. 3352 with Hano 1986, 12; Hölscher 1988, no. 218; Fless 1995, 12; and Bergmann 2010, no. 33. Manlius altar: Vatican inv. 9964, *CIL* 11.3616, with Hano 1986, 11, and Gradel 2002, 251–60. Palmer 1989/98 argues that this was not a compital altar, although the *lares* wear *bullae*.

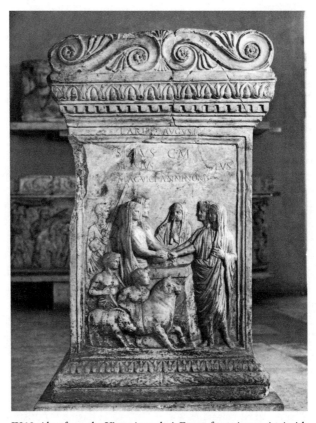

IV.19. Altar from the Vicus Aesculeti. Front, four *vicomagistri* with attendants at the sacrifice of a bull and pig. Roma, Musei Capitolini, Centrale Montemartini, inv. 855.

that the sacrifice of a bull was combined with the depiction of *lares* in the Augustan style in contexts outside the city. Meanwhile, no representations of bulls have been found in similar settings at Pompeii.[4]

Nevertheless, the bull on the three other altars from Rome must have been chosen by the artists for a reason that is connected to ritual practice: the bull cannot simply be a decorative element in these archetypal renderings of animal sacrifice but requires some logical explanation.[5] The other two altars from Rome are incomplete and lack inscriptions. They both seem to show a single bull being led to the altar where one celebrant is pouring a libation. Much, therefore, depends on how we interpret the heavily restored altar from the Vicus Aesculeti.

4 Van Andringa 2000, 79.

5 Prescendi 2007, 32–35, describes the choice of the sacrificial animal as an essential and formal part of sacrifice. Lott 2004, 142 (with 236 n. 180), simply sees the bull as "a ubiquitous victim in Augustan art" rather than a reference to any actual ritual practice. Otto (*RE genius*) 1163 sees the bull as the animal specifically for the *genius*. Gradel 2002, 128 and 137, accepts the bull as the sacrifice for the emperor's *genius*, but only by analogy with the sacrifice for the *genius* of the Roman people. To reiterate, there is no direct ancient evidence to demonstrate that Augustus' *genius* ever received a bull as a sacrifice.

IV.20. Altar from the Vicus Aesculeti. Right side, statue of a *lar augustus* holding a laurel branch. Roma, Musei Capitolini, Centrale Montemartini, inv. 855.

The altar from the Vicus Aesculeti, found in the Via Arenula, presents us with what is clearly a main side that features all four *vicomagistri* of year nine (AD 2–3) at a sacrifice together, with a bull and pig being brought to a single square altar, whose plainness contrasts with the altar on which it is represented. The sides feature two *lares* represented specifically as statues on bases, each holding a large laurel branch. These are, therefore, very much identified as *lares augusti* in this context, although *lares* had held such branches on Delos in honor of Apollo before. The back once had an oak wreath with ribbons, now lost. The base and top are richly carved. The dedication to the *lares augusti* is inscribed over the sacrifice scene itself, rather than next to the representation of the gods. The rather disorganized inscription fits the names of the *magistri* onto different sides of the altar, in a pattern that looks like an afterthought rather than a plan for integrating word with image within the composition.

The artist has made every effort to include as many details as possible on the main side, leaving the other sides relatively simple and essentially formulaic. In complete contrast, the four *vicomagistri* are represented with individualized faces and four attendants have been squeezed into the frame, in addition to the bull and pig, who appear diminutive in the foreground. The *vicomagistri* are wearing their togas, with which they cover their heads for prayer, and are accompanied by a *lictor*

with *fasces,* another indication of their rank. There is a clear stress on their magis-
terial office in this particular religious setting. The flute player, who seems to play
loudly, is especially vividly rendered. The ritual has, therefore, already started. The
other attendants include the usual *camillus* and *popa,* although their presence
makes for dense crowding in front. The commissioners paying for the altar evi-
dently wanted all these details, each making its own connection both with the
practices of civic cult and with the representation of that cult in state reliefs.

The composition especially stresses their joint celebration together as each man
touches the gifts already on the altar, which are quite large but hard to identify. It
is this very act of concelebrating, so rare in Roman civic art, that further stress the
identification of these men as the four *vicomagistri.* The other altars show a single
celebrant for the sacrifice of a bull, thus leaving any other magistrates and animals
implied. It is not clear if this rendering from the Vicus Aesculeti should be under-
stood as a narrative representation of events in which certain items are offered on
the altar *before* the animal sacrifice takes place (rather than the more usual liba-
tion that introduces such a ritual). Alternatively, we may perhaps see the animals
coming to the sacrifice in front but also already being present on the altar behind.
In any case, it is the individuality of every detail that speaks to the importance of
the design to the men paying for the dedication, as well as to the skill and imagina-
tion of the artist in creating a unique scene rich with specific details. By compari-
son, a simpler version of a bull sacrifice can be seen on a fragmentary altar in the
Vatican that features a single celebrant pouring a libation onto a flaming altar as a
bull is being presented before him. This scene also stresses the five sacrificial at-
tendants, perhaps at the expense of other celebrants, but is very weathered.[6] The
sides show a *patera* and a jug. It may have been paid for by an individual rather than
a group. (See figure IV.21.)

As the detailed depiction of the sacrifice on the altar from the Vicus Aesculeti
suggests, a particular and special type of ritual is being memorialized at consider-
able expense to the commissioners. In other words, the sacrifice scenes that fea-
ture a bull (with a pig added in one case) do not show the habitual sacrifice of a
pig to the *lares* at the crossroads, a ritual that was probably performed by the *vico-
magistri* on various occasions throughout their year in office. One pig would often
be offered to both *lares* jointly. While it is clear that the *lares* had long been inter-
preted as uncomplicated gods who appreciated modest tokens from passersby on
an everyday basis, including especially garlands of flowers, their habitual animal
of choice would have been well established, as was the case for other deities within
Roman ritual practice.

The inscriptions, where they survive, all name the *lares augusti* in the dative case
as the only recipients of the altars themselves.[7] The texts, as well as some evidence
from altars found in what seems to be their original context, have been used to iden-
tify the altars as compital. There is no reason to doubt that these were indeed the
new altars set up at the crossroads themselves to commemorate and serve the new
cult of *lares augusti.* Those dedicants who could afford inscriptions on their altars
most often included the explicit dedication to the *lares augusti,* just as they included
the typically Augustan iconography of the laurel and oak wreath as a visual

6 Vatican inv. 958 (Belvedere cortile) = Siebert 1999b, I 13, with Panciera 1987, 73.
7 For *laribus augustis* spelled out, see earlier notes 17 and 18 on page 288.

expression of the emperor's epithet and by extension now that of the *lares* also.[8] However, the scenes of sacrifice, which appear only on these few extant altars, represent a libation and the preparations for the sacrifice of a bull. It might be reasonable to suppose that where only a libation is depicted, an animal sacrifice may still be implied, although a simple libation would also have been an acceptable and frequent ritual performed for the *lares* (both by *vicomagistri* and by others).[9]

All this having been said, it remains a distinctive feature of the new compital altars that they do not memorialize the more everyday rituals in honor of the *lares augusti*. There is no sign here

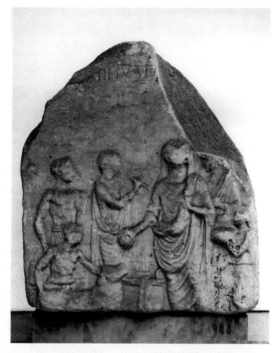

IV.21. Fragmentary altar representing a bull sacrifice. Musei Vaticani, inv. 958.

of the "restored" *ludi compitalicii* for which Augustus would have received recognition during these years and which had been so frequently depicted in the liturgical paintings on Delos. Nor, interestingly, do the altars commemorate the two new flower tributes that the princeps introduced in spring and summer to honor the *lares* at their compital shrines throughout the city. After all, the *vicomagistri* had been put in charge of the cult of the *lares augusti* by the princeps himself. A deliberate choice must lie behind the representation of a bull, rather than another animal or a different ritual action or another role of the *vicomagistri*.

The dedication of a marble altar to *lares augusti*, paid for by the *vicomagistri* themselves out of their own pockets, was an important investment in their own self-representation as *magistri* and served to commemorate their year in office. Indeed, many of the altars we have seem to have been close to their original places of dedication.[10] The patterns of weathering and wear suggest that they were in use at the crossroads over many years. In other words, making such a dedication was a significant step for a freedman in Rome, both in terms of the initial investment and with a view to his own self-representation within his local community. Some men chose to hold office more than once and to make separate dedications on each occasion.[11] There is, therefore, every reason to expect the *vicomagistri* to have chosen

8 For Augustus' attributes, see Alföldi 1973 and Gradel 2002, 49–53.

9 For the libation as the preface to animal sacrifice, see Scheid 2005, 44–50 and Prescendi 2007, 36, 80–95.

10 Lanciani cited two compital altars in situ: at the Vicus Sobrius (San Martino ai Monti 8) and the Vicus Vestae (next to the temple of Vesta in the Forum). Neither of these seems to be compital (Andrews and Flower 2015 and section II.xiii earlier).

11 See Lott 2004, 61–62, with table 1 at 92–94.

the designs and inscriptions on their altars with care and attention to detail. At the same time, the new cult will have created a demand that local artists could cater to by producing designs that conformed to the tastes and budgets of these *vicomagistri*.[12]

If we are to gain some understanding of these altars, and the other dedications made by *vicomagistri*, we need to read them in their specifically local and historical context. These dedications represent the *vicomagistri* in their specific roles as local magistrates in charge of the cult of *lares augusti*. Despite their many other administrative functions, the *vicomagistri* chose the religious sphere for their self-representation. Some altars carefully show all four *magistri* sharing these duties, and the altar from the Vicus Aesculeti seems to feature portrait-like representations of the individuals in question.[13] Consequently, the meaning of the altar as a whole, and of the sacrifice scene in particular, must be sought in the (self-consciously represented) role of the *magistri* at the *compitum*, within the context of the local vici.

The sacrifice of a bull would not have been a common occurrence in a local neighborhood setting. It would have been a special, festive occasion. Indeed, one of the most striking aspects of these scenes of sacrifice is the very fact that they show freedmen, sometimes identified by name in an inscription, performing a sacrifice that looks so very much like the central ritual of so many cults of the state religion. These freedmen are depicted playing roles that elite priests, including most notably the princeps himself, filled on the great holidays of the most important deities and temples in Rome. Moreover, Augustus' role as a priest had recently been enhanced by his promotion to become *pontifex maximus* in 12 BC.[14] In other words, Augustus' introduction of *lares augusti* to the *compita* allowed and encouraged the *vicomagistri* to represent themselves as magistrates and priests of a civic cult.

The ritual of sacrificing a bull must, therefore, have been part of the official duties of a *vicomagister*. The reference should be to a particular (annual) sacrifice, just as is perhaps the case in the procession reliefs on the Ara Pacis Augustae dedicated in 9 BC.[15] The *vicomagistri* set up altars dedicated to *lares augusti* at the crossroads of their local neighborhoods: the scenes they chose for these altars included that of the most magnificent sacrifice they themselves presided over during their year in office. This ritual included a libation by way of introduction to the sacrifice of a bull, but apparently then also of a pig (and perhaps also other animals?). The combination of at least two different animals at the same ceremony also assimilates the ritual to the most important ones depicted in state art, where multiple animals of various kinds can be seen in procession before a grand sacrifice at a major festival.[16]

12 For the artists of the *lares* altars, see Ryberg 1955; Zanker 1970–71 and 1988; Hano 1986; Schraudolph 1995; Fless 1995; and Siebert 1999b.

13 The sacrifice scene on the altar from the Vicus Aesculeti shows what appear to be portraits of the *vicomagistri*. The altar from the Sala delle Muse at the Vatican also has four celebrants, but its state of preservation is too poor for detailed analysis of the faces.

14 Kleiner 1992, 63 with fig. 41, dates the famous statue of Augustus in a toga with his head veiled (from the Via Labicana, now in the Terme museum) to around this time.

15 Ryberg 1955 remains a classic treatment of religion in public art in Rome. For sacrifice scenes in republican art, see Holliday 2002, 156–81. For the Ara Pacis, see Holliday 1990 and Elsner 1991. For Augustan art, see Zanker 1988, 126–35; Hölscher 1988, 351–400; and Kleiner 1992, 81–89. For the first-century BC Ara Borghesi, which features a calf and a pig, see Fless 1995, no. 3, and Holliday 2002, 170–72 with figs. 89–91.

16 Two famous scenes of *suovetaurilia* in civic cult are both in the Louvre: the republican census as shown on the "altar of Domitius Ahenobarbus" (inv. 975, early first century BC) and the

Within the smaller scale of the scenes on a compital altar, the local artists and their patrons sought to assimilate the role of the *vicomagistri* in compital cult to the sacrifices in honor of the most important deities of state cult.

The sacrifice of a bull and a pig in a local context should not leave many ritual scenarios to choose from. My suggestion is to read the ritual as a *lustratio*, a common type of sacrifice used to demark or reinforce boundaries and to purify a specifically designated space and group within those specific boundaries. This ritual is mentioned on inscriptions in connection with vici and compital *lares*.[17] The *lustratio* might be performed either in connection with the setting up of a new altar, in this case to *lares augusti*, or the ceremony could also be held on an annual basis as part of the official duties of the *vicomagistri* themselves. In other words, the sacrifice scene commemorates a *lustratio* held in the vicus and at the compital altar, perhaps more than once a year.

A *lustratio* would normally include a procession of a variety of sacrificial animals around the boundaries of the space in question (whether a field or an urban space), followed by a solemn sacrifice and banquet, when the meat of the sacrificed animals would be eaten. This type of sacrifice was also called a *suovetaurilia*, a name that recalls the three animals that were the most frequent victims, the pig, the sheep, and the bull.[18] The animals could either be young or adult, depending on the circumstances. This type of offering was very common in Roman ritual practice, from the grandest sacrifice to mark the conclusion of a census presided over by a republican magistrate to the simplest ceremony in a field on the farm, one that could be delegated to the field hands, who were often slaves. The most common recipient was Mars, both in the census and often on a farm, at least according to our slim evidence. However, this same type of ritual could be offered to (m)any deities, including, for example, to Dea Dia by the Arval brothers. The gift of three animals seems to have come as a special "package," which was eventually also offered to such newer deities as Mithras. In this case, Mars could indeed be the recipient, but the *lares* themselves are surely the most likely gods to be honored.[19]

Such a *lustratio* might coincide either with the taking of office by new *vicomagistri* on 1st August or with the celebration of the Compitalia around the New Year or perhaps with both.[20] January was a typical month for holding a *lustratio*, as at

procession on the Grimani relief (inv. 1096, 1097, Julio-Claudian). See, conveniently, Bergmann 2010, nos. 26 and 27, with description and bibliography.

17 Scheid 2005, 61: "la lustratio définit et constitue une chose ou un groupe" (the lustration defines and constructs an object or a group). Information comes from the Arval rituals, which called on Mars to defend the boundaries of the Roman state and from Cato (*de Agric.* 141), where the individual field on a privately owned farm is also defined by a similar ritual in honor of Mars (see Scheid 2005, 145–52). For general discussion, see Boehm in *RE*, Linderski in *OCD*⁴, with Petersmann 1973; Versnel 1975; Harmon 1978; Rüpke 1990, 144–46; and esp. Baudy 1998. Lott 2004, 36, sees the *lustratio* as a primary part of the Compitalia, as a pig was led around to purify the people and their vicus.

18 For *suovetaurilia*, see Cato *de Agric.* 141 and Festus 154L. Siebert in *BNP* is especially clear in explaining the outline of what we know. The recipient of the ritual is not always named.

19 Propertius (who died around 15 BC, before the reform) twice uses the verb *lustrare* in connection with *compita*: 2.22a.3 and 4.1.23–24. See Benoist 1999, 312, and Stek 2009, 145, who discusses the *lustratio* at both the Compitalia and the Paganalia in the country.

20 Meslin 1970, 46–47, describes the *lustratio* in the context of the beginning of the new year in January.

the country festival of Paganalia, for example.[21] Some inscriptions, however, indicate a *lustratio* was held on a date of local significance in that particular vicus. One text informs us that the *lustratio* of the Vicus Censorinus was to take place on the Ides of September.[22] Another records a *lustratio* in mid-August for a dedication (of an altar or statue?) in honor of Stata Mater Augusta by the four *magistri* of the Vicus Minervi in regio VII in year 50 (AD 42).[23] Whether one imagines this dedication at a *compitum* or elsewhere in the vicus, the procession and sacrifice of a *lustratio* was clearly part of the dedication ceremony itself. It seems most likely that the *lustratio* was, in fact, the only type of ceremony in which a bull was sacrificed locally, perhaps at the altar of the *lares* at the crossroads, if there was enough room. The depiction of the sacrifice at the *lustratio* both celebrated the function of the *compitum* as a shrine at a key point in local topography and highlighted the role of the *vicomagistri* as celebrants and magistrates, clad in the *toga praetexta* and accompanied by a *lictor*, at the most solemn and exalted religious moment(s) in their careers.[24]

The novel impact of Augustus' reform of the vici and of their compital cult can be seen reflected in the iconography and inscriptions chosen by *vicomagistri* for their dedications. The Roman texts and images celebrated the newness of *lares augusti*, carefully labeled in so many instances, combined with the typical iconographic emblems of the princeps, such as the oak wreath and the two laurel trees. In this context, their own religious roles were assimilated to those of the highest magistrates and priests at Rome in scenes of solemn animal sacrifice. Augustus' urban reorganization laid stress on the *vicomagistri* as local officials. In these reliefs we can catch a glimpse of them celebrating this role in a formal religious context. The *lustratio* procession with its sacrifice of multiple animals will have been closely associated with their term in office as magistrates. At the same time, this ritual was intimately linked to the concepts of space (the vicus as a sacred space for the local community protected by *lares augusti*) and time (the annual magistracy that now started from 1st August or its climax in the joyous festival of Compitalia, soon after midwinter). Moreover, by the year 7 BC, the iconography of the sacrificing official of the state cult was already closely identified with the princeps himself, who appeared or would soon be represented as the officiator in so much civic art.[25]

21 Baudy 1998 gives an excellent overview of the various different occasions for a *lustratio* in Roman religious culture, both privately on the farm and publicly, from local rites to the grand *lustrum* of Rome itself performed by the censors. See also section III.xvii for further discussion.

22 *CIL* 6. 821 = EDCS-17300959.

23 *CIL* 6.766 = *ILS* 3309 = Lott 2004, no. 34 = EDCS-17300907.

24 It is also notable that some associations of artisans in Rome numbered their years on inscriptions explicitly by counting *lustra* (*CIL* 6.148 = 30703 = 14.5 = *ILS* 3776 = EDCS-17200238; *CIL* 6.321 = EDCS-17700079; *CIL* 6. 384 = EDCS-17800062; *CIL* 6.7861 = *ILS* 7243 = EDCS-18700286; *CIL* 6.9034 = EDCS-18900318; *CIL* 6.9406 = *ILS* 7240 = EDCS-19100627; *CIL* 6. 9471 = EDCS-19200183; *CIL* 6.30982 = EDCS-18600571; *AE* 1941.71 = *AE* 1949.192 = EDCS-15100072; Gordon 1958, no. 128), which implies an annual ritual at the beginning or end of the period of time being measured.

25 See Gordon 1990, 202–19, for the importance of the emperor as the central figure in civic rituals, especially of animal sacrifice.

In fact, Augustus had himself presided over a solemn *lustrum* of the whole city at the end of his third official counting of the population in 8 BC.[26] If Dio is correct that the census process was started in 11 BC, then its conclusion may have been delayed precisely to fit into the middle of the series of events from 9 to 7, which culminated in the new Augustan era in the vici.[27] As a result, a *lustratio* on a compital altar could refer both to the duties and office of the *vicomagistri*, even as it showed their role as being an echo of a recent and repeated religious ritual performed by the princeps himself in the city. The local *lares* were the most logical recipients in a vicus. The connection between *vicomagister* and princeps was illustrated in a way that was easy for all to see and that was related to a familiar religious ritual that could be read as a reference to a specific occasion, as well as to its annual repetition.

26 For Augustus completing a census, by means of consular power, with the traditional *lustrum*, see *RGDA* 8.2–3, with Cooley 2009 ad loc. The religious ritual of the *lustrum* is discussed by Baudy 1998, 223–61.

27 Dio 54.35.1.

XXIX *ARA PACIS AUGUSTAE*: WHO GETS THE PIG?

cum ex Hispania Galliaque, rebus in iis provincis prospere gestis,
Romam redi, Tiberio Nerone Publio Quintilio consulibus, aram
Pacis Augustae senatus pro reditu meo consecrandam censuit ad
campum Martium, in qua magistratus et sacerdotes virginesque
Vestales anniversarium sacrificium facere decrevit.

AUGUSTUS *RGDA* 12.2

Examination of the iconography, function, and historical context of the newly
embellished cult sites for *lares augusti*, which were set up in 7 BC and in the years
following Augustus' urban reforms, invites a (re)consideration of the Ara Pacis
Augustae (Altar of August Peace), the splendid first altar to an august deity in
Rome.[1] The dedication of this altar by the senate (9 BC) in honor of Augustus'
most recent return to the city (13 BC), at the very time when his urban reforms
were about to be implemented, provides precious evidence for religious and civic
themes of renewal that were in the air around the time when Augustus became
pontifex maximus. There can be little doubt that the dedication of the altar was
delayed to coincide with a key sequence of anniversaries from 29 BC to 19 BC to 9
BC, even as the actual ceremony itself was timed to coincide with Livia's fiftieth
birthday at the end of January in that year.

On the previous occasion when Augustus had returned to the city, in 19 BC, the
senate had commemorated his arrival with an altar to Fortuna Redux (Fortune who
leads back).[2] That altar was vowed on the day of his return (12th October) and ded-
icated on 15th December of an unknown year; it most probably did not have the
monumental scale and intricate iconography of the altar to August Peace. Most im-
portantly, for present purposes, the goddess Fortuna was not designated *augusta* by
the senate (or by anyone else), although it seems that her festival was known as the
Augustalia. In other words, although the custom of marking the princeps' return to
Rome from foreign wars with a celebration and an altar just outside the city was not
without precedent, the Ara Pacis Augustae set a new fashion for august deities that
would spread rapidly after the introduction of *lares augusti* at the compital shrines
in 7 BC, accompanied by a variety of other august deities in subsequent years. The
altar provides invaluable (although incomplete) evidence for what were the newest
themes in public monuments immediately before the introduction of *lares augusti*
and the commissioning of new religious dedications by the local *vicomagistri*.

The Ara Pacis Augustae is one of the most important surviving examples of Au-
gustan art and has consequently received much attention from scholars, notably
since its reconstruction in the 1930s.[3] It seems to have been the first monumental

1 For the Ara Pacis Augustae: Torelli in *LTUR*, with Ryberg 1955; Zanker 1988, 120–23, 172–
75, 203–4; Bowersock 1990; Elsner 1991; Kleiner 1992, 90–99; Galinsky 1996, 141–55; Conlin
1997; Anderson 1998; Pasco-Pranger 2006, 187–200; Armstrong 2008; Kleiner 2008; and Pollini
2012, 204–308. Eder 2005, 29, connects the Ara Pacis Augustae very closely with a cult of Augus-
tus' *genius* without even any mention of *lares augusti*!

2 Altar of Fortuna Redux: *RGDA* 11; Tacitus *Ann.* 1.15.2–3, 2.83; Coarelli in *LTUR* with Ben-
oist 1999, 84–86; Lott 2004, 119; and Cooley 2009, 152. There may have been political unrest in
Rome before Augustus' return.

3 For the reconstruction, see Rossini 2006, esp. 14–21 and 108–25, and Cooley 2009, 51–55.

IV.22. Ara Pacis Augustae, 13–9 BC. Front view.

enclosed altar and to have set a fashion for others like it that were built to mark later imperial occasions, although none have been excavated so far (for example, Ara Providentiae Augustae).[4] Its position in the Campus Martius put the Ara Pacis Augustae in a strategic location in relation to Agrippa's complex of buildings (especially the so-called Pantheon), to the Mausoleum of Augustus, and to the new Horologium, with its magnificent Egyptian obelisk, which was dedicated shortly before in 10 BC (or perhaps also in 9 BC).[5]

The complexity of its iconography and the skill of the Italian artists who made the altar and its fine enclosure have continued to fascinate.[6] (See figures IV.22, IV.23, IV.24.) Themes of religious celebration presented in the procession of priests and leading Romans, closely linked to abundance, fertility, and empire, appear juxtaposed with references to Rome's mythical past and allegorical present. Meanwhile, the surviving iconography has little to do with a return from northern wars

4 For later state altars to august gods, Ryberg 1955, 64–80; Scheid 2001, 97–99; Lott 1996 and 2004, 103; and esp. Cooley 2006. The Ara Providentiae Augustae is usually dated sometime after AD 4 (see now Fishwick 2010).

5 Rossini 2006, 6–13, provides a map and illustrates the new model and reconstruction in the new museum. For the *horologium*, see Buchner 1982 and in *LTUR*, with Schutz 1990; Barton 1995; Rehak 2001, 200–201; and Wallace-Hadrill 2008, 244–45.

6 See Conlin 1997 for the artists of the Ara Pacis.

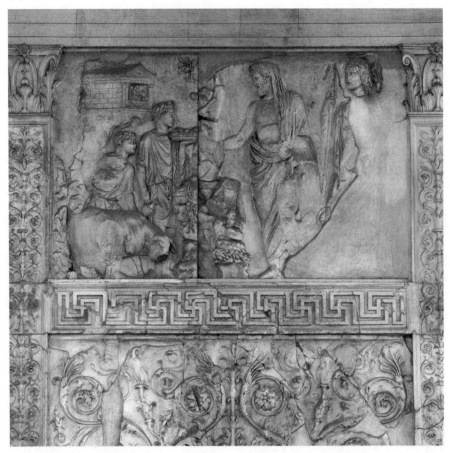

IV.23. Ara Pacis Augustae, 13–9 BC. Relief panel representing the sacrifice of a pig in front of a small temple containing two gods.

or even with a straightforward depiction of the goddess Pax herself.[7] On the altar's enclosure the strikingly detailed procession of religious celebrants, which includes portrait-like renderings of the princeps with his family and close associates, appears above an elaborate vegetal frieze and in juxtaposition with four large relief panels at either end of the altar's enclosure.

Only two of the panels survive, one from each end. The rear entrance was framed by allegorical scenes; the surviving panel shows a female goddess (Tellus? Italia? Venus genetrix?) holding twin babies and surrounded by a rich variety of symbols of fertility and abundance in an idealized rural setting.[8] While the complexity of the imagery defies a simple explanation, the general message is unambiguous. This panel points to the prosperity of Italy and her people in the time of Augustus, even as it situates this picture of a golden age in an abstract,

7 There is no figure of the goddess Pax in the reconstructed parts of the altar (Galinsky 2012, 156–57), unless the Tellus relief shows Pax (Rehak 2001, 199). But so much is missing that we cannot be sure of the original design.

8 Rossini 2006, 36–45, gives an overview. Galinsky 1992 identifies the goddess as Venus Genetrix.

IV.24. Ara Pacis Augustae, 13–9 BC. Detail of the temple in the background of the pig sacrifice scene.

allegorical world that does not contain any recognizably human figures. It was perhaps balanced by a scene of a seated goddess Roma, in a setting that alluded to conquest and empire. Unfortunately, this other panel is almost completely destroyed.[9]

By contrast, the entrance of the altar's enclosure was flanked by two scenes that seem to recall the legendary time of Rome's founding, neither of which has the abstract allegorical character of the reliefs on the back. A Roman viewer would presumably have seen these simply as historical subjects. The panels were obviously very important, since they presented the viewer standing at the front with a first impression of the whole complex and its message(s). The left-hand side apparently showed a version of the famous scene of the wolf with the twins (Romulus and Remus) under the *ficus Ruminalis* (fig tree) flanked by Mars (not always represented in this context) on the left and a figure who seems to be the shepherd Faustulus on

9 Rossini 2006, 46–47.

the right.[10] The current reconstruction is plausible but remains unprovable; much detail is completely lost in a composition whose rich style apparently made little use of blank space. No fragment of either the wolf or the twins survives.[11]

The relief on the right is much better preserved, although not complete or undamaged. It shows a scene of a bearded man in an archaic costume preparing to sacrifice a pig in a rustic setting in front of a small but finely made temple occupied by two virtually identical male deities seated next to each other.[12] This relief has been identified as either Aeneas sacrificing the prodigious sow soon after his arrival in Italy or Numa, Rome's second king, making a peace treaty with a foreign leader by sacrificing a pig. In other words, the front of the enclosure would feature the founders Romulus and Remus perhaps with Aeneas (an earlier founder who had arrived from Troy) or with Numa (a religious founder who succeeded Romulus as Rome's second king). Either juxtaposition would speak to the foundation of Rome, whether with or without a reference to Trojan origins and the mythical ancestor of Augustus' family, and each pairing would invoke religious ritual in a number of ways, most obviously in the sacrifice of the pig (regardless of its exact context). The altar's enclosure, therefore, featured three types of figural scenes: historical with male figures (from the period[s] of foundation) on the front, allegorical with female figures (timeless) on the back, and what is surely meant to be read as a single procession on the two sides, a religious procession that is definitely in the present and may well refer to a specific contemporary occasion (such as Augustus assuming the office of *pontifex maximus* on 6th March 12 BC or the dedication of this very altar to Pax Augusta at the end of January 9 BC).

Children appear in the processional scene, perhaps for the first time in state art, in a way that evokes fertility and a hope for the future. There is a related theme that involves twins. The goddess of abundance on the back holds two young twins, who have been interpreted as an allusion to Gaius and Lucius, Augustus' grandsons, whom he had adopted in 17 BC. Romulus and Remus are a more obvious pair of twins, who apparently appear in the first panel the viewer might look at if reading the imagery on the front from left to right.[13] The founding twins on the left would balance the twin deities in a small temple on the right hand panel, although these gods are represented as adults. A rich world of religious imagery meets the eye of the viewer, but only part of it is still visible today. Can any of what does survive provide more information about *lares* in the city of Rome, so many of whom were about to become *augusti*?

10 Rossini 2006, 34–35, describes the reconstruction of the small fragments. For the Lupercal (dedicated to Mars and Faunus), see Coarelli in *LTUR*, with Dionysius of Halicarnassus 1.32.3 and Ovid *Fast.* 2.267–68. According to Suetonius *DA* 31.4, Augustus "revived" the Lupercalia festival.

11 Anderson 1998 suggests that another subject involving Mars is perhaps more plausible, without putting forward a specific suggestion.

12 The pieces of this panel were found in 1859 and 1903. Sieveking 1907 identified the main figure as Aeneas, an interpretation that soon became widely accepted. See Ryberg 1955, 40–41; Settis 1988, 412–13; and Galinsky 1996, 107, 142. Rehak 2001 suggested Numa instead. Rossini 2006, 30–33, seems torn between Aeneas and Numa. The pig is the only sacrificial animal on the enclosure. Augustus is nearest to this panel in the procession on the south frieze. For the theme of sacrifice in general, see Elsner 1991.

13 Dardenay 2012, 77–132, gives a useful overview of the iconography associated with the wolf and twins in Roman art throughout antiquity.

It is tempting to identify the paired male deities in the small temple as the *lares praestites*, who are about to be honored with the traditional sacrifice of the pig in an archaic context.[14] Such an identification would rule out either Aeneas or Numa as the main presider at the sacrifice. A person who is credited with introducing the cult of these *lares* to Rome was Titus Tatius, the Sabine king of Rome who ruled jointly with Romulus, after the Sabine women made peace between the two peoples.[15] This reading of the scene would involve a juxtaposition of Romulus, at a foundational moment at the Lupercal, with Titus Tatius, his eventual co-ruler, sacrificing to the *lares praestites,* who were understood as the protectors of the city and of its walls. Both scenes would, therefore, evoke a definition of the young city and its boundaries in terms of sacred spaces. The following arguments can be adduced to support this interpretation.

There are many reasons to question the identification of the prominent male sacrificiant as Aeneas.[16] He appears older and bearded, quite unlike the usual iconography for Aeneas, and not in line with the narrative of a younger Aeneas arriving in Italy, as described in Vergil's recently published *Aeneid*.[17] The pig for the sacrifice is not obviously large or female and has no single piglet, let alone the thirty produced by the great white sow of the famous prodigy.[18] Moreover, the male deities and their shrine do not fit with the legend either, since Aeneas sacrifices the sow and her offspring at the site of a future settlement, not in front of an established sanctuary.[19] (See figure IV.25.)

The argument for Numa, however, is not much stronger.[20] If this is a scene that refers to the taking of an oath and making a treaty, then the two parties should stand

14 Tarpin 2014, 61, equates *lares* on the Ara Pacis Augustae with the *compitales*, which he interprets as the familial *lares* of Augustus (and thus also those of Aeneas).

15 Titus Tatius: Varro *LL* 5.74: *e<t> ar<a>e Sabinum linguam olent, quae Tati regis voto sunt Romae dedicatae: nam, ut annales dicunt, vovit Opi, Flor<a>e, Vedio[io]vi Saturnoque, Soli, Lunae, Volcano et Summano, itemque Larundae, Termino, Quirino, Vortumno, Laribus, Dianae Lucinaeque* (The altars have a whiff of the Sabine language that were dedicated at Rome by King Tatius to fulfill a vow. For, as the annals tell, he vowed for Ops, Flora, Vediovis and Saturn, the Sun, the Moon, Volcanus and Summanus, likewise for Larunda, Terminus, Quirinus, Vortumnus, the *lares*, Diana and Lucina). Ovid *Fast.* 5.131 may also contain a reference to the Sabine town of Cures, depending on the text here.

16 Rehak 2001 argued convincingly against the identification with Aeneas on the basis of iconography. Aeneas should be young, unbearded, in armor, and in a different setting with his son Ascanius, who should be a child. See Pollini 2012, 234–37, for counterarguments (plate 24 shows a reconstruction in color), based on an older Aeneas with an adult Ascanius sacrificing in front of a temple that was not built yet.

17 Vergil *Aen.* 8.81–85 (cf. 3.388–93 and 8.36–48). The *Aeneid* was probably published shortly after Vergil's death in 19 BC. Vergil has Aeneas sacrifice to Juno. For alternative versions, see Dionysius of Halicarnassus 1.57.1 (*penates*) and Varro *LL* 5.144 (household gods). For the sacrifice of the prodigious sow to the *lares grundiles*, see section II.xii.

18 For the sow and thirty piglets in art, see the Belvedere altar (Vat. 1115), with Ryberg 1955, 58, and Rehak 2001, 203 n. 39, and a Campanian terracotta plaque with Aeneas and Ascanius getting off a boat (Settis 1988, 412–13, with Abb. 190), and the marble plaque from the British Museum in figure IV.25. Dardenay 2012, 56–71, gives an overview of the iconography associated with Aeneas' arrival in Latium, with a discussion of this panel at 63–66.

19 The case for identifying the gods as the *penates* is fully explained (with previous bibliography) by Dubourdieu 1989, 209–16 and 424–26. See now Pollini 2012, 220–28.

20 Rehak 2001 argues the case in detail.

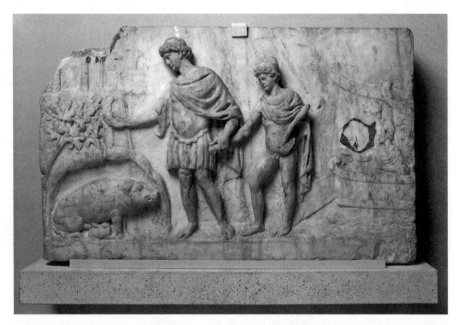

IV.25. Marble plaque with relief of Aeneas, Ascanius, and the sow. Ca. AD 140–150. 37 cm×61 cm. British Museum, 1927, 1212.1.

on either side of the pig after it is sacrificed.[21] Such an agreement would be between the two sides in an alliance (ending a former conflict); it would not be represented in the format of a standard sacrifice in front of a shrine. The fragmentary figure beside the sacrificiant is in the wrong position to be the party to an oath or to share fully in the joint sacrifice of the pig.[22] Unfortunately, not much can be said about this very incomplete figure, but the sacrificiant has his back turned to him. Moreover, this scenario leaves the deities in the temple unexplained and superfluous to the essential action of the sacrifice, if it is an oath, treaty, or other agreement.[23] The familiar configuration of animal sacrifice at an altar in front of a shrine requires an explanation that fits this basic format. Any interpretation must be based on a positive reading of the surviving elements of the relief.

21 Rehak 2001, 194 fig. 6 (coin of 16 BC with the sacrifice of a pig) and fig. 9 (L. Pomponius Molo's *denarius* of ca. 97 BC with Numa sacrificing a goat). Earlier oath scenes can be found on coins from the Social War and in the handshake depicted in the Tomb of the Fabii on the Esquiline. See also *RRC* 234.1, with an oath and the sacrifice of a pig from 137 BC.

22 Rehak 2001, 192, and Rossini 2006, 30, both claim the figure is a foreigner based on his sleeve.

23 Rehak 2001, 194, draws attention to the careful detail in the rendering of the small temple, which contrasts with the rough altar. He identifies the gods as two major deities, Jupiter and his brother Pluto, 197: "The gods are the guarantors of the oath, not the recipients of the sacrifice." Ryberg 1955, 41, interprets them as the *penates publici* (holding spears), Aeneas' household gods. Obviously, her interpretation depends on the main sacrificiant being Aeneas. For a succinct statement of this standard view, see Kleiner 1992, 93–96. At 96, she describes the temple as a "domestic shrine" rendered in a smaller scale in the background. Zanker 1988, 204–5 interprets Aeneas as appearing in a costume associated with the statues of the old kings on the Capitol. He sees the formal little temple of the *penates* as a reference to the many new temples in Rome. For the costume of the Roman kings on their statues, see Pliny *Nat.* 34.23.

This scene centers on the sacrifice of a pig, as it shows the libation, which immediately precedes and introduces the ritual, being poured on a rustic altar made of rocks and lumps of earth. There is a single celebrant and a single victim, accompanied by the usual religious personnel, the attendant (*camillus*) and the sacrificer (*popa*).[24] It is perhaps a bit surprising to see these attendants in virtually contemporary garb and function assisting a celebrant who is dressed in the old-fashioned style of the regal period, including his full beard. Despite the rustic altar, the context appears official because of the fine shrine in the background and the presence of the standard ritual attendants. A Roman viewer would naturally read the sacrifice as being addressed to the two deities in the shrine.

It is unusual to see two identical gods inside the little temple; pairs of mature male gods are not common in Roman civic cult.[25] The *patera* and *lituus* in the pediment of the little shrine are not much help in suggesting an identification. Moreover, we know that in temples dedicated to multiple deities, it was the established norm to give each deity his or her own *cella* (cult room) inside the temple.[26] Each deity would also expect to receive an individual sacrifice of an animal that was the usual offering within the context of his or her cult. It is problematic, in terms of the logic of Roman sacrifice, to imagine a single animal being offered to two major gods of the Roman or Greek pantheon. So we are faced with an archaic style sacrifice of one pig to two identical, probably unbearded male deities, seated, wearing cloaks and holding staffs, who share a single, modest shrine. Despite the absence of their characteristic companion the dog, it is nevertheless tempting to identify the deities as the *lares praestites*, who had their traditional feast day on 1st May.

Not much evidence survives about the cult of the *lares praestites*, which is discussed in section II.xii.[27] In one version of the story, Titus Tatius seems to be credited with the introduction of their cult to Rome soon after the founding of the city. These *lares* certainly had a small shrine of some kind in the historical part of the city, not far from the *Lupercal* where Romulus and Remus' exposure and discovery was celebrated by tradition. In the present state of our evidence, the interpretation of this panel remains hypothetical, both because the scene itself is incomplete and because the imagery of the whole altar is so al/elusive and complicated. The only complete end panel (Tellus?) appears multivalent at best, and the processions of historical figures have also produced vigorous and ongoing debate about their most suitable context. Nevertheless, the sacrifice of a single pig (which is neither the prodigious sow of Aeneas nor the usual more expensive bull or cow of state cult) in a context that evokes the trappings of state sacrifice, is as rare as the unusual, seated twin gods, holding their matching staffs, who share one small sanctuary and appear content to receive this lone pig. The *lares praestites* do come to mind, even without the dog.

24 Rehak 2001, 192–93.

25 For pairs of male gods, see Dasen 2005, 179–83. The Dioscuri had an old cult at Rome and were popular in southern Italy. However, they were depicted as young men in military dress, usually with horses and distinctly elite overtones. The *penates* were also a pair of young men in armor (Dionysius of Halicarnassus 1.68.2). For the iconography of the *penates*, see Mambella in *LIMC*, who sets out to distinguish these gods clearly from *lares*.

26 For the controversy over Marcellus' temple of Honos and Virtus in the late third century BC, see Livy 27.25.7–10; Plutarch *Marc.* 28.1, with Flower 2000, esp. 38–39.

27 Tarpin 2002, 155–57, 161.

Needless to say, if these are the *lares praestites*, then their presence clearly indicates an interest on the part of the senate in *lares* as particular protectors of the city that would be mirrored in the actions of the princeps at the compital shrines so soon after.[28] To take this argument a step further, it is even possible that the presently very fragmentary scene on left also featured *lares praestites*, perhaps as babies, instead of the more canonical twins Romulus and Remus.[29] Yet, if the *lares praestites* received a prominent place on the front of the *Ara Pacis Augustae*, why did Ovid claim to have searched for their archaic shrine in vain only to find a thousand new *lares* throughout the city?[30] Is he being playful or sarcastic? Is he being critical of this new altar and its reliefs? Does he comment on the dog at length precisely because the animal does not appear here? There is so much about the Ara Pacis Augustae and about Ovid's *Fasti* that we simply do not know.

28 Buxton 2014 raises the idea that a similar temple might have been depicted in the missing part of the scene of the prodigious sow on the Belvedere altar, which dates to around the same time, but its iconography is untypical, so it is hard to say what may be missing.

29 Wiseman 1995, 65–71, identified a similar scene that includes a wolf and twins on an Etruscan mirror (third quarter of the fourth century BC, Praenestine workmanship) as the *lares praestites*. If his hypothetical interpretation is correct, then the whole front of the Ara Pacis Augustae could have been given over to these gods, their birth and role as guardians of the city.

30 Ovid *Fast.* 5.143: *bina gemellorum quaerebam signa deorum* (I was searching for the two statues of the twin gods) (ca. AD 1–4). For commentary, see Barchiesi 1984, 96–99, and Wiseman and Wiseman 2011.

XXX AUGUST GODS IN THE VICI

Volcano Quieto Augusto / et Statae Matri Augustae / sacrum /
P. Pinarius Thiasus et / M. Rabutius Berullus / mag(istri) Vici
Armilustri anni V
 —*CIL* 6.802 = *ILS* 3306

More than a dozen separate dedications to other gods labeled with the epithet *augustus/a,* put up by *vicomagistri* of the Augustan period in Rome, bear witness to the apparently independent development of religious ideas and practices in the local neighborhoods beyond the cult of *lares augusti* at the compital shrines.[1] Such practices also continued after Augustus' time and dedications survive from later periods, each still labeled with a year in the epoch counting from the Augustan reform.[2] The choice of gods reflects traditional deities, who were popular with ordinary people, even as the decision to designate them as "august gods" seems to have been quite new and made by individuals locally. These dedications provide a remarkable example of religious innovation on the part of freedmen in a neighborhood context, where they felt at liberty to play variations on the new theme of august deities suggested by the Ara Pacis Augustae and especially by the rapid spread of *lares augusti* throughout the compital shrines of the city.

Before examining the (other) deities honored as august, the first question is whether all these dedications should necessarily also be associated with compital shrines. It has often been tacitly assumed that any dedication of whatever kind that was made by a *vicomagister* or *minister* was at or very near the crossroads shrine in his neighborhood.[3] It is important to keep in mind, however, that the *vicomagistri* were in charge of the whole vicus and of many aspects of local life and administration; they were more than simply priests at a single *compitum*. The *compita* were the most important and characteristic altars the *vicomagistri* oversaw, where they presided over the new cult of the *lares augusti*. Nevertheless, as argued in section II.xiv, even in earlier times not all small, open air shrines (*sacella*) in a vicus were compital. Nor is it self-evident that the *compita* regularly accommodated a crowd of gods. Many were of modest dimensions. The street shrines in Pompeii sometimes do show other gods associated with the typical *lares* and snakes, but most often do not.[4]

Moreover, in a city the size of Rome vici surely came in very different shapes and sizes with very different levels of cultural sophistication, ethnic flavor,

1 For dedications made by *vicomagistri* to other august gods, see Lott 2004, nos. 5, 6, 11, 13, 17, 19, 21, 24, 30, 31, 32, 34, 48, 54 (= 14), as well as the *ara augusta* at no. 25. For further discussion, see Panciera 2003; Lott 2004, 103, 165–68; and Cooley 2006. For august gods in Italy (outside Rome), see Gregori 2009, who catalogues about 350 inscriptions in honor of about sixty deities.

2 For three later august gods, see Lott 2004, nos. 34 (Stata Mater Augusta in AD 42), 35 (Apollo Augustus in AD 44), and 54 (Concordia Augusta at an unknown date).

3 Lott 2004 assumes that all dedications by local *vicomagistri* are compital, and uses this as the basis for his appendix (180–212).

4 There are three notable examples from the Via dell' Abbondanza: Fröhlich 1991 F 60 (East façade of VIII.3), F 65 (IX.7.20), and F 66 (IX.11.1), with the tables at 351–52, and Van Andringa 2000, 48. See section II.xv for street shrines in Pompeii.

material resources, and religious tastes.[5] The altars and other gifts for the *lares augusti* themselves demonstrate, not surprisingly, that some *vicomagistri* had a great deal more money to spend on such dedications than others. A number of the dedications to other august gods may have been near a *compitum*, but it is far from certain that they all were. In fact, it seems more likely that the *vicomagistri* who extended the use of the epithet *augustus* to further deities, would have done so precisely in order to patronize other existing shrines or to dedicate completely new ones on their own initiative. For *vicomagistri* who could afford additional religious dedications after their compital shrines had been renewed, the extension of their official-looking gifts to other local sites of religious significance could help to build their image as magistrates whose names appeared on structures in the city, even as they advertised their wealth, personal piety, and devotion to Rome's august leader.[6]

The most commonly favored deity was one most closely associated with the culture of the vici, namely Stata Mater (Augusta), five of whose statues are attested.[7] This particularly Roman goddess was called upon for protection from fires. It was she who was credited with stopping a fire from spreading at the spot where she stood on guard. Consequently, she is also associated with the fire god Vulcan, as in the case of a dedication by the local magistrates of year 5 in the Vicus Armilustri of statues of Stata Mater Augusta with Volcanus Quietus Augustus.[8] (See figure IV.26.) She could also share a dedication with the *lares augusti* themselves, which would presumably have put her at a compital shrine. Her role is associated with the *lares* who protect the neighborhood and with the *vicomagistri* who had local responsibility for firefighting during most of Augustus' time. She also had a statue in the forum in the early first century BC, as well as a whole vicus named in her honor.[9] An inscription from the Vicus Sandalarius put up by two *vicomagistri* in AD 11–12 calls her Stata Fortuna Augusta.[10] She was, however, principally a local goddess and did not have a temple or public priest in Rome. It is possible that she was regularly cultivated at a compital shrine with the *lares*, unless she was placed at another boundary point to provide further protection for the neighborhood in addition to the *compita* at various official "corners" and boundaries.

As discussed earlier, some vici were named after gods, many after temples, at least one after a *compitum*, and two we know of after *lares*.[11] Consequently, it is

5 Tarpin 2008 envisages large vici in the imperial period. His statistical method presupposes fairly uniform sizes of local neighborhoods.

6 Wealth is measured in relative terms. The most obvious examples are the altar of the Vicus Aesculeti and that of Numerius Lucius Hermeros (Aequitas), see Lott 2004, 161–65, with nos. 6, 28, 48.

7 Stata Mater (five examples): Lott 2004, nos. 11 (*CIL* 6.763 = *ILS* 3307 = EDCS-17300904); 13 (year 2 *CIL* 6.764 = EDCS-17300905); 19 (year 5 *CIL* 6.802 = *ILS* 3306 = *ILMN* 18, MAN Naples inv. 2597 = EDCS-17300942); 30 (year 18 *CIL* 6.761 = *ILS* 3308 = EDCS-17300902); 34 (year 50 *CIL* 6.36809 = *ILS* 9250 = EDCS-19600479).

8 According to the surviving sources, there were eight (notable) fires in Rome between 27 BC and AD 14.

9 Festus 416L. The statue was put up by an Aurelius Cotta in ca. 78 BC to protect the new pavement in the Forum built by Sulla. For the Vicus Statae Matris, see Buzzetti in *LTUR* and Haselberger 2002 ad loc.

10 Lott 2004, 30 (year 18 = AD 12: *CIL* 6.761 = *ILS* 3308 = EDCS-17300902) put up by two *magistri* of the Vicus Sandalarius.

11 For the names of vici, see Palombi in *LTUR* and the Capitoline base of AD 136 (*CIL* 6.975 = *ILS* 6073 = EDCS-46000015), discussed in section III.xix. Temples and geographical features

IV.26. Inscribed plaque dedicated to Volcanus Quietus and Stata Mater by two *vicomagistri* of the Vicus Armilustri in year 5, 3–2 BC. Museo Archeologico Nazionale di Napoli, inv. 2597.

not surprising to see a variety of well-known gods, who had their own profiles in the local neighborhoods, receive dedications from *vicomagistri*. The most popular from the Augustan period were Diana Augusta, Mercury Augustus, and Hercules (not called *augustus* in the two surviving dedications), all important state gods with well-established Greek pedigrees, quite unlike a local, native deity such as Stata Mater.[12] A fine dedication to Venus Augusta from the Forum Boarium serves as a convenient example of the genre.[13] (See figure IV.27.) The other august gods attested in neighborhood inscriptions are Apollo Augustus, Aesculapius Augustus, and Concordia Augusta.[14] In other words, most of the august gods honored in the vici were the same as those of state cult and indeed the very gods whom Augustus himself was cultivating and honoring at around the same time. Concordia Augusta

often gave their names to the local neighborhoods. Named deities include Fors Fortuna, Hercules Olivarius, Vesta, Minerva, Hercules Sullanus. The only name that recalls a crossroads shrine is the famous Vicus Compiti Acilii, which refers to a venerable shrine at an important place in the city.

12 Diana Augusta: Lott 2004, no. 5 from the Capitol (now lost) *CIL* 6.128 = EDCS-17200224 (cf. Lott nos. 24 and 49 for other dedications to Diana). Mercury Augustus: Lott 2004, no. 6 from the Forum Boarium near S. Maria in Cosmedin (*CIL* 6. 283 = *AE* 1980. 54 = EDCS-17200347, with Panciera 1978, 1980, 203–4, 206); no. 17 from the Via Marmorata (*CIL* 6.34 = EDCS-17700088 now in Naples). Hercules: no. 28 from near S. Maria in Cosmedin (*CIL* 6.282 = *ILS* 5615 = EDCS-17200375, with Panciera 1978, 1980, 204); no. 33 for Hercules Tutor (Mus. Cap. *CIL* 6.343 = 30743 = EDCS-17700105).

13 Venus Augusta: Lott 2004, no. 48 from the Forum Boarium (*MNR* inv. 205824: *AE* 1980.54 = EDCS-08900007, with Panciera 1980, 203, and Zanker 1988, 134–36, no. 7).

14 Apollo Augustus: Lott 2004, no. 21 (*CIL* 6.33 = EDCS-17700087 = *LTUR* tav. 40); no. 35 from the Via Marmorata (*CIL* 6.35 = *ILS* 3219 = EDCS-17700089). Aesculapius Augustus: Lott 2004, no. 32 from the Tiber Island (*CIL* 6.12 = *ILS* 3837 = EDCS-17200101).

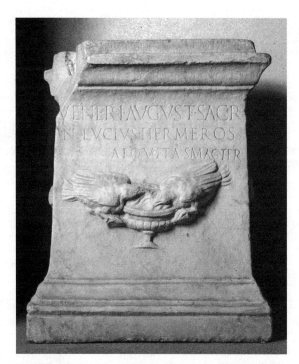

IV.27. Statue base from the Forum Boarium, dedicated to Venus Augusta by Numerius Lucius Hermeros Aequitas, when he was *vicomagister* for the third time. Augustan. Museo Nazionale Romano—Palazzo Massimo alle Terme, inv. 205824.

(locally honored near the Forum Boarium) is a reflection of the cultivation of this deity by Livia and Tiberius in 7 BC.[15] Livia's goddess Concord, however, was not given the epithet *augusta* at the time when the *lares* were being renamed.

As we have seen, Augustus dedicated a statue to Mercury in the Subura as a New Year's gift around 10 BC, but did not designate him Mercurius Augustus, as he would soon be named by *vicomagistri* in 7 BC in the Forum Boarium (near Santa Maria in Cosmedin) and in 2–1 BC in the vicus of the *Fasti of the Magistri Vici*.[16] Similarly, Apollo was clearly one of Augustus' most important patrons and his immediate neighbor in the splendid new temple on the Palatine. Yet the neighborhoods did not refer to Apollo as Palatine or Actian, nor did Augustus make a dedication to Apollo Augustus as was done by both *vicomagistri* and *ministri* in the vicus of the *Fasti of the Magistri Vici* in 2–1 BC and again later in AD 44.[17] Furthermore, Augustus did not name Mars Ultor as an august deity in 2 BC, despite the popularity of such cults to other gods in the neighborhoods over the previous decade. Meanwhile, no neighborhood seems to have honored Pax Augusta with a local altar or statue, despite the magnificent altar dedicated by the senate

15 Concordia Augusta: Lott 2004, no. 54 from in front of S. Maria in Cosmedin, with Colini 1970–71. Livia dedicated a shrine to Concordia (in this case, marital concord) inside the porticus Liviae, which was by her dedicated with Tiberius in 7 BC. For discussion, see esp. Flory 1984 with Panella (Porticus Liviae) in *LTUR*.

16 See Lott 2004, nos. 6 and 17.

17 See Lott 2004, nos. 21 and 35.

shortly before the compital reform. We should not be surprised at this pattern, which was typical within a religious world that was affected by a variety of factors, including especially local topography and social status. The few official "august" gods complemented the more numerous local *augusti* at various little shrines throughout the city.

In this context, the most unusual dedication is the so-called *ara augusta* paid for by L. Lucretius Zethus in AD 1 in the northern Campus Martius, near the Tiber River.[18] (See plate 24.) Only an incomplete part of the front section with the inscription is extant, so it is unclear exactly how large the altar originally was and the text is unfortunately fragmentary. Restorations in this unusual inscription are much more difficult to make than in a formulaic one.

<div align="center">

Mercurio

Aeterno deo I[ovi]

[I]unoni Regin(ae) Min[ervae]

[So]li Lunae Apol[lini]

[Dia]nae Fortuna[e]

[3]nae Opi Isi Pe[lagiae(?)]

[3] Fatiis D[ivinis]

[quod bo]num [faustum]

[feli]xque [sit]

Imp(eratori) Caesari Augus[to imperio]

eius senat(u)i populi[que Romani]

et gentibus nono [anno]

introeunte felic[iter]

C(aio) Caesare L(ucio) Pau[llo co(n)s(ulibus)]

L(ucius) Lucretius L(uci) l(ibertus) Zethus

iussu Iovis aram Augustam

posuit

Salus Semonia populi victoria

For Mercury

For Jove the eternal god, queen Juno, Minerva, the Sun, the Moon, Apollo, Diana, Fortuna, ?, Ops, Isis Pelagia?, ? the Divine Fates, let it be good and prosperous for Imperator Caesar Augustus and his rule, and the senate and Roman people, and all people/nations, at the beginning of the ninth year starting propitiously, in the consulship of Gaius (Julius) Caesar and Lucius (Aemilius) Paullus (AD 1), Lucius Lucretius Zethus, freedman of Lucius, built this august altar on the instruction of Jove.

Salus Semonia | the Victory of the People

</div>

18 *MNR* inv. 72473 (48.3 cm high×31.5 cm wide): *CIL* 6.30975 = *ILS* 3090 = EDCS-18600565 = Lott 2004, no. 25 with 124, 146–48. Gaspari and Paris 2013, 82, and Jovine in Paris, Bruni, and Roghi 2014, 122–23, both wrongly call this a prayer! See Palmer 1990, 18–28, for a detailed commentary on what he sees as a compital altar (because of the adjective *augustus*) and a map of the findspot. He also points to the fact that votive games for Augustus were held nearby. He places the statue of Jupiter Tragoedus donated by Augustus in this area. The connection to imperial events is reminiscent of the altar from the Vicus Sandalarius. The surviving inscribed area is not large and the letters are cramped.

The altar is dedicated to Jove (*aeternus deus*), Juno Regina, Minerva, Sol, Luna, Apollo, Diana, Fortuna, Ops, Isis Pelagia and a divine consort, and the Divine Fates. Several other gods have been added later to the top and bottom of the inscription, apparently by more than one person (in italics earlier). It goes without saying that a single altar for so many gods was not a norm in Roman ritual practice.

Zethus claims to erect the altar on direct instruction from Jove, presumably in a dream. The wording of the dedication and the array of gods recall the *ludi saeculares* of 17 BC, which took place not far away at the place called Tarentum. The altar is apparently put up for the benefit of Augustus, the senate, and the Roman people, but then also for all the peoples or nations (*gentibus*?). None of the gods is called august; only the altar itself is described with that epithet. It would, of course, have taken up much more space to add even the abbreviated form of AUG to each deity's name. The idea of an "august altar" presumably also plays on the Ara Pacis Augustae, nearby on the Campus Martius, whose enclosure features a variety of divine figures and which had been dedicated a decade before.

It comes as no surprise that Zethus' highly individualistic dedication also suggests an "irregular" era that looks as if it started in 8 BC.[19] The word for year is, however, missing and has been restored in the Latin. The dedication is (perhaps) described as the beginning of the ninth year ("starting propitiously"). If this was the era of a vicus, the date would be 1st August AD 1. But there is no evidence, other than the simple mention of a new year (in an unnamed vicus) and the use of the adjective *augustus*, to think this is at or near a *compitum*. Moreover, in the vici under Augustus the date is usually expressed in terms of a number that describes the local *magistri* (for example, first, second). Zethus does not claim to be a *magister*. Some other era may be referred to, which would have been evident in the original context of the inscription. The first day of January would be the most logical start to a "new year." It is also possible that the anniversary referred to is a personal one. The august altar of Zethus affords us a fascinating glimpse of the truly eccentric and individualized in the context of local religion while still asserting a direct connection to Augustus.

All these local dedications raise, once again, the interrelated questions of what it meant to describe a deity as "august" and who had the authority or motive to make such a designation. As we have seen, the vast majority of gods in Rome never received this title.[20] The *lares augusti* are described in one vicus as the gift of the princeps himself. The number of new cults to this pair in 7 BC indicates a centralized program, linked to the reorganization of the city in that same year, within about eighteen months of the dedication of the Ara Pacis Augustae. However, the number of other deities to be officially designated "august" in a state cult remained carefully circumscribed and specific during Augustus' lifetime.[21] In fact, it seems

19 In AD 1, Zethus apparently refers to the beginning of year 9, which would suggest a foundation date of 8 BC. Nothing about this inscription is standard or formulaic.

20 See also the insightful discussion in Panciera 2003. He surveys all attested august gods in Rome in antiquity. Of 90 Latin inscriptions, 33 honor *lares augusti* (in addition to which, we also, of course, have other evidence for compital cult that lacks a surviving inscription). Overall, however, august gods are in the minority, since about 1,800 inscriptions honor about 200 deities in Rome, of whom only about 25 are given the title *augustus/a*.

21 The five official august gods honored by the princeps and/or the senate over a period of over twenty years are: Pax Augusta (9 BC), Providentia Augusta (ca. AD 4), Ops Augusta in the Vicus Iugarius (AD 7), Concordia Augusta (started in 7 BC but not dedicated until AD 10), and Iustitia

that Pax Augusta remained the only officially august deity until the time when Tiberius became Augustus' heir, after AD 4.

By contrast, the pattern of individual or magisterial initiatives in honor of newly august deities in the neighborhoods is complex, varied, and stubbornly local.[22] Like *lares augusti*, the august gods in the neighborhoods also start receiving gifts in 7 BC.[23] In other words, there seems to be a nuanced but free interplay between a cautious and well-defined official policy of sharing the princeps' epithet with a very select group of deities, all divine qualities or *lares*, on selected occasions of importance to the *domus augusta*, in complete contrast to a local pattern of giving the title to any deity of choice, whether native or Hellenized, apparently on the individualized initiative of slaves and freedmen.

As far as we know, Augustus did not intervene to prevent or perhaps even to monitor the spread of august gods in the neighborhoods or to oversee local shrines put up by the *vicomagistri*. He simply introduced *lares augusti* at the *compita* and let local people react as they might wish. They, in turn, showed both ingenuity and imagination in integrating new august gods in such a way that transformed the sacred landscape of Rome beyond the *compita* to other *sacella*. Nearly all dedications to august gods were made by slaves or freedmen.[24] In this sense, august gods were both truly popular and specifically local. These dedications served to celebrate the princeps at the same time as the *vicomagistri* were memorializing their own local status and personal resources.

Augusta in the Circus Flaminius (AD 13). For discussion, see Fears 1981 and Lott 2004, 103 and 231 n. 132.

22 Panciera 2003 notes that the august gods are not necessarily chosen from the most popular deities to be epigraphically attested in Rome. Gregori 2009 records significant regional variability in the (slow and uneven) spread of august gods in Italy.

23 There are two examples of local august gods dated to 7 BC: Lott 2004, no. 5, Diana Augusta, and no. 6, Mercury Augustus. See Lott 2004, 124, table 2, for the dedications by *vicomagistri* arranged chronologically by year. Thirty-one dedications (but he includes the *stips* texts) are extant from the first twenty years, of which twenty-eight inscribed monuments fall in the first eleven years of the new era.

24 See the table of dedicants (C and D) in Panciera 2003.

XXXI THE "NEW AGE" OF AUGUSTUS: TIME AND HISTORY

> quo pro merito meo senatus consulto Augustus appellatus sum
> et laureis postes aedium mearum vestiti publice coronaque
> civica super ianuam meam fixa est, et clupeus aureus in curia
> Iulia positus, quem mihi senatum populumque Romanum dare
> virtutis clementiaeque iustitiae et pietatis causa testatum est per
> eius clupei inscriptionem.
> —AUGUSTUS *RGDA* 34.2

Augustus not only innovated in the specific design of the cult for new *lares augusti* at the *compita,* but he carefully drew attention to this reform by enacting it at a pivotal anniversary moment in his principate, itself now designed as the beginning of a new age.[1] Monarchs tend to favor anniversaries and jubilees of various kinds; Augustus, despite calling himself princeps ("first citizen" or "leading man"), behaved in a similar way. He lost no opportunity to memorialize a special day, to change the birthday of a temple he had rededicated to a date of personal import, and to create convergences between dates of significance to his family and official religious holidays throughout the year.[2] The inscribed calendar of the Arval brethren shows that they were busy celebrating an ever-increasing number of anniversaries connected in some way with the *domus augusta* and its various members.[3] In this same spirit, the dedication of the completed Ara Pacis Augustae took place on 30th January 9 BC, which was Augustus' wife Livia's birthday. Moreover, it seems to have been her fiftieth birthday that was marked by the special celebrations at the beautiful, new altar in Augustus' honor to the first officially august deity.[4]

Within two years, in 7 BC, the new *lares augusti* were highlighted in two particularly Augustan ways, namely in the cyclical pattern of the princeps' reformed calendar year and in the linear narrative of his special epochal time. Both approaches to thinking about time were closely connected with the princeps himself. The convergence of these two ways of experiencing and expressing time in a moment of highly visible religious innovation contrasted with Augustus' earlier habits of avowed revival and self-conscious archaizing.

As many inscriptions put up by *vicomagistri* attest, the new civic era of their local magistracy in the vici began on 1st August 7 BC.[5] It was on this day every year that the *vicomagistri* took office and from this date that they counted the era of their vicus in Rome. In other words, the *vicomagistri* who served from 1st August 7 BC

1 See calendar and timeline in appendixes 2 and 3.

2 For Augustan festival dates, see Gros 1976; Wallace-Hadrill 1987; Galinsky 1996, 300; and Scheid 2001, 90. Behrwald 2009 is especially useful for the interplay between cyclical time and the concept of an era. Lott 2004, 112, 116–17, argues that Augustus' new compital holidays were placed on existing feast days in honor of public *lares.*

3 For holidays and the *domus augusta,* see Benoist 1999 and Feeney 2007, 131–34. For discussion of Ovid, see Pasco-Pranger 2006, 174–216. For the chronological framework, see Kienast 2004, 61–68.

4 For Livia's birthday on 30th January 59 BC, see Tacitus *Ann.* 5.1.1 and Dio 58.2.1, with Suerbaum 1980 and Barrett 2002, 9, 309–10.

5 Lott 2004 has a catalogue of thirty-one items of compital dedications from Augustus' lifetime (among which he includes the five New Year's dedications, which I argue were not compital).

to 31st July 6 BC described themselves as being the first in office (*primi*).[6] The connection of this new "august" era with religious innovation is explicitly made on the *Fasti of the Magistri Vici*, a local calendar from a vicus in Rome, which claims that Augustus "gave" the *lares augusti* to the *vicomagistri* in that same year.[7] This Augustan era in the vici is documented by a series of inscriptions starting in 7 BC and continuing into the third century AD.[8] In other words, for over 200 years (well into the Severan period) local magistrates in Rome numbered their eras from the Augustan reform of the city in 7 BC. After Augustus died, the local era in the vici reverted (probably simply for convenience) to a starting date of 1st January to coincide with the regular civic year, but the special Augustan time is well attested on inscriptions in the first princeps' lifetime.[9]

In 8 BC, Augustus had introduced some adjustments to Caesar's reformed (Julian) calendar.[10] He took that occasion to rename the eighth month of the Roman year, previously known as Sextilis, with his own epithet as Augustus.[11] Since 44 BC, the previous month of Quintilis had been known as Iulius, in honor of his adopted father Julius Caesar but also recalling his own family name (*nomen*). Such renaming was simplified by the fact that these names were expressed as adjectives in Latin, in the same way as the old names for the months, which were based on numbers. The princeps' birthday fell on 23rd September, but he chose to designate the eighth rather than the ninth month with his epithet in order to commemorate three special anniversaries that fell in August/Sextilis: the beginning of his first consulship in 43 BC, his capture of Alexandria in 30 BC, and his triple triumph in 29 BC. The month was renamed in the same way as the *lares* themselves; each received the same descriptive adjective as a new name, while keeping their established place(s) in time and space.

In 7 BC, therefore, the new era of the reorganized vici in the new city of the fourteen regiones began on the first day of the new month of August. The five dedications we have from this first year indicate that the local magistrates and their attendants had been well prepared for the new era and were eager to represent

6 Four inscribed monuments honor the *lares augusti* from year 1 of the new era: Lott 2004, nos. 7 (Vat. 311 = *CIL* 6.445 = *ILS* 3613 = EDCS-17300598); 8 (two matching texts from the Tiber Island); 9 (an *aedicula* from the Vicus Aesculeti); and 10 (fragmentary altar from the neighborhood of the *Fasti of the Magistri Vici*, found near the schola). For comparison, see three dedications by *vicomagistri* to other gods from the same time: Lott 2004, nos. 5 (Diana Augusta); 6 (Mercury Augustus); and 11 (Stata Mater). Later inscriptions tended to use the number of the year rather than of the magistrates.

7 *MNR* inv. 121558 of 2 BC with additions going down to AD 21 from the Via Marmorata at the crossroads with Via Giovanni Branca (see Lott 2004, 153, pl. 17). *II* 13.1.279–89, no. 20 = *II* 13.2.90–98, no.12 = Gordon 1958, no. 32 = Lott 2004, no. 22. See Wallace-Hadrill 2008, 283–87, for further discussion.

8 Tarpin 2002, R 15 and R16, are from the 230th year of the new era. Lott 2004, nos. 36–47, consist of eleven restorations of Augustan *compita* dating from AD 53 to 223. For discussion, see Tarpin 2002, 164–74; Gradel 2002, 119; and Wallace-Hadrill 2008, 278.

9 Lott 2004, 94–96, argues for this change under Tiberius, who went on to mention the *vicomagistri* of Rome in his will (Suetonius *Tib.* 76).

10 For Augustus' calendar reform (8 BC), see Suetonius *DA* 31.2, with Scheid 2001b, 89; Feeney 2007, 184–89; and Louis 2010 and Wardle 2014 ad loc. For the Augustan inscribed calendars, see Rüpke 1995 and 2011, with Benoist 1999, 32–34.

11 Suetonius *DA* 31, Dio 55.6.6, Censorinus *DN* 22.16, and Macrobius *Sat.* 1.12.34–35, with Benoist 1999, 37–38, and Lott, 2004, 88–89.

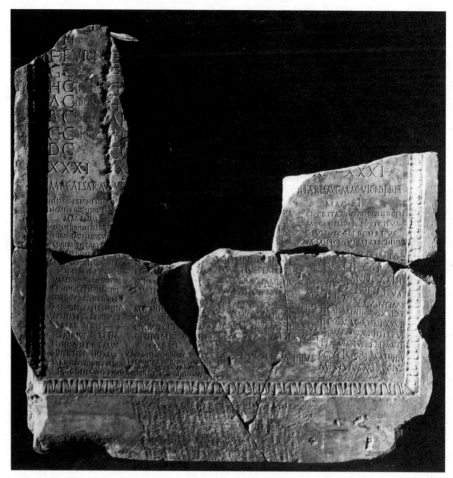

IV.28. *Fasti* of the *Magistri Vici*, front side. Museo Nazionale Romano—Palazzo Massimo alle Terme, inv. 121558.

themselves as integral to this "new age." The connection of the new month with the princeps' first consulship is made particularly evident in the *Fasti of the Magistri Vici* of 2 BC. This unusual double-sided inscription on marble was found in a small building that seems to have been a local meeting place on the Via Marmorata. (See figure IV.28.) The top half of each side contains a calendar with six months on each side. The bottom half of the stone records a list of magistrates, the consuls who gave their names to the year on one side and the local *vicomagistri* on the other side. Instead of putting the calendar on one side and the list of magistrates on the other, these two ways of measuring time are juxtaposed. This inscription, therefore, represents time both as cyclical and as linear by inviting the viewer to look at both aspects at once.

Augustus' gift of *lares augusti* to the *vicomagistri* in 7 BC is carefully recorded as the central item in slightly larger letters in the middle of the text. The list of consuls (and censors) begins with C. Iulius (that is to say Octavian's first consulship, with his colleague Q. Pedius), which he assumed in August 43 BC after the deaths

of the elected consuls A. Hirtius and C. Vibius Pansa.[12] In other words, the *vicom-agistri* draw attention to their own annual cycle of office as being shared in a very special way with the princeps, while also suggesting that his entry into politics had itself created a previous new era, some forty years before the inscription of this particular text.

Augustus, therefore, created a new civic year for the vici, which began on 1st August and was numbered by year from the year we call 7 BC. As we have seen, the first day in office was probably also marked by one of his new flower festivals, when the compital altars were decorated with summer flowers, probably at his expense. Within that local year, Compitalia in late December or early January would probably have remained the most splendid festival and the only one that definitely had ludi associated with it. Taking office in August would have given the *vicomagistri* time to plan these games and associated festivities, while also deliberately separating their entry into office from the beginning of the Roman civic year on 1st January inaugurated by the new consuls. The compital shrines would also have been decorated with spring flowers later in the year, perhaps on 1st May.

This new cycle of local civic and religious life was inaugurated twenty years after Octavian had been given the name Augustus by the senate in 27 BC and ten years after the *ludi saeculares* marked an earlier and different "new age" in 17 BC.[13] Five years later, in 2 BC, Augustus would accept the honorific title of *pater patriae*, which he represents as the culmination of his achievements (that is, twenty-five years after being called Augustus). In 2 BC, he dedicated the temple of Mars Ultor and its surrounding complex, the new Forum Augustum.[14] Meanwhile, these anniversaries were also timed to coincide with the princeps' own life cycle. Augustus was thirty-five in the year 27 BC, forty-five in 17 BC, fifty-five in 7 BC, and sixty years old in 2 BC.[15] His skill in crafting these successive anniversaries as historically significant moments distinguishes him as a consummate image-maker. Despite the fact that some of his initial political plans were unsuccessful (most notably in securing a successor who would also be his own biological descendant) and that he obviously could not foresee how long he would live, he engaged in a dynamic construction of his own image that built on the past by using the calendar and appeals to Roman tradition, while becoming ever bolder in proclaiming a succession of "new ages" for Rome, each specifically associated with himself. The rest of this section will explore the ways in which he celebrated anniversaries, not only on single days or in memory of a given year, but in successive "cycles of renewal" every ten years.

Although this story has often been told, a very brief outline of events in the most significant years can help to illustrate how Augustus eventually achieved his new time map. The doors of the temple of Janus were closed on 11th January 29 BC, signifying the end of war.[16] This year and the following one saw the first real census

12 For Augustus' first consulship (from 19th August 43 BC), see Syme 1939, 185–86; Benoist 1999, 198 n. 11; and Kienast 2004. His colleague Q. Pedius was a relative.

13 Laurence and Smith 1995–96 is the fundamental discussion from which my argument develops.

14 Mars Ultor: see conveniently Kockel in *LTUR* with bibliography.

15 Augustus was born on 23rd September 63 BC: Suerbaum 1980; Scheid 2001b, 99; Feeney 2007, 148–49, 154–55, 280 n. 107; and Pasco-Pranger 2006, 176–81. Gellius *NA* 15.7.3 preserves a letter from Augustus to Gaius on his surviving his 63rd year (considered to be a fateful time).

16 See the *Fast. Praenest.* for 11th January, with *RGDA* 13 and Dio 51.20.

since 70 BC, which included a revision of the membership list of the senate.[17] Octavian's triple triumph on 13th, 14th, and 15th August 29 BC has already been alluded to as a moment when he included ordinary people in the local neighborhoods in the celebration of his outstanding military achievements.[18] This celebration was made notable, certainly in retrospect, by being the last occasion on which the princeps would triumph. The end of the long era of civil and foreign wars was celebrated with every possible festivity. Octavian now dedicated the principal buildings that commemorated his deified father, the curia Julia and the temple of Divus Julius on 18th Sextilis / August, followed by magnificent public games that included gladiatorial combat and exotic animals.[19] The altar of Victory, including the famous statue of this goddess from Tarentum, in the new senate house was dedicated ten days later.[20] The reinstitution of the archaic *augurium salutis* marked a notable religious revival at this same time.[21]

Octavian and Agrippa held the consulship together in 28 BC. Many illegal measures enacted by the triumvirs were revoked, and the elections of lower magistrates were restored.[22] The mausoleum of the Julian family was begun on the Campus Martius.[23] The *Res Gestae Divi Augusti* records the "restoration" of eighty-two temples in the city.[24] Outside Rome, traditional cults of Dea Dia, Fors Fortuna, Robigo, and Fortuna Muliebris were renewed and revived.[25] The first games to commemorate the victory at Actium were celebrated on 2nd September 28 BC.[26] On 9th October 28 BC, the magnificent temple of Apollo on the Palatine was inaugurated next to the princeps' house.[27]

Between the triple triumph (August 29 BC) and Octavian's redefinition of his position (January 27 BC), 28 BC can be seen as a year of transition and preparation for the events of January 27 BC, when he was awarded, in a series of senate meetings, the name Augustus and the special decorations on his house (and soon also at his new mausoleum in the Campus Martius) of the oak wreath and the two laurel trees, as well as the shield inscribed with his virtues (*clipeus virtutis*) displayed in the senate house itself.[28] In other words, in mid-January Octavian claimed to

17 *RGDA* 13 and 8.2 with Cooley 2009, 139–40.

18 For the triple triumph on 13th, 14th, and 15th August 29 BC (to celebrate victories over Dalmatia 36–34 BC, Actium 31 BC, and Egypt 30 BC), see Livy *Per.* 133 and Dio 51.21.5–7, with Gurval 1995.

19 Curia Julia: Tortorici in *LTUR* (*RGDA* 19.1, Appian *BC* 2.5, Dio 51.22). Temple of Divus Julius: Gros in *LTUR* (*RGDA* 19.1 and Dio 47.18.4).

20 Dio 51.22.1 and 28th August in *Fasti Maff.*, *Fasti Vat.*

21 *Augurium salutis*: *ILS* 9337, Suetonius *DA* 31.4, Dio 51.20.4, with Meslin 1970, 24, and Scheid 2005, 182.

22 Tacitus *Ann.* 3.38.2 and Dio 53.2.5, with Cooley 2009, 258–60. Cf. the gold coin of 27 BC (probably from Ephesus) with the restoration of rights and laws in Galinsky 2012, 62–63, fig. 7.

23 Mausoleum of Augustus: Panciera and von Hesberg 1994 and Cooley 2009.

24 *RGDA* 20.4 (compare Livy 4.20.7, who calls Augustus the founder and restorer of all the temples in the 20s BC). For discussion, see Sablayrolles 1981 and Scheid 2001, 89–91, and 2005, 182.

25 Scheid 2001b, 93–94, on these ancient cults, whose restoration made Augustus seem like a second Romulus (before 27 BC).

26 First Actian games: *RGDA* 9.1 (with Cooley 2009 ad loc.) and Dio 53.1.4–6.

27 Apollo on the Palatine (9th October 28 BC): *RGDA* 4.1, 19.1; Propertius 2.31.9; Pliny *Nat.* 34.24.32, with Gros 1993 and in *LTUR*; Gurval 1995, 123–36; and Miller 2009.

28 *RGDA* 34 with Cooley 2009, 262–71 (with illustrations of the relevant coins), and Dio 53.16.4. For Julius Caesar's wreathed statue at the *rostra*, see Appian *BC* 2.16.106 and Dio 44.4.5. For the laurels of Augustus, see esp. Alföldi 1973 with Pliny *Nat.* 15.39.127, 40.133. For the *clipeus*

have handed back control over the state to the senate and Roman people, a move that was represented as a restoration of a constitutional government (*res publica*). The newly named leader Augustus retained overall command of most of Rome's armies and soon left the city to fight in Gaul and Spain.[29] The honors he received in return for his services from the senate and people of Rome commemorated and described how he had stepped down from absolute power and taken a new role in society and a status based on the general recognition of his achievements and benefactions to the whole community.[30]

The honorific awards of 27 BC, therefore, comprised his new name Augustus ("holy / revered") and three closely associated prizes: the oak wreath (a military decoration awarded for saving the life of a citizen in battle), the two laurel trees planted at either side of the door of his house (a marker shared with the most important priests in Rome), and the golden shield inscribed with his four virtues (*virtus, iustitia, clementia, pietas*: courage, righteousness, mercy, duty) in the senate house (also based on a military award for saving a life in combat). Two of these awards were forms of well-known military decorations and suggested that he could be viewed as a personal savior by every Roman because he had put an end both to civil war and to foreign threats. By contrast, the new name and the two laurel trees connected him with the divine sphere by recalling his role as a priest (unlike any Roman before him, he was a member of each major priestly college) and by suggesting that he himself had a share in the "holiness" of the gods.

Ten years after 29 BC, Augustus again returned from war and received the consular power for life in 19 BC. In addition to the Altar of Fortuna Redux outside the city, which was voted in his honor by the senate, an arch celebrating the return of the standards from Parthia was dedicated in the Forum.[31] Great games marked the occasion. A census was held again. In this year, Cornelius Balbus became the last person who was not a member of the imperial household to celebrate a triumph and to dedicate a building in Rome in his own name.[32] Augustus erected the inscribed version of the *fasti triumphales* that showed the names of previous celebrators of a triumph but with no room for more entries: it was, once again, very visibly the "end of an era."[33] In 18 BC, Augustus' provincial powers were renewed.[34] It was in this year that Augustus enacted a series of moral and social reforms (apparently attempted unsuccessfully before) that were designed to remake Roman society and to foster carefully selected and newly defined "traditional" values.[35]

virtutis, see *ILS* 81 (the shield from Arles), with Hölscher 1988, 387–90, no. 216, and Galinsky 1996, 80–89. The shield can also be found on the Belvedere altar and, in a more allusive manner, on the altar from the vicus Sandalarius.

29 See Galinsky 2012, xvii–xix, for a very useful and succinct timeline. Augustus was in Spain 27–24 BC, in Sicily and the East 22–19 BC, and in Gaul 16–13 BC, 11–10 BC, and some of 8 BC.

30 *RGDA* 34 (see Cooley 2009 ad loc. and now Rowe 2013).

31 For the altar of Fortuna Redux just outside the Porta Capena on the Via Appia near the temple of Honos and Virtus, see *RGDA* 11 and Dio 44.10.3, with Coarelli in *LTUR*. For the *ludi (Divi) Augusti et Fortunae Reducis* of 5th October (after AD 14), see Scheid 2001b, 94–97.

32 L. Cornelius Balbus: *RE* 70 (Münzer); *PIR*² C 1331; Louis 2010, 256–57.

33 For the *Fasti triumphales*, see Itgenshorst 2004 and 2005 with complete lists, and further discussion in Beard 2007, 61–67.

34 Augustus' provincial imperium of 28 BC was renewed after ten years. For his position and its development, see Crook 1996, Gruen 2005, and Eder 2005.

35 For the moral and social legislation, see Treggiari 1991, 277–98, and Milnor 2005, 140–54.

Either 18/17 BC or 8 BC saw the Sybilline books being moved from the Temple of Jupiter on the Capitol to the Temple of Apollo on the Palatine.[36]

This series of innovations and reforms culminated in 17 BC with the celebration of Secular Games (*ludi saeculares*, 31st May to 2nd June) and the adoption by Augustus of his two young grandsons, Gaius and Lucius (26th June?).[37] The *ludi saeculares* were games that celebrated the passing of an "age" (recently redefined by the princeps and his advisers as a span of 110 years) and the consequent beginning of a new cycle of life for the whole community.[38] There is evidence that such games had been held on at least two previous occasions, but Augustus both adjusted the timing of this particular celebration to coincide with his own timeframe and redesigned the rituals themselves to invoke a completely new set of deities.

Another decade passed before the dedication of the Ara Pacis Augustae on 30th January 9 BC and the holding of games to celebrate Augustus' most recent return to Rome in 13 BC.[39] It is notable that Livy ended his history of Rome from its foundation with the events of this year. Another census was completed in 8 BC.[40] In addition to the calendar reform, Augustus reorganized the city of Rome into fourteen new regions (subdivided into vici at the local level) and redefined the job of the *vicomagistri*, four in each vicus. The new fourteen regiones replaced the archaic four regiones attributed to King Servius Tullius.[41] Tiberius celebrated a triumph on 1st January in this year and joined his mother Livia in dedicating her portico, within which she placed a shrine to Concordia.[42] In 7 BC, in the consulship of Tiberius and Cn. Calpurnius Piso, the new age of the vici was inaugurated on the first day of the new month of August, named for the princeps.

Consequently, we can see that Augustus was engaged in a project of self-conscious and public historicizing of his own role and status in Roman society. This creation of a completely new type of Augustan time-map went beyond simply observing individual anniversaries each year or decade. Rather, initiatives were grouped in patterns across discrete spans of many months (falling in three calendar year segments each time) that functioned as "eras of innovation," both in their own context and in direct relation to previous initiatives (see appendix 3). In this sense, the time from the triple triumph of August 29 BC to the restoration of constitutional government in January of 27 BC forms a distinct unit that was echoed a

36 Suetonius *DA* 31.1 and Servius on *Aen.* 6.72.

37 The adoption of Gaius and Lucius (26th June 17 BC?): Vell. Pat. 2.96.1, Suetonius *DA* 64.1, and Dio 54.18.1, with Hurley 1997, 428–29 n. 55.

38 *Ludi saeculares*: *CIL* 6.32323 = EDCS-41100033, with Pighi 1941/65 and Schnegg-Köhler 2002. *RGDA* 22.2, Horace *Carm Saec.*, Censorinus *DN* 17.7–11. For discussion, see Rüpke in *BNP*, with Scheid 2005, 97–110; Cooley 2006, 230–36; and Feeney 2007, 145–48, 184–89. Susan Bilynskyj Dunning's PhD dissertation titled "Roman Ludi Saeculares from the Republic to Empire" (Toronto, 2016) makes an important new contribution.

39 For the Ara Pacis Augustae, see section IV.xxix.

40 *RGDA* 8.3 (with Cooley 2009 ad loc.); Tarpin 2002, 119–27; and Lo Cascio 2008.

41 For the four regiones of Servius Tullius and the fourteen regiones of Augustus, see Fraschetti and Palombi in *LTUR*. The Hadrianic base: *CIL* 6. 975 = *ILS* 6073 = EDCS-46000015 (see section III.xix) and Dio 55.8.5–7. Fraschetti 2005, 168–76, consistently argues for no formal administrative districts before Augustus. See Paillier 1985 for an eloquent argument in favor of a city of five regions.

42 Flory 1984 remains the classic discussion. It is interesting that Concordia was not called *augusta* by Livia. Tiberius' elaborate restoration of the old temple of Concord in the Roman forum, renamed Concordia Augusta, did not conclude until AD 10 (Ferroni in *LTUR*). It is, therefore, not evident that the goddess would necessarily have been renamed before the rededication.

decade later, after Augustus returned again from foreign wars in October of 19 BC. Further definition of his legal powers in 19 and 18 BC, and the program of moral and social renewal of 18 BC, culminated in the *ludi saeculares* in mid-17 BC. Another ten years later, the inauguration of the Ara Pacis Augustae in January of 9 BC (a delayed recelebration of Augustus' return to the city from abroad in 13 BC) was followed by Augustus' censorship in 8 BC, which set the stage for the massive urban reforms of 7 BC. The time between 9 and 7 BC was, therefore, framed by august deities, starting with Pax Augusta and culminating with the *lares augusti* in Augustus' own month.

The full impact of the new era of the *vicomagistri* and the installation of the *lares augusti* at their compital shrines on 1st August 7 BC can be appreciated only within this very deliberately staged set of chronological frameworks, which takes on its full meaning when viewed retrospectively. In this context, the use by the *vicomagistri* of so many Augustan motifs from 27 BC (such as the oak wreath, the laurel trees, and sometimes the shield with the virtues) emerges as a reference not just to the princeps himself in general but also more specifically to the events of January 27 BC, as consciously recalled and celebrated twenty years later. The characteristic Augustan symbols had appeared on coins in the intervening years, but were not part of such a widespread popular iconography before the new era of the *lares augusti* in the vici.

An appreciation for the careful and elaborate planning involved in staging major events on specifically selected dates helps to settle a long-standing debate about whether any vicus had a cult of *lares augusti* or a new local era before 7 BC.[43] It should come as no surprise that some vici established their own local eras after 7 BC, most often because the vicus or compital shrine in question was not in place in 7 BC.[44] The city was continually evolving and neighborhood cults inevitably came and went with these changes. Nevertheless, two much later inscriptions, which record restorations of compital shrines in the Vicus Iovis Fagutalis (AD 109) and the Vicus Honoris et Virtutis (AD 83), have irregular eras that suggest foundation dates before 7 BC, in 12 BC and 9 BC, respectively.[45]

The five years between 12 and 7 BC may not seem so significant, but much discussion and interpretation has depended on these two texts. Do these inscriptions

43 For earlier discussions, see Gatti 1906 and Niebling 1956. Scheid 2001b, 101, simply takes the irregular eras at face value. Tarpin 2002, 139, tends to support a single reform but says "rien ne permet de trancher de manière catégorique cette difficile question" (nothing allows us to settle this difficult question in a definitive manner). Fraschetti 2005, 239–42, uses the anomalous eras to support his speculative argument that the *lares augusti* represent the deceased members of the imperial household, which means that the cult spread with the death of each person, now considered a "*lar.*" See also Lott 2004, 85–87.

44 Vicus Cornicularius: *AE* 1960.61 = Lott 2004, no. 36, of AD 53 yields a foundation date of 6/5 BC. Lega in *LTUR* places this in the area of the Via Labicana.

45 Vicus Iovis Fagutalis: *CIL* 6.452 = *ILS* 3620 = EDCS-17300605 = Lott 2004, no. 40, of AD 109 from the Quirinal, with Buzzetti in *LTUR*. Gatti 1906 (followed by Niebling 1956) argued for a scribal error that produced CXXI for CXVI to suggest 12 BC instead of 7 BC. Vicus Honoris et Virtutis: *CIL* 6.449 = *ILS* 3617 = EDCS-17300602 = Lott 2004, 85–86, and no. 37 of AD 83 yields a date of 9 BC. See also Pollard in *LTUR* and Haselberger 2002, 286, as well as Niebling 1956, 327 n. 121. There was a second restoration in this vicus in AD 205 or 208 (Lott 2004, no. 44). Each of these two inscriptions is dated by the titles of the emperor at the time (Domitian and Trajan), thus also raising the possibility that there could have been a mistake of some kind in those numerals— for example, if they were copied from a source that was out of date. The key issue is the synchronization of the two ways of dating the year, neither of which was the simple consular date.

show that the religious reform was not carried out at a single moment in an organized and centralized plan? Would the introduction of *lares augusti* in 12 BC, the year in which Augustus assumed the office of *pontifex maximus*, indicate a spontaneous popular acclamation of the princeps and his new office in the form of religious innovation within an individual vicus? Or is the introduction of *lares augusti* by the princeps himself closely linked with a specific event in 12 BC, such as the building of a shrine to Vesta in Augustus' house once he became *pontifex maximus*?

For two interrelated reasons, the chronological patterns discussed earlier seem to rule out either the "invention" of *lares augusti* on a local level or a gradual introduction of such a new cult as a grassroots initiative. The dating of the reform according to our best sources, notably the inscriptions from Augustus' own lifetime, all point to a single reform in 7 BC that is directly attributable to the initiative of the princeps himself. It is very hard to see how the dates and anniversaries could line up so neatly by mere coincidence. Rather, the whole point of a new era linked to the new *lares augusti* was precisely that every existing (functional) vicus in Rome could take part. Presumably most did. The fact that a few might have been slow or disorganized implies nothing about the overall design and implementation of the great urban reform.

It is not methodologically sound to prefer inferences from two much later texts, which may well record numbers that are inaccurate for a variety of reasons (misnumbering or mistakes in inscribing the letters, for example), over a solid body of contemporary evidence that points to a single reform in 7 BC, associated with an established pattern of imperial planning around recognized anniversaries. Furthermore, the introduction of *lares augusti* as early as 12 BC would predate the solemn dedication in 9 BC of the Ara Pacis Augustae, whose importance as a monumental altar and a religious milestone needs to be given full consideration (see section IV.xxix). Before the renaming of the month Sextilis as Augustus, and the related reform of the vici and their *magistri*, a new era starting on 1st August would not have made sense.[46] Rather, on the basis of the ancient evidence we should be confident that the princeps introduced *lares augusti* into Rome's vici through the *vicomagistri* in 7 BC, in whatever way the practical aspects were handled at that time.

As already noted, the *Fasti of the Magistri Vici* records that Augustus himself gave (*dedit*) the *lares augusti* to the *vicomagistri*. The text of the inscription does not specify whether this gift was a special favor to this particular neighborhood or whether Augustus himself gave new *lares augusti* to every compital shrine in the city. A common assumption posits that Augustus donated the *lares augusti* in the form of new (small) statues to each *compitum*.[47] However, some have questioned the logistics and suggested that the single grand gesture on the part of the princeps would have been virtually impossible to put into practice. Such an argument does not take into account the previous history of communication between the central organs of government and the vici. As discussed in section III.xix, there is plenty of evidence for distributions of key items among the inhabitants of Rome precisely by using the network of vici and their local leaders.[48] This procedure is denoted by the traditional Latin adverb *vicatim* (by vicus). Distributions of grain,

46 Lott 2004, 85–86, makes this point very clearly.
47 Lott 2004, 104, imagines a single gesture of handing over statuettes in a single location in 7 BC.
48 See Tarpin 2002, 94.

wine, and oil are the items most commonly recorded, and such distributions are attested as early as the Hannibalic War in the late third century BC.[49] Julius Caesar had also used local resources to conduct his census in 46 BC, a practice already followed by Augustus in 28 BC.[50] Consequently, it would be unsurprising for Augustus to have chosen the interconnected networks of vici and compital shrines to enact a religious reform, particularly at the time when we know that he was in fact just reorganizing the vici to fit in with the general redistricting of the whole city. The gesture of the princeps himself handing over small cult images (*lares* and Minerva) is also recorded both on the Belvedere altar and on the altar of the woodworkers from San Giorgio in Velabro, as well as being memorialized on the *Fasti of the Magistri Vici*.[51]

In sum, Augustus' historicizing of a new era in the vici involved a (re)sacralization of time itself, which was linked to a narrative of religious innovation that did not follow traditional Roman patterns. The *lares augusti* were *lares* at the crossroads, depicted with recognizable imagery. Their traditional function as protectors and patrons of the local neighborhoods had not disappeared and the types of ritual with which they were invoked and appeased seem to have remained largely the same, but were enhanced and multiplied. Yet this cult was consciously designated as "new" and connected directly to the princeps himself as the founder of a "new age" in the city of Rome. So far there is no reliable evidence to suggest that any other Roman town renamed its neighborhood *lares* in this organized way.[52] In fact, the reverse seems to have been the case; the new *lares augusti* distinguished the *compita* in Rome from those in other cities. The princeps' epithet *augustus* (itself an overtly religious term) was now displayed at every crossroads shrine in Rome and associated with a systematic religious reform throughout the city. In this context, Augustus' carefully developed role as a restorer of traditional religion and values was ostentatiously juxtaposed with the image of a bold religious reformer, whose very special connection to the divine linked him to the local protective gods of each compital shrine and even to each of their individual worshippers, many of whom were freedmen and slaves.

49 Livy 25.2.8 and 30.26.

50 Suetonius *DJ* 41.5 and 44, with Lo Cascio 1990, 1997, and 2008, and Louis 2010 and Wardle 2014 ad loc.

51 For the altar of the woodworkers, see note 34 on page 280.

52 Van Andringa 2000, 78–80, argues against *lares augusti* at street shrines in Pompeii. Bloch 1962 shows that *lares augusti* at Ostia were introduced at a central shrine by Claudius. Bakker 1994, 118–33, adduces evidence for seven compital shrines at Ostia. *Lares vicinales* are clearly attested after Augustus. Gregori 2009 has studied the epithet *augustus* throughout Italy and shows very marked regional variations that do *not* suggest a centralized effort to spread any of these cults beyond Rome. As we can see, even in Ostia, Rome's own port city, the first *lares augusti* are dated to AD 51 and are attested only at a single location. I do not think that the *sacrarium* set up by L. Aurelius Rufus at Acerra honored *lares augusti* (*CIL* 10.3757 = *ILS* 137 = *CE* 18 = EDCS-17700016); contra Koortbojian 2013, 160 and 269 n. 15.

XXXII AUGUSTUS AND *LARES AUGUSTI*

> At the street corners the pious had put out little dishes of honey
> cakes as new year offerings to the neighborhood gods, for we
> worshipped the spirits of the crossroads in those days rather than
> the great god Augustus, and the hungry birds were pecking at
> them, rising and fluttering and settling again as we hurried past.
>
> —ROBERT HARRIS IN HIS NOVEL *CONSPIRATA*
> (2010, 22), IN THE VOICE OF TIRO, CICERO'S LONG-TIME
> SECRETARY AND FREEDMAN

The compital shrines had always enjoyed a very particular place within an urban
landscape permeated by a multitude of modest altars, deities in small niches, and
various kinds of sacred images, many of which were simply painted on walls or
around doorways. Augustus had surely been aware from his childhood onward of
this everyday religious world and of the significance of *compita* and their *lares*
within it. He himself had perhaps started life as a man of rather conventional reli-
gious tastes and habits, to judge from some anecdotes in Suetonius, even if he may
at the same time also have developed a genuine personal belief in his own special
destiny.[1] His story was certainly unusual enough and the odds he beat high
enough to make some divine help seem essential within a traditionally Roman
worldview.

Yet the decision to introduce new *lares augusti* to the compital shrines through-
out the city, or rather to rename the existing *lares compitales* with his own special
epithet (simply through a gift of new statues?), as a striking way of celebrating
twenty years of himself using the name Augustus, was bold, original, and highly
effective. These *lares augusti* managed, therefore, to be both old and new at the
same time. Augustus had been and would continue to be the patron of many local
shrines to a wide variety of deities, including using and memorializing the gifts he
received from ordinary people at every New Year, but his relationship with the
compita and their *vicomagistri* remained unique. The *vicomagistri* (and probably
others) in turn, created cults of other august gods both at and also beyond the
compita, according to the religious landscape of each individual neighborhood.

The ubiquitous and well-loved *lares* at the crossroads, who did not have a set of
distinctive stories or accomplishments commonly associated with them, provided
the perfect opportunity for the decisive gesture with which the princeps reached
out and made his own special time a new era in the local neighborhoods, at the
grassroots levels of city life. The timeless and essentially ahistorical *lares* were used
to express an identity and an epoch shared in a very particular way by Augustus
and the *vicomagistri.* The types of offerings they received were also traditional and
thoroughly familiar (flowers, a pig, a *suovetaurilia* in the context of a traditional *lus-
tratio*, and so on), but now made new by Augustus. The response of local freedmen
and slaves, at least in the first generation, was enthusiastic, immediate, and wide-
spread. They recognized and endorsed twenty years of living under Augustus'

1 For Augustus' religious beliefs, see Suetonius *DA* 61 with Galinsky 1996, 288–331, and War-
dle 2014 ad loc. Overall, see also Scheid 2005 and Galinsky 2012, who gives a very helpful, bio-
graphical context. Gradel 2002, 137, notes that in state cult, offerings were made on Augustus'
behalf to the traditional gods or to certain august gods.

regime, at the same time as they inaugurated a new era in his name. They represented themselves in roles assigned by him but also parallel to and in harmony with his own. They joined Augustus to reshape the city and decorate it with new reliefs and inscriptions on marble.

Meanwhile, the acclamation of the princeps as a type of religious leader, both a priest and yet one also partaking of the very sanctity of the gods, lay at the heart of his self-presentation. Rather than the sphere of religion collapsing into politics (through manipulation and propaganda), the sphere of politics seemed to be collapsing into that of religion, albeit gradually over time. The details of Augustus' constitutional powers, obviously vital in their own way, were much less visible than his holy name, his multiple priestly functions, his powerfully innovative use of the office of *pontifex maximus*, his creation of a new sacred landscape of temples and shrines throughout Rome, the sheer number of his anniversaries marked with religious ritual in Rome's annual calendar, and, in a special way, by the new era associated with *lares augusti*.

Augustus did not himself apparently choose to commemorate the *lares augusti*, although their cult can, at least from our perspective, be seen as one of the most innovative religious initiatives he undertook in the city of Rome. Rather, he inspired the many freedmen *vicomagistri* of Rome to spend their own money to celebrate and monumentalize august *lares* in their new era associated with his special symbols, as well as to appropriate the princeps' epithet as they associated other favorite or local gods with his personal quality. The very success of *lares augusti* in Rome quickly made august gods a familiar feature of local neighborhoods in Rome. He let the enthusiasm of Rome's newest citizens for him speak for itself, without needing to elucidate the theological implications of the thousands of *lares augusti* in Rome. It was the very ubiquity and popularity of the august *lares* (and various other august gods) that was met by silence in elite texts. Nevertheless, Augustus' interventions in Rome's vici, when viewed as a whole, testify to his deep knowledge of and appreciation for local life as it had developed in tandem with the growth of the city.

EPILOGUE

huic filia una est. ea mihi cottidie
aut ture aut vino aut aliqui semper supplicat,
dat mihi coronas.
 —PLAUTUS *AULULARIA* 23–25 (CA. 195 BC)

Larib(us) d(onum) d(edit/erunt) romano
more dedicata

Dedicated to (the) *lares* in the Roman manner, s/he (or they?) gave (this) gift
 —*CIL* 9.4185 = *ILS* 3628 = EDCS-14805216,
 Schraudolph 1993, L 89

This inscription is preserved in clear letters on a broken altar from Amiternum (San Vittorino, near L'Aquila) in Sabine country, where the historian and senator Sallust had been born. Above the dedication floating ribbons are all that remain of what was perhaps an oak wreath in the typical Augustan style. On the back, the single word *sacrum* (sacred) survives. This simple text strikingly demonstrates the particular cult(s) associated with the *lares* in Rome. As is so often the case, however, this glimpse of devotion to *lares* raises as many questions as it answers. These *lares* are not named and are not called *augusti*, although the iconography associated with them (while still intact) may readily have implied this epithet to an ancient viewer. The person (or group?) making the dedication to these *lares*, although not recording their own name for posterity, wanted to be sure to memorialize the characteristically "Roman" way in which this gift had been given, a description that could refer both to the gods themselves and to the particular rituals they were honored with. Alternatively, this may be read as a special "Roman" gift for local *lares*, perhaps inspired by a memorable visit to Rome. A claim made in Latin to honor *lares* "in the Roman way" has complex resonances that are overtly religious, but that also relate to social class, ethnic identity, political allegiance, familiarity with Roman customs, and a claim to cultural sophistication.

 Like the dedicator(s) of this altar, I have chosen as my focus the "Roman" *lares*, even while paying attention, in the way that they did, to *lares* in other places where Roman habits informed or contrasted with local practices. *Lares* of various kinds permeated a very Roman sense of religious experience, habit, and identity. As we have seen, these gods marked places and times in the monthly and yearly cycle; they embodied home but also protected travel on the roads (and sometimes even throughout the seas); they watched over transitions in the life cycle, especially coming of age and entering into a marriage; they happily received used objects that were no longer needed and scraps of food, even ill-omened ones that had been

dropped on the floor. They were to be found at the hearth where the food was pre-
pared for the household and at street corners or the edges of farms, the places where
home or neighborhood converged with a larger world. Consequently, they watched
over all in the household, even as they brought neighbors together to share a feast
and recognize the contours of local relationships. Their simple yet essential role
made them the easiest and most important gods to share with a slave or freedman.
In this sense, they also helped facilitate relations between masters and slaves, as
well as maintaining continuity with those freed and enfranchised, Rome's newest
citizens. Their cults provided highly visible markers for the houses where Italians
and Romans lived on Hellenistic Delos.

This characteristic ubiquity of *lares* in the Roman home, town, and countryside
is matched by the impressive survival of their cults throughout antiquity. Most of
my discussion has investigated *lares* in republican and early imperial times, but they
survived well into the world of late antiquity, despite increasingly heated competi-
tion from an army of new and exotic gods, some of whom made elaborate prom-
ises of personal salvation and a future life of bliss. A section of the Theodosian Code
(published on 15th February AD 438) provides a fitting way to conclude this study,
which has drawn on many small case studies and individual pieces of evidence to
offer a mosaic picture of life with *lares*.

The Theodosian Code here quotes a law promulgated on 8th November AD 392
at Constantinople that bans traditional Roman practices. The opening sentence that
forms the preamble focuses in particular on *lares* and related cults.

> IMPPP. Theodosius, Arcadius et Honorius aaa. Ad Rufinum praefectum
> praetorio
> Nullus omnino ex quolibet genere ordine hominum dignitatum vel in
> potestate positus vel honore perfunctus, sive potens sorte nascendi seu hu-
> milis genere condicione fortuna in nullo penitus loco, in nulla urbe sensu
> carentibus simulacris vel insontem victimam caedet vel secretiore piaculo
> larem igne, mero genium, penates odore veneratus accendat lumina, imponat
> tura, serta suspendat.

> The august emperors Theodosius, Arcadius and Honorius—to Rufinus pre-
> fect of the East
> Let no person whatsoever—from whatever station or class of persons, ei-
> ther occupying a position of power or a previous office holder, whether
> someone born into a position of rank or a humble person by birth, legal sta-
> tus, or fortune—in no place at all, in no city let anyone slaughter an innocent
> animal as a sacrifice for an idol that lacks senses, nor more secretly, as an of-
> fering of expiation, let anyone venerate a *lar* with fire, a *genius* with pure
> wine, or offer fragrant smells to family gods (*penates*); let no one light a lamp
> (or candle), offer incense, hang up a garland of flowers.
> (Theod. Cod. 16.10.12 pr.)

The two basic elements of "pagan" religion that are introduced here are animal
sacrifice addressed to an image of a traditional god and the household cults associ-
ated with *lares*, *genius*, and the gods of individuals related by blood, known col-
lectively as *penates*. There is particular stress on preventing elite participation in
any such cults.

It is striking to see that the ritual actions so carefully specified are immediately recognizable from a wealth of older evidence about *lares*. The gestures of cult indeed appear consistent across the centuries, even as the rhetorical structure of this elaborate sentence stresses them in almost loving detail. It is these everyday acts of worship that provide such important targets for the Christian emperors. It was apparently not enough simply to ban the worship of household gods in a general statement like the one describing animal sacrifice. Rather, the lawyers working for the emperors needed to make themselves clear through enumeration: *do not* worship a *lar* in the fire of the hearth; *do not* pay homage to a *genius* or *penates*; *do not* pour a libation of undiluted wine, offer a pinch of incense, light a candle, or hang a garland of flowers. The flowers at the end of the sentence inevitably and specifically recall the *lares* to whom they were such habitual offerings, hung in garlands on the nails found next to household shrines in Pompeii or at compital shrines on one of Augustus' special flower festivals in the spring and summer.

By this date, the *lares* had survived the loss of Compitalia, compital shrines in the vicus overseen by *vicomagistri*, visits from Roman brides, the crowd of slaves in Rome, and so much else. The detailed legal ban on personal religious gestures imagined as being performed in the home brings to mind the deliberate damage we see on most Augustan altars from the crossroads of Rome. These late first-century BC altars show significant wear from long exposure to the elements and to life in a bustling metropolis, but also the marks of calculated attacks, mostly aimed at the heads of the individual figures, both human and divine. Some altars have been found in pieces, perhaps as a result of being smashed. Yet the defacement and desecration of the *compita* did not make the *lares* and their cults disappear from Rome.

In the ban of AD 392, we see a set of religious gestures that would have been thoroughly familiar to Plautus or to Cato the Elder (and to the audiences of their works) at the turn of the second century BC, some six hundred years earlier. We may even recall the inscription for the little *lar* from Tor Tignosa, which may also date to around the same time. By contrast, the hymn sung by the Arval brothers was already old in Cato's day. These same ritual actions are also commonplace in paintings from Delos and Pompeii. Once again, it is essential to stress that the Theodosian Code targets rituals rather than specific images or festivals or shrines. These simple but powerful gestures, not described in terms of belief or theology or cult association (*collegium*), survived as vital relics of the "old ways." One senses in them the fondness of Romans for traditional interactions with these groups of little gods who comprised a nexus in everyday life. Individual gestures continued once the noisy public festivals, with their popular entertainments and prizes, roast pork and plentiful wine, were long gone. The heart of such cults did not lie in grand temples or great works of art depicting the gods, but in the patterns of traditional piety in the home, devoid of elaborate myths or commemorative narratives, but closely bound to a profound sense of place, self, and community.

These ritual gestures persisted, especially since they could easily be performed in private and out of sight, within a brief time frame and without elaborate props, expensive gifts, or even images of the dancing gods; the *lares* lived in any hearth and the *genius* was the faithful companion of each individual person during his or her lifetime. But were these ritual gestures really precisely "the same" across time and space throughout the centuries? It is very hard for us to tell. Even the severe later lawmakers did not themselves apparently stop to ask what it all really "meant."

They saw these habits as a target for detailed bans, presumably because many Romans still practiced them, perhaps at the same time as new, monotheistic rituals. Of course, we cannot know if identical ritual gestures and objects of cult conveyed the same set of meanings and solicited the same experiences in republican and imperial Rome as they did in late antiquity. Rather, simplicity and flexibility made *lares* (and other local and household deities) attractive, familiar, and hard to do without. The sense of belonging they created had easily coexisted with many other religious practices over the centuries and appealed to a wide variety of ancient people. The ban of 392 again highlights the fact that the *lares* were not gods specifically "for the slaves," as many moderns have postulated; rather they were by their very nature native deities closely associated with Rome and Romanness. It was for the same reason that, centuries earlier, in 88 BC on the island of Delos, the invading soldiers of Mithridates of Pontus had targeted their images for erasure while leaving dedications to other deities intact.

Appendix 1

REFERENCES TO *LARES* BY ROMAN AUTHORS: A LIST

IA PROSE AUTHORS WITH BOTH SINGULAR *LAR* AND PLURAL *LARES* IN DOMESTIC CULT (PLURAL IN BOLD)

Apuleius: *Apol.* 21; **53; 54; 55.** *Flor.* 18; *Met.* 1.8, 19, 21, 23; 2.3, 30; 3.19, 23; 5.4, 7, 9; 8.23; 9.24, 25, 26, 31; 11.19, 26; **4.12; 5.10; 11.7, 27.**

Cicero: *Verr.* 2.3.125; *Leg.* 2.55; *Att.* 16.4.2; *Phil.* 2.75, 14.10; **Quinct. 85; Dom. 108; Sest. 30; Tim. 38; Fam. 1.9.20, Leg. 2.42.**

Digest of Justinian (6th century AD), quoting Ulpian (early 3rd century AD): 25.3.1.2; **6.1.38.**

Pliny the Elder: *Nat.* 14.52; 28.27; 36.204; **28.267.**

Porphyrio's commentary on Horace: *Sat.* 2.5 lemm. 14; *Odes* 1.12 lemm. 43–44; *Epist.* 1.1 lemm. 13; ***Carmen Saec.* lemm 37; *Epod.* 16 lemm. 17; *Sat.* 1.5 lemm. 65–66;** *Odes* 3.23 lemm. 9–10.

Quintilian: *Inst.* 13.2; **9.11 and 12; 13.4; 260.27; 321.20.**

Seneca the Younger: *de Ben.* 4.5.3; ***Ep. ad Lucilium* 90.28.**

Servius' commentary on Vergil: *Georg.* 2.159; 3.344; *Aen.* 8.543; 9.256; **3.64; 3.134.**

Valerius Maximus: 7.7.3; **2.4.5; 2.10.2; 7.7.1.**

Varro: *LL* 5.92; **6.2.10.**

IB VERSE AUTHORS CITING SINGULAR *LAR* AND PLURAL *LARES*

Horace: *Sat.* 2.5.14; 2.6.66; **1.5.66; 2.3.165;** *Epist.* 1.1.13; 1.7.58; 2.2.51; ***Epod.* 2.66; 16.19;** *Carmen Saec.* 39?; *Od.* 1.12.44; 3.29.14.

Juvenal: 3.110; 8.14; 14.20; **6.7?; 9.137; 12.89; 12.113?;** 15.153.

Martial: 1.76.2; 10.61.5; 11.82.2; **1.70.2; 3.5.6; 5.42.2; 9.18.2; 9.43.12; 9.61.15; 10.58.10.**

Ovid: ***Rem. Am.* 237–302;** *Am.* **1.8.113;** *Fast.* 1.136; 1.478; 6.95 and 362?; **2.634; 4.802?;** *Trist.* 1.3.30; 3.12.52; **1.3.43; 4.8.22;** *Ep. ex Pont.* 1.1.10; 1.7.58.

Persius: *Sat.* 5.109; **5.31.**

Plautus: *Aul.* preface and 385–87; *Most.* 499–500; *Trin.* 29; *Miles* 1339; *Merc.* 834–37; 864–65; ***Rud.* 1207.**

Propertius: 4.10.18; **2.30a.22; 4.1b.128; 4.3.54; 4.8.50.**

Seneca: *Medea* 21; 224; 478; *Herc. Fur.* 197; 381; *Phaedra* 863; *Oedipus* **258;** 672; *Thyestes* **264;** *Agamemnon* **6; 392; 782;** *Phoenissae* 511; 594; **344;** *Herc. Oet.* 359; **100; 245; 318; 632; 756; 1492.**

Silius Italicus: *Pun.* 1.659; 3.566; 4.27; 6.440; 7.558; 9.81; **4.234; 7.173.**

Statius: *Achill.* 1.740; **1.933;** *Theb.* 1.587, 2.439, 4.57, 7.157 and 787, 8.617 and 737, 10.88; **4.374, 7.600, 9.515, 10.585, 12.327;** *Silv.* 2.2.22; 3.1.65; 3.1.83; 3.3.197; 4.8.23; 5.1.146; 5.3.168; **4.5.2?.**

Tibullus: 1.3.34; 1.7.58; **1.10.15?** and **25**; **2.4.54**; **2.5.20** and **42?**.
Varro: *Ep.* fr. 1.1, **fr. 372**.

IIA A SINGLE *LAR* AS THE ONLY OPTION (VERSE AND PROSE)

Calpurnius Siculus: *Ecl.* 4.154.
Cato: *de Agr.* 2.1; 143.
Catullus: 31.9.
Columella: *RR* 1.1.18; 10.1.1?; 11.1.9.
Curtius Rufus: *Alex.* 5.12.2.
Germanicus Caesar: *Arat.* 124; fr. 4 v. 16.
Granius Flaccus: fr.1.1.
Iunius Silanus: fr.1.
L. Pomponius Bononiensis: Atellanae fr. 61.
D. Laberius: line 152 in an unknown mime.
Livy: 1.29.4; 26.25.12.
Pliny the Younger: *Pan.* 47.6.
Ps-Seneca: *Octavia* 747.
Remmius Palaemon: *Ars* p. 535 l. 38.
Sallust: *BC* 20.12.
SHA Probus 24; *SHA Clod. Alb.* 4.
Symmachus: *Carm.* fr. 2.2.
Vergil: *Georg.* 2.159; 4.43; *Aen.* 5.744; 8. 543; 9.259.

IIB PLURAL *LARES* AS THE ONLY OPTION (VERSE AND PROSE)

Afranius quoted in Festus 277L.
C. Caesius Bassus: *de Comp.* p. 311.
Ennius: fr. 619.
Florus: 2.2.
Fronto: *Ep. Ad Ant. Pium* 5.1.
Hyginus: *Fab.* 15.2.
Lucan: *BC* 1.278, 507; 5.528; 6.511; 7.394; 8.113; 9.992.
Petronius: *Sat.* 29, 60.
Q. Terentius Scaurus: *de Orth.* p. 13; *SHA* Pertinax 14.3.
Suetonius: *DA* 7.1; *Cal.* 5.1; *Ner.* 46.2; *Vit.* 2.5; *Dom.* 17.2.
Valerius Flaccus: *Arg.* 2.246.

III ADJECTIVES DESCRIBING *LARES*: AN OVERVIEW (POSSESSIVE ADJECTIVES ARE VERY FREQUENT)

adsuetus: Statius *Theb.* 11.109.
alienus: Seneca *Phoen.* 511; Apuleius *Met.* 4.12.

angustus: Lucan *BC* 5.528.

antiquus: Ovid *Trist.* 4.8.22.

argenteus: Petronius *Sat.* 29.8.

avitus: Valerius Maximus 7.7.1; Quintilian *DMai.* 13.4.

bullatus: Petronius *Sat.* 60.

certus: Horace *Epist.* 1.7.58; Seneca *Med.* 478.

clausus: Propertius 4.3.54.

communis: Ovid *Fast.* 6.95.

desertus: Apuleius *Met.* 5.4.

errans: Tibullus 2.5.42.

exiguus: Seneca *Phoen.* 594; Apuleius *Met.* 1.21.

exornatus: Suetonius *Ner.* 46.2.

familiaris: Pomponius Bon. *Atell.* 61t.; Cato *Agr.* 2, 143; Cicero *Verr.* 2.3.27 and 125; *Phil.* 2.75; 14.10; *Quinct.* 85; *Dom.* 108; *Sest.* 30; *Leg.* 2.42; Sallust *BC* 20.12; Varro *Ep.* fr. 1; Val. Max. 2.4.5; Pliny *Nat.* 36.204.

fidus: Seneca *Med.* 224; *Oed.* 258.

fraternus: Seneca *Ag.* 6.

gracilis: Apuleius *Apol.* 21.

hesternus: Servius on *Aen.* 8.543.

hospitalis: Hyginus *Fab.* 15.2.

humilis: Statius *Silv.* 3.1.83; Silius Italicus *Pun.* 7.17.

incertus: Seneca *Med.* 21.

incinctus: Ovid *Fast.* 2.634.

innocuus: Statius *Silv.* 2.2.22.

maculatus: Seneca *Phoen.* 344.

maximus: Vergil *Georg.* 2.159; Seneca *Ben.* 4.5.3.

miserus: Seneca *Herc. Oet.* 756.

modicus: SHA *Clod. Alb.* 4.3.

motus: Seneca *Thyes.* 264.

nitidus: Martial 1.70.2.

nullius: Germanicus Caesar *Arat.* 124.

parcus: Propertius 4.10.18.

parvulus: Apuleius *Met.* 1.23.

parvus: Juvenal 9.137; Martial 9.18.2; Silius Italicus *Pun.* 7.173.

paternus: Quintilian *DMai.* 9.12; Juvenal 12.89.

patrius: Horace *Epod.* 16.19; Propertius 2.30a.22; Tibullus 1.10.15; Ovid *Rem. Am.* 237, 239; Quintilian *DMai.* 13.2; Seneca *Ag.* 392, 782; *Herc. Oet.* 359, 379–80, Lucan 1.278; Statius *Theb.* 12.327; *Martial* 5.42.2; Apuleius *Met.* 2.3, 11.26; Silius Italicus *Pun.* 9.81; Ps-Seneca *Oct.* 747.

paulus: Varro *LL* 5.92.

pauper: Horace *Od.* 3.29.14; Apuleius *Met.* 5.10.

perpetuus: Martial 10.61.5.

pius: Statius *Silv.* 4.8.23, 5.1.146.

privatus: Ovid *Ep. ex Pont.* 1.1.10; Pliny *Nat.* 21.11; Martial 9.43.12.

proprius: Horace *Sat.* 2.6.66; Valerius Maximus 7.7.3; Apuleius *Met.* 2.3.

publicus: Pliny *Nat.* 21.11.

raptus: Tibullus 2.5.20.

regius: Seneca *Phaed.* 863.

renidens: Horace *Epod.* 2.66.

rusticus: Iunius Silanus fr. 1.3; Columella *RR* 1.1.8.

secretus: Seneca *Herc. Fur.* 197.

securus: Statius *Theb.* 10.88.

socius: Lucan *BC* 8.113.

subcinctus: Persius 5.31.
tenuis: Propertius 4.1b.128.
trepidus: Juvenal 14.20.
urbanus: Columella *RR* 1.1.8.
vicinus: Martial 10.58.10.
victus: Seneca *Herc. Oet.* 100.

Appendix 2

LARES IN THE CALENDAR AT ROME

NB: On the farm, every *kalends, nones,* and *ides* is sacred to the lar(es) at the hearth in every home. Compitalia falls in late December or early January.

1ˢᵗ May: *Lares praestites,*

Augustan flower festival at the *compita* (?)

27ᵗʰ June: *Lares v(iales? vicinales?) lares* of roads or neighborhoods?

Augustan flower festival at the *compita* (?)

Temple of *lares in summa sacra via*, Temple of Jupiter Stator

7ᵗʰ July: Sacrifice at the altar of Consus in the Circus Maximus

1ˢᵗ August: Opening of the new year in the vici from 7 BC,

Vicomagistri enter office with a celebration

(*lustratio* and *suovetaurilia*?),

Augustan flower festival at the *compita* (?)

21ˢᵗ August: Sacrifice at the altar of Consus in the Circus Maximus

21ˢᵗ December: Sacrifice at the altar of Consus in the Circus Maximus, Divalia

22ⁿᵈ December: *Lares permarini* in the Campus Martius

23ʳᵈ December: Larentalia, Temple of the Sea Storms

Announcement of the date for Compitalia by the urban praetor at the winter solstice, on one of these December days.

For the festivals of *lares*, see Coarelli 2012, 183–84.

Appendix 3

AUGUSTAN TIME PATTERNS

12 (50): Augustus becomes *pontifex maximus* (6 Mar),
Vesta shrine on Palatine (28 Apr)

2 (60): Augustus named *pater patriae* (5 Feb),
dedicates temple of Mars Ultor and his new Forum
Augustum (12 May)

Augustus' absences from Rome: Return to the city after Actium in 30, extended
absences 27 to 24, 22 to 19, 16 to 13

AUGUST AND AUGUSTUS

1st Capture of Alexandria and suicide of Antony in 30

12th Suicide of Cleopatra in 30

13th–15th Triple triumph in 29

18th Dedication of Divus Julius temple and curia Julia in 29

19th First consulship in 43

28th Statue of Victory in curia in 29

AUGUSTAN TIME PATTERNS

Note: All dates are BC. Augustus' age appears in parentheses adjacent to the year, see section IV.xxxi.

29 (33)	19 (43)	9 (53)
Closing of doors of Janus temple (11 January).	Augustus receives consular power for life.	*ARA PACIS AUGUSTAE* (30 January).
Census, *augurium salutis*.	Augustus sits between the consuls: Census.	Games celebrate Augustus' return (in 13).
Arch in the Forum.	Parthian Arch in the Forum: *Fasti triumphales* inscribed.	Livy chose this year as the end of his history.
Triple Triumph (13–15 August).	Balbus is the last private person to triumph.	
Dedication of temple of divus Julius (18 August).	Augustus and Agrippa refuse to triumph.	
Dedication of Curia Julia (18 August).	Altar of Fortuna Redux vowed by senate; games.	
Dedication of altar of Victory (28 August).	Balbus is the last private person to dedicate a public building in Rome.	

28 (34)	18 (44)	8 (54)
Octavian and Agrippa, consuls; *lectio senatus*.	Augustus' *imperium* in his provinces is renewed.	Census.
Octavian becomes *princeps senatus*.	*Lectio senatus*.	*Ludi pro reditu*.
Abolition of illegal triumviral acts.	Moral and social legislation.	Calendar reform: new August month.
Eighty-two temples restored plus shrines outside the city	Agrippa's *imperium* is renewed, *tribunicia potestas*.	
First Actian Games (2 September).	New *lex annalis*?	
Dedication of temple of Apollo, Palatine (9 October).	Sibylline books moved to Apollo on the Palatine (or in 17 or in 8?).	
Mausoleum of Augustus begun.		
Many magisterial functions restored.		

27 (35)	17 (45)	7 (55)
Octavian becomes AUGUSTUS (13 and 16 January) and receives special insignia in the senate: oak wreath, shield with virtues, twin laurels.	*LUDI SAECULARES* (31 May–2 June).	Tiberius consul with Piso: Tiberius triumphs (1 January).
Augustus receives command in provinces.	Augustus adopts Gaius and Lucius (26 June?).	New era in the vici on 1 August; *LARES AUGUSTI* at the *compita*.
Leaves for Gaul and Spain (doors of Janus reopen).		Urban reform: fourteen *regiones*: *ludi pro reditu?*
		New flower festivals for *lares* in spring and summer.
		Agrippa's map, *Diribitorium*; memorial gladiatorial games for Agrippa.
		Livia's porticus and Concordia shrine.

BIBLIOGRAPHY

ABBREVIATIONS

Abbreviations of journal titles follow the conventions of *L'Année philologique*. Greek authors are abbreviated according to the conventions in H. G. Liddell, R. Scott, and H. S. Jones, *Greek-English Lexicon* (Oxford, 1968); Latin authors according to P.G.W. Glare, *Oxford Latin Dictionary* (Oxford, 1982).

AE *L'Année Epigraphique*

BNP *Brill's New Pauly: Encyclopaedia of the Ancient World: Antiquity*, 16 vols., Leiden, 2002–10

CAH² *The Cambridge Ancient History*, 2nd edition, 14 vols., Cambridge, 1970–2000

CIL *Corpus Inscriptionum Latinarum*, multiple vols., Berlin, 1893–

EDCS *Epigraphische Datenbank Clauss-Slaby*, http://db.edcs.eu/epigr/epibeleg.php?s_sprache=en

FRHist *The Fragments of the Roman Historians*, ed. T. Cornell, 3 vols., Oxford, 2013

IIS *Inscriptiones Italiae*, 13 vols., Rome, 1931–

ILLRP A. Degrassi, *Inscriptiones Latinae Liberae Rei Publicae*, 2 vols., Florence, 1957–63

ILS *H. Dessau, Inscriptiones Latinae Selectae², 5 vols., Berlin, 1954–55*

LIMC *Lexicon Iconographicum Mythologiae Classicae*, 11 vols., Zurich, 1981–2009

LTUR E. M. Steinby, *Lexicon Topographicum Urbis Romae*, 6 vols., Rome, 1993–2000

MRR T.R.S. Broughton, *Magistrates of the Roman Republic*, 3 vols., New York, 1951–86

OCD⁴ S. Hornblower, A. Spawforth, and Esther Eidinow, *The Oxford Classical Dictionary* 4th edition, Oxford, 2012

RE G. Wissowa, *Paulys Real-encyclopädie der classischen Altertumswissenschaft*, multiple vols., Stuttgart, 1894–

RRC M. Crawford, *Roman Republican Coinage*. 2 vols., Cambridge, 1974

Syll. W. Dittenberger, *Sylloge inscriptionum Graecarum*, 3rd ed., 4 vols., Leipzig, 1915–24

ThesCRA *Thesaurus cultus et rituum antiquorum*, 8 vols., Basel/Los Angeles, 2004–14

TLL *Thesaurus Linguae Latinae*, Berlin, 1894–

USEFUL WEBSITES

Associations in the Greco-Roman World: http://philipharland.com/
greco-roman-associations/

Complete photographic plan of Pompeii: http://pompeiiinpictures.com/
pompeiiinpictures/index.htm

Database of ancient coins: http://www.coinarchives.com/

Epigraphical database of Greek inscriptions: http://epigraphy.packhum.org/

Epigraphical database of Latin inscriptions: http://www.manfredclauss.de/

FastiOnline, database of archaeological excavations since 2000: http://www.fastionline.org

Stanford digital Severan marble plan of Rome: http://formaurbis.stanford.edu/

Stanford Geospatial Network Model of the Roman World: http://orbis.stanford.edu/

Via dell'Abbondanza in Pompeii: http://www.pompeiiperspectives.org

WORKS CITED

Aberson, M. 1994. *Temples votifs et butin de guerre dans la Rome republicaine.* Rome.

Accame, S. 1942. "La legislazione romana intorno ai collegi nel I sec. a. C." *BMIR* 13:
13–48.

Adamo-Muscettola, S. 1984. "Osservazioni sulla composizione dei larari con statuette in
bronzo di Pompei ed Ercolano." In *Toreutik und figurliche Bronzen römischer Zeit.* Ber-
lin. 9–32.

Adams, J. N. 2003. *Bilingualism and the Latin Language.* Cambridge.

Alföldi, A. 1971. *Der Vater des Vaterlandes im römischen Denken.* Darmstadt.

———. 1973. *Die zwei Lorbeerbäume des Augustus.* Bonn.

Alföldy, G. 1991. "Augustus und die Inschriften: Tradition und Innovation." *Gymnasium*
98: 289–324.

Alton, E. H., D.E.W. Wormell, and E. Courtney. 2005. *P. Ovidius Naso Fastorum libri sex.*
Munich.

Ameling, W. 1993. *Karthago. Studien zu Militär, Staat, und Gesellschaft.* Munich.

Amodio, G. 1996. "Sui uici e le circoscrizioni elettorali di Pompei." *Athenaeum* 85:
457–78.

Anderson, J. C. 1998. "The Ara Pacis Augustae: Legends, Facts and Flights of Fancy." In
*The Shapes of City Life in Rome and Pompeii: Essays in Honor of Lawrence Richardson
Jr. on the Occasion of His Retirement*, ed. M. T. Boatwright and H. B. Evans. New Rochelle,
NY. 27–51.

Andrews, M. M., and H. I. Flower, 2015. "Mercury on the Esquiline: A Reconsideration of
a Local Shrine Restored by Augustus." *AJA* 119.1: 1–21.

Anniboletti, L. 2007. "Testimonianze preromane del culto domestico a Pompeii: i com-
pita vicinalia sulla facciata di abitazioni." www.fastionline.org/docs/FOLDER-
it-2007-83.pdf.

———. 2008. "Aspetti del culto domestico di epoca tardo-sannitica: i sacelli sulle facciate
di abitazione pompeiane." In *Nuove ricerche archeologiche a Pompei ed Ercolano*, ed. P.
G. Guzzo and M. Guidobaldi. Studi della Soprintendenza Archeologica di Pompei 10.
Naples. 209–22.

———. 2010. "*Compita vicinalia* a Pompei: testimonianze del culto." *Vesuviana* 2: 77–138.

———. 2011. "*Compita vicinalia* di Pompei e Delo: testimonianze archeologiche del culto domestico di *theoi propylaioi.*" In *Religionem significare. Aspetti strutturali, iconografia e materiali si sacra privata*, ed. F. Ghedini and M Bassani. Padua. 57–78.

Antonini, R. 2004. "*Eituns* a Pompeii: un frammento di DNA Italico." In *Pompei, Capri, e la Peninsola Sorrentina*, ed. F. Senatore. Capri. 273–322.

———. 2007. "Contributi Pompeiani II–IV." *Quaderni di Studi Pompeiani* 1: 47–113.

Aretsinger, K. 1992. "Birthday Rituals: Friends and Patrons in Roman Poetry and Cult. *CA* 11.2: 175–93.

Astin, A. 1978. *Cato the Censor.* Oxford.

Aubert, J.-J. 1994. *Business Managers in Ancient Rome: A Social and Economic Study of Institores 200 BC–AD 250.* Leiden.

Auricchio, M. O. (ed.). 2001. *La casa di Giulio Polibio. Giornale di scavo.* Vol. 1. Tokyo.

Ausbüttel, F. M. 1982. *Untersuchungen zu den Vereinen im Westen des römischen Reiches.* Kallmünz.

Badian, E. 1962. "Waiting for Sulla." *JRS* 52: 47–61.

———. 1970. *Lucius Sulla: The Deadly Reformer.* Seventh Todd Memorial Lecture. Sydney.

———. 1972. "Tiberius Gracchus and the Beginning of the Roman Revolution." *ANRW* 1: 668–731.

———. 1989. "The *Scribae* of the Roman Republic." *Klio* 7: 582–603.

Bakker, J. T. 1994. *Living and Working with the Gods: Studies of Evidence for Private Religion and Its Material Environment in the City of Ostia (100–500 AD).* Amsterdam.

Baldassarre, I., A. Pontrandolfo, A. Rouveret, and M. Salvadori. 2002. *Pittura romana. Dall'ellenismo al tardo anitico.* Milan.

Ballu, A. 1902. *Théâtre et forum de Timgad, antique Thamugadi. État actuel et restauration.* Paris.

Bassani, M. 2008. *Sacraria. Ambienti e piccoli edifice per il culto domestico in area vesuviana.* Rome.

Baudy, D. 1998. *Römische Umgangsriten. Eine ethologische Untersuchung der Funktion von Wiederholung für religiöses Verhalten.* Berlin.

Barchiesi, A. 1984. *La traccia del modello: effetti omerici nella narrazione virgiliana.* Pisa.

Barrett, A. 2002. *Livia: The First Lady of Imperial Rome.* New Haven, CT.

Barton, T. 1995. "Augustus and Capricorn: Astrological Polyvalency and Imperial Rhetoric." *JRS* 85: 33–51.

Beard, M. 2007. *The Roman Triumph.* Cambridge, MA.

Beard, M., J. North, and S. Price. 1998. *Religions of Rome.* 2 vols. Cambridge.

Beck, H. 2005. *Karriere und Hierarchie. Die römische Aristokratie und die Anfänge des cursus honorum in der mittleren Republik.* Berlin.

Beck, H., and U. Walter. 2001–4. *Die frühen römischen Historiker.* 2 vols. Darmstadt.

Behr, H. 1993. *Die Selbstdarstellung Sullas. Ein aristokratischer Politiker zwischen persönlichem Führungsanspruch und Standessolidarität.* Frankfurt.

Behrwald, R. 2009. "Festkalender der frühen Kaiserzeit als Medien der Erinnerung." In *Feiern und Erinnern. Geschichtsbilder im Spiegel Antiker Feste*, ed. H. Beck and H.-U. Wiemer. Berlin. 141–66.

Belayche, N., and V. Pirenne-Delforge (eds.). 2015. *Fabriquer du divin: constructions et ajustements de la représentation des dieux dans l'antiquité.* Religions 5. Liège.

Bendala Galán, M. 1973. "Tablas de Juego in Italica." *Habis* 4: 263–72.

Bendlin, A. 2002. "Gemeinschaft, Öffentlichkeit und Identität: Forschungsgeschichtliche Anmerkungen zu den Mustern sozialer Ordnung in Rom." In *Religiöse Vereine in der Römischen Antike. Untersuchungen zu Organisation, Ritual und Raumordnung*, ed. U. Egelhaaf-Gaiser and A. Schäfer. Tübingen. 9–40.

Benner, H. 1987. *Die Politik des P. Clodius Pulcher. Untersuchungen zur Denaturierung des Clientelwesens in der ausgehenden römischen Republik.* Stuttgart.

Benoist, S. 1999. *La fête à Rome au premier siècle de l'empire. Recherches sur l'univers festif sous les règnes d'Auguste et des Julio-Claudiens.* Brussels.

Bergmann, B. 2010. *Der Kranz des Kaisers. Genese und Bedeutung der römischen Insignie.* Berlin.

Bernstein, F. 1998. *Ludi publici. Untersuchungen zur Entstehung und Entwicklung der öffentlichen Spiele im republikanischen Rom.* Stuttgart.

Berthold, R. M. 1984. *Rhodes in the Hellenistic Age.* Ithaca, NY.

Bettini, M. 1991. *Anthropology and Roman Culture: Kinship, Time, Images of the Soul.* Trans. J. Van Sickle. Baltimore, MD.

———. 2007. "*Lar familiaris*: un dio semplice." *Lares* 73.3: 533–51.

Bezerra de Meneses, U., and H. Sarian. 1973. "Nouvelles peintures liturgiques de Délos." *Études Déliennes, BCH* Suppl. 1: 77–109.

Binder, G. 1997. "Kommunikative Elemente im römischen Staatskult am Ende der Republik. Das Beispiel der Lupercalia des Jahres 44." In *Stätten und Formen der Kommunikation im Altertum VI. BAC* 26, ed. G. Binder and K. Ehlich. Trier. 225–41.

Bispham, E. 2007. *From Asculum to Actium: The Municipalization of Italy from the Social War to Augustus.* Oxford.

Blake, M. E. 1947. *Ancient Roman Construction in Italy from the Prehistoric Period to Augustus.* Washington, DC.

Bleckmann, B. 2002. *Die römische Nobilität im Ersten Punischen Krieg. Untersuchungen zur aristokratischen Konkurrenz in der Republik.* Berlin.

Bloch, H. 1962. "A Monument of the *Lares Augusti* in the Forum of Ostia." *Harvard Theological Review* 55.4: 211–23.

Boatwright, M. T. 1984–85. "Tacitus on Claudius and the Pomerium, *Annals* 12.23.2–34." *CJ* 80: 36–43.

———. 1987. *Hadrian and the City of Rome.* Princeton, NJ.

Bodel, J. 2008. "Cicero's Minerva, *Penates*, and the Mother of the *Lares*: An Outline of Roman Domestic Religion." In *Household and Family Religion in Antiquity*, ed. J. Bodel and S. M. Olyan. Malden, MA. 248–75.

Boëls-Janssen, N. 1993. *La vie religieuse des matrones dans la Rome archaïque.* Rome.

Boeswillwald, É., G. R. Cagnat, and A. Ballu. 1905. *Timgad, une cité africaine sous l'empire romain.* Paris.

Bömer, F. 1957–58. *P. Ovidius Naso: Die Fasten.* 2 vols. Heidelberg.

———. 1981. *Untersuchungen über die Religion der Sklaven in Griechenland und Rom.* Wiesbaden.

Bonfante, G., and L. Bonfante. 2002. *The Etruscan Language: An Introduction.* 2nd ed. Manchester.

Borbonus, D. 2014. *Columbarium Tombs and Collective Identity in Augustan Rome.* Cambridge.

Boscolo, F. 2013. "*Magistri* e *ministri* in un'iscrizione veronese dell' anno 1 a.C." *Epigrafica* 75: 439–47.

Bowersock, G. 1990. "The Pontificate of Augustus." In *Between Republic and Empire: Interpretations of Augustus and his Principate*, ed. K. Raaflaub and M. Toher. Berkeley, CA. 380–94.

Boyce, G. K. 1937. *Corpus of the Lararia of Pompeii. MAAR* 14. Rome.

———. 1940. "The Pompeian *Compita*." *AJA* 44: 113.

———. 1942. "The Significance of the Serpent." *AJA* 46: 14–22.

Bragantini, I., and V. Sampaolo. 2010. *Pittura pompeiana.* Naples.

Bradley, K. 2011. "Slavery in the Roman Republic." In *The Cambridge World History of Slavery: The Ancient Mediterranean World*, vol. 1, ed. K. Bradley and P. Cartledge. Cambridge. 214–64.

Brennan, T. C. 1995. "Notes on Praetors in Spain in the Mid-Second Century BC." *Emerita* 63: 47–76.

———. 2000. *The Praetorship in the Roman Republic.* 2 vols. Oxford.

Brennan, T. C., F. Perrone, and G. D. Farney. 2005. *Early Coinage of the Roman Republic, 280 to 91 B.C.E.* New Brunswick, NJ.

Breton, E. 1855. *Pompeia décrite et dessinée*. Paris.

Briquel, D. 1976. "L'oiseau ominal, la louve de Mars, la truie féconde." *MEFRA* 88.1: 31–50.

Briscoe, J. 1981. *A Commentary on Livy, Books 34–37*. Oxford.

———. 2008. *A Commentary on Livy, Books 38–40*. Oxford and New York.

Brocato, P. 2000. "Il deposito di fondazione." In *Roma 2000. Romolo, Remo e la fondazione della città, Catalogo della Mostra*, ed. A. Carandini and R. Cappelli. Milan. 280.

Bruneau, P. 1970. *Recherches sur les cultes de Délos à l'époque hellenistique et à l'époque impériale*. Paris.

———. 1975. "Deliaca." *BCH* 99: 292–93.

Bruneau, P., and J. Ducat. 2005. *Guide de Délos* 4th edition. Paris.

Brunet, M. 1999. "Le paysage agraire de Délos dans l'antiquité." *Journal des Savants*, 1–50.

Buchner, E. 1982. *Die Sonnenuhr des Augustus*. Mainz.

Bulard, M. 1926. *Description des revêtements peints à sujets religieux*. *EAD* 9. Paris.

Burkert, W. 1985. *Greek Religion*. Trans. J. Raffan. Cambridge, MA.

Burton, P. J. 2003. "*Clientela* or *Amicitia*: Modeling Roman International Behavior in the Middle Republic (246–146 B.C.)." *Klio* 85: 333–69.

Butterworth, R., and R. Laurence. 2005. *Pompeii: The Living City*. London.

Buxton, B. 2014. "A New Reading of the Belvedere Altar." *AJA* 118.1: 91–111.

Cadaro, M. 2015. "Le statuette in bronzo in contesto tra culti, ornamenta e pezzi da collezione." In *Piccoli grandi bronzi. Capolavori greci, eruschi e romani delle collezioni Mediceo-Lorenesi nel Museo Archeologico Nazionale di Firenze*, ed. B. Arbeid and M. Iozzo. Florence. 53–59.

Caillois, R. 1967. "Jeux et sport." *Encyclopèdie de la Pléiade XXIII*. Paris.

Camodeca, G. 1977. "L'ordinamento in *regiones* e *uici* di Puteoli." *Puteoli* 1: 62–98.

Campbell, B. 2000. *The Writings of the Roman Landsurveyors: Introduction, Text, and Commentary*. London.

Capdetrey, L., and C. Hasenohr, 2012. *Agoranomes et édiles: Institutions des marches antiques*. Scripta Antiqua 44. Bordeaux.

Capogrossi Colognesi, L. 2002. *Perstitenza e innovazione nelle strutture territoriali dell'Italia romana. L'ambiguità di una interpretazione storiografica e dei suoi modelli*. Naples.

Cappelli, R. 1984–85. "L'altare del Belvedere." *Ann. Fac. Lett. Fil. Perugia* 22: 89–101.

Carandini, A. 1988. *Schiavi in Italia: gli strumenti pensanti dei Romani fra tarda Repubblica e medio Impero*. Rome.

———. 1997. *La nascita di Roma: dei, lari, eroi e uomini all'alba di una civiltà*. Turin.

———. 2011. *Rome: Day One*. Princeton, NJ.

Carandini, A., and P. Carafa (eds.). 1995. *Palatium e Sacra Via, I. Prima delle mura, l'età delle mura e l'età case arcaiche*. Bollettino di Archeologia. Rome. 31–34.

Carandini, A., and E. Papi (eds.). 2005. *Palatium e Sacra Via, II. L'età tardo-repubblicana e la prima età imperiale (fine 3 sec. a. C.–64 d. C.)*. Bollettino di Archeologia. Rome. Vols. 59–60.

Carlsen, J. 1993. "The *Vilica* and Roman Estate Management." In *De Agricultura: In memoriam Pieter Willem de Neeve*, ed. H. Sancisi-Weerdenburg. Amsterdam. 197–205.

———. 1995. *Vilici and Roman Estate Managers until AD 284*. Rome.

Caruso, C. 2008. "La professione di cantante nel mondo romano. La terminologia specifica attraverso le fonti letterarie ed epigrafiche." In *Epigrafia 2006. Atti della XIVe Rencontre sur l'épigraphie in onore di S. Panciera con altri contribute di colleghi, allievi e collaboratori*, ed. M. L. Caldelli, G. L. Gregori, and S. Orlandi. Rome. 1407–30.

Castagnoli, F. 1974. "Topografia e urbanistica di Roma nel IV secolo a.C." *StRom* 22: 425–43.

Castrén, P. 1975. *Ordo Populusque Pompeianus*. Rome.

———. 2000. "*Vici* and *Insulae*: The Houses and Addresses of the Romans." *Arctos* 34: 7–21.

Cecamore, C. 2002. "Le Curiae Veteres sulla Forma Urbis Marmorea e il pomerio romuleo secondo Tacito." *MDAIR* 109: 43–58.

Chapoutier, F. 1935. *Les Dioscures au service d'une déesse. Étude d'iconographie religieuse.* Paris.

Charles-Laforge, M. O. 2011. "Le culte imperial à Pompéi. Demeures privées et autels compitaux." In *La norme religieuse dans l'antiquité*, ed. B. Cabouret and M. O. Charles-Laforge. Paris. 125–73.

Chassignet, M. 1996–2004. *L'annalistique romaine.* 3 vols. Paris.

Christ, K. 2002. *Sulla. Eine römische Karriere.* Munich.

Christenson, D. 2000. *Plautus Amphitruo.* Cambridge.

Ciarallo, A., and E. De Carolis (eds.). 2001. *La casa di Giulio Polibio: Studi interdisciplinari.* Vol. 2. Tokyo.

Cicirelli, C. 1995. *Vita religiosa nell'antica Pompei.* Naples.

———. 2000. "La Villa 1 di Terzigno, La villa 2 di Terzigno, La Villa 6 di Terzigno, i proprietari delle ville rustiche in epoca romana, il Tesoro della Villa 2 di Terzigno." In *Casali di ieri, casali di oggi. Architetture rurali e tecniche agricole nel territorio di Pompei e Stabile*, ed. P. G. Guzzo. Naples. 81.

———. 2003. "Terzigno. La villa 2. Il gruzzolo monetale dello scheletro III. La villa 6." In *Storie da un'eruzione Pompei, Ercolano, Oplontis*, ed. A. d'Ambrosio, P. G. Guzzo, and M. Mastroroberto. Milan. 214–21.

Claridge, A. 2010. *Rome: An Archaeological Guide* 2nd edition. Oxford.

Clark, A. 2007. *Divine Qualities: Cult and Community in Republican Rome.* Oxford.

Classen, C. J. 1963. "Gottmenschentum in der römischen Republik." *Gymnasium* 70: 312–38.

Coarelli, F. 1977. "Public Building in Rome between the Second Punic War and Sulla." *PBSR* 45: 1–23.

———. 1983. *Il Foro Romano I: Periodo arcaico.* Rome.

———. 1988. *Il Foro Boario dalle origini alla fine della repubblica.* Rome.

———. (ed.) 1989. *Minturnae.* Rome.

———. 1991. "Un monumento onorario dei Domizi dal Campidoglio." *Epigrafia* 143: 209–23.

———. 1993. "Clivus Salutis." In *Lexicon Topographicum Urbis Romae*, vol. 1, ed. E. M. Steinby, 285–86. Rome.

———. 1995. "Vici di Ariminum." *Caesarodunum* 29: 175–80.

———. 1996. "Mefitis, Aedes, Lucus." In *Lexicon Topographicum Urbis Romae*, vol. 3, ed. E. M. Steinby, 239–40. Rome.

———. 1997. *Il Campo Marzio: dalle origini alla fine della Repubblica.* Rome.

———. 1998. "The Odyssey Frescos of the via Graziosa: A Proposed Context." *PBSR* 66: 21–37.

———. 2000. "Gli spazi della vita sociale." In *Roma imperiale. Una metropolis antica*, ed. E. Lo Cascio. Rome. 221–47.

———. 2003. "Remoria." In *Myth, History, and Culture in Republican Rome: Studies in Honour of T. P. Wiseman*, ed. D. Braund and C. Gill. Exeter. 41–55.

———. 2004. "Il teatro di Minturnae e i *magistri collegiorum* repubblicani." In *Hommages à M. Clavel-Lévêque*, vol. 3, ed. M. Garrido-Hory and A. Gonzalès. Besançon. 215–21.

———. 2008. *Rome and Environs: An Archaeological Guide.* Berkeley, CA.

———. 2012. *Palatium. Il Palatino dalle origini all'impero.* Rome.

Coarelli, F., and G. Sauron. 1978. "La tête Petini. Contribution à l'approche méthodologique du néo-atticisme." *MEFRA* 90: 705–51.

Cole, S. G. 1984. *Theoi Megaloi: The Cult of the Great Gods at Samothrace.* Leiden.

———. 1989. "The Mysteries of Samothrace during the Roman Period." *ANRW* 2.18.2: 1565–98.

Colini, A. M. 1961–62. "Compitum Acili." *BullCom* 78: 147–57.

Combet-Farnoux, B. 1980. *Mercure romain. Le culte public de Mercure et la function mercantile à Rome de la république archaïque à l'époque augusteenne.* Rome.

Conlin, D. A. 1997. *The Artists of the Ara Pacis: The Process of Hellenization in Roman Relief Sculpture.* Chapel Hill, NC.

Conte, G. 1994. *Latin Literature: a History.* Baltimore, MD.

Cool, H.E.M., and D. G. Griffiths. 2015. "The Miniature Vessels of Insula VI.1 Pompeii: New Evidence for Neighborhood Cults." www.fastionline.org/docs/FOLDER-it-2015-325.pdf.

Cooley, A. 2009. *Res Gestae Divi Augusti: Text, Translation, and Commentary.* Cambridge.

Cooley, A., and M.G.L. Cooley. 2004. *Pompeii: A Sourcebook.* London and New York.

Cornell, T. J. 1975. "Aeneas and the Twins: The Development of the Roman Foundation Legend." *PCPS* 21: 1–32.

———. 1995. *The Beginnings of Rome: Italy and Rome from the Bronze Age to the Punic Wars (c. 1000–264 B.C.).* London.

Corswandt, I. 1982. *Oscilla. Untersuchung zu einer römischen Reliefgattung.* Berlin.

Coudry, M., and M. Humm (eds.). 2009. *Praeda: butin de guerre et société dans la Rome républicaine = Kriegsbeute und Gesellschaft im republikanischen Rom.* Stuttgart.

Couillond-Le Dinahet, M.-T. 1991. "Autels monoliths et monolithoides de Delos. In *L'Espace sacrificiel dans les civilisations méditerranénnes de l'antiquité,* ed. R. Étienne and M.-T. Le Dinahet. Paris. 109–20.

Courtney, E. 1999. *Archaic Latin Prose.* Atlanta, GA.

Crawford, M. H. 1968. "The Edict of M. Marius Gratidianus." *PCPS* 14: 1–4.

———. 1974. *Roman Republican Coinage.* 2 vols. Cambridge.

Crook, J. A. 1996. "Augustus: Power, Authority, Achievement." In *The Cambridge Ancient History 2nd Edition, Vol. 10: The Augustan Empire, 43 B.C.–A.D. 69,* ed. A. K. Bowman, E. Champlin, and A. Lintott. Cambridge. 113–46.

Culham, P. 1982. "The Lex Oppia." *Latomus* 41: 786–93.

Cumont, F. 1949. *Lux Perpetua.* Paris.

Cupito, C. 2004. "Il culto dei lari nel lotto regio: i focolari." *Workshop di archaeologia classica* 1: 123–34.

Daguet-Gagey, A. 2015. *Splendor aedilitatum: L'édilité à Rome (Ier s. av. J.-C.–IIIe s. après J.-C.).* Rome.

Dalby, A. 1998. *Cato. On Farming. De Agricultura: A Modern Translation with Commentary.* Blackawton, UK.

D'Alessio, A. 2006. "Il santuario della Magna Mater dalla fondazione all'éta imperiale: sviluppo architettonico, funzione e paesaggio urbano." *Scienze dell'Antichità* 13: 429–54.

D'Alessio, M. T. 2009. *I culti a Pompei. Divinità, luoghi e frequentatori (VI sec. a. C.–79 d. C.).* Rome.

D'Ambra, E. 2014. "Beauty and the Roman Female Portrait." In *Art and Rhetoric in Roman Culture,* ed. J. Elsner and M. Meyer. Cambridge. 155–80.

Damon, C. 1992. "Sextus Cloelius, *scriba.*" *HSCP* 94: 227–50.

Dardenay, A. 2012. *Images des fondateurs d'Énée à Romulus.* Paris.

Dart, C. J., and F. J. Vervaet. 2011. "The Significance of the Naval Triumph in Roman History (260–29 BCE)." *ZPE* 176: 267–80.

Dasen, V. 2005. *Jumeaux, jumelles dans l'antiquité grecque et romaine.* Kilchberg.

De Angeli, S. 2001. "L'annua *stips* e i *pretiosissima deorum simulacra* di Augusto. Un caso di rinnovo dei luoghi e delle immagini di culto a Roma in età augustea." *Daidalos* 3: 185–208.

De Caro, S., and C. Gialanella. 2002. *Il Rione Terra di Pozzuoli.* Naples.

Degrassi, A. 1963. *Inscriptiones latinae liberae rei publicae.* Florence.

———. 1965. *Inscriptiones latinae liberae rei publicae: imagines (CIL, Auctarium).* Berlin.

della Casa, A. 1962. *Nigidio Figulo.* Rome.

della Corte, M. 1965. *Case ed abitanti di Pompei.* Napoli.

Dench, E. 2005. *Romulus' Asylum: Roman Identities from the Age of Alexander to the Age of Hadrian.* Oxford.

De Sanctis, G. 2007. "Lari." *Lares* 73.3: 477–527.

Dettenhofer, M. 2000. *Herrschaft und Widerstand im augusteischen Principat: die Konkurrenz zwischen res publica und domus Augusta*. Stuttgart.

Diosono, F. 2007. *Collegia: le associazioni professionali nel mondo romano*. Rome.

Dobbins, J. J., and P. Foss (eds.). 2007. *The World of Pompeii*. London.

Dolansky, Fanny. 2011. "Celebrating the *Saturnalia*: Religious Ritual and Roman Domestic Life." In *A Companion to Families in the Greek and Roman Worlds*, ed. B. Rawson. Malden, MA. 488–503.

Donati, N., and P. Stefanetti. 2006. *Dies natalis. I calendari romani e gli anniversari dei culti*. Rome.

Dondin-Payre, M. 1987. "Topographie et propagande gentilice: le *compitum Acilium* et l'origine des Acilii Glabriones." In *L'urbs: espace urbain et histoire (Ier s. ap. J.C.). Actes du colloque international organisé par la Centre national de la recherche scientifique et l'École française de Rome (Rome, 8–12 mai 1985)*. Rome. 87–109.

———. 1993. *Exercice du pouvoir et continuité gentilice: les Acilii Glabriones du IIIe siècle av. J.-C. au Ve siècle ap. J.-C.* Rome.

Dondin-Payre, M., and N. Tran (eds.). 2012. *Collegia: Le phénomène associative dans l'Occident romain*. Bordeaux.

Dubouloz, J. 2011. *La propriété immobilière à Rome et en Italie (Ier–Ve siècles): organisation et transmission des praedia urbana*. Rome.

Dubourdieu, A. 1989. *Les origins et le développement du culte des Pénates à Rome*. Rome.

Dubourdieu, A., and E. Lemirre. 1997. "La rumeur dans l'affaire des Bacchanales." *Latomus* 56: 293–306.

Ducos, M. 1995. "Le tombeau: *locus religiosus*." In *La mort au quotidien dans le monde romain: actes du colloque organisé par l'Université de Paris–IV (Paris–Sorbonne 7–9 octobre 1993)*, ed. F. Hinard. Paris. 135–44.

Dumser, E. A. 2013. "The Urban Topography of Rome." In *The Cambridge Companion to Ancient Rome*, ed. P. Erdkamp. Cambridge. 131–50.

Eckert, A. 2016. *Lucius Cornelius Sulla in der antiken Erinnerung. Jener Mörder, der sich Felix nannte*. Berlin.

Eckstein, A. M. 2012. *Rome Enters the Greek East: From Anarchy to Hierarchy in the Hellenistic Mediterranean, 230–170 BC*. Malden, MA, and Oxford.

Eder, W. 2005. "Augustus and the Power of Tradition." In *The Cambridge Companion to the Age of Augustus*, ed. G. K. Galinsky. Cambridge and New York. 13–32.

Edlund-Berry, I.E.M. 2006. "Ritual Space and Boundaries in Etruscan Religion." In *The Religion of the Etruscans*, ed. N. T. De Grummond and E. Simon. Austin, TX. 116–31.

Elliott, J. 2013. *Ennius and the Architecture of the* Annales. Cambridge.

Engels, D. 2007. *Das römische Vorzeichenwesen (753–27 v.Chr.): Quellen, Terminologie, Kommentar, historische Entwicklung*. Stuttgart.

Elsner, J. 1991. "Cult and Sculpture: Sacrifice in the Ara Pacis Augustae." *JRS* 81: 50–61.

Erdkamp, P. (ed.). 2013. *The Cambridge Companion to Ancient Rome*. Cambridge.

Erkell, H. 1952. *Augustus, Felicitas, Fortuna. Lateinische Wortstudien*. Göteborg.

Étienne, R. 2002. "Introduction." In *Les Italiens dans le monde grec*, ed. C. Müller and C. Hasenohr. *BCH* Suppl. 41. Paris. 1–8.

Evans, J. D. (ed.). 2013. *A Companion to the Archaeology of the Roman Republic*. Chichester, UK.

Fantham, E. 2004. *The Roman World of Cicero's De Oratore*. Oxford and New York.

Fasce, S. 1984. "I tre assi della sposa." *Studi Noniani* 9: 97–110.

Favro, D. 1996. *The Urban Image of Augustan Rome*. Cambridge.

———. 2005. "Making Rome a World City. " In *The Cambridge Companion to the Age of Augustus*, ed. G. K. Galinsky. Cambridge and New York. 234–63.

Fears, J. R. 1981. "The Cult of the Virtues and Roman Imperial Ideology." *ANRW* 2.17.2: 827–948.

Feeney, D. 1992. "*Si licet et fas est*: Ovid's *Fasti* and the Problem of Free Speech under the Principate." In *Roman Poetry and Propaganda in the Age of Augustus*, ed. A. Powell. London. 1–25.

———. 2007. *Caesar's Calendar: Ancient Time and the Beginnings of History*. Berkeley, CA.

Ferrary, J.-L., C. Hasenohr, and M.-T. Le Dinahet, 2002. "Liste des Italiens de Délos." In *Les Italiens dans le monde grec*, ed. C. Müller and C. Hasenohr. *BCH* Suppl. 41. Paris. 183–239.

Ferri, G. 2010. *Tutela urbis: il significato e la concezione della divinità tutelare cittadina nella religione romana*. Stuttgart.

Feyel, C. 2006. *Les artisans dans les sanctuaires grecs aux époques classique et hellénistique à travers la documentation financière en Grèce*. Paris.

Fezzi, L. 1999. "La legislazione tribunizia di Publio Clodio Pulchro (58 a. J. C.) e la ricerca del consensus a Roma." *SCO* 47: 245–341.

Filippi, D. 2004. "Ricerche e scavi in corso sulle pendici settentrionali del Palatino." www.fastionline.org/docs/FOLDER-it-2004-20.pdf.

———. 2010. "La topografia." In *Il santuario di Vesta. La casa delle Vestale e il tempio di Vesta, VIII sec. AC–64 DC. Rapporto preliminare*, ed. N. Aravantis. Pisa. 19–25.

Fisher, J. 2014. *The Annals of Quintus Ennius and the Italic Tradition*. Baltimore, MD.

Fishwick, D. 1987. *The Imperial Cult in the Latin West. Studies in the Ruler Cult of the Western Provinces of the Roman Empire*. 3 vols. Leiden.

———. 2010. "Agrippa and the *Ara Providentiae*." *ZPE* 174: 251–58.

Fittà, M. 1997. *Giochi e giocattoli nell'antichità*. Milan.

Flach, D. 2005. *Marcus Porcius Cato: über den Ackerbau*. Stuttgart.

Flambard, J.-M. 1977. "Clodius, les collèges, la plèbe et les esclaves." *MEFRA* 89: 115–56.

———. 1981. "*Collegia compitalicia*: phénoméne associatif, cadres territoriaux et cadres civiques dans le monde romain à l'époque républicaine." *Ktema* 6: 143–66.

———. 1983. "Observations sur la nature des magistri italiens de Délos." In *Delo e l'Italia*, ed. F. Coarelli, D. Musti, and H. Solin. *Opuscula Instituti Finlandiae* 2. Rome. 67–77.

Fless, F. 1995. *Opferdiener und Kultmusiker auf stadtrömischen historischen Reliefs. Untersuchungen zur Ikonographie, Funktion und Benennung*. Mainz.

Flohr, M. 2013. *The World of the Fullo: Work, Economy, and Society in Roman Italy*. Oxford.

Flory, M. B. 1984. "*Sic exempla parantur*: Livia's Shrine to *Concordia* and the Porticus Liviae." *Historia* 33: 309–30.

Flower, H. I. 1996. *Ancestor Masks and Aristocratic Power in Roman Culture*. Oxford.

———. 2000. "The Tradition of the *Spolia Opima*: M. Claudius Marcellus and Augustus." *ClAnt* 19.1: 34–64.

———. 2002. "Rereading the *Senatus Consultum de Bacchanalibus* of 186 BC: Gender Roles in the Roman Middle Republic." In *Oikistes: Essays in Honor of A. J. Graham*, ed. V. B. Gorman and E. W. Robinson. Leiden. 79–98.

———. 2006. *The Art of Forgetting: Disgrace and Oblivion in Roman Political Culture*. Chapel Hill, NC.

———. 2008. "Remembering and Forgetting Temple Destruction: The Destruction of the Temple of Jupiter Optimus Maximus in 83 BC." In *Antiquity in Antiquity: Jewish and Christian Pasts in the Greco-Roman World*, ed. G. Gardner and K. L. Osterloh. Texts and Studies in Ancient Judaism, Mohr-Siebeck Verlag 123. Tübingen. 74–92.

———. 2010. *Roman Republics*. Princeton, NJ.

———. 2012. "Beyond the *Contio*: Political Communication in the Tribunate of Tiberius Gracchus." In *Community and Communication: Oratory and Politics in Republican Rome*, ed. C. Steel and H. van der Blom. Oxford. 85–100.

Fontana, F. 1997. *I culti di Aquileia repubblicana: aspetti della politica religiosa in Gallia Cisaplina tra il III e il II sec. a. c.* Rome.

Fornara, C. W. 1983. *The Nature of History in Ancient Greece and Rome*. Berkeley, CA.

Forsythe, G. 1990. "Some Notes on the History of Cassius Hemina." *Phoenix* 44: 326–44.

Forsythe, G. 2005. *A Critical History of Early Rome: From Early Times to the First Punic War.* Berkeley, CA.

Foss, P. W. 1997. "Watchful *Lares*: Roman Household Organization and the Rituals of Cooking and Eating." In *Domestic Space in the Roman World: Pompeii and Beyond,* ed. R. Laurence and A. Wallace-Hadrill. Portsmouth, RI. 197–218.

Foti, G. 2011. "Funzioni e caratteri del *pullarius* in età repubblicana e imperiale." *Acme* 64: 89–121.

Fraschetti, A. 2005. *Roma e il Principe* 2ⁿᵈ editon. Rome/Bari.

Fredericksen, M. W. 1959. "Republican Capua. A Social and Economic Study." *PBSR* 27: 80–113.

———. 1984. *Campania.* London.

Fridh, Å. 1990. "*Sacellum, Sacrarium, Fanum,* and Related Terms." In *Greek and Latin Studies in Memory of C. Fabricius,* ed. S.-T. Teodorsson. Göteborg. 173–87.

Friggeri, R. 2001. *The Epigraphic Collection of the Museo Nazionale Romano at the Baths of Diocletian.* Trans. E. De Sena. Rome.

Friggeri, R., M. G. Granino Cercere, and G. L. Gregori. 2012. *Terme di Diocleziano: la collezione epigrafica.* Milan.

Fröhlich, T. 1991. *Lararien- und Fassadenbilder in den Vesuvstädten. Untersuchungen zur "volkstümlichen" pompejanischen Malerei.* Mainz.

Gabba, E. 1967. *Appianus: Bellorum civilium liber primus* 2ⁿᵈ editon. Florence.

———. 1991. *Dionysius and the History of Archaic Rome.* Berkeley, CA.

———. 2000. *Roma arcaica: storia e storiografia.* Rome.

Galinsky, K. 1992. "Venus, Polysemy, and the Ara Pacis Augustae." *AJA* 96: 457–75.

———. 1996. *Augustan Culture.* Princeton, NJ.

———. 2005. *The Cambridge Companion to the Age of Augustus.* Cambridge.

———. 2012. *Augustus: Introduction to the Life of an Emperor.* New York and Cambridge.

———. 2015. "*Auctoritas* and *Res Gestae* 34.3." *Hermes* 143: 244–49.

Ganzert, J. 1984. *Das Kenotaph für Gaius Caesar in Limyra.* Tübingen.

Gargola, D. J. 1995. *Lands, Laws, and Gods. Magistrates and Ceremony in the Regulation of Public Lands in Republican Rome.* Chapel Hill, NC.

Garnsey, P., and D. Rathbone. 1985. "The Background to the Grain Law of Gaius Gracchus." *JRS* 75: 20–25.

Gaspari, C., and R. Paris (eds.). 2013. *Palazzo Massimo alle Terme: le collezioni.* Milan.

Gatti, G. 1888. "Di un sacello compitale dell'antichissima regione esquilina." *BullCom* 16: 221–39.

———. 1906. "L'era dei vico-magistri." *BullCom* 34: 198–208.

Gauthier, P. 1974. "'Générosité' romaine et 'avarice' grecque: sur l'octroi du droit de cite." In *Mélanges d'histoire ancienne offerts à William Seston.* Paris. 207–15.

Gesemann, B. 1996. *Die Strassen der antiken Stadt Pompeji: Entwicklung und Gestaltung.* Vienna.

Giacobello, F. 2008. *Larari pompeiani. Iconogafia e culto dei Lari in ambito domestico.* Milan.

Giannelli, G. 1996. "Iuno Lucina, Aedes." In *Lexicon Topographicum Urbis Romae,* vol. 3, ed. E. M. Steinby. Rome. 122–23.

Gildenhard, I. 2003. "The 'Annalist' before the Annalists: Ennius and His *Annales.*" In *Formen römischer Geschichtsschreibung von den Anfängen bis Livius: Gattungen, Autoren, Kontexte,* eds. U. Eigler, U. Gotter, N. Luraghi, U. Walter. Darmstadt. 93–114.

Giordano, C. 1974. "Iscrizione graffite e dipinte nella Casa di C. Giulio Polibio." *Rend. Acc. Napoli* 49: 21–28.

Giovagnoli, M. 2014. "Ancora sulla *societas cantorum Graecorum* (*CIL* I² 2519)." *Rivista di Filologia* 142.1: 91–102.

Glinister, F., and C. Woods (eds.), with J. A. North and M. H. Crawford. 2007. *Verrius, Festus, and Paul: Lexicography, Scholarship, and Society.* London.

Goldberg, S. M. 1995. *Epic in Republican Rome.* Oxford.

————. 1998. "Plautus on the Palatine." *JRS* 88: 1–20.

Goldschmidt, N. 2013. *Shaggy Crowns: Ennius' Annales and Virgil's Aeneid*. Oxford.

Gonzalez, J. "Tacitus, Germanicus, Piso and the *Tabula Siarensis*." *AJP* 120.1: 123–42.

Gordon, A. 1958. *Album of Dated Latin Inscriptions*. 4 vols. Berkeley, CA.

————. 1983. *An Illustrated Introduction to Latin Epigraphy*. Berkeley, CA.

Gordon, R. L. 1990. "The Veil of Power: Emperors, Sacrificers, and Benefactors." In *Pagan Priests: Religion and Power in the Ancient World*, ed. M. Beard and J. North. London. 201–55.

Gorski, G. J., and J. E. Packer, 2015. *The Roman Forum: A Reconstruction and Architectural Guide*. Cambridge.

Gotter, U. 1996. *Der Diktator ist tot! Politik in Rom zwischen den Iden des März und der Begründung des Zweiten Triumvirats*. Stuttgart.

Gouillart, C. 1986. *Tite-Live, Histoire Romaine, Tome XXX: Livre XL*. Paris.

Goujard, R. 2002. *Caton: de Agricultura* 2nd editon. Paris.

Gourevitch, D., and M.-T. Raepsaet-Charlier. 2001. *La femme dans la Rome antique*. Paris.

Gradel, I. 2002. *Emperor Worship and Roman Religion*. Oxford.

Graf, F. 1997. *Der Lauf des rollenden Jahres. Zeit und Kalender in Rom*. Stuttgart.

————. 1998. "*Kalendae Ianuariae*." In *Ansichten griechischer Rituale. Geburtstags-Symposium für Walter Burkert*, ed. F. Graf. Stuttgart. 199–216.

Grandazzi, A. 1997. *The Foundation of Rome: Myth and History*. Ithaca, NY.

Greene, J. A., and D. P. Kehoe. 1995. "Mago the Carthaginian." In *Actes du IIIe congrès international des études phéniciennes et puniques*, vol. 2, ed. M. Fantar and M. Ghaki. Tunis. 110–17.

Greenidge, A.H.J., and A. M. Clay. 1960. *Sources for Roman History 133–70 BC*. 2nd ed. Oxford.

Gregori, G.-L. (ed.). 2001. *La collezione epigrafica dell'antiquarium del Celio*. Rome.

Gregori, G.-L., and M. Mattei, 1999. *I Musei Capitolini*. Rome.

Gros, P. 1976. *Aurea Templa: Recherches sur l'architecture religieuse de Rome à l'époque d'Auguste*. Rome.

————. 1995. "*Fortuna Huiusce Diei, aedes*." In *Lexicon Topographicum Urbis Romae*, vol. 2, ed. E. M. Steinby. Rome. 269–70,

————. 1996. "Le palais hellénistique et l'architecture augustéenne: l'exemple du complexe du Palatin." In *Basileia: die Paläste der hellenistischen Könige. Internationales Symposion in Berlin vom 16.12.1992 bis 20.12.1992*, ed. W. Hoepfner and G. Brands. Mainz. 234–39.

Gros, P., and G. Sauron. 1988. "Das politische Programm der öffentlichen Bauten." In *Antikenmuseum Berlin: Kaiser Augustus und die verlorene Republik*. Berlin. 48–68.

Gruen, E. S. 1974. *The Last Generation of the Roman Republic*. Berkeley, CA.

————. 1984. *The Hellenistic World and the Coming of Rome*. Berkeley, CA.

————. 1990. *Studies in Greek Culture and Roman Policy*. Leiden.

————. 1996. "The Bacchanalian Affair." In *Studies in Greek Culture and Roman Policy*. Berkeley, CA. 34–78.

————. 2005. "Augustus and the Making of the Principate." In *The Cambridge Companion to the Age of Augustus*, ed. G. K. Galinsky. Cambridge and New York. 33–51.

Guarducci, M. 1956–58. "Cippo latino arcaico con dedica ad Enea." *BullComm* 76: 3–13.

Guidobaldi, M. P., and F. Pesando. 1989. "*Note di prosopografia minturnense.*" In *Minturnae*, ed. F. Coarelli. Rome. 61–63, 71–73.

Guillaume-Coirer, G. 1999. "L'*ars coronaria* dans la Rome antique." *RA* 2: 331–70.

Gurval, R. 1995. *Actium and Augustus: The Politics and Emotions of Civil War*. Ann Arbor, MI.

Guzzo, P. G. (ed.). 2003. *Tales from an Eruption: Pompeii, Herculaneum, Oplontis: Guide to the Exhibition*. Milan.

Habicht, C. 1991. "Zu den Epimeleten von Delos 167–88." *Hermes* 119: 195–216.

————. 2006. "Epigraphic Evidence for the History of Thessaly." In *The Hellenistic Monarchies*, 59–73. Ann Arbor, MI.

Hänlein-Schäfer, H. 1996. "Die Ikonographie des *Genius* Augusti im Kompital- und Hauskult der frühen Kaiserzeit." In *Subject and Ruler: The Cult of the Ruling Power in Classical Antiquity*, ed. A. Small. *JRA* Suppl. 17. Portsmouth, RI. 73–98.

Hannick, J.-M. 1968. "Remarques sur les lettres de Philippe V de Macédoine à la cite de Larissa (*IG* X 2.517)." In *Antidorum: W. Peremans sexagenario ab alumnis oblatum*. Louvain. 97–104.

Hano, M. 1986. "À l'origine du culte imperial: les autels des *Lares Augusti*. Recherches sur les themes iconographiques et leur signification." *ANRW* 2.16.3: 2333–81.

Harmon, D. P. 1978. "The Family Festivals of Rome." *ANRW* 2.16.2: 1592–1603.

Harrison, I. 2010. "Catiline, Clodius and Popular Politics at Rome during the 60s and 50s BCE." *BICS* 51: 95–118.

Haselberger, L. 2002. *Mapping Augustan Rome. JRA* Suppl. 50. Portsmouth, RI.

———. 2007. *Urbem adornare: die Stadt Rom und ihre Gestaltumwandlung unter Augustus = Rome's Urban Metamorphosis under Augustus. JRA* Suppl. 64. Portsmouth, RI.

Hasenohr, C. 2001. "Les monuments des colleges italiens sur l'agora des Compétaliastes à Délos (2e–1er siècle av. J.-C.)." In *Constructions publiques et programmes édilitaires en Grèce entre le IIe siècle av. J.-C. et le Ie siècle ap. J.-C.*, ed. J.-Y. Marc and J.-C. Moretti. *BCH* Suppl. 39. Paris. 329–48.

———. 2002a. "L'Agora des Compétaliastes et ses abords à Délos: topographie et histoire d'un secteur occupé de l'époque archaique aux temps byzantins." *REA* 104: 85–110.

———. 2002b. "Les collèges de *magistri* et la communauté italienne de Délos." In *Les italiens dans le monde grec, IIe siècle av. J.-C.–Ie ap. J.-C.: circulation, activités, integration*, ed. C. Müller and C. Hasenohr. *BCH* Suppl. 41. Paris. 67–76.

———. 2003. "Les *Compitalia* à Delos." *BCH* 127: 167–249.

———. 2007a. "Les italiens à Délos; entre romanité et hellénisme." *Pallas* 73: 221–32.

———. 2007b. "Italiens et phéniciens à Délos: organization et relations de deux groups d'étrangers residents (IIe–Ie siècles av. J.-C)." In *Étrangers dans la cité romaine*, ed. R. Compatangelo-Soussignan and Ch.-G. Schwentzel. Rennes. 77–90.

———. 2008. "Délos: L'Agora des Competaliastes." *BCH* 132: 817–22.

Hasenohr, C., and C. Müller. 2002. "Gentilices et circulation des Italiens: quelques réflexions méthologiques." In *Les italiens dans le monde grec: IIe siècle av. J.-C.–Ier siècle ap. J.-C.: circulation, activités, intégration*, ed. C. Müller and C. Hasenohr. Paris. 11–20.

Helbig, W. 1868. *Wandgemälde der vom Vesuv verschütteten Städte Campaniens*. Leipzig.

Hermann, W. 1961. *Römische Götteraltare*. Kallmünz.

Hermann-Otto, E. 2013. "Slaves and Freedmen." In *The Cambridge Companion to Ancient Rome*, ed. P. Erdkamp. Cambridge. 60–76.

Hersch, K. K. 2010. *The Roman Wedding: Ritual and Meaning in Antiquity*. Cambridge.

Hin, S. 2008. "Counting Romans." In *People, Land and Politics: Demographic Developments and the Transformation of Roman Italy, 300 BC–AD 14*, ed. L. de Ligt and S. Northwood. Leiden. 171–222.

Hinard, F. 1984. "La male mort. Exécutions et statut du corps au moment de la première proscription." In *Actes du colloque "Du châtiment dans la cité."* Rome. 295–311.

Hölkeskamp, K.-J. 2000. "Lucius Cornelius Sulla—Revolutionär und restaurativer Reformer." In *Von Romulus zu Augustus. Große Gestalten der römischen Republik*, ed. K.-J. Hölkeskamp and E. Stein-Hölkeskamp. Munich. 199–218.

Holleran, C. 2012. *Shopping in Ancient Rome: The Retail Trade in the Late Republic and the Principate*. Oxford.

Holliday, P. J. 1990. "Time, History, and Ritual on the Ara Pacis Augustae." *Art Bulletin* 62: 542–57.

———. 2002. *The Origins of Roman Historical Commemoration in the Visual Arts*. Cambridge and New York.

Hölscher, T. 1988. "Historische Reliefs." In *Kaiser Augustus und die verlorene Republik. Eine Ausstellung im Martin-Gropius-Bau, Berlin, 7 Juni–14 August 1988*. Mainz. 351–400.

————. 1994. *Monumenti statali e pubblico*. Rome.

Huet, V., and S. Wyler. 2015. "Associations de dieux en images dans les laraires de Pompéi." In *Figures de dieux. Construire le divin en images*, ed. S. Estienne, V. Huet, F. Lissarrague, and F. Prost. Rennes. 195–221.

Hülsen, C. 1906. *The Roman Forum, Its History and Monuments*, trans. from the third German ed. by Jesse Benedict Carter. Rome.

Itgenshorst, T. 2004. "Augustus und der republikanische Triumph." *Hermes* 132: 436–57.

————. 2005. *Tota illa pompa. Der Triumph in der römischen Republik*. Göttingen.

Jackson, M., D. Deocampo, F. Marra, and B. Scheetz. 2010. "Mid-Pleistocene Volcanic Ash in Ancient Roman Concretes." *Geoarchaeology* 25: 36–74.

Jackson, M., and F. Marra. 2006. "Roman Stone Masonry: Volcanic Foundations of the Ancient City." *AJA* 110: 403–36.

Jashemski, W. 1979. *The Gardens of Pompeii, Herculaneum and the Villas Destroyed by Vesuvius*. Vol. 1. New Rochelle, NY.

Jenkyns, R. 2013. *God, Space, and City in the Roman Imagination*. Oxford.

Johansson, L. 2010. "The Roman Wedding and the Household Gods. The *Genius* and the *Lares* and Their Different Roles in the Rituals of Marriage." In *Ancient Marriage in Myth and Reality*, ed. L. Larsson Lovén and A. Strömberg. Newcastle upon Tyne, UK. 136–49.

Johnson, J. 1933. *Excavations at Minturnae. Volume II Inscriptions: Republican Magistri*. Philadelphia.

Johnston, 1991. "Crossroads." *ZPE* 86: 217–24.

Jordan, H. 1862. "De Larum imaginibus atque cultu." *AdI* 34: 300–339.

Kahn, C. H. 2001. *Pythagoras and the Pythagoreans: A Brief History*. Indianapolis.

Kajava, M. 1994. *Roman Female Praenomina: Studies in the Nomenclature of Roman Women*. Rome.

————. 1998. "Visceratio." *Arctos* 32: 109–31.

Kastenmeier, P. 2007. *I luoghi del lavoro domestico nella casa pompeiana*. Rome.

Kaster, R. A. 2006. *Cicero: Speech on Behalf of Publius Sestius*. Oxford.

————. 2011a. *Macrobius: Saturnalia*. 3 vols. Harvard.

————. 2011b. *Macrobii Ambrosii Theodosii Saturnalia*. Oxford.

————. 2016a. *C. Suetoni Tranquilli: De vita Caesarum libros VIII et de Gramaticis et Rhetoribus librum*. Oxford.

————. 2016b. *Studies on the Text of Suetonius'* De vita Caesarum. Oxford.

Katz, J. T. 1998. "*Testimonia ritus Italici*: Male Genitalia, Solemn Declarations, and a New Latin Sound Law." *HSCP* 98: 183–217.

Kaufmann-Heinimann, A. 1998. *Götter und Lararien aus Augusta Raurica. Herstellung, Fundzusammenhänge und sakrale Funktion figürlicher Bronzen in einer römischen Stadt*. Augst.

————. 2007a. "Statuettes de laraire et religion domestique à Pompéi." *Archaeologia Vesuviana* 151–57.

————. 2007b. "Religion in the House." In *A Companion to Roman Religion*, ed. J. Rüpke. Oxford. 188–201.

Kelly, G. 2006. *A History of Exile in the Roman Republic*. Cambridge.

Kendall, S. 2013. *The Struggle for Roman Citizenship: Romans, Allies, and the Wars of 91–77 BC*. Piscataway, NJ.

Ker, J. 2010. "'*Nundinae*': The Culture of the Roman Week." *Phoenix* 64: 360–85.

Kienast, D. 1982. *Augustus: Prinzeps und Monarch*. Darmstadt.

————. 2004. *Römische Kaisertabelle* 2nd edition. Darmstadt.

King, R. J. 2010. "*Ad capita bubula*: The Birth of Augustus and Rome's Imperial Centre." *CQ* 60: 450–69.

Kleiner, D.E.E. 1992. *Roman Sculpture*. New Haven, CT.

Kleiner, D.E.E., and B. Buxton. 2008. "Pledges of Empire: The Ara Pacis and the Donations of Rome." *AJA* 112: 57–90.

Koestermann, E. 1963–68. *Cornelius Tacitus Annalen*. 4 vols. Heidelberg.

Kolb, F. 1995. *Rom. Die Geschichte der Stadt in der Antike*. Munich.

Kondratieff, E. 2003. "Popular Power in Action: Tribunes of the Plebs in the Later Republic." PhD Dissertation, University of Pennsylvania.

———. 2004. "The Column and Coinage of C. Duilius: Innovations in Iconography in Large and Small Media in the Middle Republic." *SCI* 23: 1–39.

Koortbojian, M. 2013. *The Divinization of Caesar and Augustus: Precedents, Consequences, Implications*. Cambridge.

Kunckel, H. 1974. *Der römische Genius*. Heidelberg.

La Follette, L. 1994. "The Costume of the Roman Bride." In *The World of Roman Costume*, ed. L. Bonfante and J. Sebesta. Madison, WI. 54–64.

Lancaster, L. C. 2005. *Concrete Vaulted Construction in Imperial Rome: Innovations in Context*. Cambridge.

Lanciani, R. 1990. *Forma Urbis Romae*. (Reprint of Lanciani 1893–1901, Milan.) Rome.

La Regina, A. 2013. "Lacus ad sacellum Larum." In *Dall'Italia: Omaggio a Barbro Santillo Frizell*, ed. A. Capoferro, L. D'Amelio, and S. Renzetti. Florence. 133–50.

———. 2015. "Dedica ai lari, non al 'lare Aenia' (*CIL* I² 2843)." *Epigraphica* 76: 433–36.

La Rocca, E. 2011. "Dal culto di Ottaviano all'apoteosi di Augusto." In *Dicere laudes. Elogio, comunicazione, creazione del consenso*, ed. G. Urso. Pisa. 179–204.

——— (ed.). 2013. *Augusto. Catalogo della mostra Scuderie del Quirinale 18 ottobre 2013–9 febbraio 2014*. Milan.

Laurence, R. 1994. "Rumour and Communication in Roman Politics." *Greece and Rome* 41: 62–74.

———. 1999. *The Roads of Roman Italy: Mobility and Cultural Change*. London.

———. 2007. *Roman Pompeii: Space and Society* 2nd edition. London.

Laurence, R., and C. J. Smith. 1995–96. "Ritual, Time and Power in Ancient Rome." *Accordia Research Papers* 6: 133–52.

Lavagne, H. 1987. "Le tombeau, mémoire du mort." In *La mort, les morts et l'au-delà dans le monde romain*, ed. F. Hinard. Caen. 159–65.

Lavagne, H., and M. Gschaid. 1996. "Une inscription métrique de Castra Regina (Ratisbonne) à la déesse Larunda." *CRAI* 4: 1251–61.

Le Boeuffle, A. 1989. *Le ciel des romains*. Paris.

Lefèvre, E. 2001. *Plautus' Aulularia*. Tübingen.

Leigh, M. 1993. "Hopelessly Devoted to You: Traces of the Decii in Virgil's Aeneid." *PVS* 21: 89–110.

Leone, A., and D. Palombi. 2008. "Mercurio Sobrio tra Africa e Roma." *ArchClass* 59: 409–33.

Le pitture antiche di Ercolano e contorni. 1757. Naples.

Letta, C. 2003. "Novità epigrafiche sul culto del *Genius Augusti* in Italia." In *Usi e abusi epigrafici*, ed. M. G. Angeli Bertinelli and A. Donati. Rome. 217–36.

———. 2005. "Vicus rurale e vicus urbano nella definizione di Festo (pp. 502 e 508 L)." *RCCM* 47: 81–96.

Levick, B. 1990. *Claudius*. New Haven, CT.

———. 1999. *Vespasian*. London and New York.

Lewis, M.J.T. 2001. *Surveying Instruments of Greece and Rome*. Cambridge.

Lewis, R. G. 2006. *Asconius: Commentaries on Speeches by Cicero*. Oxford.

Linderski, J. 1968. "Der Senat und die Vereine." In *Gesellschaft und Recht im griechisch-römischen Altertum*, ed. M. Andreev. Berlin. 94–132.

———. 1986. "The Augural Law." *ANRW* 2.16.3: 2147–2312.

———. 1993. "Roman Religion in Livy." In *Livius: Aspekte seines Werkes*, ed. W. Schuller. Konstanz. 53–70.

————. 1995. *Roman Questions*. Stuttgart.

————. 2002. "The Pontiff and the Tribune: The Death of Tiberius Gracchus." *Athenaeum* 90.2: 339–66.

————. 2007. "Banqueting." In *Roman Questions: Selected Papers*, vol. 2. Stuttgart. 326–31.

Lintott, A. 1999a. *The Constitution of the Roman Republic*. Oxford.

————. 1999b. *Violence in Republican Rome* 2nd edition. Oxford.

Lipka, M. 2009. *Roman Gods: A Conceptual Approach*. Leiden.

Liu, J. 2013. "Professional Associations." In *The Cambridge Companion to Ancient Rome*, ed. P. Erdkamp. Cambridge. 352–68.

Lo Cascio, E. 1979. "Carbone, Druso e Gratidiano: le gestione della res nummaria a Roma tra la lex Papiria e la lex Cornelia." *Athenaeum* 57: 215–38.

————. 1990. "Le 'professiones' della 'tabula Hercleensis' e le procedure del 'census' in età cesariana." *Athenaeum* 78.2: 287–318.

————. 1991. "La società pompeiana. Dalla società sannitica alla colonia romana." In *Pompei*, vol. 1, ed. F. Zevi. Naples. 115–30.

————. 1997. "Le procedure di 'recensus' dalla tarda repubblica al tardo antico e il calcolo della popolazione di Roma." In *La Rome impériale. Démographie et logistique*. Rome. 3–76.

————. 2001. "Recruitment and the Size of the Roman Population from the Third to the First Century BCE." In *Debating Roman Demography*, ed. W. Scheidel. Leiden. 111–38.

————. 2007. "Il ruolo dei 'vici' e delle 'regiones' nel controllo della popolazione e nell'amministrazione di Roma." In *Herrschen und Verwalten: der Alltag der römischen Administration in der Hohen Kaiserzeit*, ed. R. Haensch and J. Heinrichs. Cologne. 145–59.

————. 2008. "*Vici, regiones* e forme di interazione sociale nella Roma imperiale." In *Rome des Quartiers: des vici aux rioni. Cadres institutionnels, pratiques sociales, et requalifications entre Antiquité et époque moderne*, ed. M. Royo, E. Hubert, and A. Bérenger. Paris. 65–76.

Lo Cascio, E., and G. D. Merola (eds.). 2007. *Forme di aggregazione nel mondo romano*. Bari.

Lomas, K. 2014. "Italy during the Roman Republic 338–31 BC." In *The Cambridge Companion to the Roman Republic* 2nd edition, ed. H. I. Flower. Cambridge. 233–59.

Lott, J. B. 1995. "The Earliest Use of the Divine Epithet Augustus, 27 BCE–37 CE: Dynastic Names and Religion in the Augustan Principate." PhD Dissertation, University of Pennsylvania.

————. 2004. *The Neighborhoods of Augustan Rome*. Cambridge.

Louis, N. 2010. *Commentaire historique et traduction du* Diuus Augustus *de Suétone*. Brussels.

Lundberg, W. B., and J. A. Pinto, 2007. *Steps off the Beaten Path / Sentieri smarriti e ritrovati. Nineteenth Century Photographs of Rome and Its Environs. Images from the Collection of Delaney and W. Bruce Lundberg*. Milan.

MacBain, B. 1982. *Prodigy and Expiation: A Study in Religion and Politics in Republican Rome*. Brussels.

Mackay, C. S. 2000. "Sulla and the Monuments: Studies in His Public Persona." *Historia* 49.2: 161–210.

Mann, C. 2002. "Greichischer Sport und römische Identität: die *certamina athletarum* in Rom." *Nikephoros* 15: 125–58.

Mansuelli, G. A. 1958. *Sculture antiche degli Uffizi: 2 Vols*. Milan.

Manuwald, G. 2011. *Roman Republican Theater*. Cambridge.

Marcattili, F. 2005. "Compitum." In *Thesaurus Cultus et Rituum Antiquorum*, vol. 4. Basel and Los Angeles. 222.

————. 2015. "L'altare del vicus Sandalarius agli Uffizi. Culto compitale e politiche dinastiche." *BABESCH* 90: 125–37.

Marco Simón, F., and F. Pina Polo. 2000. "Mario Gratidiano, los compita y la religiosidad popular a fines de la república." *Klio* 82.1: 154–70.

Marin, E. 1998. "La publication des inscriptions romaines de Salone et de Narone." In *Epigrafia romana in area adriatica: Actes de la IXᵉ rencontre franco-italienne sur l'épigraphie du monde romain*, ed. G. Paci. Pisa. 51–60.

Marquardt, J. 1879. *Handbuch der römischen Alterthümer*, 2ⁿᵈ ed. Vol. 7: *Privatleben der Römer*. Leipzig.

Márquez, C., and M. I. Gutiérrez Desa. 2006. "El templo de Via delle Botteghe Oscure en Roma." In *El concepto de lo provincial en el mundo antiguo. Homenaje a la Prof. Pilar León*, vol. 1, ed. D. Vaquerizo and J. F. Murillo. Cordoba. 301–36.

Marroni, E. 2010. *I culti del Esquilino*. Rome.

Marshall, B. A. 1985. *A Historical Commentary on Asconius*. Columbia, MO.

Marx, F. 1928. *Plautus Rudens*. Leipzig.

Mastrocinque, A. 1988. *Lucio Giunio Bruto*. Trento.

Mastroroberto, M. 2001. "Il quartiere sul Sarno e i recenti rinvenimenti a Moregine." *MEFRA* 113: 953–66.

Mattusch, C. 2015. *Enduring Bronze: Ancient Art, Modern Views*. Los Angeles.

Mau, A. 1907. *Pompeii, Its Life and Art*. Trans. F. W. Kelsey. New York.

Mavrojannis, T. 1995. "L'*aedicula* dei *lares compitales* nel *compitum* degli Hermaistai a Delo." *BCH* 119: 89–123.

Maxfield, V. A. 1981. *Military Decorations of the Roman Army*. London.

Mayer, M. 2008. "Sila y el uso político del epigrafía." In *Epigrafia 2006. Atti della XIVe rencontre sur l'épigraphie in onore di Silvio Panciera* (Tituli 9), 77–91. Rome.

Mazois, F. 1812–38. *Les ruines de Pompéi*. 5 vols. Paris.

McDonnell, M. 2006. *Roman Manliness: Virtus and the Roman Republic*. Cambridge.

McGing, B. 2003. "Subjection and Resistance: To the Death of Mithridates." In *A Companion to the Hellenistic World*, ed. A. Erskine. Oxford. 71–89.

Menella, G. 1983. "Il *vicus* di Pisaurum." *Ep.* 45: 146–51.

Menichetti, M. 2005. "*Sacellum* (mondo romano)." In *Thesaurus Cultus et Rituum Antiquorum*, vol. 4, ed. B. Jaeger. Basel and Los Angeles. 313–15.

Meritt, L., T. Shoe, and I.E.M. Edlund-Berry. 2000. *Etruscan and Republican Mouldings*. (Reissue of the Memoirs of the American Academy in Rome 28, 1965, by Lucy T. Shoe.) Philadelphia.

Meslin, M. 1970. *La fête des kalendes de janvier dans l'empire romain. Étude d'un rituel de nouvel an*. Brussels.

Michels, A. 1967. *The Calendar of the Roman Republic*. Princeton, NJ.

Millar, F.G.B. 1998. *The Crowd in Rome in the Late Republic*. Ann Arbor, MI.

Miller, J. F. 2009. *Apollo, Augustus, and the Poets*. Cambridge and New York.

Milnor, K. 2005. *Gender, Domesticity, and the Age of Augustus: Inventing Private Life*. Oxford.

———. 2014. *Graffiti and the Literary Landscape in Roman Pompeii*. Oxford.

Moatti, C. 2013. "Immigration and Cosmopolitanization." In *The Cambridge Companion to Ancient Rome*, ed. P. Erdkamp. Cambridge. 77–92.

Mommsen, T. 1843. *De collegiis et sodaliciis Romanorum, accedit inscriptio lanuvina*. Kiel.

Moreno, C. M. 2006. "El temple de Via delle Botteghe Oscure en Roma." In *El concepto de la provincial en el mundo antiguo: Homanaje a la Profesora Pilar León Alonso*, vol. 1, ed. D. V. Gil and J. F. Murillo Redondo. Cordoba. 301–26.

Morley, N. 2002. *Metropolis and Hinterland: The City of Rome and the Italian Economy, 200 BC–AD 200*. Cambridge.

Mouritsen, H. 2001. *Plebs and Politics in the Late Roman Republic*. Cambridge.

———. 2011. *The Freedman in the Roman World*. Cambridge.

Mulvin, L., and S. E. Sidebotham. 2004. "Roman Game Boards from Abu Sha'ar (Red Coast, Egypt)." *Antiquity* 78: 602–17.

Newlands, C. 1995. *Playing with Time: Ovid and the Fasti*. Ithaca, NY.

Nicolet, C. 1987. "La table d'Heraclée et les origins du cadastre romain." In *L'Urbs. Éspace urbain et histoire*. Rome. 1–25.

———. 1988. *L'inventaire du monde: géographie et politique aux origins de l'empire romain*. Paris.

Niebling, G. 1956. "*Laribus Augustis Magistri Primi*. Der Beginn des Compitalkultes der *Lares* und des *Genius Augusti*." *Historia* 5: 303–31.

Nippel, W. 1995. *Public Order in Ancient Rome*. Cambridge.

Nisbet, R. 1961. *Cicero: In L. Calpurnium Pisonem Oratio*. Oxford.

Nista, L. (ed.). 1991. *Sacellum Herculis: le sculture del tempio di Ercole a Trastevere*. Rome.

North, J. A. 2013. "Disguising Change in the First Century." In *The Individual in the Religions of the Ancient Mediterranean*, ed. J. Rüpke. Oxford. 58–85.

Noy, D. 2000. *Foreigners at Rome: Citizens and Strangers*. London.

Nutton, V. 1986. "The Perils of Patriotism: Pliny and the Roman Medicine." In *Science in the Early Roman Empire: Pliny the Elder, His Sources and Influence*, ed. R. French and F. Greenaway. London. 30–58.

———. 1993. "Roman Medicine: Tradition, Confrontation, Assimilation." *ANRW* 2.37.1: 49–78.

———. 2004. *Ancient Medicine*. London and New York.

Oakley, S. P. 1997–2005. *Commentary on Livy Books 6–10*. 4 vols. Oxford.

———. 2005. *A Commentary on Livy Book 10*. Oxford.

O'Donnell, J. J. 2015. *Pagans: The End of Traditional Religion and the Rise of Christianity*. New York.

Ogilvie, R. M. 1965. *A Commentary on Livy, Books 1–5*. Oxford.

Orlin, E. 1997. *Temples, Religion, and Politics in the Roman Republic*. Leiden.

———. 2010. *Foreign Cults in Rome: Creating a Roman Empire*. New York and Oxford.

Orr, D. G. 1978. "Roman Domestic Religion: The Evidence of the Household Shrines." *ANRW* 2.16.2: 1557–91.

———. 1988. "Learning from *Lararia*: Notes on the Household Shrines of Pompeii." In *Studia Pompeiana et Classica in Honor of W. F. Jashemski*, vol. 1, ed. R. I. Curtis. New Rochelle, NY. 293–99.

Osborne, S. 1988. "Social and Economic Implications of the Leasing of Land and Property in Classical and Hellenistic Greece." *Chiron* 18: 279–323.

Osgood, J. 2006. *Caesar's Legacy: Civil War and the Emergence of the Roman Empire*. Cambridge.

Paillier, J.-M. 1982. "Les oscilla retrouvées." *MEFRA* 94: 743–820.

———. 1985. "Rome aux cinq regions?" *MEFRA* 97: 785–97.

Palmer, R.E.A. 1973. "A Roman Street Named Good." *JIES* 1: 370–78.

———. 1974. "The *Excusatio Magisteri* and the Administration of Rome under Commodus." *Athenaeum* 52: 266–88.

———. 1976. "A Poem for All Seasons (*AE* 1928.108)." *Phoenix* 30: 159–73.

———. 1978. "Silvanus, Sylvester, and the Chair of St. Peter." *PAPhS* 122: 222–47.

———. 1978/79. "C. Verres' Legacy of Charm and Love in the City of Rome: A New Document." *RPAA* 51–52: 111–36.

———. 1981. "Topography and Social History of Rome's Trastevere." *PAPhS* 125: 368–97.

———. 1989/98. "Bullae insignia ingenuitatis." *AJAH* 14.2: 1–69.

———. 1990. "Studies of the Northern Campus Martius in Ancient Rome." *TAPhA* 80.2.

———. 1996. "'Private' Religion and *Compita* at Ostia." *JRA* 9: 381–85.

———. 1997. *Rome and Carthage at Peace*. Stuttgart.

Palombi, D. 1996. "Ianus, Concordia, Salus, Pax, statuae et ara." In *Lexicon Topographicum Urbis Romae*, vol. 3, ed. E. M. Steinby. Rome. 91–92.

———. 1997–98. "Compitum Acilium: la scoperta, il monumento e la tradizione medica del quartiere." *RPAA* 70: 115–35.

Palombi, D. 2000. "Vicus Sobrius." In *Lexicon Topographicum Urbis Romae*, vol. 5, ed. E. M. Steinby. Rome. 190.

———. 2007. "Medici e medicina a Roma tra Carine, Velia e Sacra Via." In *Salute e guarigione nella tarda antichità: atti della giornata tematica dei Seminari di archeologia Cristiana, Roma, 20 maggio 2004*, ed. H. Brandenburg, S. Heid, and C. Markschies. Vatican City. 53–78.

Panayotakis, C. 2005. "Comedy, Atellane farce, and Mime." In *A Companion to Latin Literature*, ed. S. J. Harrison. Malden, MA. 130–47.

———. 2010. "Comic Theatre, Roman." In *The Oxford Encyclopedia of Ancient Greece and Rome*, ed. M. Gagarin and E. Fantham. Oxford.

Panciera, S. 1970. "Tra epigrafia e topografia." *Arch. Class.* 22: 131–63.

———. 1978. "*Invigulantes pro vicinia*." In *Scritti storico-epigrafici in memoria di Marcello Zambelli*, ed. L. Gasperini. Rome. 315–20.

———. 1980. "Nuovi luoghi di culto a Roma dalle testimonianze epigrafiche, III." *Archeol. laziale, III: Terzo incontro di studio del Comitato per l'archeologia laziale.* Rome. 202–13.

———. 1987. "Ancora tra epigrafia e topografia." In *L'Urbs: espace urbain et histoire (1e siècle av. J.C.–3e siècle ap. J.-C.)*. Rome. 61–86.

———. 2003. "Umano, sovrumano o divino?: le divinità auguste e l'imperatore a Roma." In *The Representation and Perception of Roman Imperial Power*, ed. L. De Blois, P. Erdkamp, O. Hekster, G. de Kleijn and S. Mols. Amsterdam. 215–39.

———. 2006. *Epigrafi, epigrafia, epigrafisti. Scritti vari editi e inediti (1956–2005) con note complementari e indici*. 2 vols. Rome.

Panciera, S., and H. von Hesberg. 1994. *Das Mausoleum des Augustus: Der Bau und seine Inschriften*. Munich.

Panella, C. 2006. "Piazza del Colosseo. Scavo dell'area della Meta Sudans." In *Roma. Memorie dal sottosuolo. Ritrovamenti archeologici 1980/2006*, ed. M. Tomei. Verona. 85–89.

———. (ed.). 2013. *Scavere nel centro di Roma: storie, uomini, paesaggi*. Rome.

Papakosta, P. 2012. "The Role of the *Lares* in the 'Augustan' Theology of Tibullus." *Acta Ant. Hung.* 52: 349–62.

Papi, E. 1994. "Un'attestazione del culto imperiale a Capua in un'epigrafe mal cognoscuito." *MEFRA* 106: 139–66.

———. 2002. "La turba impia: artigiani e commercanti del Foro Romano e dintorni (I sec. a.C.–64 d. C.)." *JRA* 15: 45–62.

Pappalardo, U. 2001. *La descrizione di Pompei per Giuseppe Fiorelli (1875): con una cronistoria per immagini e la lettera alla Guardia Nazionale del distretto di Castellammare di Stabia.* Naples.

———. 2009. *The Splendor of Roman Wall Painting*. Los Angeles.

Paris, R., S. Bruni, and M. Roghi (eds.). 2014. *Rivoluzione Augusto. L'imperatore che riscrisse il tempo e la città*. Milan.

Parker, H. N. 2007. *The Birthday Book: Censorinus*. Chicago.

Parker, H. N., and S. Braund, 2012. "Imperial Satire and the Scholars." In *A Companion to Persius and Juvenal*, ed. J. Osgood and S. Braund. Chichester, UK. 436–64.

Pasco-Pranger, M. 2006. *Founding the Year: Ovid's* Fasti *and the Poetics of the Roman Calendar*. Leiden.

Patton, K. C. 2009. *Religion of the Gods: Ritual, Paradox, Reflexivity*. Oxford.

Peachin, M. 2004. *Frontinus and the* Curae *of the* Curator Aquarum. Stuttgart.

Pelikan Pittenger, M. 2008. *Contested Triumphs: Politics, Pageantry and Performance in Livy's Republican Rome*. Berkeley, CA.

Pelling, C.B.R. 1996. "The Triumviral Period." In *The Cambridge Ancient History* 2nd edition, vol. 10, ed. A. K. Bowman, E. Champlin, and A. Lintott. Cambridge. 1–69.

Perry, J. S. 2006. *The Roman* Collegia*: The Modern Evolution of an Ancient Concept*. Leiden.

Petersmann, H. 1973. "Zu einem altrömischen Opferritual (Cato *de agricultura* c. 141)."
 RhM 116: 238–55.

Piccaluga, G. 1974. *Terminus: i segni di confine nella religione romana.* Rome.

Pietrangeli, C. 1942. "Un frammento sconosciuto di ara dei Lari." *BCAR* 127–30.

Pighi, G. B. 1941/1965. *De ludis saecularibus populi romani Quiritium libri sex.* Amsterdam.

Pina Polo, F. 2010. "*Frigidus rumor*: The Creation of a (Negative) Public Image in Rome."
 In *Private and Public Lies: The Discourse of Despotism and Deceit in the Graeco-Roman
 World,* ed. A. J. Turner, K. O. Chong-Gossard, and F. J. Vervaet. Leiden. 75–90.

———. 2013. "Foreign Eloquence in the Roman Senate." In *Community and Communica-
 tion: Oratory and Politics in Republican Rome,* ed. C. Steel and H. van der Blom. Oxford.
 247–66.

Pisani Sartorio, G. 1988. "Compita larum: edicole sacre nei crocicchi di Roma antica." In
 Scritti in onore di A. M. Colini, Bolletino dell'Unione Storia ed Arte 31: 23–34.

———. 1993. "Compitum Acilii." In *Lexicon Topographicum Urbis Romae,* vol. 1, ed. E. M.
 Steinby. Rome. 314–15.

Pollini, J. 2008. "A New Bronze *Lar* and the Role of the *Lares* in the Domestic and Civic
 Religion of the Romans." *Latomus* 67: 391–98.

———. 2012. *From Republic to Empire: Rhetoric, Religion, and Power in the Visual Culture
 of Ancient Rome.* Norman, OK.

Pollitt, J. J. 1986. *Art in the Hellenistic Age.* Cambridge.

Popkin, M. L. 2015. "Samothracian Influences at Rome: Cultic and Architectural Exchange
 in the Second Century BCE." *AJA* 119.3: 343–73.

Pötscher, W. 1982. "*Numen* und *numen Augusti.*" *ANRW* 2.16.1: 355–92.

Poucet, J. 2000. *Les rois de Rome: tradition et histoire.* Brussels.

Prack, N. 1996. *Der römische Kalender (264–168 v. Chr.). Verlauf und Synchronisation.*
 Sinzheim.

Prescendi, F. 2007. *Décrire et comprendre le sacrifice. Les réflexions des Romains sur leur
 propre religion à partir de la littérature antiquaire.* Stuttgart.

Pucci, G. 2007. "*Lares* che giocano fuori casa." *Lares* 73.3: 529–32.

Purcell, N. 1983. "The *Apparitores*: A Study in Social Mobility." *PBSR* 51: 125–73.

———. 1994. "The City of Rome and the *Plebs Urbana* in the Late Republic." In *The Cam-
 bridge Ancient History* 2nd edition, vol. 9, ed. J. A. Crook, A. Lintott, and E. Rawson.
 Cambridge. 644–88.

———. 1995. "Literate Games: Roman Urban Society and the Game of *Alea.*" *PastPres* 147:
 3–37.

———. 1996. "Rome and Its Development under Augustus and His Successors." In *The
 Cambridge Ancient History* 2nd edition, vol. 10, ed. A. K. Bowman, E. Champlin, and A.
 Lintott. Cambridge. 782–811.

Questa, C. 2004. *Sei letture plautine: Aulularia, Casina, Menaechmi, Miles gloriosus, Mo-
 stellaria, Pseudolus.* Urbino.

Radke, G. 1972. "Acca Larentia und die *fratres arvales*: ein Stück römisch-sabinische Früh-
 geschichte." *ANRW* 1.2: 412–41.

———. 1979. *Die Götter Altitaliens.* Münster.

———. 1990. *Fasti Romani: Betrachtungen zur Frühgeschichte des römischen Kalenders.*
 Münster.

Ragghianti, C. L. 1963. *Pittori di Pompei.* Milan.

Ramage, E. S. 1987. *The Nature and Purpose of Augustus' Res Gestae.* Stuttgart.

———. 1991. "Sulla's Propaganda." *Klio* 73: 93–121.

Ramos Crespo, J. M. 1988. "Pilae, effigies y maniae." *Helmantica* 118–19: 207–22.

Rasmus Brandt, J. 2010. "*Sacra privata* in the Roman *domus*: Private or Public? A Study of
 Household Shrines in an Architectural Context at Pompeii and Ostia." *AAAH* 23:
 57–117.

Rauh, N. 1993. *The Sacred Bonds of Commerce: Religion, Economy, and Trade Society at Hellenistic Roman Delos, 167–87 BC*. Amsterdam.

Rawson, E. 1985. *Intellectual Life in the Late Roman Republic*. Baltimore, MD.

———. 1991. "The First Latin Annalists." [= 1976, *Latomus* 35: 689–717.] In *Roman Culture and Society: Collected Papers*, by E. Rawson. Oxford and New York. 245–71.

Reay, B. 2005. "Agriculture, Writing, and Cato's Aristocratic Self-Fashioning." *CA* 24: 331–61.

Reger, G. 1994. *Regionalism and Change in the Economy of Independent Delos, 314–167 BC*. Berkeley, CA.

Rehak, P. 2001. "Aeneas or Numa?: Rethinking the Meaning of the Ara Pacis Augustae." *ABull* 2001 83.2: 190–208.

Renberg, G. H. 2006–7. "Public and Private Places of Worship in the Cult of Asclepius at Rome." *MAAR* 51/52: 87–172.

Rescigno, R. 2000. "I Penates tra Lares, Genius e Iuno." *Studi di storia e di geostoria antica*. Naples. 13–37.

Richardson, J. S. 1986. *Hispaniae: Spain and the Development of Roman Imperialism 218–82 BC*. Cambridge.

Rickman, G. 1980. *The Corn Supply of Ancient Rome*. Oxford.

———. 1983. "Porticus Minucia." *ARID* Suppl. 10: 105–8.

Rieger, M. 2007. *Tribus und Stadt. Die Entstehung der römischen Wahlbezirke im urbanen und mediterranen Kontext (ca. 750–450 v. Chr.)*. Göttingen.

Riposati, B. 1939. *M. Terenti Varronis De Vita Populi Romani*. Milan.

Robinson, M. 2011. *Ovid Fasti Book 2 with Introduction and Commentary*. Oxford.

Rodaz, J.-M. 1984. *Marcus Agrippa*. Paris.

Rodríguez Almeida, E. 2002. *Forma Urbis Antiquae: le mappe marmoree di Roma tra la repubblica e Settimio Severo*. Rome.

Roller, M. 2009. "The Exemplary Past in Roman Historiography and Culture." In *The Cambridge Companion to the Roman Historians*, ed. A. Feldherr. Cambridge and New York. 214–30.

Rose, C. B. 1997. *Dynastic Commemoration and Imperial Portraiture in the Julio-Claudian Period*. Cambridge.

———. 2005. "The Parthians in Augustan Rome," *AJA* 109: 21–75.

Roselaar, S. T. 2010. *Public Land in the Roman Republic: A Social and Economic History of Ager Publicus in Italy, 396–89 B.C.* Oxford.

Rossini, O. 2006. *Ara Pacis*. Rome.

Rosso, E. 2015. "*Genius Augusti*. Construire la divinité imperiale en images." In *Figures de dieux. Construire le divin en images*, ed. S. Estienne, V. Huet, F. Lissarrague, and F. Prost. Rennes. 39–76.

Roth, U. 2004. "Inscribed Meaning: The *Vilica* and the Villa Economy." *PBSR* 72: 101–24.

Rowe, G. 2013. "Reconsidering the *Auctoritas* of Augustus." *JRS* 103: 1–15.

Royden, H. L. 1988. *The Magistrates of the Roman Professional Collegia in Italy from the First to the Third Century AD*. Pisa.

Rüpke, J. 1990. Domi militiae: *die religiöse Konstruktion des Krieges in Rom*. Stuttgart.

———. 1998. "Les archives des petits collèges: le cas des *vicomagistri*." *La mémoire perdue 2. Recherches sur l'administration romaine*. Rome. 27–44.

———. 2002. "*Collegia sacerdotum*: Religiöse Vereine in der Oberschicht." In *Religiöse Vereine in der Römischen Antike. Untersuchungen zu Organisation, Ritual und Raumordnung*, ed. U. Egelhaaf-Gaiser and A. Schäfer. Tübingen. 41–68.

———. 2005. "Gäste der Götter–Götter als Gäste. Zur Konstruktion des römischen Opferbanketts." In *La cuisine et l'autel: les sacrifices en questions dans les sociétés de la Méditerranée ancienne*, ed. S. Georgoudi, R. Koch Piettre, F. Schmidt. Turnhout. 227–39.

————. 2008. *Fasti sacerdotum: a Prosopography of Pagan, Jewish, and Christian Religious Officials in the City of Rome, 300 BC to AD 499*. Oxford.

————. 2011. *The Roman Calendar from Numa to Constantine: Time, History, and the Fasti*. Chichester, UK.

Russell, A. 2016. "Why Did Clodius Shut the Shops? The Rhetoric of Mobilizing a Crowd in the Late Republic." *Historia* 65.2: 186–210.

Ryberg, I. S. 1955. *Rites of the State Religion in Roman Art*. *MAAR* 22. Rome.

Sablayrolles, R. 1981. "Espace urbain et propagande politique. L'organisation du centre de Rome par Auguste (*Res gestae*, 19 à 21)." *Pallas* 28: 59–77.

————. 1996. *Libertinus miles: les cohorts des vigiles*. Rome.

Saddington, D. B. 2007. "*Classes*: The Evolution of the Roman Imperial Fleets." In *A Companion to the Roman Army*, ed. P. Erdkamp. Malden, MA. 201–17.

Salerno, F. 1984–85. "*Collegia adversus rem publicam*?" In *Sodalitas. Scritti in onore di Antonio Guarino*, vol. 2, ed. V. Giuffrè. Naples. 615–31.

Sallmann, K. 1983. "Censorinus' *De die natali*. Zwischen Rhetorik und Wissenschaft." *Hermes* 111: 233–48.

————. 1988. *Betrachtungen zum Tag der Geburt. De die natali*. Leipzig.

Salmon, E. T. 1967. *Samnium and the Samnites*. Cambridge.

Salvadore, M. 2004. *M. Terenti Varronis fragmenta omnia quae extant. II de vita populi Romani libri IV*. Hildesheim.

Salza Prina Ricotti, E. 1995. *Giocchi e giocattoli*. Rome.

Samter, E. 1901. *Familienfeste der Griechen und Römer*. Berlin.

Santangelo, F. 2007. *Sulla, the Elites and the Empire: A Study of Roman Policies in Italy and the Greek East*. Leiden.

————. 2012. *Divination, Prediction, and the End of the Roman Republic*. Cambridge.

Santini, C. 1995. *I frammenti di L. Cassio Emina: introduzione, testo, traduzione e commento*. Pisa.

Satterfield, Susan. 2012. "Intention and Exoticism in Magna Mater's Introduction in Rome." *Latomus* 71.2: 373–91.

Scheid, J. 1990. *Romulus et ses frères. Le collège des frères arvales, modèle du culte public dans la Rome des empereurs*. Rome.

————. 1993. "Die Parentalien für die verstorbenen Caesaren als Modell für den römischen Totenkult." *Klio* 75: 188–201.

————. 1998. *Commentarii fratrum arvalium qui supersunt / Les copies épigraphiques des protocoles annuels de la confrèrie arvale (21 av.–304 ap. J.-C.)*. Rome and Paris.

————. 2001a. *Religion et piété à Rome*. Paris.

————. 2001b. "Honorer le prince et vénérer les dieux: culte public, cultes des quartiers et culte impérial dans la Rome augustéenne." In *Rome, les Césars et la ville aux deux premiers siècles de notre ère*, ed. N. Belayche. Rennes. 85–105.

————. 2005a. *Quand faire, c'est croire. Les rites sacrificiels des Romains*. Paris.

————. 2005b. "Augustus and Roman Religion: Continuity, Conservatism, and Innovation." In *The Cambridge Companion to the Age of Augustus*, ed. K. Galinsky. Cambridge. 175–92.

————. 2005c. "Manger avec les dieux. Partage sacrificiel et commensalité dans la Rome antique." In *La cuisine et l'autel: Les sacrifices en questions dans les sociétés de la Méditerranée ancienne*, ed. S. Georgoudi, R. Koch Piettre, and F. Schmidt. Turnhout. 273–87.

————. 2007. *Res gestae divi Augusti = Hauts faits du divin Auguste*. Paris.

Scheidel, W. 2003. "Germs for Rome." In *Rome the Cosmopolis*, ed. C. Edwards and G. Woolf. Cambridge. 158–76.

————. 2009a. "Population and Demography." In *A Companion to Ancient History*, ed. A. Erskine. Oxford. 234–45.

Scheidel, W. 2009b. "When Did Livy Write Books 1, 3, 28, and 59?" *CQ* 59: 653–58.

———. 2011. "The Roman Slave Supply." In *The Cambridge World History of Slavery: The Ancient Mediterranean World*, vol. 1, ed. K. Bradley and P. Cartledge. Cambridge. 287–310.

———. 2013. "Disease and Death." In *The Cambridge Companion to Ancient Rome*, ed. P. Erdkamp. Cambridge. 45–59.

Schilling, R. 1976. "Les 'Lares Grundiles.'" In *Mélanges offerts à Jacques Heurgon. L'Italie préromaine et al Rome républicaine*, vol. 2. Paris. 947–60.

———. 1984. "Cippo di Tor Tignosa." In *Enciclopedia Virgiliana*, vol. I. Rome. 787–89.

———. 2003. *Ovide Les Fastes*. Vol. 2. Paris.

Schnegg-Köhler, B. 2002. *Die augusteischen Säkularspiele*. Münich/Leipzig.

Scholz, P., and U. Walter. 2013. *Fragmente römischer Memoiren*. Darmstadt.

Schönberger, O. 2000. *Vom Landbau; Fragmente / Marcus Porcius Cato*. Münich/Zürich.

Schraudolph, E. 1993. *Römische Götterweihungen mit Reliefschmuck aus Italien. Altäre, Basen und Reliefs*. Heidelberg.

Schultz, C. 2006. *Women's Religious Activity in the Roman Republic*. Chapel Hill, NC.

Schütz, M. 1990. "Zur Sonnenuhr des Augustus auf dem Marsfeld." *Gymnasium* 97: 432–57.

Scobie, A. 1986. "Slums, Sanitation and Mortality in the Roman World." *Klio* 68: 399–433.

Scullard, H. H. 1981. *Festivals and Ceremonies of the Roman Republic*. Oxford.

Scullion, S. 1994. "Olympian and Chthonian." *ClAnt* 13: 75–119.

Seager, R. 1994. "Sulla." In *The Cambridge Ancient History* 2nd edition, vol. 9, *The Last Age of the Roman Republic 146–43 B.C.*, ed. J. A. Crook, A. Lintott, and E. Rawson. Cambridge. 165–207.

Sebesta, J. L. 1994. "Symbolism in the Costume of the Roman Woman." In *The World of Roman Costume*, ed. J. L. Sebesta and L. Bonfante. Madison, WI. 46–53.

Sehlmeyer, M. 1999. *Stadtrömische Ehrenstatuen der republikanischen Zeit: Historizität und Kontext von Symbolen nobilitären Standesbewusstseins*. Stuttgart.

———. 2003. "Die Anfänge der antiquarischen Literatur in Rom: Motivation und Bezug zur Historiographie bis in die Zeit von Tuditanus und Gracchanus." In *Formen römischer Geschichtsschreibung von den Anfängen bis Livius: Gattungen, Autoren, Kontexte*, ed. U. Eigler et al. Darmstadt. 157–71.

Settis, S. 1988. "Die Ara Pacis." In *Kaiser Augustus und die verlorene Republik. Eine Ausstellung im Martin-Gropius-Bau, Berlin, 7 Juni–14 August 1988*. Mainz. 400–426.

Severy, B. 2003. *Augustus and the Family at the Birth of the Roman Empire*. New York.

Shaw, B. D. 1987. "The Age of Roman Girls at Marriage: Some Reconsiderations." *JRS* 77: 30–46.

Sherwin-White, A. N. 1966. *The Letters of Pliny: A Historical and Social Commentary*. Oxford.

Siebert, A. V. 1999a. *Axt und Altar. Kult und Ritual als Schlüssel zur römischen Kultur*. Erfurt.

———. 1999b. *Instrumenta sacra. Untersuchungen zu römischen Opfer-, Kult- und Priestergeräten*. Berlin.

Siebert, G. 2001. *L'îlot des bijoux, l'îlot des bronzes, la maison des sceaux. Topographie et architecture*. *EAD* 38. 2 vols. Paris.

Sieveking, J. 1907. "Zur Ara Pacis Augustae." *Jh. Oest. Arch.* I.10: 175–99, and Suppl.: 107–9.

Simon, E. 2006. "Gods in Harmony: The Etruscan Pantheon." In *The Religion of the Etruscans*, ed. N. T. De Grummond and E. Simon. Austin, TX. 45–65.

Simpson, C. J. 1977. "The Date of Dedication of the Temple of Mars Ultor." *JRS* 77: 91–94.

Skutsch, O. 1985. *Ennius*. Oxford.

Slater, N. 1985/2000. *Plautus in Performance: The Theater of the Mind*. Princeton, NJ.

Small, A. 2007. "Urban, Suburban, and Rural Religion in the Roman Period." In *The World of Pompeii*, ed. J. J. Dobbins and P. Foss. London. 184–211.

Smith, C., and A. Powell (eds.). 2009. *The Lost Memoirs of Augustus and the Development of Roman Autobiography*. Swansea.

Smith, M. E. 2009. "To Seek the Boundaries of the Roman Lares: Interaction and Evolution." MA Thesis, University of Kansas.

Sofroniew, A. 2015. *Household Gods: Private Devotion in Ancient Greece and Rome*. Los Angeles.

Spinazzola, V. 1953. *Pompei alla luce degli scavi nuovi di Via dell'Abbondanza (anni 1910– 1923)*. Rome.

Stambaugh, J. 1988. *The Ancient Roman City*. Baltimore, MD.

Steel, C. 2013. *The End of the Roman Republic 146 to 44 BC: Conquest and Crisis*. Edinburgh.

Stefani, G. (ed.). 2005. *Cibi e sapori a Pompei e dintorni*. Naples.

Steinby, E. M. (ed.). 1989. *Lacus Iuturnae* I. Rome.

——. 1993–2000. *Lexicon Topographicum Urbis Romae*. 6 vols. Rome.

Steinhauer, J. 2014. *Religious Associations in the Post-classical Polis*. Stuttgart.

Stek, T. 2009. *Cult Places and Cultural Change in Republican Italy: A Contextual Approach to Religious Aspects of Rural Society after the Roman Conquest*. Amsterdam.

Stockton, D. 1979. *The Gracchi*. Oxford.

Stroup, S. C. 2010. *Catullus, Cicero, and a Society of Patrons: The Generation of the Text*. Cambridge.

Suerbaum, W. 1980. "Merkwürdige Geburtstage." *Chiron* 10: 327–55.

——(ed.). 2002. *Handbuch der lateinischen Literatur der Antike 1: Die archaische Literatur*. Munich.

Sumi, G. 1997. "Power and Ritual: The Crowd at Clodius' Funeral." *Historia* 46: 80–102.

Syme, R. 1939. *The Roman Revolution*. Oxford.

Tabeling, E. 1932. *Mater Larum. Zum Wesen der Larenreligion*. Frankfurt am Main.

Talbert, R.J.A. 2012. "Urbs Roma to Orbis Romanus: Roman Mapping on the Grand Scale." In *Ancient Perspectives: Maps and Their Place in Mesopotamia, Egypt, Greece, and Rome*, ed. R.J.A. Talbert. Chicago. 163–92.

Tamassia, A. M. 1961–62. "Iscrizioni del *compitum Acili*." *BullCom* 78: 158–63.

Tarpin, M. 2001. "Y avait-il des registres de citoyens dans les quartiers de Rome?" *MEFRA* 113: 753–64.

——. 2002. *Vici et pagi dans l'Occident romain*. Rome.

——. 2008. "Les *vici* de Rome, entre sociabilité de voisinage et organization administrative." In *Rome des Quartiers: des vici aux rioni. Cadres institutionnels, pratiques sociales, et requalifications entre Antiquité et époque moderne*, ed. M. Royo, E. Hubert, and A. Bérenger. Paris. 35–64.

——. 2014. "Vici, *compita* et 'plebe' à Rome: rhétoriques, société et topographie." In *Lire la Ville: Fragments d'une archéologie littéraire de Rome antique*, ed. D. Nelis and M. Royo, *Scripta Antiqua* 65. Paris. 41–64.

Tatum, W. J. 1999. *The Patrician Tribune: P. Clodius Pulcher*. Chapel Hill, NC.

Taylor, L. R. 1931 = 1975. *The Divinity of the Roman Emperor*. New York.

——. 1960 = 2013. *The Voting Districts of the Roman Republic: The Thirty-five Urban and Rural Tribes*. With additions by J. Linderski. Ann Arbor, MI.

Terrenato, N. 2012. "The Enigma of 'Catonian' Villas: The *De Agricultura* in the Context of Second Century Italian Architecture." In *Roman Republican Villas. Architecture, Context, and Ideology*, ed. J. A. Becker and N. Terrenato. Ann Arbor, MI. 69–93.

Thédenat, H. 1923. *Le Forum romain et les Forums impériaux*. Paris.

Thein, A. 2002. "Sulla's Public Image and the Politics of Civic Renewal." PhD Dissertation, University of Pennsylvania.

——. 2010. "Sulla's Veteran Settlement Policy." In *Militärsiedlungen und Territorialherrschaft in der Antike (Topoi / Berlin Studies of the Ancient World 3)*, ed. F. Daubner. Berlin. 79–99.

Thein, A. 2014. "Capitoline Jupiter and the Historiography of Roman World Rule." *HIS-TOS: The On-line Journal of Ancient Historiography* 8: 284–319. http://research.ncl. ac.uk/histos/documents/2014A10TheinCapitolineJupiter.pdf.

Thomsen, R. 1980. *King Servius Tullius: A Historical Synthesis*. Copenhagen.

Thuillier, J.-P. 1985. *Les jeux athlétiques dans la civilization etrusque*. Rome.

Todisco, E. 2006. "Sulla glossa <*vici*> nel *De verborum significatu* di Festo. La struttura del testo." In *Gli Statuti Municipali*, ed. L. Capogrossi Colognesi and E. Gabba. Pavia. 605–14.

Torelli, M. 2011. "La preistoria dei *Lares*." In *Religionem significare. Aspetti storico-religiosi, strutturali, iconografici e materiali dei sacra privata*, ed. F. Ghedini and M. Bassani. Rome. 41–55.

Toynbee, J.M.C. 1971. *Death and Burial in the Roman World*. Ithaca, NY.

Tracy, S. V. 1979. "Athens in 100 BC." *HSCP* 83: 213–36.

Treggiari, S. 1969. *Roman Freedmen during the Late Republic*. Oxford.

———. 1991. *Roman Marriage:* Iusti Coniuges *from the Time of Cicero to the Time of Ulpian*. Oxford.

Trifilò, F. 2011. "Movement, Gaming, and the Use of Space in the Forum." In *Rome, Ostia, and Pompeii: Movement and Space*, ed. R. Laurence and D. J. Newsome. Oxford. 312–31.

True, M., and K. Hamma (eds.). 1994. *A Passion for Antiquities: Ancient Art from the Collection of Barbara and Lawrence Fleishman*. Los Angeles.

Trümper, M. 2011. "Where the Non-Delians Met in Delos. The Meeting-Places of Foreign Associations and Ethnic Communities in Late Hellenistic Delos." In *Political Culture in the Greek City after the Classical Age*, ed. O. M. van Nijf and R. Alston. Leuven. 49–100.

Turfa, J. M. 2006. "The Etruscan Brontoscopic Calendar." In *The Religion of the Etruscans*, ed. N. T. De Grummond and E. Simon. Austin, TX. 173–90.

———. 2012. *Divining the Etruscan World: The Brontoscopic Calendar and Religious Practice*. Cambridge.

Tybout, R. A. 1996. "Domestic Shrines and Popular Painting: Style and Social Context." *JRA* 9: 358–74.

Ulf, C. 1982. *Das römische Luperkalienfest*. Darmstadt.

Ulrich, R. B. 2007. *Roman Woodworking*. New Haven, CT.

Vallois, R. 1923. *Les portiques au sud du Hiéron*. *EAD* VII.1.

Van Andringa, W. 2000. "Autels de carrefour, organization vicinale et rapports de voisinage à Pompéi." *Rivista di Studi Pompeiani* 11: 47–86.

———. 2009. *Quotidien des dieux et des hommes. La vie religieuse dans les cités de Vésuve à l'époque romaine*. Rome.

Van Deman, E. B. 1912. "Methods of Determining the Date of Roman Concrete Monuments (Second Paper)." *AJA* 16: 387–432.

van den Hout, Michel P. J. 1988. *M. Cornelii Frontonis Epistulae*. Leiden.

Vanderbroeck, P.J.J. 1987. *Popular Leadership and Collective Behavior in the Late Roman Republic (ca. 80–50 BC)*. Amsterdam.

Varone, A., and G. Stefani. 2009. *Titulorum pictorum Pompeianorum qui in CIL vol. IV collecti sunt: Imagines*. Rome.

Vernole, V. E. 2002. *Servius Tullius*. Rome.

Versnel, H. 1975. "*Sacrificium Lustrale*. The Death of Mettius Fufetius (Livy 1,28): Studies in Roman Lustration—Ritual I." In *Meddelingen van het Nederlands Instituut te Rome* 37: 97–115.

———. 1980. "Destruction, *Devotio* and Despair in a Situation of Anomy: The Mourning for Germanicus in Triple Perspective." In *Perennitas: Studi in onore di Angelo Brelich*. Rome. 541–618.

———. 1993. "Saturn and the *Saturnalia*: The Question of Origin." In *Inconsistencies in Greek and Roman Religion: Transition and Reversal in Myth and Ritual*. Vol. 2. Leiden. 136–227.

Versnel, H., and W. Eisenhut. 2013. "Argei." In *BNP*, http://referenceworks.brillonline.com/entries/brill-s-new-pauly/argei-e134200.

Vetter, E. 1953. *Handbuch der italischen Dialekte*. Vol. 1. Heidelberg.

Veyne, P. 1990. "Images de divinités tenant une phiale ou patère. La libation comme 'rite de passage' et non pas offrande." *Metis* 5: 17–30.

Vial, C. 1984. *Délos indépendante (314–167 av. J.-C.): Étude d'une communauté civique et de ses institutions*. Paris.

Viglietti, C. 2007. "*Lares* poco familiari." *Lares* 73.3: 553–70.

Vine, B. 1993. *Studies in Archaic Latin Inscriptions*. Innsbruck.

Virlouvet, C. 1995. *Tessera frumentaria. Les procédures de la distribution du blé public à Rome*. Rome.

———. 2009. *La plèbe frumentaire dans les témoinages épigraphiques: essai d'histoire sociale et administrative du people de Roma antique*. Rome.

Von Hesberg, H. 1978. "Archäologische Denkmäler zum römischen Kaiserkult." *ANRW* 2.16.2: 911–95.

———. 1988. "Die Veränderung des Erscheinungsbild der Stadt Rom unter Augustus." In *Kaiser Augustus und die verlorene Republik. Eine Ausstellung im Martin-Gropius-Bau, Berlin, 7 Juni–14 August 1988*. Mainz. 93–115.

Von Premerstein, 1937. *Vom Werden und Wesen des Prinzipats*. Munich.

Vos, M. de. 1982. "Pavimenti e pitture. Terzo e quarto stile negli scarichi trovati sotto i pavimenti." *MDAI(R)* 89: 315–52.

Wachter, R. 1987. *Altlateinische Inschriften. Sprachliche und epigraphische Untersuchungen zu den Dokumenten bis etwa 150 v. Chr*. Bonn.

Walbank, F. 1940. *Philip V of Macedon*. Cambridge.

Wallace-Hadrill, A. 1987. *Time for Augustus: Ovid, Augustus and the* Fasti. In *Homo viator: Classical Essays for John Bramble*, ed. M. Whitby. Bristol. 221–30.

———. 1994. *Houses and Society in Pompeii and Herculaneum*. Princeton, NJ.

———. 1995. "Public Honor and Private Shame: The Urban Texture of Pompeii." In *Urban Society in Roman Italy*, ed. T. J. Cornell and Kathryn Lomas. London. 39–62.

———. 2003. "The Streets of Rome as a Representation of Imperial Power." In *The Representation and Perception of Roman Imperial Power*, ed. L. De Blois, P. Erdkamp, O. Heckster, G. de Kleijn, and S. Mols. Amsterdam. 189–204.

———. 2008. *Rome's Cultural Revolution*. Cambridge.

———. 2011. *Herculaneum: Past and Future*. London.

Wardle, D. 2006. *Cicero On Divination:* De Divinatione Book 1, *Translated with Introduction and Historical Commentary*. Oxford.

———. 2014. *Suetonius: Life of Augustus,* Vita Divi Augusti. Oxford.

Warmington, E. H. 1935. *Remains of Old Latin*. 4 vols. Cambridge, MA.

Watson, A. 1971. *The Law of Succession in the Later Roman Republic*. Oxford.

Weinstock, S. 1971. *Divus Julius*. Oxford.

Welch, K. 1999. "Subura." In *Lexicon Topographicum Urbis Romae*, vol. 4, ed. E. M. Steinby. Rome. 379–83.

Wescoat, B. D. 2013. "*Insula Sacra*: Samothrace between Troy and Rome." In *Roman Power and Greek Sanctuaries: Forms of Interaction and Communication*, ed. M. Galli. Athens. 45–81.

Wiater, N. 2014. *Dionysius von Halikarnass. Römische Frühgeschichte*. Vol. 1. Stuttgart.

Williams, R. D. 1960. *P. Vergili Maronis Aeneidos liber quintus*. Oxford.

Wiseman, T. P. 1994. "The Senate and the *Populares*, 69–60 B.C." In *The Cambridge Ancient History* 2nd edition, vol. 9, ed. J. A. Crook, A. Lintott, and E. Rawson Cambridge. 327–67.

———. 1995a. *Remus: A Roman Myth*. Cambridge.

———. 1995b. "The God of the Lupercal." *JRS* 85: 1–22.

———. 2009. *Remembering the Roman People: Essays on Late-Republican Politics and Literature*. Oxford.

Wilson, A., and M. Flohr (eds.). 2016. *Urban Craftsmen and Traders in the Roman World.* Oxford.

Wiseman, T. P. 2013. "The Palatine, from Evander to Elagabalus." *JRS* 103: 234–68.

Wiseman, T. P., and A. Wiseman. 2011. *Ovid: Times and Reasons. A New Translation of the Fasti.* Oxford.

Wissowa, G. 1912. *Religion und Kultus der Römer.* Munich.

Yakobson, A. 1999. *Elections and Electioneering in Rome: A Study in the Political System of the Late Republic.* Stuttgart.

Yavetz, Z. 1983. *Julius Caesar and His Public Image.* London.

Zanda, E. 2011. *Fighting Hydra-like Luxury: Sumptuary Regulation in the Roman Republic.* London.

Zanker, P. 1970–71. "Über die Werkstätten augusteischer Larenaltäre und damit zusammenhängende Probleme der Interpretation." *BCAR* 82: 147–55.

———. 1988. *The Power of Images in the Age of Augustus.* Ann Arbor, MI.

Zarmakoupi, M. 2013. "The City of Late Hellenistic Delos and the Integration of Economic Activities in the Domestic Sphere." *CHS Research Bulletin* 1, no. 2. http://nrs.harvard.edu/urn-3:hlnc.essay:ZarmakoupiM.The_City_of_Late_Hellenistic_Delos.2013.

Zeggio, S., and G. Pardini. 2007. "Roma—Meta Sudans. I monumenti, lo scavo, la storia." http://www.fastionline.org/docs/FOLDER-it-2007-99.pdf.

Zevi, F. 1995. "Tempio D del Largo Argentina: tempio delle Ninfe in Campo?" *Archeol. Laziale* 12.1: 135–43.

———. 1997. "Il tempio dei lari permarini, la Rome degli Emilii e il mondo Greco." *MDAIR* 104: 81–115.

———. 2014. "Giove Statore in Palatio." In *Scritti in onore di Lucos Cozza, Lexicon Topographicum Urbis Romae* Suppl. 7, ed. R. Coates-Stephens and L. Cozza. Rome. 49–61.

Ziólkowski, A. 1998–99. "Ritual Cleaning-up of the City: From the Lupercalia to the Argei." *Ancient Society* 29: 191–218.

———. 2004. Sacra Via: *Twenty Years After.* Warsaw.

INDEX

aedes. See Temple

aedile, 95, 143, 149, 198–99, 203, 210–13, 224; Agrippa as, 258–59, 265, 269

Aemilius Regulus, Lucius (praetor 189 BC), 91–103

Aeneas, 108; at Anchises' tomb, 67–70, 308–9; on Ara Pacis Augustae relief, 324–26; and prodigious sow, 106; as *lar*, 14–16, 350, and *penates*, 8, 53, 97; shield of, 171, 260

Afranius, Lucius (playwright) 5, 25, 27, 171

Agrippa, Marcus Vipsanius, 259

altar (*ara*): Amiternum, 348; of Augustan Peace (*see* Ara Pacis Augustae); Belvedere, 256, 272, 275–82, 291, 328, 341, 345; bulls on fragmentary altars, 303–4, 311–15; of Concordia Augusta, 325–34, 342; of Consus, 92, 103–4, 112–15, 163; on Delos, 183–91; of Fortuna Redux, 320, 341; of Manlius, from Caere, 83, 311–12; Mercury and Maia, 111, 181–82, 214–15; in Pompeii, 47–48; in Rome 116–36, 192, 250–54; Soriano, 311–12; Vatican (Sala delle Muse), 288, 304–6, 316; Venus Augusta, 331–32; of the Vicus Aesculeti, 208, 311–16, 330, 337; of the Vicus Censori (Tiber Island), 284–86, 318; of the Vicus Sandalarius, 256, 279–82, 288, 291–98, 330; of the Vicus Statae Matris, 286–88, 318, 329–330; of Zethus, from the Campus Martius, 333–35

Antiochus III, king, 91–103

Apollo Sandalarius, 138, 264–66, 272

Ara Pacis Augustae, 287, 320–29, 316; dedication day, 336, 343–44; and Zethus altar 334–35

Ariminum, 226–27

Arnobius of Sicca, 7–10, 108

Arval brothers (and hymn), 5, 18, 22–25, 30, 37, 49, 86, 88, 103, 114, 126, 157–58, 168, 171, 310–11, 313, 317, 336, 350

as (bronze coin), 78–85

atrium, ix, 4, 11, 26, 33, 48–51, 62, 81–82

Augustus (Octavian before 27 BC), ix, xi, 89, 115; and august deities, 256, 271, 329–35; bans *collegia*, 247; and census in the neighborhoods, 119–20, 202–4, 260–61; flower festivals, his new, xi, 109, 273–74, 289, 339, 350; and irregular eras in the *vici*, 343–44; and *lares*, 46, 61, 86, 90–91, 111, 119–20, 126, 254, 284–98; and *lares augusti*, 136, 255–347; and *lares praestites*, 110; and *ludi compitalicii*, 249, 262–63, 273; Meta Sudans fountain and shrine (Compitum Fabricium), 127–31, 137, 269, 274; *numen Augusti*, 307–9; as *pontifex maximus* (from 12 BC), 263–78, 316, 320, 324, 344, 347; reform of 7 BC, 118, 136, 148, 156, 166, 190, 199, 206, 256–57, 271–83, 335–39, 343–45; restores temple of the *lares summa sacra via*, 90–91, 102; and Rome (before 7 BC), 194, 258–70; and *stips*, 237, 263–70, 283, 291, 332, 335, 346; time and calendar, 336–45, 359–60; triple triumph in 29 BC, 260–61, 274, 337, 340, 342; and *vigils* (fire-fighters), 134, 195, 224; restores Volcanal, 111. *See also* Compitum Acilium; Compitum Fabricium

Bacchanalia, 222–23

birthday, 6, 8, 75, 269, 303–4, 307, 320, 336–37

boxers, on Delos, 185–86

bride, 4, 34, 76–85, 116, 165, 169, 202, 294–95, 350

bulla, 38, 83–84, 311

Cabiri (Great Gods of Samothrace), 8, 97–98, 111, 158

calendar: for Circus Maximus rituals, 113; on the farm, 40–45, 165, 357; at Rome 91, 96, 110, 126, 162–65, 234, 252–54, 256, 262–63, 272, 307–8, 336–39, 342, 347; for wedding season, 79

Capua, x, 77, 161, 175, 191, 226–29, 231, 248

Caristia, festival of, 11, 58, 307

Cassius Hemina, Gaius, 5, 25, 28, 105–8, 125

Cato, the Elder (Marcus Porcius Cato), 5, 16, 20, 25, 28–30, 35–37, 40–47, 49, 53, 55, 58–59, 64, 74–75, 96, 106, 125–26, 160, 162, 165, 169–70, 176, 208–9, 311, 317, 350

Censorinus, 6–7, 56, 299, 304, 308

censors and local shrines, 142–43

census, 76, 118, 148, 169–70, 202–4, 232, 234, 254, 260–61, 263, 289, 317, 319, 339, 341–42, 345

Clodius Pulcher, Publius (tribune of the plebs 58 BC), xi, 100, 132, 216, 225, 239, 241–49

IMAGE CREDITS

Figures

Frontispiece. Photo Dutton.

I.1. Author photograph. By permission of the Ministero dei beni e delle attività culturali e del turismo—Soprintendenza Speciale per il Colosseo, il Museo Nazionale Romano e l'Area archeologica di Roma.

I.2. From Boyce 1937, pl. 31.1. Photograph Marquand Library of Art and Archaeology, Princeton University. Photo John Błażejewski, Princeton University.

I.3. Rosalind Flower.

I.4. From Mazois 1824, vol. 2, plate 24.2. Marquand Library of Art and Archaeology, Princeton University. Photo John Błażejewski, Princeton University.

I.5. Collection of W. Bruce and Delany H. Lundberg. Used by permission.

I.6. From *Le pitture antichi di Ercolano* (1757), p. 207, plate 38. Marquand Library of Art and Archaeology, Princeton University. Presented by Dr. Allan Marquand. Photo John Błażejewski, Princeton University.

II.1. Photo Oscar Savio. Archivio Fotografico dei Musei Capitolini, Rome.

II.2. Photo Oscar Savio, Archivio Fotografico dei Musei Capitolini, Rome.

II.3. Margaret Andrews.

II.4. Joshua Fincher.

II.5. Courtesy of Nomos AG, Zurich.

II.6. Photo © Vatican Museums. All rights reserved. Vat. neg. XXVIII.4.81.

II.7. Rosalind Flower.

II.8. Fototeca Unione, American Academy in Rome, FU.1691.

II.9. Fototeca Unione, American Academy in Rome, FU.6086.

II.10. Fototeca Unione, American Academy in Rome, Alinari 6745.

II.11. Margaret Andrews.

II.12. Margaret Andrews.

II.13. Margaret Andrews.

II.14. Margaret Andrews.

II.15. Fototeca Unione, American Academy in Rome, FU.1952/257.

II.16. From Hülsen 1906, p. 195, fig. 111. Marquand Library of Art and Archaeology, Princeton University. Photo John Błażejewski, Princeton University.

II.17. Rosalind Flower.

II.18. Fototeca Unione, American Academy in Rome, FU.260.

II.19. Fototeca Unione, American Academy in Rome, FU.11217.

II.20. Fototeca Unione, American Academy in Rome, FU.9069.

II.21. From Mazois 1824, Vol. 2, Plate 2.1. Marquand Library of Art and Archaeology, Princeton University. Photo John Błażejewski, Princeton University.

II.22. From Breton 1855, p. 288. Marquand Library of Art and Archaeology, Princeton University. Gift of Chas. G. Rockwood, Jr. 1879 for the Elizabeth Foundation. Photo John Błażejewski, Princeton University.

III.1. Margaret Andrews.

III.2. Joshua Fincher.

III.3. From Bulard 1908, p. 38, fig. 14. Marquand Library of Art and Archaeology, Princeton University. Photo John Błażejewski, Princeton University.

III.4. From Vallois 1923, plate XII. Marquand Library of Art and Archaeology, Princeton University. Photo John Błażejewski, Princeton University.

III.5. Joshua Fincher.

III.6. From Bulard 1926, No. 25, plate 13.1. Marquand Library of Art and Archaeology, Princeton University. Photo John Błażejewski, Princeton University.

III.7. From Bulard 1926, No. 25, fig. 49. Marquand Library of Art and Archaeology, Princeton University. Photo John Błażejewski, Princeton University.

III.8. From Bulard 1926, No. 25 fig. 54. Marquand Library of Art and Archaeology, Princeton University. Photo John Błażejewski, Princeton University.

III.9. From Bulard 1926, No. 27, plate XVII.2. Marquand Library of Art and Archaeology, Princeton University. Photo John Błażejewski, Princeton University.

III.10. From Bulard 1926, No. 27, plate XVIII. Marquand Library of Art and Archaeology, Princeton University. Photo John Błażejewski,Princeton University.

III.11. Rosalind Flower.

III.12. Rosalind Flower.

III.13. Photo Werner Hermann (from the archive of R.E.A. Palmer).

III.14. Rosalind Flower.

III.15. By permission of the of the Ministero dei Beni e delle Attività Culturali e del Turismo—Soprintendenza Speciale per il Colosseo, il Museo Nazionale Romano e l'Area archeologica di Roma.

III.16. From Johnson 1933, No. 15, fig. 20, p. 33. Marquand Library of Art and Archaeology, Princeton University. Photo John Błażejewski, Princeton University.

III.17. Courtesy of Massimo Ossana, Director General of the Soprintendenza of the Archaeological Sites of Pompeii, Herculaneum, and Stabia, and Amsterdam University Press.

III.18. By permission of the Ministero dei Beni e delle Attività Culturali e del Turismo—Museo Archeologico Nazionale di Napoli.

IV.1. Margaret Andrews. From Andrews and Flower 2015, fig. 16, by permission of the *American Journal of Archaeology*.

IV.2. Margaret Andrews. From Andrews and Flower 2015, fig. 15, by permission of the *American Journal of Archaeology*.

IV.3. By permission of the Ministero dei Beni e delle Attività Culturali e del Turismo—Museo Archeologico Nazionale di Napoli.

IV.4. Photo © Vatican Museums. All rights reserved. VAT. II.3.14.

IV.5. Photo © Vatican Museums. All rights reserved. VAT. II.2.22.

IV.6. Photo © Vatican Museums. All rights reserved. VAT. II.2.21.

IV.7. Photo © Vatican Museums. All rights reserved. VAT. II.2.23.

IV.8. Photo © Vatican Museums. All rights reserved. VAT. A.17.1.

IV.9. Photo © Vatican Museums. All rights reserved. VAT. XXV. 9.35.

IV.10. Photo by C. Rossa, Neg. D-DAI-Rom 76.1748.

IV.11. Photo Oscar Savio, Archivio Fotografico dei Musei Capitolini, Rome.

IV.12. Photo Oscar Savio, Archivio Fotografico dei Musei Capitolini, Rome.

IV.13. By permission of the Ministero dei Beni e delle Attività Culturali e del Turismo, Florence. Uffizi neg. 14575.

IV.14. By permission of the Ministero dei Beni e delle Attività Culturali e del Turismo, Florence. Uffizi neg. 141578.

IV.15. By permission of the Ministero dei Beni e delle Attività Culturali e del Turismo, Florence. Uffizi neg. 5693.

IV.16. By permission of the Ministero dei Beni e delle Attività Culturali e del Turismo, Florence. Uffizi neg. 14575.

IV.17. Photo © Vatican Museums. All rights reserved. VAT XXI.25.13.

IV.18. Photo © Vatican Museums. All rights reserved. VAT XXI.25.14.

IV.19. Photo Oscar Savio, Archivio Fotografico dei Musei Capitolini, Rome.

IV.20. Photo Oscar Savio, Archivio Fotografico dei Musei Capitolini, Rome.

IV.21. Photo © Vatican Museums. All rights reserved. VAT.92VAT229.

IV.22. Photo by G. Singer, Neg. D-DAI-Rom 72.647.

IV.23. Photo by G. Singer, Neg. D-DAI-Rom 72.648.

IV.24. Photo by B. Malter, Cologne Digital Archaeology Laboratory, Mal1089-04. http://arachne.uni-koeln.de/item/marbilder/7246977.

IV.25. Photo © The Trustees of the British Museum, London.

IV.26. By permission of the Ministero dei Beni e delle Attività Culturali e del Turismo—Museo Archeologico Nazionale di Napoli.

IV.27. By permission of the Ministero dei Beni e delle Attività Culturali e del Turismo—Soprintendenza Speciale per il Colosseo, il Museo Nazionale Romano e l'Area archeologica di Roma.

IV.28. Photo Oscar Savio, by permission of the Ministero dei beni e delle attività culturali e del turismo—Soprintendenza Speciale per il Colosseo, il Museo Nazionale Romano e l'Area archeologica di Roma.

Plates

Plate 1. From Mazois 1824, Vol. 3, Plate 7.1. Heidelberg University Library, C 3612 Gross RES:3–4.

Plate 2. Photograph Laura Shea, by permission of the Mount Holyoke College Art Museum.

Plate 3. By permission of the J. Paul Getty Museum, Villa Collection, Malibu, California.

Plate 4. Author photograph. By permission of the Ministero dei Beni e delle Attività Culturali e del Turismo—Soprintendenza Pompei.

Plate 5. From V. Spinazzola, ed. 1953. *Pompei alla luce degli scavi nuovi di Via dell'Abbondanza*. Plate XII. Marquand Library of Art and Archaeology, Princeton University. Barr Ferree Collection. Photo John Błażejewski, Princeton University. Courtesy of the Istituto Poligrafico e Zecca dello Stato, Rome.

Plate 6. By permission of the Ministero dei Beni e delle Attività Culturali e del Turismo—Museo Archeologico Nazionale di Napoli.

Plate 7. By permission of the Ministero dei Beni e delle Attività Culturali e del Turismo—Soprintendenza Pompei.

Plate 8. Author photograph. By permission of the Ministero dei Beni e delle Attività Culturali e del Turismo—Soprintendenza Pompei.

Plate 9. Author photograph. By permission of the Ministero dei Beni e delle Attività Culturali e del Turismo—Soprintendenza Pompei.

Plate 10. Author photograph. By permission of the Ministero dei Beni e delle Attività Culturali e del Turismo—Soprintendenza Pompei.

Plate 11. Author photograph. By permission of the Ministero dei Beni e delle Attività Culturali e del Turismo—Soprintendenza Pompei.

Plate 12. Author photograph. By permission of the Ministero dei Beni e delle Attività Culturali e del Turismo—Soprintendenza Pompei.

Plate 13. Author photograph. By permission of the Ministero dei Beni e delle Attività Culturali e del Turismo—Soprintendenza Pompei.

Plate 14. Author photograph. By permission of the Ministero dei Beni e delle Attività Culturali e del Turismo—Soprintendenza Pompei.

Plate 15. Author photograph. By permission of the Ministero dei Beni e delle Attività Culturali e del Turismo—Soprintendenza Pompei.

Plate 16. By permission of the Ministero dei Beni e delle Attività Culturali e del Turismo—Museo Archeologico Nazionale di Napoli.

Plate 17. From V. Spinazzola, ed. 1953. *Pompei alla luce degli scavi nuovi di Via dell'Abbondanza*. Plate I. Marquand Library of Art and Archaeology, Princeton University. Barr Ferree Collection. Photo John Błażejewski, Princeton University. Courtesy of the Istituto Poligrafico e Zecca dello Stato, Rome.

Plate 18. From V. Spinazzola, ed. 1953. *Pompei alla luce degli scavi nuovi di Via dell'Abbondanza*. Plate III. Marquand Library of Art and Archaeology, Princeton University. Barr Ferree Collection. Photo John Błażejewski, Princeton University. Courtesy of the Istituto Poligrafico e Zecca dello Stato, Rome.

Plate 19. From V. Spinazzola, ed. 1953. *Pompei alla luce degli scavi nuovi di Via dell'Abbondanza*. Plate XVIII. Marquand Library of Art and Archaeology, Princeton University. Barr Ferree Collection. Photo John Błażejewski, Princeton University. Courtesy of the Istituto Poligrafico e Zecca dello Stato, Rome.

Plate 20. From V. Spinazzola, ed. 1953. *Pompei alla luce degli scavi nuovi di Via dell'Abbondanza*. Plate IV. Marquand Library of Art and Archaeology, Princeton University. Barr Ferree Collection. Photo John Błażejewski, Princeton University. Courtesy of the Istituto Poligrafico e Zecca dello Stato, Rome.

Plate 21. © Roma, Sovrintendenza Capitolina ai Beni Culturali. Antiquarium Comunale—Archivio Fotografico dei Musei Capitolini, Rome.

Plate 22. From Bulard 1926, no. 10, pl. 19. Marquand Library of Art and Archaeology, Princeton University. Photo John Błażejewski, Princeton University.

Plate 23. Courtesy of the Ephor for Antiquities of the Cyclades. © Hellenic Ministry of Culture, All Rights Reserved.

Plate 24. By permission of the Ministero dei Beni e delle Attività Culturali e del Turismo—Soprintendenza Speciale per il Colosseo, il Museo Nazionale Romano e l'Area archeologica di Roma.